PII OP2116

D1353576

The Other Hogarth

BRITISH MUSEUM
WITHDRAWN
2001
DEPARTMENT OF
PRINTS AND DRAWINGS

Princeton University Press Princeton and Oxford

The Other Hogarth

Aesthetics of Difference

Edited by
Bernadette Fort
and Angela Rosenthal

Cover illustration: Simon François Ravenet after William Hogarth, *Marriage A-la-Mode,* Plate 4, *The Toilette*, 1745. (Detail of pl. M4)

Details used on divider pages:
Title Page: William Hogarth, *The Analysis of Beauty,*
 Plate 2, 1753 (fig. 22)
Plates Section: William Hogarth, *A Rake's Progress,*
 Plate 8, 1735 (pl. R8)
Part I: William Hogarth, *A Harlot's Progress,*
 Plate 2, 1732 (pl. H2)
Part II: William Hogarth, *A Rake's Progress,*
 Plate 2, 1735 (pl. R2)
Part III: Bernard Baron after William Hogarth, *Marriage
 A-la-Mode,* Plate 3, *The Inspection,* 1745 (pl. M3)
Part IV: William Hogarth, *The Four Times of Day,*
 Plate 2, *Noon,* 1738 (fig. 18)

The plates of *A Harlot's Progress, A Rake's Progress,* and *Marriage A-la-Mode* are reproduced in full on pp. 16–35.

Published by Princeton University Press,
41 William Street, Princeton, New Jersey 08540
In the United Kingdom: Princeton University Press,
3 Market Place, Woodstock, Oxfordshire OX20 1SY
www.pup.princeton.edu

Copyright © 2001 Princeton University Press. All Rights Reserved. No part of this book may be reproduced in any form or by any electronic or mechanical means, including information storage or retrieval systems, without permission in writing from the publishers, except by a reviewer who may quote brief passages in a review.

Publication of this book has been made possible in part through grants from the Northwestern University Research Grants Committee, the Dean of the Faculty Office at Dartmouth College, and the International Fine Print Dealers Association, Inc. We gratefully acknowledge this assistance.

Designed and typeset by Bessas & Ackerman
Printed by South China Printing

Printed in Hong Kong
(Cloth) 10 9 8 7 6 5 4 3 2 1
(Paper) 10 9 8 7 6 5 4 3 2 1

Library of Congress Cataloging-in-Publication Data

The other Hogarth: aesthetics of difference / edited by Bernadette Fort and Angela Rosenthal.
p. cm.
Includes bibliographical references and index.
ISBN 0-691-01012-9 (cloth: alk. paper)—
ISBN 0-691-01013-7 (pbk: alk. paper)
1. Hogarth, William, 1697–1764—Criticism and interpretation. 2. Hogarth, William, 1697–1764—Aesthetics. 3. Gender identity in art. 4. Femininity in art. 5. Women in art. 6. Racism in art. 7. Women—Europe—Social life and customs—18th century—Caricatures and cartoons. 8. English wit and humor, Pictorial. I. Fort, Bernadette. II. Rosenthal, Angela.

NE642.H6 O87 2001
769.92—dc21 00-051496

Contents

Contents

Acknowledgments

Many institutions and individuals have incurred our debt along the way; without them this volume would not have made it to press in this form. For their generous subventions, we would like to thank three institutions: Dartmouth College, Northwestern University, and the International Fine Print Dealers Association, Inc. It was our goal to reproduce a large number of high-quality, detailed reproductions. The tremendous expense for illustrations makes publishing for scholars in visual culture increasingly difficult. We are all the more grateful, therefore, to a number of individuals at academic institutions who have supported this project by generously supplying excellent photographic reproductions and/or waiving reproduction rights. In this regard, we are especially indebted to Stephanie Cannizzo and Benjamin Blackwell at the Berkeley Art Museum, University of California; Joan Sussler and Richard Williams at the Print Collection, Lewis Walpole Library, Yale University, Farmington, Connecticut; Lord Viscount Boyne and R. C. Roundell, Christie's, North West Midlands and North Wales; and the Hood Museum of Art, Dartmouth College, Hanover, New Hampshire. At the latter institution, Kathleen O'Malley and Jeffrey Nintzel provided invaluable help. Similarly, the staff of the Visual Resources Collection at Dartmouth College, curator Elizabeth O'Donnell, Janice Smarsik, and the staff of the Sherman Art Library, especially librarian Barbara Reed and Susan Jorgensen, as well as Elizabeth Alexander in the Art History Department Office, all deserve our sincere thanks. Above all, we would like to express our gratitude to our colleagues at the Hood Museum, Kathy Hart, a specialist in British print culture whose observations have been particularly welcome, and in the Art History Departments at Dartmouth College and Northwestern University. We wish to offer special thanks to Adrian Randolph, who has supported this project as a reader and a commentator from its inception, and to Hollis S. Clayson, who actively encouraged its publication.

This volume emerged out of a conference convened in conjunction with the 1997 exhibition *Hogarth and Eighteenth-Century Print Culture* in the Mary and Leigh Block Gallery (now Mary and Leigh Block Museum of Art) at Northwestern University. The exhibition and conference were planned as part of the international events marking the 300th anniversary of Hogarth's birth. The goal of both the conference and the exhibition was to explore matters of contemporary relevance in Hogarth's graphic work within the broader context of eighteenth-century print culture, focusing on issues of aesthetics and theatricality, gender and sexuality, representations of race, as well as the decay of the modern city.

The success of the exhibition and the conference led directly to the production of this book, and we would like to thank all the individuals who helped make both possible. Special thanks must go to the graduate students in Angela Rosenthal's seminar at the Department of Art History at Northwestern University who participated in curating the exhibition— Sarah Betzer, Nnamdi Elleh, Gina Fearmonti, Christine Geisler, Dabney Hailey, Stephanie Karamitzoz, Jennifer Pospielovsky, and Ming Tiampo—and to the staff of the Block Gallery, in particular David Mickenberg, the director, and Amy Winter, the collection's curator. We would also especially like to acknowledge the invaluable help provided by R. Russell Maylone, Curator of the Charles Deering McCormick Library of Special Collections, and the staff of Special Collections, at Northwestern University Library, which, with the

loan of one hundred and ten original prints by Hogarth, provided the core of works for the exhibition. We are grateful as well to Russell Maylone for providing the photo CD of the reproductions featured on the web site constructed by the Mary and Leigh Block Museum of Art at Northwestern.

Thanks are also due to all those who contributed to the conference co-organized by Bernadette Fort and Angela Rosenthal, as well as those scholars from England, France, Germany, and the United States who have written essays for the present volume. We would like to acknowledge the extraordinary efforts of Deborah Hodges, whose editorial skills have contributed fundamentally to the present form of the text. Finally, at Princeton University Press, we express our gratitude to Patricia Fidler, Nancy Grubb, Sarah Henry, Devra Kupor, Ken Wong, and Kate Zanzucchi. Sally Hayden copyedited the manuscript, June Cuffner proofread the page proofs, and Martin White prepared the index. We sincerely thank the Editorial Board at Princeton for their endorsement and the anonymous readers of the initial proposal and the final manuscript for their insightful commentary and constructive criticism.

The Other Hogarth

The Analysis of Difference

Bernadette Fort and
Angela Rosenthal

Scene four of Hogarth's *Marriage A-la-Mode*, *The Toilette* (pl. M4), presents an odd assembly of characters in a domestic space. A heterogeneous gaggle of chattering hangers-on has congregated in a well-appointed, if somewhat garish, bedroom to join the young Countess Squanderfield in her morning *levée*. Hogarth's parody of French aristocratic style and taste aped by the British upper class offers, in fact, a constellation of aesthetic, cultural, racial, and sexual difference.

The represented space is literally structured in difference. Continental Old Master paintings depicting scenes of seduction and rape line the walls, and exotic items acquired at an auction are strewn on the carpet. Taking a visual inventory, one notes a microcosm of banal commodities, from Chinese dolls to an ornate screen representing a Turkish masquerade. The heterogeneity of the "English" interior complements and comments on the Countess's attendants and visitors. A French hairdresser fusses with her hair while a German flautist accompanies the bloated Italian castrato. At the back, an "unfeeling fox-hunter" is seated in a slumber, while his wife, Mrs. Lane, passionately admires the castrato.[1] The assembly includes a servant and a page boy, both of African origin. The former offers hot chocolate, while the latter plays with a carved statuette of Actaeon. The scene reveals, by a spectrum of positions, a company defined by class and gender, as well as race, ethnicity, and nationality. Visually, these differences are articulated by the way in which the bodies are marked or made up, dressed or undressed, and how they set themselves in dialogue with one another and with objects through poses, gestures, glances, and even the suggestion of sound (chatting, singing, sipping, and snoring). The identities in this picture do not exist prior to representation, nor do they emerge *sui generis*; rather, they are brought into being through a complex iconographic orchestration based on alterity. The interlacing of references and meaningful juxtapositions make sense within a system of differences. Not marked as fixed, unchanging, or essential, this assortment of peculiar characters and the objects that scaffold their virtual space come into being through complex visual markings that work with and against one another, producing significance.

The Toilette is by no means an exception in Hogarth's work; rather, it is emblematic of the way in which Hogarth articulates his representations on the basis of a complex network of differences by which identities are constructed and deconstructed. The goal of this volume is to trace this network in the interstices of Hogarth's work by drawing on a broad range of critical perspectives, including recent theoretical ones, and turning to fundamental yet often overlooked themes.

In 1997, museums, libraries, and universities in the United States and Europe commemorated the tercentenary of Hogarth's birth with a series of exhibitions and symposia dedicated

to the manifold aspects of his wide-ranging work.[2] Celebrations of and publications on the artist continued into 1999, testifying to Hogarth's enduring popularity with a wide public and with the more rarefied circles of scholarly research.[3] The present volume, which originated in one of these commemorative events—an exhibition and symposium at Northwestern University—brings together well-known scholars in Hogarth studies from the United States, England, France, and Germany, who make a concerted and sustained attempt to address issues of difference in Hogarth's oeuvre.[4]

Publications on Hogarth have usually taken the form of biographies and catalogues providing general introductions to the public and, in some cases, invaluable reference sources for specialists.[5] Substantial studies on Hogarth have, with few exceptions,[6] tended to focus on particular media, such as the graphic arts, painting, and drawing.[7] A range of interpretative studies has placed his work more firmly within art-historical and iconographic traditions, focusing on Hogarth's pictorial sources and artistic references and demonstrating the intellectual and learned dimension of his art.[8] Mining Hogarth's Modern Moral Subjects for their documentary interest, social historians have used Hogarth's representations of family and urban life as precious sources for understanding both high and low life in eighteenth-century London. Literary critics, however, have dominated Hogarth studies—a tradition that dates back to Hogarth's first commentator, Jean André Rouquet, whom Hogarth empowered to give a verbal translation of some of his prints, and to the astute *Commentaries* by the German "physiognomist" Georg Christoph Lichtenberg, who provided detailed, subtle, and incisive interpretations of Hogarth's progresses.[9] Literary critics have since focused on defining and examining Hogarth's brand of moral satire in the context of contemporary lit-

erary satire, at its peak in Hogarth's time with writers such as Swift, Pope, and Fielding.[10] In the wake of structuralist studies, some scholars have emphasized the need to recover the system of polysemic visual signs through which meaning emerges in Hogarth's prints.[11] Because of Hogarth's exuberant incorporation of textual material in a variety of forms and his celebrated "intermedial" visual and verbal games, his engravings have become a staple of "sister arts" criticism. The interconnection in his work of word and image, of visuality and textuality, has been explored in recent Hogarth studies, while an increased emphasis was placed on the dynamic dialogue between the artist's work and other kinds of visual representations.[12]

Instead of privileging the biographical, museographic, art-historical, sociohistorical, or literary-semiotic approaches, *The Other Hogarth* draws on all of these while foregrounding the insights of cultural history and late twentieth-century theories of gender and race. Welcoming the participation of scholars from a broad methodological spectrum and including the testimony of a woman artist of African descent who took Hogarth as her inspiration, *The Other Hogarth* privileges an interdisciplinary approach that draws connections between different strands of critical inquiry. In particular, it addresses a question that has received short shrift in Hogarth scholarship: how did Hogarth, in creating his Modern Moral Subjects, stage relations of difference, of self and otherness, which were at the forefront of British consciousness in the eighteenth century? Except for David Dabydeen's groundbreaking 1985 study, *Hogarth's Blacks*, Marcia Pointon's discussion of Hogarth in *Hanging the Head*, and Christina Kiaer's 1993 article in *Art History* (reprinted in this volume), little attention has been paid to issues of race and gender in Hogarth's work.[13] The lack of sustained inquiry into gender construction in Hogarth's

work is even more surprising, given that Hogarth was part of a culture that sought to define, critique, and legislate gender roles for men and women. The artist also belonged to an intellectual establishment in which views of woman as either saint or whore (Clarissa or Moll Flanders) and issues of "maleness" and "effeminacy" were hotly debated in fiction and satiric verse, elite poetry and popular pamphlets. This was a time when a misogynist ideology was often broadcast by prominent poets such as Swift and Pope.

Hogarth's interest in the roles, functions, professions, and prospects of women in different walks of life, his reflection on ideals of masculinity—or, more often, their failure—emerge in nearly all of his prints and in many of his paintings, yet they have never been the focus of a distinct inquiry. Whether he pictures a shrimp girl, an actress, a wealthy female patron, a fashionable countess, or a gin-addicted woman, or—on the other side of the gender spectrum—a gouty and impotent earl, his effeminate son, or a dissolute rake, Hogarth's work explores the human character in a strikingly modern manner, emphasizing the multiple construction of identities and situating his examination at the heart of the most controversial contemporary social, political, and religious debates. Examining Hogarth's works, we reflect on pressing contemporary issues: consumption and commercialization in an expanding global market, chronic disease of both bodies and societies, and the construction, performance, and masking of identity. It is in large part this productive terrain that *The Other Hogarth* opens up for critical consideration. Focused examinations of key moments and details of his oeuvre, whether they center on a breast, a beauty patch, a fan, a broken nose, or the color of skin, reveal a significantly different Hogarth, indeed an "other" Hogarth than the cozy moralist or the acerbic satirist of official accounts. As James Grantham Turner

points out in this volume, "the moralistic reading of Hogarth—together with the associated tendency to attach unitary, determinate meanings to his images and attitude—has partly given way to a greater sense of his ambiguity." The essays gathered here reveal an artist whose representation of difference is constantly informed by an aesthetics that is itself attuned to subtle gradations and differences, an artist who puts the considerable ammunition of his artistic theory and practice in the service of both creating and uncovering ambiguity.

Crafting the Erotic Body

Hogarth's figurative paintings privilege the human body as a key site for the communication of meaning. The body appears in various guises and functions as a bearer of aesthetic as well as erotic expression and desire, as an iconic reference to actual people inhabiting Hogarth's cultural milieu, and as an articulation of diverse sexual, social, and cultural identities. The body also appears on the one hand as a site of disease and decay, operating as a metaphor for societal corruption, and on the other in its uncorrupted form, as a sign of physical and moral health and productivity.

All essays in this volume emphasize different aspects of corporeal signification. They all recognize, moreover, that meaning is produced in communication within particular contextual frames. Three contributions address Hogarth's crafting of the erotic body, examining how Hogarth's artistic and theoretical language betrays aesthetic and erotic desires that cannot be separated from discourses of gender. These essays complicate our views on Hogarth's erotic depictions. The question of how erotic desire is inscribed into Hogarth's works is traced through his visual and theoretical texts, embracing both the minutiae of Hogarth's artistic praxis and the theorization of desire in his aesthetic writings.

In " 'A Wanton Kind of Chace': Display

as Procurement in *A Harlot's Progress* and Its Reception," James Turner traces Hogarth's self-inscription as an engraver, reading the burin's marks on the copper plate as traces of artistic desire that correlate with his depicted subject. Rather than seeing the linear language of engraving entirely confined to the satirical and moral message of the engraving, Turner argues (against the grain of the dominant interpretation that looked to Hogarth as a moralist) that Hogarth attached a definite erotic charge to the movement of his hand and eye, aligning touches with the burin to a "kind of toilette or primping of the copper plate." Drawing upon Lichtenberg's incisive probing of the engraver's marks, Turner explores the sexualized dichotomy of "spur and touch" in Hogarth's handling of the engraver's tools when he etches his prostitute in *A Harlot's Progress* (1732).

Focusing on the progress of the series and documenting its bawdy lure in the avalanche of literary spin-offs it produced—anecdotes, commentaries, poems, narratives, and theatrical renderings—Turner further expands our understanding of how Hogarth's *Harlot*, like its female protagonist, "circulated" in contemporary print culture. He is thus able to modify the canonical interpretation of this progress as a moral paradigm. He shows that the figure of the prostitute was, from the start, both attractive to the author and made teasingly seductive by him, and that the harlot triggered an erotically charged reception in the public. Thus a male-desiring gaze is seen at work not only in the physical production of Hogarth's plates (or, as Paulson has argued, in Hogarth's oil paintings), but as informing the artist's more abstract aesthetic and philosophical concerns.

In his essay, "The Flesh of Theory: The Erotics of Hogarth's Lines," Frédéric Ogée pursues this line of thinking, demonstrating that the Line of Beauty and its companion, the Line of Grace, as theorized by Hogarth in his *Analysis of Beauty* (1753), reveal the artist's tactile approach to his subject matter.[14] Moving from the artist's craft to the viewer's reception, and guided by Hogarth's aesthetic treatise, Ogée concentrates on the sensual, haptic pleasures of a male viewer. Although Hogarth at times felt that women were better judges of beauty, Ogée recognizes in the Line of Beauty an expression of masculine principles of heterosexual desire, addressing the "emotional" side of an artist who was often held to be a down-to-earth, middle-class English craftsman.[15] Far from being an "abstract metaphysical concept," the Line of Beauty exists, according to Ogée, in dialogue with the physical substance of flesh. The undulating line suggests a gesture of the hand caressing the skin or the "form of nature." Examining a series of paintings of erotic subject matter, Ogée argues that beauty in Hogarth is also experienced by the beholder whose eye travels and creates lines from one character to the other, one plate to the next, and who thus experiences Hogarth's artistic "process" as in flux rather than residing in the final product.

In a similar vein, Christina Kiaer's essay, "Professional Femininity in Hogarth's *Strolling Actresses Dressing in a Barn*," describes Hogarth's Line of Beauty as both an aesthetic form and an expression of erotic investment. While Turner and Ogée posit a male heterosexual viewer often equated with the artist himself, Kiaer is above all concerned with the question of how gender in Hogarth's aesthetic theory complicates the reading of satire. A brand of subliminally misogynist criticism has traditionally read *Strolling Actresses* as a mock-heroic satire on "low-life" actresses aping Augustan ideals, assuming that the print ridiculed the impropriety of working women trying to impersonate goddesses in the midst of the mundane tasks of domesticity and child-rearing. Kiaer proposes an altogether different interpretation, one that is guided and controlled by the reading of gender difference. She argues that the aesthetic strategies at work in

Hogarth's famous representation of actresses support a positive interpretation of women's actions, gestures, and choices and that the print manifests a sympathetic understanding of the resourcefulness and self-enfranchisement displayed by the women. Using *The Analysis of Beauty* as a key text to unlock how deeply aesthetic forms of expression are embedded in discourses of gender and desire, she examines how gender complicates the operation of traditional satire. Like Ogée, Kiaer argues that the language Hogarth employs in this treatise aligns the abstract notion of the serpentine line with that of the human body. The serpentine line becomes the sign "for the movement of desire in narrative." The erotic language is both tamed (or controlled) by aesthetic discourse and revealed in it. It is the use of expressive language that leads her to question the reading of satire in the print. While for Turner the graphic medium is imbued with erotic gesture, for Kiaer it serves to uncouple it from the moral and antifeminist satirical stance prevalent in the texts of Hogarth's contemporaries.

The Anatomy of Difference

Hogarth's famous assertion, "my picture was my stage and men and women my players, who by means of certain actions and gestures, are to exhibit a *dumb shew*,"[16] speaks of a faith in the expressive body to communicate and produce meaning. In his *Analysis of Beauty*, Hogarth states that "action is a sort of language which perhaps one time or other, may come to be taught by a kind of grammar-rules; at present, it is only got by rote and imitation."[17] The four essays addressing "embodied signs" question how, in an urban culture of waxing somatic ambiguity, Hogarth's bodies maintain or fail to maintain their legibility within a system of culturally specific articulations—gestures and expressions, conventions and codes, props and adornments—and in an ever-increasing network of visual communication.

Peter Wagner turns to the appearance of beauty spots on the bodies and faces of Hogarth's characters. Complementing Turner's insights concerning the erotically and sadistically charged gestures of touches and spurs, Wagner traces the meaning of beauty spots within a multivalent semiotic system. In his analysis, spots can "signify warts, (innocuous) moles, or marks left by smallpox"; they can be "read as symptoms of diseases, particularly venereal diseases"; and they can also be "mere" beauty spots or "spots which mark the skin in old age." These natural and artificial body markers produce contradictory information, creating ambivalence and tension. Thus Hogarth's bodies bring into play the various meanings of beauty spots to create "semantic ambiguity undermining both traditional frames of satire and the representation of women."

In "Unfolding Gender: Women and the 'Secret' Sign Language of Fans in Hogarth's Work," Angela Rosenthal perceives the female body and its performative language as central to the production of meaning in Hogarth's oeuvre. Like beauty spots, fans direct the gaze and inflect readings of bodies armed with them. Linked to the commerce of luxury goods and associated with the duplicity of female sexuality, fans were a quintessentially feminine and "foreign" prop. In the hands of women, the unfolding pictures paraded in Hogarth's prints honed desirous gazes, while simultaneously veiling their owners and acting as emblems of female modesty. Rosenthal also turns the issue inside out by considering fan leaves printed with Hogarth's narratives. Often made by and almost exclusively for women, these mass-produced printed visual artifacts present an unacknowledged contribution of women to the economy of luxury, but also to the paper culture and the public sphere, in which Hogarth was a major participant.

Mark Hallett's recent book *The Spectacle of Difference* encouraged a more radical reading of

Hogarth's art within the larger production of early eighteenth-century paper culture.[18] His essay in this volume, "Manly Satire: William Hogarth's *A Rake's Progress*," takes this challenge further and exemplifies Hallett's complex intermedial approach. Viewing Hogarth's *Rake* through a variety of cultural lenses, Hallett develops a concept of Hogarth's "manly satire" as something that "operates across a network of pictorial, spatial, and spectatorial sites, existing both inside and outside the visual frame he produced." Hallett traces the narrative threads linking the contemporary viewer to the image of the Rake, focusing on the performativity of gender in eighteenth-century urban culture. Hallett constructs a history of visual prototypes of the rake in seventeenth-century Dutch and early-eighteenth-century English paintings and engravings, less with a view of celebrating Hogarth's aesthetic superiority than to discover in what ways the artist's reworking of a well-entrenched pictorial narrative of masculine debauchery addressed a specific set of anxieties concerning gender identity in his own time. In so doing, Hallett uncovers a fascinating array of highly differentiated masculine stereotypes, from the fop and the cit, the latter an aspiring bourgeois "slavishly preoccupied with appearance," who "purchases genteel status," to the rake, who "exhausts it."

While Hallett traces "manly" satire in Hogarth, referring specifically to the heterosexual (though not untroubled) debauchery and garrulous excess of the rake, Richard Meyer, in "'Nature Revers'd': Satire and Homosexual Difference in Hogarth's London," acquaints us with a different concept of masculinity in Hogarth's art. Pursuing the question of how Hogarth registers various forms of effeminacy in his depiction of the male body, Meyer, like Turner and Hallett, turns to contemporary popular texts and broadsheets in order to trace a broad-ranging eighteenth-century understanding of homosexuality. In

London, popular curiosity concerning homosexual subgroups significantly increased. As Netta Murray Goldsmith has pointed out, around 1700 there were in London, with its population of over 700,000, enough homosexuals to form coteries, creating a social culture in so-called molly houses, or men's clubs, that acquired a high degree of visibility in the city.[19] Shifting from the "rake" to the "molly," we discover in Hogarth's world allusions to same-sex and all-male ghettoes that demand careful scrutiny. Following Michel Foucault, Meyer, however, cautions against applying twentieth-century concepts of sexual identity in describing mid-eighteenth-century ideas about gender and sexuality.[20] Resisting any simple reading of Hogarth's images, Meyer sees the molly only implicitly represented in Hogarth's art and investigates one such appearance in John Cheere's statuary yard at Hyde Park Corner pictured in *The Analysis of Beauty*. Here, the effeminate dancing master, identifiable as John Essex, propositions the beautifully curved figure of Antinous (fig. 71), seemingly offending the Farnese Hercules, whose "manly" physique towers above the pair.[21]

Cultural Critique

The Antinous in the statuary yard is at the same time an object of beauty, even erotic desire, admired by Hogarth in *The Analysis* as representing the "utmost beauty of proportion," and a profane fake, a simple luxury commodity within the active market fed by contemporary taste for the antique. David Solkin's essay, "The Fetish over the Fireplace: Disease as *genius loci* in *Marriage A-la-Mode*," focuses on a luxury item that could easily have been purchased from John Cheere: the fake marble bust of the second plate of *Marriage A-la-Mode* on the Squanderfields's mantelpiece. Solkin offers a provocative reading of the bust over the fireplace, which "exerts a controlling influence over the bodies and minds of

those individuals who fall beneath its spell," as a symptom of sexual and moral disease.

Solkin addresses the concept of luxury in this progress from a triple point of view: etymological, historical, and anthropological. Relating *luxuria* both to Roman political theory and to the writings of Church Fathers and medieval theologians, Solkin analyzes the confluence in the eighteenth century of its two strands of meaning: "the use of wealth to serve private satisfactions" and the inordinate pursuit of sexual desire known as "lechery." Scanning the profusion of fashionable chinoiseries on the mantelpiece of the second plate, Solkin isolates the antique bust with its repaired nose and interprets it as a commentary on luxury. According to Solkin's penetrating analysis, the broken nose, with its traces of oozing glue still visible, functions in the economy of the painting as a synecdoche for the underlying theme of the whole progress: the venereal and moral disease that attends a life dedicated to the unrestrained pursuit of *luxuria*—that is, excessive and therefore dangerous, material and sexual desire, as exemplified by the Squanderfields.

Also addressing *Marriage A-la-Mode* in a joint essay, which is itself an attractive marriage of sociohistorical and iconographic methodology, Sarah Maza and Sean Shesgreen investigate the conception of marriage and family that underpins Hogarth's famous narrative series. In "Marriage in the French and English Manners: Hogarth and Abraham Bosse," they discuss a major artistic prototype for Hogarth's *Marriage*, Abraham Bosse's *Le Mariage à la ville* (1633, also a story in six plates). Here, too, the notion of difference is at the forefront of inquiry, as the imagery and narrative of marriage in the two series are read in terms of the different matrimonial economies obtaining in seventeenth-century France and eighteenth-century Britain. Shesgreen and Maza argue that, while Hogarth seeks to establish his difference from—indeed,

his superiority over—the French artist in aesthetic terms, he also exploits that difference in the indictment of a foreign cultural practice, that of the marriage of convenience.

Like Solkin, Maza and Shesgreen chart Hogarth's staging of the devastating effects of luxury on the core institution of society, the family. Opposing the sparseness of objects in Bosse's seventeenth-century interiors in *Le Mariage à la ville* to the huge heteroclite jumble of luxury items piled up in all but the last two prints of Hogarth's series—a point which could be made about *A Rake's Progress*, as well as about many other prints and paintings by Hogarth depicting a culture of indiscriminate and pathological acquisition—Maza and Shesgreen suggestively link material infrastructure to cultural values and gender roles in the two societies represented by Bosse and Hogarth. Their comparative approach throws into relief Hogarth's point about the deleterious effects of the consumer economy on the institution of the "marriage of property." It also makes an interesting point concerning the positioning of women within a patriarchal culture based on reproduction, as opposed to one based on commerce. When marriage is mostly about reproduction, as it is in Bosse's suite, the authors point out, women can retain some control. When it is purely about commerce, as in Hogarth's *Marriage A-la-Mode*, they are likely to lose out. Even if Bosse's French culture subjects women to the reproductive ideals of the patriarchy, the outlook for women in eighteenth-century British aristocracy was still bleaker.

Nadia Tscherny's here republished essay, "An Un-Married Woman: Mary Edwards, William Hogarth, and a Case of Eighteenth-Century British Patronage," highlights a fascinating and rare case of female patronage in eighteenth-century England as it bears on Hogarth's work as a portraitist. Tscherny discusses how Mary Edwards, an affluent woman who rejected the bonds of a senseless marriage to

manage her property herself, became a patron of Hogarth. The artist repaid the favor by celebrating her as a rare example of female independence in his famous portrait of 1742. This essay offers an important counterpoint to the examination of the dysphoric British marriage chronicled by Hogarth in *Marriage A-la-Mode*: a self-reliant, financially independent woman, Mary Edwards was the opposite of the merchant girl traded by her father for marriage to an earl. She proved the exception to the rule posited by Maza and Shesgreen.

Like Tscherny's, Kiaer's, and Rosenthal's, Patricia Crown's essay on "Hogarth's Working Women: Commerce and Consumption," explores the artist's representation of the polyvalent roles of women in a culture of increasing commodification. Examining both Hogarth's real and fictional worlds, Crown lays emphasis on the often-neglected contribution of eighteenth-century common women to the production and sale of consumer goods in the new and fast-expanding consumer economy. She reminds us of the presence of women in a variety of trades in Hogarth's own family and underlines Hogarth's own participation in the world of trade at an early stage of his career with his engraving of trade cards. She lists a variety of forgotten female trades that are crucial to the recovery of eighteenth-century material culture and emphasizes how the work performed by women contributed not only to a domestic economy and the early formation of a working-class family, but to the state's economy as well.

Moving from the historical to the visual field, this approach renews interest in such overlooked figures in Hogarth's work as the splendid milkmaid who dominates the left section of Hogarth's *The Enraged Musician* (1741).[22] In this print, as in his celebrated painting *The Shrimp Girl* (c. 1745), Hogarth's glamorization of female street vendors is evidenced by the aesthetic care he lavishes on

them, turning them into compelling pictorial emblems of the graceful "living women," which he sets over even the "Grecian Venus" in *The Analysis of Beauty*. In this context, Crown's reflections on the originality of Hogarth's representation of what is still today called derogatively "women's work" are suggestive. Women's work in the luxury trades brought them into close and daily contact with prostitution, a trend which increased dramatically in the nineteenth century. Significantly, along the path blazed by feminist scholars of prostitution, Crown argues that Hogarth does not join in the misogynous equation of "working girls" with prostitutes that is familiar to his male contemporaries. His images allow for an interpretation of prostitution as an *other* profession in which women are seen performing as skillful and demanding a task as any other bread-winning trade. Thus, while Turner and Hallett give us a rakish Hogarth to behold, Crown, along with Kiaer, emphasizes a Hogarth deeply attuned to the plight of common women exploited by men who turn them into sexual prey.

That Hogarth's art could lead in his time as well as in our own to significantly unstable and shifting perceptions is the subject of Amelia Rauser's essay, "Embodied Liberty: Why Hogarth's Caricature of John Wilkes Backfired." Hogarth's self-appointed position as a political artist has initiated lively debates. In her essay, Rauser shifts from questions of intention and authorship to those of reception and demonstrates the instability of a visual language employed for political means. Basing her case on a close examination of the numerous pamphlets and images printed in the wake of Hogarth's famous caricature of *John Wilkes, Esqr.* in 1763, she argues in favor of a different understanding—indeed, a drastic revision of the afterlife of this print in the highly politicized culture of the time. She reminds us of what historians of the press here and in Europe have stressed: namely, that once launched in

the whirlpool of eighteenth-century print culture, images and words were no longer owned by their originator but could be reworked and reappropriated in ways entirely opposite to the message they were originally made to carry. Rauser's analysis goes beyond the detailed discussion of this one Hogarthian print to address what Hallett describes as a "context of cross-fertilization" between printed and visual artifacts in eighteenth-century culture. In this way, a different understanding of the role of political caricature in mid-eighteenth-century British culture is offered. Replacing a now-obsolete view of Hogarth as reflecting the social reality of eighteenth-century London, this and other essays in this volume, on the contrary, show how his works shaped the culture of his time in unsuspected ways.

Race and Representation

The volume closes with essays that attempt to rethink the significance of Hogarth's work for the construction of what our time has, along with gender, identified as a crucial component of difference: race. Since the publication of David Dabydeen's study of *Hogarth's Blacks*, art history and other disciplines within broadly conceived cultural studies have developed more differentiated methodologies to examine the complex interconnections among race, gender, political, and aesthetic discourses.[23] Recent analyses have insisted on the danger of projecting onto the past ethical and humanitarian considerations that did not obtain for eighteenth-century times. "Race" and "racism," as we now understand these concepts, were categories with quite different (or perhaps even no) currency in Hogarth's world.

In an important essay, David Bindman demonstrated that race cannot be reduced to its "visible" representations of black subjects, but that through the institution of slavery it was nevertheless a presence, "in one sense or another, in virtually all eighteenth-century

British art, because of the decisive economic role [slavery] played in the expansion of the British economy."[24] Civic and national power in England and slave ownership in the West Indies were firmly interconnected throughout the eighteenth century, and "a very large proportion of the wealthy population of England, from the royal family through the aristocracy to relatively small merchants" profited from it "by investing or loaning money."[25]

In his essay in this volume, " 'A Voluptuous Alliance between Africa and Europe': Hogarth's Africans," Bindman underlines the fact that eighteenth-century debate was not about the immorality or inhumanity of slavery—as it would be in the abolitionist movement later on in the century—but about whether slavery was a "natural" attribute of the African or whether he could be educated, disciplined, and, finally, christianized and absorbed into the state. Bindman cautions against the anachronistic and sentimentalizing view that ascribes retrospectively to Hogarth a sympathy for black slaves that it was not in the mental or emotional scope of his time to possess. Examining relevant passages from *The Analysis of Beauty* that are explicitly "non-racist," Bindman draws attention to the artist's uncondescending treatment of the black face or the black body in his work and thus highlights Hogarth's refusal to participate in the ongoing exoticization or aestheticization of the African "other." Paralleling his revisionist approach to the issue of Hogarth's politics,[26] Bindman is able to propose a more muted view of Hogarth as an artist steeped in a culture that depended on slavery, but who, when it came to his art, made no concession to the dominant view of the African as belonging to an inferior brand of humanity.

Quite a few artists in the twentieth century (David Hockney is perhaps the best known) have been inspired by Hogarth's multifaceted art and felt called upon to enter

into dialogue with his representations. To understand how Hogarth speaks to modern-day artists who conceive of their art primarily in terms of difference, whether it is focused on race, class, gender, politics, aesthetics, or some or all of the above categories, we invited the autobiographical testimony of a contemporary artist whose artistic production has been crucially informed by these issues and whose work at one point intersected with Hogarth. An artist of African descent who has worked in Britain for the past two decades, Lubaina Himid experienced the sting and challenge of difference from the moment she entered the British cultural scene and sought to produce and exhibit her work in a white- and male-dominated and fashion-driven world. Aware that Western artists have repeatedly drawn inspiration from Africa, she has often reversed the lens and used the work of Western artists to promote a black consciousness and agency in her own.[27] In 1986, she took scene four of Hogarth's *Marriage A-la-Mode* as a template for her multimedia installation *A Fashionable Marriage*, exhibited in Leeds. The essay she contributes to this volume is an important, sustained retrospective reflection on her reasons for choosing Hogarth as a blueprint for her work. Quoting Michel Foucault's notion that in all relations of power "there is necessarily the possibility of resistance," the black theorist bell hooks insists that the gaze "is and has been the site of resistance for colonized black people globally."[28] What holds true for the history of cinema as theorized by hooks, can also be said for art history—namely, that black women are either not represented at all (in a "negation of black representation") or they are "servants to white people."[29] It is precisely this question that Himid addresses by her transformative appropriation of Hogarth's characters and narrative in *A Fashionable Marriage*. For example, her decision to create an opposition between a black woman artist and a (white)

feminist artist engages the conjugated conflicts of race and gender head on. Similarly, her decision to turn the black servants featured in Hogarth's scene into key actors in control of the gaze in her installation constitutes an important aesthetic and political statement by a black woman artist seeking to come to terms with her post-colonial identity.

In her essay on Himid and Hogarth, "Lubaina Himid's *A Fashionable Marriage*: A Post-Colonial Hogarthian 'Dumb Show,'" Bernadette Fort examines the "oppositional" agenda, the aesthetic, political, and ethical beliefs that both differentiate and unite the self-declared xenophobic male, white, eighteenth-century British artist and the twentieth-century radical feminist artist of African descent. Performing a detailed comparison of scene four of Hogarth's *Marriage A-la-Mode* and Himid's *A Fashionable Marriage* in search of the palimpsistic Hogarthian trace behind the post-colonial "dumb show" staged by Himid, Fort is interested in tracing the extensive web of similarities and differences through which an artistic identity is fashioned in these two works. She examines the set of appropriations, reworkings, and transformations performed by Himid on Hogarth's work to show how she builds on Hogarth's aesthetics of difference and inflects it differently. The satiric stance that these two artists, positioned at two ends of a historical, racial, and gender divide, unexpectedly share is emphasized in the essay by Himid, who writes that she is looking forward to a renewed *alliance* with Hogarth. This shows that there always was and always will be in Hogarth's art a substratum not reducible to any clear-cut party politics, to any fixed ideology, nor to any rigid theory of gender or race. It is this flexible, elusive, hidden, unexpected quantity that insures the workings of difference in his oeuvre and that allows to read through his images toward the broader operations of visual culture in the eighteenth century.

Notes

1. See Lichtenberg 1966, 114–28, for a detailed description of these characters.

2. For an overview of events dedicated to Hogarth during the tercentenary, see Crown 1999, 131–36, Egerton 1998, and "Museums around the UK Celebrate with a Year of Exhibitions," *The Art Newspaper* 8 (April 1997): 24.

3. Two of the most noteworthy publications merging the two publics are Bindman 1997a and Uglow 1997.

4. The editors of this volume co-organized a symposium on *Hogarth and His Times Reconsidered* at Northwestern University in 1997 in coordination with the exhibition *Hogarth and Eighteenth-Century Print Culture*, curated by Angela Rosenthal and a group of graduate students at the Mary and Leigh Block Gallery. The exhibition survives as a popular teaching tool on the internet (http://www.library.nwu.edu/spec/hogarth/main.html).

5. The two main biographies are Paulson 1971 and Uglow 1997. See also Bindman 1981a. Bindman 1997a is the very example of a scholarly publication made accessible to a wide public.

6. See, for example, the collective volumes Möller 1996 and Ogée 1997.

7. For the graphic arts, see Paulson 1965, 1970, 1989a; Burke and Caldwell 1968; Shesgreen 1973; on painting, see Einberg and Egerton 1988; Einberg 1997; McWilliam 1993; on drawing, see Oppé 1948.

8. Antal 1947, 1962; Busch 1977; Carretta 1983; Paulson 1991–93a; Krysmanski 1996; Shesgreen 1983. See also Hallett 1999.

9. Rouquet 1746 and Lichtenberg 1966.

10. Antal 1947, 1952, 1962; Ogée 1997.

11. Ogée 1997; Wagner 1992, 1993a, 1993b, 1995a, 1995b.

12. Wagner 1991b, 1995a, 1995b, 1998. On inscribing Hogarth more firmly within a visual artistic tradition see Hallett 1999, and Hallett and Rauser, this volume.

13. Dabydeen 1985; Pointon 1993; Kiaer 1993. The exhibitions curated by Patricia Crown, *Depictions of Women by Hogarth and his Contemporaries* (Huntington Art Gallery, San Marino, Calif., 1995) and by Rosenthal and graduate students (Block Gallery, Evanston, Ill., 1997) can also be named in this context. See Crown's essay in this volume.

14. For the most recent edition of Hogarth's *Analysis of Beauty*, see Hogarth 1997. The text is edited by Ronald Paulson.

15. Hogarth remarks that "Ladies always speak skillfully of necks, hands and arms; and often will point out such particular beauties or defects in their make, as might easily escape the man of science." For a discussion of this quotation, see R. W. Jones 1998.

16. Hogarth 1955, 209.

17. Quoted in Ronald Paulson's edition of *The Analysis of Beauty*; Hogarth 1997, 104–13.

18. Hallett 1999.

19. Goldsmith 1998, 22.

20. Foucault 1978–86.

21. As Ronald Paulson has pointed out, the heterogeneous display presents itself performatively, since the objects on display appear animated and enter into a dialogue "presenting the statues' unofficial, private off-duty self." See Paulson 1989b, 162.

22. Shesgreen 1973, cat. 47.

23. Dabydeen 1985.

24. Bindman 1994, 69.

25. Ibid.

26. Bindman 1997a.

27. See Fort's essay, this volume.

28. hooks 1992, 116.

29. Ibid., 117.

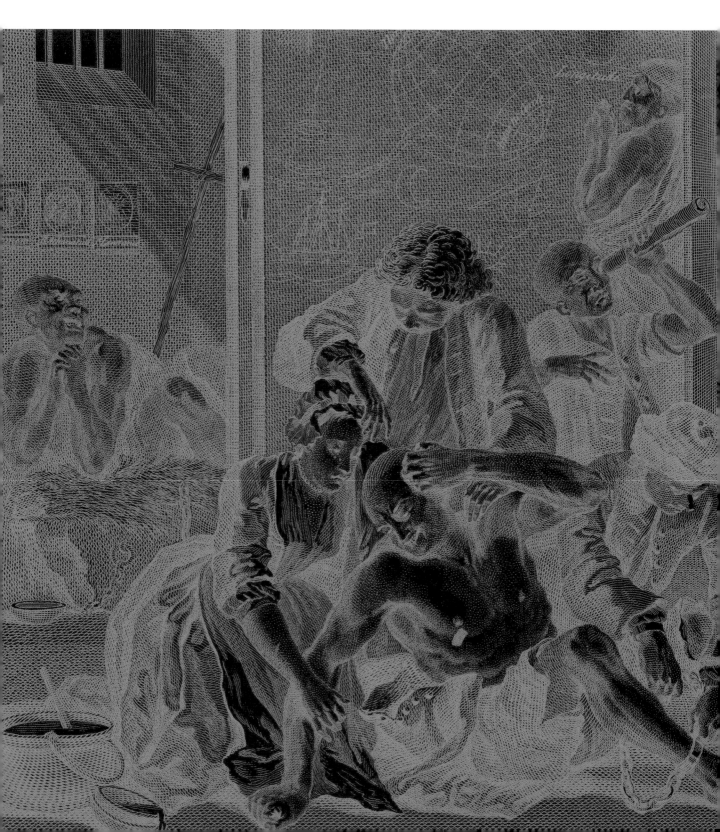

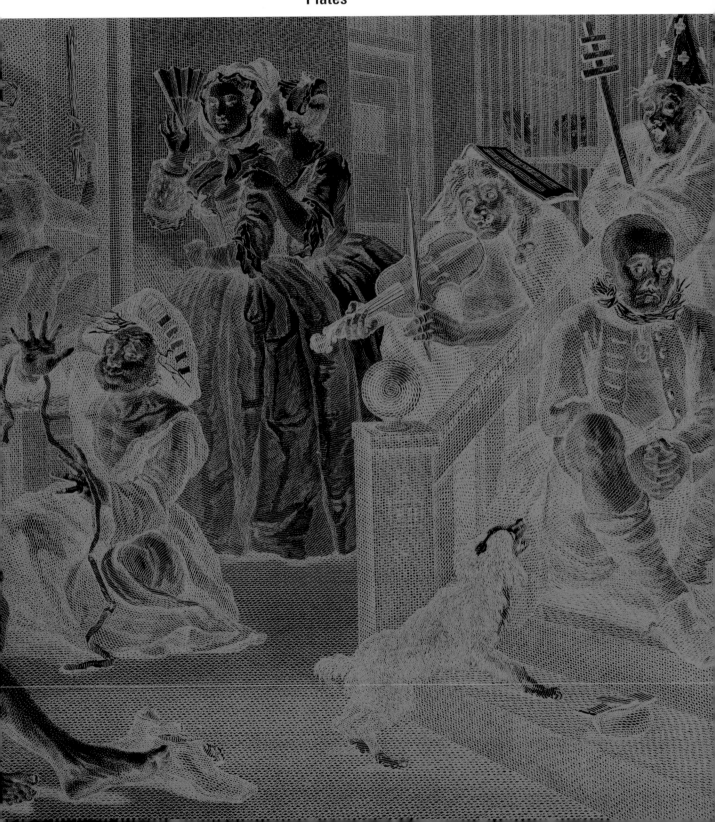

A Harlot's Progress

Plates H1–H6. William Hogarth, *A Harlot's Progress*, 1732. Etching and engraving. University of California, Berkeley Art Museum

Plate H1

A Harlot's Progress Plate 1. Wᵐ Hogarth inv⁴ pinx⁴ et sculp⁴.

Plate H2

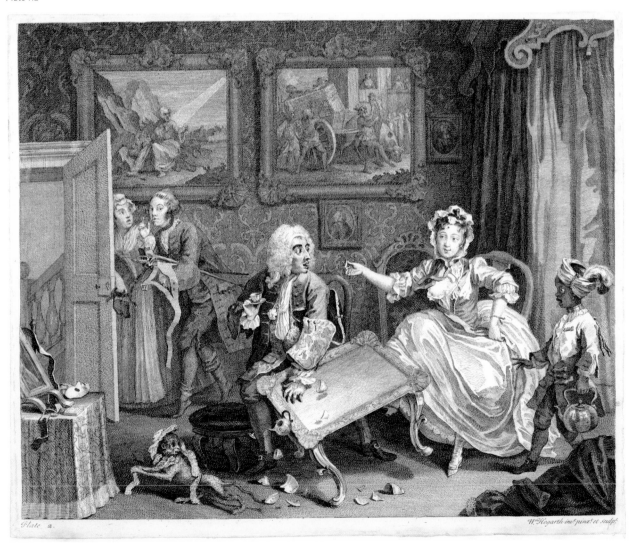

Plate H3

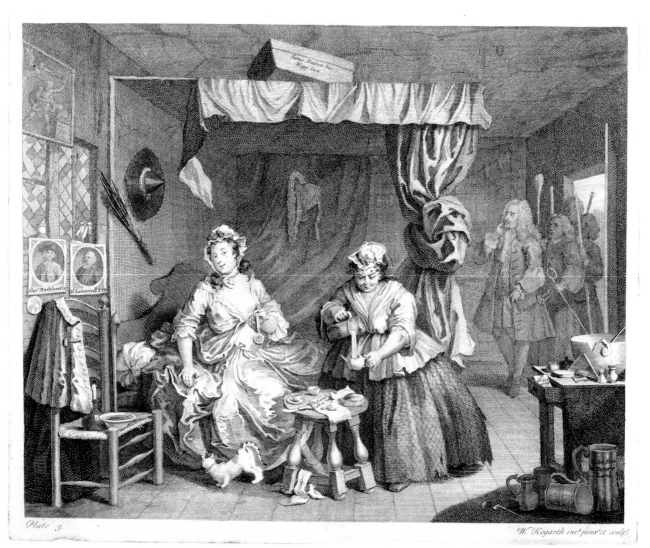

Plate 3. W. Hogarth inv.ᵗ pinx.ᵗ et sculp.

Plate H4

Better to Work
than Stand thus

Plate 4.

W^m. Hogarth inv^t. pinx^t et sculp^t.

Plate H5

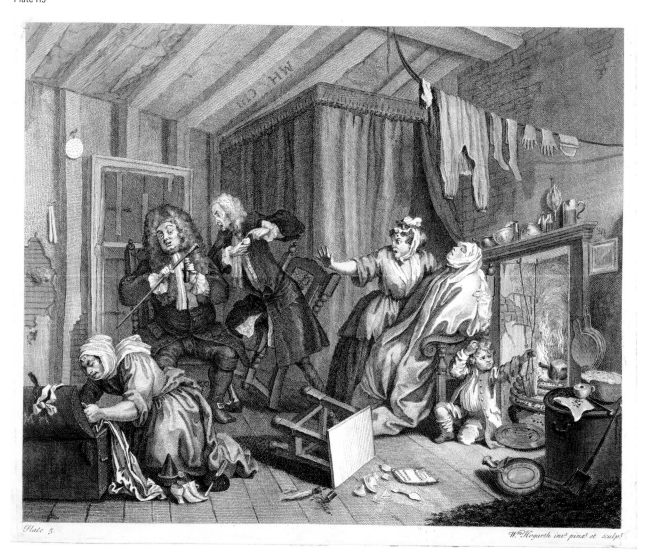

Plate 5. W.ᵐ Hogarth inv.ᵗ pinx.ᵗ et sculp.ᵗ

Plate H6

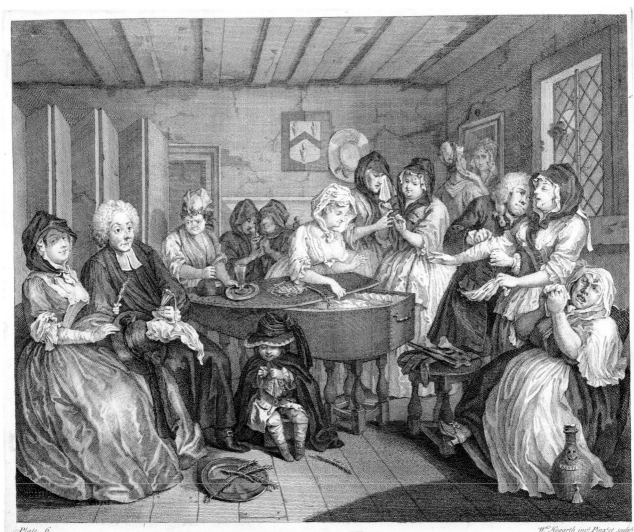

Plate 6.

W.^m Hogarth inv.^t Pinx.^t et sculp.^t

A Rake's Progress

Plates R1–R8. William
Hogarth, *A Rake's Progress*,
1735. Etching and engraving.
University of California,
Berkeley Art Museum

Plate R1

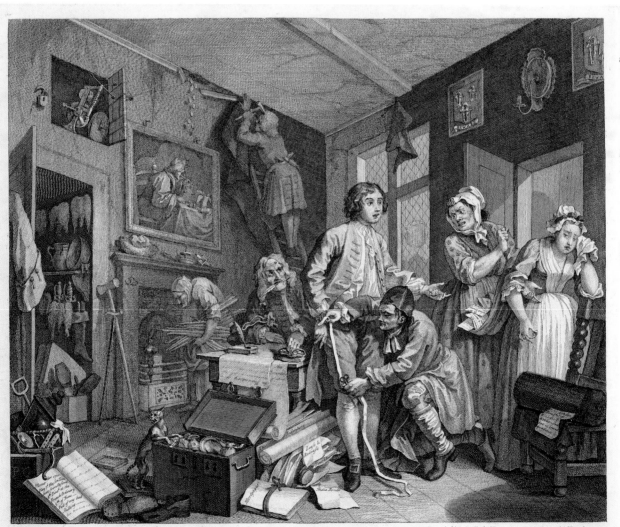

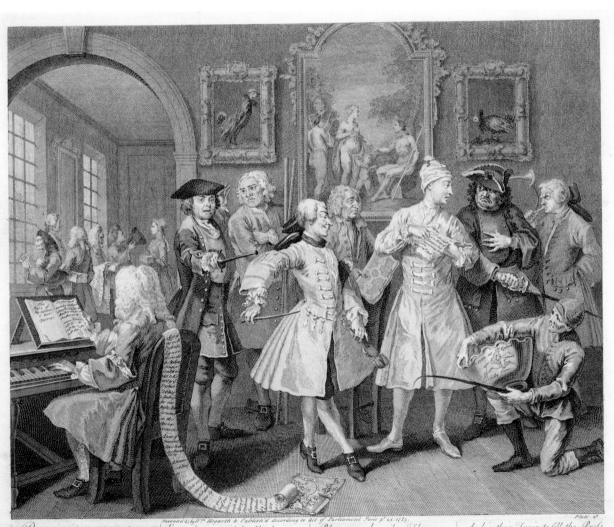

Invented & by W^m. Hogarth & Publish'd according to Act of Parliament June y^e 25. 1735.

Plate 2.

Prosperity, (with Harlot's smiles, | Enter the unprovided Mind, | Pleasure on her silver Throne | And in their Train, to fill the Prefs,
Most pleasing, when she most beguiles,) | And Memory in fetters bind; | Smiling comes, nor comes alone; | Come apish Dance, and swollen Excefs,
How soon, Sweet foe, can all thy Train | Load faith and Love with golden chain | Venus moves with her along; | Mechanic Honour, vicious Taste,
Of false, gay, frantick, loud & vain. | And sprinkle Lethe o're the Brain! | And smooth Lyaeus, ever-young. | And fashion in her changing Vest.

Plate R3

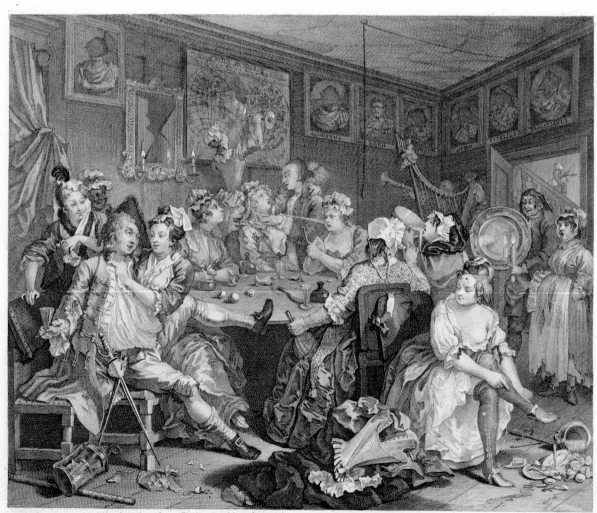

O, Vanity of youthfull Blood, | Source of every Houshold Blessing, | Such Divine to outward Viewing, | With Freedom led to every Part, | To enter in with covert Treason,
So by Misuse to poison Good! | All Charm in Innocence possessing, | Abler Minister of Ruin! | And secret chamber of y. Heart: | O'erthrow the drowsy Guard of Reason,
Woman, form'd for Social Love, | But turn'd to Vice, all Plagues above: | And Thou, no less of Gift divine, | Dost Thou thy friendly Host betray, | To ransack the abandon'd Place,
Fairest Gift of Powers above! | Foe to thy Being, Foe to Love: | Sweet Poison of Misused Wine! | And Shew thy riotous gang y' way | And revel there with wild Excess!

Invented Painted Eng.rav'd & Publish'd by W.m Hogarth June y.e 25. 1735. According to Act of Parlement.

Plate 3.

O Vanity of youthfull Blood,
So by Misuse to poison Good:
Reason awakes, & views unbard
The sacred Gates he watch'd to guard.

Approaching views the Harpy Law,
And Poverty with icy Paw

Ready to seize the poor Remains
That Vice hath left of all his Gains.

Cold Penitence, lame After-Thought,
With Fears, Despair, & Horrors fraught;

Call back his guilty Pleasures dead,
Whom he hath wrong'd, & whom betray'd.

Invented Painted & Engrav'd by W.m Hogarth. & Publish'd June y.e 25. 1735. According to Act of Parliament.

Plate. 4.

New to y̌ School of hard Mishap, What Shames will Nature not embrace Gold can the Charms of youth bestow, Gold can avert y̌ Sting of Shame, Can couple Youth with hoary Age,
Driven from y̌ Ease of Fortune's Lap, T'avoid less Shame of lean Distress? And mask Deformity with Shew, In Winter's Arms create a Flame, And make Antipathies engage.

Invented Painted & Engrav'd by Wᵐ Hogarth & Publish'd June 25, 1735. According to Act of Parliament. ────

Plate 5

Gold, Thou bright Son of Phœbus, Source | No longer Bond of Humankind, | Doubt & Mistrust are thrown on Heaven, | Sad Purchase of a tortur'd Mind.
Of Universal Intercourse; | But Bane of every virtuous Mind, | And all its Power to Chance is given, | To an imprison'd Body join'd!
Of weeping Virtue Sweet Redress, | What Chaos such Misuse attends: | Sad Purchase of repentant Tears,
And blessing Those who live to bless; | Friendship stoops to prey on Friends; | Of needless Quarrels, endless Fears,
Yet oft behold this sacred Trust | Health, that gives Relish to Delight, | Of Hopes & Moments, Pangs of Years!
The Tool of Avaricious Lust. | Is wasted with ye Wasting Night.

Invented Painted & Engrav'd by
Wm Hogarth, & Publish'd June ye 25 1735 According to Act of Parliament.
Sold at ye Golden Head in Leicester Fields Lonn Plate 6.

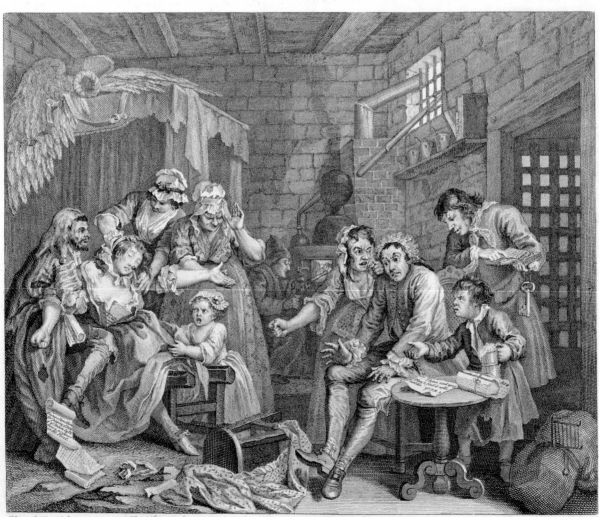

Happy the Man whose constant Thought, | Who Self-approving can review | Not So the Guilty Wretch confin'd, | Talents idle, & unus'd, | Reason the Vessel leaves to Steer,
(Tho in the School of Hardship taught,) | Scenes of past Virtues that Shine thro' | No Pleasures meet his roving Mind, | And every Gift of Heaven abus'd,— | And gives the Helm to mad Despair.
can send Remembrance back to fetch | The Gloom of Age, & cast a Ray, | No Blessings fetch'd from early Youth, | In Seas of Sad Reflection lost, | Invented & by Wm. Hogarth & Publish'd.
Treasures from Life's earliest Stretch: | To gild the Evening of his Day: | But broken Faith, & wrested Truth, | From Horrors still to Horrors tost. | According to Act of Parliament June 25. 1735.

Plate 7

Plate R8

Madneſs, Thou Chaos of ẙ Brain, | With Rude disjointed, Shapeleſs Meaſure | Shapes of Pleaſure, that but ſeen | The headstrong Courſe of youth thus runs | See Him by Thee to Ruin ſold,
What are ẙ That Pleaſure giẟ, and Pain ? | Filld with Horrer, filld with Pleaſure : | Would ſplit the ſhaking ſides of Spleen | What Comfort from this darling ſon ! | And curſe thy ſelf, & curſe thy Gold.
Tyranny of Fancy's Reign ! | Shapes of Horrer, that wou'd even | O Vanity of Age : here ſee | His rattling ẟains with Terror hear,
Mechanic Fancy; that can build | laſt Doubt of Mercy upon Heaven. | The Stamp of Heaven efac't by Thee | Behold Death grappling with Despair,
Vaſt Labaẙnths, & Mazes wild.

Invented ẟc by Wᵐ Hogarth & Publish'd according to Act of Parliament June ẙᵉ 25. 1735.

Marriage A-la-Mode

Plates M1–M6. *Marriage A-la-Mode*, 1745. Hood Museum of Art, Dartmouth College, Hanover, New Hampshire. Purchased through a gift from the Hermit Hill Charitable Lead Trust

Plate M1. Gérard Scotin (French, 1698–1755) after William Hogarth, *The Marriage Settlement*, 1745. Engraving

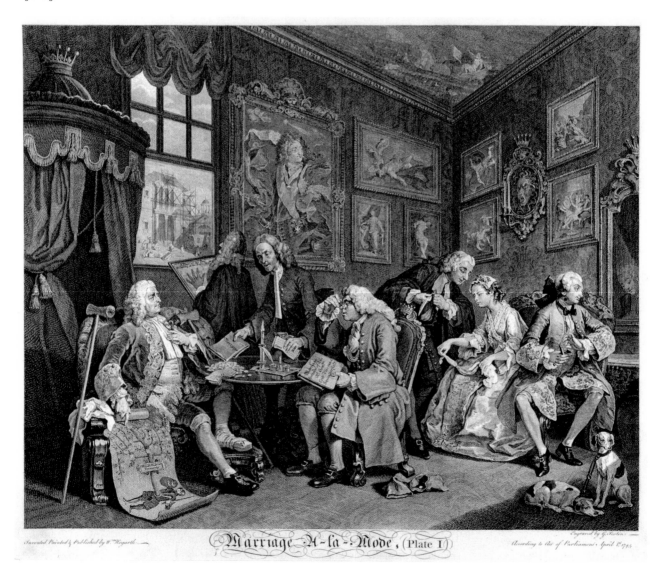

Invented Painted & Published by W.ᵐ Hogarth

Marriage-A-la-Mode, (Plate I)

Engraved by G. Scotin

According to Act of Parliament April 1.ˢᵗ 1745

Plate M2. Bernard Baron
(French, 1696–1762) after
William Hogarth, *The Tête à
Tête*, 1745. Etching and
engraving

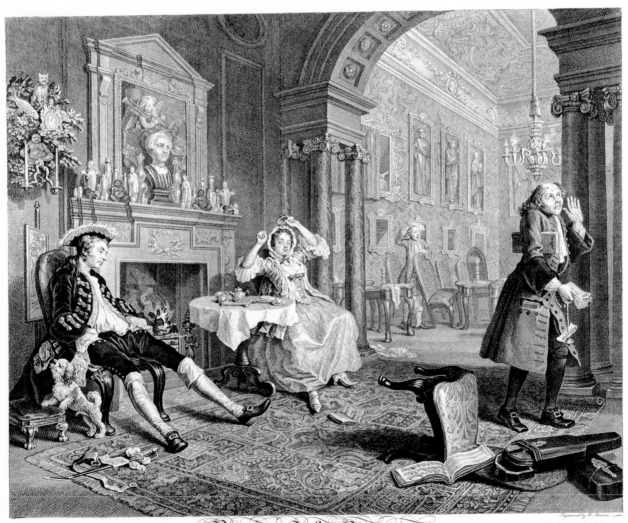

Plate M3. Bernard Baron
after William Hogarth, *The
Inspection*, 1745. Etching and
engraving

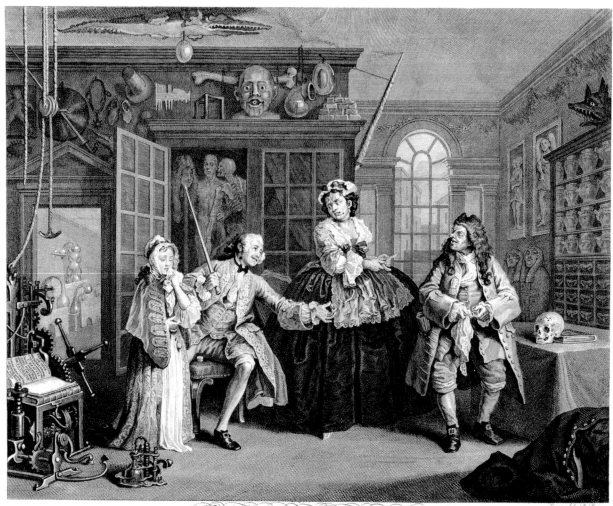

Invented Painted & Published by W. Hogarth

Marriage A-la-Mode, (Plate III)

Engraved by B. Baron.
According to Act of Parliament. April 1745.

Plate M4. Simon François
Ravenet (French, 1706/21–1774)
after William Hogarth,
The Toilette, 1745. Engraving

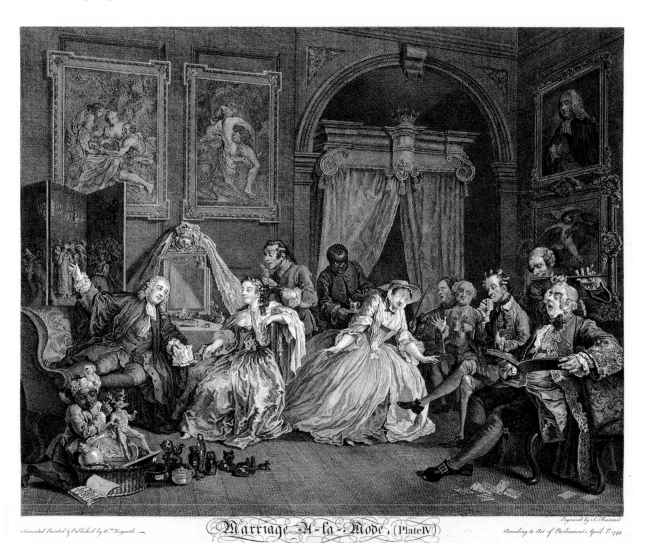

Marriage A-la-Mode, (Plate IV)

Invented Painted & Published by W.m Hogarth

Engraved by S. Ravenet

According to Act of Parliament April 1.st 1745

Plate M5. Simon François
Ravenet after William Hogarth,
The Bagnio, 1745. Engraving

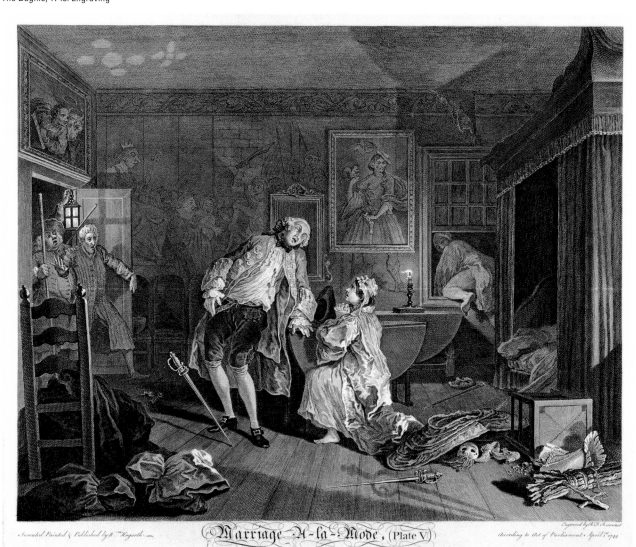

Marriage A-la-Mode, (Plate V)

Plate M6. Gérard Scotin after
William Hogarth, *The Lady's
Death*, 1745. Etching and
engraving

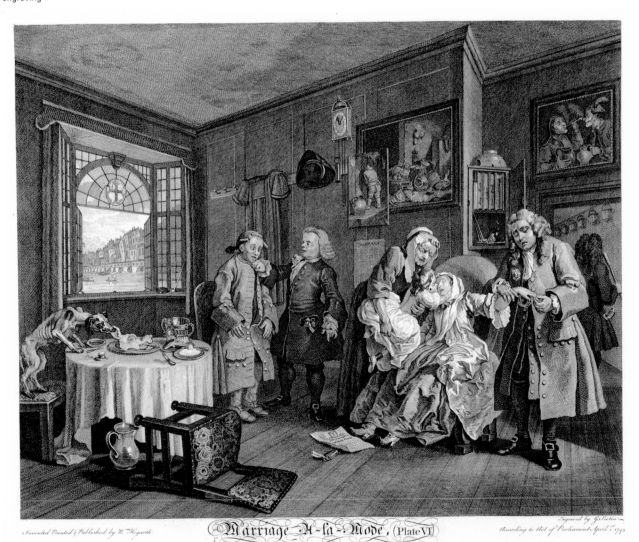

Invented Painted & Published by W.^m Hogarth. Marriage A-la-Mode, (Plate VI) Engraved by G. Scotin.
According to Act of Parliament April 1 1745

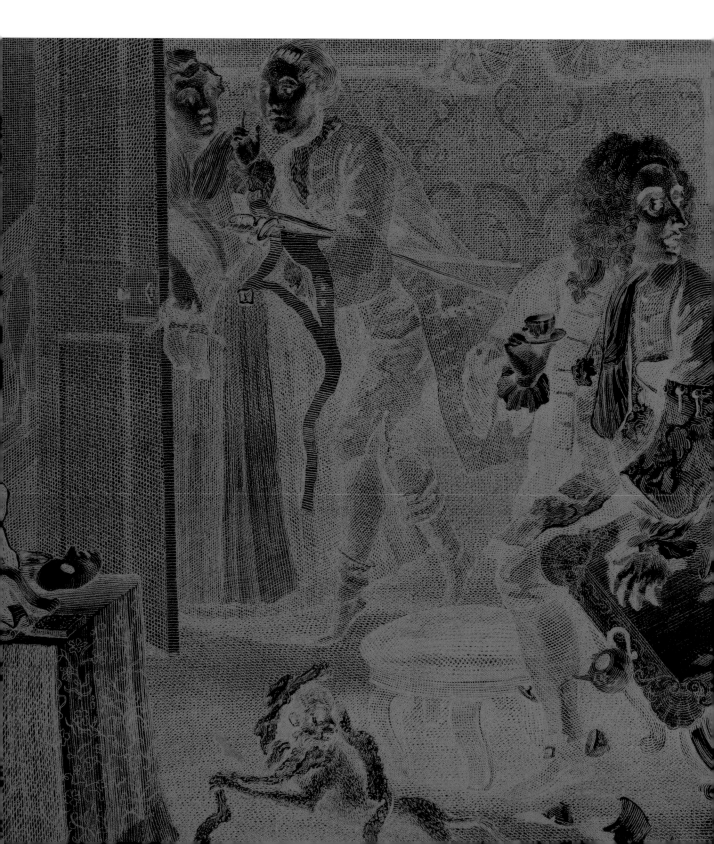

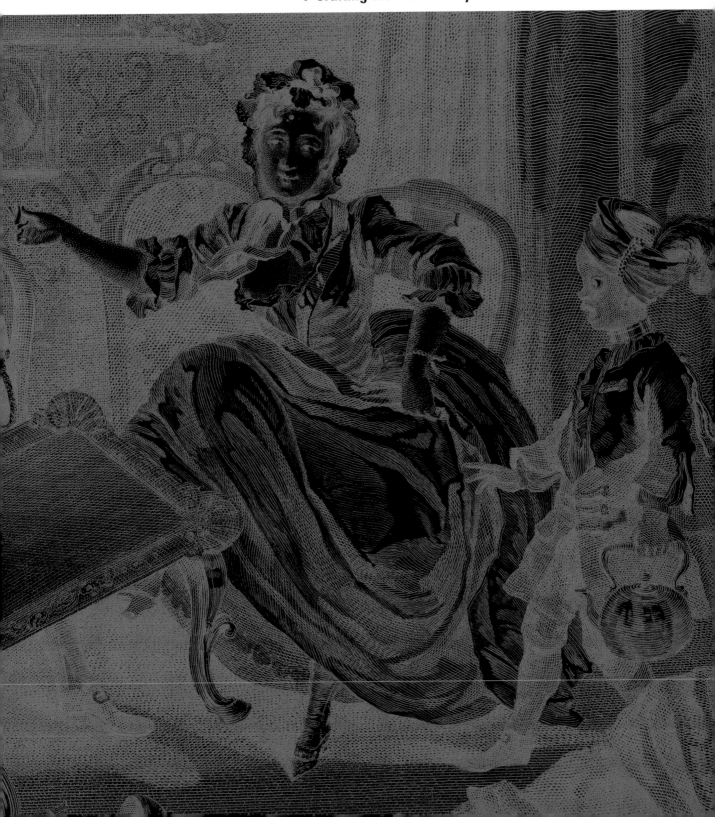

"A Wanton Kind of Chace": Display as Procurement in *A Harlot's Progress* and Its Reception

James Grantham Turner

Intricacy in form, therefore, I shall define to be that peculiarity in the lines which compose it, that *leads the eye a wanton kind of chace.* . . . Curls falling loosely over the face, and by that means breaking the regularity of the oval, have an effect too alluring to be strictly decent, as is very well known to the loose and lowest class of women.

William Hogarth
The Analysis of Beauty

Reading *A Harlot's Progress* in and against the context of contemporary writing—which includes Hogarth's own *Analysis of Beauty*—poses the question of how the aesthetics of the "wanton chase" relate to the erotics of "the loose and lowest class of women." Until recently such an inquiry was largely occluded by the official interpretation of Hogarth as a moralist, promulgated by the artist himself, then vastly amplified by his widow and by Henry Fielding, who declared that Hogarth's prints were "calculated more to serve the Cause of Virtue, and for the Preservation of Mankind, than all the Folios of Morality which have been ever written; and a sober Family should no more be without them than without the *Whole Duty of Man*."[1] The moralistic reading of Hogarth—together with the associated tendency to attach unitary, determinate meanings to his images and attitude—has partly given way to a greater sense of his ambiguity: two recent conferences and exhibitions, for example, emphasize the "Other" Hogarth and the contradictory responses he provoked.[2] Critics now talk of Hogarth's mixed motiva-

tion, the coexistence of social reformism with other flavors such as amusement or erotic stimulus: Ronald Paulson, for example, finds a "mixture of pity, tenderness, and prurience" in the *Harlot's Progress* and even "noticeable reverberations of pornography."[3] One text in particular has played a crucial role in this critical change, the earliest of the paratexts or literary anecdotes that surround the series—George Vertue's account of its origins in Hogarth's own studio. As we shall see, Vertue explains the painting of the prostitute, the reaction of the first viewers, and the subsequent expansion into a series wholly in terms of erotic visual pleasure. Thus David Bindman cites Vertue's anecdote to prove Hogarth's motivation less than "high-minded" and to explain the series' popularity; the *Harlot's Progress* succeeded because it contained "elements which could appeal equally to the parson and the hedonist." In Bindman's recent exhibition catalogue, Vertue's Hogarth becomes positively "cynical," belonging among those satirists who "exploit" the titillating "visual appeal" of sexual vice.[4]

I propose to build on these accounts of the coexistence of erotic and reformist "elements"—which I relate to what I call the "spurring" and "touching" impulses in Hogarth's engraving technique—by raising the question of how they act upon one another. I suggest that the staging of the "woman of pleasure"—as an object of physical allure, as a figure for the artist's own appeal, and as the subject of an entire subculture of illicit plea-

sure, sexual expertise, and bawdy allusion—runs persistently through the entire series and just as persistently conflicts with the ostensible purpose of creating a Modern Moral Subject. I propose that in many respects the art of *A Harlot's Progress* allies Hogarth not with the penetrating, vigilante magistrate but with the prostitute herself—not with the individual harlot "M. Hackabout" (who is in truth barely individualized, hardly more than a disposable exemplum), but with the entire industry of desire, the whole enterprise of allurement, display, procurement, seduction, enjoyment, reincitement, settlement, and disposal.

I will read these much-discussed plates only glancingly and dwell at more length on the progress of Hogarth's images through the culture, the transmission and dissemination of that series in contemporary anecdotes and commentaries, and in the more or less pornographic poems, narratives, and dramas that burst out within months of the *Harlot*'s appearance: no less than six separate publications bore the title *Harlot's Progress*, and some of them included abysmal copies of the engravings. These paratexts cannot of course determine the meaning of the artifact, nor can they tell us "*exactly* what a contemporary saw in the prints"; on the other hand, they are less irrelevant than some art historians pronounce them.[5] Textual emulations of the *Harlot* engravings help to construct the story of their internal progress, their genesis and development from frame to frame.

The problem with this contextualizing approach is that it threatens to reduce the visual specificity of these prints. Much of the work on Hogarth has been done by literary experts, amateur and professional, while even art historians (with a few exceptions) have tended to analyze the content rather than the facture, the marks on paper and canvas.[6] Paradoxically, however, my textually derived elucidation will not take the form of additional identifications, of adding yet more anecdotes to the already overwhelming accumulation of discursive-narrative explanations of Hogarth that have piled up since the eighteenth century and which have certainly influenced or confirmed the dominant critical idea that Hogarth is really a kind of writer—either splendidly or oppressively verbal, according to whether you follow Horace Walpole, Hazlitt, or Baudelaire. This discursive approach is encouraged by the *horror vacui* in Hogarth's prints, the crowding of labels and inscriptions; he seems himself enclosed in the prison house or Bedlam of language. I prefer to reconstruct from this discursive matrix some sense of the print as an object, as the product of certain movements of the hand and eye resulting in certain marks in the copper—inscriptions in the literal sense—and as a "loose" sheet that can be traded and copied, bound in a book or folded into a fan, pinned on the wall or used to wrap butter (as the harlot herself uses her small collection of prints and pamphlets).

I recognize at the outset that facture does not necessarily convey meaning, particularly in

a standardized technique like engraving for mass production. Etching uses *aqua fortis*, but that does not automatically make it vitriolic. The system of hatching for shadows and stipple for flesh tones had been established long before Hogarth and could be applied mechanically. I would argue, nonetheless, that the illicit eroticism of the *Harlot* raises the threshold of potential emotional significance, and that Hogarth individually attached a definite erotic charge to the movements of the artist's hand and eye. His allusions to technique—"that beautiful stroke on copper," which "can only be done with a quick Touch" otherwise it grows "languid"—certainly recognizes that the sensibility of an artist flows from the fingers into the burin. Hogarth insisted on keeping the faces for his own "touch" even when he farmed out the rest of the plate to professional specialists. In the *Analysis* he reveals his eccentric idea that the natural coloring of the human face comes from a network of tinted lines or "tender threads," exactly like the cross-hatching of engraving, and he finds such significance in the serpentine movement of the draftsman's hand as it traces the line of beauty onto a curved molding that he recommends it as a graceful, winning way of handing a lady her fan. Technique becomes deportment, with both at the service of ceremonial seduction. Successful art causes the eye to move in "wanton chace," and vice versa. Wanton movements of the eye illustrate an aesthetic motion virtually indistinguishable from desire: following a "favorite" woman as she performs a winding country dance, the visual beam itself "was dancing with her all the time."[7]

"Flecks of Significance": Lichtenberg's Elucidation of Hogarth's Engravings

I would like to draw my initial paradigms from Hogarth's most intelligent literary interpreter, the German Enlightenment scientist and journalist Georg Christoph Lichtenberg. Lichten-

berg's 1790s *Ausführliche Erklärung der Hogarthischen Kupferstiche* is just as garrulous as the English anecdotalists and moralists that he criticizes, just as prone to spin out narratives to explain exactly how Moll Hackabout came to town or exactly what happened between the third and fourth plates (thus accounting for the resplendent silk gown that she wears to beat hemp in the Bridewell). He participates to the full in what David Brewer calls "imaginative expansion" or "readerly visualization," the discursive amplification of every detail in an artifact that already seems crammed to the limit with excessively clear and over-interpreted details.[8] Instead, I will isolate a few moments where, rather than filling in or encrusting with literal meaning the already encrusted image, Lichtenberg instead reflects upon the expressive movement of eye and hand, peels back the narrative surface, reconstructs meaning from how Hogarth makes his mark.

Lichtenberg pays special attention to roughed-up textures, breaks, and irruptions—for example, in the fourth plate of *A Harlot's Progress*, the holed stockings of the bawdy maid in Bridewell or, in the first plate, the worn-out knees of the clergyman and his horse or the correspondence between the face of the bawd, repaired with beauty patches, and the crumbling wall of the inn "which significantly serves as its ground" (Lichtenberg 1983/1966, 90/14).[9] And at times he infers from these pockmarks the agency that caused them, as in his fanciful interpretation of the flanks of the clergyman's wretched horse. The area under scrutiny (fig. 1) could be read as an abstract pattern of crosshatched lines or a shadowy representation of the horse's ribs, but Lichtenberg concludes that he sees the lacerations of the spur.[10] His sensitive eye glimpses "*ein Fleckchen von Wichtigkeit*" [a little fleck of significance] which cost the artist only "one thrust of the engraving tool" [*einen Druck mit dem Griffel*] but cost the horse "precious blood" (Lichten-

Fig. 1. William Hogarth, *A Harlot's Progress*, Plate 1 (detail), 1732. Etching and engraving. University of California, Berkeley Art Museum

Fig. 2. Ernst Ludwig Riepenhausen (German, 1765–1840) after Hogarth, *A Harlot's Progress*, Plate 1 (detail). From Georg Christoph Lichtenberg, *Ausführliche Erklärung der Hogarthischen Kupferstiche, Bildatlas* (Göttingen, n.d. [1794]). Engraving. Bancroft Library, University of California, Berkeley

berg 1983/1966, 82/8). In a burst of Sternean sentiment he adds that it would cost Hogarth more than one "*Strich*" or stroke to show the "scars" of misery that the curate hides under his gown. Moreover, when Lichtenberg commissioned copies from Riepenhausen to accompany his publication, he evidently made sure that his insight was confirmed and that the *Fleckchen* were visible (fig. 2). In this view the stylus *is* a spur, its image-forming pressure a deliberate but cruel stimulus giving speed and direction to the progress.

I suggest that we can extend Lichtenberg's intuition to a variety of engraving effects, both those that emulate the broken, pierced, abraded surfaces that denote sordid or punitive reality closing in on the harlot and the softer and more glamorous techniques by which Hogarth models his glimpses of the seductive body or his fashion-plate faces. "Flecks of significance" applies equally to the flyweight hatching and stippling used to identify the flesh tones of the sexually available female, marks analogous to the beauty spots so fussily arranged on those faces, which both emphasize and conceal the pecks or lesions engraved in the perfect skin by time and disease. In some renderings of the harlot and the bawd the smallest of these cosmetic patches is scarcely bigger than the largest of the dots that model the contours of the face. This fussing with the beauty spot is shared by the engraver and his courtesan subjects; many of the changes Hogarth made between states involve a kind of toilette or primping of his copper plate— rearranging the folds of a skirt or bonnet, deepening a pout or emphasizing a breast— and in the first plate he gave the bawd a complete makeover and redistributed all the spots and stipples on her face.[11] This "spottiness" is further thematized and extended (in all states) by giving her a dotted transparent shawl, at once a dazzling display of engraving technique and a symbol of her leopard-like character. I

41

would argue, in fact, that the *Harlot's Progress* can be understood in terms of an unresolved dichotomy between two kinds of eroticized *Fleck*-making, sadistic spurring and cosmetic touching up.

At moments the ultraverbal Lichtenberg recognizes the inadequacy of words to represent the specifically visual and engraverly effects "that Hogarth has drawn so inimitably." Speaking more as a professor of physics than as a literary journalist, he admits that he "can't wholly bring into words the forces at work" in the technique of the *Harlot's Progress* (Lichtenberg 1983/1966, 135/57). He interprets the drawn or incised line—indeed, the *act* of drawing, if we remember his remarks on the pressure of the burin—as the operation of *Kräfte* or "forces," some "constant and calm," some "variable and turbulent" (*die steten und stillen Kräfte sowohl als die veränderlichen und tobenden, die hier wirkten*). Lichtenberg's typology of "forces" roughly corresponds to my dichotomy of "spur" and "touch."[12]

In certain passages of detailed analysis, Lichtenberg acknowledges the interaction of these forces with the erotic dynamics of prostitution itself, and thus helps us situate Hogarth *within* the "progress of a harlot" rather than at a safe moral distance. Interpreting the exuberantly lewd figure of the maid who pulls on her stockings in Bridewell (fig. 3), Lichtenberg dwells on the stocking itself and the hole or "breakthrough" that reveals the skin beneath, and he comments on a feature that he first explains as a technical error and then ingeniously transforms into a direct manifestation or grapheme of the flow of erotic energy between artist, image, and viewer. The maid figure is "no masterpiece of drawing or shading"; she "consists almost entirely of bosom and legs" (a compendium of commodified erotic body parts rather than a classically composed figure), and an inexplicable "brightness" shines from under her skirt: "one can see so

clearly" in a zone where properly one should not see at all. To a modern eye this luminosity or "phosphorescence" is not obvious, but Lichtenberg evidently persuaded himself (after long contemplation?) that the flashes of skin and underlinen were too white for such a criminal, insufficiently worked over with punitive stripes and cuts. In effect, he goes on, this badly executed but riveting section of the plate concretizes Hogarth's own sexual gaze. He explains the shading problem as "a reflection of the light from the rogue eyes of the artist [*den Schelmen-Augen des Künstlers*], which momentarily flash upon the character of this infamous creature." Moreover, the viewer as well as the artist is implicated in this shaping of the visual field. Hogarth releases this lightning burst of focused sight, rendered by lightening the "pressure of the engraving-tool," "in order to prompt Decency itself to do the same." *Sittsamkeit* (decency or morality) becomes, in the blink of an eye, "prompted," "instigated," "prevailed upon"—we might say "spurred on"—to replicate the gaze of Hogarth himself, that "unfathomable rogue." Lichtenberg equates the content of this prison scene with the experience of viewing it: "Morality" also allegorizes the ferocious warder, gazing fixedly at the maid as she exposes her legs and leers suggestively in his direction. He too is instigated to look, pop-eyed, frozen between fascination and threat, holding up the famous whip that he would use to mark the white skin of his ladylike captives; contemporary literature, which revels in such scenes of flagellation, identifies it as the desiccated penis of a bull.[13]

For Lichtenberg, then, Hogarth is the heteroclite, the rogue artist whose "burin-thrusts" force us to see with his own "*Schelmen-Augen*." He frequently uses the equivalent of "rogue" when explicating or hinting at the double entendres in the *Harlot's Progress*. The Bridewell scene yields further concealed jokes, typical of "*einem so unergründlichen Schalke, wie*

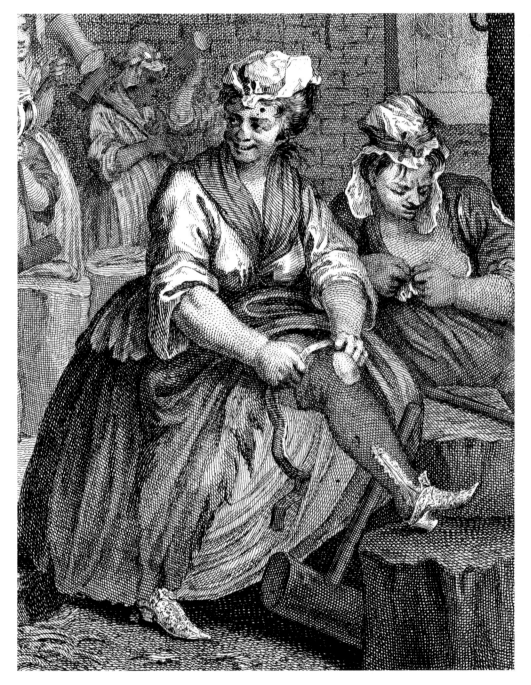

Fig. 3. William Hogarth, *A Harlot's Progress*, Plate 4 (detail), 1732. Etching and engraving. University of California, Berkeley Art Museum

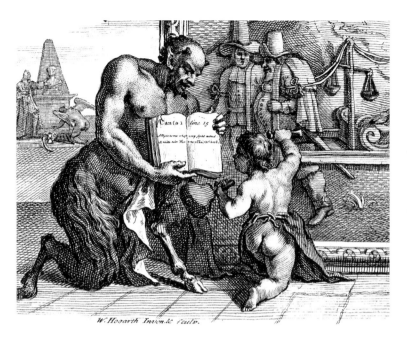

Fig. 4. William Hogarth,
frontispiece for Samuel
Butler's *Hudibras* (detail).
Etching and engraving. The
British Museum, London

Hogarth," and details like the healing finger in the funeral scene (the sixth plate) likewise show "what a rogue [*Schalk*] our artist is, even in his camouflage. He conceals a wanton thought [*einen mutwilligen Gedanken*], and his concealment is again an act of wantonness [*Mutwillen*]." Hogarth earns the half-reproachful title *Schelm* for his sexual jesting in the scene of death, his visual puns that make the viewer's eye reenact the "wanton" game of concealment and revelation. This rogue quality is epitomized in the faux-noble coat of arms behind Moll Hackabout's coffin, which reads as the royal lilies of France but actually shows "three spigots in three faucets screwed."[14]

Artist as Satyr

Lichtenberg wrote at the end of the eighteenth century, but this perception of the roguish and wantonly ambiguous Hogarth—the subverter rather than the champion of conventional morality—plays a major role in contemporary reactions from the 1730s. Swift wishes he had the help of "humorous *Hogart*" to depict Irish politics, because "Thou I hear, a pleasant

Rogue art."[15] This excruciating rhyme is typical of the "Hudibrastic" mode perfected by Samuel Butler, and binds the artist and the poet together in common appreciation of that satirist. For some reviewers in the 1730s, Hogarth's expertise in grotesque, rakish humor debilitates his claim to invent the moral subject, since he sacrifices manners for the "arch conceit." The ballad-opera *The Progress of a Harlot* sets the tone of arch double entendre in its very first line—"The *Harlot's Progress*! o' my word a fit title for a—— taking performance"—where the long dash tells the actor to extract the maximum suggestiveness from the title. The unknown dramatist then introduces a choric figure or "Time-teller" to provide narrative continuity and to spell out all the "hints" taken "From the keen satyr in sly *Hogarth's* prints."[16] The spelling *satyr* reminds us that the old etymology linking satire to the amoral and priapic satyr still exerted cultural power. Several critics have noted how frequently Hogarth invokes this association by introducing the classical-yet-scurrilous satyr as an allegory of his own work as an artist-satirist. In his frontispiece for Butler's *Hudibras*, for example, the satyr figure appears no less than three times. The most prominent one kneels reverently in the left foreground (fig. 4), holding the written text of *Hudibras* so that the sculptor-putto can translate Butler's pen strokes directly into chisel blows (which are in turn "*Sculpt*" by Hogarth himself, as the inscription proclaims below). The relief on the sarcophagus shows a second satyr riding in triumph and driving Hudibras before him, while a third redaction of the satyr lies concealed in the form of the boy sculptor, visible only to the eye of the connoisseur. Both the kneeling satyr and the chiseling putto—that is, both the Nature figure and the Art figure—derive from one of the few Old Master paintings to have influenced Hogarth directly, the Rubens-Breughel *Nature Adorned by the Graces* owned by his father-in-

law Thornhill and thus visible on a daily basis (fig. 5). The putto retains the deep kneeling posture viewed from behind, while the shaggy creature himself has been rotated sideways. As if to emphasize this occult affinity, both have been equipped with a tool. Like his Renaissance ancestors, Hogarth's satyr (unlike Rubens's) sports a visible erection—defined by a line almost a millimeter thick, deeply etched or gouged with an emphatic *Druck von der Griffel* (as Lichtenberg would say).[17] Spurring on through the lighter lines that indicate drapery or fur, this rough, trenchant mark outlines the whole apparatus of animal sexuality, large goat-like scrotum, and tapering phallus.

The satyr figure (and Rubens's painting) feature again in Hogarth's publicity for the *Harlot* series, giving it an air of festive sexuality. In the etched receipt or subscription ticket, a juvenile faun or satyr pulls aside Nature's drapes and peers directly at her genitals, embodying the

gaze that is everywhere implied though never directly satisfied in the *Harlot's Progress* itself. In Rubens the many-breasted herm of Natura/Diana lacks genitalia and is elevated beyond the satyrs' reach, attended by the Graces instead (fig. 5); Hogarth "telescopes" the composition, bringing satyr and statue into the closest proximity, and conceals the stone base by turning Nature's veil into a skirt-like garment. Paradoxically, this closing of the view opens up the possibility of a "natural" organ visible beneath. And the priapic element of the *Hudibras* frontispiece—in the Rubens-derived figure of the kneeling satyr—suggested a further experiment with the edges of the visible: Hogarth's preparation drawing for the *Harlot* ticket (fig. 6) also appears to show erectile spectatorship, since one of the putti sports a dark shaft-like appendage with an upward-curving tip, its straight side reinforced by an incised line for most of its length. In the finished etching this phallus-like excrescence is scaled down from a distinct cylinder to a suggestive bump in the drapery. Significantly, Hogarth gives the excited member not to the "natural" satyr (as we might expect) but to the "cultural" putto—another

Fig. 5. Peter Paul Rubens (Flemish, 1577–1640) and Jan Breughel the Elder (Flemish, 1568–1625), *Nature Adorned by the Graces*, c. 1615. Oil on panel, 42 x 28½ in. (106.7 x 72.4 cm). Glasgow Museums, Art Gallery and Museum, Kelvingrove

Fig. 6. William Hogarth, Subscription ticket to *A Harlot's Progress*, preparatory drawing, 1731. Pencil and gray wash, with pen and black ink, 4 x 5¼ in. (10.2 x 13.3 cm). Royal Library, Windsor, The Royal Collection, Her Majesty Queen Elizabeth II

Fig. 7. Giles King (English, fl. 1732–1746) after Hogarth, frame for *A Harlot's Progress* (detail), 1732. Etching and engraving. The British Museum, London

classical oak or acanthus. Hanging from an iron ring set into massive stonework, it suggests a prison; in this setting the "natural" satyrs form a visual pun or rebus on the "Newgate Pastoral," Gay's subtitle for *The Beggar's Opera*. And their reaction to the Modern Moral Subjects they frame continues the comic mood. Unlike the solemn satyr who holds Butler's *Hudibras*, they leer and point suggestively downwards. This "arch conceit" implicitly celebrates shameless, anarchic arousal as a vehicle of truth. Hogarth's satyrs allow him to indulge a taste for phallic display that compromises Fielding's praise of the indefatigable Champion of Virtue, whose works should be owned by every family and displayed alongside *The Whole Duty of Man*.

Marketing Seduction

The *Harlot's Progress* subscription ticket, we should recall, is both a visual image and a practical object; the subscriber would keep the little etching as a sample of Hogarth's art and as a receipt for half the price of the future series. This first venture into self-publishing simultaneously represents and facilitates the progress of the *Harlot* into the marketplace. With its libertine-satyric theme, its puns on "seeking your old Mother," and its Horatian quotations about permissible *Licentia*, it exemplifies the "sly," "roguish" side of Hogarth that contemporaries celebrated and moralists suppressed. Other artifacts associated with the marketing of the *Harlot*—like the teacups and the printed fans—likewise sustain the idea of visual representation as pleasurable flaunting rather than reformist exposé. As Angela Rosenthal makes clear in her essay, the fan sets the sign in motion: Hogarth himself illustrates the line of beauty by the gallant movement of the hand when presenting a fan, and this is only the first of a series of seductive gestures that together give the fan its "language." One of the *Harlot's Progress* fans, a spidery outline engraving that

visual pun on the artist's tools conspicuously wielded by the other two boys? The gesture thus becomes more ambiguous than critics make it: the putto may not be "preventing" the intrusion and thus repudiating the lustful approach to Nature, but fighting over who gets to peep, insisting "Me too."[18]

When Hogarth authorized inexpensive redactions of the *Harlot's Progress* series, I think we can assume it was he who designed the frame of seated satyrs (fig. 7), who form a kind of audience for the prints themselves.[19] This frame uses elements that would later appear in the borders of *Industry and Idleness*— a masonry background and the volutes of a Baroque church façade—but here they are scaled up and combined with a triumphal swag of foliage that on close inspection looks made of mock-heroic cabbage leaves rather than

combines five of the six plates into one composition, has clearly been designed for playfully slow unfolding, revealing the sequence pleat by pleat.[20] Here the Modern Moral Subject is rendered diaphanous and mobile, literally placed in flirtatious movement and thereby participating in the dance of seduction, cooling only to increase ardor, hiding to reveal, motioning away to a further encounter. As Lichtenberg cleverly puts it, the owners of these fans could "contemplate them in times of heat and send sidelong glances from under them in case of need (*Darunterwegschielen in der Not*)."[21] The image is looked *at* and looked *past*, treated as representation and as object. Surely the prints themselves, like the engravings tacked up in the Harlot's own garret, circulated in a similar visual-erotic economy?

Hogarth does not of course advertise prostitution in any gross or literal way, but he certainly participates in the dance of seduction and sympathizes at some level with the sexual entrepreneuse. Like his harlot character he was a self-made figure, sprung from fecklessly respectable northern parents, making his way in town with only his personal charms (which enabled him to marry into Thornhill's family) and his self-generated capacity to create public appetite for his image(s). (The wall decorations in the third plate give Moll Hackabout a taste for prints and a devotion to *The Beggar's Opera*, illustrations of which launched Hogarth's career in Comic History Painting.) The *Harlot* represented his own début as entrepreneur, the first occasion on which he conceived, painted, engraved, published, advertised, and sold the work himself. The tumbling language of his "Autobiographical Notes" captures the close association of "passionate" arousal, market trading, and individual proprietorship: success suddenly seemed within his grasp, "provided I could strike the passions and by small sums from many by means of prints which I could Engrav[e] from my Picture myself I could

secure my Property to my self" (Hogarth 1955, 216). Piracies of the *Harlot* series increased his sense of possessiveness and inspired his campaign to extend copyright to engravings; Hogarth's appeal to Parliament (probably written as well as commissioned by him) dramatizes the case of the artist who has "chosen a new Subject, and executed his Design to the Satisfaction of the Town"—evidently by "striking the passions" of a great many customers, ready to press small sums upon him—but who is then ruined by the print sellers. He grips the members' attention with a progress-like "View of the several Stages by which many a great Genius has descended to Poverty and Slavery."[22]

Pursuing the prostitution analogy into the engravings themselves suggests several points of affinity or complicity, each one gendering the artist-entrepreneur somewhat differently. Michael Podro has observed of paintings like the *Election* series that the facture itself, the "fluency and agility of the loaded brush," gives the work of art an ironic independence, "refusing to be complicitous with how depicted figures or institutions like the Church or Parliament would present themselves"; the scene of riot is valued for "the opportunity it offered to wholeheartedly disrespectful, amoral ingenuity for participants and painter."[23] I would argue that the reverse may be true when the social relation is reversed and the subject unofficial and "low"—that the dashing engraving of the *Harlot's Progress* (at least at those moments when Hogarth overcomes his difficulties with the medium) increases our sense of complicity with the amoral subject. In certain respects he objectifies or commodifies the harlot, flattening her into a two-dimensional grapheme of male fantasy (sometimes literally, posing her in awkward "stage-front" positions that show off her charms without adding to the plausibility of the scene). As we shall see in Vertue's account of Hogarth's studio, and in his own *Analysis of Beauty*, the attractiveness of the

"loose woman" provided the primary motive for the original painting and remained a favorite illustration of the aesthetic. Hogarth empathizes with the client's acquisitive desire when he creates an alluring, fashion-plate style for the harlot figure, inconsistent with the quotidian or grotesque treatment of her surroundings. This holds true for technique as well as composition: the heavily hatched, slashing or "spurring" rendition of the various backgrounds and attendants, lascivious or punitive, contrasts violently with the areas of the harlot figure on which the aroused eye "flashes," brilliant confections of flecks, dashes, and serpentine lines. On the other hand, this loving creation of marketable beauty makes him complicit with the harlot herself, involved in the same trade as a kind of procuress if not an alter ego. He is, after all, manipulating her image to entice a specifically male gaze, to align visual decoding and aesthetic connoisseurship with the aroused fascination that she needs to inspire professionally. The harlot and the printmaker both need to fix the attention of the strolling gentleman and lead him on to a determinate sequence of scenes or acts that culminates in payment (ideally a contract or serial subscription rather than a one-time retail transaction). As Lichtenberg hinted, the artist's seduction depends on his "instigating" graphic marks that fix the attention on erotic zones bathed in (or defined by) the reflected light of his "roguish eyes."

Even when the specific sequence shows increasing disease, misery, and death, the economy of desire continues with resurgent vigor and confidence. The show goes on, for example, in the irrepressible serving wench of the fourth plate, flashing her stockings while the original Harlot languishes at the block, and grinning at the pizzle-wielding warden with an expression that, according to one poet, "spoke fine things in praise of Vice."[24] Erotic sensibility is invested in the limp, shimmering silk dress that the harlot wears so incongruously; erotic energy is concentrated in the ragged-skirted servant, whose posture drew the "rogue eyes" of Lichtenberg. The German critic, we recall, saw her as an assemblage of the body parts that she flaunts (bosom, legs, luminous underwear) and merged the artist's achievement with the character's effect, that of instigating—or, we might say, procuring—the aroused gaze. He sums up a half-century of literary interpretations that invariably bring out the prurience of this Bridewell scene, disturbingly mingled with vigilante moralism. Even before the *Harlot's Progress*, most literary representations of Bridewell—where convicted prostitutes were ceremonially stripped and flogged in public, as Hogarth must have known—betray a smirking enjoyment of the erotic spectacle mingling with the virtuous man's satisfaction at seeing justice done. Richard Head's "English Rogue" enjoys seeing his wife "well lasht" there, entreating the officers to "add one half-dozen stripes to the number intended." Edward Ward's "London Spy" protests that flogging the "tender Back and tempting Bubbies" of prostitutes in Bridewell "was design'd rather to Feast the Eyes of the Spectators, or Stir up the Beastly Appetites of Lascivious Persons, than to Correct Vice or Reform Manners"; his worldly guide, however, dissolves this apparently humane objection by interpreting it as a sexual ploy "to curry Favour with the Fair Sex" or seduce a "Town Lady" without paying.[25] Hogarth selects a moment on the brink of this familiar spectacle, ripe with tension between "tempting" and "flogging," "Correcting Vice" and "Feasting the Eyes." Literary emulations like *The Harlot's Progress . . . in Six Hudibrastic Cantos* (which retranslates Hogarth's engravings into the kind of "satyric" verse that he himself favored) bring out this dual attitude. The narrator describes the harlot, beating hemp in her luxurious gown, with a repulsive mixture of erotic slavering and moral-

istic jeering: the fashionable textures of bro-
cade, lace, and fringe excite him so much that
he is tempted to proposition her, to procure
what he gallantly calls "a silly, snotty Pleasure, /
But she, poor Girl, was not at Leisure" (38). In
this account both the merrily vicious maid and
the suffering harlot extend the world of prosti-
tution rather than correcting it; together they
constitute the comic-erotic spectacle of
Bridewell, or what the caption to the attached
plate calls "the Humors of the Place."

Hogarth was evidently so pleased with the
sturdy composition of the maid—which com-
bines a powerful, uncoiling *contrapposto* with
the titillating display of chest, thighs and holed
stockings—that he reinvented it in *A Rake's
Progress* (fig. 8). In both cases the figure of
erotic enterprise provides an "opportunity for
disrespectful, amoral ingenuity." In both
Bridewell and the Rose Tavern the woman
undresses at the front or downstage edge of the
composition, and in the tavern scene (for
which the painting survives) she is also bathed
in a soft light that seems to emanate from the
viewing position. Weak as the painting is
anatomically, it still creates an effect of inti-
macy by touching the left thigh with a blush-
colored highlight. To create the more
glamorized *Rake* version, Hogarth removed
the maid's "low," caricatural physiognomy
(despite his lifelong affection for pug-nosed
creatures) and endowed her with the genteel
look of the original Harlot. The image of the
prostitute as performer (rather than victim)
thus "progresses" from series to series—and
from state to state in addition, since this was
one of the areas most reworked in the plate.
(The changes are all cosmetic and include
darkening and enlarging the exposed nipple.)
The *Rake* figure is associated even more
explicitly with prostitutional art: according to
an anecdote that supposedly passed from Ho-
garth to Rouquet and then to Trussler and
Lichtenberg, she portrays "Aretine" the posture

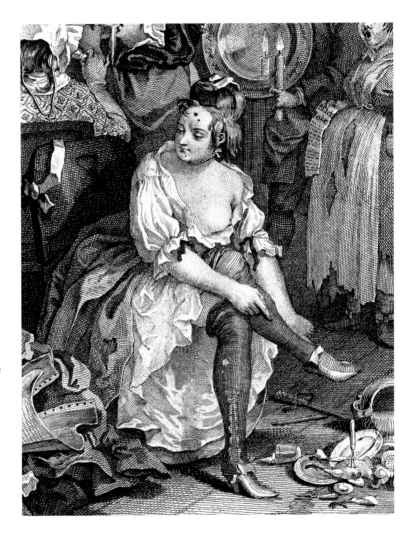

Fig. 8. William Hogarth, *A Rake's Progress*, Plate 3 (detail), 1735. Etching and engraving. University of California, Berkeley Art Museum

woman, who performs a series of erotic
tableaux on a polished silver plate with only
a candle as prop. Rouquet's understatement—
"one can divine the destination of the candle"—
provides yet another glimpse of genital action
through the veil of non-representation. But
why should this particular trick take up so
much of the frame (as her discarded corset and
outer garments spread out around her)? Per-
haps Hogarth made another occult identifica-
tion with this serial performer, whose stage is
exactly the place where he began his own career,
as an engraver of silverware for aristocratic

Fig. 9. William Hogarth, *A Harlot's Progress*, Plate 5 (detail), 1732. Etching and engraving. University of California, Berkeley Art Museum

clients. The massive plate held by the smirking waiter represents at once an expensive accessory (engraved with the name of the tavern), a mirror held out toward the picture plane, and a reflective "ground" on which courtesan and engraver must work to produce a replicable kind of erotic beauty.[26]

In the fifth plate of the *Harlot's Progress* Hogarth even glamorizes the death scene, endowing the prostitute with the emaciated beauty of a Bernini saint and modeling her face with an ultralight line that (at least to the modern eye) gives her a *Vogue*ish sheen (fig. 9). The entire composition alludes to Titian's *Venus of Urbino* and thus to the most luxurious visual possibilities of courtesan culture: in this 180-degree reversal of space and fortune, the servant kneeling and rummaging in the trunk now occupies the foreground and the *bella donna* is shrouded in her sheet rather than displayed upon it, but the trace of beauty persists nonetheless.[27] The graceful volute of the death

chair and the willfully serpentine lines of the wrapper could almost serve as illustrations for the *Analysis of Beauty*.

As a subject of representation, then, the harlot enjoys something like the ambiguity of the rake, as Mark Hallett defines it in his essay: a deplorable moral subject who deserves his (individual) fate, but at the same time an admirable source of energy and wit whose high spirits drive a kind of perpetuum mobile. If Rakewell can be interpreted as a failed example rather than a condemnation of the type, then Moll Hackabout can be written off as a loser in the game that her survivors win. This seems to be the (anti)moral of the final funeral scene (the sixth plate), where Hackabout herself has sunk from visibility, but two prosperous-looking women of pleasure conduct business as usual, drawing out Hogarth's utmost powers of erotic representation and bawdy innuendo. One adopts a swooning look while picking the pocket of the adoring undertaker; the other receives the invisible hand of the clergyman, who is so excited by what he feels that his glass runneth over. The literary spin-offs milk this episode to the full, though they add nothing that is not already suggested by Hogarth. The *Hudibrastic Cantos* jest about the priest who

> made his F[inge]r do by Proxy,
> What would become a nobler Part,
> To do with Pleasure, and with Art,

following this with extensive commentary on the liquor flowing into his "Codpiece" (which should have been conveyed the "other way," to "give Life and please") and on the "Hat sublime! [whose] Brims have cover'd / The deepest *Thing* Man has discover'd." John Breval's *The Lure of Venus, or The Harlot's Progress* (which claims to be a respectable and improving version purged of obscenity) explains at even greater length how the lady feels "The nat'ral Man" under the "sacred Vestments."[28] What these poems cannot quite capture, how-

ever, is the look of this figure who dominates the downstage left corner of the composition (fig. 10). She mediates between the artist's invention and the spectator's fascination, turning out from the narrative frame toward the viewer with an inimitable expression of languorous arousal, sensibility, complicity, and suppressed amusement. This face with its framing fabric is one of Hogarth's most virtuoso creations, an assemblage of the lightest and most seductive "flecks of significance," feathery strokes, petite beauty spots, and "wanton" serpentine lines. Like the entrepreneurial bawd herself, in staging the "progress" of the individual harlot into ruin, Hogarth procures fresh models of available beauty.

Many details in this crowded funeral scene couple its risqué glamour with fresh bawdy allusions, which largely reinforce the interpreter's complicity with the culture of lewd enjoyment. The groping parson is only the most obvious of these. For Lichtenberg, as we have seen, the two women examining a finger (healed by insertion into the corpse?) show Hogarth at his most "wanton." Violating the realism that otherwise prevails, the mock-heraldic escutcheon placed on the rear wall displays what the *Hudibrastic Cantos* correctly identify—in full awareness of the double entendre—as "Three Spigots in three Fossets screw'd."[29] The poem sets up this pun with a long sermon by the wine-spilling clergyman on whether nailing or "Screwing" is more appropriate for closing the coffin lid, but the original joke, the "opportunity for amoral ingenuity," is entirely Hogarth's. He likewise invents a less conspicuous but more eloquent detail that poses the question of where he stands: the rough object suspended in the leaded window might be a rag or paper to keep out the draft or a stone flung by an angry mob—ancestor of the dazzlingly painted stones and bricks that hurtle through the window in the *Election Entertainment*. It is this detail that inspires Podro's comment on Hogarth's affinity with anti-official

Fig. 10. William Hogarth, *A Harlot's Progress*, Plate 6 (detail), 1732. Etching and engraving. University of California, Berkeley Art Museum

spontaneity, which in the political painting takes the ominous form of an anti-Semitic riot parading the effigy of a Jew. Riots like these often enforced traditional sexual morality, especially when the violator was perceived as socially privileged; when an outraged crowd attacked Colonel Charteris—the elderly lecher who sizes up Hackabout in the first plate—and rescued one of his captives from a fate exactly like hers, they armed themselves with "Stones, Brickbats, and other Such Vulgar Ammunition."[30] Does the satyr-artist protect the demimonde from within, or does he spur on this pelting crowd to storm it from the street?

The Progress of the *Harlot*: Anecdotes of Origin

Alerted to the affinity between *A Harlot's Progress* and the production of commercial desire, let us turn to George Vertue's much-quoted notes on the genesis of the project and

the transformation of Hogarth's original idea into a massive publishing venture. This "most remarkable Subject that captivated the Minds of most People" began when Hogarth designed "a small painting of a common harlot, supposd to dwell in Drewry Lane, just riseing about noon out of bed, and at breakfast, a bunter waiting on her."[31] The painted scene described by Vertue is quite different in feel from the British Museum drawing associated with this originary moment by some Hogarthians, in which a bedraggled prostitute changes a bandage while her ragged, legless servant waits by a conspicuous open lavatory; this awkward preparation drawing for an unknown painting documents the general culture of prostitution invoked by Hogarth and his literary adaptors—its details include condoms, a venereal syringe, and a popular sex manual—but it shows nothing to "captivate" the viewer's mind or "strike the passions."[32] Vertue's note emphasizes charm rather than sordidness: "this whore's desabillé careless and a pretty Countenance and air—this thought pleasd many." He breathes not a word about Moral Subjects, even though this image would evolve into the third plate at the midsection of the series, already signifying decay and criminality. Vertue shares as well as identifies the predominant emotion of the viewer—a sort of melting pleasure suggestively enacted in the dissolute syntax that flows around the "whore's desabillé careless and a pretty Countenance and air."

This erotic charge, which Vertue considers quite enough to account for the passion generated in Hogarth's clients in the complicit space of his Covent Garden studio, explains not only the *affect* of this single free image, but the *progress* or proliferation of the whole series. As Vertue tells it, the motive force was not narrative or novelistic, but rather a kind of accidental procreation: "this thought"—that is, the "pretty" whore in her "careless" déshabillé—"pleased many," and consequently "some advisd

him to make another to it as a pair." Hogarth thus becomes something between a mother and a breeder or *Kuppler*, creating paired images as he would later do with the explicitly sexual *Before and After* pendants.[33] This procreational hint becomes explicit as Vertue continues, "Other thoughts encreas'd and multiplyd by his fruitful invention"—echoing the famous command "increase and multiply" in *Genesis*, chapter 1, which comic libertines never tired of quoting to prove the godliness of fornication—and this teeming fertility in turn bred new desiring subjects: "He made six different subjects which he painted so naturally, the thoughts, and strikeing the expressions that it drew every body to see them." Vertue's account of the painting series anticipates Lichtenberg's vision of Hogarth "drawing every body to see," fixing the public gaze, instigating even the virtuous to look with his "rogue-eyes"; indeed, we have seen that Hogarth's own subscription ticket re-creates this rush-to-see as a specifically sexual act. According to Vertue, translating this seduction into print only increased the allure of Hogarth and his harlot, "without Courting or soliciting subscriptions all comeing to his dwelling in common Garden."[34] This odd phrase presumably reflects the vulgar pronunciation of Covent Garden (where Hogarth "livd with his father-in-Law Sir James Thornhill" and his many-breasted Rubens), but it does suggest that the "common harlot" is still running in Vertue's mind.

This hedonistic-seductive account of the *Harlot's Progress* cannot simply be dismissed as the malicious innuendo of a rival. As Michael Godby demonstrates, Vertue's tale of discontinuous improvisation matches the visual evidence of the plates more plausibly than the story Hogarth himself later imposed on the series, where Moral Subjects form a coherent six-part narrative (Godby 1987, 26–29). Hogarth often adopts Vertue's language of

"captivation" and genteel excitement in his own writings—for example, in his advertisement for a second impression of the *Harlot*, "solicited" even by the original subscribers and now produced "in Compliance with their Desires."[35] In his argument for copyright protection—provoked by the piracies of *A Harlot's Progress*—he paints a heroic self-portrait of the artist who has "executed his Design to the Satisfaction of the Town." And in the *Analysis of Beauty* he gives the highest aesthetic status to sensuous experiences that sound uncannily like the encounter between a cruising customer and a harlot expert in the art of careless déshabillé. Though Godby dismisses Hogarth's language of passions and profits as "frivolous" (24), I suggest that it confirms his own intuition about Vertue's perceptiveness, that Vertue has correctly defined the "soliciting" impulse as well as the developmental sequence of the *Harlot* series.

Every critic notices the "highly sexualized pursuit of beauty and pleasure" in the *Analysis*, and several chapters (like mine) display in their title Hogarth's provocative idea that Beauty depends on an inviting intricacy, which "*leads the eye a wanton kind of chace.*"[36] The serpentine line unfolds through time and space to form gestures—presenting the fan, threading through a country dance—that link social rituals of seduction to the movement of the artist's hand and eye. Hogarth repeatedly defines the dance as "elegant Wantoness," and his conceptual sketch brackets "Variety [which] excites the lively feeling of wantonness and play" together with "Intricacy like the joy of persute." (Like any other sportsman or Don Juan, he deprecates "the pleasure of easy attainment" and requires some modesty and part concealment to awaken the pursuit instinct.) Most conspicuously, his title page cites the primal cruising scene, Satan's approach to Eve in *Paradise Lost* (directly above a serpent-headed Line of Beauty that resembles a spermato-

zoon): in this epigraph, an unspecified agent "curl'd many a wanton wreath, in sight of Eve, / To lure her eye." Artfully suppressing the Satanic referent, Hogarth isolates the aesthetic of wanton chase and sidesteps the moral issue, which casts hardly a shadow on this sunlit garden of serpentine paths. Though Hogarth tries to demonstrate his waving line in all kinds of homely objects, he keeps recurring to examples from female fashion. The empty, freestanding corset, which looms large in the *Rake's Progress* undressing scene and serves as the most explicit indicator of sexual availability in the *Before and After* engravings, reappears in the plate and text of the *Analysis* to illustrate the spectrum of possible curves ("Aratine" the posture woman seems to enjoy the perfect form). Pursuit and Intricacy are exemplified in the "ribbon edge," the fluctuating hem that softens the border between the clothed area and the exposed skin. Above all, Hogarth dwells on the controlled transgressiveness of a careless lock of hair breaking the regularity of a perfect oval face, the curls of "naturally intermingling locks" that "ravish the eye with the pleasure of the pursuit." In his manuscript drafts he allowed himself an even fuller treatment of what makes female dress "inviting" and a lusher vocabulary for the "motions [aesthetic objects] excite in us." Hogarth's wanton chase leads to precisely the details from which his harlots are composed: artfully irregular beauty patches, clothing that hints at the body beneath, "the pretty effect of curls falling loosely over the face." At this point the prostitution analogy, implicit throughout the *Analysis*, becomes explicit: this "pretty effect" is cited as the quintessence of beauty even though it is "too alluring to be strictly decent, as is very well known to the loose and lowest class of women."[37]

One further anecdote, once again defining the precise moment when Hogarth "rose into fame" because of his *Harlot* prints, appears to

Fig. 11. William Hogarth, *A Harlot's Progress*, Plate 3 (detail), 1732. Etching and engraving. University of California, Berkeley Art Museum

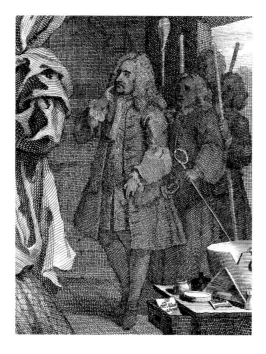

identify their mass appeal with moralistic exposé and thus to undermine my analogy between the artist-entrepreneur and the "loose and lowest class of women." When a civil servant reports the Treasury Lords' enthusiastic response to the third plate, he singles out their approval of the magistrate figure who walks into Hackabout's Drury Lane garret to arrest her. This is indeed an important detail, since the officer and his posse (armed with staves and a "Bull's Pizzle" cane) breach the harlot's self-enclosed space and propel the narrative forward into the next plate of the *Progress*, the Bridewell scene. But the point of the story does not actually support the moralistic pro-police reading: this elite audience did indeed identify figure 11 as the famously severe prosecutor of prostitutes Sir John Gonson—indeed, recognizing this "striking likeness . . . gave universal satisfaction"—but they did not therefore identify *with* him. These are high-spirited aristocrats who recognize the portrait and rush to obtain their copies. Surely their "satisfaction"

derives from mockery of the city police chief rather than solidarity with him, jeering at his prurience, and so by implication supporting the alliance of gentleman and whore that this middle-class busybody is seeking to break apart.[38]

Hogarth's handling may encourage this irreverent response: the beady-eyed Gonson figure does rather pointedly resemble the slit-eyed Charteris figure at the same position in the first plate; his heavily theatrical gesture of hesitation does suggest stupidity at the very least, and—in the eyes of many contemporary viewers—a nonplused and embarrassing form of sexual response. The *Hudibrastic Cantos* ascribe to the magistrate some of the aestheticized eroticism that must have been provoked by the studio paintings:

> He view'd the *Siren*'s Dishabil,
> Her Shape—and in Surprize stood still;
> Her Skin as white as Cream in *Spring*,
> Her Air, her Shape, her ev'ry thing—
> Did almost shake him; but his *Zeal*
> O'ercame his Passions . . .
> Anon. 1740, 35

Breval's mock-heroic version elevates the diction but maintains, even intensifies, the sexual-visual dynamic: Sir John bursts in on "Madam, in her Dishabille,"

> But stopping short, her curious Form to scan,
> The Beauties of her Air, her Face, and Shape,
> Did on his Zeal well nigh commit a Rape;
> Soften'd his Rage, and almost drew him in,
> To fall a Victim to the pleasing Sin.
> Breval 1733, 28–29

Theophilus Cibber's pantomime version, performed at the Theatre Royal Drury Lane, makes fun of the Justice and his forces by showing the constable looting the apartment and the arrest thwarted by the tricks of Harlequin, the Harlot's irrepressible lover.[39] The ballad-opera, after showing Moll at home "sit-

ting in dishabilee," makes Justice Mittimus declare "(*sighing*.) She's a very pretty girl; I had much ado to maintain my magisterial gravity in committing her."[40] Since Vertue's anecdote remained unpublished until the twentieth century, it is particularly striking to find exactly the same vocabulary of rococo seduction used in printed sources like this, confirming his observation that "this whore's desabillé careless and a pretty Countenance and air—this thought pleased many."

The sense that Gonson is repudiated as an intruder rather than celebrated as a moral force—an interpretation spelled out at length in these extraneous textual artifacts—is embodied compositionally within the print itself by his wavering gesture, shadowy rendering, and strangely marginal, upstage position.[41] Socially, he represents power and authority and the two women criminal marginality; artistically, they embody significance and self-confidence while he is a scratched-in afterthought. And here I think we can show that this is literally the case. The paintings of *A Harlot's Progress* vanished in a fire in 1755, but in *The Battle of the Pictures*, announcing their auction in 1745, Hogarth shows the prototype of the third plate being speared in mid-air by a Penitent Magdalene (fig. 12). This is not of course a photographic record of the lost painting, but every element in it corresponds to the engraving: the harlot lolling in her loose gown (displaying an expanse of chest and a stolen watch), the "bunter" serving breakfast, the bed curtain, the flogging birch, the oval prints, the cat with its tail in the air.[42] (This creature appears to have been moved, in the print, closer to the central vent of the harlot's robe—and thus closer to the "peeking" position of the satyr in the *Harlot* ticket.) So it is especially significant that Hogarth shows what seems to be the original painting that prompted so much pleasure in Vertue's anecdote, in a format squarer than what he later chose for the

Fig. 12. William Hogarth, *The Battle of the Pictures* (detail), 1745. Etching. The British Museum, London

engravings—a format that frames the bed symmetrically and places the "whore's desabillé" and "pretty Countenance" closer to the center, filling the frame more sumptuously. It is not simply that Hogarth's sketch omits the magistrate and his team entering at the rear; *there is no room for them to appear in this canvas at all*. The forces of punitive Decency butt into the original frame, the original space in which the artist and his harlot gave universal "satisfaction to the Town."

Return to the Breast

Virtually every commentator uses one word—déshabillé—to define what is appealing about these prints, what is taking about their "taking performance." Déshabillé or "undress" is both a state—"careless" informality between full dress and nudity—and an action, the participle of a verb meaning "to undress." Hogarth's fascination with déshabillé brings out the paradox that the artist with the most erotic aesthetic theory has the least interest in the nude: as he explains it in the *Analysis of Beauty*, the body

"would soon satiate the eye, were it to be as constantly exposed [as the face], nor would it have more effect than a marble statue. But when it is artfully cloath'd and decorated, the mind at every turn resumes its imaginary pursuits." This anticlassicism even leads him to declare "faces and necks, hands and arms in living women" the supreme work of art, which "even the Grecian Venus but coarsely imitates." The manuscript draft spells out how beauty-in-variety can be achieved through clothing that, like the fan, hides and reveals at the same time: "Some parts of dress should be loose and at liberty to play into foulds . . . winding as the body moves."[43] In the subscription ticket for *A Harlot's Progress*, we should recall, it is the addition of a "loose" skirt to the statue of Nature that focuses and incites the desire to peep at her "folds." In the *Progress* itself this desire is focused most intently on the breast, the area that (even more than the stockinged leg) mediates between dress and nudity; this "careless" drapery of the breast is surely what Vertue meant by the déshabillé that excited Hogarth's original customers.[44]

Hogarth treats the "face and neck" (meaning the expanse of the bosom) as the plate or field on which he can perform his seduction by deploying "flecks of significance": the contrast of heavy "spur" and light "touch," the graduated system of spots and stipples, the smooth skin "broken" by a curl or ribbon, the loose waving edge (in some cases, like the beauty in plate 6, formed by the original etched line with no additional "pressure of the burin"). This edge is serpentinized quite wantonly, to emphasize the curve of the breast and draw attention to the nipple, another significant "*Fleck*" in the constellation of beauty spots. But whose wantonness is on display in the "déshabillé" plate of *A Harlot's Progress* or in the second plate, where she distracts her keeper, or in several other prints where the breast is staged in this way? Does it simply show the fashion-

able coquetry of "the loose and lowest class of women"? I suggest, rather, that the display of the breast is frequently implausible in terms of realism: the corsage of the seductress at the funeral looks quite distorted, and the harlot in the third plate (alone with her servant and unaware of the police raid behind her) has no motive to assume the self-conscious pose that Hogarth gives her, as if auditioning for the viewer or stage audience. In particular, the placing of her robe and her watch ribbon seems exclusively designed to draw attention to the nipple, to fix the focus of the gaze and instigate the viewer's "imaginary pursuits." The nipples are suppressed, incidentally, in the Giles King copies of the second and third plates, authorized by Hogarth for the general public rather than the gentleman-subscriber. In the Drury Lane scene (and elsewhere) the dress looks pulled down on one side rather than "carelessly" or artfully abandoned. It is clearly Hogarth who does the pulling; the harlot has been *déshabillée* by an external force, undressed as a verb.

This gratuitously teasing exposure of the breast—sometimes bordering on asymmetrical deformation—recurs so often in "sly Hogarth" that it becomes a personal tic. In the posture woman of the *Rake's Progress*, for example, he deepens the shadow under her breast and enlarges her nipple between states, adding dark, coarse lines to bring out the contrast with the "ribbon-edge" of the smock that passes just below it. In *The Sleeping Congregation* this edge effect is reproduced on a scale barely visible to the naked eye, presumably a deliberate visual trap, since both the parson and his clerk are in fact holding magnifying glasses. In both *The Sleeping Congregation* and the *Noon* scene of *The Four Times of Day* he emphasizes the "dishabille" by juxtaposition with grotesque caricatures of ocular desire (the toadlike Church clerk, the cannibalistic African), which work to divert the viewer in both senses: they

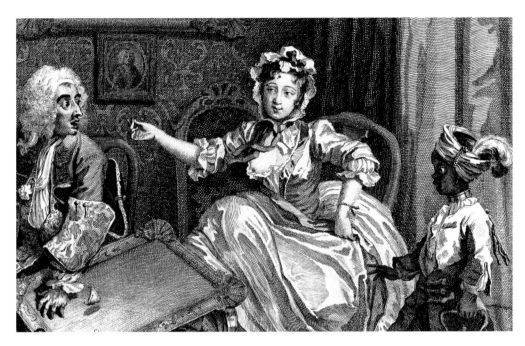

Fig. 13. William Hogarth, *A Harlot's Progress*, Plate 2 (detail), 1732. Etching and engraving. University of California, Berkeley Art Museum

Fig. 14. William Hogarth, *A Harlot's Progress*, Plate 2 (detail), 1732. Etching and engraving. University of California, Berkeley Art Museum

amuse by their frankness and at the same time deflect attention from the artist's perverse inventiveness, externalize and disavow his own agency and his complicity with the "rogue-eyes" of the worldly subscriber.[45] In *Noon* the cartoonish, groping Black man even rolls down the hem of the dress himself, as if preparing the demonstration for a lecture from the *Analysis of Beauty*.

In the second plate of *A Harlot's Progress* Hogarth creates not one but two racial stereotypes who gaze pop-eyed at the harlot, fixated above all by her "careless," exaggerated, and fascinatingly detailed "déshabillé" (fig. 13). (Hogarth's predilection for the stone-throwing anti-Semitic mob is foreshadowed in his simian caricature of the Jewish keeper.) The Black boy looks, in fact, directly at the nipple, which is rendered with some anatomical accuracy, the ubiquitous flecks or dots arranged in a circle around the alveole (fig. 14). Hogarth draws the eye as the exact graphic equivalent of the nipple and the beauty spot, circular patches identical in volume and density, and thereby "draws the eye" in Lichtenberg's sense.[46] This focal point of the déshabillé thus becomes a figure for seeing as well as an object to be seen. Hogarth enacts and elicits the erotic gaze as well as representing it, and it is this drawing power—this visual "force," as Lichtenberg would call it—that really drives the progress of *A Harlot's Progress*.

James Grantham Turner

Notes

The full text of the epigraph can be found in Hogarth 1955, 42, 51–52.

1. Cited in Paulson 1965, 1:41; this praise, apparently uttered without irony, makes Fielding sound like the enthusiastic idiots he parodies so cruelly in *Shamela*.

2. At Northwestern University (organized by the editors of this volume) and at the University of California Berkeley Art Museum (organized in conjunction with the British Museum traveling exhibition, *Hogarth and His Times: Serious Comedy*); the publicity materials for the Berkeley event gave maximum emphasis to the contradictions in Hogarth's role. For an all-out attack on determinate meanings and fixed identifications in Hogarth studies, inspired by Foucault and Derrida, see Wagner 1995a, 203–40. Wagner's work on Hogarth, however, sometimes replicates the moralizing and textualizing tendency of earlier critics—e.g., by dwelling on the documents shown in the *Harlot's Progress* (Wagner 1995b, 106–13); cf. also Wagner 1991b, 53–75.

3. Paulson 1991–93a, 1:238; for "pornography," cf. Paulson 1971, 1:239.

4. Bindman 1981a, 56, 62; Bindman 1997a, cat. nos. 30, 96.

5. Paulson 1991–93a, 1:77 (my emphasis); Kunzle 1973a, 307 ("in part ingenious, in part irrelevant, in part obscene").

6. In one presentation at the Berkeley conference, slides of the *Marriage A-la-Mode* paintings were shown after the lecture, in awestruck silence. One exception to this separation of facture from discursivity is the tantalizingly brief reading of the *Election Entertainment* in Podro 1998, 135–37, which exemplifies Podro's judicious separation of "the sportiveness of painting" from moralistic issues (131).

7. Hogarth 1955, 45, 126 (in the MS and Plate 2 he actually illustrates his color theory with a crosshatched profile, instructing us to read the blackest lines on the page as the palest lines in the real face), 153, 202, 226–27.

8. D. Brewer 1998, and D. Brewer forthcoming.

9. Page references from Lichtenberg 1983, followed by the corresponding passage in Lichtenberg 1966, retranslated where necessary. For an appreciation of Lichtenberg's untranslatable complexity, see Wagner 1995a.

10. In state 3 (which Lichtenberg evidently knew and gave to Riepenhausen to copy) the rib-cage area shows a more uniform surface but two heavier lines just behind the harlot's *necessaire*; to us this is evidence of wear and reworking in the plate, but Lichtenberg evidently read it as a representation of spur wounds.

11. The changes between states are described in Paulson 1989a, 1:143–48 (cat. nos. 121–26); for comparable changes in the brothel scene of the *Rake's Progress*, see Paulson, cat. no. 134, text and plates (they include deepening the shadow to bring out the exposed breast of the "posture-woman," a figure closely related to the earlier *Harlot* series, as I argue below).

12. Angela Rosenthal points out (private communication) that this dichotomy of "forces" in Lichtenberg recalls the gendered contrast of (relaxed) Beauty and (strenuous) Sublimity in Edmund Burke.

13. Lichtenberg 1983, 127–28/50 ("*ein Reflex des Lichts aus den Schelmen-Augen des Künstlers, die auf den Charakter dieses infamen Geschöpfs einen Augenblick hinblitzen, um die Sittsamkeit selbst zu veranlassen, auch ein Augenblick ein Gleiches zu tun*"). Technically, the hole or *Durchbruch* (127) in the stocking is achieved by suspending the cross-hatching, leaving one set of parallel lines, and interrupting the heavier set. For an eye-witness account (1725) of a kept mistress beating hemp in a silk gown (accused of stealing a watch, as in the third plate) and the overseer who "made her arms quite red with the little raps he gave her with the cane," see Uglow 1997, 206 (and further discussion of Bridewell, 48–49 above); for the "Pizzle of a Bull," see (for example) Anon. 1740, 38 (on 40–41 this becomes "the Keeper's Pizzle" or "what he often made her feel," an "Excellent Cure" for upper-class vapors). Rosenthal (private communication) suggests a further metaphorical connection between the pizzle whip (which points out of the picture frame) and the engraver's burin.

14. Lichtenberg 1983, 129/51 (and cf. "Schalkheit" in 147n/68n); 152/72 (Grimm's *Wörterbuch*, "Mutwille" 7, makes it clear that eighteenth-century usage still retained the older meaning "libido" or "lasciviousness" ["Mutwille" 5]); 158/78 (and see 51 above for other comments on the coat of arms, including the phrase quoted here).

15. "The Legion Club," cited in Paulson 1991–93a, 2:46.

16. Anon. 1733, f. B1 (this acted "Introduction" is missing in some editions), 8. For reviews of Hogarth's "arch" treatment of the Rake, see Hallett's essay in this volume.

17. Hogarth might intend us to read the upper edge as the satyr's left thigh, though this is anatomically impossible. In the drawing (Oppé 1948, cat. no. 5) the organ is suggestively wrapped in drapery. Paulson 1989a, 1:117, relates the *Hudibras* satyr to the Glasgow painting (fig. 5), without spelling out their exact relation.

18. Bindman 1997a, cat. no. 37. Paulson 1991–93a, 1:275–80, in a persuasive reading of the printed ticket, fully aware of potentially bawdy meanings in its literary mottoes (e.g., "Antiquam Matrem"

as Mother Needham), still assumes that the putto is restraining the faun/satyr (and replicates this suppression by titling the piece *Boys Peeping at Nature*). Paulson points out that the herm of Nature terminates in "smooth stone" in Rubens's version, but the faun's expectation is still quite realistic; herms normally did include highly realistic genitals set into the otherwise stylized pillar base. (The putto painter renders the question moot by cutting her off at the waist.) In another discussion of this *Harlot* ticket, he remarks that "Beauty is telescoped with Nature, Truth, and the earthy and sexual" (Paulson 1989a, 195); I adapt his phrase to describe the composition, relative to Rubens, rather than the theme.

19. By Giles King; Bindman 1997a (cat. no. 11) included one of the two three-scene engravings, relating the frame volutes to "mantelpieces" but declining to speculate on Hogarth's contribution to the design (where Paulson 1991–93a, 1:309, finds the artist's "guiding hand"). The anatomical construction of the satyrs is even weaker than usual in Hogarth (especially the thighs), and we can assume that King executed them. This venture may have confirmed the idea of the satyr as Hogarth's trademark; in several of his cartoons Paul Sandby places a satyr close to Hogarth himself, one of them showing him his own pug face in a mirror (Bindman 1997a, cat. nos. 104, 108).

20. Hogarth's series was reproduced on at least two different printed fans. The colored, double-sided version described in newspaper advertisements (with three plates on each side and illustrated in Angela Rosenthal's essay in this volume, fig. 50) differs from the outline etching in reddish-brown ink (Bindman 1997a, cat. no. 12), which shows five scenes on a single side. They are ingeniously overlapped rather than forced into compartments, but if the owner began with the center fold and fanned first to the left and then to the right, the story would unfold in order, with the Harlot's dying body on the last pleat.

21. Lichtenberg 1983, 77/3 (in prominent position at the very start of the *Harlot's Progress* volume); Grimm's *Wörterbuch*, while not recording the coinage *Darunterwegschielen*, gives many eighteenth-century examples of *schielen* used for the sexual glance.

22. Hogarth 1975, ff. A3v, A5; the irresolvability of Hogarth's authorship can be gauged from the differing assumptions in successive editions of Paulson 1989a and 1991–93a.

23. Podro 1998, 109, 136–37; I have conflated a general, theoretical passage with a particular analysis of the *Election Entertainment* because the former seems fulfilled in the latter. I use "complicity" to mean the sense of being involved in an analogous activity (inferable, e.g., from shared vocabulary or a visual gesture of invitation), when that activity is illicit or immoral according to the prevailing code.

24. Anon. 1740, 42; the poem here refers generally to the crowd of prostitutes beating hemp, but the previous line ("And lous'd themselves, and eat the Lice") clearly shows that his eye is on the two figures in the right foreground.

25. Head 1665, third pagination 24–25 (ff. Bbb4v-5); Ward 1993, 141–43. The 1725 journal of César de Saussure (Saussure 1995), uncannily similar to Hogarth's scene, suggests that Bridewell was a must-see for foreign tourists.

26. For the different states and the anecdotal identification of the character, see Paulson 1989a, cat. no. 134, and Lichtenberg 1983, 199/222. (Though commentators all agree that the ballad sung to usher in this performance ["The Black Joke"] is extremely lewd, I have not been able to discover why; extant theatrical records record it as a dance rather than a text, and published ballads refer to it only as a tune.) In the painting (Sir John Soane's Museum, London) the platter is now quite dull, whereas in the engraving Hogarth has worked it up to a professional shine. As Rosenthal suggests (private communication), this mirroring effect might emblematize the satirist's project, making a similar point to Swift's *Battle of the Books* preface ("Satyr is a sort of *Glass*, wherein Beholders do generally discover every body's Face but their Own"). The figure of "Aretine" (fig. 8) continues to serve as an icon of eighteenth-century sexuality: in the dust-jacket design for Trumbach 1998 she is placed prominently on the front flap and seems to push the printed text aside.

27. I am grateful to Martha Pollak for suggesting this resemblance.

28. Anon. 1740, 56–57; Breval 1733, 55. Ironically, the Breval version, which claims high-cultural status and disparages the other literary versions as "pitiful Performances" full of "Obscenity" (ii), recycles a large number of the "Hudibrastic" poem's lewd expansions. One of the earliest and most opportunistic spin-offs, which improvises the Harlot's life without actually having seen Hogarth's images (summarized on the title page but not in the text itself), still manages to invent a funeral scene with a drunken parson who "must needs be meddling with one of the Ladies, who (while he was in the midst of his Amorous Play) pick'd his Pocket of his Watch"; Anon. 1732c, 47.

29. Anon. 1740, 64; this clearly predates Grose and Partridge's first examples of the modern usage of "screw."

30. Cited in Uglow 1997, 194; for Podro's account of the *Election*, see p. 47 above.

31. Vertue 1934, 58 (punctuation lightly modernized); the passage is extensively cited in Paulson 1991–93a, 1:237–38 and *passim*, and it forms the basis of Godby 1987, 23–37.

32. British Museum Dept. of Prints and Drawings, ref. no. BM

Z.1.3 (007304-1026). Oppé 1948, cat. no. 32, attributes it to Hogarth only questionably (and sets it apart from the *Harlot* series itself), but Paulson 1991–93a, 1:237, 247, refers to it as autograph; the weaknesses in this drawing include the harlot's poorly modeled right thigh, the uneven size of her shoes (which makes the farther foot seem nearer), the curving wash line, and the uncertain relation of the table legs to the floor. The cat is particularly ugly (more like an overgrown rat), and it is difficult to imagine Hogarth's hand working on it. Though she sports two smudgy beauty spots, the harlot is not presented as "careless" or "pretty" (and certainly displays no "desabillé" in the sense of exposed flesh); the fringes of her dress clearly represent ragged threads (not fur trimming), and the entire scene emphasizes poverty and decay. The objects around her include an open book with ARISTOTLE visible on the title page (i.e., *Aristotle's Masterpiece*), two indistinct prints that might be "postures," a syringe, a bundle of flagellation rods (an object also displayed in the third plate of the *Harlot's Progress* and flogged to death by the bawdy poetic versions), and condoms with tie-on ribbons, which do not appear in the extant prints (though Uglow 1997, 207, refers to the tallow candles in plate 5 as "sheaths") but which are several times mentioned among the harlot's goods in the *Hudibrastic Cantos* (Anon. 1740, 46, 48). Since it is squared and numbered for enlargement into a painting, perhaps an unknown artist was attempting a rival series, after Hogarth's paintings had gone on view to such acclaim.

33. A connection made in Uglow 1997, 192.

34. Vertue 1934, 58; the word "thought" in Vertue's account is itself an afterthought, added with a caret. He does recognize the narrative coherence of the finished series, which he sketches as lightly as the fan designer: "Persons of fashion and Artists came to see these pictures the story of them being related. how this Girl came to Town. how Mother Needham. and Col. Charteris first deluded her. how a Jew kept her how she livd in Drury lane. when she was sent to bridewell by Sr. John Gonson Justice and her salivation & death."

35. Cited in Paulson 1991–93a, 1:309; cf. Hogarth 1975, cited p. 47 above.

36. Hogarth 1955, 42; R. W. Jones 1998, 54 (and ch. 1 *passim*). For other recent studies, see Podro 1998, ch. 5, and Uglow 1997, ch. 25.

37. Hogarth 1955, 1 (title page), 42, 45, 51–53, 66, 159, and for the MS drafts, 170–75, 188; Plate 1, Figure 53 (panels numbered 1–7), shows the graduation of stays (which were worn by men as well as women in the period). For an interpretation that connects these "wanton" passages to the *Harlot's Progress* and its subscription ticket, see Paulson 1989b, 195–97; Paulson recognizes the close association between Hogarth's aesthetics and

sexual temptation (Cleopatra, "the woman and the serpent" seen "as graceful forms") but takes the Milton epigraph to mean that Hogarth teaches a "moral" lesson about the fall.

38. Christopher Tilson (as told to William Huggins), cited in Paulson 1991–93a, 1:307, and 1989a, 1:146. The identification of Gonson and Charteris does seem justified (the Colonel is authenticated in Giles King's caption, though the intruders in the third plate are just called "Informers"); generally, however, the certainty of personal identification should be taken as an effect of the prints and the literature, not as objective fact. Most recent critics speak with confidence of "Mrs Needham," for example, but the literary spin-offs come up with different, and contradictory, identifications expressed with equal certainty: cf. Breval 1733, 7 ("Bentley was her Name").

39. Cibber 1733, 11–12 (the stage name "Justice Mittimus" is also borrowed by the ballad-opera). Harlequin's intervention in each scene makes him a surrogate for the curiosity and desire of the pro-harlot spectator: he peers in at windows, climbs into the trunk, becomes the sly lover escaping in the second plate (while transforming the Jewish keeper into one of his own pictures), and turns himself into the hemp-beating block in Bridewell, leaping back into his own form to save her from captivity.

40. Anon. 1732c, 26, 32; note that even the prose narrative *The Progress of a Harlot*, slung together with only a vague knowledge of the actual plates (n. 28 above), invents an arrest scene and a lecherous Magistrate who releases her from Bridewell and makes an assignation (40–41).

41. The figure of Gonson (fig. 11) in the engraving (plate 3) looks unemphatic because it is rendered with an extremely uniform system of hatching, identical in tone if not direction to the wall behind him, and only varied infinitesimally to create faint highlights.

42. As noted in Paulson 1991–93a, 1:279, however, his point that Gonson "was not in Hogarth's original drawing and presumably painting" (247) seems to derive from the questionable chalk drawing (n. 32 above) rather than the *Battle of the Pictures*. Godby 1987 uses the *Battle* detail to infer that Gonson was an afterthought and suggests that he was added to balance the lover exiting through a door in the second plate, at a stage when that and the third plate formed a before-and-after pendant pair (27). As circumstantial evidence for the accuracy of Hogarth's auction ticket, two other canvases depicted, from the *Rake* and the *Marriage*, correspond closely to those that have survived; the painting of the churchgoing lady from *Morning*, however, does not correspond to its surviving canvas.

43. Hogarth 1955, 53, 82, 175; in a draft of the chapter on color, Hogarth seems to categorize the breast among parts of the body that are seen rather than covered by the dress ("simplicity or distinct oppositions of firm colour for the parts which call for

our particular attention as the Eyes and mouth, uniformity as the cheeks, nipples &c," 177). The portrait of *Sir Francis Dashwood at His Devotions* (private collection, fig. 19) shows that Hogarth *could* paint a nude on occasion.

44. Hogarth's mammographic fixation does not prevent him from occasionally displaying the thighs (as we have seen in the maid and the "posture-woman," figs. 3 and 8): in *Southwark Fair*, for example, the actress in Theophilus Cibber's *Fall of Bajazet* is gratuitously tumbled to show her legs and underlinen as the stage collapses. Hogarth may here be exacting revenge on Cibber, who played his pantomime *The Harlot's Progress* on this stage in a double bill with *Bajazet*; the thighs may therefore belong to the actress who pirated "his" Harlot.

45. This grotesquerie is much more pronounced in the print than in the painted versions of a comparable scene, *Orator Henley Christening a Child* (cf. the oil sketch, Bindman 1997a, cat. no. 35). For a different account of the link between Hogarth's aesthetics and the exposed female beauty, see Paulson 1989, esp. 151; the clerk's furtive glance at the woman's bosom in *The Sleeping Congregation* is interpreted as "idolatry" (a puzzling thesis, since idolatry has just been defined as "deny[ing the] physical reality" of the object or regarding it as "a godless, that is, a lifeless statue").

46. Cf. the passage cited n. 13 above. This drawing power apparently continues today; the poster for David Bindman's lecture at the Berkeley conference (since published in this volume) shows a detail from the second plate corresponding to my fig. 13, placing the nipple at dead center.

The Flesh of Theory: The Erotics of Hogarth's Lines

Frédéric Ogée

Hogarth's explanation, in chapter XIV of *The Analysis of Beauty* (1753), of "the beauty of colouring"—"that disposition of colours on objects, together with their proper shades, which appear at the same time both distinctly varied and artfully united, in composition of any kind"—is centered upon the quintessential and demonstrative qualities of "the prime tint of flesh," "for the composition of this, when rightly understood, comprehends every thing that can be said of the colouring of all other objects whatever."[1]

Beyond the empirical and technical "progress" of Hogarth's analysis in the chapter, itself the methodological epitome of his enterprise throughout the treatise, one discovers some of Hogarth's most sensitive remarks on beauty, and the delicacy of his approach on such a "tender" subject[2] sheds a rare emotional light on what is commonly regarded as the matter-of-fact aesthetics of a down-to-earth middle-class English artist.

That flesh is indeed the "heart" of the matter—human or aesthetic—is made clear from Hogarth's implicit equation of its "mystery" with the whole notion of beauty and grace in art, the irritating, escapist *je ne sais quoi* approach that, the Preface explained, his *Analysis* was attempting to refute: "I am apt to believe, that the not knowing nature's artful, and intricate method of uniting colours for the production of the variegated composition, or prime tint of flesh, hath made colouring, in the art of painting, a kind of mystery in all ages."[3]

Recommending, as he often does else-

where, the method of direct observation of "nature's curious ways of producing all sorts of complexions . . . so as to see why they cause the effect of beauty," Hogarth identifies the skin as the crucial terrain of "experience" and delicately unveils and reveils the human body to reveal the secret of nature's wonderful "variety" (the key word of his aesthetics): "Nature hath contrived a transparent skin, the cuticula, with a lining to it of a very extraordinary kind, called the cutis." And it is this "lining . . . of a very extraordinary kind" which is "composed of tender threads like network, fill'd with different colour'd juices"—white, yellow, brownish-yellow, green-yellow, dark brown, black—"these different colour'd juices, together with the different *mashes* of the network, and the size of its threads in this or that part, causes [sic] the variety of complexions."[4] As Hogarth had observed earlier, "The skin . . . is form'd with the utmost delicacy in nature; and [is] therefore the most proper subject of the study of every one, who desires to imitate the works of nature, *as a master should do*, or to judge of the performances of others *as a real connoisseur ought*."[5]

But before explaining the technical possibilities of its artistic representation or examining "how by art the like appearance may be made,"[6] Hogarth inserts two cursory remarks that encapsulate in remarkably "sentimental" terms the natural challenge that empirical artists were all somehow trying to meet—namely, the depiction of, and resistance to, the passing of time.

The first remark concerns the impression-ability of delicate complexions, the way certain "networks" register and circulate sudden, unpredictable emotions in ways that affect their coloring: "Some persons have the net-work so equally wove over the whole body, face and all, that the greatest heat or cold will hardly make them change their colour; and these are seldom seen to blush, tho' ever so bashful, whilst the texture is so fine in some young women, that they redden, or turn pale, on the least occasion." The second remark sug-gests that the delicacy of the complexion, and therefore its variety and the essence of beauty, is of both a textural and temporal nature: "I am apt to think the texture of this network is of a very tender kind, subject to damage many ways, but able to recover itself again, especially in youth."[7]

The task of the artist is here implicitly outlined: the aesthetic pleasure created by his work will be the effect of his ability to grasp and render the transience of this delicacy, as much as the delicacy of this transience, both tangibly and suggestively.

Although the conclusion of the chapter, after its technical examination of possible "translations" of nature into art, reads like an easy escape from the central issue at stake with Hogarth's Couéistic, roundabout remark— "Upon the whole of this account we find, that the utmost beauty of colouring depends on the great principle of varying by all the means of varying"—followed by the usual dismissal of most previous artists "who have labour'd to attain it,"[8] one cannot fail to notice the remarkably erotic approach at the heart of Hogarth's aesthetics, symbolized by his specific handling of the serpentine line.

The artist truly concerned with the crea-tion of "natural" beauty is invited to feel the delicate veil that covers the human form, "the most complex and beautiful of all," to stroke the skin and endeavor "to conceive, as accurate an idea as possible, of the inside of those sur-faces"—in other words, to feel those "varied contents" which the waving and winding of the serpentine line is said to enclose and whose variety "cannot be expressed on paper . . . with-out the assistance of the imagination."[9]

In all meanings of the term, Hogarth's "Line of Beauty" is conceived as a *moving* line, since its attempt at creating the effect of move-ment and caressing or espousing the forms of nature is meant to cause the delight of the beholder's eye, who is invited to enter "the wan-ton kind of chace."[10] In his description of "the compositions with the serpentine line" (chapter X), Hogarth defines a dynamic aesthetics of "pleasing discovery" illustrated by the line's most erotic way of gradually teasing knowledge out of form until the "sublime" climax:

The very great difficulty there is in describing this line . . . will make it necessary for me to proceed very slowly in what I have to say in this chapter, and to beg the reader's patience whilst I lead him step by step into the knowledge of what I think the sublime in form, so remarkably

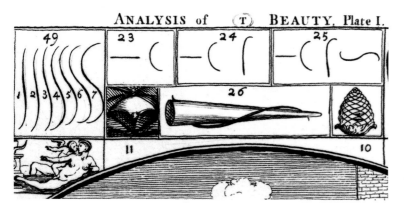

Fig. 15. William Hogarth, *The Analysis of Beauty*, Plate 1 (detail), 1753. Etching and engraving. Lewis Walpole Library, Yale University, Farmington, Connecticut

display'd in the human body. . . . The serpentine-line . . . as it dips out of sight . . . and returns again . . . , not only gives play to the imagination, and delights the eye, on that account; but informs it likewise of the quantity and variety of the contents.[11]

Before moving on to the physical "discovery" of the human body, Hogarth takes the example of the line winding around a horn (fig. 15), in what reads remarkably like some amorous dance, as the most striking source of "graceful" actions:

It will be sufficient, therefore, at present only to observe, first, that the whole horn acquires a beauty by its being thus genteely bent two different ways; secondly, that whatever lines are drawn on its external surface become graceful, as they must all of them, from the twist that is given the horn, partake in some degree or other, of the shape of the serpentine-line: and, lastly, when the horn is split, and the inner, as well as the outward surface of its shell-like form is exposed, the eye is peculiarly entertained and relieved in the pursuit of these serpentine-lines, as in their twistings their concavities and convexities are alternately offer'd to its view.[12]

Essentially different from Boucher-like voyeurism, Hogarth's aesthetics—unsurprisingly like Sterne's, as I suggest below—relies on that pleasure of the pursuit which is at the heart of true eroticism and its two active principles: suggestiveness (a combination of actual and imaginary discovery) and potentiality (a combination of progress and suspension).

The crux of Hogarth's theory is the formal explanation of beauty in nature and art in relation to the number of serpentine lines found in objects, which led him to declare that "the human frame hath more of its parts composed of serpentine lines than any other object in nature; which is a proof both of its superior beauty to all others, and, at the same time, that its beauty proceeds from those lines."[13] Hogarth's overall conception of beauty is clearly determined by "manly" qualities and most often exemplified by decidedly masculine principles. Yet deriding the artistic bigotry of connoisseurs who fail to recognize that "even the Grecian Venus doth but coarsely imitate" the "faces and necks, hands and arms in living women,"[14] he makes use of a whole array of concrete examples to extol the merits and "attractiveness" of natural beauty. Some of the examples include gender-biased images (e.g., the seductive and serpentine grace of ribbons, "wanton ringlets," or "curls of hair"). And it is precisely where beauty hinges on grace (Hogarth's ideal and the whole point of his demonstration) that "feminine" qualities are introduced, refining, as it were, the beautiful into the graceful and providing a form of neo-Platonic completion of the former's otherwise imperfect nature.

A logical and practical consequence of this idea has been a gradual regendering of beauty. As Ronald Paulson and David Bindman have noted, one of the striking conclusions in Hogarth's analysis of beauty is its progressive establishment of the superiority of Venus over Apollo and ultimately of "living women" over "even the Grecian Venus" which "but coarsely imitate[s]" them.[15] This conspicuous detachment from traditional, "ideal" aesthetic discourse à la Shaftesbury comes as the cogent outcome of a concrete demonstration in which Hogarth, true to his observational, experimen-

Fig. 16. William Hogarth, *The Four Stages of Cruelty*, Plate 4, *The Reward of Cruelty*, 1751 (reproduced c. 1822). Etching and engraving. The Charles Deering McCormick Library of Special Collections, Northwestern University Library, Evanston, Illinois

tal bias, adopts an anatomical approach to the body in order to breathe new life into models of antiquity whose canonical status can only be explained by the ancients' "perfect knowledge . . . of the use of the precise serpentine line" to recover "that *peculiar taste of elegance* found in the natural body."[16]

Other than his disturbing idea of running wires (or staylace) along various parts of the body,[17] Hogarth's anatomical inquiry has none of the brutal reality represented in the fourth plate of *The Four Stages of Cruelty* (1751; fig. 16). As if to suggest the flimsiness and fragility of the *poco piu* he would like his reader "insensibly"

to grasp, Hogarth, in a passage which teems with expressions like "utmost delicacy," "soften'd shapes," "sweetly connected," "fine simplicity," etc., invites the reader to partake of a truly poetic apprehension of the lay of the land ("perhaps a Stow"):

In order just to form a true idea of the elegant use that is made of the skin and fat beneath it, to conceal from the eye all that is hard and disagreeable, and at the same time to preserve to it whatever is necessary in the shapes of the parts beneath, to give grace and beauty to the whole limb: [the reader] will find himself insensibly led into the principles of that grace and beauty which is to be found in well-turn'd limbs, in fine, elegant, healthy life, or in those of the best antique statues; as well as into the reason why his eye has so often unknowingly been pleased and delighted with them.[18]

The skin is presented as that most delicate terrain of negotiation between the inside and the outside of the body—the skin is what touches and sends (inwardly) sensorial data throughout the body; it is also what "expresses to the eye the idea of [the body's] contents with the utmost delicacy of beauty and grace" as well as what reveals (outwardly) the emotional reactions of that body (blushing, turning pale, etc.). The serpentine line, and with it the beholder's eye, runs in a similar manner over the "different curvatures" and "easily . . . glides along the varied wavings of its sweep . . . as pleasantly as the lightest skiff dances over the gentlest wave."[19]

The aesthetic and social benefit to be drawn from such a "touching" experience is underlined in terms that read like an echo of Addison's demonstration in his "Pleasures of the Imagination" essays:

Now whoever can conceive lines thus constantly flowing, and delicately varying over every part of the body even to the fingers ends, and will call to his remembrance what led us to this last description of what the Italians call, Il poco piu (*the little more* that is expected from the hand of a master) will, in my mind, want very little more than what his own observation on the works of art and nature will

lead him to, to acquire a true idea of the word *Taste*, when applied to form.[20]

In the end, Hogarthian beauty and grace, far from being some abstract metaphysical concept or the aesthetic consequences of the application of a set of rules, emerge as transient, "living," physical phenomena apprehended through visual caresses and imaginary frictions, where the beholder plays a crucial, fulfilling role.

The way this tactile conception of beauty translated into Hogarth's own artistic practice, and the extent to which it has conditioned the beholder's reception of his works, are complex issues. When compared, for instance, to contemporary French art, it does not require much art historical finesse to notice how clearly unerotic—from a thematic point of view, that is—Hogarth's whole oeuvre looks, even though most of his major works, including the three famous series, do in fact address sexual issues.

Whether they are read as satirical attacks on French *scènes galantes*, as morally ironic deconstructions in the Swiftian vein of erotic expectations and their consequences, or simply as signs of Hogarth's reluctance "to abandon the kind of moralism which had its roots in the Puritan middle class," as Peter Wagner has argued,[21] all his representations of sexuality are conceived in terms of disorder, in both the medical and the social meaning of the term. The driving force behind all the forms of "progresses" he depicts, from lust to venereal disease, rape to prostitution, mismatching to adultery, sex (which is never actually shown) comes across as a disturbing cluster of animal desires in urgent need of control. However much present in nature, flesh is certainly not conducive to the experience of any beauty, and no form of caressing is in any way encouraged or even hinted at.[22]

In fact the debunking of erotic tension and the lack of any form of real sexual attractiveness in the pictures that might lead the

beholder's imagination astray are the result of Hogarth's systematic—some would say symptomatic—treatment of sex, either in the comic or the tragic mode, as perhaps the most efficient prophylactic against the "risk" of arousal.[23] In *The Sleeping Congregation* (fig. 17), the lustful plunge of the clergyman's eyes into the inviting bosom of the attractive young girl dozing in the foreground and the pornographic display of the lion's sexual organs[24] are straightforward comic details adding to the well-framed representation of a Godless assembly.

In *Noon*, both in the picture and in the second plate of the series *The Four Times of Day* (fig. 18), as Peter Wagner has remarked, "the repeated pictorial allusion to sexuality . . . [is] made in the form of emblematic encodings of an essentially repressive discourse on sexual behaviour," subdued but ludicrously narcissistic on the right half of the picture, "cast into much cruder images suggesting savagery and even cannibalism" in the other half, with the striking presence of "objects referring to penetration and spillage, i.e. ejaculation." Within that "disorderly" context, and when the picture is read as a "modern" rendering of the *points du jour* iconographic tradition that serves as its "hypotext," the cook-maid's emphatic attractiveness and her function as modern Venus are obviously subverted:

Thus the entwined lovers on the left, the cook-maid and her paramour, represent Hogarth's satirical interpretation of the mythological meeting of Europe and Africa, of Apollo and Venus. Venus's nakedness indicates her carnality. . . . Her beauty stands in sharp and deliberate contrast to the ugly low-life figures around her. Since she is so beautiful, showing the typical Hogarthian serpentine lines of a desirable young woman, her toleration of the black man's sexual advances must be all the more shocking to the observer.[25]

The most "graphic" representations of sexual matter in Hogarth's work are to be found in commissioned paintings, the two sets

known as *Before* and *After* dating from the 1730s (the engraving of this work, as will be discussed below, raises different issues), and the portrait of the so-called "Medmenhamite" Brother, Francis Dashwood, *Sir Francis Dashwood at His Devotions*, of the mid-1750s (fig. 19).[26] Their (relative) boldness is of course primarily attributable to the privacy of their reception and destination, which removed the moral "burden" and its cleansing effect. And yet, in both cases, sexual titillation is still diverted by comic devices—on the one hand, the embryonic narrative of *Before* and *After*,

Fig. 17. William Hogarth, *The Sleeping Congregation*, 1736. Etching and engraving. Lewis Walpole Library, Yale University, Farmington, Connecticut

Frédéric Ogée

Fig. 18. William Hogarth, *The Four Times of Day*, Plate 2, *Noon*, 1738. Etching and engraving. Hood Museum of Art, Dartmouth College, Hanover, New Hampshire. Purchased through the Guernsey Center Moore 1904 Memorial Fund

with its crude gendered clichés on sexual behavior; on the other hand, the grotesque iconolatrous presentation of Dashwood as a mock St. Francis, dressed in a monastic habit and staring lecherously between the legs of a miniature naked female who is meant to stand (or rather here, to lie) for Venus.[27]

However careful one needs to be in the historicization of sexual response, the grinning bluntness of such pictures, which may in a way corroborate that "extraordinary openness of sexuality, in contrast to other ages," perceived by Roy Porter in eighteenth-century England,[28] is far from the vaguely similar

contemporary erotics of, say, Cleland's *Memoirs of a Woman of Pleasure* (1748–49)—possibly an exception in itself, but a work in which desire is definitely central—and far, too, from any aesthetic use of flesh as erotic tension. Hogarth's paintings hover uncomfortably between the ludicrous and the salacious, and in the case of *Before* and *After* (figs. 37 and 26), even Frederick Antal, who tried to trace "some resemblance" with "similar contemporary French rococo types of erotic pictures" of the kind painted by Jean-François de Troy, had to admit that "the comparison emphasized the wide gulf separating the French and English pictures. In the gay thirties of Fielding's farces, the young Hogarth displays an uncouth bluntness, an unabashed brutality without any precedent in painting, particularly not in French rococo, where, however erotic the subject, a veneer of gracefulness was always requisite. . . . From the formal viewpoint, judged by the French standards though by them alone, the possibility of an elegant rococo pattern of lines, particularly in the second scene, was ruled out by the realistic, unmitigated vehemence of the conception."[29]

The tragic pendant to these examples of comic escapism is most demonstratively found in Hogarth's three major series, *A Harlot's Progress*, *A Rake's Progress*, and *Marriage A-la-Mode*, which all display, in laconic sequences, the dramatic consequences of the "progress" of sexual excess, along with the edifying stories of three emblematic case studies: a woman, a man, and a couple. These well-known works need not be discussed again, except to underline the unerotic (moralistic?) presence of flesh in them.

In a fine discussion of *Rake*, Ronald Paulson has conducted a careful observation of the function of color in the painted version and thus raised the problematic issue of their visual charm as distracting from the moral message at stake:

The technique of Hogarth's paintings—his bravura brushwork, his rich and creamy colors—seems to remove the scene from the harsh newsprint reality of the engraving. Even in the grim world of the *Rake*, in scene after scene one is bewitched by the soft, lovely colors and textures and distracted from the relentless message.[30]

The allure, however, remains of a purely "plastic" nature, and the flesh is all too literal, sheer body matter in putrid progress:

The colors locate the peak of pleasure and involvement with the colorful world [of the brothel scene], and then document the Rake's gradual isolation, until he is merely a spot of flesh or color, laid out almost like a piece of meat in a market, a cool pink that recalls by contrast the warm reds of the brothel.[31]

It is the same melodrama of plural, dissipated pleasures, as opposed to the abstract reverie, the "happy illusion" of Watteauesque blue-skied fêtes, which Jean Starobinski finds so tragic in the sordid, post-coitum fleshiness that shapes

Fig. 19. William Hogarth, *Sir Francis Dashwood at His Devotions*, mid-1750s. Oil on canvas, 48 x 35 in. (121.9 x 88.9 cm). Private collection

the expressions of the Squanderfield couple in the second plate of *Marriage A-la-Mode*.[32]

Whether he would not or could not represent it, eroticism as the quest for sexual pleasure is not a theme in Hogarth's art, for reasons (Puritan restraint? rejection of French *scènes galantes*? lack of artistic "refinement"? English urban boisterousness? wrong patrons? etc.) that are individually unconvincing, but that may somehow have combined to deter him from attempting it. The erotics, the pleasure of the "chace" at the heart of his theory of beauty were obviously of a different nature and should be understood as a formal rather than a thematic concern.

One of Hogarth's lesser known—yet most finished—paintings, *The Lady's Last Stake* (or, as Hogarth originally called it, *Picquet, or Virtue in Danger*) of 1758–59 (fig. 20), provides a rare example of the kind of aesthetic pleasure he was trying to create and formalize. Although a commissioned work, based on the subplot of a play by Colley Cibber, it depicts a scene of erotic suspense that transcends any knowledge of its topical circumstances.[33]

If, as Paulson claims, Hogarth "leave[s] the choice [of the lady] and its consequences in the air" for the audience to "fill them in," this will not be done through the beholders' knowledge of the "external" of the play. To my mind, Paulson errs in seeing the subject of the painting as "once more, choice" and its consequences.[34] On the contrary, the clear injunction "NUNC NUNC" inscribed on the pedestal of the little Cupid with a scythe seems an unambiguous invitation to enjoy the quality of this precious moment. Pleasure and virtue, body and soul are in a state of poised tension; all possible scenarios are envisaged and caressed silently, momentarily free of the weight of "consequences." "Filling in" the story would immediately weight the picture with a narrative framework (before and after) that would destroy the enjoyment of its fragile momen-

tariness. What we have is suspension, not suspense, and if there is beauty, it stems from a sentimental enjoyment of the pleasure of the pursuit *hic et nunc*, rather than from some incentive to the pursuit of pleasure.

I have suggested elsewhere the extent to which the aesthetics of Fragonard and Sterne's sentimentalism relied similarly on the erotic richness of such withholding of narrative.[35] Just as Yorick, in the famous scene with the "fair *fille de chambre*" in Sterne's *Sentimental Journey* (1768), scolds the reader for wanting to make sense of the aposiopetic "and then—" on which the chapter ("The Temptation") remains suspended, Hogarth seems to invite the beholder to an enjoyment of his painting that shuns any consideration of consummation (the *petite mort* of beauty).[36] The two characters depicted in *The Lady's Last Stake* look pleasantly puzzled by the charm of their present situation. The vague tinge of anxiety on the lady's face seems more a reaction to the beholder's (inevitably judging) gaze than to the consideration of any moral dilemma, while the young man's elegant eagerness is similar to that of many young lovers in Fragonard's paintings.[37] As Jenny Uglow writes (although she, too, presents the painting as "a classic moment of choice"): "The woman's assessing gaze, her half-open mouth and flushed cheek and the casual way she taps her satin slipper against the fire screen and rests her hand on its scene of offered fruit are all suggestive. Far from the sharp morality of *Marriage A-la-Mode* this is a moment of indecision to enjoy."[38]

Most connoisseurs of Hogarth's oeuvre would tend to agree that this example of an aesthetics of suspension is indeed "far from the sharp morality of *Marriage A-la-Mode*," and Hogarth's reputation as a "narrative moral" artist would seem to confirm the singularity of *The Lady's Last Stake*. Yet recent critical readings of his works have pointed out the hermeneutic indeterminacy and the downright

Fig. 20. William Hogarth, *The Lady's Last Stake*, 1759. Oil on canvas, 36 x 41½ in. (91.4 x 113 cm). The Albright-Knox Art Gallery, Buffalo, New York. Seymour H. Knox Fund through special gifts to the fund by Mrs. Marjorie Knox Campbell, Mrs. Dorothy Knox Rogers and Seymour H. Knox, Jr., 1945

moral ambiguity of some, if not most, of his major works,[39] together with Hogarth's own insistence, in the *Analysis*, on the necessity of distinguishing between morals and aesthetics. Perhaps this should invite us to free his enterprise from the ethical and storytelling framework within which it has so often been read to allow the full scope of his pictorial originality to emerge—and to be more recognized by art historians, who from Hogarth's time to the present day have tended to downplay his formal and plastic concerns and to leave the interpretation of his works to literary critics and specialists of eighteenth-century satire.[40]

As I have shown in previous studies, Hogarth's boldest innovations were his use of the serial format and of graphic proliferation.[41] Beyond the thematic concerns of which they are undoubtedly the vehicles (descriptions of the causes and effects of the passing of time, on the one hand, and representation of several forms of disorder on the other), they invite the beholder into a visually tactile and "moving" apprehension of pictures whose *raison d'être* is aesthetic pleasure—in other words, to an experience of beauty that ultimately derives from the beauty of experience. Whether this experience of beauty has a moral effect is an issue that writers and artists were beginning to question.

Be it in the various "progressive" series of pictures, in single "busy" pictures like *A Midnight*

Modern Conversation (1733) or *Southwark Fair* (1733), or—his greatest achievement—in a combination of the two, as in *An Election: Four Pictures* (1754; engr. 1757), beauty in Hogarth is experienced in the visual pursuit, in the "progress," in the flux, and not in the final outcome. The beholder's pleasure comes from his/her gradual and free pursuit of the windings of the pictures' lines, from the variety and suspense of their meanderings, and not from the completion of the "chace" or the eventual capture of its elusive moral prey.

If the real moral issue is often problematic, it may be because the moral of the story is rarely the point, and the state of suspension (*Est-il bon, est-il méchant?*) that seems to preside over so many of Hogarth's pictures is perhaps to be understood primarily, though obviously not exclusively, as an aesthetic choice rather than as a thematic ambiguity.

In the engravings of *Before* (fig. 37) and *After*, the concrete presence or "presentness," the physicality of the subjects' conversation is enhanced by a closer focalization than in the two sets of paintings. Whereas the erotic interest is clearly vectorized by the title and its cause-and-effect, left-to-right movement, dissolving the bawdy into the jocular, the aesthetic pleasure, however simple, arises from the visual friction of the two pictures. The characters are positioned to successively form the two branches of a "V," which seems to point to the gap between the two pictures, "that present tense of narration ('Now') which the 'voyeur' is free to imagine,"[42] a bit like the ever-actualized—and therefore age-proof—beauty of Widow Wadman on the blank page of *Tristram Shandy*.

In all the major series, Hogarth makes use of that device and sets up intricate networks ["mashes"] of suggested lines that take the beholder's eye in and out of the represented scenes (see, for instance, the remarkable serpentine line the eye can draw in linking the characters' heads in the first plate of *Marriage A-la-Mode*, with, as Robert Cowley has shown, the enjambment effect into plate 2),[43] leading it "a wanton kind of chace [which] from the pleasure that gives the mind, entitles it to the name of beautiful."[44]

Similarly, in the numerous "crowded" pictures (e.g., *Southwark Fair*, *The March to Finchley*, the eleventh and twelfth plates of *Industry and Idleness*, the first, third, and fourth plates of *An Election: Four Pictures*), the tangible physicality of the depicted masses of people, whatever its social or political significance, is designed to be visually enjoyed as a proliferation of lines and motifs, blurring, if not impeding, any clear scanning of the picture in one glance.[45] Partaking of the same aesthetic strategy as the serial structure, these visually "excessive" pictures rely primarily on an active perceptive "chace," and "instead of being subservient to some global architectonic structure, a centrifugal whole, the forms of these images of disorder, which, as Pope put it, may only be 'harmony not understood,' are divided into local units of meaning, which invite the eye from one area of the picture to another, and produce a network of perception each time renewed and different, from which moral as much as aesthetic beauty will perhaps emerge."[46]

In most, if not all, of Hogarth's pictures, from the singular physicality of a Captain Coram to the bustling energy generated by crowd movements, it is always and insistently the human body that endows his art with its textural, formal, and rhythmic qualities. In chapter 11 ("Of Proportion") of the *Analysis*, Hogarth wrote

We find . . . that the profuse variety of shapes, which present themselves from the whole animal creation, arise chiefly from the nice fitness of their parts, designed for accomplishing the peculiar movements of each. . . . Yet, properly speaking, no living creatures are capable of moving in such truly varied and graceful directions, as the human

species; and it would be needless to say how much superior in beauty their forms and textures likewise are.[47]

This textural quality of Hogarth's art is meant to be literally "felt" by the beholder, who is invited to follow or imagine the various wavings and windings of human "nature" and to take part, there and then, in its action.

In the concluding pages of his treatise, Hogarth stressed the importance of action in the production of variety, and therefore of beauty: "To the amazing variety of forms made still infinitely more various in appearance by light, shade and colour, nature hath added another way of increasing that variety, still more to enhance the value of all her compositions. This is accomplished by means of action."[48]

Beauty in Hogarth's art is the result of a corporeal, sensorial experience of the passing of time (NUNC . . .) and of the wonderful variety of the human body in action (. . . NUNC). Essentially erotic in nature, the aesthetic pleasure of Hogarth's pictures arises from the pursuit and the gradual discovery of forms, visually caressed in the unfolding spectacle of their conversation.

Notes

1. Hogarth 1997, 87–88.

2. "His favorite word in this chapter is 'tender' " (Paulson 1991–93a, 3:99).

3. Hogarth 1997, 92.

4. Ibid., 88.

5. Ibid., 55.

6. Ibid., 89.

7. Ibid.

8. Ibid., 92.

9. Ibid., 22, 21, 42.

10. Ibid., 33.

11. Ibid., 50.

12. Hogarth 1997, 52. Hogarth's *Analysis* ends with remarks on grace in dancing (Hogarth 1997, 109–11).

13. Hogarth 1997, 53. This mechanical link between beauty and the number of serpentine lines is also, of course, the great flaw in his demonstration, and soon became the butt of the satire against it.

14. Ibid., 59.

15. See, in particular, Paulson 1991–93a, 3:77–81, 100–109, as well as his "Introduction" to Hogarth 1997, xxv–xxvi, and Bindman 1997a, 53–56.

16. Hogarth 1997, 74.

17. David Kunzle has pointed out Hogarth's curious choice of women's stays to illustrate his theory: "This is not just a matter of contour or silhouette, but an invitation to the eye to conceive of line in a three-dimensional movement. . . . One imagines the artist running the staylace around his wife in the manner described." (Kunzle 1973a, 99).

18. Hogarth 1997, 54–55.

19. Ibid., 55, 56.

20. Ibid., 59. For Addison's series of essays, see Addison and Steele 1965, nos. 411–21 (21 June–3 July 1712).

21. Wagner 1992, 93. Wagner adds: "Whereas the French 'estampe galante' is more often than not remarkable for its moral treatment of love and sex as a pleasurable game or as a pastime, the English artists differed in taste and philosophy, including and preferring overt moral arguments. It is this strong didacticism, frequently jarring with eroticism, which is one of the most characteristic aspects of English graphic erotica. . . . Although the English painters and engravers occasionally produced works for aristocrats who were known for their amoral attitudes and libertine life-styles, the artists seemed to have been too class-conscious to ignore the English bourgeois tradition of didacticism in art and literature. Significantly, even English pornographic prints . . . are not frank or downright obscene as the French examples from the same period."

22. Writing from a more political perspective, Roy Porter writes: "In their quest for modes of life which were rational, liberal, polite and happy, men of the Enlightenment habitually contrasted themselves to the common people (whom they regarded as leading lives dominated by custom and superstition, little better than animals), and the courtly aristocracy (whose lives were artificial, dissipated and useless). At the dawn of the Enlightenment those two strata were leading very distinct sexual lives, both of which were unacceptable to Enlightenment opinion"; Porter 1982, 2. It is no coincidence, of course, that Hogarth's line of "grace" should steer a middle course.

23. "William Hogarth's engravings which are concerned with aspects of human sexuality contain a decidedly moral if ironical discourse which is intended to satirize the titillations of eroticism"; Wagner 1992, 88. One might even say "neutralize" them.

24. To which can be added, as Bernd Krysmanski has suggested, the shape and the positioning of the clergyman's spectacles across his phallic thumb. See Krysmanski 1998, 393–408.

25. Wagner 1992, 90. Wagner's reading of the black man as someone then associated with lust, cannibalism, and savagery, going against David Dabydeen's more positive interpretation of his presence here (Dabydeen 1985, 64), explains his presentation of sexual advances as something "shocking."

26. The original *Before* and *After* was a set of two "outdoor" pictures (now in the Fitzwilliam Museum, Cambridge), commissioned in the early 1730s by John Thomson, M.P. for Great Marlow, whose involvement in the speculative fiddle of the Charitable Corporation for the Relief of the Industrious Poor led him to flee to France before he could pick up the paintings. Their "creatural realism," as Ronald Paulson describes it, consists primarily in the frank depiction of the man's inflamed penis after the sex act. The second, "indoor" version (now in the J. Paul Getty Collection) is decidedly more sober, a "safer, more Hogarthian version," as Paulson calls it, before concluding that "the erotic scene was a genre that Hogarth, so far as we know, did not pursue further" (Paulson 1991–93a, 1:218–20). The Dashwood picture and, more generally, Hogarth's association with the Dashwood-Sandwich circle and the Medmenhamite Brotherhood are discussed in Paulson 1991–93a, 3:270–76. See also Trumbach 1993.

27. Although Paulson 1991–93a, 3:276, underlines the essential link between aesthetics and erotics, his concluding remark that Hogarth may have "turned what was a metaphorical worship of Venus (of female flesh, of harlots) into his own channels and made Dashwood more of a Hogarthian than he in reality was (rather than vice versa)" seems difficult to endorse in view of the obviously unaesthetic aspect of this sacrilegious form of worship.

28. Porter 1982, 11. "Sexuality was very visible in the public arena. Throughout the century women's garb was conspicuous by its extremely low *décolletage*. . . . Furthermore, sexual indulgence seems—by the standards of other ages—to have been remarkably open, easy and unrepressed"; 9:12.

29. Antal 1962, 95.

30. Paulson 1991–93a, 2:31–32.

31. Ibid., 2:30.

32. "With the close or distant disciples of Watteau, the image of the *fête* is an ever renewed commonplace, as if no one could tire of those minuets under eternally blue skies, away from the calls of history, away from the demands of trivial life. A fanciful commonplace, like the picture of Armide's gardens or of the golden age. One pretends to be going there, when in fact one is staying away from it—a discrepancy satire will have a great time criticizing. It will reveal that men live their lives in a different manner—heavily, stupidly, vulgarly. Hogarth excelled in this art of denunciation. For the couple in *Marriage A-la-Mode*, a life of pleasure is leading them melodramatically to adultery, murder and death. In Scene 2 we are only seeing the first signs of tragedy; in the early hours of the morning, each has just emerged from a different fête in a stupor. The steward who has come with a sheaf of bills is vainly invoking God's mercy: the liabilities will be heavy"; (Starobinski 1964, 95, my translation).

33. The painting was commissioned by James Caulfield, Lord Charlemont, and represents a scene from Colley Cibber's play *The Lady's Last Stake* (1707; revived in 1756), in which Lady Gentle is tricked by Lord George Brilliant into a last game of picquet, which she loses and for which she should have to surrender her virtue. For further details, see Paulson 1991–93a, 3:218–23.

34. Ibid., 2:221, 220.

35. Ogée 1996, 136–48.

36. Because Hogarth did two illustrations for volume 1 of Sterne's *Tristram Shandy* in 1759—the same year as *The Lady's Last Stake*—and then Reynolds painted Sterne's portrait the year after, it has often been assumed (wrongly) that Sterne tended to reject Hogarth's concrete formalism in favor of Reynolds's intellectual (and academic) idealism. Ronald Paulson writes that "[Sterne's] and Hogarth's aesthetics, based on the senses, was totally at odds with Reynolds's" and underlines the fact that "Sterne's novels, particularly the second, depend on a spectrum of pursuit, flight, and dawdling along the way which is obsessively centered on a woman's body"; Paulson 1991–93a, 3:282, 284. Jenny Uglow also writes that "both [Hogarth and Sterne], beneath the comic disorder and unfairness of life, felt the lure of desire and the call of compassion"; Uglow 1997, 625.

37. See, for instance, the young man in *The Meeting*, one of the panels of *The Progress of Love* (1771–72; The Frick Collection, New York). Paulson, in a sort of second thought, tentatively suggests a *rapprochement* of *The Lady's Last Stake* with Fragonard, though his remark remains unexploited: "Instead of choice [the painting] suggests an intense erotic moment which looks forward to works like Fragonard's *Le Baisir* [sic] *à la dérobée* (Hermitage, Leningrad)"; Paulson 1991–93a, 3:221.

38. Uglow 1997, 610.

39. See, for instance, Paulson's reading of the apparently simple contrasts in the twelve plates of *Industry and Idleness*, which gradually release "a feeling of countermovement against the purely schematic pull of the series"; Paulson 1991–93a, 2:300, or Wagner 1997, 117–27.

40. On the way Hogarth's art emerged from a "paper culture" to gradually promote the autonomy of images, see Bindman, Ogée, and Wagner forthcoming.

41. See Ogée 1997 "Introduction" and two essays, 1–26, 79–96, 177–89.

42. Ogée 1997, 185. See Hogarth's definition of the serpentine line, "whose varied contents . . . cannot be expressed . . . without the assistance of the imagination"; Hogarth 1997, 42.

43. "The disposition of heads forms a wave-like movement across the span of the two tableaux. It passes from a large crest (the apex of the major tableau) through the lawyer to the bridegroom on the right. His head forms the crest of an incomplete wave directed towards the next print, which creates an expectancy similar in effect to that of an *enjambment* at the end of a line of verse"; Cowley 1983, 51.

44. Hogarth 1997, 33.

45. At times, the lines aim at chaotic, painful (sublime?) effects: "In the fourth scene [of the *Election* paintings], to illustrate the release of disorder that is implicit but restrained in 1 and 2, Hogarth spreads out the architectural verticals and shows the crowd flowing unchecked in all directions. . . . If the eye does not altogether come to rest, it is because it is studying ramifications of the central torque. . . . The crowd with its inchoate energies, representing one aspect of Beauty (variety), comes to threaten the other (unity)"; Paulson 1991–93a, 3:155–57.

46. Ogée 1997, 86.

47. Hogarth 1997, 85, 88.

48. Ibid., 148.

Professional Femininity in Hogarth's *Strolling Actresses Dressing in a Barn*

Christina Kiaer

Christina Kiaer

Opposite:
Fig. 21. William Hogarth, *Strolling Actresses Dressing in a Barn*, 1738. Etching and engraving. Lewis Walpole Library, Yale University, Farmington, Connecticut

In William Hogarth's engraving *Strolling Actresses Dressing in a Barn* of 1738 (fig. 21), members of a traveling troupe of players, having come to a halt in a small town somewhere in the provinces, prepare for the show that they will present in the barn on that same evening. The playbill unrolled across the bed gives the title of the play as *The Devil to Pay in Heaven* and lists the *dramatis personae* as Jupiter, Juno, Diana, Flora, the Night, a Siren, Aurora, an Eagle, Cupid, two Devils, a Ghost and Attendants, "To which will be added Rope dancing and Tumbling." This jumbled array of characters offers no clue to a specific story line, suggesting instead that these far-from-idealized actresses will be performing some overblown mythological extravaganza. Commentators on the engraving have consistently taken Hogarth's tone to be one of satire, directed at the Augustan veneration of the classical past, and more specifically at "low-life" actors who ape Augustan ideals.[1]

This reading of the picture erases the specific ways in which the effects of gender complicate the working of satire. It is the only instance in his work in which Hogarth claims to represent a space populated exclusively by women. Why does he offer "actresses," rather than players of both sexes? Why does he show them "dressing," rather than performing or strolling?[2] The picture turns not only upon the satirical play between Augustan pretension and shabby reality in the space of the theater, but also on the perception of Woman as a figure of pretence and deception, the consummate actress. Hogarth deliberately situates his picture in the context of the anti-feminist satire of Jonathan Swift and Alexander Pope, particularly the convention of the satirist who exposes femininity by penetrating into the boudoir to lay bare the deceptions practiced there.[3] Yet the women in this most feminine of spaces have won from Hogarth a pictorial sympathy unprecedented in his satirical oeuvre; the rich visual language of "beauty and grace" (I take this phrasing from Hogarth's own writing)[4] conveys a complexity of feeling and tone that resists and exceeds the dualities of antifeminist satire and of satire in general.

Hogarth's specific and topical references to the real-life experiences of women, particularly poor women, also complicate the satirical myths of femininity. At the price of five shillings a print, owning an impression of *Strolling Actresses* would have been affordable only to the middle class, but it is important to remember that it would also be displayed in taverns, coffeehouses, and other public places, where it would be seen by a diverse audience.[5] Ronald Paulson argues that Hogarth's visual images offered a double interpretation: "What the rich will see as peripheral irony, the poor will see as central."[6] In the case of this image in particular, Paulson's argument about class differences in viewing needs to be extended to include gender differences. Female viewers, especially lower-class ones, could recognize central and salient aspects of their own experience

Christina Kiaer

Fig. 22. William Hogarth, *The Analysis of Beauty*, Plate 2, 1753. Etching and engraving. Lewis Walpole Library, Yale University, Farmington, Connecticut

in *Strolling Actresses*. The carefully articulated manifestations of the everyday life of women, presented in a formal language of sensuous beauty, call into question the adequacy of the term "satire" to describe the working of this picture. Taking into account the specificity of the feminine subject matter will help to make sense of the breakdown of satire and open up the possibility for more subversive readings of this web of theatricality, femininity, and social experience.

The Serpentine Line of Beauty

The print's special, considerable beauty meets Hogarth's own definition of the word, as he would spell it out in his book *The Analysis of Beauty* of 1753, as fully as any of his works. His foremost principle of beauty is the serpentine line, which "gives play to the imagination and

delights the eye."[7] Hogarth's language emphasizes the inseparability of the abstract notion of the serpentine line from the lines of the human body: other lines approach, but do not attain, the line of beauty "by their bulging too much in their curvature, becoming gross and clumsy; and, on the contrary . . . as they straighten, becoming mean and poor."[8] We might even take the serpentine line as a sign for the movement of desire in narrative: it "*leads the eye a wanton kind of chase, and from the pleasure that gives the mind, intitles it to the name of beautiful.*"[9] What is at stake in the serpentine line is the fantasy of a single visual sign that can bridge the gap between the mind's will to knowledge, or narrative, and the eye's desire for aesthetic pleasure.[10]

In his discussion of the main image of plate 2 of *The Analysis of Beauty* (fig. 22), an engraving called *The Country Dance*, Hogarth

78

makes a clear connection between beautiful action, or narrative, and visual beauty. He provides a key to this image in figure 71 in the upper left corner of his plate 2, the odd, diagrammatic lines of which "describe, in some measure, the several figures and actions, mostly of the ridiculous kind, that are represented."[11] He insists upon the appropriateness of the waving line for depicting the grace of the young, elegant, virtuous and exemplary bridal pair on the left, and reserves scornful words like "sprawling . . . awkward . . . pecking . . . scanty . . . angular . . . capering . . . poking"[12] to describe the rest of the country bumpkins in the line of the dance.

What interests me here is that Hogarth drops this careful pairing of action with visual characterization when it comes to the *Strolling Actresses*. Their activities are the stuff of satire, contrasting as they do with the high-flown costumes and props that surround them. From left to right, they feed retching babies, nurse toothaches, squeeze blemishes, get drunk, pour wax on their heads, declaim half naked, play queen of the gods, mend stockings—yet Hogarth lavishes upon most of them all the arts of beauty that he has at his disposal. His grand, graceful, and baroque composition here seems to have freed itself from the constraints of appropriate narrative, following the visual line of desire into the makeshift dressing room in the barn to construct a complex narrative of feminine experience.

My claim for the special beauty of the picture is strengthened by its uniqueness within Hogarth's canon of prints. According to Paulson, Hogarth subordinated his practice of painting to the business of engraving, in the sense that he would paint a composition in reverse in order to facilitate engraving in the direction in which he intended the composition to work. "Work," for Paulson, is the moral meaning, the cause and effect when one reads from left to right, or in the Progresses, from

one print to the next.[13] In the painting, the fixed meaning that Hogarth intended to convey was not yet fully operative. Instead of focusing on getting his moral point across, he could allow himself leeway in terms of focus, distinctness, and the play of light, color, and texture. Paulson argues that the black-and-white linear language of engraving is inherently satiric or moral, while "Hogarth had not discovered how to paint a morality."[14]

This particular engraving, however, incorporates those qualities that Paulson ascribes only to Hogarth's practice of painting. (The painting of *Strolling Actresses* was destroyed by a fire in 1874.) The language is black and white, of course, and the actual markings of the etching tools are linear, but everything about the composition revolts against linearity. In contrast to the more classically delineated interior spaces of, for example, *A Rake's Progress*, the linear architectural elements are here softened and obscured by the rising crest of the dragon's wings, the fullness of the draped flag, the drooping arcs of the laundry lines, and the garlands of flowers wreathed round the classical portico. Hogarth has even arranged the figures in two waving lines: one follows the lighted path from the lower left corner up through the central Diana and on to the two women holding the cat, probably the Ghost and Attendant, while the other, shorter one curves in darkness from the kittens in the center foreground up to the bright figure of Juno, Queen of the Gods. Intricacy, variety, and the line of beauty compose the major figures; we should note, for example, the imploding serpentine line of Diana's figure. Except for the deliberately awkward movements and caricaturized faces of Aurora, the Ghost, and the Attendant, Hogarth has given grace to the figures and a marked loveliness to the faces of the main characters. The significance of this loveliness should not be underestimated, as he devoted a long chapter in *The*

Analysis of Beauty to the topic of properly depicting the face.

To locate *Strolling Actresses* within Hogarth's practice of transforming painting into print, we might turn to another composition involving strolling players, *Southwark Fair*, to examine the contrast between the painting (fig. 23) and the engraving (fig. 24), both of 1733. In the painting, the drummeress is picked out from the darker jumble of the crowd by the extreme whiteness of her fair skin, the feathers in her hat, and her billowing, transparent sleeves, which contrast exaggeratedly with the orange and brown fleshtones that surround her. In the print, however, all the light tones are white; she is simply more so. Several areas that are difficult to read in the painting are resolved into clarity in the print, most notably the murky dark brown area in the left foreground, which is made perfectly clear in the print as a seated man looking into a portable peep show. In the painting, the British flag and the white turret from which it waves, as well as the other flag, take on a delicate translucence and immateriality in relation to the puffy, radiant clouds of the sky, but in the print all these objects are given determinate lines and solid shapes. It is exactly this determinacy and solidity that the print of *Strolling Actresses* resists, with its swirling composition and the shadows that obscure recessed figures and objects.

The most striking aspect of this print is the way that Hogarth manages to shift his focus and offer areas of greater and lesser distinctness, as well as to play with texture and highlights. For example, the Ghost as well as the area behind her, with its painted scenery, tools, and military props, are particularly indistinct. The strong contrast between this old hag and the fair Juno in front of her works pictorially despite the limitations of the print medium: dark versus light, angular versus round, even the contrast in skin textures, all signify. The painting would have rendered these distinctions to a much greater degree, of course; we can only imagine how Diana's skin would glow pearly pink and white, and Juno's jewels flash in bold colors, while the darker areas would be impenetrable blackness punctuated only by glints of color or metal. No part of the print is truly unreadable or indistinguishable, but it suggests rich and complex variations in distinctness and texture nonetheless—variations that are tied to the cultural meanings of the figures and objects in question. In particular, as we will see, Hogarth sets in play cultural notions of the underside of femininity, that which is normally hidden from view, as well as femininity in its most obvious and visible aspects.

A "Modern History" of Strolling

Hogarth's practice of "Modern History Painting" entailed the depiction of subject matter that was contemporary, topical, and readily understandable to a wide public; different nuances would appeal to different viewers, depending on their relative knowledge of painting and literature or London street life. Unlicensed playhouses and troupes of players were particularly topical in 1736–37, the year in which *Strolling Actresses* was conceived, as the Playhouse Bill which had been introduced in Parliament in 1735 was designed to limit their activities. The bill was debated in the press, and a popular print satirizing the plight of the players was published in March 1735, called *The Player's Last Refuge: Or the Strollers in Distress* (fig. 25).[15] The Bill was withdrawn the same year, to be succeeded in 1737 by the Licensing Act. The playbill on the bed in *Strolling Actresses* refers to this by announcing the show as "Being the last time of acting before the Act commences." Passed by Parliament in June of 1737, one month after Hogarth had begun work on the picture, the Act made it illegal for any company to perform without a royal patent, thus restricting legal theater to the two royal playhouses in London, Drury Lane and Covent Garden.

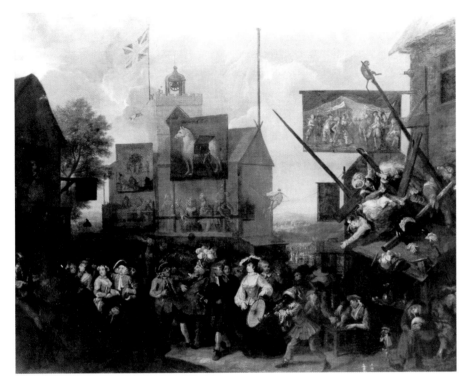

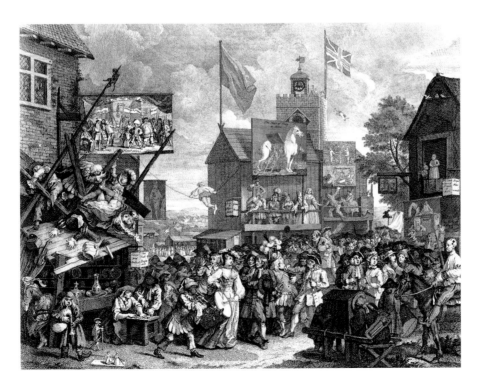

Fig. 23. William Hogarth, *Southwark Fair*, 1733. Oil on canvas, 47½ x 59½ in. (120.6 x 151 cm). Cincinnati Art Museum. The Edwin and Virginia Irwin Memorial (1983.138)

Fig. 24. William Hogarth, *Southwark Fair*, 1733. Engraving. The Henry E. Huntington Library, San Marino, California

Fig. 25. Anonymous,
*The Player's Last Refuge:
Or the Strollers in Distress*,
1735. Etching. The British
Museum, London

The troupes of players who strolled the countryside provided obvious butts for satire, as they were generally considered to be of lesser talent—and morals—than the actors of the two official London theaters. One participant observer wrote: "going a strolling is . . . a very contemptible Life; rendered so, through the impudent and ignorant Behavior of the Generality of those who pursue it."[16] Strollers were considered forces of social disorder and denounced by middle-class writers such as the author of *The New Canting Dictionary* of 1725. Written to inform and warn gentlefolk travelers about the jargon of the many tribes of "strowlers" or "canters" who roamed the English countryside, it defines "strowlers" as:

Vagabonds, Itinerants, Men of no settled Abode, of a precarious Life, Wanderers of Fortune, such as Gypsies, Beggars, Pedlars, Hawkers, Mountebanks, Fidlers, Country-Players, Rope Dancers, Juglers, Tumblers, Shewers of Tricks, and Raree-Shewmen.[17]

A country troupe would therefore exploit any London experience in order to advertise itself as comprising Londoners rather than vagabonds;

our troupe touts itself as "A Company of Comedi-ans from the London Theater at the George Inn."

Although the Bill of 1735 may have pro-vided the immediate impetus for making a pic-ture of strollers, Hogarth's picture is clearly far more complex than a purely topical print like *The Player's Last Refuge*, produced rapidly in order to satirize the political issues and real-life participants in the playhouse debate. Ho-garth had long been fascinated by the theater and the possibilities it offered for representa-tion, and strolling players in particular com-bined the theatrical with the popular of the street and the fair. In *Southwark Fair*, one troupe of players advertises its show by parad-ing on the balcony of the center building, and on the left another tumbles down from tempo-rary scaffolding while engaged in the same activity,[18] enacting quite literally the break-down of the social order that strollers were thought to foster. Hogarth's interest here lies precisely with that public perception of the strolling life. As vagabonds untrammeled by the conventions of family and domestic order, they were assumed to be sexually free; Hogarth signals this by the amount of bare thigh exposed by the actress tumbling down on the left, by the peep show on the right, and by the two women behind and to the right of the peep show, smiling and being pinched on the cheek by a potential customer, representing the prostitution either practiced or encouraged by traveling players. Immediately to their left, a brightly lit gentleman has his pocket picked by a shadowy man, either a thieving stroller or the kind of "riff-raff" brought out by the presence of the strollers. Finally, we should note the gambling with dice going on at the left, sym-bolic of the dishonest and hazardous strolling life and the threat it poses to the pocket of the honest, gullible citizen. Except for the drum-meress, who is given a dignity and self-possession that stands out in this image and in Hogarth's work as a whole, the strolling

players here are expertly satirized along with the rest of the teeming crowd in the bustling and colorful scene of the fair.

Four years later, in *Strolling Actresses*, Ho-garth has focused in on the figure of the strolling player, in particular the drummeress, not when she is in the midst of the crowd, engaged in the public spectacle that is her pro-fession, but in the semi-privacy of her dressing room.[19] The crowd, the distant landscape, the sky and the men have all disappeared. Hogarth has imagined a makeshift ladies' dressing room, in which he can expose to the light the dark secrets behind the exotic stage beauties and demystify the illusions offered by the the-ater. By directing this operation of demystifica-tion at a female theatrical world, Hogarth makes his satire more specific: it intervenes in the literary practice of antifeminist satire as it appeared in the poetry of Jonathan Swift and Alexander Pope in the 1730s.

Antifeminist Satire

The antifeminist satirist creates a fiction of power between himself and his victim: he is firmly in control, maintaining a careful dis-tance from the disorder that womankind rep-resents. He makes sense of the irrationality and unknowability attributed to Woman by con-taining her within two arbitrary, opposed cate-gories: the bright myths of feminine virtue and beauty, versus the "reality" of deceit and gross bodily excess. As Felicity Nussbaum puts it in her study of the tradition,

women become a metaphor for all that is threatening and offensive to the society at large . . . the imposition of form (satire) on formlessness provides meaning and rationality when the fear of meaninglessness and insanity arises.[20]

Like strolling players, women were per-ceived as a source of potential threat to the social order if they were not adequately con-tained. In *Strolling Actresses*, then, Hogarth offers a particularly loaded cultural symbol of

disorder—the female strolling player—as yet uncontained either by the Licensing Act or by marriage and ordered domesticity.

For Jonathan Swift—one of Hogarth's favorite authors, whose book appears in his *Self Portrait with Pug Dog* of 1745—women's bodies become the metaphor for the physicality he dreads. He attacks the dangerous, "filthy materiality" of women's bodies lurking beneath their idealization as delicate creatures.[21] His poems penetrate and expose the myths of femininity as inadequate fictions for concealing the true nature of womanhood. Thus the superhumanly delicate and beautiful Chloe in "Strephon and Chloe" of 1734 reveals her scatological physicality to Strephon only on their wedding night. Swift concludes the poem by urging husbands to build a marriage on more than beauty because it is only a thin disguise that will fade in time: "For fine Ideas vanish fast,/While all the gross and filthy last."[22]

In *Strolling Actresses*, Hogarth exposes the exact moment when the main figures transform themselves from their "gross and filthy" daily life of poverty and squalor into their dazzling stage personas, the female goddesses who embody the "fine Ideas" of femininity. Hogarth's interest in imagining—and his viewers' in witnessing—this transformation should not be underestimated. According to Terry Castle, "eighteenth-century English society was indeed a world of masqueraders and artificers," in its fascination with the public entertainment of the masquerade, with farces and operas on the stage, with masked highwaymen and transvestite figures. In this "culture of travesty,"[23] as she calls it, Swift's vicious desire to expose goes against the grain. We find Hogarth eager to expose, like Swift, but also caught up in, and respectful of, the fascination and pleasure of the masquerade. Thus in Hogarth's imagination of the scene, his gaze does not quite penetrate into a private sanctum to spy unnoticed upon these women in their *déshabillé*. The

composition is, rather, deliberately stagey: the perspectival lines of the barn roof open up a wide space; the lighting is full and dramatic, with the exception of a few key areas; the figures are ranged before us in a relatively shallow space. In fact they are all grouped to face us, as on a stage, and Diana is playing right to us, albeit not yet in full costume.

Hogarth thus challenges the conceit of Swift's "The Lady's Dressing Room," where the lover Strephon penetrates into Celia's boudoir while she and her maid are absent. There he finds all the chaotic evidence of the filth and artifice that lies behind Celia's outward beauty, for which Swift provides an "inventory." The gleeful pleasure he takes in this painstaking enumeration points up the fact that no satire ever strictly upholds its dualities. There will always be a measure of desire directed toward that which is being derided, erupting in this instance in Swift's rapt attention to the artifacts of female bodily existence: "a dirty Smock appeared,/beneath the Arm-pits well besmeared"; filthy combs filled with "Sweat, Dandriff, Powder, Lead and Hair"; "A Forehead-Cloth with Oil upon't"; towels "Begumm'd, bematter'd and beslim'd;/ With Dirt, and Sweat, and Ear-wax grim'd"; "Petticoats in frowzy heaps"; stockings "Stained with the Moisture of her Toes"; and, worst of all, a full chamber pot.[24] Hogarth similarly provides indications of gross physicality in his own imagined dressing room scene: Flora's comb, makeup, and especially the hot wax she drips in her hair; the blemish on the Siren's skin being squeezed by Aurora; Diana's soiled petticoats; the broken eggs spilling onto the bedcover; and the chamber pot standing next to the bed. Yet Hogarth's tone differs markedly from Swift's. He satirizes the actresses' physicality, but at the same time he ties its representations to their profession and their poverty, rather than to their sex: the actresses are professional shape-shifters, and

the crowded barn is forced upon them as strollers. Further, the sympathy with which they are depicted indicates that the private aspects of femininity provoked for Hogarth a less sadistic fantasy, a pictorial musing on the intimacies of a feminine world where the evidences of physicality could be depicted with beauty and good humor. The overall impression is not so much the Swiftian dressing room of deceit, but rather a kind of household that works as both a domestic and professional space.

As Hogarth's female viewers would have known only too well, the domestic and professional space were, in fact, usually the same for women in eighteenth-century England. Among lower-class women, domestic service was a major occupation, and many others earned money by taking in washing. Middle-class women's lives also centered around domestic space: the leisured mistress of the home, prudent, modest, pious, and unobtrusively witty, became the ideal of an age in which women's leisure was the sign of the wealth of husbands and fathers.[25] Alexander Pope expresses succinctly the polite ideal of womanhood in his *Epistle to a Lady* of 1735:

> But grant, in public men sometimes are shown,
> A woman's seen in private life alone:
> Our bolder talents in full light displayed;
> Your virtues open fairest in the shade.[26]

Unlike Swift, who was twenty years his senior, Pope was comfortable with this newly emerged middle-class myth of passive womanhood; he could base his representations of women on that myth of idleness and domestication.[27] His target is especially those women whose idleness leads to frivolity, vanity, sloth and deftly concealed sexual intrigues. Pope satirizes Woman by exposing her as inconstant, "Matter too soft a lasting mark to bear."[28] In the portrait gallery of fickle, immoral, and irresponsible women that he catalogues in "Epistle to a Lady" (its subtitle is "Of the Characters of

Women"), none of the women lives up to the ideal of domestic order and virtue except his friend Martha Blount, to whom the epistle is addressed.

In *Strolling Actresses*, Hogarth takes up this myth of domesticity to enrich his satire, by placing his motley crew of exotic actresses in a domestic context. Although the profusion of exotic theatrical props seems fantastical, the actresses turn them to practical uses—far more practical than their exalted "true" functions on stage will entail: the baby's gruel is placed on the king's crown, beer and pipe are set down on the ornate altar, stockings are hung to dry on the clouds below the dragon-drawn chariot. Georg Christoph Lichtenberg, the German commentator who wrote in the 1790s on Hogarth's prints, was concerned to establish a logic for the household space in the barn. Two copies of the playbill, he writes,

are lying there on the bed, directly behind the grill, close to the broken eggs, the chamber pot and the empty pair of trousers . . . which in any orderly household would hardly be found simultaneously in as many square rods.[29]

Writing in the *Spectator* in 1711, Addison set out the expectations of an orderly household in his description of the life of Aurelia, a woman of quality, and her husband who loves her:

They both abound with good Sense, consummate Virtue, and a mutual esteem; and are a perpetual Entertainment to one another. Their family is under so regular an Oeconomy, in its Hours of Devotion and Repast, Employment and Diversion, that it looks like a little Common-Wealth within it self.[30]

The little world represented in *Strolling Actresses* constitutes a kind of commonwealth as well, although its functioning household "oeconomy" flies in the face of the emerging bourgeois ideal of feminine domesticity.

The portrayal of the barn household does, however, tie very closely to the real-life experience of most lower-class women, the majority of whose "households" did in fact consist of one

room. Even artisan families could afford only one or at best two rooms.[31] Francis Place remarked in his autobiography on the degradation of a woman who had "to eat and drink and cook and wash and iron and transact all her domestic concerns in the room in which her husband works."[32] Add to that list of concerns childbirth and the care of children, and the impression of lower-class domesticity begins to differ radically from the bourgeois ideal upheld by Pope. By representing a familiar aspect of the everyday hardships of poor women's lives, in the colorful and playful context of the theatrical barn, Hogarth's topsy-turvy household would have appealed quite directly to people who could only view it in public places, in ways that those who could afford to buy his works may have only dimly perceived.

This difference in perception can be seen in the different ways the temporal instability of the marginal household can be construed. The flame from one of the candles below the large basket that serves as Flora's dressing table has just begun to kindle the contents of the basket. As a typical device of satire—one subtle detail that transforms the entire meaning of the presented scene—most commentators seize on this threatened fire as proof of Hogarth's censure of the players. Yet I would also argue that this one tiny detail, promising the total destruction of the barn, serves to cover Hogarth's back. It allows him full latitude to explore the scene in the barn with interest and sympathy, without fear of offending those viewers with less tolerance for the disorder presented there. Another reading of temporality, one attuned to the reality of doing all one's living in one room, offers a different resolution to the disorder: tonight's performance will probably be staged in this very space, entailing the transformation of the household, not into an inferno, but into the temporary, artificial order of the stage. As viewers, we are asked to tidy up this space, to imagine it as it will be in

a few hours: the set pieces in place, the various objects worn or wielded by their appropriate owners, the laundry lines removed, the baby fed, costumes mended, lines learned.

In his concern for real women and their experiences, Hogarth has conveyed the intensity of the private, real-life relationships between the actresses as they are played out within their mutable, semi-theatrical world. Most of the separate narrative vignettes represent the actresses working in helpful concert to ensure that the show will go on: the mother eagle in the corner feeds her baby; the Siren offers her friend with a toothache a drink of gin while Aurora fixes the blemish on the Siren's shoulder; Cupid fetches stockings for the figure in the gold crown from the cloud where they were hung to dry; the attendant holds the clawing cat while the Ghost draws blood from its tail for the night's performance; Juno learns her lines while Night mends her stocking. These private narrative events make pointed references to the harsh realities of strolling life, such as the grueling work of learning long parts in a short time, drunkenness, makeshift sanitation, or the bodily discomforts of coping with a hungry infant or a toothache when one has no home and little income.[33] The washing hung to dry would have resonated particularly for many viewers: even in wealthy homes wash days were major events, as so many of the maids would be busy with it, and in one-room households wash day meant wet clothes hanging to dry in already cramped living space. Water had to be fetched from pumps and heated in the same pots normally used for cooking.[34] Thus the smocks and bonnets hanging decoratively from the clothesline represent hours of hard work by the women in the barn. Yet given the spirit of camaraderie that seems to reign, we might also assume that the labor of washing had been shared. Indeed, although the most prominent and reiterated association with strolling players

was their extreme poverty, they shared that poverty: the earnings from performances were usually divided evenly among the company.[35] Hogarth depicts the actresses as completely comfortable in their communal twilight world; topsy-turvy as their domestic life is, their household seems to function quite smoothly according to its own rhythms.

In imagining his peek into the "ladies'" dressing room, Hogarth refuses the ready answers about their essential nature—their deception and bestial physicality—that Swift needed in order to distance himself from them. Nor does Hogarth buy into Pope's confidence in the myth of the idle, domesticated woman. He offers, instead, a mutable feminine space, part boudoir, part household, part workplace, which takes up the terms of satire, but also resists them in quite deliberate ways. We will need a closer examination of the individual figures and objects and their relation to each other, to see how Hogarth sets a multiplicity of cultural meanings into play.

The Goddesses

We should begin by attending to the goddess figures (or personifications) who are meant to embody the positive feminine ideals of virtue, fecundity, beauty and delicacy: Diana, Flora, Juno, Aurora. We should also include the Siren, if we focus on her not as evil temptress, but as an alluring figure of pleasure offered. These are the most visible figures within the composition, and not by accident; they represent those feminine qualities that should be most prominently displayed. Where antifeminist satire exposes the contrast between vain, empty real women and lofty female allegorical figures, Hogarth gives that tradition an extra twist by personifying the ideals of femininity through actresses who style themselves as divinities not out of vanity, but because of their daily work.

Most prominently displayed is the central figure of Diana (fig. 29). The light, entering front right, illuminates her entire body. The locus of the most explicit satire of the picture, she embodies the low comic actress aping the Augustan ideal of a goddess. Although the actress has already put on Diana's traditional headdress with the half-moon, her body is as yet dressed only in a ripped smock. The curvy body and frank address reveal the "true" character of the actress before she has taken on the part of the cool and virtuous Diana, goddess of the moon and hunt, who was by all accounts tall, slim, and chaste in her demeanor. Hogarth has arranged her in the typical stance of Diana the Huntress, as it was illustrated in Montfaucon's archaeological compendia and numerous other sources: right arm curved to hold the bow, left arm raised to reach for an arrow from the quiver on her back.[36] As she is not yet in full costume, however, there are no bows and arrows in sight, and her position looks more like a declamatory theatrical stance.[37]

Diana's traditional costume always left her legs bare up to the knees, whereas our Diana is actually modestly covered to just above the knees, but then audaciously bare-thighed. Hogarth makes her drapery swirl upwards, almost offering a peek at her genitals. Her left leg is in fact very similar to that of the woman in his painting *After (Outdoor scene)* of 1731 (fig. 26). In this painting, Hogarth's most physically explicit (note the graphic depiction of the area between the man's shirt and trousers), the woman's thighs are also uncovered as far as possible before revealing a shadow of pubic hair and framed by a swirling white petticoat. Just as this maiden who attempted to resist temptation in the *Before* scene has obviously fallen and lost her virtue in *After*, our actress fell from Diana's heights of chastity some time ago. This travesty of virtue produces the horrified look of the Medusa on the shield behind Diana, although that outraged horror is itself ridiculed pictorially, as Medusa is partially obscured by Diana's plump calf, while the gay ribbon-ends from her

Christina Kiaer

Fig. 26. William Hogarth, *After (Outdoor scene)*, 1731. Oil on canvas, 14 x 17½ in. (35.6 x 44.5 cm). Fitzwilliam Museum, Cambridge

stocking jokingly repeat the hideous snakes of Medusa's hair. The Gorgon's dark power to comment on the action around her has been domesticated within this space of reversed (or uncertain) meanings.[38]

Like the "Petticoats in frowzy Heaps" that Strephon found on Celia's floor, the soiled petticoats upon which Diana stands indicate the reality behind the illusion of feminine charm, as do the rips in her smock. A large tear reveals a sizable patch of belly and hip, rewarding the viewer's foray into the boudoir with a glimpse of some bare skin. But it also reminds us of the actresses' poverty and the social circumstances that forced them into their precarious profession. Diana's direct look out must entail, at least on one level of meaning, a kind of bravado in the face of the squalor that surrounds her. Of all the figures going about their behind-the-scenes business, she is the only one who is "on," deliberately performing her part as Diana and as an actress. By making her address the viewer, Hogarth mixes the genres of the private scene delivered

up to a privileged, anonymous spectator, and the theatrical performance directed explicitly at an audience. Hogarth relinquishes his own voyeuristic control in favor of an engagement with the subjectivity of the central victim of his satire—an engagement which cracks the veneer of distance that the satirist needs to maintain in relation to his victim.

In marked contrast to Diana's awareness of the voyeur, the kneeling figure of Flora (fig. 32) embodies the self-absorbed narcissism traditionally imputed to women at their dressing table. Swiftian attributes surround her: cracked mirror, comb with teeth missing, shell filled with rouge, hot candle wax to prepare a sticky bed for the golden pollen in the shaker. But the soft lines of her face and the roundness of her arms and exposed breast characterize her with pictorial grace. Smiling placidly and going about her primping ritual quite stolidly, she is less vain and wanton than concentrated and absorbed. Hers is a professional task.

Hogarth depicts Juno, Queen of the Gods, in a moment of dramatic transport: hand raised, face tilted upwards, cape swirling extravagantly above her head (fig. 28). As a self-important "tragedy queen" rehearsing her role with great pomp, she embodies the vanity of women—an empty vanity, as emphasized by the large hole in her stocking that Night is busily mending. The joke is obvious: the vain actress pretends she's a queen while her clothes are in rags. Another element of the joke would also have been obvious to contemporary viewers: many actresses were thought originally to have been seamstresses, so Juno's "tragedizing"[39] is contrasted with the humble profession from which she may have come. This was a contrast current at the time; one critic of the theater, in his argument for closing unlicensed playhouses, had no worries about the resulting unemployed players:

Let 'em return to their primitive Occupations. It may be a *severe Trial*, indeed; but let this be their Consolation, they

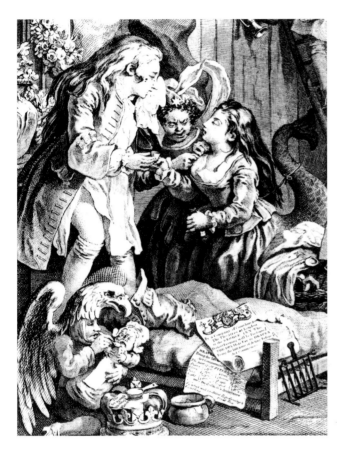

will appear *strong*, in *Character*, they will *play* their *Part* with *Applause*, the *Hero* in his proper Occupation of a *Barber*, adjusting a *Toupee*, and the *Heroine*, as a *Mantua-maker*, sewing up a *Seam*.[40]

Yet given the friendly intimacy with which Night sews the stocking while Juno wears it, the visual reference to seamstresses suggests a kind of community of women's activities as much as it pokes fun at the mantua-maker turned tragedy queen. Although the context of Juno's posture suggests vanity, the posture itself is graceful.

The rounded body and sensual aspect of the Siren live up to the qualities of feminine allure associated with her character, but the narrative details of the very obvious piece of rope securing her tail, the blemish on her shoulder that Aurora busily squeezes out with

two thumbnails, and her bleary-eyed look from too much gin, detract from her appeal (fig. 27). Hogarth uses her figure to satirize the drunkenness that was often associated with actresses. In the *Grub Street Journal* of 1 May 1735, a spurious petition appeared, ostensibly from the actresses and female dancers of Drury Lane and Covent Garden, in which they protested the clause in the proposed Playhouse Bill that would forbid selling liquor in the playhouses:

it will be impossible for us to perform our parts with any spirit, if this clause should continue: for, as speaking with that loudness, which is absolutely necessary (more especially in Tragedy) and capering for so long as we your dancing petitioners are obliged to, are apt to make the throat extremely dry, and consequently the voice hoarse.[41]

Fig. 27. William Hogarth, *Strolling Actresses Dressing in a Barn* (detail), 1738. Etching and engraving. Lewis Walpole Library, Yale University, Farmington, Connecticut

Fig. 28. William Hogarth, *Strolling Actresses Dressing in a Barn* (detail), 1738. Etching and engraving. Lewis Walpole Library, Yale University, Farmington, Connecticut

The stereotype of the tippling actress is portrayed in *The Player's Last Refuge*, where the actress on the left is satirically explained in the caption as "a strolling Sophonisba who rather than submit to the Power of the Common Council, heroically deprives herself of Life by a Draught of Hollands." With her affected facial expression and pose, and the scanty angularity of her body, she offers a telling foil to Hogarth's pretty Siren, who in fact leans forward with great concern to share a medicinal dram with her friend with the toothache. Here Hogarth's satire reveals itself yet again as ambiguous and engaged. Indeed, the only unambiguous satire of a goddess figure is directed at Aurora, who should be "rising with rosy fingers from the saffron-coloured bed of Tithonus"[42] but instead emerges with a markedly unlovely face, picking at the Siren's pimple with great gusto.

The Gender-Reversed World

The ironic presentation of a topsy-turvy, reversed world is a central tool of satire, as it calls attention to the rightness of the norm. As I have already discussed in the case of Swift, the pleasures from the side of disorder will always bleed into satire's imposition of order, inflecting and complicating its dualities. Why, for example, does Hogarth make such mystery of the gender of the figures? In the title he calls them actresses, of course, but certain figures cast this into doubt; most commentators note this "mistake" on Hogarth's part.[43] The playbill's list of characters would seem to offer secure gender identification, as it indicates "the part of JUPITER by Mr. Bilkvillage, Cupid by Mr. ————, while the goddesses and Eagle will be acted by different players identified as Mrs. ————." Yet the playbill leaves two figures unaccounted for: the woman in male dress standing on the bed at the left, and the figure in the gold crown with its back turned. Commentators disagree on the gold-crowned figure, some following the playbill and calling it Jupiter, others assuming that the gold crown indicates the traditional headdress of Apollo. If the figure is indeed a male actor, Mr. Bilkvillage, playing the part of Apollo or Jupiter, how could eighteenth-century rules of propriety allow him into the actresses' dressing room? Perhaps "Mr. Bilkvillage" is an alias for yet another actress—it is clearly not the name of a real person, but rather a satirical name for one who bilks (cheats) the village. And why did Hogarth throw a shadow across "Mr. Bilkvillage" to make it illegible in subsequent states of the print?[44] Perhaps the artist wanted to remove such a nasty example of the satire traditionally aimed at country players—it doesn't fit with the gentleness of the rest of his picture—or perhaps he wanted to make it even less clear whether or not this company of strollers included a male member.

Whether played by a male or a female, it is significant that this figure of uncertain gender has its back turned within the feminine space. Apollo Belvedere had accompanied Diana the Huntress in an ancient statue group, and Apollos were often placed together with statues of Flora in garden sculpture arrangements, to contrast male wisdom with female fruitfulness.[45] If the figure represents Apollo, then male wisdom has here been eclipsed by both the ebullient huntress and the full figure of female plenty.

Jupiter, on the other hand, would represent male virility. Pierre Danet's *Complete Dictionary of the Greek and Roman Antiquities* notes that "Poets tell us that *Jupiter* married several Wives, and even *Juno* his Sister . . . and that being a fruitful Lover, he begat a great many Children, both legitimate and natural."[46] Just as Juno is the supreme goddess of womanhood, presiding over matrimony and women in labor, her brother and husband Jupiter reigns over male divinities and even represents maleness itself. Danet sums it up like this:

In one word, *Juno* was like a Guardian Angel to Women, in the like manner that the God *Genius* was the keeper of Men; for according to the Opinion of the Ancients, the *Genius*'s of Men were Males, and those of Women Females: Wherefore Women swore by *Juno*, and Men by *Jupiter*.[47]

If Hogarth made the only (possibly) adult male character in the picture into Jupiter (fig. 21), the figure of maleness itself, he also completely obscured and dematerialized him pictorially. His back is turned, we see only a shadowy profile, and his most salient feature is his golden hat, which serves to reflect the light of Diana and the feminine space around him (fig. 29). This is the topsy-turvy version of Pope's "Our bolder talents in full light displayed;/Your virtues open fairest in the shade."[48] Indeed, Jupiter's counterpart of female genius, Juno (fig. 28), shines in full light on the other side of the composition.

She has in fact appropriated Jupiter's thunderbolt; it lies next to her book on the overturned trunk that functions as her table. A thunderbolt had specific phallic connotations. Consider these lines from the poem "The Imperfect Enjoyment" by John Wilmot, Second Earl of Rochester:

> With arms, legs, lips close clinging to embrace,
> She clips me to her breast, and sucks me to her face.
> Her nimble tongue, Loves's lesser lightning, played
> Within my mouth, and to my thoughts conveyed
> Swift orders that I should prepare to throw
> The all-dissolving thunderbolt below.[49]

In Hogarth's painting *Before (Interior Scene)* of 1731, a copy of *Rochester's Poems* peeks out from the dressing-table drawer of the lady being seduced, in order to indicate her proclivity for seduction. Rochester's thunderbolt in the poem suffered from the same problems as Jupiter's in our picture; the poem is about Rochester's impotence in the face of the lady's "swift orders," and he goes on to deride his ineffectual member as a "base deserter" to its

Fig. 29. William Hogarth, *Strolling Actresses Dressing in a Barn,* second state (detail), 1738. Etching and engraving. Private collection, Germany

duty to "King or country."[50] Likewise, Jupiter's thunderbolt, unwielded and detached from its rightful owner, provides an ineffectual signifier of maleness in a feminine space. Although Hogarth has not given this thunderbolt a particularly phallic look, the association is activated by the male coding of the whole series of stage props that surrounds the scene in the barn in a semicircle, starting at the upper left with the drum, curving toward the right along the upper level and down around to the orb in the center foreground: drum, bugle, chariot;

flag of England with St George's cross; paint pot, palette and brushes indicating an absent, no doubt male, scene painter; a Roman banner with the legend "SPQR" ("Senatus Populusque Romanus"—Roman Senate and People); a Roman legionary standard topped by the image of a hand; thunderbolt, Roman helmet, bishop's mitre, full-bottomed wig, lyre and orb. This silent chorus of objects constitutes a very weak male fortification against the onslaught of femininity, however: the bugle hangs limply from the partition; the Roman legionary standard tilts precariously, as if the hand held up against the scene is about to fall in battle; and, down below, kittens take the lyre and orb as their toys and the little monkey urinates into the Roman helmet.

Just as the inanimate masculine objects surround but fail to contain the world of feminine activity on the floor, Hogarth has posted highly unauthoritative "animate" masculine guards at the four corners of the barn. In the upper right corner, Lichtenberg directs our attention to "a village Acteon" who peeks through a hole in the roof to catch a glimpse of Diana.[51] This one-dimensional, disembodied voyeur is a sorry representative of male order, as is the dragon on the upper left, who roars angrily into thin air. In the lower left, the stern father figure of the eagle's head frightens no one but the little baby, and on the right, the monkey's tiny male organ proves an ineffective tool in the face of all the feminine excess.

Mother Midnight and the Underside of Femininity

In a typical satirical power reversal, the symbols of male power are sidelined while women's relations are in the limelight. Natalie Zemon Davis has argued that while rituals of gender inversion function as a "safety valve" for social conflicts, serving ultimately to "renew the system," they can also undermine that system through their "connections with everyday circumstances out-side the privileged time of carnival and stage-play."[52] This is precisely the argument I wish to make for the reversed world of the *Strolling Actresses*, in which Hogarth complicates the dualities of satire with references to specific eighteenth-century female experiences, as well as by indulging his own pleasure in the chase of the visual and narrative serpentine line.

Hogarth taps into layers of popular meaning that unsettle the stability of the topsy-turvy world of satire, suggesting (albeit fugitively) a darker and more fluid set of meanings about womanhood that threaten the order upheld by simple reversals. In the midst of his exposé of the dressing room, he composed a sinister grouping of shadowy figures: the Ghost and attendant above, and the figure of Night below (figs. 21 and 28). The contorted face of the attendant, comically similar to that of the snarling cat, and the evil, one-toothed grin of the Ghost, are satirical-type figures of ugliness and immorality in Hogarth's physiognomic canon. The Ghost's entire aspect, especially the fact that she has only one eye, also brings to mind the ageing whore of Swift's poem *Beautiful Young Nymph Going to Bed* of 1734, which catalogues in hideous detail the transformation of an artificially beautiful woman into a monster of physical decay, as she removes her hair, corset, cheek-plumpers, dentures, and glass eye.[53] Tucked in the shadows behind the laundry line, with a cross-shaped dagger protruding from her breast, she is associated with darkness, death, and the violence of her bloody task. Although the picture's main narrative probably has her cut the tail of the cat in order to draw blood for a gory scene in the evening's performance, this metaphoric act of castration also functions as a deliberate exhibition of the threatening underside of eighteenth-century notions of womanhood: woman as bloodletter through abortion, infanticide, and murder.[54] Associating the cat's tail with the phallus may seem overdetermined, but consider its proxim-

ity to the rising curve of the guitar to the left, the drooping tail of the little devil that echoes that of the cat, and especially the diagonal contiguity with the monkey's active member, rising to meet the arc of the cat's tail, and likewise spouting a stream of liquid.

What are we to make of this hideous hag, cloaked in dark clothes but baring her rigidly corseted bosom, expertly cutting the cord of the cat's tail? She will play the part of a Ghost, according to the playbill; she may also suggest a witch, due to her interaction with the cat, the traditional "familiar" of witches.[55] Unlike the young goddess figures, where the satire lies in the difference between the actress and the deity she personifies, Hogarth meant this figure to signify wholly as a dangerous old woman, a Ghost in the proposed play but not any different in her "real" life in the barn. He may have intended her to suggest a "Mother Midnight," defined by the *New Canting Dictionary* as "a Midwife (often a Bawd)," and the name Moll gives to her "Governess" in Daniel Defoe's 1722 novel *Moll Flanders*. In his study of the Mother Midnight figure in literature, Robert Erickson proposes that writers like Defoe, Richardson, and Sterne would expect their readers to be familiar with the conventional image of the midwife that persisted from the time of the English Renaissance. He quotes the description of the complete midwife given in William Sermon's *Ladies Companion* of 1671 as one which retained its power for eighteenth-century novelists:

they were frequently called cunning women . . . these last [midwives] took upon them . . . to make the match . . . and to joyn the husband with the wife; and likewise to pass Judgement whether they were fit and capable . . . to beget children . . . to be present at the delivery of women, which work was committed to none but such that have had children, (as *Plato* saith) . . . neither did the said *Midwives* attempt this Art, til they were past Childbearing, because *Diana* (the Patroness of women in child-bed) was barren.[56]

In her role as matchmaker, the midwife frequently was associated with the more sexualized figure of the procuress or bawd. Her responsibility for bringing children into the world allied her with fate and death. She carried a sharp pair of scissors for cutting the umbilical chord. The length of the umbilical cord was believed to determine the virility of boys and the childbearing capacity of girls, making her task especially fateful.

These descriptions indicate that our Ghost figure may indeed be meant to call up such associations: she is old enough to be past childbearing; her low-cut dress and corset tie her to the figure of the bawd; and her expert wielding of the scissors on the hapless cat's tail could bring to mind the cutting of the umbilical chord, if the other connections were in place. Hogarth emphasizes her Mother Midnight identity compositionally: the fictive stage figure of Juno, beautiful Guardian Angel of women who presides over matrimony and childbirth, is in full focus in the light, while her bloodletting counterpart, who did the actual work of matchmaker/bawd and midwife, is less distinct in the shadows directly behind her. The rounded, graceful figure of Juno contrasts markedly with the angular, lurching form behind her—the visible ideal of womanhood with its dark, secret, and violent underside.

Because of her intimate ties with birth and death and her advanced age, which put her outside the time of reproduction even while she has power over it, the midwife is equated with the ancient figure of Fate. The Fates, according to Danet, were "the Daughters of *Erebus* [Darkness] and the *Night*,"[57] and Night herself was held to be "the Mother of Love, Deceit, Old Age, Death, Sleep, Dreams, Complaint, Fear, Darkness."[58] These are the manifestations of the unconscious, the forces of disorder and loss of control that antifeminist satirists associated with the body and nature of Woman.

Hogarth caricatures the figure of the hag who represents them, making her hideous and placing her in the shadows where she belongs. Yet he allows her figure a kind of confidence and gleefulness that hardly works to allay fears of her action. As the darkened end point of the main, lighted waving line of figures, she represents the limit of his desire to explore the serpentine narrative of femininity: at once the stock sexual fantasy of the castrating mother who both terrifies and excites the little boy and a real midwife who actually delivered women (sometimes in secret) and even arranged the murder of their children. This Ghost figure is not merely another imaginary female monster from Pope's gallery of women.

Just as the Ghost cuts the cat's tail and the midwife cuts the umbilical cord, the three sister Fates, daughters of Night, spin, control, and eventually cut off the thread of life. In the right corner, Night kneels in the shadows beneath Mother Midnight, sewing with needle and thread. She inhabits the picture's *repoussoir* space, a standard compositional device of academic painting in which a grouping of darkened, de-emphasized figures or objects in a foreground corner functions to map out the depth of the picture plane and set off the central focus of the subject matter. Hogarth here saturates this academic compositional device with meaning, suggesting the dark, fateful side of femininity at the very entrance to the bright gaiety of Diana's theatrical world. Instead of controlling the thread of life, Night darns a hole in Juno's stocking—an obvious satirical reversal—yet her bulky, impervious figure, made up in blackface, retains a measure of unknowability. Her dark flesh places her, along with the Mother Midnight figure, at the limits of feminine visibility. In Jonson's *The Masque of Blackness*, Night personified the evil and danger of blackness; her "charms of darkness" worked on the side of vice against virtue.[59] Metaphoric "blackness" linked up all too easily

with real black people. Hogarth activated notions of the primitive sexuality of the black person by pairing Night with the monkey, his little cape echoing the flow of her veil. The monkey's sexuality is made manifest by the graphic depiction of his sexual organ.[60] The *repoussoir* space further includes objects related to the underside of reality: Night's dark lantern "for a stage conspirator,"[61] and cups, balls, and rope for conjuring tricks.[62] The astonishing complex of associations assembled in this right corner of the composition indicates, I believe, Hogarth's desire to give free visual play to the twists and turns of the serpentine narrative of femininity.

Even as Hogarth invokes Mother Midnight as a figure of fearful power within the popular imagination, her context also reveals her as the useful expert that she is. Her powers are not terrifying to the women in the barn, only to the male world that is excluded from it. If, as the playbill suggests, there is only one man (or no men) in the troupe of players, these actresses constitute an unusually independent group of women, particularly in an age when single women were seen as a threat to society because they were not subject to the control of husbands.[63] Within this autonomous female world, the maternal as defined by the patriarchal order is destabilized. Where is the father? Where is the orderly household? Yet maternity obviously thrives on different terms: witness the two little boys dressed up as devils, the boy or girl in Cupid costume, the grumpy baby in the left corner. These children are most likely the actresses' own, and have perhaps been delivered with the help of the Mother Midnight. The composition helps to enforce a sense of her connectedness to the younger women in the barn. The tiny woman in the eagle costume, for example, who has recently given birth to the baby she feeds, is part of a particularly strong diagonal that runs along the lighted path on the floor past Diana,

the barren goddess of childbirth, and on toward the Mother Midnight figure. Thus Hogarth's invocation of an image of woman from contemporary popular culture takes on a specificity within the picture, and it allows the picture to speak about much more than theatricality and satire.

The Breeches Part and the Island of Lesbos

The grouping of figures in the left corner of the composition also speaks to a reality outside the confines of the theater, and outside the accepted bounds of femininity (fig. 27). The transvestite figure standing on the bed is the most explicit symbol of the topsy-turvy world of the theater: she is an actress playing a "breeches part," a topos of the eighteenth-century theater.[64] The breeches part became popular not only for practical reasons—there were far more male than female parts—but also because of the novel sexual dynamics it entailed. The most attractive actresses performed the male parts, portraying a superficial and conventional masculinity and ensuring that their femininity showed through. The gender transformations of the theater could offer female audience members a "sense of release through identification with the rakish actresses in breeches"[65] who represented the freedom and social mobility of the male, much like at the masquerade,[66] while the male theatergoer took his pleasure from the novel view. This codified instance of gender inversion, contained within the space of the theatrical performance, functioned most often to call attention to the rightness of gender norms.

The playbill nestled against the breeches on the bed announces the play to be performed that night as *The Devil to Pay in Heaven*. *The Devil to Pay: or, the Wives Metamorphos'd* was an actual popular "opera" by Charles Coffey, in which the women-on-top beginning is resolved back into the norm by the end of the play. It tells the story of the rich Sir John Loverule,

newly married to a shrewish wife, and a poor cobbler, Jobson, with a good wife, Nell. The footman says of the new wife in Sir John's house: "Here's a house turn'd topsy-turvy, from heaven to hell, since she came hither."[67] A traveling doctor appears who magically transposes sweet Nell into Lady Loverule's body and vice versa. Lady Loverule is miserable as the poor wife of the cobbler Jobson, who beats her, while Sir John is delighted with his newly obedient wife. When, at the end of the play, the Doctor transposes them back again, Lady Loverule is so grateful to be returned to her proper economic station that she accepts the ideal of passive femininity demanded by it, getting down on her knees before her husband and pledging eternal obedience to him. Invoking the plot of this well-known popular comedy, then, satirizes the notion of a world where women rule their husbands.

Hogarth transposes the action of this play to heaven, suggesting perhaps that the heaven and hell reversals of the opera will not resolve themselves back to the norm so neatly—here heaven is, after all, the fantasy realm of goddesses assembled in the barn. According to Paulson, with this picture Hogarth was referring to his friend Henry Fielding's farcical plays of the mid-1730s, in which actors appeared in and out of character, dressed as mythological personages, the artificiality of their costumes and roles emphasized by the low comic language of their lines.[68] These farces ridiculed the pretensions of Augustan ideals in high art and drama, just as Hogarth ridiculed the pomposity of history paintings, with their many archaeologically correct props. Hogarth's picture also gestures to Fielding through the reference on the playbill to Walpole's Licensing Act of 1737, which had been specifically aimed at curtailing the irreverent, anti-Walpole Whig dissident politics of Fielding's farces, produced in the unlicensed Little Theater in the Haymarket.

In 1736–37, the year in which Hogarth's picture was conceived, Fielding cast Charlotte Charke, a highly conspicuous actress and male impersonator about town during the 1730s, in the lead male parts in his farces *Pasquin, Euridice Hiss'd* and *The Historical Register* at the Little Theater.[69] Charke had also played the role of Sir John Loverule, the lead part of *The Devil to Pay*, in 1734 at Lincoln's Inn Field. She was the estranged daughter of Colley Cibber, dramatist, theater manager and Poet Laureate, and the sister of Theophilus Cibber, the famous actor and member of the Freemasons' Lodge to which Hogarth belonged.[70] Perhaps Hogarth deliberately referred to Charlotte Charke in our transvestite figure; perhaps she is Sir John transposed to heaven.

If this figure does refer to Charke, the topsy-turvy world that serves only to re-codify traditional gender relations is undermined by Davis's "connections with everyday circumstances outside the privileged time of carnival and stage-play."[71] Charke was a well-known cross-dresser and lesbian in her real life, causing her theatrical transvestism to reflect her sexuality more pointedly than that of the more common, feminine "breeches part" actresses.[72] Hogarth has placed this figure in warm interaction with another female figure, the Siren, whose character is associated with alluring sexuality. John Nichols sees their interaction as grounds for assuming the transvestite figure is male:

whoever will examine the linen of the weeping figure receiving a dram-glas from the *Syren*, and look for the object that attracts her regard, may discover an indication that the other sex has also a representative in this theatrical parliament.[73]

Lichtenberg provides the only complex response to the gender and sexuality of the pair, albeit in his own sly, obfuscatory manner. He notes of the Siren that "It is probably only the drowsiness of intoxication which some-what clouds her gaze,"[74] but then refers later to Nichols's perception "in the eye of the little siren [of] something more than mere medico-surgical comfort, namely love."[75] Unlike Nichols, however, he remains unconvinced that the Charke figure is male. He notes defeatedly, "I will not sway the reader's judgement in anything . . . I at least have been fascinated for many years, not so much by the wholly unmistakable in the artist's wit and mood, but by the easily mistakable and the actually mistaken."[76] Yet he does attempt to sway our judgement by making two more innuendoes. First, he comments on the set piece up in the hayloft, a painting of Oedipus and Jocasta with their names painted in gilt above them. One commentator, he tells us, thought that "Hogarth alluded by this to the incestuous life of these actresses."[77] After having thus alluded to it himself, he vigorously denies that Hogarth could ever advance so abhorrent an idea. The second innuendo is even more ambiguous. At the end of the essay, he writes that the picture is not free of "naughtiness,"[78] but he refuses to elaborate: "I fear the censor, and so will keep silent. My readers do not lose anything thereby. It is only a small island which is concerned, and that may without detriment remain unknown land."[79] Given his previous allusions, does it not seem possible that he is referring to the small island of Lesbos?

Was Hogarth, then, suggesting a sexual relationship between the transvestite and the Siren? I think that he was, and quite deliberately so. The transvestite stands on the bed, making their scene of encounter the bedchamber, and also making her considerably taller (i.e., more manly) than the Siren. Her bare, rounded thigh, caught by the light, evokes the similar thighs of Diana and the woman in the painting of *After*—there is no doubt that this is a woman playing a breeches part. Her hand brushes that of the Siren as they exchange a glass of gin. The ritual of exchange could be

quite significant; Stephens notes that the Roman portico wreathed with flowers behind them will "be used in playing a marriage festival."[80] Aurora could be a wedding attendant, or even a priestess. Outlandish as such a wedding ritual might seem, the *Register Book of Fleet Marriages* recorded on 20 May 1737 a marriage where "by ye opinion after matrimony, my clerk judg'd they were both women, if ye person by name John Smith be a man, he's a little short fair thin man, not above 5 foot."[81]

We should note the graceful, serpentine slouch of the Charke figure, and the jokey but impeccable wave of the Siren's tail, but even more significantly, Hogarth endows the pair with a visual signifier of beauty and sensuality unique in his oeuvre: they both have long, flowing hair, unhindered by the bonnets or pins that are literally ever-present on the heads of his female figures. Considering the delight he expresses for loose hair in his chapter "Of Intricacy" in *The Analysis of Beauty*, it surprises me that he represents it nowhere else, not even when he depicts harlots in bed, female criminals in prisons, or biblical maidens. "The most amiable in itself," he writes, "is the flowing curl; and the many waving and contrasted turns of naturally intermingling locks ravish the eye with the pleasure of the pursuit."[82] This moment of intense visual ravishment occurs on the pair of figures that narratively deviates most intensely from the accepted bounds of femininity, collapsing and doubling the visual and narrative "pleasure of the pursuit" afforded by the serpentine line.

The subject matter of *Strolling Actresses Dressing in a Barn* offers an array of targets for satire: the pretensions of the theater; the drunkenness, sexual promiscuity, and general squalor of the strolling life; and women themselves, for all the reasons set out by the antifeminist tradition. I have attempted, however, to demonstrate the inadequacy of satire as a term for talking about this picture. Although eighteenth-century satire

was admittedly already a complicated category, shading into irony and burlesque, imposing its dualities only incompletely, Hogarth's departure here is more decisive than a difference in shading and tone. Producing a single print rather than his accustomed moral progresses or cycles freed him from the need to sustain a coherent moral narrative. His confinement within the transitory, makeshift, and feminine space enclosed by the barn seems to have engaged his desire and led him to take risks with both artistic form and cultural meaning. He offers the gender-reversed world of satire, but does not ridicule it pictorially to uphold the rightness of gender norms. He makes visible, without attempting adequately to satirize and contain, aspects of female experience like lesbianism and the powerful midwife. His engagement with the effects of femininity in this picture deepens and extends the meaning of his serpentine line of beauty, as it applies both to visual form and narrative content. The *Strolling Actresses* asks us to reconsider *The Analysis of Beauty*, to understand it less as an idiosyncratic eighteenth-century theory of aesthetics, and more as a persuasive account of the links between desire and visual representation.

Notes

I am grateful to Michael Baxandall for his encouragement of this project and his valuable critiques of its earlier versions. I would like to thank Anne Wagner, Catherine Gallagher, George W. Kresak, Richard Meyer, and Amy Greenstadt for their helpful responses to the essay. Special thanks are due to *Art History* for authorization to reprint this essay, which appeared in 1993.

1. Paulson 1971, 397, argues that the satire is directed not at the actresses as people but at "the inappropriate ideals of a certain kind of art, and . . . society." Shesgreen 1973, cat. 46, insists that the satire is aimed at what he characterizes as the vain, wanton actresses themselves.

2. Antal 1962, 27: the picture set a narrative precedent as "the first prosaic representation of the life of actors, divested of flattery." Antal elaborates in note number 60 (234): "Representations

of rehearsals and of actors dressing for a performance existed before Hogarth, but probably never before had actors been shown dressing and rehearsing against the background of their miserable everyday life."

3. The term "anti-feminist satire" is used in Nussbaum 1984.

4. Hogarth 1997, ch. X, "Of compositions with the serpentine line," 51.

5. Paulson 1979, 245, n. 11.

6. Ibid., 7.

7. Hogarth 1997, ch. X, 50.

8. Ibid., ch. IX, "Of compositions with the wavering line," 48.

9. Ibid., ch. V, "Of Intricacy," 33.

10. I take this provocative and original reading of Hogarth's serpentine line from Emily Apter, who suggests that it "satisfies epistemological hungers . . . *and* the appetite for visual seduction"; Apter 1995, 166.

11. Hogarth 1997, ch. XVI, "Of Attitude," 102.

12. Ibid., ch. XVI, 102–3.

13. Paulson 1971, 409, cites studies of visual perception which show that in reading a picture, the eye moves from the lower left up and into the depth of the picture and toward the right.

14. Ibid.

15. For the debates, see *The Grub Street Journal* 274 (27 March 1735), 1; 279 (1 May 1735), 3; *The Gentleman's Magazine* V (April 1735), 192. The print is no. 2146 in BMC 1870–1954.

16. Charke 1969, 187.

17. *A New Canting Dictionary* 1725.

18. Particulars about advertising and performing at Southwark Fair can be found in Rosenfeld 1960.

19. Paulson 1971, 397, writes that "the scene is populated by goddesses, by actresses, by girls, as if the drummeress in *Southwark Fair*, among all those players and sharpers, had been multiplied."

20. Nussbaum 1984, 19–20.

21. Gubar 1977, 380, calls women in Swift's poetry "emblems of filthy materiality."

22. Swift 1958, 257, "Strephon and Chloe," lines 233–34. All dates given for Swift's poems are dates of first publication.

23. Castle 1987, 156.

24. Swift 1958, 243–44, "The Lady's Dressing Room," from lines 12–52.

25. Rumbold 1989, 1.

26. Pope 1954, 87, "Epistle II: To a Lady; Of the Characters of Women," lines 199–202.

27. See Pollak 1978 for a discussion of the differences between Pope and Swift.

28. Pope 1954, 87, line 3.

29. Lichtenberg 1966, 156.

30. *Spectator* no. 15 (17 March 1711), quoted in Nussbaum 1984, 5.

31. Hill 1989, 105.

32. *The Autobiography of Francis Place (1771–1854)*, quoted in Hill 1989, 105.

33. On drinking among strolling actresses, see Charke 1969, 161; on learning long parts, see Rosenfeld 1939, 26.

34. The ardors of washing are discussed by Hill 1989 in her chapter on "Housework."

35. On their poverty and financial arrangements, see Rosenfeld 1939 and Grice 1977.

36. Montfaucon 1722, plate opposite 148.

37. Paulson 1989a, 166, discusses Diana's relation to the poses of classical statues.

38. In the first plate of Hogarth's *Marriage A-la-Mode* of 1743, Medusa looks down upon the betrothal scene of the doomed marriage with powerfully foreboding horror.

39. I take this term from Charke's description of strolling players as "Travelling-Tragedizers"; Charke 1969, 186.

40. Dramaticus 1735, 192.

41. *Grub Street Journal* 279 (1 May 1735), 3.

42. This is the definition of Aurora, unreferenced, given in the *Oxford English Dictionary* (1989).

43. Nichols 1781, 251, states the confusion most clearly: "I know not why this print should have received its title only from its female agents." Lichtenberg 1966, 155–56, makes much of the gender confusion of the title and attributes it—correctly I think—to slyness on Hogarth's part. Stephens and Hawkins (in BMC 1870–1954, 280–81) indicate later titles given to the piece that correct the gender mistake of Hogarth's original title: *Strolling Players, The Company of Strollers,* and *Strolling Players, Rehearsing in a Barn.*

44. This is documented by Stephens and Hawkins (BMC 1870–1954, 280–81).

45. Paulson 1989b, 161.

46. Danet 1700, under "Jupiter."

47. Ibid., under "Juno."

48. Pope 1954, *Epistle to a Lady*, lines 201–2.

49. Rochester 1968, 38, "The Imperfect Enjoyment," lines 5–10.

50. Ibid., lines 46 and 56.

51. Lichtenberg 1966, 160.

52. N. Davis 1975, 130–31.

53. Swift 1958, 247–49.

54. Accusing women of violence and cruelty is another aspect of the tradition of antifeminist satire, dating back to Juvenal's *Sixth Satire* on women. See Nussbaum 1984, 82.

55. Lichtenberg 1966, 162, picked up on this association, although the author notes that she would hardly be cutting off the tail of the cat if it were really a fellow witch in disguise.

56. Quoted in R. Erickson 1986, 5.

57. Danet 1700, under "Parcae."

58. Galtruchius, quoted in R. Erickson 1986, 7.

59. Barthelemy 1987, 27–28.

60. Dabydeen 1987 documents the frequency with which Hogarth paired blacks and monkeys in his works and the ways in which he made use of sexual stereotypes about blacks to comment on the morality of the English, see especially 128–30 .

61. BMC 1870–1954, 277.

62. Lichtenberg 1966, 168, points out that they are instruments for conjuring tricks, while Stephens and Hawkings (BMC 1870–1954, 277) write that they will be used for "legerdemain."

63. This is discussed in Hill 1989, 229–31.

64. Lichtenberg 1966, 164; surprisingly, in his lengthy discussion of this figure Lichtenberg never refers to the part she plays by name; rather, he speaks at length about the breeches, lying before her on the bed—he fears they will be too small for her, noting that they are already opened to the widest belt buckle in preparation for the struggle.

65. Rogers 1982, 253.

66. The phenomenon of the social freedom gained by women at the masquerade is discussed in Castle 1986.

67. Coffey 1777, 2.

68. Paulson 1971, 395.

69. Castle 1982, 617. My reading of Hogarth's engagement with the actresses is indebted to Castle's analysis of *The Female Husband*, Fielding's viciously satirical, fictionalized account of the story of Mary Hamilton, a female transvestite tried in 1746 for marrying another woman while impersonating a man. Castle demonstrates that, even as Hamilton elicits Fielding's anxiety and scorn, the very boldness of her performance engages his sense of the theatrical entertainer.

70. According to Paulson 1971, 342, he was one of the "members who formed the nucleus of Hogarth's intimates."

71. N. Davis 1975, 131.

72. The life of Mrs. Charke, as she was known, is unusually well documented, as she wrote an autobiography in 1755; Charke 1969. She relates, among other escapades, how she posed for many years as a man, was known as Mr. Brown, and shared a home with her friend and presumed lover Mrs. Brown.

73. Nichols 1781, 251.

74. Lichtenberg 1966, 163.

75. Ibid., 167.

76. Ibid.

77. Ibid., 170.

78. I here translate from the German *Ungezogenheit*. The English translation in Lichtenberg 1966, 171, is "misbehavior."

79. Lichtenberg 1966, 171. The German is equally ambiguous: "*Es betrifft bloss eine kleine Insel, und die mag dann ohne Schaden unbekanntes Land bleiben.*"

80. BMC 1870–1954, 278.

81. Quoted in Bridget Hill's collection of original documents; Hill 1984, 89.

82. Hogarth 1997, ch. V, "Of Intricacy," 34.

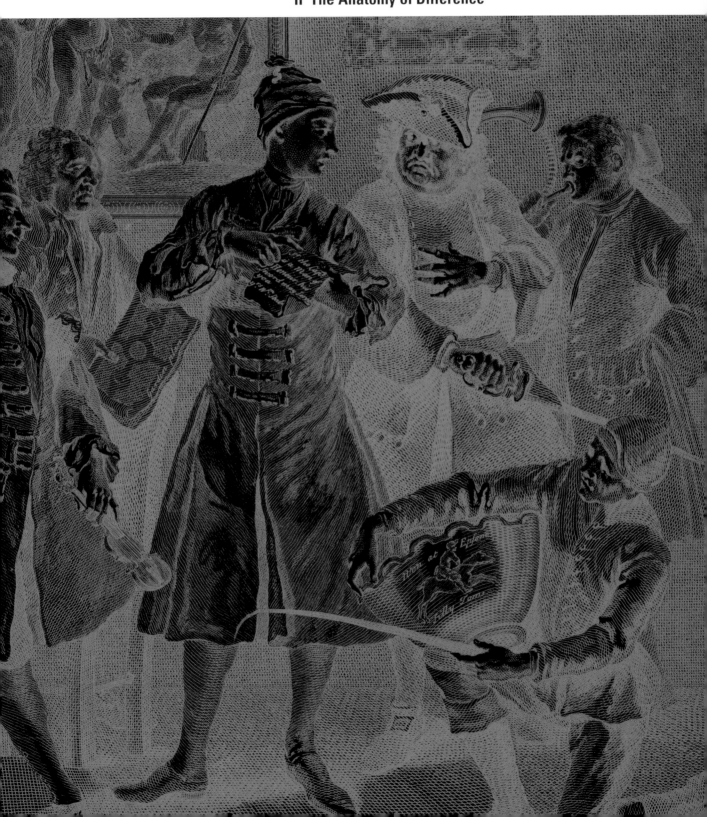

Spotting the Symptoms: Hogarthian Bodies as Sites of Semantic Ambiguity

Peter Wagner

The field of eighteenth-century studies has profited recently from an increasing interdisciplinary interest in what might be termed body language. To a certain extent, this attention to the verbal and visual representation of the body in the Enlightenment may be seen as a reaction to the pioneering work of Michel Foucault.[1] Art historians, literary critics, and historians of medicine have begun to reconsider the human body in terms of a highly complicated discursive field. The field has been enlarged and popularized, as it were, by surgeons exhibiting "body worlds," late twentieth-century *Wunderkammern*, to a fascinated (and somewhat shocked) lay audience on three continents.[2] The Enlightenment section of that field has become an archeological site where scholars from several disciplines are busily digging in search of vestiges of a great variety of representations that met, mingled, and made meaning in and on the eighteenth-century body.[3]

It seems to me that the male and female figures peopling Hogarth's works deserve attention in the context of this new archeological search, for the bodies in Hogarth's paintings and engravings constitute fascinating sites/sights of meaning-making. They have been studied as embodiments of and artistic responses to eighteenth-century reality, yet they are far more interesting when seen as the battleground of signs and codes that allude not to reality but to traces of more or less hegemonic mentalities, including prejudices and stereotypes. Since the time of Georg Christoph

Lichtenberg, who wrote the first semiotic ekphrasis of Hogarth's prints, very few commentators have ventured into the field of Hogarthian body language.[4]

Hogarth must have become aware of the semantic range and the artistic possibilities of this code—one among many in his works—as he was improving and complicating his graphic art. One notices, for instance, the presence of comic-strip balloons (containing words) in his first independent satires published in 1724 (*Masquerades and Operas* and *A Just View of the British Stage*). By the early 1730s, however, he abandoned this device for the more expressive and ambiguous medium of the body as a signifier with rhetorical and semantic dimensions, putting it to impressive use in *A Harlot's Progress*. Lichtenberg's commentary on the second plate of that series implicitly charts some of the *terrae incognitae* of Hogarthian bodies, for despite the gender bias that comes to the fore on a number of occasions,[5] the German philosopher, scientist, and proto-art historian took cognizance of the fact that in Hogarth's graphic art human (and animal) shapes function as signs. Creating indeterminacy rather than fixed meaning, these signs are made up of visual and verbal crossings that combine and conflate such sign systems as natural body movements (walking, dancing, gesturing) and artificial, theatrical, and rhetorical gestures and "attitudes" (i.e., theatrical poses),[6] deaf sign language, and the representation of the passions[7] and physiognomy[8] as

applied in history painting and portraiture. A good example can be found in the representation of the harlot in the second plate of Hogarth's first best-seller, a body Lichtenberg describes first as a construction site and then in terms of a contemporary picturesque landscape with ruins.[9] To Lichtenberg's lucid explanation one could add the codes of dressing/undressing and the sophisticated, orchestrated combination of these and other codes introduced by the bodies of the black boy, the lover and the maid in the background, the monkey at left, and the human figures in the pictures on the wall. One of the sign systems associated with the harlot is that of masquerading (her mask is on the table on the left), which plays an important semantic and satirical role in this scene and the series as a whole.[10]

In a recent article on the codes of visual language in the Ancien Régime, Nicholas Mirzoeff has shown that the linguistic communication invested in the corporal sign is misunderstood if reduced to a reading in the context of Le Brun's seminal treatise on the passions.[11] Indeed, the painted sign has much in common with deaf sign language, and when eighteenth-century artists depicted the body as sign, they "used the gestural sign language of the deaf as a technology of signification peculiarly well suited to the silent artwork, in keeping with the polysemicity and diversity of the body and the sign."[12] If the signs employed in the French art of the Ancien Régime were always contingent and polysemic, borrowing as

they did from the major and minor codes of signification known at that time, Hogarth's graphic art is also distinguished by such a mixture of codes that make meaning through the use of multivocal, fragmented signs. When Hogarth confessed in his autobiographical notes that he endeavored to treat his subjects as a dramatic writer, that "my picture was my stage and men and women my players, who by means of certain actions and gestures, are to exhibit a *dumb shew*," and when, in his treatise *The Analysis of Beauty* (1753), he explained his specific aesthetic theory with examples from dancing, ballet, pantomime, and "Stage-action,"[13] we should be alerted to the conflation in his engravings of codes that are directly related to the sign systems of these art forms.

Obviously, body language in Hogarth's works is far too large and intricate a subject to be treated exhaustively within the scope of an essay.[14] I shall limit the subject by focusing on spots constituting what may be termed an important code, although it is ultimately only one small area within the field of body language. The Hogarthian prints, especially those published after 1732, exploit this code to its full artistic potential. To demonstrate the importance of the code, I shall discuss three of the major semantic functions of (beauty) spots. I shall deal initially with their role within the contexts of Hogarth's satire and aesthetics, which are both enriched and complicated by a gender issue.[15] I shall then demonstrate the dissemination of the spots as signs, while

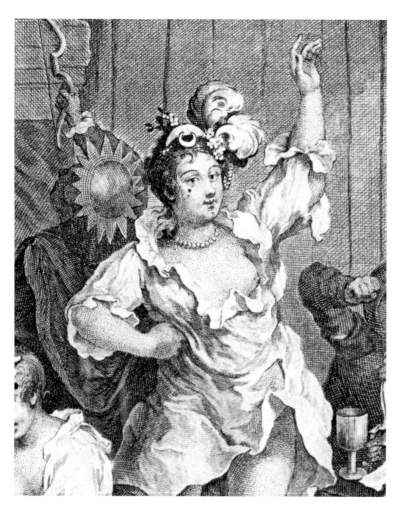

Barn [sic]. The girls playing Diana, Juno, and Ganymede all have discreet, small "moles" below their right eyes. Their delicate size, their strategic placing to enhance the eye, and the way they are almost identically placed, suggest they are fashionable beauty spots. The nubile innocence of the women certainly suggests nothing sinister in them.[16]

Since I am not so sure about the innocence of the actresses and the nature and number of their spots, I begin my discussion with this print (fig. 21) to point out how such (beauty) spots create semantic ambiguity undermining both traditional frames of satire and the representation of women.[17]

Strolling Actresses Dressing in a Barn was published in May 1738. In its ironical use of circumstantial and seemingly unimportant details it is an outstanding satire in which meaning is simultaneously created and suspended or deferred. In fact, the (beauty) spots may serve as an ideal example of *différance* in Hogarth's prints—the spots establish and play with signification not by fixing sense but through allusions to the *déjà vu*, *déjà lu*, and *déjà entendu*, to what is not there or visible but was known to the observer of Hogarth's day and age. If we consider the spots on the faces of the actresses as allusive signifiers, they are not simply "moles" but references to a sophisticated code and a highly expressive system of communication. The woman playing Diana, in the center (fig. 30), sports two small spots of different sizes below her right eye, and so does Ganymede, at left, who has two additional black spots (probably signifying warts) on the side of the nose (fig. 31). Juno, practicing her lines at right, has either one or two spots (depending on the state of the etching/engraving),[18] again below the right eye. These spots could be birthmarks or moles—i.e., natural spots[19]—but in the context of the satire on classical myths and travesties of high art and pastoral scenes[20] it seems more logical to read them as beauty patches, and perhaps even as patches hiding skin lesions.

Fig. 30. William Hogarth, *Strolling Actresses Dressing in a Barn*, second state (detail), 1738. Etching and engraving. Private collection, Germany

addressing the implications of the code in terms of class and the representation of time.

I

In an article concerned with "beauty spots" and sexually transmitted diseases in Hogarth's graphic art, Fred Lowe explained that

there are numerous people in Hogarth's works with black spots on their skins. Some of these people clearly have beauty spots applied to enhance their features. The most obvious examples of these genuine cosmetic spots are to be found on the actresses in the print *Strolling Actresses in a*

Even in Hogarth's day such artificial spots or patches had a long history and various functions in cosmetics, and it is precisely to this aspect, and the observer's knowledge of it, that the spots allude. Lichtenberg points out what could be termed their aesthetic function. Taking Diana to be a former country girl who had "thrashed something more useful than blank verse" and is totally unsuitable for this role, he refers to her (beauty) spots as *Blick-Ableiter*, a pun on the German *Blitz-Ableiter* (with the literal meaning, "lightning rod"), which the girl has stuck on her plain, "uncouth" face to make it more attractive.[21] Hogarth was quite aware of this aesthetic effect of the beauty spots. Indeed, his remarks on the subject in *The Analysis of Beauty* would seem to explain the use and location of the spots on the faces of the gods and goddesses in *Strolling Actresses Dressing in a Barn*. Discussing variety in women's clothes and makeup, he argued that ladies who are at liberty to make what shapes they please in ornamenting their persons choose the irregular as the more engaging—for example, no two patches are ever of the same size or placed at the same height. Similarly, a single one is never placed in the middle of a feature unless it is to hide a blemish.[22]

Lichtenberg's punning verbal re-creation of Hogarth's satirical use of spots in the contexts of satire and aesthetics appears quite appropriate, for the spots (like the lightning rod) both attract and divert. They arrest the spectator's gaze (which, with a "spotless" face, might run on to other parts of the body or the picture) while illustrating[23] Hogarthian notions of (feminine) beauty. In his treatise, Hogarth links beauty with "intricacy" and "variety," arguing that his famous serpentine line "leads the eye a wanton kind of chace," a glancing, as it were, that derives most pleasure from such irregularities as curls or patches.[24] The spots are thus part of what Christine Kiaer has recognized as a revolt against linearity in the *Strolling Actresses*.[25]

There is more to be said about such facial spots. During the Enlightenment, they were known as "mouches." A brief look at their history discloses another dimension of their signifying potential. It seems that in Europe[26] the beauty patches first emerged in the seventeenth century as a means of covering or hiding moles, birthmarks, or pimples on the face or neck.[27] They soon became fashionable, not least because their black color could enhance the whiteness of the skin and draw attention to the parts of the face or body where they were stuck. Hence Lichtenberg's pun, *Blick-Ableiter*. A French source from 1655 makes clear the erotic potential of such artificial cosmetic aids: a "mouche" is defined as a *petite rondelle de taffetas noir que les dames se collaient sur le visage par coquetterie* [a small round and black plaster which the ladies stuck on their faces to look attractive].[28] It is interesting to compare this use of "mouches" to Hogarth's reevaluation in terms of aesthetics when he connects them with feminine taste in the passage quoted above.[29]

When Diderot and D'Alembert defined the term shortly after the middle of the eighteenth century in their *Encyclopédie ou Dictionnaire raisonné des sciences, des arts et des métiers* (1757), the various textiles and fabrics mentioned indicate that the decorative and aesthetic aspect had now become most important; a "mouche" is described as *un morceau d'étoffe de soie, velours, satin, ou autre, taillé en rond, en cercle, ou autre fig., que les dames mettent sur leurs visages par forme de parure & d'ornement; la mouche est gommée en dessous* [a piece of fabric made of silk, velour, satin or other, in a round or circular shape or some other form, which the ladies put on their faces to look beautiful; underneath, the *mouche* has a rubber side]. (Later in the century, the patches were sometimes simply painted and could be wiped off, as Lichtenberg suggests in his interpretation of Ganymede's spots in *Strolling Actresses*.)[30] As fashions go, beauty patches became the rage

among the *beau monde*. Other sources confirm Diderot's remark about the different shapes that developed, including the most extraordinary sizes; in some cases mouches were as large as the plasters covering real wounds (see the Viscount's beauty spot in the first scene of *Marriage A-la-Mode*, discussed below, fig. 36), and these were sometimes decorated with jewels. The most popular mouches took the forms of moons, stars, or animals, including fleas and spiders.[31]

By the eighteenth century, men also sported beauty spots as cosmetic aids. The actors in Stanley Kubrick's film version of *Barry Lyndon* and in Fellini's equally excellent *Casanova* were rather convincing in re-creating this physical aspect of the faces of eighteenth-century *beaux*. In another movie on an eighteenth-century topic, *The Flight to Varennes,* there is a scene in which Marcello Mastroianni, as a decrepit Casanova, restores his face in a toilet room with the help of beauty patches. What seems to be at first

glance a subtle allusion to eighteenth-century reality in these films can also be ascribed to enduring twentieth-century perceptions of the use of cosmetics as indicative of the transgression of gender boundaries.

It is the "transvestite figure standing on the bed" in *Strolling Actresses* which provides not only an explicit "symbol of the topsy-turvy world of the theater"[32] but also of the play with gender roles and gendered codes in this extremely rich engraving: Ganymede (fig. 31), on the left, is obviously suffering from toothache. The "siren" offering him/her gin, perhaps to ease the pain, has two spots, one below the left eye and one on the upper part of her left breast (fig. 27). The lower one could be a beauty spot or, more likely, the trace of a flea bite, since the (black?) woman, in the role of Aurora, who seems to adjust the siren's costume, is perhaps killing lice—the gesture of her hands, also an example of body language, is ambiguous enough to allow both readings.[33]

Several commentators have speculated on the (real) sex of Ganymede, especially in view of a "love" relationship between the cross-dresser and the siren.[34] Christine Kiaer believes that Hogarth was "suggesting a sexual relationship between the transvestite and the Siren."[35] Since Hogarth is dead and cannot provide an answer, we shall have to do with the ambiguous signifiers of his visual representations. In the case of the spots on the face of the potential male lover and the woman in front of "him," one could of course follow Lichtenberg who implied (with the gender bias of his own time and country) that we are seeing a pair of lesbian lovers. The question is—and I would maintain that the picture leaves it open—whether or not such a reading must necessarily lead to a negative view of the women represented here (e.g., as lewd, devious, and morally flawed). What is interesting, ultimately, is that Lichtenberg connects this visual detail with an allusion to a set piece in the hayloft, a painting of Oedipus and

Jocasta, thus suggesting that some sort of (sexual) illegitimacy. What needs further investigation, then, is Lichtenberg's gender bias, for the entire passage in which he implies that these women have made love to each other is an ekphrasis that may have kicked off a whole line of such biased interpretations.[36]

We shall probably never find out whether the Ganymede represented here is a man or a woman (unless we maintain, on the basis of alleged visual or verbal evidence, that Hogarth intended to show us one of the two). It is the playing with gender issues that is important here, a play that is set in motion, first by the allusion to a Greek mythological figure (with a whole series of gender implications: Ganymede was Zeus's boy lover), and then, on a visual level, by the introduction of two beauty patches/spots, which were normally used by women in this way. The engraving both complicates and heightens the satire by showing the patches on the face of a person who is (about to be) dressed as a man, but the trousers lying on the bed and an exposed thigh suggest a female body.[37] And if we remember Lichtenberg's remark that such spots could be wiped off, things get even more confusing—and interesting—in light of the two warts (or pimples?) that are clearly visible on Ganymede's nose. This detail is one of the best examples of how the gendered issues implied in the use of the code of spots could be employed for both artistic ambiguity and rich satire.

What is important for my context—Hogarthian satire in the light of a gendered aesthetics—is that beauty spots did not signify the same thing in men and women. In the case of Ganymede in *Strolling Actresses* one might argue that it is gender which is responsible for the semiotic variation and the implied satire on the sexual life of actresses. For women used beauty spots as a more or less secret code that depended on the location of the mouches in the face.[38] If we can trust the German sexologist Eduard Fuchs, women who wanted to create the impression of impishness stuck them near the corner of the mouth; those who wanted to flirt chose the cheek; those in love put a beauty spot beside the eye; a spot on the chin indicated roguishness or playfulness, a patch on the nose cheekiness; the lip was preferred by the coquettish lady; and the forehead was reserved for the proud.[39]

Returning to Hogarth's *Strolling Actresses* with this code in mind, we can decipher the beauty spots of the "goddesses" as polyvalent signals/signifiers used by flirtatious women. This is quite inappropriate for Diana, in the middle, who represents the goddess of chastity, and for Juno, at the right, the Roman goddess of women and marriage. It is precisely because their beauty spots turn up in the wrong facial area (suggesting amorousness) that this seemingly unimportant iconographic detail adds to the travesty of the entire scene. Since actresses belonged to the demimonde of eighteenth-century urban life, the observer of Hogarth's print would also have wondered about the nature of the beauty spots—i.e., whether they were truly artificial or were hiding symptoms of actual diseases. This "sinister" reading, as Fred Lowe would call it,[40] should not be excluded, for it constitutes a second level of meaning.[41]

There are two additional women in *Strolling Actresses* who deserve our attention in the context of spots as ambiguous gendered signifiers or codes. One of these is Flora, in front of Diana, a figure who at first glance appears to be without blemish and spots. But in the first state of the print (the one Lichtenberg must have seen), she has two large, square plasters on the side and at the top of her forehead (fig. 32). Lichtenberg argues that what looks like hair dressing with a tallow candle is really a Hogarthian visual/verbal pun on the name Flora; like the siren, Flora (the flower) may have been bitten by aphids (plant lice),

107

Peter Wagner

Fig. 32. William Hogarth, *Strolling Actresses Dressing in a Barn*, first state (detail), 1738. Etching and engraving. Private collection, Germany

Fig. 33. William Hogarth, *The Company of Undertakers*, second state, 1737. Etching and engraving. Private collection, Germany

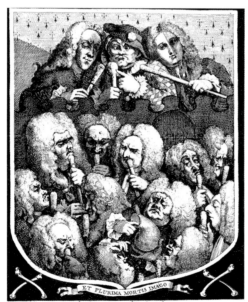

and she will try to cover the bites (Lichtenberg puns in German, calling the bites *Blüten*[42]— i.e., blossoms) with the paint in the shell on the table, much as she has already covered other sores or bites with plasters.[43]

On the basis of what we have seen so far, (beauty) spots in Hogarth's prints, then, can signify several things: while foregrounding and playing with gender boundaries in satire and aesthetics, they represent a cosmetic means of rendering oneself more beautiful or attractive, an aesthetic aid to cover blemishes of the skin or symptoms of diseases, and "blossoms" as the consequences of flea or louse bites. When Hogarth's visual satires play with the signifiers of spots, at least two, and often three levels of meaning are involved. I will now focus on some other prints, leaving aside the paintings in which Hogarth sometimes employs color for similar effects.[44]

Classifying the extraordinary number of people with (beauty) spots in Hogarth's prints, one can distinguish between four kinds of black marks. First, spots can signify warts, (innocuous) moles, or marks left by smallpox, sometimes in the depiction of characters who were identifiable to contemporaries. Examples can be found in *The Company of Undertakers* (fig. 33): Dr. Joshua Ward, represented at the "sinister" side of the central Mrs. Mapp, was known as "Spot Ward" for the port-wine birthmark on his face. Among the doctors below, one is marked with two spots that I take to be warts.[45] But even here ambiguity and irony may be at work, for in Hogarth's time and into the nineteenth century warts (if we do not read them as a reference to the doctors who may have had such "naevi," but as an allusion) were traditionally associated with witches. As death-bringers, the doctors could also be associated with Genesis 4:15 where God, after Cain has killed his brother Abel, "set a mark upon Cain, lest any finding him should kill him." Hogarth's prints showing

doctors always associate them with death. This is, then, an additional, "meaningful," aspect of what seems to be a marginal detail. The same ambiguity can be noticed in the retouched version, published in 1762, of *The Sleeping Congregation* (fig. 17): the officiant in the pulpit has been identified as a likeness of the Freemason John Theophilus Desaguliers; therefore Paulson could be right in reading the spots on his cheek and forehead as warts (if Desaguliers had such warts).[46] But other readings are possible: the marks may be those left by smallpox, if not of what was then referred to as the pox. Such a reading would fit the undercurrent of sexuality in this print.

Second, spots or patches may be read as symptoms of diseases, particularly venereal diseases. For example, in the case of the woman depicted in the center of *Gin Lane*, the meaning of the rectangular patches seems to be, for once, quite clear: she reminds one of Swift's "Beautiful Young Nymph Going to Bed" (1732). In the privacy of her room,

> With gentlest touch, she next explores
> Her shankers, issues, running sores;
> Effects of many a sad disaster,
> And then to each applies a plaster. (lines 29–32)

Judging from additional contextual evidence, one can also assume the spots on the faces of the bawds in Hogarth's prints (e.g., Mother Needham in the first plate of *A Harlot's Progress*, fig. 34) to be, in Fred Lowe's words, "actual skin marks rather than plasters or cosmetic enhancements"; these spots can be read as skin lesions and therefore associate the women with venereal disease.[47]

Third, black marks can be "mere" beauty spots. Since the satirical aim in Hogarth's prints consists in exploiting ambiguity, especially—as we have seen in *Strolling Actresses*—where innocence is questioned or undermined, such cases are very rare. Usually, the marks permit at least two, often contradictory, read-

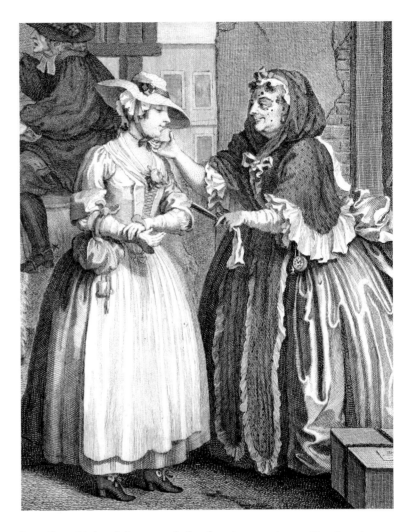

Fig. 34. William Hogarth, *A Harlot's Progress*, Plate 1 (detail), 1732. Etching and engraving. University of California, Berkeley Art Museum

ings. One thinks of the master's daughter in the second (fig. 45) and sixth plates of *Industry and Idleness*. The small black spot on her forehead makes sense either as a birthmark or as a cosmetic aid to enhance the artless face. But in the eighteenth-century code discussed above, it is also an index of pride. In this case, it is difficult to conceive of the spot as a sign for a disease.

Finally, black marks on the face or body also function as parodic allusions to Old Master paintings. Adding to the satirical potential of the engravings, these visual allusions were made for the connoisseurs who could identify

Peter Wagner

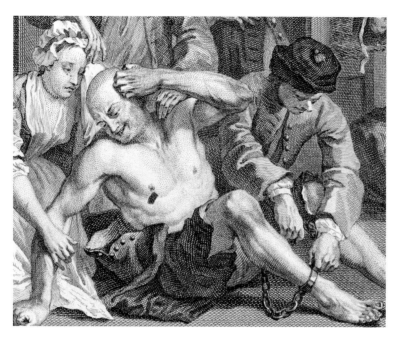

Fig. 35. William Hogarth, *A Rake's Progress*, Plate 8 (detail), 1735. Etching and engraving. University of California, Berkeley Art Museum

sus, naevus spilus, et al.), the most common being the *naevus pigmentosus*. And it is precisely because the spots, once one reads them as a code, enhance the satirical, subversive rhetoric of the engravings that we must consider their full semantic potential. Take the Viscount in *Marriage A-la-Mode* (fig. 36): the large round mark on his neck has been interpreted as a signifier that is simply a beauty spot or, in the context of diseases passed on from father to child, a patch hiding a venereal sore.[50] Like Lichtenberg, who terms the patch a "very meaningful *bon ton*-plaster,"[51] I prefer to read the black mark on the young nobleman's neck as an indexical signifier that suggests both a beauty spot (it is part of his fashionable makeup and dress) and a plaster.[52] The satirical point is that the spot has several denotations, and, given the prominent subject of hereditary and venereal diseases in the series, a host of connotations.

It is this sophisticated playing with visual details and codes that makes for outstanding graphic satire. For instance, the context of the penultimate scene of *A Harlot's Progress* suggests that Moll Hackabout is dying of syphilis or, more precisely, has become the victim of dangerous quacks (pl. H5).[53] But Hogarth's skillful exploitation of her (beauty) spots does not allow us to say exactly when or where she contracted what was then called the French malaise. In the first picture, her face and skin are as white and clean as that of the young women representing beauty and innocence in *The Enraged Musician*, *Noon* (the English maid), *Marriage A-la-Mode* (the first plate), and *Beer Street*. However, her straw hat hides a large part of her forehead; she might already be infected, undermining the myth that combines country with innocence.[54] In the second picture (fig. 13), Moll has sprouted two ambiguous spots on her forehead; as "mere" beauty spots, they exemplify Hogarth's idea of variety, and they may also indicate her pride (accord-

the originals and chuckle at the Hogarthian subversion of high art. The most obvious example of this satirical iconographic procedure is the allusion to Christ's wound in a Renaissance *pietà* as made through the dark patch on the Rake's ribs in the final plate of *A Rake's Progress* (fig. 35).[48] Less obvious is the visual intermedial playing with Old Masters (e.g., Rembrandt and Breughel) in *Enthusiasm Delineated* and its revised version, *Credulity, Superstition and Fanaticism*, in which the preacher (at least in the second version) is marked by a black spot on his forehead, a trace of liver spots such as one finds in the faces of Old Testament characters painted by Rubens, Rembrandt, Breughel, and others (again, one could also read it as the mark of Cain).[49]

In fact, the actual medical terms for the spots provide some idea of their indeterminacy, which in turn underpins satirical ambiguity. While one may distinguish between the congenital *naevus* and the so-called *naevus tardus*, there are all sorts of skin marks or blemishes (e.g., *naevus linearis, naevus morus, naevus pilo-*

110

ing to the system of facial beauty spots discussed above), but we cannot exclude the possibility that the spots are the first symptoms of the disease that will lead to her death. In the third and fourth plates (pls. H3, H4) more spots have appeared, and we still cannot tell exactly what they signify. The point, again, is not exact meaning but ambiguity. And if, surprisingly, we cannot find any spots in the face of the dying harlot, it is because she is here (fig. 9) depicted in the role of a moribund, ecstatic saint; that aspect seems more important for the representation at this stage of the series than the code of beauty spots. But the code reappears forcefully in the sixth plate (pl. H6), in which all the prostitutes (Moll's colleagues) are again marked with spots.

As we saw in *Strolling Actresses Dressing in a Barn*, the code of (beauty) spots serves to question and undermine all sorts of seemingly innocent scenes and human figures. For example, the lady whose body language creates the impression of being chaste in *Before* (fig. 37) is marked, as it were, by two spots beside her left eye. Fred Lowe, who sees only one spot "of dubious meaning," argues that "just as the literature and the picture suggest she is not unwilling, so the spot may suggest she is not so innocent."[55] Indeed, the spots suffice to put her innocence into question. Placed beside the eye, they signify "I am in love" (therefore, her shock amounts to pretense); again, we cannot tell whether the marks/spots are mere cosmetic beauty patches or the visible symptoms of some disease. Such ambiguity justifies different readings of the scene—e.g., a reading which sees the two lovers as a couple who merely play or perform a seduction scene.

Perhaps the most interesting examples are Hogarth's embodiments of a popular satirical type, the (possibly lecherous) old maid. As we try to understand the body language of the spinsters (or widows) represented in *Morning* and the fifth plate of *A Rake's Progress*, we

Fig. 36. Gérard Scotin (French, 1698–1755) after William Hogarth, *Marriage A-la-Mode*, Plate 1, *The Marriage Settlement* (detail), 1745. Engraving. Hood Museum of Art, Dartmouth College, Hanover, New Hampshire. Purchased through a gift from the Hermit Hill Charitable Lead Trust

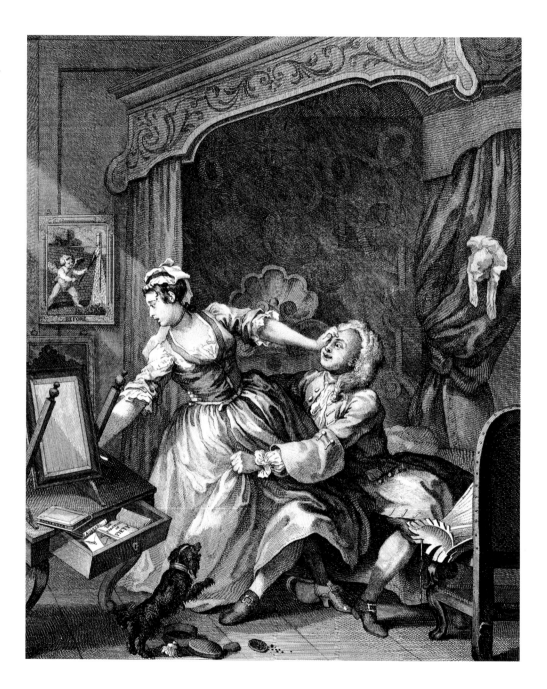

Fig. 37. William Hogarth, *Before*, Plate 1, first state, 1736. Etching and engraving. Private collection, Germany

should bear in mind that Hogarth's images always allude to texts. In these two examples, the implied texts constituted a subdivision of the misogynist satires on women and marriage, with old maids serving as one butt of ribald attacks. Later in the century, Henry Fielding was to draw on such bawdry and on Hogarth's engravings for Bridget Allworthy, Tom Jones's mother, who confirms the stereotype.[56] The old lady in the print *Morning* on her way to church (fig. 38), can be interpreted in this context and related genres of satire, such as Ned Ward's portraits of Covent Garden types in *The London Spy* (1698–1700), in which "Religious Lady-Birds, arm'd against the assaults of Satan with Bible and Common-Prayer-Book . . . speed to Covent-Garden Church . . . to make Assignments."[57] Hogarth's version of this type has four black spots, two above and two below her right eye. Lichtenberg reads the spots as "mouches" and therefore as an attempt by the woman to render herself attractive at an age when it is too late for such attempts. He continues, punning on the meaning of "mouches," that the beauty spots seem to buzz around her burning eye like flies around a light, a "warning for the glances of young men who intend to do alike."[58] Lichtenberg was obviously aware of the sexual connotation of the spots, and if one takes into account the intermedial context of the print (Covent Garden, with its brothels and taverns, the quack selling cures against syphilis in the background, and the rakes fondling young women at right), one could arrive at what Fred Lowe terms "a more sinister interpretation"—i.e., that the old lady has tried the quack's medicine, hence her spots.[59] I think the satire in this case again depends on our awareness of at least two ways of reading the "mouches" on the spinster's face (a third possibility is that the spots, or some of them, are *naevi pigmentosi* or *naevi tardi*, which mark the skin in old age).

These different ways of reading also apply to the happy old woman in the fifth plate of

A Rake's Progress (fig. 39). Comparing her ruined countenance to that of her future husband, Lichtenberg provides a wonderfully hilarious ekphrasis of facial landscapes, this time in terms of prosody. Her eyes, he writes, form an "iamb," and the bridegroom's a spondee, while the beauty spots on her forehead, an "artful" attempt to overcome nature, actually draw the observer's attention to the missing eye instead of diverting it to her "natural" beauty.[60]

II

Given the medium of black-and-white prints, it should be obvious that (beauty) spots do not

Fig. 38. William Hogarth (with the assistance of Bernard Baron [French, 1696–1762]), *The Four Times of the Day*, Plate 1, *Morning*, first state (detail), 1738. Etching and engraving. Hood Museum of Art, Dartmouth College, Hanover, New Hampshire. Purchased through the Guernsey Center Moore 1904 Memorial Fund

Fig. 39. William Hogarth, *A Rake's Progress*, Plate 5 (detail), 1735. Etching and engraving. University of California, Berkeley Art Museum

lend themselves to satirical comments on race relations in eighteenth-century England. The African and the American Indian, for example, much like the stereotypical Frenchman or the Oriental (derived from Montesquieu), have their (marginal if satirically important) places in Hogarth's graphic art.[61] As representations of the "Other," they are essential in the establishment of an allegedly genuine and singular English identity.[62]

As gendered signifiers, the facial spots of Hogarth's characters are not only polysemic and without clear boundaries between their indexical, rhetorical, and metaphorical meanings; they are also strongly connected with issues of social rank. Indeed, the gendering of the code of spots/marks is most striking when Hogarthian pictures juxtapose the social strata of the eighteenth century in an effort to attack extreme (immoral) behavior in the upper and lower classes, even while implicitly advocating a middle way. As David Bindman has shown, this was an age-old strategy of satirists reaching back to Horace and Juvenal.[63] Conditioned as it was by particular frames of presentation in

terms of Augustan satire, Hogarth's view of society was rather simplified and schematic; he obviously saw it divided among three "self-contained classes: the wealthy, 'the middling sorts' and the poor."[64] The gendering that occurs in the satirical representation of such a three-tier system preferably attributes facial spots and body marks to upper-class men (as those who bear and spread diseases, which gain symbolic meaning in this class context) and lower-class women. The typical example of the first category is the Viscount in the first plate of *Marriage A-la-Mode* (fig. 36)—the patch on his neck is a symbol of the corruption that runs in the family.

In contrast, the representatives of the middle class are exempted. Thus the rake and his faithful lover appear "spotless" throughout the series (the mark on the rake's body in the final plate [fig. 35], does not suggest corruption but a parallel with the life of Christ); and the industrious 'Prentice as well as the alderman's daughter in *Marriage A-la-Mode* show us their impeccable faces precisely because they embody the bourgeois ideal of a middle way, although one must add that Lady Squanderfield in the latter series is also a victim of the bourgeois aping of aristocratic lifestyles. A typical scene in which such gendering merges with the class issue is the third plate of *A Rake's Progress*. Tom Rakewell, the son of a miserly merchant, ends in misery and insanity precisely because his ideal (like that of the Harlot) is the life and behavior of his social superiors. Since, to some extent, he is a victim of social evils (as Hogarth saw them), the code of spots is not applied to his face or body, which appear white and hence innocent until the very end of the series. The faces of the women surrounding him in this nocturnal scene (set in the Rose Tavern, then a notorious place in London's red light district) are marked by spots which (as in the first plate of *A Harlot's Progress*) reinforce the themes of disease,

immorality, and corruption (as in the third plate). Like the rakes from the upper class and the *nouveaux riches*, the prostitutes in the third *Rake* plate and other prints with similar subject[65] are "marked." As an ambiguous code that partly refers to makeup and seduction and partly to (venereal) disease and death, their facial spots reinforce the gendering in Hogarth's works, a gendering that "largely resulted in women being condemned as whores or praised as madonnas, and consigned them to a passive role as objects to be surveyed by a male audience."[66] Despite their ludic ambiguity, the spots as a code work within Augustan patriarchic discourses, which knew only a few, limited models for the representation of women.[67] This would seem to provide further evidence for David Bindman's assumption, which is radically different from Ronald Paulson's reading of Hogarth's art, that the artist "worked, however uncomfortably, *with* the grain of society rather than against it" and that his visual representations of English Augustan society "did more to reassure those in power than perturb them."[68]

The (beauty) spots, in addition to the satirical and ideological dimensions outlined above, also work in a temporal context of *différance*.[69] Mieke Bal has argued that the representation of time in art invariably unfolds into space and that the "difficulty of narrating visually is . . . most acute when speech is to be represented imagistically."[70] Hogarth, we have seen, employs various codes of body language to narrate and to convey his satirical messages. In doing so, he fills the space of his canvasses and engraved sheets with signifiers that are both iconotextual[71] and chronotopical. Art historian Wolfgang Kemp has recently introduced "chronotopos," a term borrowed from Bakhtin, who applied it to fictional narrative (e.g., the journey in the novel) to describe the fusing of spatial and temporal signs in a new, concrete, whole of a work of art. In this process, Bakhtin argues, time is compressed and becomes visible

in space.[72] If we return to Hogarth's *Strolling Actresses Dressing in a Barn* (fig. 21) with this additional code in mind, we notice that the temporal dimension is established with external and internal texts that include the title, the "Act against Strolling Players" on the crown in the left foreground, and the playbills on the bed that provide the title of the play ("The Devil to Pay in Heaven") as well as the names of the "Company of Comedians from The Theatres at London" while specifying that this is "the last time of Acting Before ye Act [i.e., the Theatre Licensing Act of 1737] Commences." This means that the scene can be dated around June 24, 1737, when unlicensed theaters closed.[73] This is the present, as it were. The past and future, however, are also suggested.

These dimensions of time enter the picture through emblematic signs, such as the Medusa head on Diana's shield commenting ironically on the "terrible" view of this scene—and the spots on the actors' bodies. In fact, the bodies (and, by implication, body language) constitute a chronotopos similar to the house discussed by Kemp which, at first glance, seems to be marginal but, upon closer inspection, proves a major component in the satirical thrust of the representation. On the temporal level, the spots may connote a licentious past and a miserable future of disease and suffering. The bodies of the strolling actresses are thus chronotopical, in that the spots we discover (provided we read them as symptoms of diseases) fuse time and space while subverting the roles being played by reminding us that the women, and especially Diana in the center, have had a past that is probably far from innocent. Simultaneously, their equally unpleasant future is signaled by the spots on their bodies. All this finds an ironic echo in the face of the Medusa, who gets a view of Diana's private parts.

The facial spots marking characters in Hogarth's prints, then, refer to a great variety of signifieds. Like other important codes relating

to body language (e.g., gestures and clothes), they contribute to the satirical frame in a process that creates meaning in allusions to what the contemporary observer knew from other verbal and visual sources. In recent critical parlance, this process is called *différance*. If we want to reach an approximate understanding, we must re-create the knowledge of the eighteenth-century observer—especially the knowledge Hogarth shared with his audience (general assumptions, prejudices; in short, mentalities). This is what Pierre Bourdieu, in *Les règles de l'art*, terms *comprendre le comprendre*.[74] If Hogarth's graphic art continues to fascinate us, it may be precisely because in trying to make sense of his pictures we cannot arrest meaning. As the (beauty) spots show, his works play with (crossings of) gendered codes and gendered frames of representation that ultimately prove to be sites generating not precise meaning but ambiguous satire.

Notes

I wish to thank Sandra Carroll, Bernadette Fort, and Angela Rosenthal for their helpful suggestions and critical comments on an earlier version of this essay.

1. One thinks especially of *The Birth of the Clinic* (Foucault 1975), *Discipline and Punish* (Foucault 1977) and the monumental *History of Sexuality* (Foucault 1978–86).

2. I refer specifically to the exhibition (shown in Japan, Europe, and North America) of "plastinized bodies" prepared by Gunther von Hagens, M.D. See the exhibition catalogue, *Körperwelten* (von Hagens 1997), and von Hagens's comments on the critical objections voiced by some of his colleagues and by the official churches, 201–6.

3. For a general survey of recent approaches in what has now become an extremely busy and large field, see Porter 1991, 206–33. Recent important studies in art and art history reaching back to the Renaissance include Stafford 1991; D. Johnson 1989; Adler and Pointon 1993, 175–89; and Sawday 1995. The body in literature has been analyzed in Scarry 1988; Korte 1993; Bohm 1994; Kelly and von Mücke 1994; and Scholz 1997. On medicine and the body, see Clarke and Aycock 1990; Vila 1994; and Roberts and Porter 1993, 1–23 (esp. note 24). The suffering body throughout the ages is the focus of Roy Porter's recent

monumental monograph, Porter 1997a. Studies with a wider scope and particular attention to the body as a signifying system are Gallagher and Laqueur 1987 and Josipovici 1982.

4. See Lichtenberg 1991. All subsequent references to Lichtenberg's commentary are to this edition, which I prefer to the translation by Gustav and Innes Herdan (Herdan and Herdan 1966). More often than not, the English version fails to capture and transmit Lichtenberg's witty punning and his ekphrastic attempt to re-create Hogarth's visual punning in the engravings. Body language in one of Hogarth's works is the partial subject of Busch 1984, 82–99.

5. For a more detailed analysis of this bias, see the discussion below of gendering in beauty spots in connection with the group of characters on the left in Hogarth's *Strolling Actresses*.

6. On the background of this aspect of body language see Knab 1996; Bremmer and Roodenburg 1991; Knapp 1990; DeRitter 1994; and Barnett 1987.

7. See Montagu 1994.

8. For a recent collection of essays focusing especially on the dispute between Lavater and Lichtenberg and the literary representation of "individuality" in the wake of these writers, see Groddeck and Stadler 1994. See also Tytler 1995.

9. Lichtenberg 1991, 108.

10. On the cultural and ideological implications of masked balls and masquerading in the English Enlightenment, see especially Castle 1986 and 1987.

11. Mirzoeff 1992, 561–85.

12. Ibid., 564.

13. Hogarth 1955, 209 and chapter XVII ("Of Action") of *The Analysis of Beauty.*

14. My forthcoming monograph on the problems of reading Hogarth will contain a longer chapter on the codes informing Hogarth's representations of the body. What we need at the moment are more studies of the major and minor sign systems in the public sphere of Hogarth's time. A good beginning has been made by Ogée 1997. See also Bindman, Ogée, and Wagner forthcoming.

15. Christine H. Kiaer argues persuasively that in *Strolling Actresses* "Hogarth sets in play cultural notions of the underside of femininity . . . as well as femininity in its most obvious and visible aspects" (see her essay in this volume).

16. Lowe 1992, 74; also see Lowe 1996.

17. I would agree with Kiaer that in this image Hogarth "sets a multiplicity of cultural meanings into play," which partly derives

from a "feminine excess," but I hesitate to follow when she speculates, like Paulson, on Hogarth's intentions. See Kiaer's essay in this volume [1993, 251, 256, and 261–62]. On the dialectics of such details and ambiguity in Hogarth's works, with special consideration of one series, see Busch 1998, 70–84.

18. See the second state, published in May 1738, reproduced in Paulson 1989b, no. 150; the version in the Huntington Library (San Marino, California), which is also reproduced in Kiaer's essay (where Juno is shown with just one facial spot); the first state of the print (25 March 1738), as reproduced in Lichtenberg 1991, which is based on the collection of Hogarth prints in the Städelsches Kunstinstitut in Frankfurt, Germany; and the reproduction from the same state in the Lichtenberg collection at Göttingen (Guratzsch 1987, 111). Unnoticed by Paulson, Juno has two beauty spots in the first state (compared to Diana's spots; however, they differ slightly as to size and location), but only one spot in the second state. There are similar changes in the case of Flora, the figure in front of Diana, whose large plasters or beauty patches in the first state have gone (or are hidden) in the second state reproduced in Paulson's catalogue.

19. In the advertisements she did for a watch in European magazines, Cindy Crawford sports such a natural mole in her face. Facial moles sprouting hairs have been traditionally considered the sign of a witch: see, for instance, the cover illustration, by B. Willy, in Weldon 1993, which obviously plays with this superstitious belief.

20. On that context, see Paulson 1989a, 108–9; and Paulson 1989b, 165–67, 186–87, and passim; and Paulson 1991–93a, 2:128–41.

21. Lichtenberg 1991, 24.

22. Hogarth 1955, 51; see also Hogarth 1997, 39, in chapter VI, "Of Quantity." The merchant's daughter, who marries Francis Goodchild in Hogarth's *Industry and Idleness*, serves as a bad example here, as she places her spot (or has one) "in the middle of a feature." This may also characterize her as a plain girl who does not care very much about fashionable taste.

23. I use the term "illustrating" in the sense explored by J. Hillis Miller (Miller 1992), for in his attempt to explain his "line of grace/beauty," Hogarth must constantly appeal to important absences.

24. See chapter V, "Of Intricacy," and chapter VI, "Of Quantity," in Hogarth 1997, 33 and 39. On the gender implications of the gaze (defined by Bryson as prolonged and contemplative vision with disengagement) and the glance, a looking with desire, see Bryson 1983, 87–133; Bal 1991, 140–43. For a critique of this view, see Heffernan 1993, 144–45; and Wagner 1996a, 301–3.

25. Kiaer, in this volume.

26. The European tradition of using patches in cosmetics seems to derive from Indian and Chinese cults and body painting. In the last few years, this has caught on again in the West, with henna-designs and tattoos used by many young people, partly inspired by such pop icons as Madonna.

27. In the following passage I have drawn on Fuchs 1910, 251–53; and Krysmanski 1996, 130–35.

28. Quoted in Lexis 1975: s.v. "mouche."

29. See Hogarth 1997, 39 ("those of the best taste choose the irregular as the more engaging").

30. Lichtenberg 1991, 29.

31. Fuchs 1910, 252.

32. Kiaer, in this volume.

33. Kiaer adds a third one by arguing that Aurora picks at the "Siren's pimple with great gusto" (Kiaer, in this volume).

34. For a discussion of this issue, see Kiaer, in this volume.

35. Ibid.

36. In her discussion of Lichtenberg's commentary, Kiaer has overlooked Lichtenberg's sly, tongue-in-cheek remarks about the "third sense" (tasting—in other words, licking) with which the picture could be explored. Typically, he alludes to that sense only to say that he will not speak about it (*"Den dritten Sinn wollen wir ruhen lassen"*). This is the beginning of a passage marked by sexual innuendo in connection with lesbianism. See Lichtenberg 1991, 38.

37. On these feminine aspects of Ganymede (including the long hair), see Kiaer (this volume), who argues that the cross-dresser and transvestite Charlotte Charke was Hogarth's model in this case.

38. On a similar code—that of fans being used by ladies to signal erotic interest—see Krysmanski 1996, 47, and Rosenthal's essay in this volume.

39. Fuchs 1910, 251. The code, it seems, still exists in the twentieth century, although it is probably better known in Mediterranean countries.

40. Lowe 1992, 78.

41. On feminine space in the world of strolling players and the negative image they faced, see Kiaer in this volume.

42. *Blüten* refers to red pimples on the face, which may indicate some sort of genital disease.

43. Lichtenberg 1991, 25.

44. See, for example, the dark spots on the human bodies, especially those of the women, in the painted version of the third scene, set in the Rose Tavern, of Hogarth's *A Rake's Progress* (1735). The differences between the painted and engraved versions are sometimes quite remarkable, and they are worth exploring, not least because the different details suggest substantial changes in meaning. Since this is not the place to venture into an exploration of such a sophisticated problem, I shall mention just two examples. In the painting entitled *Noon*, the second of *The Four Times of the Day*, the French lady sports a large round red spot on each cheek, a kind of makeup or paint put on for cosmetic or medical purposes or both. In that sense she is reminiscent of Flora in *Strolling Actresses*. In the engraved version, however, she is shown with two black spots of different sizes on her forehead. According to the taxonomy discussed above, these spots would indicate pride, yet they may also cover the symptoms of a disease in the same way in which the loose gown hides a pregnancy or a walking impediment. Similar differences exist between the painted and engraved versions of the first scene of *Marriage A-la-Mode*. In the painting, the Viscount has a conspicuous circular mark on his neck and, unnoticed by commentators, a small spot on the side of the chin (a sign of roguishness). The engraving retains only the large black mark; the smaller one on the chin has disappeared. It is impossible to decide whether the dark spot at the corner of the mouth is a beauty spot or the shadow of a wrinkle, though the ambiguity is again typical of the play with such ostensibly marginal details.

45. For a detailed discussion of this picture, see Wagner 1993a, 200–226 (especially 213–16), and Haslam 1996, 52–67. Paulson 1989a, 101, notes that the doctors below the three quacks at the top were probably also identifiable to contemporaries.

46. Paulson 1989a, 99; and Paulson 1991–93a, 2:97–103.

47. Lowe 1992, 78–79, discusses some of these women. Other Hogarthian bawds with such spots are the mysterious woman in the third plate of *Marriage A-la-Mode* and Mother Douglas, the woman on the floor, in *Enthusiasm Delineated*. On Mother Douglas, see also Krysmanski 1996, 130–44, who comments on Hogarth's indebtedness to Swift in the satirical combination of religiosity and sexuality.

48. Paulson 1989a, 98, notes that the allusions could be to Correggio's *Pietà* in Parma or to Annibale Carrachi's *Pietà* in the National Gallery, London.

49. On this intermedial aspect, see Krysmanski 1996, chs. 3–4, and illustrations 345–46 and 385 in vol. 2. I am less persuaded by Krysmanski's conclusion (823) that Hogarth's major aim with the satirical figure of the preacher was an attack on Old Masters and (the "enthusiasm" of) their connoisseurs.

50. See Paulson, who seems to have changed his mind about the spot between the publication of Paulson 1965, 1:268, and Paulson 1989a, 116. Also see Paulson 1991–93a, 2:217. Robert L. S. Cowley and Fred Lowe both speculate on the nature of the Viscount's congenital disease, suggesting scrophula, rickets, and/or syphilis. See Cowley 1983, 39 and 150; and Lowe 1992, 71–73.

51. Lichtenberg 1991, 293.

52. Lowe notes that there were two kinds of plaster—a patch of material with an adhesive substance that was placed over a sore or a mixture of wax and a curative unction applied to the sore or lesion; see Lowe 1992, 78.

53. On the medical background of this scene, see Paulson 1989a, 82, and Haslam 1996, 67–101.

54. I am grateful to Thomas Krämer, who has analyzed the representation of women, including the idea of innocence (Krämer 1998). The straw hat, innocence, potential disease, and the country are again linked in the final scene of the *Harlot* series, where the hat appears on the wall above one of the prostitutes.

55. Lowe 1992, 79.

56. On the old maid as a prominent figure of satirical attacks within the larger field of eighteenth-century misogynist satire, see Wagner 1990, 151–57; and Denizot 1976, 37–58.

57. Quoted in Shesgreen 1983, 115–16.

58. Lichtenberg 1991, 56.

59. See Lowe 1992, 78.

60. Lichtenberg 1991, 242–43.

61. On these issues, which I cannot cover in this essay, see especially Dabydeen 1985; Paulson 1991–93a, 1:226–29; Wagner 1992, 87–97; and Wagner 1996b, 107–32.

62. On the "Other" in Hogarth's prints and eighteenth-century culture, see Castle 1995; and Wagner 1993b.

63. Bindman 1997a, 33–41.

64. Ibid., 9.

65. See for instance, Hogarth's *Southwark Fair* and *The March to Finchley*.

66. Haslam 1996, 8–9.

67. See Wagner 1998 and Krämer 1998.

68. Bindman 1997, 28, challenges Paulson's view of Hogarth who, during Paulson's long career as a critic, has changed from "being an elitist Augustan satirist to a subversive popular artist and then to something more complex than either" (Paulson

1991–93a, 1:xvi).

69. On Hogarth's handling of time in his serial art, see Macey 1976.

70. Bal 1991, 100.

71. This term is used in consideration of the fact that most visual allusions in Hogarth's works are highly charged signifiers referring to both texts and images. For a detailed study of such "iconotexts," see Wagner 1995b: chs. 3–4 and 6.

72. See Kemp 1997, 31.

73. For details, see Paulson 1989a, 108.

74. Bourdieu 1992. What he refers to is the attempt to retrieve the unsaid, the unspoken, and the commonly if silently shared attitudes of a civilization.

Unfolding Gender: Women and the "Secret" Sign Language of Fans in Hogarth's Work

Angela Rosenthal

In early eighteenth-century England new wealth and a growing market for consumer goods fueled an unprecedented desire for personal display and conspicuous consumption. Exotic fabrics, continental paintings, fine china, and oriental carpets were acquired for fashionable homes, while the body became of central importance as a means of communicating social status.[1] Name and title no longer guaranteed social standing, since financial mobility allowed people to craft desired personae. The body was a prime site for the performative expression of social class, rank, and gender roles. As David Solkin has put it, "For a ruling class which depended more on culture than on force as a means of social control, appearance became a matter of inescapable political significance, no less so in art, than in life."[2] Women played a central role in this drama of sartorial and corporeal display and thereby contributed fundamentally to the formation of a "public" for cultural consumption.

It was for this reason that female bodies were policed so anxiously by conduct books and social commentaries.[3] Etiquette manuals like François Nivelon's *Rudiments of Genteel Behaviour* (1737) sought to regulate appearance, developing Manichaean concepts of social and sexual difference.

The female body—squeezed into shape with corsets and ensconced in hyperbolic hoop-dresses—was clothed, molded, and adorned in accordance with notions of social order and physical ideals. This carefully sculpted, overdetermined body not only held sexual difference in place, but also, by permitting or denying cultural access, served to maintain class positions.[4]

In his iconoclastic *Some of the Principal Inhabitants of ye Moon: Royalty, Episcopacy and Law* of 1724 (figs. 40 and 126), William Hogarth mocks royal, ecclesiastical, and juridical figures as empty, mechanical automatons constructed from emblems and pretentious signs of wealth.[5] Besides the Bishop, the Lawyer, and the King, an aristocratic couple appears on the right. The "woman" wears a stiff hoop-dress, has a large fan for a torso, a neck in the form of a glass, and a teapot for a head, its spout-nose pointing to her affected partner. He turns toward her on fanstick legs, showing a face in the form of a coat-of-arms framed by a ridiculously large wig. Hogarth's trenchant satire of his contemporaries' infatuation with external display and the accoutrements of status renders the objects of his derision mere robots of spectacle, empty machines manufactured from luxurious components. This eviscerated body becomes an (anti)icon of the culture of display and consumption that emerged and dominated eighteenth-century British social life. Hogarth's artificial bodies are, however, an expression not only of a distaste for materialism but also of a cultural negotiation of the body in light of rational and scientific discourses in the age of Enlightenment.

Barbara Maria Stafford addressed the mechanization of the body and its movements,

characterizing the eighteenth century as a time of increasing "tension between automation and handwork, abstract language and physical expression, conception and technique."[6] In a society that set more and more weight on technical advancement and where new emphasis was placed on abstraction and theoretical knowledge, vigorous attempts were made to counter the hollowing out of the body by reinscribing carnal significance into physical action. Thus theorists like the historian, theologian, and machinist Jacob Leupold in his *Theatrum Arithmetico-Geometricum* of 1727 tried to ground abstract language in corporeal essences. Leupold, for example, discovered the origins of Roman numerals in gestural imagery, demonstrating "how the three-dimensional patterns, made by flexing the fingers, literally incarnated ciphers and characters."[7] In his treatise on *Manuloquio*, or the natural "language with the hands," Leupold further extended his embodied alphabet "to embrace infinite nuances of human expression: crying, pondering, doubting, grieving, suffering."[8]

Both Hogarth's robotic confections and Leupold's digital essentialism were motivated by an increasing dissatisfaction with corporeal constructedness and the social artificiality on which it was founded. Thus etiquette books codifying poses and gestures, as well as Leupold's anthropomorphic language, express a desire to bring rational systems under the control of the human body—to naturalize the artifice—and to establish an assumed "natural"

Fig. 40. William Hogarth, *Some of the Principal Inhabitants of ye Moon: Royalty, Episcopacy and Law* (detail), 1724. Etching and engraving. Lewis Walpole Library, Yale University, Farmington, Connecticut

link between gesture and meaning. I find Leupold's theories of manual communication particularly relevant, given Hogarth's concern with hands and their movement.

Hogarth, alternately a critic and proponent of the culture of consumption and spectacle within which he thrived, realized that virtue could not result from piling goods onto the body, but rather depended upon the subtle gestures that activated and transformed such corporeal display. "It is known that bodies in

motion always describe some line or other in the air," wrote Hogarth in his theoretical treatise *The Analysis of Beauty*, in a chapter entitled "Of Action," which was devoted to "a new method of acquiring an easy and graceful movement of the hands and arms."[9]

In early Georgian England these invisible lines "formed in the air" by the movement of the hands and arms that Hogarth encourages his readers to imagine were rarely drawn by the fingertips alone. Those belonging to fashionable society would always sport something in their hands—the gentleman a cane or a snuff-box, the ladies a handkerchief or, more commonly, a fan. Hogarth pays special attention to the manner in which objects could, by virtue of their connotations and expressive potential, serve to inflect gestures. He expresses the desire to find the seat of identity within rather than without the flesh. Referring to an explanatory illustration figure 49, in the frame of the first plate of his *Analysis of Beauty* (fig. 15), Hogarth notes, for example, "the pleasing effect of this manner of moving the hand [in a beautiful direction], is seen when a snuff-box or a fan is presented gracefully or genteelly to a lady, both in the hand moving forward and in its return, but care must be taken that the line of movement be but gentle, as No. 3 fig. 49, plate I, and not too S-like and twirling, as No. 7 in the same figure: which excess would be affected and ridiculous."[10]

I wish to take a closer look at the fan, the fanciest of all artifice in the culture of corporeal display. Imported from Asia and soon mass-produced as printed fans in England during the early years of the eighteenth century, the handheld folding fan became a perquisite accoutrement for the woman of fashion. But the fan was more than just an addition to a woman's armory of fashion accessories. The exotic fan enabled and encouraged new forms of gestural expression. From the age of ten or twelve, women of fashion would never allow themselves to be seen in company without a fan.[11] Indeed, women's hands appeared to be almost physically extended by this "little modish machine," as it was called, which functioned as a prosthetic extension exaggerating bodily movement.[12] In the seventeenth century Thomas Coryate observed during his travels through Italy the fan's practical applications for both men and women:

I observed them common in most places of Italy where I traveled. These fannes both men and women of the country doe carry to coole themselves withall in the time of heate, by the often fanning of their faces. Most of them are very elegant and pretty things.[13]

By the eighteenth century, we learn that "the Men are not expected to be furnished with them at all," and fans came to be used almost exclusively by women.[14]

Although this highly contrived tool could be used to protect against light and heat—often necessary in overcrowded assemblies and for women who were bound up in tightly fitted bodices—these pragmatic services were subordinate to the primary function of the fan as a means of focusing the gaze and enhancing communication. Controlled by the hands and fingers of women, the fan was mobile and subject to permanent transformation. It thus registered and betrayed in its dynamic deployment—and even via the sounds produced by its sudden unfolding, nervous fluttering, or abrupt closure—the thoughts and emotions of its owner. As a famous poem addressing fans put it: "So shall each passion by the fan be seen, / From noisie anger to the sullen spleen."[15]

With a "light touch" a fan could expand into a shield against unwanted gazes—not only signaling the woman's awareness of being looked at but literally trapping the gaze of others. Thus reading the fan simply as a defense against the desiring gaze of others would be shortsighted. Like the gesture of a *Venus*

Pudica, the fan simultaneously deflects and attracts amorous glances.[16] With this in mind, women armed with fans can be recast not only as targets but also as active participants in the visual field, for, with the flick of a wrist, a woman could transform eighteenth-century scopic hierarchies: the power of the gaze was, quite literally, in her hand.

Fans, as we shall see, could also affect communication by inflecting and amplifying manual gestures. In this manner, they produced a sign language predicated on the mediation between "machine" and body. Many fans, bearing imagery, were also unfolding pictures. The *Spectator* of 1711 specifically comments on women's picture-making activity, describing when, at a surprising moment, a fan is unfurled and suddenly "an infinite number of Cupids, Altars, Birds, Beasts, Rainbows and the like agreeable Figures . . . display themselves to View, whilst every one in the Regiment holds a Picture in her Hand."[17]

The fan, therefore, offers a remarkably rich field for investigation. As a social marker, a gestural prosthesis, and a pictorial bearer, the fan proves to be a rich site of eighteenth-century British visual culture. I would like to consider how Hogarth drew on the fan as a multivalent and powerful sign. In so doing, I hope not only to relocate Hogarth's art within a public cultural space of performance and display dominated by women but also to consider its interpretation and reception through consideration of the playful language of gossip.

Marketing

The popularity of folding fans in the British Isles stemmed from broader interests in foreign, especially Asian trade in the late seventeenth and early eighteenth century.[18] The East India Company imported fans from India, China, and the East by the tens of thousands, along with tea, and chinoiseries like porcelain, wallpaper, and screens. Imported

fans cost as little as 3p each, "the equivalent of an hour's pay for a skilled workman in 1750," or, together with Italian imports, they challenged the luxury market for domestic painted fans which only the most affluent women could afford.[19] In London the Worshipful Company of Fanmakers, incorporated by Royal Charter of Queen Anne in 1709 with nearly 300 members in its first year,[20] was struggling against yet another challenge.

Until the 1720s, most fans were hand painted. But in that decade printed versions came increasingly to replace the more costly painted fans, expanding the potential market for these accessories considerably.[21] On 20 May 1721 the *Daily Journal* reported that "the Demand [for printed fans] is become so great, that the Ladies cannot be supply'd with them fast enough."[22] Printed fans were also comparatively cheap, selling for one or two shillings.[23] Printed fans were produced in large quantities, with runs of up to ten thousand prints taken from a single copperplate.[24] Despite these large numbers, the earliest prints for fans are extremely rare. The subject matter of these fans was as ephemeral as the objects themselves, and printing techniques improved so fast that older fan prints were destroyed—and the sticks recycled—to suit the fashions of the year, month, or week. They depicted anything from maps and games to fashionable places or reflected commemorative and, especially, political themes.[25]

Advertisements in the major eighteenth-century newspapers reveal the liveliness of the market in fans. Shops dedicated solely to their purveyance sprang up on Fleet Street, the Strand, and in Westminster.[26] A scene on a hand-colored printed mask-fan of the early eighteenth-century (fig. 41) depicts the interior of a fashionable English shop where an older woman shows a variety of mask-fans (fans with faces painted or printed on them, with openings through which one could look)

Fig. 41. Anonymous, *Mask-Fan*, England, made for the Spanish market, 1740s. Paper leaf (double), patched with skin, etched, engraved, and painted in watercolor; ivory sticks, pierced, partially painted, varnished, and gilded; mother-of-pearl buttons on brass rivet. Maximum open: 19⅛ in. (48.5 cm). Arc: 155°. Museum of Fine Arts, Boston. Esther Oldham Collection, 1976.179

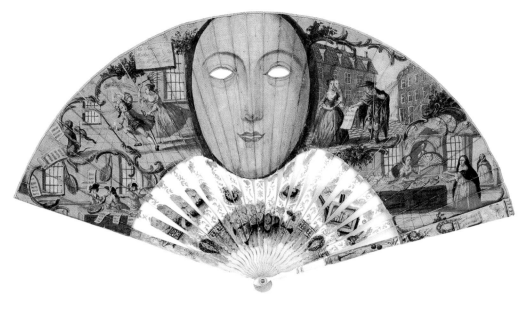

Fig. 42. Anonymous, after Hogarth, *Fan Leaf depicting Henry VIII and Ann Boleyn*, n.d. Outline etching, hand colored. Schreiber Collection, The British Museum, London

to a female client.[27] This shop appears to sell only fans, but we also read of many shops that sold fans as well as other goods.[28] Not only were women the fashionable consumers of these moving pictures but, according to Nancy Armstrong, women were also often fan makers and purveyors of fans in eighteenth-century Europe.[29] With the development of printed fans in the 1720s, fans and the women who produced and sold them contributed to the paper culture in which Hogarth played such an important role. Indeed, as we shall see, many fans were produced with designs after Hogarth. Fans, therefore, offer a means of accessing women's participation in a public sphere of paper culture normally thought of as predominantly, if not exclusively, male.

In the 1720s, Hogarth designed a shop card for Mr. Gordon's "Old Fan Warehouse" in Tavistock Street, Covent Garden, which was

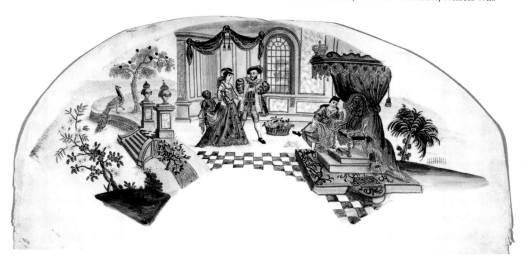

taken over by Mary Hitchcock in 1741–42.[30] He also designed and engraved the shop card for Mrs. Holt's "Italian Warehouse," where, we are informed, Italian culinaries such as wines and olives, as well as satins, velvets, and fans could be purchased.[31] While the popular pastoral themes depicted on many eighteenth-century fans can be interpreted as comments on urban culture, in that they present "visions of escape to the country side," other fans make more explicit social and even political commentary.[32] One of the leading fan producers was Martha Gamble, at the Golden Fan in St. Martin's Court, who sold political prints and large numbers of fans after Hogarth's work, including *Henry VIII and Ann Boleyn* (fig. 42), *A Harlot's Progress* (fig. 50), and *A Midnight Modern Conversation*.[33]

The Fan-ciful Public Sphere

In 1716 the *Free-holder* ironically announced:

It is with great Pleasure that I see a Race of Female-Patriots springing up in this Island. . . . The fairest among the Daughters of Great-Britain no longer confine their Cares to a Domestick Life, but are grown anxious for the Welfare of their Countrey, and shew themselves good Stateswomen as well as good Housewives.

The journalist went on to say that women now no longer busied their fingers with the knitting needle but instead aired their political opinions, "to let the World see, what Party they are of, by Figures and Designs upon these Fans; as the Knights Errant used to distinguish themselves by Devices on their Shields." It is through such display, the author concludes, that a "fan may, in the Hands of a fine Woman, become serviceable to the Publick."[34] Although irony appears in, on, and between the lines of such commentary, women did, with the advent of printed fans, participate in public discourses of print culture, communicating all kinds of commemorative,

social, and political events and information.[35] Fans openly addressing political issues, such as Martha Gamble's so-called *Excise Fan* of 1733, "afforded women a peculiarly public means of expressing political allegiance or opinion."[36] Mrs. Beardwell, printer of the Tory *Post Boy*, sold fans showing a picture of Dr. Henry Sacheverell as part of the Tory campaign in the summer of 1710.[37] Backed by the subversive power of gossip, the pictorial and potentially political fan played a fundamental and active part in early modern urban culture.

Fans with designs after Hogarth functioned in this alternate public sphere, although not always as one might expect. For example, his popular print of *A Midnight Modern Conversation*, a seemingly odd subject to put on a fan, was sold as a fan-mount by no less than four shops simultaneously, even "Wholesale at reasonable Rates." Women were provided with more detailed "insider" information. According to an advertisement in the *Daily Journal* for 24 May 1733,

This Day is Published,
A Beautiful Mount for a Fan, call'd the Midnight Modern Conversation, curiously performed from that incomparable Design of that celebrated Artist the ingenious Mr. Hogarth; to which is prefixed, for the Entertainment of the Ladies, a Description of each particular Person that Gentleman hath introduced in that Night Scene. Sold at Mr. Chinavax's great Toyshop against Suffolk-street, Charing Cross; Mr. Deard's against St. Dunstan's Church, Fleet Street; Mrs. Cambal in St. Martin's Court; and by B. Dickinson at Inigo Jones' Head against Exeter Change in the Strand, at which Place they may be had Wholesale at reasonable Rates.

Such announcements ought to remind us not to generalize concerning the viewers of Hogarth's compositions. The unexpected position of the raucous masculinity of the protagonists in *A Midnight Modern Conversation* within a field of paper culture directed toward a female audience forces

us to rethink the manner in which Hogarth's contemporaries read the scene. Moreover, it might account for a different, alternative sphere of communication between women exchanging information, chatting, laughing, and whispering behind the fan, a form of subversive "gossip," as theorized by Irit Rogoff.[38]

If the secrecy of this feminine culture suggests privacy, the sheer numbers of fans produced and their unfolding presence in the public sphere rendered these social tools powerful transmitters of female control. By mid-century, folding fans were ubiquitous in London. Matching the estimated rates of production against the female population of the city, every girl or woman from age ten on purchased, on average, at least three fans a year.[39] Obviously, the market varied according to class and wealth, but cheaply printed fans were sold in large numbers, insuring that even women of lower social standing could afford to equip themselves. In fact, the fan became an almost "natural" extension of the female body, whose presence was guarded with some anxiety. It was in this light that a mocking tale in the *Gentleman's Magazine* of April 1736 could describe a woman's temporary loss of a fan as a "catastrophe," causing much "perturbation of spirit."[40]

Fictional Fans

Hogarth's most celebrated conversation piece of the mid-1730s, showing a cast of aristocratic children performing Dryden's *The Indian Emperor* (fig. 75), narrates just such an incident.[41] At the center of the composition, in the represented audience and close to the viewer, Mary, countess of Deloraine, has just dropped her fan. Swiftly responding to the sound of the fan hitting the floor, her little daughter twists around to pick it up while pointing with her closed fan. This pointed gesture appears in contrast to that expressed by her sister, who, attending to the staged performance, sits immobile in rapt attention, her open fan emphasizing the wide aperture of her eyes, and, by implication, her mind.

The subnarrative unfolds like a fan itself, for the physical similarity of the two sisters creates the illusion that we see not two girls, but rather a single girl in a sequence of motions. The fan scene creates its own narrative and temporal sequence, suggesting an almost filmic event that serves to highlight the process of acting itself. It presents the incidental, the natural, and the spontaneous, which, juxtaposed to the coded and contrived body language of the youthful actors on stage, enlivens the entire scene.

The subversive and literally disruptive quality of the fan is only hinted at in Hogarth's conversation piece, revealing the fan's social role and buttressing traditional gender roles. Yet, read differently, the incident also provides the fan with some weight, pointing to its "dramatic" potential. Ronald Paulson has indicated that the dropping of the fan could be seen as demonstrating the law of gravity, as described by Sir Isaac Newton, the hostess's famous uncle, whose bust on the chimney piece presides over the scene.[42] If the fan comments on gravity, it simultaneously speaks of levity, for the fan—known as "the lightest of all toys"—was associated with weightlessness.[43] Through its associations with levity, the fan stood as a metaphor for woman's frivolity and mobility. In a famous passage from Samuel Johnson's *Dictionary of the English Language*, women are characterized as "much more gay and joyous than man; whether it be that their blood is more refined, their fibres more delicate, and their animal spirits more light; vivacity is the gift of *women*, gravity that of men."[44] Thus the fan narrative in Hogarth's conversation piece participates in the gendered discourses expressed through the body. The playful and unpredictability of the toy, its sudden motions and abrupt closing and opening on a touch,

Fig. 43. William Blake (English, 1757–1827) after William Hogarth, *The Beggar's Opera*, 1790. Etching and engraving. Hood Museum of Art, Dartmouth College, Hanover, New Hampshire

were aligned with the lighthearted "spirit" of women and particularly the childlike uncontrollability of female sexuality.

Advertising

The enormous popularity of fans made them a powerful means of disseminating information within the commercial communicative networks of early modern London. In 1728 John Gay used fans to advertise his tremendously successful *Beggar's Opera*. One contemporary advertisement reads: "A new and entertaining fan, consisting of fourteen of the most favorite songs taken out of the Beggar's Opera, with the musick in proper keys . . . , curiously engraved on a copper plate. Sold for the author at Gay's head, in Tavistock St."[45] These fans were certainly meant to include the audience to participate in the spectacle, both visual and animated.

In Hogarth's painted version of *Beggar's Opera* in the Paul Mellon Collection and William Blake's engraving after it (fig. 43), the often commented upon integration of audience and stage is in part also facilitated by the employment of fans. Thus, Lady Jane Cook (wearing a hood) and her companion seem actively to debate the decision-making process which unfolds on stage, the latter tilting her closed fan outward to her right, possibly indicating her support of Polly Peachum, the audience's favorite. In the box on the other side of the stage a lady is framing her face with a fan to great effect, making herself into a spectacle. Equipped with her fan, this woman would not have been perceived as a passive object to be looked at but as an active manipulator of the gaze of others—possibly here attracting the attention of Anthony Hanley, who anxiously cranes his neck forward with his opera glasses from the other side.

In Hogarth's rendition of *The Beggar's Opera*, John Gay, gazing out at the viewer, appears in close proximity to the fan-wielding woman on the right. The fans in this work bear particular scrutiny, not only because the author had used the devices as a means to advertise his *Beggar's Opera* but also because the most important theorist of the fan's powerful effects on men was none other than John Gay himself. In 1713 Gay had published a three-book allegorical comic poem called *The Fan*, which tells of the mock-mythological origins of this tool. According to this poem Venus produces the new "female toy" for the love battle between the sexes, basing its design on the peacock's tail—a symbol of the eye—and crafting the object from Cupid's arrows to function both as a shield and a trap whence to shoot:

> If conscious blushes on her cheek arise,
> With this she veils them from her lover's eyes;
> No levell'd glance betrays her am'rous heart,
> From the fan's ambush she directs the dart.[46]

Gay's allegory brings to the fore the fan's function as a shield. Bearing a fan, women could defend themselves from a "lover's eyes" in public spaces such as playhouses, theaters, the church, and the streets. Simultaneously, the fan could, in the public battle of gazes, provide women with the chance to ambush their opponents. Among "the fatal Arts which are made use of to destroy the Heedless and Unwary," the *Spectator* of May 1712 relates mockingly to the reader that "*Sylvius* was shot through the Sticks of a Fan at St. James's Church."[47]

Sparring Fans

Hogarth joins this amusing, facetious commentary on the fan in his illustration for Charles Gildon's *New Metamorphosis*.[48] The holy service seems to be insignificant to the congregants on the balcony, who engage in flirtatious interaction. The prominent woman on the left fans herself to great effect, responding to the men in the orchestra across, who project their large musical instruments—and by implication their sexual attention—toward her.

In contrast, the vulnerability of women dropping their defensive shield is articulated in Hogarth's *Sleeping Congregation* of 1736 (fig. 17).[49] In this engraving the artist depicts the interior of an English parish church where the sermon—read by a short-sighted clergyman in the pulpit—has put the entire congregation of comic and grotesque country folk to sleep. At the foot of the pulpit, an attractive young woman also dozes (fig. 44). The cleric at the lectern to the left, who presses the thumbs of his folded hands tightly together, casts a shifty glance at the girl's exposed bosom. The slippage of the book, and her guard, is matched by the failure of the fan to shield her from the licentious attention of her ogler. The relaxed and half-opened fan resembles the passive availability of the woman, suggesting her vulnerability. As a metaphor of her sex, it recalls Johnson's definition of the fan as anything "spread out like a fan."[50] Sexuality—in this scene—is turned outward for the viewer who possesses a privileged position of control aligned with that of the voyeur in the print.[51]

The significance of the fan as an ocular shield and sign of sexuality becomes apparent in the second plate of Hogarth's *Industry and Idleness*, entitled the *Industrious Apprentice Performing the Duties of a Christian* (fig. 45). As is evident from the preparatory drawing (the print reverses the design), Hogarth dropped his initial idea of presenting a person with a book to anchor the scene, choosing instead a corpulent woman with a large fan who serves to frame the composition.[52] Puffed up with Christian pride, she raises her righteous voice, along with the exemplary couple next to her. Between these figures we see a couple of suspicious fellows—one below, his open mouth emitting not notes but sonorous snores; one

above, singing, but apparently more interested in the woman before him than in reading the music book he holds open. From his perspective, the fan serves as a shield, defending the large woman from his bespectacled gaze.

Part of the joke in the image concerns the fan's growing size. An announcement in the *London Magazine* for 1744 relates that "our good Ventosus had witnessed an increase from '3 Quarters of a Foot' to 'even 2 Feet within this week past'"[53] and that, according to the *Tatler* of 1710, "the possibilities of such an instrument have, apparently, no limit. . . . A Blast or two from this machine would be sufficient to whiff away to a convenient Distance all troublesome and worthless Danglers, who may attempt to besiege its fortunate possessor." The satirist further points out that the inconvenient and ridiculous size such "modern ventilators" could possess, might even go beyond "private benefits . . . 20,000 such fans, properly drawn up on the Shore, might *Blow back* the next French invasion."[54] We are to conclude that fan-wielding women possessed an Amazonian power with which they could keep men at bay. The fan in Hogarth's composition possesses just such power, emphasizing its bearer's probity. The enormous fan shields her formidable person, its arched form, echoing that of the ecclesiastical architecture, integrating the woman into the structure of the Church. She represents, literally, the "Duties of a Christian."

If the fan could be a metaphoric shield, it was also conceived of as a potentially dangerous weapon. The *Tatler* continues:

Flavia the least and slightest toy
Can with resistless art employ.
This Fan in meaner hands would prove
An engine of small force in love;
But she, with such an air and mien,
Not to be told or safely seen,
Directs its wanton motions so,

Fig. 44. William Hogarth, *The Sleeping Congregation* (detail), 1736. Etching and engraving. Lewis Walpole Library, Yale University, Farmington, Connecticut

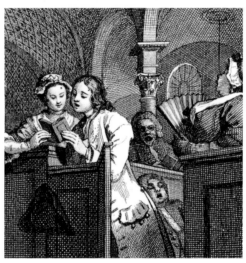

Fig. 45. William Hogarth, *Industry and Idleness*, Plate 2, *Industrious Apprentice Performing the Duties of a Christian* (detail), 1747. Etching and engraving. Lewis Walpole Library, Yale University, Farmington, Connecticut

That it wounds more than Cupid's bow;
Given coolness to the matchless dame,
To ev'ry other breast a flame.[55]

Taking the metaphor of the fan as a weapon a step further, Addison in the *Spectator* (no. 102 of 1711) described fans as military instruments, the use of which must be taught in an academy of pseudo-martial arts. Indeed, Addison suggests a system by which a certain control over female adornment could be

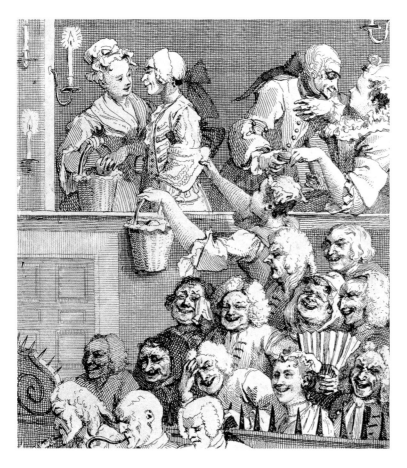

Fig. 46. William Hogarth, *The Laughing Audience*, 1733. Etching. Hood Museum of Art, Dartmouth College, Hanover, New Hampshire. Gift of Hamilton Gibson

who will apply herself diligently to her Exercise for the Space of but one half Year, shall be able to give her Fan all the Grace that can possibly enter into that little modish Machine."[56]

Through the language of ridicule in countless mocking attacks on the fans lurks a more fundamental fear about the Amazonian power of these instruments and their bearer, a suggestion about the inversion of the supposedly natural gender order, where women form regiments and rule men.

Alternatively, self-defense classes for men in fashion armory were advertised,

The Exercise of the Snuff-Box, according to the most fashionable Airs and Motions in opposition to the Exercise of the Fan. . . . The Undertaker does not question but in a short time to have form'd a Body of Regular Snuff-Boxes ready to meet and make Head against all the Regiment of Fans which have been lately Disciplin'd, and are now in Motion.[57]

Hogarth's *Laughing Audience* (fig. 46) represents the visual outcome of such satiric militarism. The print provides us not only with a guffawing audience, where the unself-conscious laughter of one couple is expressed by the bellows-like fan, but also with the performance of a duel between a man and a woman armed with fashionable devices. The gentleman on the balcony to the right proffers to the object of his affections an open snuffbox, while the woman ripostes by thrusting her closed fan into the man's ribs or his heart.[58] The oval snuffbox is figured as a man's weapon, with which he might protect himself against the fan, which has, in this instance, phallic connotations. For the changeable fan could, in its closed, stiff state, resemble an exaggerated index finger and possess the power of phallic authority, here opposed by a snuffbox that is reminiscent of female genitalia.[59] Conversely, as witnessed in *The Sleeping Congregation*, the unfolding of the fan can be interpreted as analogous to the spreading wide of female legs, triggering both desire and fear in male beholders.

guaranteed if it was inscribed in a refined language of genteel behavior, so that a duel could be fought between the sexes:

> The Ladies who carry Fans under me are drawn up twice a Day in my great Hall, where they are instructed in the Use of their Arms, and *exercised* by the following Words of Command,
> *Handle your Fans,*
> *Unfurl your Fans,*
> *Discharge your Fans,*
> *Ground your Fans,*
> *Recover your Fans,*
> *Flutter your Fans.*

Addison assures his reader that "by the right Observation of these few plain Words of Command, a Woman of a tolerable Genius

In psychoanalytical terms the fan as a prosthetic extension of the woman's body can be seen to represent the lack of and compensation for the penis. It functions simultaneously as a powerful fetish object displacing the threat onto the beautiful surface of the picture, as gratifyer of femininity and as the threat of castration and loss. It is not, therefore, surprising that modern psychoanalysis has recognized the hybrid sexual symbolism of the fan. In an essay entitled "The Fan as a Genital Symbol," Sandor Ferenczi explains that a "patient's powerful castration complex is repelled by the feminine lack of a penis; he has, therefore, to imagine the vulva as a fan-shaped split penis, but nevertheless still as a penis."[60]

Fan Language

The hybrid phallic threat of the fan can also be seen in concerns about its communicative potential. If the fan could be conceived of as a weapon in the battle between the sexes, the skirmishing spilled over into the universal language of gestures and glances.

In a diary entry of May 1764, Cleone Knox offers insight into how the fan could be perceived as complementing, or supplanting, the traditional transmitter of affection, the gaze:

My sister, examining me, was highly satisfied with my appearance, only admonishing me to use my fan gracefully, for said she, "There is a whole Language in the fan. With it the woman of fashion can express Disdain, Love, indifference, encouragement and so on." To tell you the truth I had never thought of all this before, having found my eyes sufficient up to now to convey any message I wished to the other Sex."[61]

The fluttering semaphore of fans is neatly captured in an advertisement in the *Gentleman's Magazine* of December 1740 promoting "the New Fashioned Speaking FAN!"

New schemes of dress, intrigue, and play,
Want new expressions every day:
that . . . "doubly blest! must be that mortal man,
Who may *converse* with *Sylvia* and her FAN."[62]

One can read relief in this plug, as if the "speaking fan" represented a taming of an otherwise unbridled and mystifying gestural language, one linked, like Leupold's digital morphemes, to the body and its natural hexis. With the new speaking fans, different motions of the fan were made to correspond with the letters of the alphabet. A "secret" code permitted one to conduct a silent conversation. The alphabet would be divided into five sections, omitting the letter J, which correspond to five movements:

1. Moving the fan with left hand to right arm
2. The same movement, but with the right hand to left arm
3. Placing against bosom
4. Raising it to the mouth
5. To the forehead.[63]

By signaling two numbers, therefore, one could communicate a letter, the first number corresponding to one of the five groups in the alphabet, the second to the letter's position within this group.

While this mode of communication would have been cumbersome, it does indicate, obliquely, the function of the fan as a medium for the transmission of what otherwise could not be decorously spoken. This circumvention of verbal taboos is implicit in another eighteenth-century fan code, a humorous primer ostensibly instructing women how to use their instruments to best advantage. For example, to signal to a lover that he had won her love, a woman was instructed to place the fan near her heart; to indicate the hour of a secret meeting, she should leave a certain number of sticks of the fan visible; to inform a courtier to be less impudent, she should threaten him with a shut fan; if she wants to tell him that he may kiss her, she should rest the half-opened fan to her lips; and in order to communicate that he should not betray their secret, she should cover her (left) ear with the open fan.[64] While only a

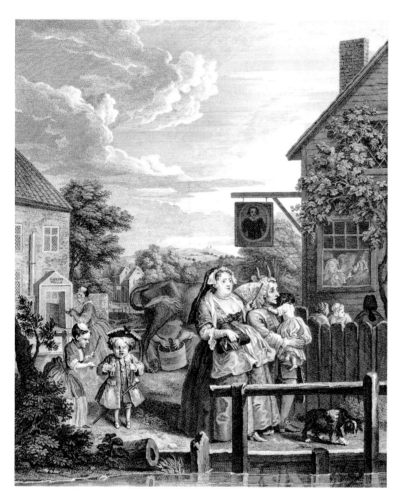

Fig. 47. Bernard Baron (French, 1696–1762) after William Hogarth, *The Four Times of the Day*, Plate 3, *Evening*, 1738. Etching and engraving. Hood Museum of Art, Dartmouth College, Hanover, New Hampshire. Purchased through the Guernsey Center Moore 1904 Memorial Fund

Hogarth capitalized upon the communicative potential of fans, linking particular positions and gestures with particular interior states. A good example can be found in the fan-bearing female protagonist of his *Morning* scene from the *The Four Times of the Day* (fig. 38), who bustles through Covent Garden to church, paradoxically dismayed at and intrigued by the earthy behavior of the rakish set before her eyes.[66] Although this woman is prudish, her appearance is paradoxically both sober and provocative. As Hogarth's eighteenth-century German commentator Lichtenberg pointed out, she "cares for her neighbor. . . . For to be sure, she would not doll herself up like that for her own benefit."[67] Dressed lavishly, and sporting a frock with a plunging neckline, her spinsterish disdain mingles with her fascination; her dress reflects her moral and emotional ambivalence.[68]

The humor of this figure is highlighted by the purposefully positioned fan, brought up to her lips. This gesture can be read in light of the code just mentioned. Pressing the fan to her lips, the woman expresses her hidden desire "to be kissed." The sexual nature of this gesture becomes clearer when we consider an analogous scene in Hogarth's *Marriage Contract*. In this oil sketch (fig. 78), an elderly woman is clearly purchasing her rakish younger husband, and the gesture of the phallic fan toward her lips underlines her expectant and desiring gaze. Here too, as also in the unequal marriage scene of *A Rake's Progress* (pl. R5 and fig. 39), the closed fan speaks ambivalently of repression and pent-up desire.

The suppressed lust registered in the fan in *Morning* has fully developed in *Evening* (fig. 47), where a fan is extravagantly opened, its extension referring to the woman's unrestrained sexuality. The shapes of the fan in both prints seem to comment, anthropomorphically, on the bodies of their respective bearers. The tightly closed fan echoes the

shared knowledge of the meaning of gestural movements would truly enable discursive exchange, the desire to codify the "language" of fans speaks of both the actual, albeit unstandardized communicative function of fans and also of male fears concerning the subversive potential of a female, secret language.

Clearly, it is not possible to accept the signals enumerated above as a fixed fan language; nonetheless, they do suggest the discursive nature of the fan and the gestures it enabled.[65] In Hogarth's prints we can recognize both the fears concerning a system of gestural signs, outside of male control, and the inherent power of an embodied mode of address. For

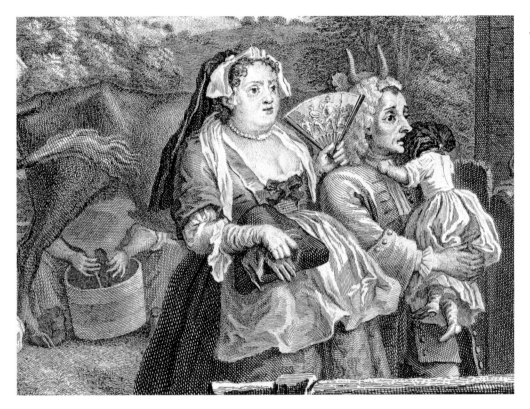

Fig. 48. Bernard Baron after William Hogarth, *The Four Times of the Day*, Plate 3, *Evening* (detail), 1738. Etching and engraving. Hood Museum of Art, Dartmouth College, Hanover, New Hampshire. Purchased through the Guernsey Center Moore 1904 Memorial Fund

gauntness of the protagonist of *Morning*, while in *Evening* the expansive fan seems to amplify the form of the woman who wields it (fig. 48).

In *Evening* we see the return of an ordinary English family, of the lower-middling orders, after an afternoon's walk in the hot sun to take tea at a teahouse in Sadler's Wells garden on the outskirts of London. The heat has risen to the countenance of the wife, whose cheeks and neck in the painting and in the hand-colored second state of the engraving are flushed an intense red.[69] The wife's fan, here potentially useful but apparently not in use, is purposefully opened, revealing to the viewer a mythological scene, "Venus detaining her lover Adonis from the Chase."[70] The manner in which the woman in *Evening* holds this fan is reminiscent of the secret sign language of fans described above, for she seems to cover her ear with the open fan as if to signal to the viewer,

"Do not betray our secret." Indeed, the humor of the print resides in the dramatic irony, pitting knowledge against ignorance. What is more, its humor hinges on the fan.

The fan establishes a boundary between the wife and her small husband, whose blue hands in the painting and in the colored print betray his profession as a dyer. Her control of the space between them signals her domination. She also controls the information disbursed to the viewer. While it was common for fan painters to adopt the mythological and pastoral themes popular in contemporary literature, in this instance the iconography bears a particular relation to the print's satiric narrative.[71] For although the woman, as Sean Shesgreen has argued, appears as a humorous rendition of Diana, goddess of the night, the scene of "Venus and Adonis" transmitted by the fan clearly implies that she, like the Goddess of Love, has taken a lover.[72]

133

The fan in representation functioned much like a veil, which, in Mary Ann Doane's words, acts "to ensure that there is a depth which lurks behind the surface of things."[73] The fan creates a second surface—quite literally a second skin (given that fans in the eighteenth century were often painted or printed on prepared chicken skin)—which produces the fiction of depth: truth lies behind the surface disclosed from view. Thus, ironically, depth becomes visible only in or through the surface, and the surface in turn becomes the projection screen for the invisible "that lurks behind." The fan, therefore, reveals a truth. But it reveals a deeper "truth," since the heroic mythological narrative on the fan heightens Hogarth's comic description of the quotidian family, underscoring the discrepancy between desire and reality. Adonis and his faithful dog are transformed into the concerned dyer and his mangy hound, the former receiving the cuckold's horns as he passes before a cow. While Venus's contemporary counterpart becomes the hot and bothered woman (on the colored print, she is noticeably rubicund), pregnant by her lover, and, like the symbolic cow before which the couple passes, bloated with fertility.

The "Venus and Adonis" fan also functions as a pendant to that held by the daughter in the left middle-ground, establishing a humorous parallelism between the pairs of figures: the parvenue parents and the mock-adult children. The girl's fan is not opened but shut, transformed into a weapon.[74] With her sticks, the bejeweled girl berates her overdressed sibling. Lichtenberg remarked that this modern Cupid or "City Amor rides on daddy's stick [*Papas Stock*]," recognizing Hogarth's mythological play and the phallic symbolism of the knob-handled hobbyhorse cane that juts from between the boy's legs.[75] "Papa's Stock" has become a toy for the boy, further suggesting the father's emasculation, while the girl's fan appears as an Amazonic weapon, through which Hogarth articulates inverted gender roles.

Deeply embedded in the language of satire, the image of the fan serves to highlight the discrepancy between ideal and reality. Yet it also functions as a sign of freedom—in this instance, as an allegorical window onto a level of meanings less inhibited by social conventions of propriety. In Hogarth's *Evening* the unfolded fan reveals the wife's hidden desires of escape from marital, sexual, and social confinement.

The Fans of Bedlam

The final scene of *A Rake's Progress* shows a chaotic spectrum of alternate meanings not governed by a single allegorical frame, but nonetheless held in place within a reality stabilized, visually, by a fan.

Tom Rakewell, reduced to madness, has been consigned to Bedlam. In a dismal company of the mentally afflicted, two figures shine, highlighted by their posture, garb, and luminosity (fig. 49). Accompanied by her maid, a fashionably dressed lady has unfurled her fan while entertaining herself by promenading through the follies of Bedlam. Bethlehem, or Bedlam as it would come to be called, was a major attraction for both Londoners and foreign travelers, its late seventeenth-century palatial architecture inviting visitors to experience the dysfunctional kingdom of the insane. Indeed, as Roy Porter has pointed out, "Early Modern Bethlem was a show. For Bethlehem, the term 'great Confinement' is hopelessly inappropriate: far better to call it the Great Exhibition."[76] Surveying the inhabitants of this human exhibition, visitors were asked to secure their own, rational positions in relation to what they saw and to mull over the analogies between the societies inside and outside Bedlam's walls. In the words of Thomas Tryon, writing at the turn of the eighteenth century, "To speak truth, the World is but a great Bed-

lam, where those that are more mad, lock up those that are less."[77]

The female visitors in Hogarth's print are both actors in this spectacle of lunacy and mediators for our own, voyeuristic gaze. In this regard, the relation between the women and the madman in cell 55 is especially important, a point recognized by Lichtenberg, who wrote:

In No. 55, upon a throne of straw, and crowned with straw by his own hands, sits the political maniac. Everything around him is light, only the scepter has full oriental weight. Before the cell stand a couple of girls in rich, pretty silks. Are they perhaps ladies of the Court? They are just being received in audience, and at the same time receive from a distance a benediction which they accept with much better grace than was intended. . . . The girls must have great freedom, to be sure, if they can lose themselves to this extent, and much ill-breeding if they forget themselves so much. That is why Hogarth placed them in his masterly way right in the midst of those who are allowed to walk about freely.[78]

The "freedom" and voyeurism of the two visitors to whom Lichtenberg alludes are underscored by the gender dialogue of unchaperoned women enjoying the sight of naked or half-dressed men who have lost all control. The fan becomes the sign of the women's voyeuristic curiosity, but their moral position cannot be easily fixed.

It is clear that Hogarth was very concerned with the two women. It was precisely this part of the composition that received his greatest attention when he reworked the plate.[79] In the first and second state of the scene (pl. R8), the woman with the fan wears a matronly headdress; a black hood is pulled over her light bonnet. Her head is turned lightly so as to peep through the sticks of the opened fan to catch a glimpse of the naked and urinating king. Her facial expression is reserved, secretive, perhaps even severe.

In the final third state (fig. 49), she turns over her shoulder, perhaps to listen more carefully to her friend, tilting her head back so as to

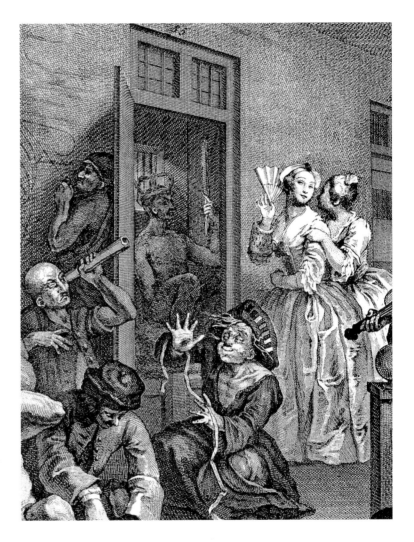

fully expose her youthful beauty to the viewer in a coquettish and playful manner. Although her eyes appear half-closed, she still looks from the corner of her eyes toward the king in cell 55. Turning away from the lewd "political maniac" and toward the viewer, she appears amused as she listens to some whispered words from her companion. Hogarth's treatment of this fashionable lady produces an ironic disjunction between the apparently sane and the insane. The "sane" lady with her ermine muff holds the fan close, ostentatiously framing her face.

Amid the turmoil, noise, and smell of the

Fig. 49. William Hogarth, *A Rake's Progress*, Plate 8, third state (detail), 1735; retouched by the artist 1763. Etching and engraving. The British Museum, London

scene, the fan might be seen to signal the "sane" woman's "madness." Raised and spread, like the hand of the mad tailor kneeling below her, the fan might have helped Hogarth underscore the insanity of fashion, not least the fashion of visiting the asylum for the insane. But the fan also operates within Hogarth's commentary on spectacle, on seeing and on being seen.

In the visual story, the fan blocks from her gaze—which nonetheless moves in that direction—the figure of the king in his cell. Naked but for his crown, the king holds a stick as his scepter and urinates against the wall and toward the lady. Her fan shields her from this sight and underscores her concern with it. The striated illumination cast through the barred windows of the cells functions analogously to the similarly striated fan. Both act as a barrier, while both also guarantee a certain visual access. The fan, therefore, emphasizes Hogarth's satirical intent. For the lady is in Bedlam both to see and not to see.

The paradox is (un)resolved in the whispered words that pass between the women and its fluttering visual expression in the fan. For the fan belonged to the domain of female communication and, like the gossip theorized by Irit Rogoff, served to disrupt and decenter uniform, linear narratives.[80] Within the urban spectacle of Bedlam and within public culture in general, the fan and the secret exchange between the women it connoted could represent fantasies about transgression and unruly excess and threaten the dull norm of dutiful words that comprised the supposedly masculine public sphere.

Shielding the women from the odors and provocative sights of Bedlam, while simultaneously serving as a definitional parameter for women's chat and secretive communication, the fan can be seen to undermine a simple moral reading of the print. The ambivalence of the fan as a sign is underscored by its association with both the noblest (sight) and hum-

blest (smell) of senses.[81] It does not provide us with a clear-cut moral position punishing those that seek pleasure in looking. Rather, we as viewers are aligned with the women in the print. More explicitly, I would like to suggest that Hogarth's visual gossip and playful humor share their very subversiveness with the playful whispers of women whose words will spread like fire through London's society, fanned by the motion of their hands.

This alignment of narrative with gossip and oral communication, which was fundamentally associated with "feminine levity," characterizes Hogarth's prints in general. As James Turner has pointed out, Hogarth's prints, having left his studio, floated freely within the broadly defined "print culture" of London, fulfilling lofty public functions as well as the prosaic necessities of trade—being used, for example, to wrap butter, as in the third plate of *A Harlot's Progress*.[82] The assumed "master-narratives" of Hogarth's progresses were destined to be diffused—like a story in oral communication—to become integrated into the performative and material culture of his day. The joining of Hogarth's imagery and the performative, mobility of culture is especially visible in his works that appear on fans: literally, moving images.

Unfurling *A Harlot's Progress*

Two months after the publication of Hogarth's *A Harlot's Progress*, Martha Gamble at the Golden Fan advertised in conjunction with Giles King "Six Prints of the Progress of a Harlot on a Fan, three on each Side, curiously-Engrav'd; wherein the Characters are justly preserv'd, and the whole not varied from the Originals. Printed in diverse beautiful Colours. Price 2s 6d."[83] This particular fan, advertised again a month later in the *Craftsman*, was a great success;[84] it even saw a second edition a year later, as a note by Gamble in the *Daily Journal* (24 January 1733) reveals: "A new edi-

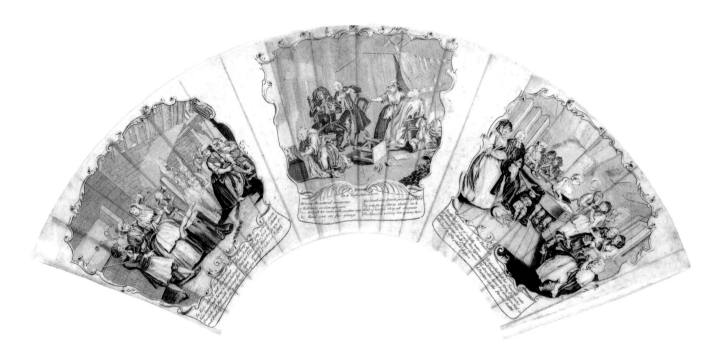

tion of the 'Harlot's Progress' in Fans, or singly to Frame."[85] Although Hogarth most certainly did *not* authorize their publication, he nevertheless seems to have approved of them, for, according to his early biographer Nichols, they "were given by Hogarth to his servants."[86] This anecdote receives partial substantiation from an inscription on a fan, now in the Art Institute of Chicago (fig. 50), which reads: "Given to me by Mrs. Hogarth, 1781."[87]

Hogarth's female, anti-heroic cycle placed on a fan seems to provide an apt afterlife for Moll Hackabout, whose moral descent—from her arrival in London as an innocent country girl to her fall into prostitution, followed by imprisonment and subsequent death of venereal disease—could now unfold in the hands of women.

Moreover, the fans within *A Harlot's Progress* play an interesting role, one brought to the fore on the fan leaves printed with the narrative. The association of fans and prostitution was not without significance. They played an active role in the riveting and shunning of amorous gazes and in the coquettish trickery of sexual commerce. The erotic coding of fans made them apt accoutrements for prostitutes. Thus in Hogarth's *March to Finchley*, prostitutes attract the attention of passing soldiers through the nervous fluttering of their fans, literally staging themselves as spectacles (fig. 93).

In scene one of *A Harlot's Progress*, bawd Needham who greets Moll Hackabout while chucking her under the chin with her right hand appears to tap the girl's arm with a closed fan in her left (fig. 34). Bewitching Moll, the bawd initiates the country girl into the dark world that will consume her. In the fifth plate of the series we find Moll wracked with venereal disease and dying. The verses below the image on the fan describe the scene:

> *In a high Salivation*
>
> Disease the natural consequence
> of Wallowing in Concupiscence
> Flies through her veins with poisonous rage
> No Maid can its fire assuage

Fig. 50. Anonymous, *Fan Leaf with Scenes after Hogarth's 'A Harlot's Progress,'* 1732. Engraving on paper. 19¾ x 6 in. (50.2 x 15.3 cm). The Art Institute of Chicago. Joseph Brooks Fair Endowment, 1947.144

yet blundering Quacks perscribe ye Physick
Fit only for a Horse that's sick
While of her life they all despair
The Nurse is robbing her young heir

In the lower left we see "the nurse" rifling through Moll's belongings: her masquerade costume, including her witch's hat, lie, emblematically on the floor (fifth plate). The mask, now turned dark, is a symbol of the falsity of her life. Through its eyes pokes a fan, symbolizing the oblique gazes employed by Moll in securing her trade. As Lichtenberg commented, the possessor of these fans could "contemplate them in time of heat and send sidelong glances from under them in case of need."[88] The angled sightlines speak of what was called in a *Spectator* article of 17 December 1711 "Heteroptics":

Let me observe that oblique Vision, when natural, was anciently the Mark of Bewitchery and magical Fascination, and to this Day 'tis a malignant ill Look; but when 'tis forc'd and affected it carries a wanton Design, and in Play-houses and other publick Places this ocular Intimidation is often an Assignation for bad Practices: But this Irregularity in Vision, together with such Enormities as tipping the Wink, the circumspective Rowl, the side Peep thro' a thin Hood or Fan, must be put in the Class of Heteropticks, as all wrong Notions of Religion are rank'd under the general Name of Heterodox.[89]

The heteroptics of the fan, signaled by its angular insertion into the mask and associated with the witchery of erotic display, is presented as a *vanitas* symbol. The blinded mask reminds us of Moll's eyes, now shut in pain and death; the fan closed, and with it her life. As Lichtenberg put it, "Those eyes in the wan face, [are] a closed fan."

More than any other work, the fan mount with scenes from *A Harlot's Progress* puts pressure on the dual nature of the fan itself. In eighteenth-century London, holding such an instrument placed women in a position of superiority over the female anti-heroine rendering the unfolding narrative subject to mobile interpretation.[90] Protected in part through her knowledge of the dangers of sexual games and equipped with a powerful tool of communication, a woman could employ the fan to control a narrative. Using it perhaps as an erotically loaded shield, the woman holding the fan demonstrates a power over her own moral judgment and over visual representation in the public sphere.

Notes

I am grateful to David Bindman, Bernadette Fort, Kathy Hart, and especially Adrian Randolph for reading and commenting on earlier drafts of this paper, first presented as a talk at the conference "Hogarth Forever! Historical Interpretation and Contemporary Perspectives" (Columbia University, 7 November 1998). I would also like to thank Christina Kiaer and Alan Staley for inviting me to speak at the conference.

1. See Brewer, McKendrick, and Plumb 1982; Brewer and Porter 1993, Brewer and Staves 1995, and R. W. Jones 1998.

2. Solkin 1986, 42.

3. Lovell 1995, 32.

4. On the argument that fashion came to dominate economic, social, and cultural life in the eighteenth century see Brewer, McKendrick, and Plumb 1982, 34–100, and Sekora 1977, 110–34. Regarding performance, see J. Brewer 1997, part IV. On gestures see also Hallett 1999, 180–82.

5. On this print see Paulson 1965, cat. 44; and Shesgreen 1973, cat. 1.

6. Stafford 1994, 202.

7. Ibid., 204.

8. Ibid. See also Barnett 1987, Bremmer and Roodenburg 1991, and Mark Hallett's discussion of etiquette books, Hallett 1999, 180–82.

9. Hogarth 1997, 104–9.

10. Ibid., 107.

11. Hart and Taylor 1998, 7; Standen 1965, 244; Wheatley 1989, 9–10.

12. *Spectator* no. 138 (Wednesday, 8 August 1711), ed. Bond, 2:47.

13. Coryate 1611 (1905), 1:256; Samuel Johnson's *Dictionary of the English Language* defined fans as an "instrument used by ladies to move the air and cool themselves" (S. Johnson 1773, s. v. Fans).

14. "Of the MODERN FANS," in the *London Magazine and Monthly Chronologer, Universal Spectator* no. 813 (5 May 1744): 249–51. William Hogarth, however, does present us with an exceptional man at the Countess's morning *levée,* whose fan dangles from his wrist (fig. M4). According to Lichtenberg 1966, 123, this "fop" represents the "most sugary sentimentality of behaviour, and an extreme expression in masculine shape of affection and delight."

15. Gay 1713, no pagination.

16. The nude female statue hiding her genital area in a gesture of modesty simultaneously draws attention to her sexuality. For a discussion see Salomon 1996, 69–87.

17. [Addison], *Spectator* no. 102 (Wednesday, 27 June 1711), ed. Bond, 1:27.

18. These small, decorative folding fans quickly replaced the fixed fan whose history goes back to the earliest Egyptian dynasties. The major studies on fans providing historical overviews are: Flory 1895, 1–68; Woolliscroft Rhead 1910; N. Armstrong 1978, 10–11; De Vere Green 1979; N. Armstrong 1984; Mayor 1980; A. Bennett 1980, 6–10; Kopplin 1983; A. Bennett 1988, 12–17; Wheatley 1989; Parmal 1990; Du Mortier 1992; and Hart and Taylor 1998.

19. Wheatley 1989, 10.

20. The *Gentleman's Magazine* of November 1752 quotes an advertisement that appeared in the *Daily Advertiser*, "from the poor unfortunate artificers in the several branches of the fan trade, whose number is nearly 1000; returning thanks to the Company of Fanmakers for petitioning the E. India directors to discontinue the importation of fans. To excite the regard and compassion of the ladies, it asserts that the home-made fans are in every way preferable to foreign; and that by discouraging the latter, they will relieve a number of unfortunate families from the most grievous distress and despair." The Fanmakers' Company, created by Charter in 1709, for nearly 100 years protected and regulated the trade, until the reduction of protective duties on foreign fans annihilated the English trade (notes by Colonel Sewel [The Fanmakers' Company], Schreiber MS, British Museum). See Woolliscroft Rhead 1910, 183.

21. N. Armstrong 1978, 11.

22. *Daily Journal* (20 May 1721); quoted in Clayton 1997, 94. See also N. Armstrong 1978, 11.

23. "Fine printed fans were usually sold for 1s. 6d. 'painted in proper colours' and 'ready mounted upon neat sticks' 2s. 6d." (Clayton 1997, 94). By comparison, the price for a standard framed mezzotint, for instance, was 3s. 6d. Hogarth's print *The Distrest Poet* (see fig. 62) could be purchased for 3s.

24. *Public Advertiser* (13 March 1753); Clayton 1997, 94.

25. "Printed fans were made fast and furiously; as each political slogan or social event was altered a new one came in, so the fan-leaf was torn from its sticks and another slapped on" (N. Armstrong 1978, 11). See also Woolliscroft Rhead 1910, 232ff.; Hart and Taylor 1998, 69–79.

26. See Woolliscroft Rhead 1910, illustration opposite 187.

27. A. Bennett 1988, cat. 54; for a similar painted mask-fan, see Standen 1965 and Mayor 1980, 53.

28. Among publishers were women like Mrs. Beardwell, the printer of the publication, the *Post Boy*, who is known to have sold mainly political prints.

29. N. Armstrong 1978, introduction.

30. On this print, see Paulson 1965, cat. 273; for Mary Hitchcock, see Woolliscroft Rhead 1910, 187; see also Standen 1965, 256, on women in the fan business.

31. Paulson 1989a, cat. 106. On professional women in Hogarth's time see Crown, this volume.

32. Hart and Taylor 1998, 29.

33. A number of different fans after Hogarth's *A Harlot's Progress* exist. See Schreiber 1893, cat. 151–55 ("The Harlot's Progress"); one such version, the outline etching in reddish-brown ink with five scenes on a single side, is illustrated in Bindman 1997a, cat. 12. See Schreiber 1893, cat. 166 ("Henry VIII"). The fan with a *Midnight Modern Conversation* is untraced; it is mentioned in *Daily Journal* (24 May 1733) and Woolliscroft Rhead 1910, 240. On Gamble, see Woolliscroft Rhead 1910, 234ff.

34. *Free-holder, or Political Essays* no. 15 (10 February 1716) (London: D. Midwinter [etc.], 1716).

35. In Paris during the French Revolution fans were used by women to communicate and disseminate vital political information. I am grateful to Helen Horkheimer for pointing this out to me.

36. Clayton 1997, 94.

37. According to her advertisement, these "Emblematic FANS with the true Effigies of the Reverend Dr. *Henry Sacheverell* done to Life, and several curious Hieroglyphicks in Honour of the Church of England, finely painted and mounted on extraordinary genteel Sticks," were sold "only at Mrs. Beardwells next

the Red-Cross-Tavern, in Blackfriars." *Supplement* (21 August 1710); *Post Boy*, 24 August 1710. Quoted in the *Spectator*, ed. Bond, 2:244, n. 1.

38. Rogoff 1996, 58–68. For Hogarth's male audience and the cultivation of masculinity see Hallett, this volume.

39. Wheatley 1989, 10.

40. Woolliscroft Rhead 1910, 186–87

41. The hostess, Catherine Barton, was a favorite niece of Sir Isaac Newton, who appears here in a bust probably by Roubiliac or Rysbrack. Her husband, John Conduit, became master of the Mint, which allowed him to move in the highest circles.

42. Paulson 1992, 2:3; on the painting see also Webster 1979, 84.

43. There are many references to the fan's association with vivacity in the popular press; see for example Gay 1713.

44. See S. Johnson 1773, s. v. Woman. Gisborne 1798, 54, lists among the quality of women the "gay vivacity and quickness of imagination" which, however, leads to "dislike of graver studies." Porter 1985, 390, n. 20, relates that the antiquarian John Clubbe sought to tell the "light-headed from the heavy-hearted through the 'Mechanical Apparatus' of a magnetic weighing machine, which would 'weigh men in the balance' to gauge their 'intellectual gravity.'"

45. Oldham 1978, 119–27. Oldham also quotes the following advertisement: " 'The songs of the Beggar's Opera' printed by John Watts at the Printing Office in Wild Court (Tottenham Court) Lincoln's Inn Fields, price 2s. 6d."

46. Gay 1713, no pagination.

47. *Spectator* no. 377 (Tuesday, 13 May 1712), ed. Bond, 3:417.

48. Paulson 1965, cat. 36.

49. For a fascinating interpretation of this print see Krysmanski 1998, 393–408.

50. See S. Johnson 1773, s. v. Fans.

51. As Wagner 1991a, 53–74, has pointed out, Hogarth plays on the religious and sexual meanings of such terms as "matrimony" in this print "OF MATRIMONY—which also appears, with the same ironic function, in plate 5 of *A Rake's Progress* (1735)—is, in fact, an allusion to a large body of works on marriage and procreation which were read because they provided titillation as well. Nicolas Venette's *Mysteries of Conjugal Love Reveal'd* (1703 and later), Defoe's *Conjugal Lewdness or Matrimonial Whoredom* (1727), and the best-selling sex guide *Aristotle's Master-Piece* are just three examples of an important and highly ambiguous pseudo-instructional literature that

shaped the eighteenth-century English *mentalités*. (Lichtenberg 1808, 10:79, for instance, recognized Hogarth's double entendre when he termed "OF MATRIMONY" a "Copulationsformel," adding bawdy jokes about prayer books and girls that "unfold," automatically, once they are "put on their backs.")

52. For the preparatory drawing see Oppé 1948, cats. 42 and 43 (ills. 43–44).

53. Standen 1965, 244.

54. *Tatler* (19 October 1710); cited in Woolliscroft Rhead 1910, 189.

55. Ibid., 188.

56. *Spectator* no. 102 (Wednesday, 27 June 1711), ed. Bond, 2:426–27.

57. *Spectator* no. 138 (Wednesday, 8 August 1711), ed. Bond, 2:46–47.

58. The codification of genteel behaviour was embedded in discourses on gender and aesthetics. And indeed, Hogarth himself informs his readers in his *Analysis of Beauty* that "The pleasing effect of this manner of moving the hand [in a beautiful direction], is seen when a snuff-box or a fan is presented gracefully or genteelly to a lady," and he further encourages that "[d]aily practising these movements, will in a short time render the whole person graceful and easy at pleasure"; Hogarth 1997, 107.

59. I am grateful to Kathy Hart for pointing out to me the sexual symbolism of the snuffbox and with it the humorous gender inversions of the objects in relation to their respective bearers.

60. Ferenczi 1980, 361.

61. *Cleone Knox, Diary of May 1764*; cited in Hart and Taylor 1998, 28.

62. "Poetical Essays," *Gentleman's Magazine* 10 (December 1740), 616; quoted in part in Woolliscroft Rhead 1910, 253–54, but without exact reference to source.

63. Darling: D= first group of letters in the alphabet and D is the 4th letter in this group, first movement from left to right arm, second movement fan is moved to the mouth. See Woolliscroft Rhead 1910, 136–37; N. Armstrong 1978, 10; for a detailed discussion of the language of fans in Spain and England see Mayor 1980.

64. Woolliscroft Rhead 1910, 136–37.

65. "The Coquet may be looked upon as a fourth kind of Female Orator. . . . The Coquet is in particular a great Mistress of that part of Oratory which is called Action, and indeed seems to speak for no other Purpose, but as it gives her an Opportunity of stirring a Limb, or varying a Feature, of glancing her Eyes, or

playing with her Fan." *Spectator* no. 247 (Thursday, 13 December 1711), ed. Bond, 2:459.

66. Shesgreen 1973, cat. 42. "She expresses in her face and with her fan moral horror at the activities of the engaging lovers in front of her."

67. Lichtenberg 1966, 276.

68. Ibid.: "and how much does she not care for her neighbor! For to be sure, she would not doll herself up like that for her own benefit. She must have started already at four o'clock that morning, thus by artificial light; we cannot be surprised, therefore, if in practice everything has not turned out exactly as theory intended it should. . . . Beauty spots (mouches) float about her gleaming eye like midges round candle flame, a warning to any young man whose glances would like to imitate them."

69. Paulson 1965, cat. 154; Paulson 1970, 1:180; Paulson 1989a, cat. 154. For detailed analysis of the *Four Times of Day* series see Shesgreen 1983. See also Shesgreen 1983, 112–13, and 1973, cat. 44, for a detailed discussion of *Evening*. The specially colored print is discussed and reproduced in Bindman 1997a, plate I, cat. 25b.

70. The fan in the oil painting resembles the story of Diana and Actaeon; Paulson 1989, cat. 154. The wife's fan shows "Venus detaining Adonis from the Chase" (BMC 1870–1954, no. 2382).

71. Hart and Taylor 1998, ch. 3, 29.

72. Shesgreen 1983, 110ff.

73. Doane 1991, 54–55.

74. The girl did not appear in the first version of the print. Hogarth is said to have included her after Barton, the engraver, told him that the boy "has no Apparent Cause to Wimper"; see Paulson 1989a, cat. 154.

75. Lichtenberg 1966, 288. Uglow 1997, 306, describes the

cane as knob-handled.

76. Porter 1997b, 43.

77. Quoted in ibid., 45.

78. Lichtenberg 1966, 266, adds: "Papa and Mamma do not know a word about it; Papas and Mammas should take note."

79. Paulson 1965, cat. 139.

80. Rogoff 1996.

81. Classen 1997, 1–19; for a discussion of the hierarchy of senses in relation to Hogarth see David Solkin's essay, this volume.

82. See James Grantham Turner's insightful discussion of the detail, this volume. See also Paulson 1995.

83. *Daily Advertiser* (20 June 1732); Paulson 1991–93, 1:312, n. 19.

84. Clayton 1997, 83, n. 41.

85. *Daily Journal* (24 January 1733); cited in Woolliscroft Rhead 1910, 238.

86. "Copies of these plates were engraved for a Fan, three subjects on each side, and were given by Hogarth to his servants"; Nichols 1833, 325. See also Paulson 1965, 1:142; Bindman 1997a, cat. 12.

87. See Woolliscroft Rhead 1910, 238, who suggests that the inscription was done by the collector "Baker."

88. Lichtenberg, as quoted in Turner, this volume; Lichtenberg 1966, 3, *The Harlot's Progress* was "painted on fans to be looked at on hot days, and looked past, too, if needed."

89. *Spectator* no. 250 (Monday, 17 December 1711), ed. Bond, 2:472.

90. Hogarth's servants might also have held the fans as advertisement for their employer.

Manly Satire: William Hogarth's *A Rake's Progress*

Mark Hallett

On 11 May 1732, the back page of London's *Daily Journal* was dominated by two lengthy advertisements that appeared side by side, clearly competing for the reader's attention. One announced the publication of a pamphlet called *The Rake's Progress: or, the Templar's Exit*, a poem in "Ten Hudibrastic verses." In the advertisement, the stages of this rake's "progress" are summarized in some detail. They include "his going to Brasen-nose college in Oxford" and being "expelled for his debaucheries"; "his conversation with Old Bawds, young whores, and Town Sharpers"; and losing "his reputation, estate and Constitution." The advertisement goes on to declare that the whole is "interspersed with innocent mirth, good morals, and too much of the author's own experience," and it ends by noting that the poem is written by the author of a ribald commentary on William Hogarth's recently published and already famous print series of *A Harlot's Progress*. The second advertisement was for a similar publication called *The Progress of a Rake*, and it promised a salacious narrative of intrigue and escapade. This included an account of the rake's "adventures with the whores in Drury Lane," "his intrigue with a Butcher's wife," "his quarrel with a young officer, and the duel thereupon," and "several other entertaining passages and occurences." Prospective buyers were directed to the premises of "N. Cox, Bookseller, under the Middle Piazza, near Mr Hogarth's, Covent Garden."[1]

Hogarth, of course, was to go on to produce a *Rake's Progress* of his own in a celebrated series of eight images, which were exhibited as paintings and published as engravings between 1733 and 1735. His pictures focus on a young man called Tom Rakewell, whose activities and fortunes closely echo those of the rakes described in the *Daily Journal*. The first image shows Tom being measured for a suit soon after inheriting his miserly father's fortune. Even as he is fitted for a new life in the metropolis, we see him trying to buy off a pregnant young woman, Sarah Young, whom he had seduced with promises of marriage while a student at Oxford. The second image depicts Tom at the center of a retinue of servants, lackeys, and hangers-on in his newly acquired London town house, while the third shows him sprawling with prostitutes at the Rose Tavern in Drury Lane. In the next two installments of the narrative, Tom is shown being arrested for debt on his way to St. James palace and temporarily financing new extravagances by marrying a wealthy old woman. In the sixth image of the series, Hogarth depicts a London gambling den and pictures his protagonist exclaiming with grief after losing his remaining fortune. The last two canvases and engravings confirm the rake's doomed fate: in Hogarth's penultimate image Tom sits in melancholy paralysis in Fleet Prison, having been jailed for debt and having had a playscript rejected by the famous theatre manager John Rich, while in the final image Tom writhes

nearly naked across the stone floor of Bedlam mental asylum, clamped in chains and nursed by the long-suffering but loyal figure of Sarah.

Up until now this dramatic set of paintings and engravings has been analyzed mainly in relation to Hogarth's individual ambitions and output—that is, in terms of his retrospectively self-appointed role as a producer of Modern Moral Subjects and as a natural and obvious successor to his *Harlot's Progress.*[2] What the *Daily Journal* advertisements begin to suggest, however, even as they gesture to the artist's example, is that Hogarth's turn to the rake needs to be reread in relation to a broader engagement with this venerable stereotype of libidinous and chauvinistic excess in early eighteenth-century London. Hogarth's eight pictures responded to, and intervened in a collective form of cultural practice, in which the rake was making his appearance in a range of different pictorial and literary guises. And the longer one spends investigating these representations of the rake and their relationship to other stereotypes of male appearance and behavior being generated in urban culture, the more apparent it becomes that Hogarth's works can no longer stand alone or only in relation to other formulations of rakery. Rather, his series is best understood as a work of art that operated in complex dialogue with other kinds of representation shaping alternative modes of masculine identity within the contemporary city.

This perspective helps us think about the ways in which Hogarth's art could itself be seen as embodying certain kinds of masculinity. This is made clear in John Bancks's contemporary poetic ode to Hogarth, in which he praises "thy manly satire's varied grace."[3] What kinds of manliness were *A Rake's Progress* and its creator seen to embody? And what was the relation between the manliness—or lack of it—being depicted in the work and the manliness of the work? Moreover, as Whitney Davis has recently written, "It makes little sense to speak of the gender in or even of a visual representation without determining how that representation subsists in ideal, partial, or negligible concord with its many viewers, many of whom have had numerous and variable encounters with the work."[4] It is thus necessary to think about the performative inflection of gender across space and vision.

I will do this in relation to *A Rake's Progress* by returning in the final part of the essay to the work's earliest status as an ensemble of objects arranged across Hogarth's showroom, suggesting the modes of viewing that this installation might have attracted from the men—and here I shall focus only on the men—who entered this space to inspect the pictures on show. I hope to develop a fuller conception of Hogarth's "manly satire" as something that operated across a network of pictorial, spatial, and spectatorial sites existing both inside and outside the visual images he produced.

Recovering the Rake

"Give us this day our daily Riot."[5] So begins *The Rake: or, the Libertine's Religion*, a poem of 1693 in which the eponymous narrator describes his lustful, violent, and drunken nocturnal circuit around the center of London. His early eighteenth-century successors, depicted in scores of poems, pamphlets, books, and newspaper articles published in the period, were to follow similarly dissolute paths across the city. The hero of *The Virgin Seducer* of 1727, for example, having come into a large inheritance, soon "ranges uncontrouled thro' this vast wilderness, eagerly devouring the forbidden fruit which so temptingly courted his depraved curiosity. Qualified by a powerful fortune and spurred by a vicious inclination, he becomes a rake of the first rank, encouraged by the persuasive example of his libertine companions."[6] Such writings help us to start recovering those recurring characteristics of rakery that Hogarth was to pictorially recycle in his depiction of Tom's temporal and spatial passage through London. But who exactly was this figure called a rake, and what did the term mean in this period?

Rakery, it is clear, was not just a fiction— it described an actual way of life for certain individuals in the early eighteenth century. Following in the footsteps of famous rakes like the Restoration libertine and poet, the Earl of Rochester, men such as the diarist George Hilton clearly sought to cultivate a rakish lifestyle in the city. Hilton's jottings offer a succinct record of days—or, more accurately, nights—spent stumbling from tavern to tavern, drinking uproariously with male companions, cheating coachmen, and having sex with prostitutes:

Monday 26 June 1704 At the Rose Inn in Smithfield at night at St. Jones gate with Robin Hilton Tho & Ned Ward got fuddled rambled all Tuesday at Common Garden markett after gott to the rumer in Grays Inn Passage after gott into Red Lyon Street to Mr Trapp's that frolic cost me 16.0 Wednesday 28 June Att the Rose Inn in Smithfield in bed most part of th' day at night picked upp a whore . . . Thursday 6 July . . . much fuddle and bilked coachmen.[7]

While diary entries like these suggest that we should partially understand the rake as a historical figure, he is far more commonly encountered as a representation, a cultural stereotype who populated the fictional writings of the period. In this role, he was given a standardized narrative trajectory. Over and over again, he is introduced as a non-metropolitan figure—normally a young aristocrat living in the country or studying at one of the old universities. Upon receiving news of his father's death, he travels to London and begins spending his inheritance with extravagant haste. The rake was someone who dismissed the values of rural and academic life for the learning found in the streets, brothels, and taverns of London: in the words of *The Rake of Taste*, a poem of 1735, "If fond of knowledge / Seek it in town, and quit the ruddy college. / Here, the soft sex, here, the enlivening bottle, / Will teach you more than can old Aristotle."[8] Once in the city, the aspirant rake circulated around a well-established circuit of masculine sociability and pleasure and repeated the same activities night after night. These are well summarized in *The Rake Reform'd* (1717), which describes the crapulous narrator getting up at midday and stumbling outdoors for a drink: "To the frequented tavern did repair, / With the same dog to kill the follow'd hare / And drown at once my senses and my care."[9] At five, he walks to a gaming house, then later to the playhouse, and then later still to the Rose Tavern in Drury Lane, where, like Tom Rakewell in Hogarth's series, he seduces a "jilt," drinks more wine, and blearily notices that "glasses diffuse'd in broken fragments lay, / And cloathes distain'd with Wine did my Excess betray."[10] Leaving at midnight, he smashes windows, steals signs, and is pursued and caught by

the local Watch, but he is able to bribe the presiding judge and escape back to the streets and into bed. Next day, of course, he begins his routine all over again: "Thus I a round of fancy'd Bliss pursu'd, / And each succeeding Morn my course renew'd."[11]

In writings like these, rakes tended to be invoked as the butts of comic and satiric criticism and turned into the exemplars of an excessively libidinous, bibulous, and aggressive urban masculinity. They are commonly made to look back on their careers with regret and remorse and given a last chance to mend their ways. Thus the narrator of *The Rake Reform'd*, in shock at seeing a fellow libertine die, undergoes a sudden conversion to the values of rural retreat toward the end of the poem and moves to the country: "Mourning my Crimes, I fix'd to live anew; / With scorn I view'd the Town's discover'd snare, / And chang'd the City's fogs for this healthy air."[12] On the other hand, contemporary texts on the rake could also define him as a kind of urban anti-hero, the object of grudging admiration for his voracious sexual appetite, his extravagant gregariousness, his daring at the gambling table, his gargantuan drinking habits, and his utter disregard for accepted forms of civil, political, and religious authority. In this guise, he becomes dramatized as the last surviving representative of an older, aristocratic libertinism, someone who colorfully resisted and criticized the social conventions and moral codes of an increasingly polite and commercial society.[13]

The two poems being advertised in the 1732 edition of the *Daily Journal* reinforce this sense of the rake's labile identity in contemporary culture. In *The Rake's Progress: or, the Templar's Exit*, the eponymous protagonist—bankrupt, disease-ridden and friendless—ends up in his garret, exclaiming, "Ah! Woeful, miserable me, / That can't one grain of comfort see! / Where now are all my whores, false friends, / Now they have secur'd the Devil's

Ends."[14] The frontispiece to this poem (fig. 77), which offers a highly suggestive pictorial precedent to Hogarth's *Rake's Progress*, shows the stricken rake wandering forlornly around his room, clutching his sick-spattered shirt, and framed by various symbols of dissolution and vice: the illustrated copy of Rochester's poems that lies open on the table, the third plate of Hogarth's *Harlot's Progress* that hovers over his head, which focuses on the partially unclothed figure of the prostitute Moll Hackabout, and the four-poster bed that lies unmade in the corner, complete with chamber pot. The poem's narrative ends a few moments after the scene depicted here, as the rake commits suicide, hanging himself from the nail that pins Hogarth's print to the wall.

By contrast, in the other poem promoted on the same advertisement page, *The Progress of a Rake*, the rakish narrator is presented as a witty, boisterous urban comedian, keen to upset and undermine the hypocritical representatives of politics and religion in the city. And even at the end of the text, we find that he is happily pursuing his delinquent adventures—diddling undertakers, having sex, escaping the Watch, chasing parsons, and vandalizing the streets: "We spent most part of the night in roving from one place to another, breaking the windows, [and] storming the watch."[15] Here the rake is not castigated as a vicious prowler but turned into an anarchic wit and a cheerful Don Juan, offering a literary entertainment that is a bawdy combination of voyeuristic intrigue and libertarian satire.

Such publications confirm that the rake was both a well-established stereotype and a remarkably open fictional persona in this period. They also suggest the ways in which Hogarth's pictorial series echoed and duplicated the diverse concerns and subject matter of contemporary comic and satiric writings dealing with the rake. Just to give one more example of this process of cultural cross-fertilization, it is

worth pausing to note the ubiquitous references in such texts to the rake's extravagant gambling habits. A correspondent in *The Way to be Wiser, or a lecture to a Libertine* (1705) mentions "how common it is to see a losing gamester biting his nails, and raving like a mad-man, tho' perhaps his own hand threw the cast that has occasion'd his Passion,"[16] while the turn-of-the-century satirist Tom Brown described a gaming house where "rakes of various humours and conditions met together. . . . One that had played away even his shirt and cravat, and all his clothes but his breeches, stood shivering in a corner of the room, and another . . . fell a-ranting, as if hell had broke loose that very moment."[17] Returning to Hogarth's sixth plate (fig. 51), we can see how thoroughly the artist has translated and expanded upon this literary trope and recognize how Tom's twisted body, forlorn punch, and fallen wig, however eloquent in terms of Hogarth's artistic invention, are also indicative of his work's intimate engagement with contemporary writings on the rake.

A Composite Masculinity

Thus far, I have been rereading Hogarth's series in relation to the mutable narratives of rakery in early eighteenth-century London. This mutability, of course, meant that the "rake" became a figure whose outlines were constantly blurred. His identity was easily compared with, and related to, other kinds of deviant masculinity being articulated in the period. In particular, as a line from *A Covent Garden Eclogue* of 1735 usefully suggests—"Grave cits . . . , rakes and squeamish beaux, / Come reeling with their doxies from the Rose"[18]—the rake was frequently linked to the cit and the beau in contemporary urban commentary. To better understand *A Rake's Progress* and the ways in which Hogarth engages with more than one masculine stereotype in his series, it will be helpful to flesh these two figures out a little.[19]

The cit—the aspirant bourgeois who sought to purchase genteel status rather than (like the rake) to exhaust it—was becoming a recurrent fixture of contemporary satire, comedy, and comment by the early 1730s. Thus, in the *Weekly Register* of 20 May 1732, we find the fictional account of Lavish, whose career offers a suggestive parallel to that of the traditionally aristocratic figure of the rake: "Young Lavish was left by the Alderman his father in the possession of 120,000£. Having never being us'd to business, and always taught to depend on his future fortune, he acquired the pride and indolence of a man of fashion, without any of the knowledge or dignity to support it. He affected the airs and equipage of quality, and disdain'd to keep any other company."[20] Lavish, hopelessly out of his social depth, is soon exploited by his newfound, rakish gentlemen companions and by a haughty high-born wife who reduces him to slavish servitude. Meanwhile, Molière 's newly translated *Le Bourgeois Gentilhomme*—its title translated as *The Cit turn'd Gentleman* in an illustrated 1732 English edition of the French playwright's collected works—offered a powerful comic parable of the middle-class tradesman attempting to turn himself into an aristocrat through, among other things, the help of a dancing master, a fencing teacher, a master tailor, a music teacher, and a philosophy master, all of whom gather around him in his home.[21] The frontispiece that accompanies the 1732 text (fig. 52), designed by Bartholomew Dandridge, shows the extravagantly dressed cit, Mr. Jordan, blundering through a fencing lesson, watched by the smiling figures of his teachers and dwarfed by the decorated walls and the shadowed column that stand behind him. In the play he is secretly ridiculed by his various tutors and fleeced by the plotting aristocrat-rake Dorantes, who promises him an appearance at the royal court and an introduction to an elite gentlewoman.

The cit's self-delusive dreams of social status and his slavish preoccupation with appearance and etiquette echoed the characteristics of another kind of masculine anti-type that we constantly find juxtaposed with the rake—the beau, or fop, distinguished by the effeminacy of his bearing and behavior. It is again suggestive to leaf through the London newspapers of the spring of 1732 and note the titles of playhouse attractions that were being advertised in their pages: *Love makes a Man: or, the Fop's Fortune*; *The Man of Mode: or Sir Fopling Flutter*; and *Mr Taste: or the Poetical Fop*.[22] Outside the theater, the fop was a ubiquitous masculine fiction of the period, constantly portrayed flitting through the public spaces of the capital, flirting with and imitating genteel females. *The Rake of Taste* (1735), for example, derided the fops who drifted around St. James Park—men like "yonder pretty Toy, who like a Maiden trips, / In figur'd Crimson Silk, with Female hips."[23]

In these years, the figure of the fop was also frequently related to the visiting Italian opera singer and castrato Farinelli, whose appeal among elite Englishwomen was relentlessly dramatized as a shocking symptom of the feminization of British culture and the perversion of normative codes of sexual attraction. In "A censure on the ladies, with respect to the famous Farinelli," a magazine commentary of 1735, the writer turned to the males of the nation and asked, "Is there no spirit left in the young Fellows of the Age? No remains of Manhood? Will they suffer the Eyes, Ears, Hearts, and Souls, of their Mistresses, to follow an Echo of Virility?"[24] Another writer of the same year asked that a satirist "paint all the foppery and effeminacy of the coxcombs of both sexes, their affected transports, their languishing, their dying away, when the eunuch opens his wide mouth, and stretches his voice till it cracks; in fine, let him render them as ridiculous to the whole world as they are already to men of sense."[25]

Fig. 51. William Hogarth, *A Rake's Progress*, Plate 6 (detail), 1735. Etching and engraving. University of California, Berkeley Art Museum

Glancing at these attacks on cits and fops helps us recognize that the stereotype of the rake was part of an interlocking and frequently overlapping chain of representations focusing on deviant forms of masculinity. Returning to Hogarth's series, we find that his works offer a similar form of slippage between stereotypes, in which Tom is defined not only in terms of rakery but also in ways that suggest the cit and the fop. It is particularly suggestive to look at the second plate of the series, where Tom, like Lavish, having inherited a fortune from his bourgeois father, seeks to purchase and

147

Fig. 52. John Vandergucht (English, 1697–1732?) after Bartholomew Dandridge (English, 1691–1754), frontispiece for *The Cit Turned Gentleman*, from Molière, *Collected Works*, 1732. The British Library, London

manufacture an aristocratic identity for himself in the city. He is surrounded by the same kind of retinue that Molière introduced into *Le Bourgeois Gentilhomme* and that Dandridge summarized in his frontispiece: Tom's French dancing master tiptoes up to him holding a miniature violin; his fencing master thrusts his epée outwards toward the viewer; his tailor stands in the background with a new coat draped over his arms; a paid musician plays on a harpsichord; and his resident literary intellectual—an old poet—hangs about by the window holding an "Epistle to Rake."

While these details suggest the ways in which Hogarth was playing off the stereotypes of the rake and the cit, the image also suggests an equivalent play with the discourses of foppery. Tom is portrayed as an ineffectual, effemi-nate, and fragile creature of fashion and flattery, his figure pictorially aligned with those of his dancing master and the standing female in the painting behind him, the antithesis of the burly bodyguard—pictured pulling a sword out of its scabbard—whom he pays to fight his duels. At the same time, we find numerous newly introduced references to Farinelli: his name is included as the first performer on the score propped up on the harpsichord, while the long scroll that unfurls over the back of the musician's chair details the presents given to the Italian singer, including "A Gold Snuff box Chac'd with the Story of Orpheus charming the Brutes," donated by "T. Rakewell esquire." Meanwhile, the print that lies on the floor is the engraved title page of "A Poem dedicated to T. Rakewell Esq.," which shows Farinelli sitting statuelike on a pedestal, worshipped by a cluster of women. The inference is clear: Tom is depicted as one of Farinelli's foppish admirers and also defined as someone whose own self-definition as a delicately poised and exquisitely dressed focus of collective admiration apes the emasculated image of the castrato.

Hogarth's rake, it is becoming apparent, is a highly composite figure who engages with a range of representational conventions relating to deviant masculinity. If this mobility of reference parallels the remarkably fluid cultural identity of the rake in this period and offers a powerful metaphor for the ambiguities of appearance exploited by the cit and the fop, it also helps us begin recovering Hogarth's satiric practice in *A Rake's Progress*. Hogarth, we find, is maintaining the graphic satirist's traditional role as someone who self-consciously meshed a variety of materials for ironic, comic, and acidic effect.[26] In this process, meaning and interpretation are deliberately destabilized and multiplied, and a figure like Tom Rakewell, even as he is understood in terms of a specific masculine stereotype, becomes a pictorial site overlaid with alternative narratives and connotations.

The Rake in the Pictorial Field

Even though Hogarth's series is usefully linked to the preoccupations of various texts dealing with aberrant forms of masculinity and to the frontispieces and satires that shared these preoccupations, *A Rake's Progress*'s primary status as a set of images requires a closer look at the ways in which the set responded to and reworked the materials of visual culture. First of all, it is worth suggesting the extent to which Hogarth's series offers a dialogue with the biblical narrative of the Prodigal Son, which remained a paradigmatic example of excessive and irresponsible masculinity in the early modern period. The story of a young man who squanders his inheritance on "riotous living" and "harlots," before repenting and returning home to his forgiving father, had long been a subject of painted and graphic art and had often been represented as a series of images. A seventeenth-century Dutch engraving (fig. 53), like many other such prints, focuses on the prodigal as he carouses with a prostitute at a brothel, surrounded by wine bottles and glasses and accompanied by a musician. This scene is framed by six other images illustrating the different stages of the prodigal's progress and accompanied by captions. English successors to such prints maintained this concentration on the pictorial series and continued to depict the prodigal's revels in detail. Thus John Sturt produced a series of elaborate illustrations of the prodigal's story for John Goodman's *The Penitent Pardoned* (1678), including a similar engraving of the prodigal's dissolute behavior in a brothel (fig. 54). Such precedents, of course, are powerfully reminiscent of the third image of Hogarth's series (pl. R3), even down to the detail of the accompanying musician. As such, they suggest how the artist was partially adapting an established pictorial narrative of masculine irresponsibility, debauchery, and excess in his own series, something that he expected his viewers to recognize

and appreciate. In this process, the spectacle of the rake's "progress" became imaginatively mapped onto the venerable iconography of the prodigal in painted and graphic art, and Hogarth's images gained a specific kind of visual and narrative resonance as a modern retelling of an ancient pictorial story.

This has been clearly perceived by art historians, even as they have noted how dramatically Hogarth's narrative diverges from the biblical parable's ultimate focus on repentance and forgiveness.[27] Less well recognized is the extent to which Hogarth's series also responded to other pictorial materials—more particularly, those depicting the modern rake, which were frequently less obviously moralistic than the Christian narrative of the prodigal. Two images produced by immigrant artists working in London in this period provide good examples. Marcellus Laroon the elder's turn-of-the-century *Brothel Scene* (fig. 55) is an unashamedly salacious mezzotint of a prostitute and a young rake, their respective positions—in which the woman is shown casually seated, with an outstretched right hand holding a wine glass—offering an intriguing reversal of those found at the narrative center of Hogarth's orgy scene.[28] Her left hand, meanwhile, slides under the table to fondle her client's groin, a pictorial conceit that Hogarth displaces to the middle distance of his image, where we see another prostitute caressing another young rake in similar fashion. Meanwhile, the clichéd components of Laroon's erotics—the prostitute's exposed neck, breast, and stockinged leg; the rake's unbuttoned clothing, extravagant wig, and self-satisfied smile—are all recycled quite precisely in the later image, even as they are distributed across a wider range of figures.

If such a comparison suggests the ways in which Hogarth's series played with the conventions of a pornographic imagery of rakery and brothels, it is also helpful to look at a more

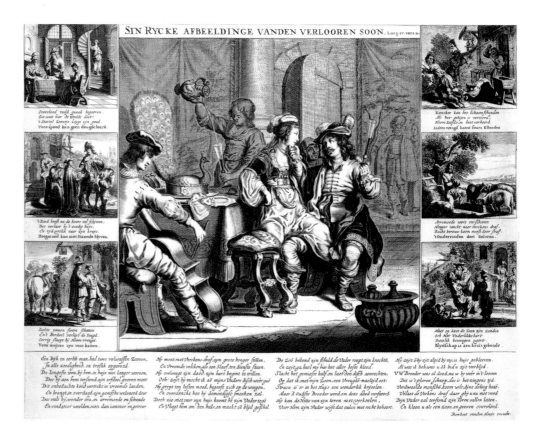

Fig. 53. Anonymous (Dutch), *Sin Rycke Afbeeldingen vanden Verlooren Soon*, seventeenth century. Engraving. Rijksmuseum, Amsterdam

Opposite: Fig. 54. John Sturt (English, 1658–1730), *The Younger Son Wasted his Substance From Riotous Living*, from John Goodman's *The Penitent Pardoned*, 1678. Engraving. The British Library, London

Fig. 55. Marcellus Laroon the Elder (Dutch, 1653–1702), *Brothel Scene*, c. 1690. Mezzotint. The British Museum, London

self-consciously refined treatment of similar themes. In Pieter Angellis's *Conversation Piece* (fig. 56), probably painted sometime in the 1720s, a central encounter between a rakish gentleman and an attentive woman is set in what seems at first sight a more salubrious and grandiose environment than that found in Laroon's print. Here, however, the mask of fashionability is surely a transparent one—on closer inspection, it is clear that what Angellis depicts is a dubious "merry company," in which the men are fashionable rakes and the women courtesans, already pairing off into couples. The painting's erotic narratives unfold across the picture space in an undulating succession of whispered propositions, gesturing hands, tender touches, and knowing smiles. In this licentious utopia of sexual collusion, an actively predatory, libidinous, and rakish form of mas-

culinity is both celebrated and dressed up in genteel pictorial clothing.

The Rose Tavern episode in Hogarth's *Rake's Progress* can now be seen as offering a satirical counterpoint to the representations of rakery found in images like Laroon's and Angellis's. On the one hand, I would argue, the depiction of Tom in this plate—stupefied, post-coital, and in the process of being robbed by the prostitute who caresses him—is used to undermine the construction of rakish masculinity found in Angellis's and Laroon's images and to define the figure of the rake as corrupt, extravagant, and foolish. This seems the most obvious conclusion to draw from such a comparison, and it is one that fits happily with the *Progress*'s dominant moral narrative, in which Tom serves as a negative exemplar of masculine irresponsibility and excess. On the other hand,

this same depiction—thanks to the fact that it ultimately demonstrates his utter ineffectuality as a rake, his comic lack of fit for the role he seeks to play, and his inability to maintain sexual potency in the company of women—may also be said to have invoked, somewhat illicitly and anxiously, that rakery we find in Angellis's and Laroon's pictures as a positive alternative. In other words, the image of sexual exhaustion and masculine ineptitude at the center of Hogarth's representation of hedonistic excess creates a kind of vacuum that asks to be imaginatively replenished by the image of its virile double. In this sense, even as Hogarth's series seems to share the moralized critique we saw in many of the writings on the rake and in the pictures of the prodigal son, the *Progress* also opens up—as a kind of unseen, unacknowledged, but subtly implied pictorial shadow to the series—that accompanying, more sympathetic imagery of the rake that was also being articulated in literary and pictorial representations of the period.

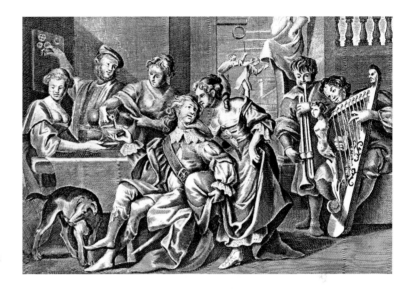

If pictures such as Laroon's and Angellis's represented one kind of pictorial template for Hogarth's series, another was provided by works that focused on the darker modes and consequences of deviant masculinity. In particular, Hogarth's last two plates, where the rake is shown sitting in despair in the Fleet prison for debtors and lying in chains in Bedlam, rework a venerable iconography of imprisonment, melancholy, and madness in British art. This iconography was found in a variety of artistic forms, including book illustrations and sculpture. The illustrations that accompanied Moses Pitt's *Cry of the Oppressed* of 1691 (fig. 57), for instance, demonstrate the extent to which graphic culture had already concentrated on the shocking spectacle offered by prisons like the Fleet, in which debtors were crowded into cells alongside other convicted felons.[29] Hogarth's seventh plate duplicates the basic pictorial conventions and

Fig. 56. Pieter Angellis (Flemish, 1685–1734), *Conversation Piece*, c. 1720. Oil on canvas, 36⅛ x 31⅜ in. (98 x 78 cm). Tate Gallery, London

naked in chains across a stone floor. Meanwhile, as has been recognized since the eighteenth century, Tom's depiction in the last plate of the *Progress* also invokes the statues of Melancholy and Raving Madness that stood above the doors of Bedlam Hospital, carved by Caius Gabriel Cibber in the seventeenth century.[30] By ending his series with such a clear reference to these allegorical figures of monumental public art, Hogarth encourages the viewer to read Tom as a vehicle of allegory and to understand the *Rake's Progress* as a series of images that ultimately subordinates the entertaining and voyeuristic depiction of the rake to a more abstracted, intellectualized form of artistic meditation.

Whether or not we respond to such pictorial cues, noting these points of contact with other art forms does suggest the representational models and conventions that Hogarth was working with in his depiction of the rake's final days, and they reveal again the variety of pictorial vocabularies that the artist was exploiting and manipulating in his series as a whole. In this process of satiric adaptation and response, the language of high art is mixed with low, the discourses of rakery tied to those of medicine and the law, and the iconography of orgiastic masculinity juxtaposed with that of a more morbid, desolate maleness, emblematized by Tom's vacant stare in the penultimate plate of the *Rake's Progress* and by his twitching, cramped body in Bedlam.

Contrasts

Collectively, Hogarth's representations of Tom Rakewell not only engaged with writings and images defining deviant or negative forms of masculinity. They also offered a resonant contrast to the models of polite manhood being articulated in contemporary culture. In this period, as a number of scholars have convincingly demonstrated, "politeness" was becoming increasingly powerful as an ideological forma-

narrative preoccupations of such imagery, even as it introduces—particularly through the figure of Tom himself—the signs of what the print's caption calls "Mad Despair."

Here and in his later depiction of the rake's descent into abject lunacy, Hogarth was engaging with well-established pictorial conventions. The frontispiece to Robert Burton's classic 1632 text *The Anatomy of Melancholy* (fig. 58), for example, depicts a series of melancholic male figures whose body language offers an eerie precedent for Tom's appearance in the final four plates of *A Rake's Progress*, where he successively stands, kneels, sits, and—just as in the frontispiece—sprawls half-

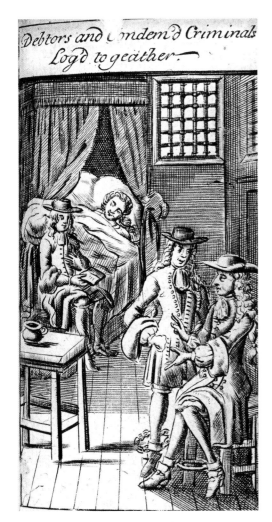

displays would indicate a lack of self-control and prove embarrassing to one's companions, and anti-social to observers. In order to avoid such situations, commentators characterized polite masculinity in terms of a second important characteristic, that of a regulated display of manners, as much concerned with avoiding offence as with promoting goodwill."[32]

Returning to the advertisement pages of the 1732 newspapers indicates the number of publications that were being promoted as blueprints for this kind of polite masculinity. In the *Daily Journal*, we find notices for the recently inaugurated *The Gentleman's Magazine, or Monthly Intelligencer,* for *The London Magazine, or Gentleman's Monthly Intelligencer,* and for a pamphlet called *The Fine Gentleman: or, the compleat Education of a young Nobleman,*

tion that offered affluent urbanites a coherent model of personal identity and behavior.[31] Politeness drew upon the values of personal civility, moderation, and benevolence and on the virtues of a decorous, controlled sociability. Polite manliness, as Philip Carter has recently noted, was based on an ideal of natural good will and good manners. On the one hand, Carter writes, "Genuine fellow-feeling produced a brand of sociability that was characterized by integrity and ease. At the same time, easiness was not expected to degenerate into an unregulated display of social affection. Such

Fig. 57. Anonymous, *Debtors and Condemn'd Criminals Log'd togeather*, from Moses Pitt, *The Cry of the Oppressed*, 1691. The British Library, London

Fig. 58. Anonymous, frontispiece for Robert Burton, *The Anatomy of Melancholy*, 1632. The University of York Library

Fig. 59. William Hogarth, *The Wedding of Stephen Beckingham and Mary Cox,* 1729–30. Oil on canvas, 50½ x 40½ in. (128.2 x 102.8 cm). The Metropolitan Museum of Art, New York. Marquand Fund, 1936 [36.111]

written by a certain Mr. Costeker.[33] While the contents of magazines and pamphlets like these helped translate polite values and virtues into specifically masculine form, contemporary pictorial representation was also helping define a polite ideal of masculine identity. A canonical example was provided by John Faber's portrait prints of the celebrated Kit-Cat Club, copied from Sir Godfrey Kneller's paintings, which were engraved and published by Faber in the same years as the *Rake's Progress*.[34] The Portraits offered a powerful ideal of urbane attentiveness and conversational ease. Leafing through a folio of these prints, the viewer

absorbed Kneller's male sitters as a collective and was invited to appreciate the flow of gestures and looks across the different engravings as a pictorially choreographed demonstration of elite conviviality, in which the Kit-Cats engaged not only with the spectator but with each other.

While Kneller and Faber's works promoted a masculinity grounded in the space of the gentleman's London club, another model of polite manhood, which situated it in a familial context, had been pictorially mediated by Hogarth himself in his conversation pieces and marriage portraits of the late 1720s and early 1730s. In *The Wedding of Stephen Beckingham and Mary Cox* of 1729–30 (fig. 59), the bride and groom are placed in a chain of figures that includes the two officiating clergymen and spans a grand architectural space. Beckingham is positioned as a sensitive husband and son, delicately lifting his wife's white finger to put on the ring, supported in his polite male status by a reassuring network of looks from his parents and prospective in-laws.[35]

Having noted this picture and those engraved by Faber, it becomes more apparent that the *Rake's Progress*'s language of masculinity would have been understood in relation to texts and images fashioning a more polite model of manhood in this period. Tom Rakewell is shown as someone whose appearance and behavior offers a comic, grotesque perversion of that masculine urbanity, fraternity, and ease dramatized by the Kit-Cat portraits. Meanwhile, the fifth plate of *A Rake's Progress* (fig. 39) seems to burlesque Hogarth's own picture of Stephen Beckingham's marriage. In a highly self-reflexive way the artist dramatizes Tom's corruption and decline through gesturing to a thoroughly polite iconography of matrimony and affection and contradicting it on a systematic basis. The soaring ecclesiastical interior we found in the Beckingham portrait is transformed into a dilapidated vestry; the two clergymen become

repulsive caricatures of venality and penury; the beautiful bride is replaced by a shrunken spinster, and the allegorical role of the two *putti* is assumed by a pair of frisky dogs. Most importantly for the purposes of this essay, Tom is pictured as a shifty-eyed near-replica of Beckingham, whose impolite, rakish status is given away by his surreptitious glance at a pretty young bridesmaid, even as he too prepares to place a ring on his new wife's finger.

Hogarth's pictures of the rake, it is now clear, were highly responsive to the period's pictorial codes of respectable masculinity. Indeed, I would like to suggest that images of figures like the rake and the polite gentleman were mutually dependent categories of representation in contemporary urban culture, each regulating and framing the boundaries of the other. However, this relationship was not clear-cut or simply formed through the combination of opposites. Rather, the representation of masculinity in contemporary visual culture was highly dialectical, as a work like Hogarth's, which invokes different representational stereotypes of polite and impolite manliness simultaneously, serves to exemplify. How, it is now possible to ask, did this dialectical construction of masculinity inform and frame Hogarth's status as a producer of "manly satire"?

Satire and Masculinity

The artists and writers who produced social satire in the first half of the eighteenth century were often seen as figures operating both inside and outside respectable urban society. However critical their focus on the underside of London life, they were frequently understood as men who must have participated in, and been infected by the corrupt environments and narratives they described in their works. Hogarth, however celebrated, was no exception. In a review of his recent output in the London *Universal Spectator* of March 1734, he is acclaimed as a highly original modern artist

and criticized as someone who all too easily veered toward the vulgarity he depicted. The writer declares that "painting, like poetry, is divided into several classes. The Grotesque, in which the Dutch are said to excel, generally exhibits the Humours of a Country-Fair, a Wedding, a Drinking-bout etc. In this species,

Fig. 60. William Hogarth, *A Rake's Progress*, Plate 5 (detail), 1735. Etching and engraving. University of California, Berkeley Art Museum

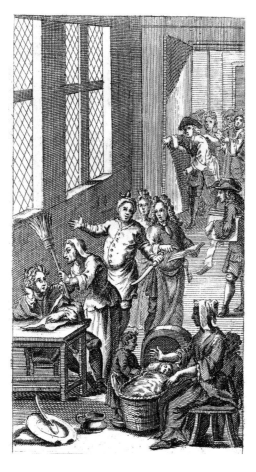

Fig. 61. Elisha Kirkall (English, c. 1682–1742), *The Poet's Condition*, illustration for Tom Brown, *Works*, 1730. Engraving. The British Library, London

we have at present a Gentleman of our own country very excellent, I mean the Ingenious Mr Hogarth, who has given the Town a new piece of Humour in his Harlot's Progress, and in that of a Rake, which will shortly appear. These grotesque painters I take to be exactly the same with the Burlesque poets, the Design of both being to please, and move laughter. But, they are both too apt to give up Decency for a joke: the Poet would leave modesty for a merry rhyme or a clench; as the painter would good manners for an arch conceit."[36]

In response to this kind of perception, social satirists tended to be pulled in one of two directions: they could either dramatize their contacts with the forbidden underworlds of the metropolis and focus with undisguised relish on the most sordid kinds of breakdown and corruption in the city, or they could remold themselves as genteel ironists who concentrated on the more respectable arenas and aspects of contemporary life. As part of this process—and this is the point I would like to pursue here—social satirists came to adopt different kinds of masculine personae. At one extreme, we are confronted with the coarse, scurrilous, rakish, and good humored man-about-town, who happily concentrated his gaze on the squalid subcultures of the city as well as on the hypocritical institutions of high life. At the other, we are faced with the refined moralist whose wit was deemed acute because of his familiarity with the etiquette and morés of respectable society and whose works, because of their elegance of style and gentility of subject matter, were deemed suitable for a polite audience.

In the literary culture of the period, the individual who provided the most celebrated model for the former kind of satire was someone who has already been encountered in this essay, the turn-of-the-century satirist Tom Brown, whose writings were constantly republished during Hogarth's career. Indeed, a collected edition of Brown's satirical writings, complete with illustrations, was issued in 1730. In this publication, Brown's narrator follows a similar topographical path to Hogarth's pictorial *Rake's Progress*, as he takes an Indian visitor on a boisterous and uproarious tour of the taverns, bawdyhouses, churches, gaming houses, and madhouses of the city. The narrator, even as he castigates these establishments, is defined as someone who revels in the low culture of the metropolis. He enjoys making dirty jokes, inventing filthy metaphors, listening to the most indecent conversations, and leering at the city's women.[37] Meanwhile, at the other extreme, the writer who was promoted as the most exquisite producer of refined satire was Molière, whose plays, as we have seen, were being newly translated and published in the

early 1730s. Works like these were appreciated as satirical dissections of bourgeois and aristocratic life that, in the words of a contemporary advertisement for the collected works, were "chaste and moral, as well as . . . most diverting."[38] Their author, in this process, was lauded as someone who, even as he made his audiences and readers smile, embodied a genteel, polite masculinity. His writings taught them to distinguish "betwixt honest satire, and scurrilous invective; betwixt decent Repartee, and tasteless ribaldry; in short, between vicious satisfactions and rational pleasures."[39]

What is so interesting about Hogarth in *A Rake's Progress* and what gives his series its variety and range, is that he seems to be simultaneously offering a pictorial version of both kinds of satire and an artistic version of both kinds of masculine identity. The parallel between his mode of social satire and that of Brown is confirmed by some of the illustrations to the literary satirist's collected writings, which closely approximate Hogarth's output. *The Poet's Condition*, engraved by Elisha Kirkall (fig. 61), is just one example of many. In this instance, Kirkall's satiric image of the starving poet in his garret is one that invites comparison with the penultimate plate of the *Rake's Progress* (pl. R7), where Tom is similarly defined as a failed writer (his rejected manuscript lying on the table beside him). He too is surrounded by a scolding woman, a man with a book in his hand and a key at his waist, and an abandoned "wife" and child. Far more obviously, however, Kirkall's image shares the concerns of Hogarth's *The Distrest Poet* (fig. 62). Studying Hogarth's output alongside the illustrated volumes of Brown's literary satires constantly throws up such parallels and suggests how closely images like *A Rake's Progress* were aligned with the most scabrous, chauvinistic, and impolite kinds of satirical commentary on the city and with a specific kind of raucous masculine comedy.

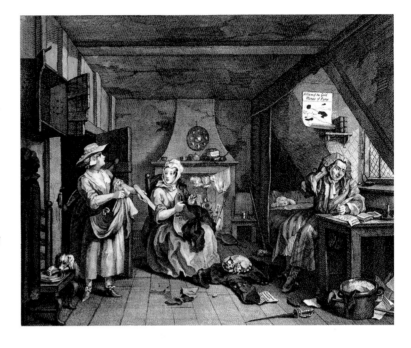

On the other hand, the links between Hogarth's work and the contemporary promotion of a more genteel kind of social satire is suggestively indicated by his involvement in the 1732 publication of Molière's collected works. Indeed, he designed the frontispiece to the opening play in the publication *The Miser, a Comedy* (fig. 63). Here the artist engages with the themes of miserliness, seduction, and emulation that were to structure the first plate of his *Rake* series, as he illustrates a scene in which Harpagon, the miser, accuses the figure on the right, Valere, of stealing his money, seducing his daughter, and pretending to a false nobility. On this reading, the opening scene of the *Rake's Progress*—in which a miser is pictured in a portrait hanging over the fireplace, and in which we find a similarly theatrical grouping of figures—could be enjoyed as the first act of an unfolding pictorial drama which approximated the "honest," "decent," and "rational" humor of Molière and defined its author as a similarly polite and gentlemanly figure.

Fig. 62. William Hogarth, *The Distrest Poet*, 1740. Etching and engraving. The British Museum, London

157

Fig. 63. John Vandergucht after William Hogarth, frontispiece for *The Miser*, from Molière, *Collected Works*, London, 1732. Engraving. The British Library, London

discussed earlier in this essay. In addition to producing satirical drawings and canvases that offer suggestive parallels to Hogarth's painted and printed works, he was famous as "a man of pleasure" who nightly caroused in the clubs and taverns of the city.[40] While Hogarth continued to cultivate a similarly gregarious, expansive, and unconventional artistic persona in these years, it is also clear that he increasingly sought to develop an identity, both as an artist and as a man, that was far more restrained and decorous. This is signaled most obviously by his move to the genteel surroundings of Leicester Fields, in the fashionable West End of the city, in 1733. It was here that the paintings and prints of *A Rake's Progress* were put on display in 1735, in a house and studio whose doorway was surmounted by a bust of Van Dyck, the most gentlemanly of artistic precedents. Another, more oblique sign of Hogarth's attempt in this series to elevate the status of his satiric images is the fact that he employed the distinguished French engraver Louis Gerard Scotin to help him translate the eight painted images into prints. In terms of both setting and style, such developments helped insure that both *A Rake's Progress* and its creator kept a certain distance from the vulgar subcultures they described and from the various modes of masculinity that were associated with them.

Hogarth's "manly satire," it is now becoming clear, can no longer be linked to just one kind of viewpoint; rather, his representation of the rake was mediated by an artistic manliness that was dialectically torn between the vulgar and the refined, the bohemian and the polite. And if Brown and Molière offered relevant literary models for these different points of view, artistic examples and precedents were also close at hand. A number of Hogarth's contemporaries in the London art world were celebrated for their colorful, bohemian lifestyles and for a satiric wit that was expressed not only in their art but also in their words and behavior. In this respect, it is worth mentioning Marcellus Laroon, the son of the artist who produced the pornographic mezzotint

Hogarth's project in *A Rake's Progress*, we can now conclude, was complexly gendered at the level of artistic production as well as at the level of subject matter. Thanks partly to the increasingly polarized dynamics of social satire as a genre of literary and pictorial production and to the emergence of the *Rake's Progess* at a point in his career when Hogarth seems to have been keeping a number of professional identities in play at once, his series can be understood as embodying a mode of artistic manliness that fluctuated between extremes of boisterous ribaldry and gentlemanly politeness.

This is another reason for the fluidity of the rake's representation in Hogarth's series. On the one hand, the perspective that Hogarth shared with writers like Brown and artists like Laroon helped define Rakewell as a feeble, immature, and effeminate interloper in a metropolitan subculture of vice and corruption that only the hardened, worldly male satirist was equipped to enter or even imagine with safety. Meanwhile, from the perspective that Hogarth shared with playwrights like Molière and the refined inhabitants of Leicester Fields, Tom was available to be understood as a naive, clumsy, and vulgar interloper into the world of high culture that only the ironic eye of the genteel male satirist could accurately decipher. In the series as a whole, of course, these different scenarios and perspectives overlap and coagulate to insure the narrative unity that links one image securely to the next. Binding these different representations together was a job completed by the viewer, as he or she walked in front of the eight paintings in the artist's showroom or leafed through the engravings of the *Rake's Progress* in a folio of prints. I would like to suggest that this activity too was gendered in rather distinctive ways.

Masculinity in Vision

Here I imagine some of the responses of heterosexual male visitors to Hogarth's showroom and do so with the aid of a poetic commentary on the series published in the year of its publication. In *The Rake's Progress: or, the Humours of Drury Lane . . . which is a complete key to the eight prints lately publish'd by the celebrated Mr Hogarth*[41] the poem's narrator is someone who both criticizes the rake and sympathizes with him and exploits every opportunity to titillate his readers with sexual innuendo and obscene description. In the poem the main villain becomes Tom's father, the miser, who is castigated for raising his son too strictly and for ignoring him in favor of his "hoards of ill-got

gains."[42] Meanwhile, the narrator exploits an image like that of the orgy scene at the Rose Tavern not only to ridicule Tom's bamboozled plight but also to offer a lascivious catalogue of the pictured prostitutes's multifarious attractions: "First Yates the darling of his heart, / Whose secret charms such bliss impart. / So sweetly move her Buttocks, Thighs, / Her Legs, her Arms, her Breast, her Eyes, / Her lover in a rapture dies . . . Next Sally King with curling hair, / All jet black, all smooth and clear, / A skin most white the contrast shews, / Near where love's sacred arbour grows; / Warm, eager, ripe for the embrace . . . and Betty with a gentle arm, / Prompt the impotent to warm, / In her soft hands the living Birch / Grew stiff, and seem'd to own her Touch."[43]

Modern scholars have tended to pass over such responses to Hogarth's series in silence.[44] But, remembering the kind of precedents offered by the texts and images of the rake we have looked at in this chapter, it is possible to appreciate this poetic redaction as one that offers a suggestive reading of Hogarth's third image as both moralized *and* loaded with pornographic associations. It is worth focusing for a moment on the fact that Tom is pictorially counterbalanced by the undressing figure of Nan the Posture maker, who is about to swivel nakedly on the silver platter being carried through the door, displaying her vagina in a variety of different positions for the males sitting around the table. Even as contemporary viewers were invited to ridicule Rakewell's stupefied gullibility then, they were also asked to imagine the spectacle of a woman displaying her body for sexual stimulation and entertainment. Unsurprisingly, this is quickly picked up by our author, who goes on to describe this spectacle in detail and to conjure up a vivid picture of the naked Nan and her sex: "View ev'ry limb and ev'ry feature, / You never saw so fine a Creature, / Its clothing like a Sable Ruff, /

159

Well furr'd, and thick, and warm enough / To make an Alderman a muff."[45]

This poetic *Rake's Progress* suggests that, even as they paced through the genteel environment of Hogarth's showroom, the male viewers of the pictorial series were temporarily assigned a spectatorial perspective that paralleled the debauched vision of the rake and followed a voyeuristic visual pathway articulated by the artist. Indeed, they were momentarily given a viewpoint that mimicked the gaze of a visitor to the brothel—the gaze of a prostitute's client[46]—even as they were invited to turn their eyes towards more exemplary subjects and their minds to more appropriately dignified meditations. Continuing their visual passage along the series and encountering the last two plates in particular, the same viewers were of course given a very different perspective, in which their viewpoint within Hogarth's showroom was aligned not so much with that of visitors to the Rose Tavern but with that of visitors to the Fleet Prison and Bedlam Hospital. In this role, they could be expected to respond to the spectacle before them with due sensitivity and gravity, and in this process confirm their status as concerned, respectable male citizens.

It now seems clear that the gendered dialectics of representation that we have been recovering necessarily extended to the process of spectatorship as well. The male visitors to Hogarth's establishment in Leicester Square, as they were asked to assume a series of different viewing perspectives—both respectable and disreputable—in front of each of the eight paintings, were actively participating in the production of a highly contentious and conflicted early-Georgian manliness, articulated not only across the field of the image or across the field of cultural production but also across the fields of space and vision.[47]

Notes

1. *Daily Journal*, London, 11 May 1732, no page number.

2. The two most important recent accounts of the series are Paulson 1992, 15–47, and Bindman 1981a, 55–71. See also Kunzle 1966, 311–48; a special issue of *Apollo* (August 1998) which is largely devoted to the series; and the relevant entries in Paulson 1989a. This chapter complements a broader discussion of Hogarth's work in Hallett 1999 and in Hallett 2000.

3. Bancks 1738, 94.

4. W. Davis 1996, 233.

5. Anon. 1693, no page number.

6. Atterburyana 1727, Section III, 62.

7. Hillman 1994, 54–55.

8. Anon. ca. 1735, 1.

9. Anon. 1718, 9.

10. Ibid., 13.

11. Ibid., 18.

12. Ibid., 20.

13. For more on the figure of the libertine, see Foxon 1965.

14. Anon. 1732a, 49.

15. Anon. 1732b, 32.

16. Anon. 1705, 33.

17. Brown 1927, 55.

18. This poem is published in the *London Magazine: or, Gentleman's Monthly Intelligencer*, London, April *1735*, 216.

19. I have dealt with the figure of the fop at more length in Hallett 1999, 187–90.

20. Reproduced in the *London Magazine*, May 1732, 74.

21. *Select Comedies of Molière, in Eight Volumes*, London, 1732, vol 2.

22. These are all advertised in the *Daily Journal*, London, 1732; see the issues for 17 April, 13 May, and 5 April respectively.

23. Anon. ca. 1735, 9.

24. *London Magazine*, vol. 4, 1735, 128–29.

25. Ibid., 185.

26. For a more detailed description of this practice, see the introduction to Hallett 1999, 1–26.

27. See especially Kunzle 1966, 311–48, and O'Dench 1990, 318–43. There is also a brief but suggestive discussion of these issues in Burstin 1998, 15–16.

28. This image is reproduced and discussed in Solkin 1993, 51–52.

29. A number of these illustrations, including the one I discuss, are reproduced and discussed in Bender 1987.

30. See Nichols 1781, 94. More recent writers have pointed to the ways that Rakewell's depiction in the final plate of the series also invokes paintings of the Pietà or the Deposition. See, for instance, Paulson 1991–93a, 2:21.

31. See, in particular, J. Brewer 1997; Klein 1994; and Solkin 1993.

32. Carter 1997.

33. For the first two titles, see the *Daily Journal* for 5 May 1732; for the final publication, see the May 19 edition of the same newspaper.

34. For extended discussions of Kneller's paintings, see Solkin 1993, 27–47, and J. Brewer 1997, 40–46. As mentioned in Einberg 1987, 51, Hogarth owned a set of Faber's prints.

35. This painting is reproduced and briefly discussed in Einberg 1987, 73–75.

36. Reproduced in the *London Magazine*, March 1734, 22–23.

37. Brown 1730. I have discussed Brown's writings at greater length in Hallett 1999, 182–87. His writings are an invaluable resource for any study of early eighteenth-century satire.

38. *Grub Street Journal*, 11 January 1732, no page number.

39. *Select Comedies of Molière*, no page number. This quote is taken from the dedication to the 1732 edition of Molière's works.

40. For Laroon's life and career, see Raines 1967.

41. Anon. 1885.

42. Ibid., 52.

43. Ibid., 23–24.

44. Given the dominant reading of Hogarth as a producer of Modern Moral Subjects, this may not be surprising. Such a reading is, of course, most closely associated with Ronald Paulson. To be fair, the poem is mentioned, but not discussed, in Paulson 1989a, 90.

45. Anon. 1885, 26.

46. For a related discussion of the viewpoints on offer in Hogarth's earlier *Harlot's Progress*, see Hallett 1999, 100–102.

47. Hogarth's series was, of course, also being scrutinized by women. I would like to suggest that one of the most striking properties of the eight paintings and prints is their self-conscious acknowledgement of the female gaze. While female viewers were expected to engage with the image of Tom—and with his intermittent "femininity"—they were also provided with a wide range of female figures they could alternately identify with or distance themselves from: the protective mother, the wealthy spinster, the corrupted prostitute, the naive bridesmaid, the fashionable asylum visitor, and, above all, the wronged but loyal figure of Sarah Young. (For more on the depiction of Sarah Young, see Crown, this volume). Indeed, moving through the series we find that Hogarth deliberately opens up a parallel narrative of female devotion, subjection, sensibility, and spectatorship to accompany his imagery of the rake. As we travel from Sarah's weeping face on the edge of the first image to her weeping face on the edge of the last, we are constantly shown pictorial spaces split into what might be called masculine and feminine pictorial zones, the latter dominated by the figures of women. These zones provided an alternative visual pathway through the series, one that offered a feminized counterpoint to the representation of Tom's doomed passage through the city.

"Nature Revers'd": Satire and Homosexual Difference in Hogarth's London

Richard Meyer

Since the early 1980s, a number of historians have analyzed the rise of a specifically male homosexual subculture in eighteenth-century London.[1] This body of historical scholarship deals primarily with textual evidence, whether literary, legal, or popular. When images appear in this history, they are most often taken as illustrations of authentic subcultural experience. This chapter looks at pictures from popular broadsheets of Hogarth's day as well as a number of prints by the artist to suggest a different, and far less stable, relationship between homosexuality and visual representation in eighteenth-century London.

In an influential book entitled *Homosexuality in Renaissance England* (1982), Alan Bray traced the emergence of the molly within British culture of the late seventeenth and eighteenth centuries. The molly marked a departure from earlier concepts of sexual deviance—the "bugger" and the "sodomite," for example—in that "[t]here was now a continuing culture to be fixed on and an extension of the area in which homosexuality could be expressed and therefore recognised; clothes, gestures, language, particular buildings, and particular public places—all could be identified as having specifically homosexual connotations. . . . What had once been thought of as a potential vice in all sinful human nature had become the particular vice of a certain kind of people, with their own distinctive way of life."[2]

One of the earliest known representations of the molly is an illustration (fig. 64) that accompanied a 1707 broadsheet entitled "The

Women-Hater's Lamentation." The image at the center is intriguing because of its ambiguous depiction of space. Are the two men pictured in a courtyard or an interior room? Are they indoors, outdoors, or in a liminal space between? The question has particular significance in relation to the subcultural marking of space that Bray describes. "There was across London," he writes, "a network of . . . houses, known to society at large as well as to their customers as molly houses (or more rarely 'mollying culls')."[3] Bray charts the houses that existed in London by 1720, moving from Margaret Clap's House on Field Lane in Holborn (where Miss Clap would host twenty to forty men on Sunday nights) to some private rooms in a Soho tavern called the Red Lion, a brandy shop in Charing Cross, and the back room of the Royal Oak, a tavern on St. James Square. "Such places," he argues, "merged into a coherent social milieu [which stood] . . . in sharp contrast to the socially amorphous forms homosexuality had taken a century earlier."[4] And it was within the "coherent social milieu" of the molly house that the scandalous activity of men dancing, kissing, and having sex with one another was said to occur.

In the illustration from "The Women-Hater's Lamentation," the dance of two mollies stands in for (and perhaps presages) other and more intense forms of physical embrace and exchange. The interlocking forms of the male couple play off against the tonal contrasts of the illustration, creating a visual syncopation

of mirroring and difference, of overlap and opposition. Notice, for example, how the same-sex matching of the mollies is choreographed against, and reiterated by, the paired but tonally inverted windows.

For all its symbolic significance, this illustration was produced within a specific disciplinary context, one that sought to warn potential sodomites of the fatal repercussions of their behavior. In the broadsheet where this image appeared, the image of two men dancing together (a dance that includes, or gives way to a kiss on the cheek) has been sandwiched between two pictures of self-inflicted death (fig. 64). Same-sex coupling is depicted as literally suicidal.

Like the pictorial images of the molly's demise, the verse of "The Women-Hater's Lamentation" describes and enforces the molly's death sentence:

> Nature they lay aside
> To gratifie their lust
> Women they hate beside
> Therefore their fate was just
>
> But see the fatal end
> That do such Crimes Pursue
> Unat'ral Deaths Attend
> Unnatural Lusts in You

In 1707, three men arrested for "intriguing with one another" committed suicide in a London prison.[5] According to Randolph Trumbach, "The Women-Hater's Lamenta-tion" was published on the occasion of this triple suicide.[6] The broadsheet functioned not to commemorate the men's deaths, however, but to exploit them as a means of social control and disciplinary threat.

As the title of "The Women-Hater's Lamentation" suggests, the molly was typically understood as a rival to and a hater of women. The rivalry between mollies and women is exemplified by a 1763 broadsheet entitled "This is not the THING: or, MOLLY EXALTED." The illustration depicts a molly in the pillory surround by onlookers—all female—who ridicule him with taunts of "Shave him close," "Flogg him," and "Cut it Off." (fig. 65). Like "The Women-Hater's Lamentation," "This is not the THING" sought to aggravate concerns among women (whom it referred to as "ye injured females") about the shortage of potential husbands by representing the molly as both an unholy competitor for available suitors and as a man who had willfully rejected his natural role as husband and father. The verse of "This is not the THING," printed beneath the image of the molly in the pillory, reads in part:

> Ye Reversers of Nature, each *dear* little Creature,
> Of soft and effeminate sight,
> See above what your fate is, and 'ere it too late is,
> Oh, learn to be—all in the *Right*.
>
> VI
> But a Race so detested, of Honour divested

Fig. 64. Anonymous, *The Women-Hater's Lamentation* (detail), 1707. Broadsheet. The Guildhall Library, Corporation of London

The **Women-Hater's** Lamentation:

OR

A New Copy of Verfes on the Fatal End of Mr. *Grant*, a Woollen-Draper, and two others that Cut their Throats or Hang'd themfelves in the *Counter*; with the Difcovery of near Hundred more that are Accufed for unnatural difpifing the *Fair Sex*, and Intriguing with one another.

To the Tune of, *Ye pretty Sailors all.*

I.

YE injur'd *Females* fee
 Juftice without the Laws,
Seeing the Injury,
 Has thus reveng'd your Caufe.

II.

For thofe that are fo blind,
 Your Beauties to defpife,
And flight your Charms, will find
 Such Fate will always rife.

III.

Of all the Crimes that Men
 Through wicked Minds do act,
There is not one of them
 Equals this Brutal Fact.

IV.

Nature they lay afide,
 To gratifie their Luft;
Women they hate befide,
 Therefore their Fate was juft.

V.

Ye *Women-haters* fay,
 What do's your Breafts infpire,
That in a Brutal way,
 You your own Sex admire?

VI.

Woman you difapprove,
 (The chief of Earthly Joys)
You that are deaf to Love,
 And all the Sex defpife.

VII.

But fee the fatal end
 That do's fuch Crimes purfue;
Unnat'ral Deaths attend,
 Unnat'ral Lufts in you.

VIII.

A Crime by Men abhor'd,
 Not Heaven can abide
Of which, when *Sodom* fhar'd,
 She juftly was deftroy'd.

IX.

But now, the fum to tell,
 (Tho' they plead Innocence)
Thefe by their own Hands fell,
 Accus'd for this Offence.

X.

A Hundred more we hear,
 Did to this Club belong,
But now they fcatter'd are,
 For this has broke the Gang.

XI.

Shop-keepers fome there were,
 And Men of good repute,
Each vow'd a Batchelor,
 Unnat'ral Luft purfu'd.

XII.

Ye *Women-Haters* then,
 Take Warning by their Shame,
Your Brutal Lufts reftrain,
 And own a Nobler Flame.

XIII.

Woman the chiefeft Blifs
 That Heaven e'er beftow'd;
Oh be afham'd of this,
 You're by bafe Luft fubdu'd.

XIV.

This piece of Juftice then
 Has well reveng'd their Caufe,
And fhews unnat'ral Luft
 Is curfs'd without the Laws.

Licenfed according to Order.

LONDON: Printed for *J. Robinfon*, in *Fitteer-Lane*, 1707.

a man at Shafford in the pillory Ap. 1763. was killed by the populace.

This is not the T H I N G:

O R,

M O L L Y E X A L T E D.

Tune, *Ye Commons and Peers.*

I.

YE Reversers of Nature, each *dear* little Creature,
 Of soft and effeminate sight,
See above what your fate is, and 'ere it too late is,
 Oh, learn to be—all in the *Right*.
 Tol de rol.

II.

On the FAIR of our Isle see the Graces all smile,
 All our Cares in this Life to requite;
But such Wretches as YOU, Nature's Laws wou'd
 undo,
 For you're *backward*—and not in the *Right*.
 Tol de rol.

III.

Can't Beauty's soft Eye, which with Phœbus may vie,
 Can't her rosy Lips yield ye Delight?
No:—they all afford sweets, which each Man of
 Sense meets,
 But not *You*,—for you're not in the *Right*.
 Tol de rol.

IV.

Where's the tender Connection, the Love and
 Protection,
 Which proceed from the conjugal Rite?
Did you once but know *this*, sure you'd ne'er do
 amiss,
 But wou'd always be—all in the *Right*.
 Tol de rol.

V.

The *Sov'reign* of ALL, who created this *Ball*,
 Ordain'd that each Sex should unite;
Ordain'd the soft *Kiss*, and more permanent Bliss,
 That ALL might be—all in the *Right*.
 Tol de rol.

VI.

But a Race so detested, of Honour divested,
 The Daughters of *Britain* invite,
Whom they leave in the Lurch, to well flog 'em
 with Birch;
 Shou'd they flay 'em then they're—all in the *Right*.
 Tol de rol.

VII.

Press ye *Sailors*, persist, come ye *Soldiers*, inlist,
 By *Land* or by *Sea* make 'em fight,
And then let *France* and *Spain*, call their Men
 home again,
 And send out their WIVES—to be *Right*.
 Tol de rol.

VIII.

Now tho'many good Men, have so frolicksome been,
 Our Pity and Mirth to excite,
Yet may these worthy Souls have the uppermost
 Holes
 In the PILLORY;—all is but *Right*.
 Tol de rol. &c.
 Ap. 1763.

To be had at the *Bee-Hive, Strand*; and at all the Print and Pamphlet Shops in *Great Britain* and *Ireland*.

Fig. 65. Anonymous, *This is not the* THING: OR, MOLLY EXALTED (detail), 1763. Broadsheet. The British Museum, London

The Daughters of *Britain* invite,
Whom they leave in the Lurch, to well flog 'em
 with Birch;
They flay 'em they're—all in the *Right*.

When the molly was represented in eighteenth-century visual culture, he was lodged within a dual register of comic denigration and criminal deviance. But, as "Molly Exalted" suggests, the effeminate male homosexual was not only an object of horror in Hogarthian London but also one of visual interest—a subject of pictorial representation "to be had at the Bee-hive, Strand; and at all the Print and Pamphlet shops in Great Britain and Ireland."[7] How might we understand the popular investment in the molly at this historical moment?

According to theater historian Laurence Senelick, "most of the sodomites arrested and tried [in early eighteenth-century London] were indistinguishable from the rest of the population: solid fathers of families, hitherto respectable tradesmen, schoolmasters, and clerics, generally mature in age. But the reports on the molly-houses stressed the transvestite masquerade and gender playacting of their inmates, and this sensational element made a profound impression on the popular imagination."[8] The molly, then, was only the most visible and, in that sense, the most vulnerable figure within eighteenth-century homosexual subculture. Unlike the solid fathers and respectable tradesmen who were also arrested and tried for sodomy, the molly was understood, in his effeminacy of dress and manner, to invert the "natural" order of gender difference. In his unmanliness, the molly confirmed the prevailing, if hardly accurate, idea that each and every sodomite would be of "soft and effeminate sight."

The emphasis on the molly's effeminacy might be said to mask a larger anxiety about homosexual practices in eighteenth-century England—namely, that the men who partook of such practices would *not* be recognizable as such. As Senelick and other historians have argued, many of those who patronized the molly houses did not manifest the flamboyant dress and effeminate manner associated with the molly but appeared indistinguishable from any schoolmaster or shopkeeper, any husband or father. According to Randolph Trumbach, "men of all ages and occupations, men who were effeminate and those who were not, single men and those who were married with families—in all varieties men entered the subculture. All stood to lose a great deal if their actions were discovered. There was daily contempt for the obvious sodomite, and for all there were the possibilities of ostracism or blackmail, the pillory or hanging.[9]

To what extent, then, were male effeminacy and homosexuality seen as discrete categories within eighteenth-century English culture? In the remainder of this chapter, I pursue this question by consulting the pictorial work of William Hogarth.[10]

Hogarth never depicted a molly within his prints or paintings, but his work was sharply attuned to the satirical possibilities of the effeminate male figure. In the second plate of *A Rake's Progress*, for example, Hogarth sets his protagonist, Tom Rakewell, amid an entourage of hangers-on and would-be instructors, central among them a French dancing master (fig. 66). When I first saw a reproduction of this print, I took the central figure to be Rakewell and was surprised by how fey and diminutive he looked in contrast to his appearance in the first plate. This mistake, however embarrassing, is not, I think, entirely indefensible. The dancing master is stationed in the central foreground of the image, nearer to the viewer than the rake, and he is further showcased by his bow and violin, by the outstretched sword of the fencing master, and by the riding crop of the jockey. Even the staff held by Paris in the central painting on

the background wall seems to direct our attention to the dancing master. Why, in this virtually all-male space of the rake's levee, should the character most explicitly associated with effeminacy be so prominently featured? And how might the dancing master's centrality to the scene inflect the larger logic of the print?

In pursuing this question, I will temporarily remove the second plate from its intended narrative context (i.e., the other seven prints in the series) to tell a rather different story from that which Hogarth narrates in *A Rake's Progress*. By way of focusing on the question of effeminacy within this image, consider the text that unfurls from the back of the harpsichordist's chair (fig. 66). Like the other texts within the scene (the opera score on the music stand, the inscription on the racing trophy, the message held by Rakewell), the scroll is both a compositional element to be viewed and a textual message to be read. Notice, for example, how the scroll seems to half encircle and almost point to the dancing master. The scroll's text reads:

A List of the rich Presents Signor Farinelli the Italian Singer Condescended to Accept of ye English Nobility & Gentry for one Nights Performance in the Opera Artaxerxes—a pair of Diamond Knee Buckles Presented by———, a Diamond Ring by———, a Bank Note enclosed in a Rich Gold Case by——— ——, a Gold Snuff box Chac'd with the story of Orpheus charming ye Brutes by T: Rakewell Esq: 100l 20 [ol.] 100 [l.].[11]

Tom Rakewell's name concludes the list of gentry who have bestowed tokens of their admiration on Farinelli. Rakewell's is, however, the only legible name on the scroll. Indeed, it is through this inscription that we first learn our protagonist's surname. The scrolled inventory of gifts ultimately overlaps and then gives way to a print of Farinelli (fig. 67). Within the miniaturized world of that print, Farinelli poses on a pedestal, worshipped by a group of fans, one of whom is kneeling next to a banner which reads "One God, One Farinelli." At one of Farinelli's London performances, a woman in

Figs. 66 and 67. William Hogarth, *A Rake's Progress*, Plate 2, second state (detail), 1735. Etching and engraving. University of California, Berkeley Art Museum

the audience, overcome by the castrato's voice, was said to have blurted out this worshipful declaration.[12] Farinelli's arrival in London in 1734 (he stayed until 1737) created a sensation among the British aristocracy, who showered him with extravagant adulation as well as gold, jewels, and other material offerings.[13] Hogarth satirizes the foolishness and prodigality of the rake, in part by positioning him as one such fan of the visiting castrato.

An anonymous (and terrifically vulgar) print from 1737 entitled *Farinelli and His Gifts* (fig. 68) underscores the paradoxical appeal of a vocal talent predicated on the castration of the body which houses it. The print presents Farinelli within a hybrid world of art and artifice, of nature giving way to theater. The apparently natural setting in which we encounter the castrato and his female companion is elevated like a stage, complete with background drapery. The props and costuming of Farinelli (e.g., the plumage behind his head

that may or may not be connected to the peacock beside him) seem to alternate between the registers of the operatic stage and the natural world. Farinelli's soprano voice signals a larger reworking of nature at the behest of culture, a kind of intervention or slice into the supposed naturalness of gender difference. The print dramatizes that slice most explicitly by the inclusion, in the right mid-ground, of scissors and a scythe, as well as a cat playing with Farinelli's severed testicles. The single line of lyric visible on the musical sheet that Farinelli holds reads "La Colpe mia nonè" [it's not my fault], an ambiguous justification for what might be called the castrato's shortcoming. "La Colpe mia nonè" would seem to be the message offered by Farinelli to the viewer of the print (at whom he gazes) and to the female figure with whom he is paired, a figure who holds Farinelli's sexual organ with her right hand while suggesting its diminutive stature with her left.[14]

Fig. 68. Anonymous, *Farinelli and His Gifts*, 1737. Etching. The British Museum, London

In both Hogarth's pictorial world and that of this anonymous French print, Farinelli is the object of satirical derision not because he is wholly outside the circuitry of heterosexual desire but because his combination of flamboyance and emasculation proves so paradoxically appealing to women.[15] The pairing of Farinelli with a female companion and the castrato's status as an object of spectacular display are evident in both prints. Whether placed on a pedestal or beneath a peacock's plumage, Farinelli is simultaneously aligned with, and set in extravagant contrast to, the femininity of women.

In a portrait of Farinelli painted by one of Hogarth's rivals, the Venetian artist Jacopo Amigoni, in 1735 (fig. 69), the same year that Hogarth published the prints for *A Rake's Progress*, Farinelli is again paired with a partially undraped female figure; in this case it is Euterpe, the muse of lyric poetry and music. With his sash of flowers and pink and cream satin dress, Farinelli is no less an object of pictorial attention and sensual allure than Euterpe. Indeed, his lips are rosier, his cheeks more flushed, his fingers yet more delicately placed than hers. As Amigoni sees it, Farinelli's emasculated beauty is to be deified rather than satirized in the Hogarthian manner.

Hogarth himself would revive the figure of the castrato (although not the particular character of Farinelli), along with that of the dancing master, in the fourth scene of *Marriage A-la-Mode* of 1745 (fig. 70). The bejeweled castrato, all velvet brocade and porcine excess, is shown in the midst of singing, while the dancing master—his hair still in paper curls, his legs crossed just so—sits in dazed disaffection. Hogarth deposits his group of four men on one side of his composition to create—as in the second plate of *A Rake's Progress*—an all-male space, a ghetto of foppish interaction. As if to reinforce the associations of this group with same-sex desire,

Fig. 69. Jacopo Amigoni (Italian, 1685–1752), *Portait of Farinelli*, 1735. Oil on canvas, 109 x 73⅓ in. (277 x 186 cm). Romanian National Museum of Art, Budapest

Hogarth has placed a version of Michelangelo's *Rape of Ganymede* on the wall behind them. Both the figure of the castrato—always presented as Italian—and that of the dancing master—typically associated with France or French culture—embody forms of masculinity which are marked as much by frills and foppery, by affectation and ornament, as by anatomical sex. It was typical not only of Hogarth but also of his cultural moment that the most effete and decadent characters should be presented as foreigners or as imitative of foreign mannerisms and dress. Tract-writers and satirists of the eighteenth century frequently traced the problem of English effeminacy to continental, especially Italian, sources. What is particularly striking about these discourses is how insistently they map social and sexual anxieties onto cultural and geographical differences. For example, a 1749 tract entitled

Richard Meyer

Fig. 70. Simon François Ravenet
(French, 1706/21–1774) after
William Hogarth, *Marriage A-
la-Mode*, Plate 4, *The Toilette*
(detail), 1745. Engraving. Hood
Museum of Art, Dartmouth
College, Hanover, New
Hampshire. Purchased through
a gift from the Hermit Hill
Charitable Lead Trust

"Since the introduction of ITALIAN OPERAS here, our men are grown insensibly more and more effeminate; and whereas they used to go from a good comedy warmed with the fire of love and from a good tragedy, fir'd with a spirit of glory; they sit indolently and supine at an OPERA, and suffer their souls to be sung away by the voices of Italian Syrens."[17] Tracts such as "Reasons for the Growth of Sodomy" exemplify the increasing anxiety over sodomy in eighteenth-century England and, alongside that, the effort to thrust the cause and source of sodomy outside the boundaries of British culture and national tradition.

The link between effeminacy and continental culture recurs in Hogarth's work in the first plate of *The Analysis of Beauty*, published in 1753, in which a dancing master is paired with a classical statue of a male nude (fig. 71). In his text for *The Analysis of Beauty*, Hogarth writes, "If a dancing-master were to see his scholar in the easy and gracefully turned attitude of the Antinous, he would cry shame on him, and tell him he looked as crooked as a ram's horn, and bid him hole up his head as he himself did."[18] Hogarth's juxtaposition of the two figures has been taken by art historians as a means of contrasting the "serpentine line of beauty"—here represented by Antinous—and the relative inelegance of the straight and narrow profile of the dancing master.[19] It has not been lost on Hogarth scholars, however, that the dancing master, a figure already associated with effeminacy, should partner a statue of Antinous. As Ronald Paulson writes,

The juxtaposition [of the statue] with the contemporary dancing master leads the spectator to ask more particular questions of the Antinous [than those having to do with the serpentine line of beauty]. Antinous was the minion of the Emperor Hadrian, deified and celebrated throughout the ancient world in versions of this statue erected by the emperor in memory of his drowned lover. The Christian Fathers were outraged by the emperor's making a god of this

"Reasons for the Growth of Sodomy in England" argued that: "Of all the customs Effeminacy has produced, none [is] more hateful, predominant, and pernicious than that of the men's *kissing* each other. This *fashion* was brought over from Italy (the Mother and Nurse of Sodomy) where the master is oftener intriguing with the page than a fair lady."[16]

The tract goes on to blame Italian operas in particular for emasculating British men:

boy who seemed to them no more than a male whore. In the context of Hogarth's composition, the effeminate dancing master activates these memories, suggesting that the dancing master may be indecently propositioning Antinous.[20]

While largely in agreement with Paulson's interpretation, I would stress the comic absurdity, rather than the "indecency," of the dancing master's proposition to a marble statue. In pairing the figures of a contemporary fop and a classical nude, Hogarth satirizes male effeminacy while avoiding the more "difficult" image of a live male couple. In this context, we might note the degree to which Hogarth has exaggerated the contrapposto stance of the Antinous so as to underscore the statue's effeminacy.

In a recent essay on the history of effeminate gestures, Thomas King writes that "Hogarth valorized the serpentine line as the standard of the beautiful, which he defined as the form and proportion necessary to sustain the subject, or the 'fitting.' But here [in fig. 71], that line is made excessive, and we are to read that excess as giving way to a *content*. Hogarth's sketch seems to ask us to see the difference between a 'fitting' serpentine line and the illustrated example [of Antinous], and to register that difference as homosexuality."[21] I am convinced by King's reading of this detail up to its last word, "homosexuality." While it is true that effeminacy and sodomy were linked within eighteenth-century discourse, the two were not equivalent (as we saw in the case of the castrato), and the concept of homosexuality as an organizing identity—a core feature of particular individuals but not of others—had yet to coalesce fully.

What is most striking about Hogarth's representations of effeminacy is the way they refuse to resolve into a stable sense of sexual identity, to mean "homo" or "hetero" in ways recognizable to us today. The satiric force of effeminacy inflects Hogarth's depiction of the

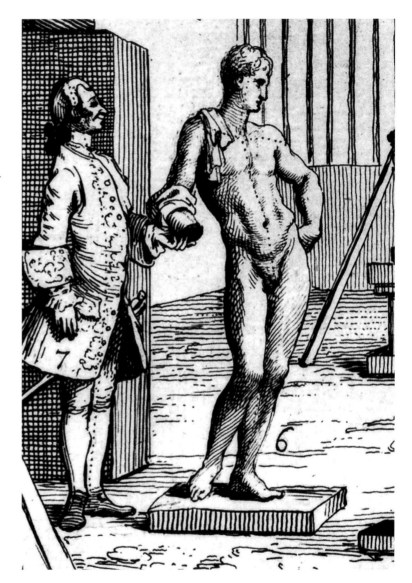

dancing master, the statue of Antinous, and even the rake, without defining any of these figures as mollies—without, that is to say, portraying them as effeminate sodomites. The statue of Antinous, for instance, is at once an example of the serpentine line of beauty and a satire of patrician effeminacy, an allusion to same-sex love and an insistence on the Italian

Fig. 71. William Hogarth, *The Analysis of Beauty*, Plate 1, *The Sculptor's Yard* (detail), 1753. Etching and engraving. Lewis Walpole Library, Yale University, Farmington, Connecticut

Richard Meyer

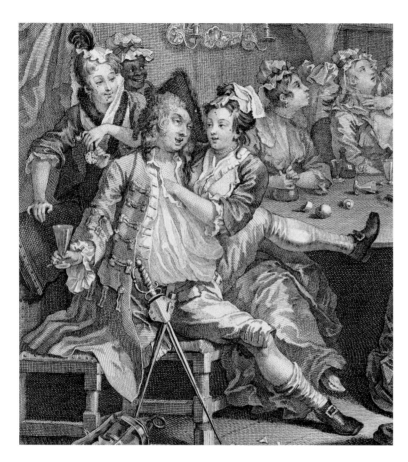

Fig. 72. William Hogarth, *A Rake's Progress*, Plate 3 (detail), 1735. Etching and engraving. University of California, Berkeley Art Museum

(which is to say, foreign) sources and artistic models for such love. *A Rake's Progress* is similarly multivalent in its handling of effeminacy: after associating Rakewell with the affectations and emasculations of the dancing master and the castrato in the second plate, the progress turns to the heterosexual pleasures of the tavern (fig. 72). The irreducibility of Hogarth's male characters (e.g., dancing master, Antinous, castrato, even Tom Rakewell) to the terms of any secure binary of homo- versus heterosexuality suggests one aspect of the complexity and difference, the queerness if you will, of gender within Hogarthian satire. As students of eighteenth-century art and visual culture, we would do well to avoid imposing our own categories of gender and sexuality onto Hogarth's quite differently ordered world.

Notes

This essay is a slightly revised version of a paper delivered at "Hogarth Forever! Historical Interpretation and Contemporary Perspectives," a conference held at Columbia University on 7 November 1998. My thanks to Christina Kiaer and Alan Staley for inviting me to speak at the conference and to Ronald Paulson and David Bindman for their helpful responses to the paper I presented there. I wish to thank George E. Haggerty for sharing his important work on male effeminacy in eighteenth-century English culture. Finally, I am grateful to David Romàn for his intellectual engagement and support.

1. See, for example, Bray 1982; Trumbach 1977, 1985, 1989; Haggerty 1999; Norton 1992; Rowland 1998; McFarlane 1997; Patterson 1997.

2. Bray 1982, 92, 104.

3. Ibid., 82.

4. Ibid., 85.

5. See Trumbach 1990, 136–37. On the arrest of these and other men accused of sodomy in 1707, Trumbach cites *The Tryal and Conviction of several reputed Sodomites . . . 20th day of October.*

6. Ibid., 136.

7. "This is not the THING: or, MOLLY EXALTED" (1763), reprinted in Wagner 1988, 38.

8. Senelick 1990, 50–51.

9. Trumbach 1997, 15.

10. On the distinctness of effeminacy and male homosexuality in English literary, popular, and visual culture of the eighteenth century, see Haggerty's excellent chapter "Straight Fops/Gay Fops"; Haggerty 1999, 44–80; and Hallett, this volume.

11. In citing the text of the scroll, I have followed the transcription offered by Paulson 1989a, 2:163.

12. According to Jeremy Howard, "After a sensational performance as Arbace in Riccardio Broschi and Adolph Hasse's opera, *Artaserses* [Farinelli] was showered with gifts and adulation and a certain Mrs. Fox-Lane was so overcome with emotion that she stood up and shouted, 'One God, One Farinelli' " (Howard 1997, 32). For this anecdote Howard cites Hawkins 1776, 5:321. See also Paulson 1991–93a, 1:163. Paulson cites the London *Daily Journal* of 6 June 1735 as having reported the "One God, One Farinelli" outburst.

13. On Farinelli's stay in London, see Freeman 1980, 397–98 and Hallett, this volume.

14. On this print, see Bindman 1997a, 111.

15. On the appeal of castrati, including Farinelli, to women, see Rosselli 1988 and Barbier 1996.

16. "Reasons for the Growth of Sodomy in England" (1749) was reprinted in McCormick 1997, 138–39. This passage recalls the central image from "The Women-Hater's Lamentation" of two mollies dancing and perhaps kissing.

17. McCormick 1997, 141.

18. Hogarth 1997, 4.

19. On the serpentine line of beauty, see Paulson's introduction to Hogarth 1997 and Bindman 1997a, 54–56.

20. Paulson 1991–93a, 3:103.

21. King 1994, 31.

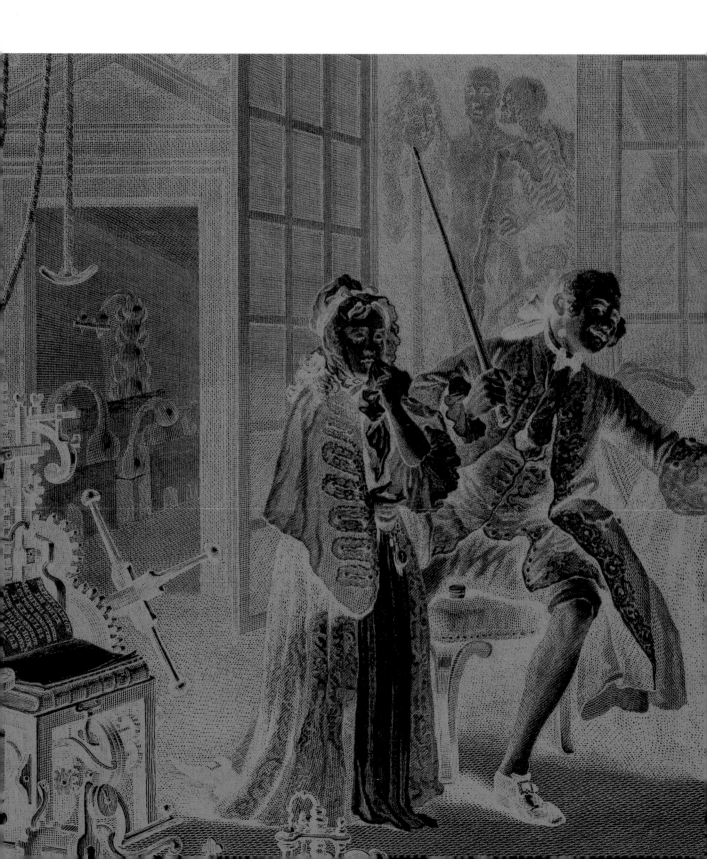

III Cultural Critique

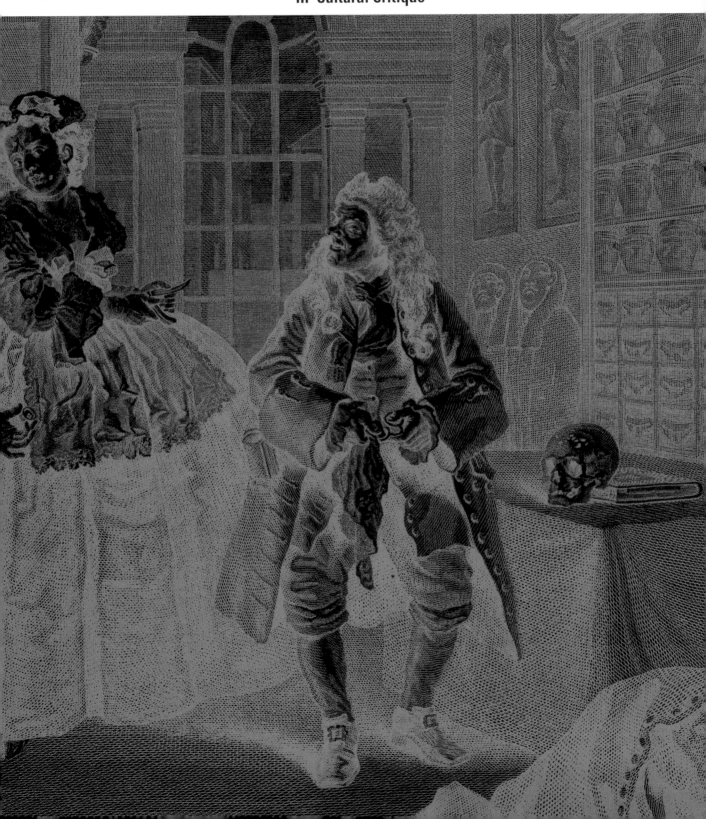

The Fetish over the Fireplace: Disease as *genius loci* in *Marriage A-la-Mode*

David Solkin

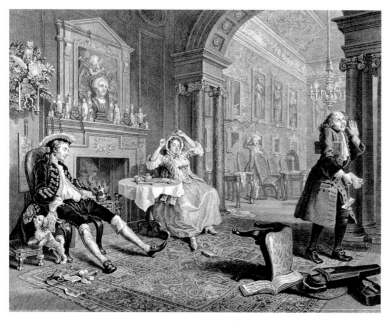

Fig. 73. Bernard Baron (French, 1696–1762) after William Hogarth, *The Tête à Tête*, 1745. Etching and engraving. Hood Museum of Art, Dartmouth College, Hanover, New Hampshire. Purchased through a gift from the Hermit Hill Charitable Lead Trust

On the left of the second scene of *Marriage A-la-Mode*, ironically entitled *The Tête à Tête* (1745; fig. 73), a marble bust of distinctly dubious quality sits in the middle of the mantelpiece, blindly surveying the scene of a union that has already gone terribly wrong (fig. 74). Like many second-rate antiquities that were palmed off on gullible eighteenth-century English collectors, the sculpture looks to be a composite production, uniting the facial features of a male portrait with a hairstyle that appears to have been lifted from the likeness of a late second-century Roman matron.[1] The torso portion with its fuscous draperies may have come from yet another source, while the

plinth underneath is probably of eighteenth-century manufacture. At some point the neck has been broken and repaired and a new nose substituted for a lost original; in both places a careless restorer has left his tracks plainly visible, marked by the glue that has oozed out of the irregular cracks and dried to a disruptively darker tone upon exposure to the air.

Those uneven lines effectively dramatize the piece's inescapable materiality and at the same time highlight its nature as a meeting place of heterogeneous elements—a modern nose and an ancient face, a man's physiognomy and a woman's hair, old marble and new adhesive—though the elements of which I am thinking are not so much material fragments as parts of different ideological worlds. In its passage from classical Italy into contemporary Britain, the object has undergone a change in identity, becoming a commodity invested with various types of significance—as a fashionable decoration, for instance, as an antiquity, and as a work of art—that are quite foreign to its origins. At the same time, however, its hodgepodge appearance in these particular circumstances also articulates a relationship between the society it has entered and that from which it has come and between their respective systems of values and beliefs. In this and in the other respects outlined, Hogarth's statue fulfills the defining criteria of what anthropologists call a "fetish,"[2] and as is consistent with the operation of other fetishes, we shall see that the bust over the fireplace exerts a controlling influence over

the bodies and minds of those individuals who fall beneath its spell.

That the sculpture in *The Tête à Tête* has been assigned a part of considerable power over the narrative is something we might already assume from its physical position, which calls to mind the deployment of similar motifs in English conversation pieces of the 1730s. Perhaps the closest comparison can be made with Hogarth's own *Indian Emperor* of 1732–35 (fig. 75), which he seems to have used as a rough compositional template for the second *Marriage* scene.[3] In the earlier painting the room is dominated by a bust of the late Sir Isaac Newton, who happens to have been related to the patron, both personally and professionally. But the inclusion of Newton's sculpted likeness does more than identify this connection as a source of family pride—the classicized bust also conveys a more general message, as the embodiment of an *exemplum virtutis*, which simultaneously represents the past and offers itself as a model of behavior for the present and the future. Perched well above the living figures, the mantelpiece sculpture in conversation-piece portraiture suggests a constellation of values and allegiances that transcends the sitters' particular differences and forges them into a meaningful community; meanwhile, the head's commanding position above the hearth places it at the symbolic center of the home, at the traditional focal point of domestic warmth and fellow-feeling. Here, like the figure of some Roman household god,

Fig. 74. Bernard Baron (French, 1696–1762) after William Hogarth, *Marriage A-la-Mode*, Plate 2, *The Tête à Tête* (detail), 1745. Etching and engraving. Hood Museum of Art, Dartmouth College, Hanover, New Hampshire. Purchased through a gift from the Hermit Hill Charitable Lead Trust

the bust gives concrete form to the spirit of the place, to the *genius loci* which both animates and presides over the interior and its inhabitants. Under normal circumstances one would expect that spirit to be healthy and benign, but in *Marriage A-la-Mode* it signals the grisly presence of sexual and moral disease.

This is hardly, I should hasten to add, a new or original observation. Hogarth's interpreters have long recognized that sickness plays a prominent part in what is arguably (and paradoxically) the most elegant of his Modern Moral Subjects; more specifically, the bust,

Fig. 75. William Hogarth,
*A Performance of "The Indian
Emperor or The Conquest of
Mexico by the Spaniards,"*
1732–35. Oil on canvas,
51 x 57 in. (131 x 146.7 cm).
Private collection

ously on a multiplicity of levels; the discourse of disease does not permit the separation of flesh and spirit, body and mind, the personal from the social, or the medical from the moral. Certain ailments, moreover—notably those (but not only those) which are seen to originate in transgressive sexual behavior—tend to be endowed with punitive associations, as we have recently seen in the case of AIDS. As Susan Sontag has observed, "Feelings about evil are projected onto a disease. And the disease (so enriched with meanings) is projected onto the world."[5] This projection of inner feelings onto external objects is absolutely central to the dynamic of fetishism: for in the words of William Pietz, the fetish is "first of all, something intensely personal, whose truth is experienced as a substantial movement from 'inside' the self . . . into the self-limited morphology of a material object situated in space 'outside'."[6] In the fictive space of the second plate of *Marriage A-la-Mode*, the bust over the fireplace operates in precisely this way, as the solid repository of deeply felt anxieties about the chaotic implications of venereal disease.

For a sculpture with a restored nose to become a symptom, however, it must occur in a suitable context, and in the case of *The Tête à Tête* this is provided in part by the preceding image in the series, where we are first introduced to disease as a major player in *Marriage A-la-Mode*. Principally at issue here is the Earl of Squander's gouty foot (fig. 76), which announces his nobility in terms no less uncertain than his coronets and his family tree: in the eighteenth century it was widely assumed that "this Disease, more than any other, is wont to afflict the noblest Patricians, and Persons of the greatest Rank and Figure in Life."[7] Beyond defining the Earl as a willing victim of his own appetites for rich foods and wine, the gout may also have suggested a history of sexual overindulgence. Among men still in the prime of life—and Squander appears far from old—this

with its crudely replaced nose, has often been identified as a marker of venereal contagion, which, once it has been unleashed, will remain a destructive force until the series comes to an end. What I am proposing here is to build upon this basic recognition by analyzing more closely the character of the doomed marriage's governing fetish, to better understand how its malignant influence shapes—one is tempted to say "deforms"—the narrative as a whole.

"The image of all disease," writes Sander Gilman, ". . . is a continuous one, and through a study of its continuities comes a sense of the interrelationship of all our projected fears of collapse."[4] The continuities to which Gilman refers are not simply those between one type of condition and another; they also encompass the cultural meanings that diseases acquire in given historical circumstances. Reading the signs of illness, in other words, requires interpreting a rich symbolic language that is deeply rooted in the communal psyche and operates simultane-

condition was generally attributed either to hereditary causes or to "an over-early use of venery" (in this case, sexual activity, not hunting).[8]

His son may also be laboring under some sort of affliction (fig. 36), but we cannot yet be sure what it is. Although the large black spot on the side of his neck may suggest venereal infection, as certain scholars have recently argued,[9] its precise identity is impossible to determine. It can be read as a symptom of scrofula, a condition often confused with syphilis; in *Gulliver's Travels*, Swift refers to "old illustrious Families" corrupted by "the Pox" (i.e., syphilis), "which hath lineally descended in scrophulous Tumours to their Posterity."[10] Another possibility is that this is a "patch" or beauty spot (in early eighteenth-century England these were worn by men and women alike), which may conceal a venereal sore,[11] or it may simply be a birthmark (Paulson makes a provocative connection with the stamp of the Earl's coronet).[12] Doubtless Hogarth would have been happy for his viewers to entertain any or all of these suppositions, but in *The Marriage Settlement* we can be certain only that Viscount Squanderfield has been marked with a stigma, a sign of some flaw in his constitution.[13] Only when we reach *The Tête à Tête* does that stigma acquire unambiguously venereal connotations.

That it does so is principally due to the fetish over the fireplace, which has been positioned in such a way as to invite comparison with the angled head of the slouching Viscount. The appearance of both figures is obviously marred—by the lines of congealed glue on the surface of the marble and the disturbing spot on the young man's neck—each suggesting the slow eruption into view of some dark fluid within the body, further implying the prospect of corporeal corruption and eventual collapse. Beneath the mantelpiece, however, the fire enacts a more rapid process of dissolution. A doubled sign of sexual passion and

Fig. 76. Gérard Scotin (French, 1698–1755) after William Hogarth, *Marriage A-la-Mode*, Plate 1, *The Marriage Settlement* (detail), 1745. Engraving. Hood Museum of Art, Dartmouth College, Hanover, New Hampshire Purchased through a gift from the Hermit Hill Charitable Lead Trust

contagion, the flames also offer a pointed reminder of that burning sensation which will soon alert the Viscount to the painful consequences of his philandering (if indeed he hasn't made this discovery already).[14]

But in keeping with Hogarth's published aim, to take "particular care . . . that there may not be the least Objection to the Decency or Elegancy of the whole Work,"[15] here as elsewhere in the series he refrains from directly portraying the ravages of syphilis, at least in anything like the guise that he and his contemporaries were used to confronting in real life. In other, less "elevated" works the artist had previously shown (in the third and fifth plates of *A Harlot's Progress*) and would subsequently depict (in the ninth scene of

David Solkin

Fig. 77. Anonymous, frontispiece to *The Rake's Progress; or, The Templar's Exit*, 1732. Engraving, 3 x 5 in. (9.5 x 12.7 cm). The British Museum, London

But three Days past — *Oh! Needles, poynts of Pins, My Back — My Head — My* XXXX *Oh! my Shinns, Lets see my Shirt Oh! Spots of Green and Yellow What will my Father say — A Pretty Fellow.*

And just to make sure that there is no doubt as to the source of the fellow's problems, the artist has included an image of plate 3 of the *Harlot's Progress* on the wall behind.[17]

In its crude banality the frontispiece reminds us of all that Hogarth leaves out—references to the discomforts, to the embarrassing effluence, and the chaotic bodily nature of the disease. Or rather, we see how he displaces the oozing discharge onto the cracks in the sculpture and the smells onto a marble nose and a sniffing dog: even if the terrier has only been aroused by the scent of perfume on the woman's cap, the sexual basis of his olfactory excitement cannot be overlooked. As Robert Cowley has pointed out, "The predominant sense of the picture [is that] of smell"[18]— which, during the eighteenth century, was ranked at the very bottom of the hierarchy of the senses. Smell was associated with the world of beasts, with the lower orders of humanity, and with women;[19] foul smells were associated with corruption and disease. The bust on the mantelpiece in the second plate of *Marriage A-la-Mode* may be incapable of sight and therefore of exercising the noblest and most masculine sense. It is, however, possessed of a prominent nose, even if this is only the substitute for a lost original.

The first time that Hogarth considered using battered Roman busts as an emblem for sexually transmitted disease, in *The Marriage Contract* oil sketch produced in preparation for the *Rake's Progress* (fig. 78), he pictured the sculptures in an unrestored state, presumably to highlight their resemblance to the noseless syphilitic. But when he returned to the motif ten years later while working on *The Tète à Tète*, he revised his original idea, sacrificing a certain ease of recognition, perhaps, in favor of saying something more complex.

What the crudely repaired physiognomy suggests, to begin with, is an attempt at a coverup, which by virtue of its obviousness cannot

Industry and Idleness) noses destroyed by the advanced stages of venereal disease, but in *Marriage A-la-Mode*, where its thematic role is arguably far more important, symptoms of the illness are invariably toned down or displaced.

One way to appreciate Hogarth's circumspection is by comparing his approach to that taken by the anonymous artist responsible for designing the frontispiece illustration for a *Rake's Progress* story first published in 1732 (fig. 77).[16] Here the eponymous protagonist is portrayed as he discovers the initial unwanted signs of gonorrhea on his underclothing, as the execrable verses underneath make clear:

> But three Days past—Oh! Needles, poynts of Pins,
> My Back—My Head—My XXXX—Oh! My Shins!
> Lets see my Shirt Oh! Spots of Green and Yellow
> What will my Father say—A Pretty Fellow.

but draw attention to the flaw that it seeks to conceal. The breakage, which has been so ineffectively masked, might aptly be termed a loss of integrity, in both the material and the moral sense, a loss which can never be recovered; the nose has gone, and with it the beauty of the face, the value of the object, and its reputation. This was how syphilis was seen to work, by defacing the noblest feature of the human body with a public badge of shame. In a poem of 1736 called *The Oeconomy of Love,* John Armstrong described venereal disease as destructive of both physiognomy and character:

> But now this Plague attacks
> With double rancour, and severely marks
> Modern Offenders: undermines at once
> The Fame and Nose, that by unseemly Lapse
> Awkard [sic] deforms the human Face divine
> With ghastly ruins. . . .[20]

The "unseemly lapse" to which Armstrong refers applied not only to the fallen nose but also to the sexual transgression that gave entry to the affliction—hence the lapse in "Fame" that was an additional burden to sufferers and the price they paid for their (moral) fall. Much the same point was made more indirectly by Dr. John Astruc, one of the period's leading authorities on venereal disorders, when he described how once "the whole Chamber of the Nose [has been] destroy'd, and the Bridge of it falling in, those who had before an elate Nose like an eagle, become flat-fac'd like an ape."[21] The progression described is from a noble to a comic beast, a precipitous decline from the sublime to the ridiculous—and though this destruction has yet to be visited on Hogarth's Viscount Squanderfield or his bride, the process might be said to have begun in the previous plate, where the Earl's aquiline proboscis stands out in such pointed contrast to the flatter, monkeylike features of his simpering son.[22]

For centuries the nose has been associated in the popular imagination with the male sex-

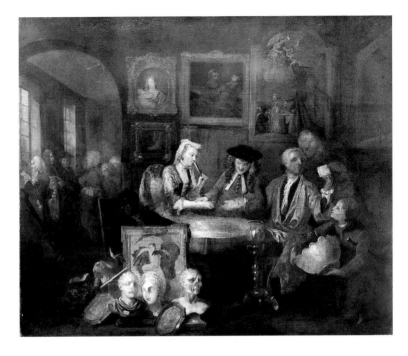

Fig. 78. William Hogarth, *The Marriage Contract* (sketch for *A Rake's Progress*), c. 1733. Oil on canvas, 24⅜ x 29 in. (62 x 75 cm). Ashmolean Museum, Oxford

ual organ; Swift may have been joking, but he was voicing a commonly held belief when he suggested that the "protuberancy" of the "superior" part must find "parity" in the size of the "inferior."[23] Thus the destruction of the nose offers itself as a metaphor for castration and as a visible indicator of the impotence that was well known to accompany syphilis in its advanced stages. Much the same point is made by the fractured and now useless sword shown lying on the floor beneath—though at least some attempt has been made to make good the loss on the statue.

This restoration marks the point of origin of the fetish, while highlighting what Pietz has described as its "power to repeat its originating act of forging an identity of articulated relations between certain otherwise heterogenous things."[24] That is to say, the creation of the bust out of its disparate components establishes a pattern of events that we find repeated elsewhere in the narrative, beginning with the attempt undertaken by a noble family to restore its flagging fortunes through marriage to a rich

bourgeois heiress. The bust is not only of a patrician figure but also a marker of patrician cultural identity, both of which evidently stand in need of shoring up—as will the Viscount's own infected body. At the same time, the application of a modern (false) nose to the face of a corroded antique implies a contrived union between new wealth and false pretensions, on the one hand, and old rank accompanied by disease on the other. And given that the repair job has been so poorly done, there seems more than a strong possibility that the fragile construction will fall apart in due course.

The comic idea of a replacement nose falling off the face of its new (and diseased) owner features in an oft-retold episode of Samuel Butler's *Hudibras* (1663), with which Hogarth and his viewers must have been well acquainted.[25] Butler caricatures the pioneering techniques of plastic surgery devised by the sixteenth-century Venetian Gaspard Tagliacozzi (1545–1599) by inventing the story that he restored the appearance of his well-born syphilitic patients by giving them new noses cut from the buttocks of serving men:

> So learned *Taliacotius* from
> The brawny part of Porter's Bum,
> Cut supplementall Noses, which
> Would Last as long as Parent Breech:
> But when the Date of *Nock* was out,
> Off dropt the Sympathetick Snout.[26]

The humorous impact of Butler's poetic anecdote rests on its imagery of noses cut from the nether regions of the lower classes being attached to the noblest parts of the socially superior and remaining in place only until the suppliers die, at which point the borrowed flesh spontaneously reverts to its original sympathies. Thus alliances forged from components of the high and the low can never overcome their ultimately inescapable incompatibility—a fact that is already self-evident in the second plate of *Marriage A-la-Mode*.

Lord Squanderfield and his City wife are not the only unsuitable coupling hinted at in the scene. In addition, there is the relationship between the Viscount and his common mistress (the mob-cap suggests a servant girl) and possibly the wife's adulterous involvement (as yet unrealized?) with her lover. They live in a world of secrets, sharing only what is hidden: the "secret malady," as syphilis was often called, which will transfer its symptoms from one partner to the next. Concealing the disease cannot make it disappear; on the contrary, it will simply make its presence felt elsewhere.

Joseph Addison was so taken by Butler's story of Taliacotius that he reprinted it in the *Tatler* as the starting point for a rather whimsical article on noses, which takes particular delight in detailing some of the unexpected consequences of the surgical techniques practiced by "the first Clap-Doctor" in recorded history. For its initial example, the essay presents the case of a Portuguese grandee, whose dark complexion proved less than a perfect match for a nose "taken from a Porter that had a white *German* skin, and cut out of those Parts that are not exposed to the Sun." "In a word," Addison continues, "the Comdé resembled one of those maimed antique Statues that has often a modern Nose of fresh Marble glewed to a Face of such a yellow, Ivory Complexion, as nothing can give but Age."[27] Not surprisingly, the notion of linking poorly restored classical busts to the stereotypical visage of the syphilitic had occurred to others prior to Hogarth, but the patchwork head is not the only motif in his *Tête à Tête* that might have reminded his viewers of the *Tatler*'s observations.

Elsewhere in his essay Addison considers the "Rise of that fatal Distemper which has always taken a particular Pleasure in venting its spight upon the Nose." Here by way of explanation he summarizes the contents of a "little Burlesque Poem in Italian," which plays with the

familiar facts of syphilis first breaking out in Europe in 1495, when, after a long siege, the French army finally forced its way into the walled city of Naples. Following its Italian source, the *Tatler* recounts how Mars "in the Shape of a *French* Colonel, received a Visit one Night from *Venus*, the Goddess of Love, who . . . came to him in the Disguise of a Sutling Wench, with a Bottle of Brandy under her Arm." The product of this union between an officer and a camp follower was a "little *Cupid*" who "came into the World with a very sickly Look and crazy Constitution. As soon as he was able to handle his Bow, he made Discoveries of a most perverse Disposition. He dipped all his Arrows in Poison, that rotted every Thing they touched; and, what was more particular, aimed all his Shafts at the Nose . . . and though his Malice was a little softened by good Instructions, he would very frequently let fly an invenomed Arrow, and wound his Votaries oftner in the Nose than in the Heart."[28]

This allegory may underpin Hogarth's placement of the damaged statue in front of a painting of Cupid, shown in a ravaged architectural setting clearly indicative of the little god's destructive powers: that he is heir to Mars, as well as Venus, is here plainly implied. Around him we see several bits of fallen masonry, including an Ionic capital echoing those in the Squanderfields' fashionable interior;[29] since both love and music were often ascribed with the power to vitiate strength of character, presumably either one or both have brought the mighty edifice of human achievements crashing to the ground. Although the infant Eros certainly looks healthy enough, the behavior that he has inspired bears eloquent testimony to the craziness spawned by his poison. He has already loosed his arrows, and they have hit their mark; all that remains for him to do now is to play a suitably vulgar and discordant serenade to accompany the confusion he has spawned.[30]

The image of a Cupid seated amidst the fragments of a great building or fortification (reminiscent, perhaps, of the city walls of Naples) asks to be read as an emblem of the deleterious consequences of excessive desire, though this is not a warning that the Squanderfields appear willing or able to understand. Not only are their backs turned to the admonitory painting, but visual access to it is in any case blocked by the poor excuse for a sculpture and the various "pagods" on either side of it. Thus a pictorial statement of the dangers of promiscuous consumption is effectively impeded by the products of that selfsame impulse. A great deal of money, it is evident, has been recently spent (presumably out of the Viscountess's dowry) on a profusion of useless and second-rate ornaments, none more prominent than a classical bust of dubious character and origin. So if our fetish embodies sexual disease, it also joins the fashionable chinoiserie around it in symbolizing *Luxuria*. Although long a standard feature in readings of *Marriage A-la-Mode*, the discursive overlap between these two tropes deserves a closer look.

In Roman political theory, as Christopher Berry has observed, "luxury represented the use of wealth to serve private satisfactions." It could take one or more of three distinct forms: ambition, avarice, or an excessive devotion to the pleasures of the body, fueled by the pursuit of material extravagance. What "these three forms have in common," he goes on to say, "is that they are species of desire . . . capable of perverting good order because they all place a premium upon self-gratification."[31] But it wasn't until Christian moralists took hold of the concept, in the writings of St. Augustine and other medieval divines, that the vice of luxury became a sin, opposed to chastity and sobriety and interchangeable with lechery. This equation remained a commonplace until the eighteenth century. What linked luxury and lechery was a founding motive—desire or

lust—and the failure of man's rational mind to exert control over his sensual body. Moreover, the two species of corruption followed a common modus operandi that achieved essentially the same results: like a venom hidden in a love potion, they embarked upon their business by masking their pernicious nature in the trappings of the sweetest pleasure, which had the effect of weakening resolve, sapping strength, and ultimately destroying virtue.

As should have been expected, perhaps, it was the classical and Christian discourse of luxury that provided those who began writing about venereal infection, from the late fifteenth century onward, with a punitive moral vocabulary to describe the causes, the mechanisms, and the effects of sexually transmitted disease. In both cases the agency of corruption was gendered feminine: just as *Luxuria* was invariably described as a temptress, in the sexual arena women were cast in the role of the femme fatale:

> Whence should that foul infectious Temper flow,
> But from the banefull source of all our wo?
> That wheedling, charming Sex, that draws us in
> To ev'ry punishment and ev'ry sin. . . .
> Though round the world the dire Contagion flew,
> She'll poison more, than e'er Pandora slew.[32]

So reads one of the dedications prefacing a late seventeenth-century translation of Girolamo Fracastoro's *Syphilis*, the most famous early modern poem written about the disease. Here as elsewhere, the source of the venereal contagion was either implicitly or explicitly identified with the figure of the prostitute, although her power to corrupt was understood to depend upon men's inability to curb their inherent susceptibility to lust.

For centuries critics of luxury had insisted repeatedly that desire clouded men's judgment and prevented them from realizing that even the most apparently innocuous surrender to temptation could produce horrendous unfore-

seen consequences. It was in precisely this manner that venereal disease was believed to act upon the bodies of its victims: its venom invaded by stealth, under the feminine guise of pleasure, before revealing the full extent of its malignant power. Thus, according to one text from 1708,

Amongst all the Diseases which Mankind are afflicted with, there is none that insinuates itself more slily, or affects after so many different and various ways, or is accompanied with more fatal Consequences, or causes more Shame and Pain, or subjects Man more to the Laws of Repentance, or produces more Disasters to the Body, or more Affliction to the Mind, than the Venereal Distemper . . . [and yet] so natural and easie is that Disease to be contracted, prompted to the occasion by the Thoughts of that most sensible Pleasure, and most gratifying Enjoyment that Man is capable of.[33]

This passage introduces us to another crucial feature that luxury and venereal disease were believed to hold in common: their corruptibility into other forms of disorder. What made luxury so dangerous to the body politic was that it made its presence manifest in a potentially infinite range of depravities, each as destructive as the next; once one illicit desire had been satisfied, new wants inevitably arose. Hence "this vice," wrote Bishop Berkeley in a political treatise of 1721, "draweth after it a train of evils which cruelly infest the public: faction, ambition, envy, avarice, and that of the worst kind."[34] It was a consistent feature of eighteenth-century medical literature that syphilis was similarly distinguished by a unique capacity to mutate into a multiplicity of equally threatening conditions; as one authority put it, "This malignant Distemper . . . makes its appearance, Proteus like, under such various and very different Shapes, that by the Consent of all the Physicians that have insight in the Nature and Accidents of the foul Disease, the like is not to be observed in any other Distemper, as yet known in these Parts of the

World."[35] John Astruc gave the same point a rather different inflection when he observed that "the nature of this Disease is of so wide an extent, and it comprehends such an infinite number of different systems, that it rather appears to be a world of Diseases than one."[36] That world, however, did not confine its boundaries to corporeal afflictions but extended in an unbroken continuum to encompass the realm of moral contagion. If syphilis borrowed its language of vice from the tradition of writing about luxury, in a reciprocal gesture it served that discourse as both metaphor and symptom of individual and social corruption.

These analogies can be extended still further into the processes by which these "poisons" grew to exert full power over the bodies they inhabited. Each gained entry in the guise of a delightful seductress, but following a dynamic that once again mirrored the progress of luxury, as the venereal venom spread and increased in potency, it lost its character of "softness,"[37] becoming instead "tyrannical, invading those that are infected with it, many times after a merciless and unaccountable manner."[38] This unfeeling tyrant may be as cold and as blind as the bust on the Squanderfields' mantelpiece, but its power has all the malevolent heat of the raging fire beneath, which consumes everything that it touches. "The Pox is a Monarch, all other Diseases are its Subjects," wrote one early eighteenth-century venereal specialist,[39] and this was a monarch whose power was capricious and absolute.

With this shift in character comes a striking change in vocabulary. Where the initial contraction of the infection is typically invoked through the verbal imagery of feminine seduction, descriptions of its subsequent progress are replete with the masculinized terminology of invasions, sieges, and military triumphs. Astruc, for example, likens the task of trying to curb the operations of this illness to an army

defending itself from simultaneous attacks on a multiplicity of fronts:

For since so many places are to be defended at the same time, there must be great danger, lest the Venereal poison attacking in greater quantities, or abounding with greater virulency than ordinary, should weaken some part or other so far as to gain admittance. In the same manner . . . as it frequently happens to those who are to defend a trench, which extends itself to a great length, if they are fallen upon by the enemy in a body, they are easily beat down and conquer'd, because being dispers'd to different parts, they are not equal in every part to a collected body of Men.[40]

That a malady attributed to the promptings of Venus was believed to behave in the manner of Mars points to a fundamental instability in the gendering of sexually transmitted disease, an instability that Addison signaled when speaking of the parentage of his "crazy" "little Cupid." This confusion finds further expression in the bust in Hogarth's *Tête à Tête*, which combines elements from antique portraits of both sexes, as noted above: we can easily understand why one early commentator called the statue a *Faustina*,[41] while another claimed it was a *Scipio*.[42] All we can say with confidence, however, is that Hogarth appears to have made a deliberate effort to eschew the gender certainties of his Ashmolean oil sketch[43] in favor of striking a significant note of sexual ambiguity—for comic, but also for serious effect.

This brings me to the final theme in the syphilis/luxury axis: the ways in which both were believed to disrupt normative constructions of gender. Bishop Berkeley was only one of many eighteenth-century moralists to describe how this worked in the case of luxury, which he condemned in an essay published in *The Ladies Library* in 1722:

Such a degenerate Age do we live in, that every thing seems inverted: the different Manners of the Sexes are confounded; Men fall into the Effeminacy and Delicacy of

Women, and Women take up the Confidence, the Boldness of Men, under a notion of good Breeding. . . . Their Gesture, their Language, nay, their Habit, too, [become] affectedly masculine, they have Men to serve them even in their Bed-chambers, and make no scruple of receiving Visits in their Beds, to imitate the Freedom of the *French*, free only in Vanity and Impudence, and Slaves in every thing else.[44]

Berkeley was addressing a female audience, warning them of the dire consequences that would follow should they pay heed to the promptings of lustful desire. Such women, it was often proclaimed, betrayed the order of nature by acting in a manner that an early commentator on Hogarth's series described as "affected, forward, pert and bold"[45]—that is to say, with an aggressiveness to be expected of Mars, perhaps, but not of any chaste goddess of love. As Ellen Pollak has written in reference to Samuel Richardson's Clarissa Harlowe, for mid-eighteenth-century English culture "the very existence of desire is a transgression of the laws of gender and is represented as the invasion of a male prerogative."[46]

The figure of Lady Squanderfield in the second plate of *Marriage A-la-Mode* eloquently speaks for just such an invasion: her legs and arms apart in a distinctly unladylike posture, her body stretching in the manner of a cat that has just awakened, her eyes provocatively half-closed, it is no wonder that she inspired the following appreciative lines from the anonymous versifier of Hogarth's series:

> Warm with the Adventures of the Night
> She h'd dreamt of a strange unfelt Delight,
> Which made her inmost Wishes rise,
> And dart their Beams from out her Eyes;
> Melted to tender kind Behaviour,
> She only long'd to grant the Favour; . . .
> In Rapture with uplifted Arms,
> She spreads abroad a thousand Charms,
> Her Neck, her Breast, expanded Legs
> And seems to grant the Boon she begs;[47]

This is a lustful, luxurious woman, in other words—though not necessarily, or at least not yet, a carrier of the pox.

As a would-be temptress she shares something in common with the prostitute, and provides an alluring reminder of the corrupting potential of her sex; but as a wife she also represents a prospective (or current) victim of contamination by her spouse. Thus she teeters uneasily on the borderline between the two principal roles given to women in the contemporary literature on venereal disease. Her adulterous husband, however, has already fallen—not only into vice but also into a weakened state of effeminacy. "What is more vile or disgraceful than an effeminate man?"[48] asked Cicero, obviously unable to imagine anything worse or more threatening to proper social order. Like most other Roman writers on luxury, Cicero believed that effeminacy arose as the consequence of a devotion to selfish forms of gratification that rendered men unable and unwilling to risk their lives on behalf of the state, which would then fall prey to internal disorders or attacks from abroad. Such concerns proved to have remarkable staying power: by the eighteenth century it had become a ubiquitous assumption of British political theory that an unconstrained pursuit of private pleasure—to quote from Bernard Mandeville—"effeminates and enervates the People, by which the Nations become an easy Prey to the first Invaders."[49]

Though this theme played a prominent part in contemporary attacks on the refinements of commercial modernity, which conservative commentators accused of softening and corrupting the body politic, there was also a powerful strand in satiric writing that focused charges of effeminacy on the more traditional target of the libertine nobleman. Jonathan Swift, for example, describes the "frequent extinction of aristocratic lines" as "a Remedy in the Order of Nature; so many great Families

coming to an End by Sloth, Luxury, and abandoned Lusts, which enervated their Breed through every Succession, producing gradually a more effeminate Race, wholly unfit for propagation."[50] What is clear from this and other similar assertions is that effeminacy was not seen as incompatible with heterosexual promiscuity; on the contrary, as Michèle Cohen has observed, "the term effeminate could refer either to a man who resembled women, or one who desired women. Effeminacy encompassed what appears to us now at the same time a blurring of gender boundaries and an affirmation of sexual difference."[51]

As one of the chief engines in this process of degeneration, lust was believed to have the same weakening effects on an individual's manhood as luxury wreaked on the manliness of society at large. The belief that excessive sexual activity sapped a man's vitality had a history that could be traced back at least as far as Galen in the second century A.D. One writer of the later 1740s phrased this familiar case in the following manner:

A Man of Pleasure may indeed, make this Copulative Science his whole Study; and by Idleness and Luxury, prompt Nature that way, and spur up the Spirits to Wantonness: but then his Constitution will be the sooner tired; for the Animal Spirits being exhausted by this Anticipation, his Body must be weaken'd, and his Nerves relax'd; neither will his irregular effeminate Life assist them in recovering their former Tone; Besides, those Parts which more particularly suffer the Violence of this Exercise, are liable to many Accidents.[52]

In Hogarth's Viscount Squanderfield we see such a man of pleasure, a rake apparently worn out by his exertions after an uninterrupted night of orgiastic revelry; but that posture of exhaustion—no less than the fire, his broken sword, his black spot, and the damaged bust above him—suggests that one of those aforementioned "accidents" has already befallen his private "parts" and that the poison has begun its deadly course. For venereal disease was also

understood to relax the "whole nervous System;"[53] as a result, "a preternatural Languor and Weariness seize the whole Body; the Strength is greatly impair'd." And "these symptoms," the writer goes on to claim, "lay a Foundation for a still greater Number of Misfortunes."[54]

Though we cannot be sure how many of these have yet befallen the young Viscount, the foundations for his ultimate collapse have been well and truly laid. By seeking sexual satisfaction outside his marriage, Squanderfield has exposed himself to venereal infection, a complaint so shameful and so various in its manifestations that it went under a multiplicity of aliases—the "secret malady," the "French disease," the "French pox," and, last but not least, the *Disease a-la mode*."[55] Thus Hogarth's title, or so N. F. Lowe has claimed, "would have led the eighteenth-century observer to look for venereal disease as . . . an encoded theme" of the series, albeit a theme "that would be hidden from innocent eyes."[56] Surely, however, given the ubiquity of this sickness and the sprawling industry of quack doctors, "cures," and medical (as well as quasi-medical) publications that thrived at the expense of those afflicted, few English viewers of the period could have failed to grasp the import of those symptoms that play so obvious a part in *Marriage A-la-Mode* from the second scene on.

Reading the engravings from left to right, as we are doubtless meant to do, one of the first things we learn of the Squanderfields' life together, thanks to the agency of the sculpted fetish, is that syphilis has entered the narrative at an early point in their marriage. Positioned between husband and wife like an unwelcome third head in their tête-à-tête, the bust operates both as a dividing line and as a point of malignant contact, a product of transgressions past and present that will propel the action forward into the future. Paradoxically, despite its blindness (which also defines its owners'

lack of vision), the marble head can see much farther than any of the living figures in the room: its eyes look over and beyond the unhappy couple toward the figure of the retreating steward ("Regeneration," as the book in his pocket is inscribed, abandoning the field to "degeneration") and beyond him into the darker scenes to come.

Once the poison has been unleashed, it takes on a life of its own. At a time when the mechanisms of its passage through the body remained utterly mysterious, one of the most terrifying features of venereal disease was that it was not only mutable but utterly unpredictable; symptoms might suddenly appear and then just as suddenly disappear or emerge as another ailment elsewhere in the body. The contagion could lie in wait for years or even decades before flaring up without evident provocation. Not everyone who had sexual contact with the same infected partner came down with the affliction, and while the consequences were sometimes fatal, more often they were not. A sizable proportion of sufferers were cured without benefit of medical intervention (which was notoriously unreliable and generally reckoned at least as dangerous as the condition itself). Syphilis, in other words, had no plot; all it had was contagion, flux, anti-plot. Hogarth could and did turn this situation to his advantage by exploiting the capacity of venereal disease as trope to enrich his story with a multifaceted and multilayered array of significant associations, but this exploding universe of meanings and metaphors could not be left to its own chaotic devices. Anti-plot had to yield to the authority of plot—not just in response to artistic imperatives, but for reasons deeply rooted in the communal and individual psyche.

The inhabitants of Hogarth's England were acutely afraid of disease, fearful that the corruption of those who had been struck down with illness would find its way into their own bodies and bring about their dissolution. Here the discourses of luxury and of venereal contagion once again found themselves on common ground, each seeking in its own fashion to manage deeply felt anxieties about the ever-present threat of corporeal and social collapse. The most complex of Hogarth's Modern Moral Subjects both expressed such anxieties and responded to them: by describing the progress of disease and its horrific consequences, *Marriage A-la-Mode* showed what *could* happen—to others, and in a world where order might be disrupted but never entirely destroyed.

"Disease," Sander Gilman has observed, "is one aspect of the indeterminable universe that we wish to distance from ourselves. To do so we must construct boundaries between ourselves and those categories whom we believe (or hope) to be more at risk than ourselves." Gilman notes that one common way to create such a division is by assigning the stigma of infection to other social types; another is to use the "fixed structures of art," which invite us to "fantasize about our potential loss of control, perhaps even revel in the fear it generates within us," but ultimately confirm that we stand apart from the chaos represented.[57] These two strategies join forces in *Marriage A-la-Mode*; by the end of the series we are left with the clear and punitive message that the malignancy which infects those "others" who indulge in illicit pleasures will have reassuringly fatal consequences. Well, not always, perhaps: certain reprehensible characters in this fictive world (like the fathers responsible for arranging the marriage) may suffer only a little, if at all, while there is at least one innocent—the Squanders' deformed child in the sixth plate—who has done nothing, beyond being the offspring of polluted parents, to deserve the heavy penalty that he (or she) is doomed to bear.

What makes *Marriage A-la-Mode* so interesting is its withholding of neat conclusions and its refusal of the proposition that the

tumultuous realm of human passions must necessarily submit to the rule of reason and moral law. Indeed that refusal, I would suggest, can be read in the battered appearance of the classical bust that has been the leitmotif of this essay. For if the sculpture is an emblem of venereal disease, it is no less a sign of elevated art. Corruption and creation, deformation and restoration, low nature and high culture—these are just some of the forces that play out their conflicts across its cracked and glued surfaces without any hope or possibility of resolution. The same holds true for *Marriage A-la-Mode* as a whole. Like some sort of fetish, Hogarth's series may work to keep the specter of disease at a distance, but it also provides a disturbing reminder that the threat of infection is never far away. Although we may try to "fix" the contagion with the help of art, in the final analysis we can only make the best of a bad job.

Notes

1. In Roman bust portraiture, the arrangement of the hair in a caplike semicircular shape, which (in the manner of a wig) stands clearly apart from the brow beneath, seems to have been used exclusively for the representation of women. The hairstyle depicted by Hogarth broadly follows the conventions used in works of the Severan period (A.D. 193–211), although the tonsure shown in the painting appears to have been cropped on both sides along its bottom edges to make it look more suited to adorn a male physiognomy. For an example of the Severan type in question, see the portrait of Julia Domna (ca. 193–94; Paris, Musée du Louvre) reproduced in Kleiner 1992, 327, fig. 290.

2. My discussion of the characteristic features of the fetish is based mainly on Pietz 1985, 5–16.

3. Aside from *A Performance of "The Indian Emperor or The Conquest of Mexico by the Spaniards,"* several Hogarth conversations of the early 1730s feature a bust upon a mantelpiece. These works include *The Wollaston Family* (1730; Trustees of the late H. C. Wollaston), *An Assembly at Wanstead House* (1730–31; Philadelphia Museum of Art), and an unidentified *Family Party* in the Yale Center for British Art, New Haven, Connecticut. The Wollastons' bust looks like a modern portrait, but

the other two examples feature ideal heads.

4. Gilman 1988, 3.

5. Sontag 1983, 62.

6. Pietz 1985, 11–12.

7. Robinson 1755, 4.

8. Sydenham 1742, 419.

9. See Lowe 1996, 174, where the spot is identified as a "venereal bubo, or tumour" of the lymphatic gland; this is certainly possible, though its black coloration would suggest otherwise. Egerton 1997, 17, asserts instead that "the black spot is in fact Hogarth's symbol for those who are taking the black mercurial pills which at the time were the only known treatment for venereal disease." While I would not dismiss this notion out of hand, it is more likely that the spot stands for the condition rather than its (supposed) cure. Evidently Egerton was unfamiliar with Lowe's essay.

10. Swift 1959, 198–99. The same passage is quoted by Guilhamet 1996, 206.

11. This is Ronald Paulson's suggestion in Paulson 1992, 217. As he points out, "The metaphor of disease permeates the series." I could not agree more. My aim is to flesh out this fundamental insight—which, while hardly unique to Paulson, has been most authoritatively articulated in his magisterial work on Hogarth.

12. Paulson 1992, 217.

13. According to Sander Gilman, by the seventeenth century "all illnesses written on the skin, following the medieval understanding of leprosy as a sexually transmitted disease, are always understood as deforming but also making one's stigma visible"; see Gilman 1995, 76.

14. As Angela Rosenthal has reminded me, flames appear in conjunction with venereal disease in at least two other works by Hogarth: Scene 5 of *A Harlot's Progress* and *The Four Times of the Day: Morning*, where fire appears beside a placard advertising Dr. Rock's cures for syphilis. In these cases too, connotations of sexual heat, contagion, and destruction would be entirely appropriate.

15. *London Daily Post and Advertiser*, 2 April 1743.

16. Anon. 1732.

17. In this context the third plate of the *Harlot's Progress* invokes two significant connections, first between the rake and the prostitute (as the likely source of his disease) and second between the rake and the syphilitic bunter (as a foretaste of the

horrors he has yet to endure). Interestingly, the inclusion of this print would seem to suggest that some of the *Harlot*'s earliest viewers might have imagined its most seductively explicit image as something a London rake might use to decorate his bedroom—presumably as a stimulus to sexual arousal and not as a moral admonition against cavorting with prostitutes. The same feature also points to the possibility, which Hogarth's interpreters have been understandably loath to consider, of individual components of his narrative series being hung on their own, where they might generate readings quite different from those prompted by the ensemble. But these issues are hardly pertinent to the main concerns of this paper, and I leave them to others to pursue.

18. Cowley 1983, 59. My investigation of certain aspects of the same Hogarth series necessarily crosses Cowley's exhaustive iconographical analysis at a range of different points, and I owe a considerable debt to his research.

19. See Classen 1997, 4–7.

20. J. Armstrong 1736, 12.

21. Astruc 1737, 2:24.

22. Egerton 1997, 16–17, has pertinently compared the young Viscount in the *Marriage Settlement* to the main figure in *The Monkey who had seen the World*, engraved by George Vandergucht after a design by John Wootton as an illustration to no. XIV of John Gay's *Fables* (London, 1727).

23. Swift 1939, 1:129. For a discussion of the long-standing association between the nose and the penis in relation to the construction of the stereotypical male Jew, see Gilman 1991, ch. 7.

24. Pietz 1985, 7.

25. Aside from the *Tatler* article referred to below (see n. 27), I have found further references to Butler's Taliacotius in Armstrong 1736, 13, and an anonymous essay in *Common Sense: or, the Englishman's Journal*, 28 January 1738, 361–62.

26. Butler 1967, 9–10. The actual technique that Tagliacozzi invented involved grafting flesh from the patient's arm onto his nose, a procedure that Butler must have felt offered considerably less in the way of comic possibilities. Tagliacozzi's classic plastic surgery text is *De curtorum chirurgia per insitionem, libri duo* (Venice, 1597). Nock, by the way, is another word for breech or fundament, though in its more common usage it refers to the notched tip of a bow—such as we see, perhaps not entirely by happenstance, in the lower left of the painting just behind the bust on the mantelpiece.

27. Addison 1710, in Bond 1987, 319.

28. Bond 1987, 318–19. This "Burlesque Poem" remains unidentified.

29. This resemblance has previously been pointed out by Cowley 1983, 75.

30. As Paulson 1992, 2:216, has pointed out, the bagpipe has "associations of cacophony and (especially in Watteau's *fêtes*) of the male sexual organ."

31. Berry 1994, 84–86. My discussion of luxury owes much to Berry's book and to Sekora 1977.

32. Anon. in Fracastorius 1686, unpaginated preface. The Latin poem was first published in Verona in 1530 under the title of *Syphilidis, sive Morbi Gallici, libri tres.*

33. Marten 1708, 204.

34. Jessop 1957, 76.

35. Sintelaer 1709, unpaginated preface.

36. Astruc 1737, 2:1.

37. Fracastorius 1686, 10, calls syphilis "the soft Invader." One of Samuel Johnson's definitions of luxurious is "softening by pleasure."

38. Marten 1708, 225.

39. Ibid., 94. Marten borrowed this phrasing from Harvey 1685, 25.

40. Astruc 1737, 1:298.

41. Lichtenberg 1966, 100.

42. Wilkes 1759, 157–58, quoted in Cowley 1983, 74.

43. The busts in the Ashmolean *Marriage Contract* are of a male youth, a *Julia*, and a *Germanicus*.

44. Berkeley 1722, 1:122–23.

45. These adjectives are used to describe the future Lady Squanderfield (in the first plate of the series) in Anon. 1746, 6.

46. Pollak 1985, 2.

47. Anon. 1746, 15. Lichtenberg 1966, 97, points out that the posture of Lady Squanderfield's arms indicates that she is "threaten[ing] her spouse with the sign of the horns."

48. Marcus Tullius Cicero, *Tusculan Disputations*, 3.17, quoted in Berry 1994, 85. In *Sir Charles Grandison* (1753), Samuel Richardson came up with an expanded version of Cicero's question, perhaps equally applicable to *Marriage A-la-Mode*: "Can there be characters more odious than those of a masculine woman, and an effeminate man?"; see S. Richardson 1972,

I:247; this passage is quoted in Gwilliam 1993, 13.

49. Mandeville 1924, 1:115.

50. Swift 1955, 12:53.

51. Cohen 1996, 7.

52. Anon. 1749, 36.

53. Robinson 1736, 168.

54. James 1743–45, 2: "Lues Venerea," unpaginated.

55. This sobriquet features in a long but not exhaustive list of the many names given to syphilis in late seventeenth-century England in Harvey 1685, 3. Recently Fiona Haslam has claimed, though without citing primary evidence, that venereal disease was also known as the "French gout"; Haslam 1996, 118.

Among modern Hogarth scholars, Lowe 1996, 172, should be credited with first observing that syphilis was sometimes described as the "alamode Disease." He mentions the example of Daniel Turner's *Syphilis: A Practical Dissertation on Venereal Disease*, 4th ed. (London, 1732), 68, as well as pointing out how frequently this phrasing appears in eighteenth-century advertisements for venereal cures. For our understanding of *Marriage A-la-Mode*, the habit of associating syphilis with modishness and Frenchness has obvious and important implications, which I do not have space to explore here. I plan to address these issues in a more extended discussion of the series in a forthcoming book, provisionally entitled *Divided Subjects: Narratives of Manhood in British Art, c.1660–1820*.

56. Lowe 1996, 118.

57. Gilman 1988, 4, 2.

Marriage in the French and English Manners: Hogarth and Abraham Bosse

Sarah Maza and Sean Shesgreen

In a richly appointed chamber hung with pictures, a marriage contract is being negotiated. Gathered around a table by an open window, the elders hammer out the particulars of the agreement. Removed a little from the bargaining table, the betrothed couple sit side by side. Gestures, looks, clothes, art, dogs—a plethora of arresting objects within the scene—offer clues to the future of this marriage, which the artist chronicles in the cycle of five titled prints that follow the opening design.[1]

Not coincidentally, this statement describes with equal accuracy the first plate of Abraham Bosse's *Le Mariage à la ville* (fig. 80), published in 1633, and William Hogarth's better-known *Marriage A-la-Mode* (fig. 79), painted in 1743 and engraved in 1745, because the British artist deliberately imitates his continental predecessor. The link between Bosse's and Hogarth's marriage suites is widely accepted (figs. 80–85 and pls. M1–6), but it has not been the object of detailed and sustained examination in formal, social, or historical terms.[2] An examination of points of similarity and difference is promising from several perspectives. For example, the radical divergence of the narratives in plates 2 through 6 is as striking as the convergence of the stories in the first plate of both series. Bosse's five subsequent images portray a sphere dominated by women; that world, composed of austerely elegant rooms, is centered on childbirth and infant care. By contrast, Hogarth's five prints offer a grim tale of coercion and mismatch leading to a marriage ruined by vanity and self-indulgence; in that story, the agency of men looms larger than the conduct or power of women, and procreation is displaced by the acquisition of lovers, bonds, mortgages, noble titles, continental paintings by "dark masters," carriages, and mansions—a whole world of consumer goods.

In this chapter we offer an interpretation of the contrast between Bosse's and Hogarth's marriage narratives that foregrounds the conditions and roles of women in the two suites, drawing on both art and social history. We document Hogarth's desire to emulate and outdo his French predecessor and show how he appropriated and drastically reworked the first plate of Bosse's suite.

Hogarth went on to produce a very different story in part, we argue, because of the divergent understandings of marriage and women's roles within the matrimonial institutions of seventeenth-century France and eighteenth-century England. We examine the different political, legal, and cultural contexts that led Bosse to put women at the bargaining table and to focus so heavily on the female networks surrounding numerous births. We focus in turn on what prompted Hogarth to tell the story of a legally hobbled and socially isolated woman cold to her only child. We do not assume, of course, that these two sets of images straightforwardly mirror the social "realities" of absolutist France and Georgian Britain. Both suites are "cultural narratives" plotted according to specific conventions of storytelling and

shaped by the ways individual authors drew upon social and material aspects of the world they knew.[3] In order to appreciate the choices made by Bosse and Hogarth, we must understand the legal, social, artistic, and material parameters of the worlds in which they lived.

I

Hogarth's hostile feelings toward continental artists like Bosse and earlier European painters (whom he sometimes scorned as either modern or old "dark masters") are well known, as are the vital economic motives and aesthetic issues that power them. So too is his distinctive method of expressing this rivalry, illustrated most saliently in his *Four Times of the Day*.[4] Characteristically confrontational in style, Hogarth modeled certain of his progresses on continental archetypes by illustrious artists. He drew attention to his "imitation" by borrowing so openly from these forerunners' motifs and even their familiar-sounding titles that the poaching invited—better yet, compelled—comparison. Such invitations to measure the best art of England against the best of France were common enough, as Timothy Clayton shows in *The English Print*.[5] Of course, not every member of Hogarth's contemporary audience would have been capable of making this learned comparison; such an analytic exercise is reserved for those knowledgeable in matters of art history—most obviously, the connoisseurs and aristocrats for whom he created *Marriage A-la-Mode*.[6] In his *Autobio-graphical Notes*, Hogarth expresses confidence that any such scrutiny will favor him, if it is carried out by an audience made up of impartial Britons. To this native constituency a comparative analysis would demonstrate the superiority of his Modern Moral Subjects and his "comic history"—which are contemporary, original, but, above all, English—over his rivals' pictures, which he views as clichéd and borrowed because they depend on exhausted traditions in French, Italian, or Northern art.

In his *Four Times of the Day*, for example, Hogarth models his designs on the *Times of the Day* by Martin de Vos, Carl van Mander, and Jan van de Passe. He modernizes their characters, anglicizes their settings, and even steals their titles in the service of a satire that cannot be understood or fully enjoyed without comparing his *Morning, Noon, Evening,* and *Night* directly with the *Morning, Noon, Evening,* and *Night* of his continental predecessors.[7] The same strategy lies behind *Marriage A-la-Mode*. That Hogarth openly borrows from Bosse, scholars agree. That he intends to communicate this borrowing to certain of his viewers, so that one portion of his audience might enjoy the progress at the level of narrative but a more sophisticated portion might also contrast it with his predecessor's cycle, is implied by the closeness with which he follows in Bosse's footsteps.

A carefully cultivated intention to provoke such a comparison would account for why the francophobic English artist uses French words ("à la mode") to name his most ambitious

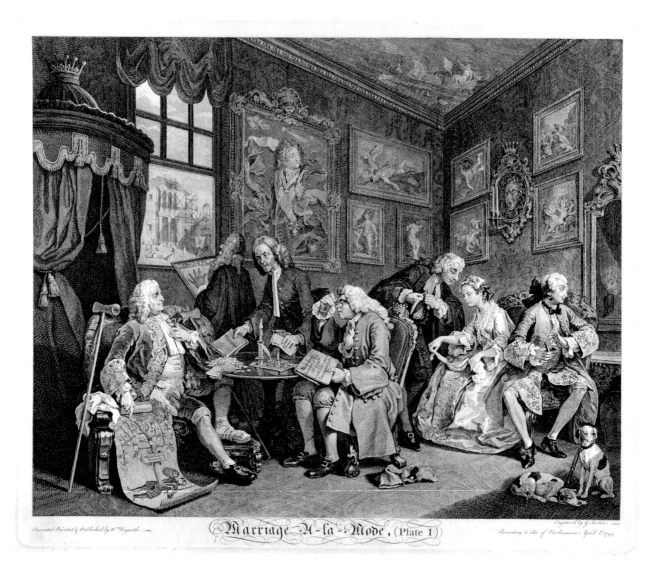

Fig. 79. Gérard Scotin (French, 1698–1755) after William Hogarth, *Marriage A-la-Mode*, Plate 1, *The Marriage Settlement*, 1745. Engraving. Hood Museum of Art, Dartmouth College, Hanover, New Hampshire. Purchased through a gift from the Hermit Hill Charitable Lead Trust

194

progress, which, like its Parisian forerunner, uses titles for its individual scenes. The first of these titles, *The Marriage Settlement*, is strikingly parallel to Bosse's first title, *Le contrat*. The five other Hogarthian titles—*The Tête à Tête*, *The Inspection*, *The Toilette*, *The Bagnio*, and *The Lady's Death*—diverge from Bosse's, though two of them use French phrasing.[8] The intent to generate a comparison with Bosse would also explain why the English artist traveled to France in May 1743 to import Parisian

engravers to reproduce his designs on copper. When that enterprise failed, he employed three French craftsmen living in London—Bernard Baron, Louis Gérard Scotin the Younger, and Simon François Ravenet—to cut and sign his designs, a move so uncharacteristic and puzzling it has prompted David Bindman to write, "It seems odd, given Hogarth's claims for English art, that the *Marriage A-la-Mode* series should have required French engravers."[9]

Following Bosse, Hogarth executed two

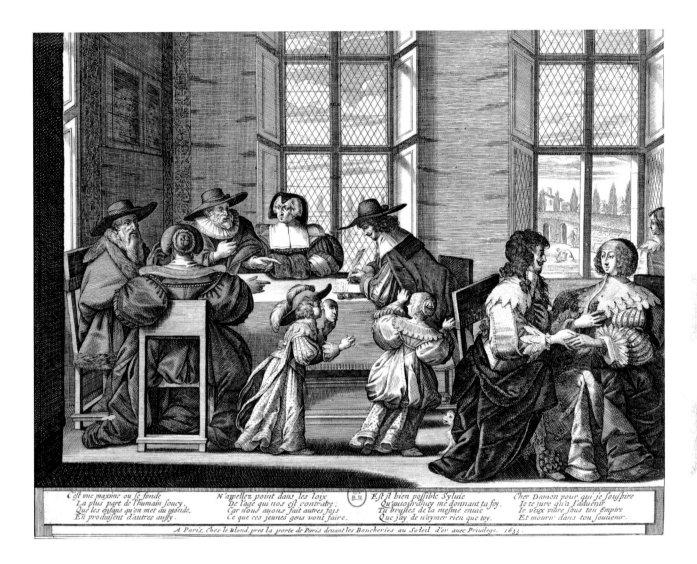

Cest vne maxime ou se fonde N'appellez point dans les loix B.R Est il bien possible Syluie Cher Damon pour qui je souspire
La plus part de l'humain soucy, De l'âge qui nos est contraire; Qu'auiourd'huy me donnant ta foy. Ie te iure qu'à l'aduenir
Que les enfans qu'on met au monde, Car nous auons fait autres fois Tu brusles de la mesme enuie Ie veux viure sous ton Empire
En produisent d'autres aussy. Ce que ces jeunes gens vont faire. Que iay de n'aymer rien que toy. Et mourir dans ton soutenir.

A Paris, Ches le Blond, pres la porte de Paris deuant les Boucheries au Soleil d'or auec Priuilege. 1633.

series on matrimony, *Marriage A-la-Mode* (which describes wedlock in the city and varies its predecessor's title only slightly) and a companion piece, *Marriage in the Country*, which copies its predecessor's title verbatim (but which the artist never completed).[10] Such direct and undisguised references to Bosse's *Le Mariage à la ville* and *Le Mariage à la campagne* make most sense as invitations to see how English wedlock compares with French matrimony and, more pointedly, how Hogarth's

progress differs from and improves upon his forerunner's narratives.

How indeed does Hogarth's *Marriage* play off Bosse's cycle, from art-historical and social perspectives? What does the English artist carry over from the Frenchman's narrative, and what does he change? What do these appropriations and alterations, especially those in the formally and thematically similar first plate, tell us about Hogarth as an artist, as a chronicler of his times, and as a middle-class

Fig. 80. Abraham Bosse (French, 1602–1676), *Le Mariage à la ville*, Plate 1, *Le contrat*, 1633. Engraving. Lewis Walpole Library, Yale University, Farmington, Connecticut

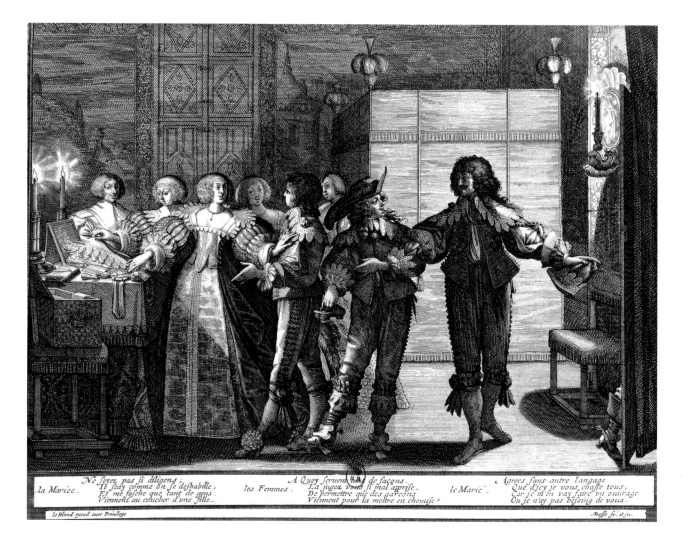

Ne seyez pas si diligens,
Ie scay comme on se deshabille,
Et me fasche que tant de gens
Viennent au coucher d'une fille.

la Mariée.

A Quoy servent tant de façons.
La jugez vous si mal apprise,
De permettre que des garçons
Viennent pour la mettre en chemise?

les Femmes.

Agrees sans autre langage
Que disje je vous chasse tous,
Car je m'en vay faire vn ouurage
Ou je n'ay pas besoing de vous.

le Marié.

le Bland excud auec Priuilege Bosse fe: it ju.

Fig. 81. Abraham Bosse,
Le Mariage à la ville, Plate 2,
La rentrée des mariés, 1633.
Engraving. Lewis Walpole
Library, Yale University,
Farmington, Connecticut

ideologue whose popular prints deliberately sought to shape the views of the people who bought them—a strategy that is particularly prominent in *Marriage*, with its anti-aristocratic didactics?

II

In formal and thematic terms, the first plate of Hogarth's progress is a self-conscious makeover of Bosse's first plate. The traditional setting for English matrimony is an Anglican church, as Antal points out;[11] in the fifth plate of the *Rake's Progress*, Tom Rakewell's wedding

is solemnized in Marylebone Old Church, familiar to Hogarth's viewers as the site of arranged, illegal, or hasty unions.[12] But in Hogarth's *Marriage*, following Bosse, the wedding is replaced by a marriage contract and is relocated to a drawing room, the grand parlor of Earl Squanderfield. From a formal perspective, the parlor drama, following Bosse again, divides into three tableaux. The first, set in the large left portion of the print, represents the realm of law. The second, set in the smaller right portion of the print, represents the realm of feeling. These two tableaux advance the

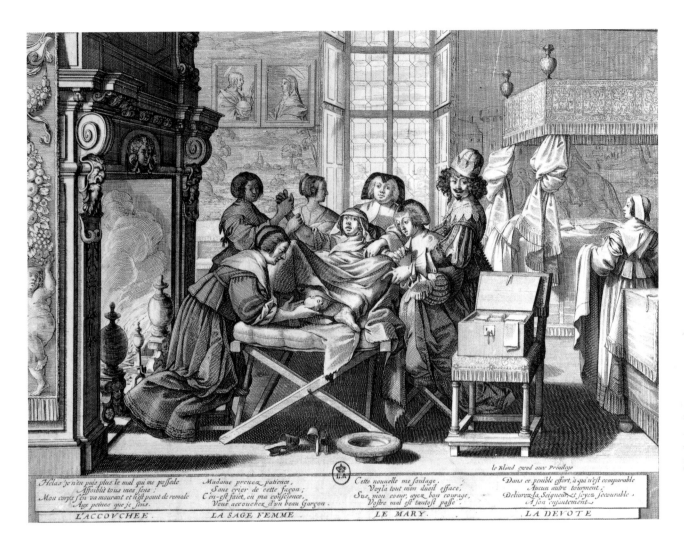

Helas je n'en puis plus le mal qui me possede,
Affoiblit tous mes sens:
Mon corps s'en va mourant et n'est point de remede
Aux peines que je sens.

Madame prenez patience,
Sans crier de cette façon;
C'en-est faict, en ma conscience,
Vous accouchez d'vn beau Garçon.

Cette nouuelle me soulage,
Voyla tout mon dueil esface,
Sus, mon coeur, ayez bon courage,
Vostre mal est tantost passe.

Dans ce penible effort, à qui n'est comparable
Aucun autre tourment;
Deliurez-la, Seigneur, et soyez secourable,
A son enfantement.

le Blond excud auec Priuilege

| L'ACCOVCHEE. | LA SAGE FEMME. | LE MARY. | LA DEVOTE |

scene's central contrasts between public and private life, ceremony and sentiment, noble appearance and tragic reality. The third tableau, framed by the parlor's only window, offers a central interpretation, not only of the first plate, but of the entire series.

In the design's first tableau, the supremely important judicial arena, the drama's elders execute the terms of the marriage compact; their mood is unified, formal, harmonious, and self-congratulatory, underlined by the haughty way the Earl holds his head high while he points to his family tree. In the second tableau,

showing the less consequential realm of emotion, the future bride and groom sit together on a couch; they are uncommunicative, discordant, and conspicuously unceremonious. The third and smallest tableau of the design is an open window that frames a busy scene relating to the construction of a new mansion. The window (formally a source of light and thematically a means of interpretive illumination) shows the Earl's opulent coach and, more important, his palatial new residence, executed in the latest neoclassical style.

So much for the similarities, predominantly

Fig. 82. Abraham Bosse, *Le Mariage à la ville*, Plate 3, *L'accouchement*, 1633. Engraving. Lewis Walpole Library, Yale University, Farmington, Connecticut

197

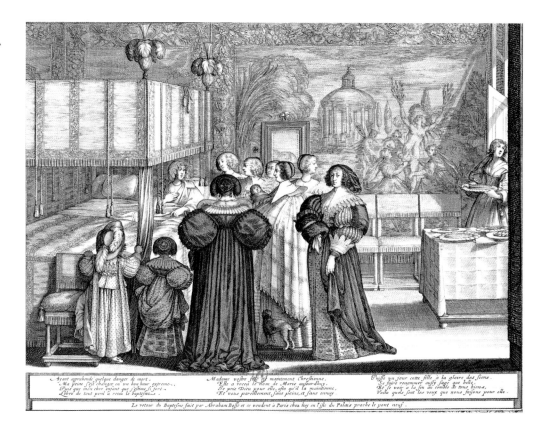

Fig. 83. Abraham Bosse, *Le Mariage à la ville*, Plate 4, *Le retour du baptême*, 1633. Engraving. Lewis Walpole Library, Yale University, Farmington, Connecticut

structural, between Bosse and Hogarth. What about the differences, which can be categorized as additions, subtractions, and alterations? The most obvious of these fall into the category of alterations. For example, Hogarth recasts Bosse's servant by inflating him from an inconspicuous factotum who gazes idly out the window (thereby inviting us to do the same) to the Earl's Palladian architect, traditionally misidentified (even in André Rouquet's "authorized" commentary) as a second lawyer.[13] A mocking reference to the prevailing craze among the nobility for extravagant Burlingtonian builders like William Kent, his importance is signaled by his physical proximity to the Earl.[14] More than anyone but the Earl, he is the culprit who, by his prodigal "Plan of the New Building of the Right Honble [Earl]," causes Squanderfield's bankruptcy,

thereby precipitating the marriage contract. He is also one of the chief beneficiaries of the financial "bailout" on which he turns his back, to admire, in a self-congratulatory way, his new mansion, previously stalled for lack of funds but now well on the way to completion. In a remarkable metamorphosis the English artist elevates the French draftsman's page (who has no thematic significance and actually looks like a bust or statue) into a recognizable English character playing a subtle but profoundly consequential role that thickens the plot of the progress and deepens its sense of causality. This surely is the kind of artful "improvement" Hogarth expects his readers to notice when he invites them to compare his design with Bosse's.

But it is not the only "improvement" or even the most central one. Hogarth alters

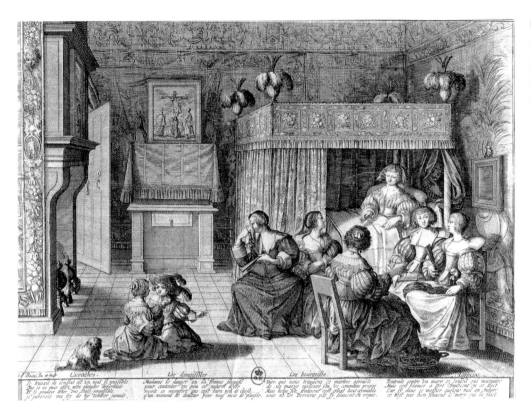

Fig. 84. Abraham Bosse, *Le Mariage à la ville*, Plate 5, *La visite à l'accouchée*, 1633. Engraving. Lewis Walpole Library, Yale University, Farmington, Connecticut

Bosse's betrothed pair in a recast that pays careful attention to substance by means of subtle posture changes. In Bosse, the happy couple, facing one another, express affection by gestures of love that are identical, highly conventional, and clichéd, almost to the point of self-parody. Mirror images of each other, the espoused twosome point with their left hands to their hearts while joining their right in a *dextrarum junctio* suggesting marital bonds. In Hogarth, the pair turn their backs on each other and declare their disaffection with expressions molded by the power of social class, a power so intense that it eclipses the forces of gender in the man and woman.

The passive and compliant Viscount (the courtesy title given to an earl's son), hiding any feeling of distress, dances nervously on the tips of his toes, takes snuff with an "effeminate" ges-ture of thumb to forefinger, and admires himself in the mirror, where he is blind to the face and predatory conduct of the old Earl's lawyer, Counselor Silvertongue. The Viscount's blindness comes from a narcissism passed on to him by a father who gestures toward himself and postures as if he were sitting for his portrait.[15] The young woman, wearing a scowl, leans forward in a hunched pose that mimics her clumsy father, a short-sighted London alderman, whose postural awkwardness Hogarth satirizes by depicting the man's sword sticking comically through his legs. The mutinous young woman expresses her anger and resistance by threading her handkerchief through her wedding ring, an act of prophetic irreverence. Her fate and that of her future husband's, as well as her sullen, oppositional nature and his acquiescent disposition, are allegorized in the sitting up and "lying

199

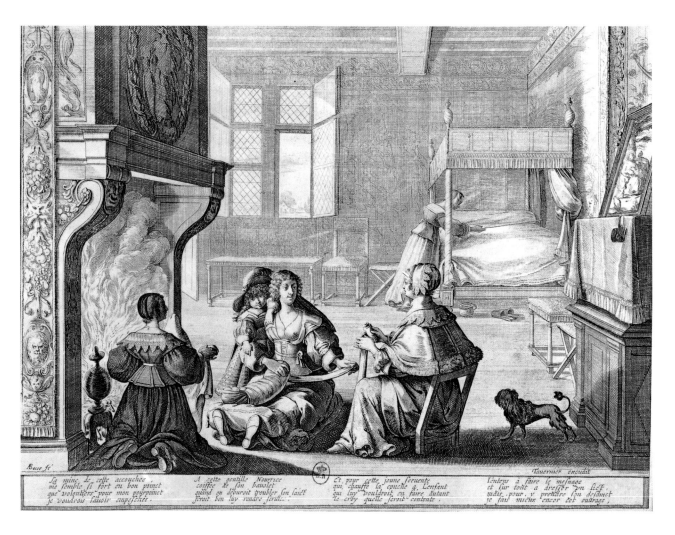

La mine de cette accouchee,
me semble si fort en bon poinct
que volentiers pour mon pourpoinct
je voudrois sauoir empescher.

A cette gentille Nourrice
coiffee de son bauolet
quand on desiroit troubler son laict
seroit bon luy rendre ferule.

Et pour cette jeune seruente
qui chauffe la couche à l'enfant
qui luy vouldroit en faire autant
ie croy quelle seroit contente.

Tenteux à faire le mesnage
et sur toit a dresser vn fief
mais pour y prendre son desduct
je fais mieux encor cet outrage,

Bosse fe
Tauernier excudit

Fig. 85. Abraham Bosse,
Le Mariage à la ville, Plate 6,
La visite à la nourrice, 1633.
Engraving. Lewis Walpole
Library, Yale University,
Farmington, Connecticut

down" foxhounds, manacled derivatives of the pup playing with the children in Bosse. The recumbent dog is branded with the Earl's proprietary coronet, a heavy-handed Hogarthian stroke. Shifting from an analysis of cause (architectural extravagance) to a study of effect (incompatible pair in venal union), Hogarth transforms Bosse's betrothed couple from simple lovers whose responses to the happiness are indistinguishable to complex victims whose responses to their fate are compellingly differentiated by their individual dispositions, by their class origins, and by their gender.

Not only does Hogarth alter Bosse's

figures, but he also adds characters who are not in *Mariage à la ville* and subtracts others who are. In addition to the architect, he adds two other specialists, a fat lawyer and a thin moneylender. If the lawyer's role is peripheral to this complex economic transaction involving banknotes, gold coins, releases, and settlements, the banker's place is central, signaled by the fact that he orchestrates the financial proceedings, releasing the Earl's mortgage while amassing sacks and bills of money for himself. These professional men, whose roles in the legal negotiation are so vital that they can be said to shape it, represent a new class of powerful

middlemen coming to the fore in English law and finance. Such "parasites" play no role in Bosse's print or in his world.

Hogarth's inclusion of these men is linked to his exclusion of women, the most notable of all his subtractions. In Bosse, five people sit around the negotiating table: the father and mother of the bride, the father and mother of the groom, and the notary. This amanuensis's modest dress, servile demeanor, and marginal seat at the bottom of the table peg him as a low-level functionary, a factotum with no say in the proceedings he records. The principals in Bosse are equals; around the table, men and women share power in an exchange that is mathematical in its balance and symmetry. Waving his hand, the gentleman by the window makes a point, to which his wife listens in respectful silence; gesturing with equal emphasis, the lady across from him seems to counter his point, to which her husband attends in silent respect. In Hogarth, power is distributed quite differently. The moneylender looms over everybody else, orchestrating the negotiation. The only woman present is the betrothed; a teenager, she is the youngest, least experienced, and most vulnerable person in the room. This critical absence of women in *Marriage A-la-Mode* shapes the mood and substance of the exchange in visible and invisible ways. The invisible effect is that the bride's interests, viewpoints, and feelings go unrepresented, not just at the bargaining table, but also at every scene that follows and flows from it. The visible effect is that men's issues eclipse women's throughout *Marriage A-la-Mode*.

In Hogarth, such issues are defined by Squanderfield's genealogical tree as well as by the mortgages, cash, and contracts that litter the table at which the Earl, the Alderman, and their agents sit; in Bosse, women's issues surface in the children playing next to the table where the elders bargain. In both plates, the concerns under negotiation are "framed" in the largest, most theoretical terms by the scenes that appear through the open windows. Above the French lovers, a window opens onto a garden, where a woman plants flowers or shrubs. This scene indicates that the French negotiation—indeed, the entire French ensemble—focuses on planting, growing, cultivating, and nurturing, literally and metaphorically. In short, Bosse's *Mariage* is rooted in nature and nurture, specifically human reproduction. Above Hogarth's Earl and Alderman, the window opens onto a nobleman's new mansion, ostentatious coach, and builders hard at work as the result of Squanderfield's fresh supply of cash. This scene confirms that the English negotiation—and indeed the entire progress—centers on the material world. Rejecting nature, it embraces culture in its most materialistic and sterile expressions, so profuse that they lead to confusion and contradiction. The Earl's extravagant coach is too big to pass through the portal leading to the stables of his new palace, a point first noted by the eighteenth-century German commentator Georg Lichtenberg, who wittily observed that the gatehouse entrance was "so low and truncated as to decapitate the entering coachman and even his coach."[16]

III

Bosse and Hogarth lived in worlds that were similar in some ways but sharply different in others. Both artists chose to depict in their opening plates the financial and legal stakes of a marriage between well-off parties—two wealthy middling kinds in Bosse, a rich middle sort and an impoverished aristocrat in Hogarth. The English artist followed his predecessor in juxtaposing the clear-eyed bargaining of adults to the obliviousness of a young couple caught up in their own feelings. In introducing significant changes to Bosse's first plate, Hogarth was, as we have seen, seeking to outdo his predecessor. But his changes may also be read as a commentary on the difference in legal

and cultural norms governing marriage from one country to the other and one century to the next. Specifically, eighteenth-century England differed from seventeenth-century France not just with respect to the financial status and role of women but also in the emotional and social expectations that the two cultures brought to the institution of marriage.

In both suites, marriage begins with a property settlement. From a perspective that is strictly historical, this is not surprising in either case, since in both seventeenth-century France and eighteenth-century England property was of central importance in marriage arrangements, especially those involving members of the wealthier classes. The contract loomed particularly large in France for political reasons: starting in the sixteenth century the monarchy, aided by its jurists, had struggled to wrest control of marriage away from the Catholic Church to secure it in the hands of the state. In the seventeenth and eighteenth centuries, secular legislators in the service of the French crown issued a steady stream of writings and decrees reinforcing the view that marriage was, above all, a secular contract to which the church merely gave its blessing.[17] In Bosse's case, the predisposition toward viewing marriage as a social contract rather than a sacrament may have been reinforced by the fact that he came from a Protestant family, and as a member of a minority religion, would have been inclined to minimize the role of the Roman Catholic ceremony.[18] In England no such ideological agenda existed, but property matters were equally central to upper-class matchmaking, and marriages involved much talk of portions, settlement, and jointures.[19]

As noted above, the most striking difference between Bosse's and Hogarth's marriage negotiation is that women appear at the bargaining table in the French scene but not in the English one. The gender distributions in the two images reflect the relationship of

women to property in both countries, especially where marriage settlements are concerned. In France, laws governing marital property arrangements varied widely, with a significant division between the written Roman law of the south and the customary law of the northern provinces. Under the *droit écrit* of southern France a wife retained, in theory, full control of her dowry, though in practice husbands often had leeway in managing their wives' goods. In the northern part of the nation, property dispositions varied from province to province. But nowhere did the husband enjoy full authority over his wife's estate. Furthermore, any prevailing legal regime could be modified by drawing up a contract. In Paris a wife retained control of what were known as her *biens propres*, the personal effects and real estate she brought to the marriage, though her husband was allowed to manage her financial affairs. He had usufruct over the interest, but he could not spend the principal, which reverted to the family of origin if his wife died without issue.[20] Abraham Bosse had married and moved from Tours to Paris the year before he drew his marriage suite; the scene he depicts is surely northern and probably Parisian. Little wonder that in Bosse, both mothers and fathers are present at the table, haggling over their property and that of their children.

English property law was, by contrast, unfavorable to married women. In the late seventeenth and early eighteenth centuries several writers, men as well as women, complained of the bias against women in English marital law and praised the relative egalitarianism of continental regimes.[21] Who knows how many English wives secretly (perhaps even openly) agreed with the heroine of Defoe's *Roxana, or the Fortunate Mistress* (1724) that "the very nature of the marriage contract was . . . nothing but giving up liberty, estate, authority and everything to a man, and the woman was

indeed a mere woman after—that is to say, a slave."[22] English law promulgated the notorious regime of "coverture," whereby a husband took full possession of his wife's property and thereby "covered" her legally and financially. As Lawrence Stone bluntly expresses it, "By marriage, the husband and wife became one person in law—and that person was the husband."[23] Especially among the aristocracy and upper gentry, the dominant practice of "strict settlement" entailed the property to the eldest male heir. The legal regime of "coverture" further promoted the desired concentration of property that is so central to the plot of Richardson's *Clarissa, or, The History of a Young Lady.* Alternative arrangements did exist, and some upper-class wives retained property in trust under the designation of "separate estate" or "pin money."[24] However, "separate estate" was a minority practice, and it was ridiculed as unseemly by several (male) writers in the eighteenth century—and the practice was aimed less at insuring a woman's independence than at protecting her natal family's money from a spendthrift husband.[25] The cash-hungry Lord Squanderfield would have spurned such an arrangement, and the young bride's social isolation from all but the opportunistic Silvertongue mirrors her legal and financial vulnerability.

Hogarth therefore departed from the gender composition and dynamics of Bosse's initial scene because the legal and financial transactions he describes would have been much different from their seventeenth-century French equivalents. The cultural assumptions surrounding marriage also differed in both societies, in ways that both these initial plates suggest, albeit in a paradoxical fashion. Literary sources, especially novels such as those written by *précieuses* like Madeleine de Scudéry, suggest that emotional expectations from marriage were low in seventeenth-century France. Women especially anticipated loveless marriages, sources of repeated pregnancies, which burdened them and endangered their lives.[26] Expressions of affection between the betrothed couple in Bosse's first plate are undermined by their deep conventionality: the young couple's names, Damon and Sylvie, come from romantic plays or novels, and the young people utter stereotypical expressions of passion: "You burn" and "I sigh." By the third plate in the series, the relationship between the spouses has become irrelevant to the story. As a married man, Damon may well frequent prostitutes or keep a mistress, while Sylvie endures serial pregnancies. Damon's philandering, indecent to show, would be of no special consequence to Bosse and his contemporaries. Bosse's view of marriage, which sees nothing wrong with hard-headed negotiation and prizes reproduction well above marital love, antedates by several generations the emergence of a modern sentimental outlook.

By contrast, the bitterness with which Hogarth portrays his estranged couple points to the expectations surrounding a new matrimonial ideal, which Lawrence Stone tagged "companionate" marriage: a union contracted not primarily for social or financial advantage but to bring together a compatible husband and wife in enduring affection and mutual respect. From the 1680s to the 1740s, arranged marriages, especially in the aristocracy, had come under increasing attack from a new generation of writers.[27] Hogarth's pictorial denunciation of a union organized by two fathers exchanging social status for financial gain propagates that critique, implicitly setting up as a positive model the new "companionate" marriage associated with middle-class couples such as Samuel and Elizabeth Pepys. Samuel Richardson's *Clarissa, or, The History of a Young Lady. Comprehending the Most Important Concerns of Private Life. And particularly shewing the Distresses that May Attend the Misconduct Both of Parents and Children, in Relation to*

Marriage, published serially between 1747 and 1748, with the first volume appearing just two years after the prints of *Marriage*, echoes many of the same economic themes found in Hogarth's print series, as the novel's full title shows. Where the French artist shows a love not expected to yield lasting personal satisfaction, his English successor indicts this view as cynical. Only true affection, Hogarth argues, could have saved the "modish" marriage from its "waste of shame." It is no paradox that the less sentimental and idealistic view of marriage, Bosse's, is also the one in which women are granted more power and autonomy.

IV

The divergences of Bosse's and Hogarth's marriage series in plates 2 through 6 are every bit as striking as the similarities between the initial plates. While Bosse's cycle focuses on the wife and shows a marriage functioning to bring children into the world, Hogarth's progress depicts a union breaking down before it begins. Every scene in *Marriage* chronicles a species of marital dysfunction, for which the husband's aristocratic conduct is to blame. While the young wife, still a bourgeois, stays at home to play cards and enjoy music with friends, he goes abroad to dawdle with a mistress whose nightcap sticks from his pocket (pl. M2). A deepening estrangement leads the pair to lives that are ever more disconnected, both physically and psychologically. Bored with conventional dalliances, the husband gratifies his sexual inclinations in increasingly perverse ways: he turns to child prostitution (pl. M3). Robert Cowley wonders why Squanderfield should even bother with such a girl and speculates that Hogarth has temporarily lost control of his plot in this scene.[28] Not at all. The Viscount may believe that sex with young girls will cure him of venereal disease, but more likely, he is indulging in characteristic aristocratic depravity by having sex with a child.[29]

After the death of the old Earl, his son's wife gives birth to a female child and continues at home, where she begins to shed bourgeois pastimes like cards. She acquires aristocratic habits and vices, collecting "dark masters" and cultivating the Italian opera (pl. M4). Provoked by her husband's neglect and not by lust (as James Lawson thinks), she goes to a masquerade and then to a *bagnio* at the urging of the opportunistic and predatory Silvertongue.[30] They are discovered in bed by the young Earl who, in obedience to male aristocratic protocol, duels with Silvertongue to vindicate his tarnished reputation. He loses his life in defense of an honor he does not have, a marriage he does not value, and a wife he does not love; as he expires, the Countess begs his pardon in the only scene where she looks at him face to face (pl. M5). Returned to her father's house after the death by hanging of her "lover" (who abandons her in a *bagnio*), the Countess commits suicide in the embrace of her daughter, who faces the future with an ominous black birthmark from her father and a deformed leg from the corrupt union of her parents (pl. M6). Just as the progress begins with a venal marriage contract shaped by three extra-familial functionaries from the new middle class, it ends in a shameful death presided over by two more such professionals, a physician and an apothecary, to whom the debilitated but ever-avaricious Alderman is an appendage bearing curious similarities to the idiot servant he keeps out of miserliness.

If diseased, perverse, and fatal sexuality, together with material consumption, dominate in Hogarth, procreation rules in Bosse. The blissful union arranged in the first plate (fig. 80) leads to a nuptial night in which bride and groom are plumed for the marriage bed (fig. 81), followed by the birth (fig. 82) and the baptism (fig. 83) of the couple's offspring. The husband vanishes after the marriage is consummated, and all men disappear in the last

two scenes, where a small army of women—young, middle-aged, and old—devote themselves to rearing (fig. 84) and swaddling their progeny (fig. 85) amidst a perpetual round of gossiping.

Crude as they are, these summaries of the diverging paths followed by Bosse and Hogarth point to a profound difference between the two artists' suites, a difference setting Hogarth's Modern Moral Subject apart from and (no doubt, in Hogarth's eyes) above Bosse's set. Following an "old" model of exposition based on formula art, Bosse's series treats marriage by means of a set of *tableaux vivants* with fixed themes, many of which derive from ritual and ceremony. These *tableaux* move from one established subject to another either chronologically or through contrast: the marriage pledge is followed by sexual consummation; the pleasures of the nuptial bed contrast with the pains of the birthing couch. Rather than telling a continuous, personal story about a generic couple, the six tableaux expound the themes of human reproduction using six different *topoi*. From this angle, Bosse's prints resemble other art forms organized by set pieces, like the four ages of man, the five senses, the four seasons, the prodigal son, and the Cries of Paris, all of which Bosse executed.[31] The programmatic nature of his marriage cycle is illustrated by the fact that the child born in figure 82, a boy, is not the child baptized in figure 83, a girl named Marie. The purpose of the suite is not to chronicle the life of Sylvie and Damon then; it is to illustrate the great chain of procreation, in which the natural act of birth is followed by the religious ceremony of christening or the arrival of a male heir is balanced by the appearance of a female child.

Hogarth's progress, on the other hand, is organized like a play or, better still, like a "modern" novel by Samuel Richardson or Henry Fielding.[32] James Lawson, focusing on *Marriage A-la-Mode*, has explored with remarkable ingenuity what the artist calls "the well-connected thread of a play or novel, which ever increases as the plot thickens."[33] Following this model, character and plot in *Marriage*, working inexorably as cause and effect, replace programmatic exposition. Old Squanderfield's materialism and narcissism infect young Squanderfield, who neglects his bride to follow pursuits laid out by his class and rank. With middle-class pragmatism, the neglected bride struggles to make a success of the marriage. Most notably, she reaches out to her husband in the second plate with a coy, sideways glance and her foot playfully extended in his direction. But scorned and betrayed, she emulates his adultery with fatal consequences. Hogarth's satiric *Marriage*, narrating incidents that are unique and contemporary and that move to a melodramatic resolution involving adultery, murder, execution, and suicide, is a progress; Bosse's serious *Mariage*, treating events that are traditional, recurring, and emblematic, is a cycle.

Hogarth's narrative, which chronicles the couple's estrangement until their lives converge tragically in the fifth plate, is more familiar to a modern audience as "the story of a marriage" than is Bosse's seemingly odd narrative, which focuses in the last four plates exclusively on a female world of birthing and childcare. Once the husband's role as progenitor has been established in the second plate, he disappears entirely. How can this be called a marriage suite? The answer is that Bosse depicts, both in literal and in broader symbolic terms, the essence of marriage among the wealthy in seventeenth-century France. The opening lines of the verse that accompanies the print series (the authorship of all these stanzas is unknown) makes perfectly clear what is at stake, as the parents in the scene declare: "The greatest part of human concern / Is given over to this maxim / That those children whom we bring into the world / Should in turn beget their own offspring."[34] Marriage was

about reproduction, not companionship. Beyond a surge of passion at the beginning of the match, husbands and wives of the elite were not expected to share a social life, even in the best of cases; utterly separate existences were the norm. The novelist Charles Sorel wrote tongue-in-cheek in 1663 that "just to see a husband and wife sharing a carriage is enough to make a person of taste feel quite ill. Fashion dictates that they flee each other's company."[35]

A pair would, however, keep private company long enough to insure numerous births. For many couples, especially in the middle and upper classes, where nutrition, space, health, clothing, and other material conditions were better, a baby every year or two for the duration of the childbearing years was common. Given the high rate of infant mortality, only half or fewer of these children would survive.[36] Bosse himself was typical in this respect: between 1635 and 1649, his wife bore him nine children, only four of whom survived to adulthood.[37] For the well-to-do in seventeenth-century France, marriage consisted in a continuous (and life-threatening) series of reproductive acts, the consequences of which were perforce more protracted and dramatic for the wife than for the husband. So the subject of Bosse's plates is not a single birth, but the archetypal stages in a series of births.

Constant reproduction was not just a fact of life; it was also an ideal tirelessly promoted and regulated by the monarchical state, as it is celebrated in Bosse's cycle. Starting in the sixteenth century, the monarchy began issuing edicts aimed at controlling hidden pregnancies: the severest penalties were decreed against women who did not declare out-of-wedlock pregnancies or, worse still, induced an abortion or committed infanticide. On the other hand, the state offered parents of numerous children significant tax exemptions, much as it does in France today.[38] The state also strengthened the authority of parents over their children by issu-

ing a series of decrees in the sixteenth and early seventeenth centuries which forbade the marriage of high-born children without the consent of their parents, especially that of their fathers.[39]

In a recent essay Sarah Hanley terms the series of edicts regulating marriage and reproduction between the 1550s and the 1690s the "Family-State Compact." These decrees were framed and issued by jurists in the service of the monarchy (most held purchased offices) who collaborated in the consolidation of the state by means of laws which gave them greater authority over wives and children.[40] But Hanley also shows that even as the long arm of the law tried to reach into the bedroom and the birthing room, individuals—especially women—succeeded in evading or manipulating the reproductive laws enforced by fathers and kings. No doubt, giving birth was often, as Bosse depicts it, a dramatically public matter. It usually took place in the household's main room. But it was also, as Bosse's imagery shows, an intensely female affair, presided over by the revered and experienced *matrone* or *bonne mère*.[41] (In Bosse, the father is present, but he is the sole male in attendance). Hanley demonstrates that parents, especially mothers, colluded with midwives and thus were able to control reproduction in spite of royal edicts; they could produce children, substitute them, or make them disappear altogether, and they did so to suit their own purposes.[42]

Bosse shows none of these "aberrations." His pictures are conventional scenes in the lives of ever-birthing women: the agony of labor, the christening, gossip with other mothers at the bedside or by the fire, the visit to the wet-nurse. One intriguing detail in the series, however, suggests the tension between the sexes and the power of women in connection with giving birth: the fifth plate, which shows women visiting the newly delivered mother, features a male spy who hides to listen in on behalf of the husband. Bosse's emphasis on

childbirth is more intelligible if one understands how heavily invested families, the state, and the artist himself were in the production of a large brood. The family's obsession with lineage and the state's concerns about population converged in the birthing room. This focus on lineage was the essence of marriage for the elite of seventeenth-century France, and the ties of feeling between husband and wife had little to do with the matter.

The focus on producing children is one reason why beds are the single most important object in Bosse's series. Massive beds with all the trimmings—curtains, pillows, canopies, ornamented posts—are conspicuous in five of the French artist's six plates. Historians of material culture confirm that the bed was the most costly and prestigious possession in seventeenth-century French households, akin to what cars represent to many people today. In modest homes, the bed, along with its accessories, often represented a quarter to a half of the total value of the family's possessions.[43] Beds were important for both practical and symbolic reasons: for reproduction, birth, illness, and death, but also for resting and just keeping warm. Even in wealthy households unmarried people doubled up in them for heat, solace, and company. Before public and private realms were strictly divided, beds occupied a central position in ceremonial rooms, and women especially entertained their friends while reclining in bed, as represented in figures 83 and 84.[44] Some of this continuity between public and private survives in Hogarth's suite, where beds are featured in two "public" scenes (pls. M1 and 4), as well as in one very private drama (pl. M5). But Hogarth's beds are mostly backdrops; the beds of adultery, they are draped, concealed, and darkened. Their importance is usurped by the other furniture (especially bad French art) that proliferates in every plate.

Facing the bed in three of Bosse's six plates is the other object of major practical and sym-

bolic importance, the hearth. In the seventeenth century, hearths in private dwellings were as big as possible, with high mantels and wide flues. As Bosse's images show, when people did not cluster around a bed, they gathered around a fireplace; some even crawled halfway into it. Chimneys are the other "heart" of the household; they provide and symbolize light, heat, food, and company.[45] Bosse's vision of archetypal married life is framed by the two central household icons, the bed and the hearth.

The conspicuousness of those objects accentuates how few possessions appear in Bosse's rooms. Certainly these are wealthy interiors—the spaciousness of the rooms suggests as much, as does the clothing and the servants, who are numerous. The beds are luxurious, the chairs are upholstered, the walls are adorned with tapestries and paintings. But these interiors antedate the consumer revolution of the 1720s and 1730s, which was to transform both continental and English societies. In the early decades of the eighteenth century, the growth of commerce and consumerism brought with it a quest for domestic comfort. Rooms shrank in size; they were better heated by smaller chimneys and stoves. Chests of drawers and softly padded armchairs appeared, bringing comfort, ease, and pleasure. People began to own more varied, pleasing, and ephemeral objects, like mirrors, china, games, toys, and knickknacks.[46] The world of comfort and consumption was still a century away from the rooms that Bosse depicts. The chairs are straight-backed, the food arrives on pewter dishes, and the furnishings are austerely functional. The inhabitants of these drafty, ceremonial rooms are not to be distracted by material possessions from their single-minded pursuit, the production of new life.

In this respect, the contrast with Hogarth's progress could not be greater. In these earlier plates especially, a clutter of material goods practically forces itself upon the viewer,

from the Squanderfields' vast collection of paintings (in pls. M1, 2, and 4) to the young couple's plethora of tasteless knickknacks (in pls. M2 and 4) and the quack's dispensary in plate M3, where a profusion of deadly "scientific" objects serves as a grim counterpoint to the baubles of the rich. Ronald Paulson, writing about Hogarth's *Marriage* and Watteau's *L'Enseigne de Gersaint*, says that "Hogarth turns Gersaint's shop into Earl Squanderfield's chamber—or the earl's chamber into a dealer's salesroom."[47] Even by Hogarthian standards the sheer weight of *things* in his progress is remarkable, and it is intensified by the fact that every scene takes place indoors, the interiors replete with furniture, art, and gimcracks; the progress has no outdoor scenes.[48]

This riot of man-made goods, which keeps the eye scurrying about, can be related to the absence of natural creation and renewal in the form of progeny.[49] The marriage ends not only in the death of both spouses but in a failure to procreate, its only offspring a diseased and obviously doomed child.[50] Whereas Bosse includes babies or young children in five of his six plates, Hogarth includes few offspring in *Marriage A-la-Mode*, a striking omission. The single exception, the child in the last plate, serves to emphasize the utter failure of the two families' reproductive ambitions, as Judy Egerton points out: "The sole heir—a child in whose veins blue blood and riches were to have mingled for the worldly advancement of both families—ends up orphaned, crippled by disease and likely to die young."[51] The only other young people in view are there to be exploited, a precocious black page in the fourth plate and the miserable girl-prostitute in the third. The match between the Earl's son and the Alderman's daughter has failed to produce viable offspring, and the pictorial narrative suggests that the desire for children has been displaced by the consumption of objects and of commodified persons.

In Hogarth's progress, the commercialized world of the eighteenth century (which has been so ably explored by historians like John Brewer, J. H. Plumb, Neil McKendrick, and Roy Porter) has arrived.[52] The plates of *Marriage A-la-Mode* express acute anxiety about the new commercial culture, suggesting that the "unnatural" and compulsive acquisition of material goods has displaced the "natural" imperatives of procreation. Hogarth's progress can be read as a pictorial contribution to one of the eighteenth century's most ubiquitous concerns, the critique of "luxury." Concerns about it recur from ancient times to the dawn of industrialism in the West, surging with special force in certain times and places. One such resurgence occurred in eighteenth-century England. John Sekora records over 460 books and pamphlets treating this theme, all published between 1721 and 1771.[53] For centuries, people understood "luxury" to mean the spurning of both necessity and hierarchy—in a word, pursuing the superfluous and forgetting one's preordained place. As Sekora points out, "luxury" was one of the few concepts available in pre-industrial culture for making sense of disruptive social change.

In the early decades of the eighteenth century, English writers saw unnerving changes all around them, with the result, Sekora writes, that between the 1680s and the 1750s, "luxury probably was the greatest single social issue and the greatest single commonplace."[54] Luxury was both cause and consequence of new and artificial wealth, social confusion, and alleged moral depravity. "Luxury" is what Hogarth depicts in his marriage suite.[55] The old Earl pursues extravagant architectural schemes, the Alderman chases social advantage, the young wife seeks out bad art, and her husband throws away cash on quack doctors. Husband and wife both pursue sensual gratification or *luxuria* outside the marriage bed. "Luxury" was routinely associated

with disease and infertility—it was commonly said by Hogarth's contemporaries to "enervate" and "effeminate" those who fell prey to it.[56] The pursuit of sterile material goods was viewed as symbolic emasculation. Even the ominous birthmark on the young Earl and his daughter can be read as the stigma of luxury. The concept of luxury, as it was understood in the eighteenth century, can thus help locate the links between social transgression (the Earl's greed for money and the Alderman's for lineage), the accumulation of material goods, and the marriage's ultimate sterility.

V

In designing *Marriage A-la-Mode*, Hogarth recasts the cycle of his continental predecessor Abraham Bosse. Although the English artist opens his series with a plate that is thematically and structurally close to Bosse's, he quickly takes his narrative in a completely different direction. The point is not, as the contrast between two first plates might initially suggest, that Bosse describes a happy marriage and Hogarth a conjugal disaster. For Bosse, the notion of a "happy marriage" would have been irrelevant, perhaps even an oxymoron. Bosse leads the viewer through a series of emblematic scenes illustrating the cycle of pregnancy and birth. This focus on reproduction may be dictated by personal and institutional male political concerns—the husband's need for lineage and the state's for population—but as the gendered composition of Bosse's images suggests, women were invested with significant power within and around childrearing. Furthermore, Bosse's society happens to be one in which women retain significant control within matrimony, owing both to the financial dispositions governing marriage and the cultural expectations surrounding childbirth. In his first plate women are literally "at the bargaining table," arguing with the men as apparent equals. Bosse makes it clear in the subsequent plates

that women completely control the reproductive process in a society where the creation of progeny was of supreme political importance to men.

The choices that Hogarth made in departing from Bosse tell us about both his artistry and the world in which he lived. Both the structure and the details of the first plate are replete with meanings that drive forward a story that is, in Hogarth's terms, "Modern"—it features highly individualized protagonists and is plotted like a novel or a play. This tale reveals, albeit by negative example, new expectations about marriage as companionship, but it also makes plain the vulnerability of the married woman. Some of that vulnerability stems from traditional legal and financial arrangements: the regime called "coverture," by a sad irony, left the woman completely exposed to the power of her husband and his family. But the fate of this young bride is also a modern one, for she is undermined by the objects that surround her. Creatures of the new consumer society, which their contemporaries identified as the fiend "luxury," she and her husband have become unable to produce. Compounding her legal disabilities, the growth of a consumer culture in this story robs the woman of her last claim to power, her body's ability to bring forth new life.

Notes

1. For stylistic simplicity, we use "prints" to refer to Hogarth's *Marriage A-la-Mode* throughout this essay. The more elaborate, detailed prints, published two years after the completion of the oils, supersede them and represent Hogarth's "definitive edition" of his *Marriage*. The six oil paintings are preserved in the National Gallery, London.

2. Antal 1962, 84, 98, 107; Cowley 1983, 15; Paulson 1992, 215.

3. On cultural narratives, see Maza 1996, 1493–1515; B. Thomas 1994. For historically informed discussions of the issue, see Walkowitz 1992, introduction; and Wahrman 1995, ch. 1.

4. Hogarth follows much the same practice in *Industry and Idleness*, however; see Shesgreen 1976, 569–98.

5. Clayton 1997, 57.

6. Paulson 1995, 27–46.

7. Shesgreen 1983, chs. 1 and 2.

8. These titles appear in printed "Proposals" published by Hogarth on 25 January 1745. As Judith Egerton points out, many other titles have been used for Hogarth's scenes, but only these have canonical status; Egerton 1997, 13.

9. Bindman 1981a, 109.

10. This progress, executed in the form of sketches, was never painted or engraved.

11. Antal 1962, 198.

12. Paulson 1989a, 95.

13. Rouquet 1746, 31. In specifying the trades that his characters follow, Hogarth follows the practice common to the Cries of London. That is, he puts into the hands of his figures the instruments of their callings. So in the first plate, the lawyer has a quill in his hand, the broker has a mortgage as well as a sheaf of banknotes, and the architect has "A Plan of the New Building of the Right Honble . . ." With just a little variation, the same shorthand way of specifying calling or identity applies to the bride's father, an alderman, who wears his aldermanic chain about his neck; it even applies to the Earl, whose crutches, footstool, and chair bear his proprietary coronet.

14. Paulson 1989a, 117.

15. Lawson 1998, 269.

16. Coley and Wensinger 1970, 29.

17. Traer 1982, 22–46.

18. Blum 1924, ch. 1.

19. Stone 1977, 179–81, 298–320; Trumbach 1978, ch. 2.

20. Pillorget 1979, 94–97; Gibson 1989, 60–61; Hanley 1989, 12–13.

21. A. Erickson 1993, 108–9.

22. Cited in Stone 1977, 195.

23. Ibid., 195

24. A. Erickson 1993, 99–104.

25. Ibid., 106–13. See also the convincing critique of Lawrence Stone, who sees in "separate estate" a symptom of the rise of more egalitarian property relations within marriage; Okin

1983–84, 121–38.

26. Gibson 1989, 41–42. Some scholars see in the *préciosité* movement of mid-century a rebellion against conventional marriage and the commodification of women's bodies it entailed. See Harth 1992, 79.

27. Stone 1977, 274–81.

28. Cowley 1983, 84.

29. In Hogarth's time, some people believed that venereal disease could be cured by sexual intercourse with a child; see J. Richardson 1995, 196.

30. Lawson 1998. The Countess does not consummate her affair with Silvertongue until several years after he first approaches her, hardly the sign of a "gross appetite" for him. By that time she has internalized the aristocratic practice of having affairs because they are fashionable.

31. *Abraham Bosse: Les Gravures du Musée des Beaux-Arts de Tours*, nos. 5, 18, 19, 30, and 32.

32. Shesgreen 1973, xiii–xxiv. In Egerton 1997, 6, Neil MacGregor compares the progress with the novels of Dickens, Trollope, and Waugh.

33. Lawson 1998, 267.

34. "*C'est une maxime ou se fonde / La plus part de l'humain soucy / Que les enfans qu'on met au monde / En produisent d'autres aussy.*" For transcriptions of the verse, see Duplessis 1859, 152–55; translations are our own.

35. Gibson 1989, 66.

36. Ibid., 70–71.

37. Blum 1924, 8.

38. Hanley 1989, 11–13; Gibson 1989, 71–72.

39. Hanley 1989, 9–11.

40. Ibid., *passim*.

41. Gibson 1989, 75–78; Gélis 1984, 169–220.

42. Hanley 1989, 15–27.

43. Roche 1987, 130–32; Pardailhé-Galabrun 1988, 275–85.

44. A similar importance attaches to the bed in Hogarth.

45. Roche 1987, 134–37; Pardailhé-Galabrun 1988, 287–91.

46. Roche 1987, 141–53; Pardailhé-Galabrun 1988, 306–64; Fairchilds 1993, 228–48.

47. Paulson 1971, 2:219.

48. Bertelsen 1983, 131.

49. Wark 1972, 162.

50. The child is usually assumed to be a girl—a final blow to the families' dynastic ambitions, even if the sickly child survived. But some scholars acknowledge that this might be a boy, since, as Robert Cowley points out, infants of both sexes wore skirts until the age of three or four; Cowley 1983, 149–50.

51. Egerton 1997, 11.

52. Brewer, McKendrick, and Plumb 1982; Brewer and Porter 1993.

53. Sekora 1977, chs. 1 and 2.

54. Ibid., 74.

55. A similar argument has recently been made by Richard Pound about another of Hogarth's suites; Pound 1998, 17–21. In addition to the themes of social confusion and degeneracy, Pound stresses the political uses of the concept of luxury, which was exploited by Bolingbroke and his followers to attack Walpole as the embodiment of factional politics.

56. Pound 1998, 65–67. For a discussion of similar themes in the French literature on luxury, see Maza 1997, 216–21.

An Un-Married Woman: Mary Edwards, William Hogarth, and a Case of Eighteenth-Century British Patronage

Nadia Tscherny

Although the role of women as patrons of the arts in eighteenth-century England is clouded by contradiction and uncertainty, nothing more convincingly challenges the negative assessment of the place ascribed to women in eighteenth-century aesthetic theory and literature than the case of Mary Edwards (1705–1743) and William Hogarth (1697–1764). For a period of time, and one that was crucial to Hogarth's development, Mary Edwards was among his few consistent patrons. The very circumstances of her personal life that enabled and compelled Edwards to patronize Hogarth also made her an inspiration to the artist, both for his portraiture and his subject pictures. Hogarth's 1742 portrait of Mary Edwards wearing a brilliant red dress (fig. 86), is one of the most cogent applications of the artist's theories of beauty, color, physiognomy, costume, and form to the practice of portraiture.[1] It is also, like the nearly contemporary portrait of the enterprising and philanthropical sea captain Thomas Coram (Thomas Coram Foundation, London), a landmark in the history of British portraiture and a challenge to the fashionable portrait painters whom Hogarth disdainfully called "phizmongers."

Little is known of Mary Edwards aside from the genealogical details of her biography and the records of the sales of her art collection at auction.[2] But these facts are so unusual that they can tell us a great deal about her relationship with Hogarth, not only why he would have appealed to her as an artist, but why she was, in many respects, exactly the kind of patron he needed at this point in his career.

Mary Edwards was the only child of Anna and Francis Edwards. Her father was a wealthy entrepreneur from Leicestershire whose property included the town of Welham, in which he had his house, as well as land in many counties of England and Ireland and in the City of London. He amassed a fortune by building new roads and reclaiming a large portion of Lincolnshire from the sea. When he died in 1728, his wife, wealthy in her own right, renounced the estate; consequently, Mary Edwards, at the age of twenty-four, became his sole heir and, according to some accounts, the richest woman in England.[3] This family background may have made her sympathetic to the ambitious and entrepreneurial character of Hogarth, which some contemporaries found distasteful in an artist.

The large collection of Old Masters in the auction following Mary Edwards's death may have been partially acquired by her father, who was certainly representative of that newly rich class that was building collections at the time. In the early eighteenth century connoisseurship was considered a pursuit too serious for women. Men were educated in art—some even at this time were making the grand tour of Europe. But, as reports from the period indicate, women were largely excluded from this activity.[4] It is clear, however, from a number of pictures, many of which were satirical, that women did attend auctions in London; these

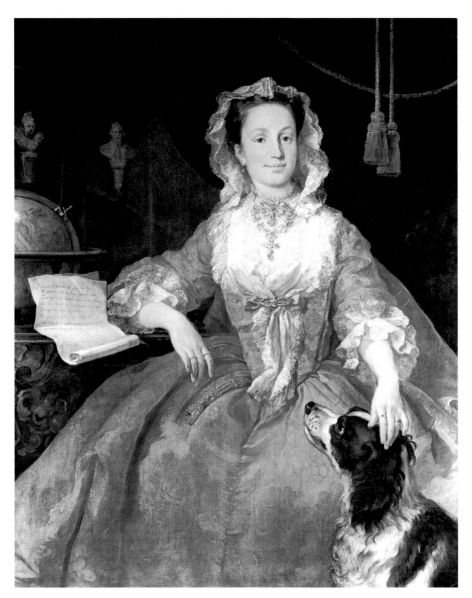

Fig. 86. William Hogarth,
Portrait of Mary Edwards,
1742. Oil on canvas, 49⅜ x
39⅛ in. (125.4 x 101.3 cm).
The Frick Collection, New York

provided an opportunity for women to educate themselves about art and brought them into the circles of dealers and other collectors. Mary Edwards may have visited salerooms such as the one depicted in Hogarth's oil sketch of London's preeminent auctioneer, Christopher Cock.[5] Cock, who later conducted the posthumous sale of her collection, was also a friend and neighbor of Hogarth; thus, it is possible that Mary became acquainted with Hogarth in this milieu.

As suggested by the single letter of Mary Edwards that has come to light, she much preferred the stimulation of London to her country manor in Welham.[6] She certainly did not want to be the wife of a country squire, and her money enabled her to avoid that eventuality. Around 1730 Mary met a young nobleman four years her junior—the third son of the fourth Duke of Hamilton, named Lord Anne Hamilton after his godmother Queen Anne. Lord Anne, like many a younger son, had a title without the financial means to back it up in full style. The *Scots Peerage* reports that his family "encouraged him to make up to the heiress."[7] Mary was no doubt flattered by the attentions of this dashing nobleman, and they were married clandestinely in the precincts of the Fleet Prison, a common locale for elopements in the eighteenth century, where the services of corrupt clergymen could be bought.[8] Lord Anne then assumed the surname and arms of the Edwards family, and, even more significantly, control of his wife's finances. On 4 March 1733, Mary gave birth to a son, Gerard Anne Hamilton Edwards.[9]

The first pictures Lady Hamilton Edwards (as Mary now styled herself) commissioned from Hogarth, which date from the early 1730s, were a portrait of her infant son in his cradle (Bearsted Collection)[10] and a conversation piece of the entire family (fig. 87).[11] Maternal love was the primary impetus for the first portrait and a major theme of the second, which shows the family in a private moment posing on the terrace of their house in Kensington. Hogarth was the current master of the conversation-piece genre, and an example by him that Mary Edwards might have known is the *Conversation Piece with Sir Andrew Fountaine* (Philadelphia Museum of Art), a work that includes two women (Cock's wife and Sir Andrew's niece) actively involved in the evaluation of art.[12] This picture indicates that in some circles women were considered intelligent enough to take part in connoisseurship and that Hogarth was evidently sympathetic to this.

In the Hamilton-Edwards family conversation piece, Gerard Anne is giving his doll a bath in a fountain, Lord Anne is taking a pause from playing the flute, and Mary Edwards is seated, gesturing to her son, while holding a book opened to one of Joseph Addison's *Spectator* essays. The *Spectator* had a large female readership, and many of its essays dealt with private family life, marriage, religion, and the upbringing of children. It seems most likely that the very legible inclusion of this text, devoted to religion, was done at Mary's request.[13] If it was Mary's injunction to Hogarth to portray her dominant role within this domestic sphere by including the open *Spectator* volume to indicate her moral guidance, he in turn responded in his use of composition, gesture, and physiognomy. Seated at a heavy mahogany table laden with a stack of books and anchored by voluminous skirts, Mary is the weightier character, whose serious spiritual influence is metaphorically extended to her son by means of her gesture, while Lord Anne, with his delicate mannerisms and vacant expression, is the lightweight, absorbed in a privileged, if not somewhat dandyish pastime of the leisured gentleman. Late seventeenth-century theoretical arguments against patriarchalism in government had done little to challenge the basic power of the father in the familial realm; however, the importance of

Fig. 87. William Hogarth,
*The Edwards Hamilton Family
on Their Terrace at Kensing-
ton*, c. 1733. Oil on canvas,
26 x 33⅛ in. (66 x 84 cm).
Private collection

women in the moral education of children was granted by John Locke and others and given increasing credence over the course of the eighteenth century.[14]

Lord Anne's apparent marginality should not necessarily be interpreted as a sign of his paternal ineffectuality or marital weakness, as this curious lack of mutual awareness between husband and wife (who are separated by a void, and whose glances do not meet) is in fact a common characterstic of the conversation-piece genre.[15] Nevertheless, by virtue of hindsight, this picture may be viewed as a record of the couple's growing alienation, which led to their eventual separation, an outcome that Mary may already have been plotting. Mary's relationship with her husband was to suffer the common consequences of a hasty union or marriage of convenience, escalated by his fiscal

mismanagement of her fortune and estates. As a family member wrote with striking understatement, "Now Lord Anne could boast the best blood in Scotland, but like many another gallant young soldier, he was no miser."[16]

Whereas most eighteenth-century couples in similar marital circumstances continued to suffer with each other, after a few years of marriage Mary Edwards began taking steps to end their union. The highly unusual conclusion to the affair, which was prompted by her own forceful character and enormous wealth, depended as well on the circumstances in which the marriage had been contracted. As early as 1733 Mary was apparently preparing for this assault by having her son baptised with the name of Edwards and herself described as a "Singlewoman."[17] This action certainly casts the conversation piece of the family in an odd

215

light—the portrait, which shows the child walking and thus around one year old, cannot date before 1734.

Since the ceremony that had joined Anne and Mary had been of questionable legality and recorded, if at all, in the private registers of the Fleet, she simply bribed the custodians to erase all trace of it. Consequently, she became the unmarried mother of a son who was now in legal terms a bastard. The break was finalized in 1734 in a deed signed by "Mary Edwards, spinster, and the Honorable Anne Hamilton, alias Anne Edwards Hamilton."[18] This restored to Mary the money she had given Anne and the right to manage her own property. The boldness of her actions illuminates an independent streak in Mary Edwards's personality that may also help to explain her patronage of Hogarth, which was not only unorthodox in the context of eighteenth-century patronage, but was also in opposition to generally held beliefs about women's place in the art world.[19]

Eighteenth-century definitions of connoisseurship traditionally excluded women, among others,[20] and limited their contribution to the role of superficial embellishers: "Whilst men with solid judgment and superior vigour are to combine ideas, to discriminate and examine a subject to the bottom, you are to give it all its brilliancy and its charm. They provide the furniture; you dispose it with propriety. They build the house, you are to fancy, and to ornament the ceiling."[21] Another commonplace perception of women as patrons is documented in a notorious painting by Hogarth's contemporary Thomas Hudson[22] in which a traditional portrait of a lady has been covered with a trompe l'oeil portrait of a man and bears the following label: "The original portrait was one of Miss Irons, a well-known beauty. When the picture came home she did not think it did her justice & returned it to Hudson to have it improved. He painted over

her face the scroll having the portrait of (?) Thomas Mudge saying he would put some sense into her head somehow & that Thomas Mudge was the wisest man he knew."[23]

That women were vain and subject to flattery was only one aspect of the problem, according to traditional theorists such as the Earl of Shaftesbury; they were furthermore without the proper education and moral grounding, hated the grand manner, and were capable of appreciating only personal ideas.[24] Their uninformed and acquisitive approach to art was alluded to in Samuel Collings's satirical picture entitled *Artistic Butchery* (fig. 88), in which the purchase of portraiture is equated with that of a mutton chop. Although this picture primarily satirizes the commodification of art, it is notable that it portrays the purchaser as a woman. That many women were difficult patrons, with superficial tastes, is undoubtedly true, but these faults were also notoriously common among contemporary male patrons. Our uncertainties regarding the role of women as patrons are complicated by the fact that women were usually married, and thus it is hard to separate their influence from that of their husbands. However, with Mary Edwards this is not the case.

A typical form that artistic support by women took in the mid-eighteenth century was that of promotional endorsement rather than direct financial patronage. Hogarth received such a fashionable sanction in 1731 from the celebrated chronicler of taste, Mary Delaney (then still Mrs. Pendarves), who wrote to a friend: "I am grown passionately fond of Hogarth's painting, there is more sense in it than many I have seen. . . . I have released Lady Sunderland from her promise of giving me her picture by Zinck, to have it done by Hogarth. I think he takes a much greater likeness and that is what I shall value my friend's picture for."[25] It is possible that Mary Edwards's initial interest in Hogarth was

prompted by her wish to be accepted in those cultured London circles in which Delaney was active. If Mrs. Delaney possessed the social position and cultural influence to advance the careers of artists like Hogarth, Mary Edwards had the financial means to actually commission works; in the 1730s this was of great importance to Hogarth who was newly married and in need of a steady income.

Nevertheless, in terms of the role of women as patrons of art in eighteenth-century England, it is revealing that Mary Delaney, who dabbled in art (by making cut-paper flower "mosaics") and was enthusiastic about contemporary painting but basically uninvolved with its purchase, could win the esteem of cultural snob Horace Walpole while Mary Edwards was snubbed,[26] the result, no doubt, of the current distaste for women purchasing art that was suggested in Collings's caricature: when men bought art, it was "patronage"; when women bought art, it was simply commerce.

Mary Delaney's interest in Hogarth may have been limited to his portraiture, the genre of painting in which the work of contemporary British artists was most readily accepted. Edwards's interest, however, progressed with the artist's development to its next, more innovative phase. In the early 1730s Hogarth began producing the tragicomic Modern Moral Subjects for which he was later famous. Lamenting the taste in English aristocratic circles for European Old Masters and portraiture, Hogarth directed his satirical pictures of contemporary life toward a different audience—that of the emerging middle-class public. Also, instead of selling one picture for a large sum, he contrived to sell many prints made after it for much less each; this marketing technique made his work accessible to a broader public while providing him with a comfortable income. Nevertheless, Hogarth's profit from this venture was always in peril because his designs were notoriously pirated, a practice that he vigorously cam-

Fig. 88. Samuel Collings (English, fl. 1784–1795), *Artistic Butchery*, n.d. Watercolor and pen and ink on paper, 6⅞ x 8 in. (17.4 x 20.4 cm). Tate Britain, London

paigned against before the momentous passage of the copyright act of 1735.

The income from the sale of original paintings was something Hogarth desired, but he had problems finding patrons. The appeal these subjects had for the middle classes did not generally extend to an audience that could afford them. But Mary Edwards was an exception and purchased the original painting from one of Hogarth's early satirical pictures—*Southwark Fair*—which was painted in 1733 and immediately reproduced for mass production (figs. 23 and 24).[27]

Aside perhaps from being an attempt by Mary Edwards to assert her financial independence through patronage at a time when she was already disillusioned with her husband, it is hard to say why she would have taken this step. While such a boisterous subject would have been considered unladylike, Edwards evidently had the acumen to recognize Hogarth's genius and the social conscience to appreciate the moral sentiments behind his satire. Her taste for such works may have been formed by

the seventeenth-century Dutch genre pictures in the collection she inherited from her father. Two vignettes in this sprawling scene allude to larger issues that may have been personally relevant for Mary Edwards. First, her religious devotion (evident in the Hamilton-Edwards conversation piece) makes it likely that Edwards would have recognized in Hogarth's depiction of Adam and Eve over a Punch and Judy pantomime in *Southwark Fair* the modern trivialization of the Bible in a contemporary spectacle.[28] Second, on the side of the picture above the collapsing stage, Hogarth included a banner mocking modern theatrical travesties of liberty and property, values in which Mary Edwards strongly believed, as is apparent from her portrait of 1742.

In this portrait (dated 1742; fig. 86) Mary Edwards's needs again seemed to mesh perfectly with the artistic aspirations and abilities of Hogarth. Mary was now independent of her frivolous husband and was aspiring to a position in London society. This was also a year when she was taking stock and insuring the future of her estate by drawing up her will. She wanted a portrait grander than what the diminutive conversation-piece genre could supply. At the same time, Hogarth was also seeking a more prestigious position in the London art world; this required that he try his hand at large-scale portraiture.

Why Mary Edwards would have chosen Hogarth, who was relatively unpracticed and certainly under-patronized in the art of formal portraiture, may be partially explained by the few options available to English patrons at this time. As noted by Abbe Le Blanc, a French traveler who visited England in 1737–44, "The portrait painters are this day more numerous and worse in London than ever they have been. . . . At some distance one might easily mistake a dozen of their portraits for twelve copies of the same original."[29] Le Blanc's observation was based not on simple nationalistic prejudice but rather on a just assessment of the situation. The genre of the conversation piece thrived in England and produced some charming portraits, but the quality of full-scale portraiture was at an all-time low. This was partly the result of the fashionable portraitists' excessive dependence on drapery painters, a practice to which Hogarth strongly objected. Hogarth's insistence on executing the costume in a portrait himself was largely the result of his theories of naturalism and beauty, according to which a painting had to be an organic whole. A sitter thus got much more when commissioning a portrait from Hogarth, and perhaps that is why, with little track record as a large-scale portrait painter, he had the nerve to charge the same prices as the more established Allan Ramsay. This action may have cost him some clients,[30] but in the case of a wealthy patron such as Edwards, it was of little significance.

Mary Edwards was seeking a painter who could not only give her portrait visual distinction but one who could also cope with the task of presenting her in a role usually occupied by men by creatively adapting a monumental and grand public style. Since Hogarth had recently accomplished a similar transformation of a baroque aristocratic portrait tradition in his portrait of a middle-class entrepreneur (Coram), he was an obvious choice. In the portrait, in addition to a brilliant red dress, Mary Edwards is wearing an extraordinary array of jewels, consisting of the two most popular and expensive gems of the time—diamonds and pearls. Hogarth has not suppressed the signs of her wealth, but neither has he flattered what might have been seen as traditional female vanity, based on the virtues of modesty and delicacy. That she is a woman possessed of strong character as well as wealth is the message here—one that Mary Edwards herself no doubt desired.

Hogarth recognized the difficulty of expressing the virtues of character by the tradi-

tional means of naturalistic painting to which he subscribed: "Nature has afforded us so many lines and shapes to indicate the deficiencies and blemishes of the mind, whilst there are none at all that point out the perfections of it beyond the appearance of common sense and placidity."[31] For this reason, Hogarth made use in his portrait of Mary Edwards, as he had in the Coram portrait, of various emblematic props. These include two busts (of Queen Elizabeth and King Alfred), a spaniel,[32] a globe, and tasseled draperies, typical accouterments of grand baroque portraiture. These props in effect announce the portrait as a public one, just as similar conventions identified the private, domestic sphere of the conversation piece.

The specific nature of the portrait's public context is made explicit by the inclusion of a written text, a scroll on the table which reads: "Remember Englishmen the Laws the Rights / The generous plan of Power deliver'd down / From age to age by your renown'd forefathers / Do thou great Liberty inspire their Souls / And make their Lives in thy possession happy / Or their Deaths glorious in thy just defence." This quotation, long unrecognized, has recently been identified by Ronald Paulson as a portion of a speech Queen Elizabeth delivered to the English troops as they set sail at Tilbury.[33] The patriotic emphasis on liberty and national heritage allies this quotation emphatically with eighteenth-century ideological currents, and its source in a speech of Queen Elizabeth's identifies it particularly with the Walpole Opposition and most specifically, as Paulson suggests, with the circle of Lord Bolingbroke, which had a nostalgic interest in Elizabeth.[34] Aside from the incidental and somewhat ironic fact that the court which the Opposition found most exemplary was that of a female ruler,[35] there was little place for women in the form of civic humanism they revered. Not only were women denied citizen-

ship in the public/political system that Bolingbroke envisioned, but also, as John Barrell has pointed out, in the "republic of taste."[36] Mary Edwards was evidently so assured of her position as the rightful heir to vast amounts of money and land that she evidently felt no contradiction in espousing a position in which she could actually have no public voice. Her selection of a quote from Queen Elizabeth, when there were innumerable similar sentiments expressed by the literary elite of her time, such as Thomson,[37] indicates not only a link to Opposition ideology, but also her search for a female prototype, albeit one to whom she could never be compared.

The patriotic quote and props in Edwards's portrait proclaim unequivocally the public, and therefore radical nature of this depiction of an eighteenth-century woman. In the Hamilton-Edwards conversation piece, Mary, though represented in a powerful role, is not portrayed in a manner significantly beyond the scope of involvement allowed women in the private realm of the family. Public or "presentation" portraits of women, on the other hand, with the exception of reigning queens, invariably stressed their beauty, their relationship to a significant male figure (usually a husband or father), their domestic skills, and, occasionally, their accomplishments in the field of letters. In appropriating Queen Elizabeth's speech, Mary Edwards was searching for a voice in the public arena, where, in fact, none existed.[38] But through the medium of portraiture, which provided a means to public representation without a forum to anyone who could afford it, all was possible; it was here that the fortuitous alliance between Edwards and Hogarth resulted in an unprecedented and convincing image of a woman in the public sphere through the assimilation of a pictorial tradition for male portraiture.

Mary Edwards was of course not alone among the women of her period in desiring an

honest and serious portrait, one that represented virtue and substance rather than vanity and superficiality. Lady Mary Wortley Montagu, for example, published an essay in 1738 in which she wrote, "I have some Thoughts of exhibiting a Set of Pictures of such meritorious Ladies, where I shall say nothing of the Fire of their Eyes, or the Pureness of their Complexions; but give them such Praises as befits a rational sensible Being: Virtues of Choice and not Beauties of Accident."[39] Unfortunately, there is no evidence that such a series was ever executed.[40]

In the decade of the 1740s Mary Edwards also continued to purchase and commission Hogarth's satirical paintings. One picture, listed in the sale of her collection as "The Queen of Hungary,"[41] would have been of particular interest to a woman like Mary. Charles VI, the Austro-Hungarian Emperor who died in 1740, was to have been succeeded by his daughter, Maria Theresa, commonly referred to as the Queen of Hungary. Her right to succession was challenged on the pretense that the female line could not legally inherit. During her struggle to maintain power, England, unlike France, supported Maria Theresa's claim; the picture (especially if it was by Hogarth) may have underscored the anti-French sentiments generated by this affair. Mary Edwards's possession of a work with this subject is further evidence that her selection of pictures was in part motivated by ideological factors, which in this case included not only her patriotism but also her belief in the right of women to inherit positions of wealth and power.

Despite commissions such as those for the Edwards and Coram portraits, Hogarth did not find the kind of success in portraiture that he desired. His friend Henry Fielding's observation (1742) that "the only source of the true Ridiculous . . . is Affectation"[42] may have turned Hogarth's attention once more to the comic modern history genre he had pioneered in *A Harlot's Progress*. This sentiment is also

apt in accounting for the subject of a work Edwards commissioned from Hogarth in that same year—*Taste in High Life* or *Taste à la Mode*.[43] In this instance Edwards may have played a more active role in the work's genesis, since its theme is consistent with her convictions. According to most accounts, Mary Edwards was mocked by London society for her refusal to follow the fashions in dress; *Taste in High Life* was intended to serve as a rebuff to her critics.[44] This is a subject that Hogarth was probably glad to take up, as he too was fond of mocking the vain frivolity of French-influenced fashion. Although Mary Edwards is said to have given Hogarth very specific ideas about the design of the picture,[45] the result, including the figures and the background filled with suitably pointed vignettes, is typically Hogarthian. The theme of the distortions and inanities of fashionable dress are repeated throughout the picture, most notably in the central figure of the lady, who teeters like a little bell in her enormous hoopskirt.

While caricatures of fashionable men and women had already appeared in Hogarth's work, during the next few years he would more pointedly satirize the foibles of this level of society in *Marriage A-la-Mode*, a series that was advertised with the title of "Modern Occurences in High Life." The subject of this Modern Moral Subject is the sad history of a contracted marriage of convenience between a young heiress and a profligate lord. Although this was a popular theme in contemporary literature,[46] Hogarth's depictions may have been informed by the parallel situation of his friend and patron Mary Edwards. Edwards may even have encouraged Hogarth to treat this subject, as, with characteristic self-confidence, she would have been proudly self-conscious of her own success in transcending the follies he illustrated.

In 1805 the artist Martin Archer Shee lamented the state of English patronage in his

Rhymes on Art. He particularly remarked on the fate of *Marriage A-la-Mode*, saying that it reduced Hogarth "to the mortifying necessity of attempting to procure by a raffle that reward for his labours which the generosity if not the justice of taste ought to have conferred on him."[47] Had Mary Edwards lived, this might have been different; however, she did not live to see the completion of this series. She died in August 1743 of excessive alcohol consumption.[48] As requested in her will, Edwards's funeral was "without plumes or escutcheon and in all respects as private as is consistent with decency."[49]

Edwards's biography sheds light on her attraction to Hogarth. The inconsistencies of her biography accord with similar dualities in Hogarth's life and career. Mary Edwards was a highly moral woman, yet she apparently drank to excess. She was proud of her position and wealth, yet she was insistent on modesty and propriety. She was intelligent and independent, yet she was a victim of a classic marriage of convenience. Sufficiently confident to assume a place in the world of men, she evinced no concern with a broader spectrum of feminist issues. Like Hogarth, she aspired to the polite world of London society, yet she remained an outsider. Finally, she is significant not only in the context of women as patrons of the arts in England during the mid-eighteenth century but also for the evolution of patronage in general. In this important time of transition Mary Edwards was in the vanguard.

Notes

I am grateful to Bernadette Fort and Angela Rosenthal for including me in their 1997 symposium on Hogarth and to the Frick Collection Art Reference Library, New York, for its assistance. Special thanks are due to Pennsylvania State University Press for allowing me to reprint this essay from the volume edited by Cynthia Lawrence, *Women and Art in Early Modern Europe: Patrons, Collectors, Connoiseurs* (1997), 236–54.

1. It is known from Hogarth's *Self-Portrait* (Tate Gallery, London) with its enigmatic reference to his "Line of Beauty," that the painter had established his aesthetic theories by the mid-1740s. These were fully worked out in *The Analysis of Beauty* (1753).

2. The fullest account of Mary Edwards's family history is given in W.F.N. Noel 1910. Her prints and drawings were sold on 17 and 18 April 1746, and her collection of original pictures was sold on 28 and 29 May 1746, at Cock's, London.

3. Bindman 1981a, 134. Her annual income was estimated to be between £50,000 and £60,000; W.F.N. Noel 1910, 7.

4. Pears 1988, 3 and 187.

5. Hogarth's *Auction of Pictures* is illustrated in Paulson 1971, 1:212, fig. 73. Cock, who sold all manner of property in his "Great Room, in the Piazzas, Covent Garden," had the most active auction business prior to Sotheby's and Christie's. See Learmount 1985, 22–28.

6. E. F. Noel 1910, 30–31.

7. Quoted in W.F.N. Noel 1910, 7.

8. W.F.N. Noel 1910, 9. On eighteenth-century marriage, see Stone 1977, and Gillis 1985. Gillis 1985, 95, wrote: "Fears that the Fleet encouraged the seduction of aristocratic heirs and heiresses appear to have been exaggerated, for there were relatively few wealthy patrons."

9. The birth was recorded in the *Gentleman's Magazine*, March 1733, 156. The seemingly contradictory birth date of 1732 given by W.F.N. Noel may be explained by the fact that in the old calendar, in use until 1752, the new year did not begin until March 25.

10. This picture is illustrated in Paulson 1971, 1:335, fig. 128.

11. For a portrait of Anne Edwards Hamilton in the uniform of the Second Regiment of Guards, 1731, which has been attributed to Hogarth, see W.F.N. Noel 1910 (opposite 9).

12. Christopher Cock owned a version of this picture.

13. Bindman 1981a, 135, identified the number of the essay and suggested Edwards's role in its inclusion. The essay primarily addresses the "Omnipresence of the Deity"; interestingly, it makes reference to music: "And if the Soul of Man can be so wonderfully affected with the Strains of Musick, which Human art is capable of producing, how much more will it be raised and elevated by those in which is exerted the whole Power of Harmony!"

14. Locke speaks of the "mistake" of paternal power, "which seems so to place the power of parents over their children wholly in the father, as if the mother had no share in it; whereas if we consult reason or revelation, we shall find she has an equal title, which may give one reason to ask whether this might not be more properly called parental power?"; Locke 1698, 52. A writer later in the century observed the dangerous

consequences of boys being raised by their fathers: "The country squire seldom fails of seeing his son as dull and awkward a booby as himself; while the debauched or foppish man of quality breeds up a rake or an empty coxcomb, who brings new diseases into the family and fresh mortgages onto the estate"; quoted in Pointon 1993, 199.

15. See, for example, Arthur Devis's *Roger Hesketh and his Family,* reproduced in Devis 1983, pl. 11.

16. W.F.N. Noel 1910, 9.

17. The Parish Register of St. Mary Abbots church reads: "March 28 1733. Gerard Ann Son of Mrs. Mary Edwards, of this Parish, Singlewoman" (communicated in letter to author by Mr. D. J. Light, Parish Clerk of St. Mary Abbots).

18. W.F.N. Noel 1910, 10.

19. For a brief discussion of eighteenth-century women as patrons and connoisseurs, see Pears 1988, 187. The subject of women as patrons of the visual arts in the eighteenth century has not been adequately studied, no doubt because marital laws gave control of a woman's finances to her husband and thus records of commissions to contemporary artists almost invariably list men as the purchasers. In order to understand the role of women as patrons, a broader definition of patronage must be used—one that takes into account the artist's working relationship with his client, rather than just the execution of payment. Portraiture, which entails substantial contact between the subject and the artist at sittings, is the most fruitful area in which to explore the nature and degree of women's input. Portraiture was also the most commonly patronized genre of painting throughout the eighteenth century.

20. Henry Home, Lord Kames, wrote, "The exclusion of classes so many and various reduces within a narrow compass those who are qualified to be judges in the fine arts"; Kames 1796, 3:371.

21. J. Bennett 1795, 1:169.

22. As illustrated in Hudson 1979, no. 66.

23. Hudson 1979, and Barrell 1986, 67.

24. Hazlitt, 1930–34, 20:41. See Barrell 1986, 65–68, and Pears 1988, 67.

25. Granville 1862, 1:283 (13 July 1731).

26. In his voluminous correspondence, Horace Walpole has little to say about Mary Edwards, except for the repetition of a snide comment regarding her death; see footnote 48 below. Mary Edwards's "eccentric ways made her the laughing stock of society"; see Mee, n.d., 218.

27. The painting is in the Cincinnati Art Museum.

28. See Bindman 1981a, 88–89, for an analysis of the moral message of *Southwark Fair.*

29. Le Blanc 1747, 1:115.

30. Paulson 1971, 1:442.

31. Hogarth 1955, 141.

32. Hogarth's inclusion of the dog as faithful companion depends on a long tradition in male portraiture. Ironically, in portraits of women, dogs were often symbols of marital fidelity.

33. Paulson 1991–93a, 3:475, n. 10.

34. On the cult of Elizabeth, see Kramnick 1968. That the speech selected related to England's victorious conquests of Spain during the reign of Elizabeth would have had further contemporary allusion, since, during the 1730s, the Opposition had consistently pushed a war with Spain on the reluctant Walpole while invoking the glories of Elizabeth's Navy.

35. The Persian Selim writes, "Thou will be surprised to hear that the period when the English nation enjoyed the greatest happiness was under the influence of a woman"; Lyttleton 1734, Letter vi; quoted in Kramnick 1968, 231.

36. Barrell 1986, 65ff. On the exclusion of women from the political/public dimension of society, see Smith 1982; Pateman 1989; and Elshtain 1981.

37. See Meehan 1986, for numerous similar sentiments about liberty in eighteenth-century English literature.

38. Elshtain 1981, 127, addressed women's lack of an appropriate public voice: "Women later were to use the language of rights to press claims. Their arguments had to be compressed within the linguistic forms of the liberal tradition. . . . [Woman] had no vocabulary, in public speech, to describe the nuances and textures of her actual social relations and social location." An early feminist, Mary Astell, with whom Mary Edwards was certainly familiar (see footnote 44 below), had sensed this contradiction in liberal political theory and would have been a precedent for the "staunch Opposition politics" Paulson ascribes to Mary Edwards; see Perry 1990, 444ff.

39. Halsband 1956, 168.

40. Montagu's own portraits in Turkish dress, painted after her disfiguring bout with smallpox by Jonathan Richardson and others, have also been recently interpreted as the result of Montagu's intervention in the process of patronage, as "a solution that re-empowers the subject not only by the actual restoration of her beauty in paint but by that beauty's allusions to the oriental other"; see Pointon 1993, 144.

41. Although the work was listed in the catalogue (London,

Cock's, 28/29 May 1746) as being by Hogarth, no work by him with this title is known. The attribution to him suggests that this was a subject picture rather than a portrait.

42. See Fielding 1742.

43. The painting, in a private collection, is illustrated in Paulson, 1971 1:467, fig. 180.

44. Ibid., 1:466. Mary Edwards was certainly aware of the writings of Mary Astell, who wrote: "Let us pride ourselves in something more excellent than the invention of a Fashion. . . . Custom has usurped such unaccountable Authority, that she who would endeavor to put a stop to its Arbitrary Sway and reduce it to Reason is in a fair way to render her self the Butt for all the Fops in Town to shoot their impertinent Cen-

sures at": see Astell 1986, 141 and 162. Astell had also had a great deal to say that was relevant to Mary Edwards's marital situation: "It is the hardest thing in the World for a Woman to know that a Man is not Mercenary"; Astell 1986, 106.

45. W.F.N. Noel 1910, 9.

46. Stone 1977, 277.

47. Shee 1805, 15–17.

48. Horace Walpole quipped, "The motto which the undertakers had placed . . . *mors janua vitae* . . . ought to have been *mors aqua vitae.*" See Walpole 1954, 20:4.

49. W.F.N. Noel 1910, 11.

Hogarth's Working Women: Commerce and Consumption

Patricia Crown

William Hogarth's immediate family, both in childhood and as an adult, was comprised of women who worked. His mother, sisters, wife, and other female relations were responsible for the organization and execution of domestic labor. Some of their domestic accomplishments were also marketable skills that bridged the apparent division of home and marketplace. His mother, Anne Gibbons Hogarth, supported her children while her husband was in debtors' prison by concocting and selling herbal medicines for children's illnesses.[1] Before her marriage, it is likely that she, as the eldest daughter in the Gibbons family was her "father's chief assistant in his business or the family housekeeper."[2] Although the nature of her father's business is unknown, her housekeeping duties can be assumed. Her father rented rooms in his house, and one of his lodgers was Richard Hogarth, a schoolmaster and writer of convoluted treatises on language—and Anne's future husband.

When it became evident that Richard would not be successful at teaching and writing, he opened a coffeehouse, which his wife helped him run from 1703 to 1708. (The most common shared occupation for couples in early eighteenth-century London was running a food-and-drink establishment—tavern, cookshop, or coffeehouse. Female domestic skills were obvious training for providing sustenance.)[3] Richard Hogarth's advertisement for his business offered as inducements to potential customers conversation in Latin and the

society of learned gentlemen. His establishment, then, sought to be a locus of polite sociability as well as a place of commercial news and political argument. It should be kept in mind that coffeehouses at this time were not generally as decorous as Richard Hogarth's advertisement suggests. They commonly offered elixirs, pills, lozenges, dentifrices, and medicines, the same sort of things that Anne Hogarth produced and purveyed from Black and White Court next door to the Ship Tavern. Many coffeehouses sold spirits as medicinal "elixirs."

Coffeehouses were also places of sexual assignation.[4] Thomas Brown and Edward Ward, writing in the late seventeenth and early eighteenth centuries, again and again describe entering coffee houses to drink brandy, whisky, and gin and to accept or decline the landlady's offer of female companionship: "Bawdy houses are fain to go in disguise, 'Coffee to be sold,' or 'fine Spanish chocolate' invite you in when in reality they sell only Ratifia, Rosa, Solis, Geneva."[5] It is possible that Brown and Ward were inclined to exaggerate the naughtiness of coffeehouse and tavern entertainment to amuse their readers, but their comments are supported by numerous examples recorded by historians and by contemporary popular images.[6] One of the most famous was Tom King's Coffee House in Covent Garden (actually operated by his widow Moll King from about 1730), which appears in Hogarth's painting *Morning* (1736). It was known as a place where

sexual services could be commanded. An anonymous print of 1737, *A Monument for Tom K—g*, epitomizes the commodities and entertainment to be found there—coffee, of course, as well as brandy, women, and brawling. This is not to claim that Richard Hogarth's place was as bawdy as King's—it certainly was not as successful—but to enlarge our sense of the scope of Anne Hogarth's experience and activities and to suggest that she had more varied knowledge of the world and a more complicated life than is customarily ascribed to the wife of a feckless, intermittent schoolmaster.

William Hogarth's sisters owned and managed a shop that sold textiles and children's clothes from 1725 until about 1742. It might have been established earlier, since there is no record of how the family managed financially after Richard Hogarth's release from debtors' prison in 1712 until the establishment of William Hogarth's business in 1720. Anne Hogarth could have worked as a seamstress with her teenage daughters, training them and supporting her family. Their trade card (fig. 89, 1730) by William Hogarth announces that they sell ready-made children's suits, coats, shirts, and drawers of fustian, flannel, and canvas; they also sold fine linen and cotton wholesale and retail. The card shows the shop with a ready-made frock coat hanging on the wall at the right, and a little boy, still dressed in the skirts of infancy but wearing a hat like his father's, being presented to the two proprietors (who probably represent Hogarth's sisters) for

his first breeches. The older boy, already in masculine garb, is pointed to as a model. He is trying on a jacket, while his parents and the proprietors exchange opinions and information. The enterprise of Hogarth's sisters is culturally interesting because it is evidence that the ready-made garment trade was well established in the first half of the eighteenth century. Previously it was thought that most clothes were made at home or to order by tailors, but dress historians have shown that a substantial amount of clothing was sold in shops.[7] We see Hogarth's sisters, then, working in what Beverly Lemire has called "an important part of a national clothing market in which the total annual consumption of clothing accounted for about one quarter of all national expenditure." This excited protest and complaints from the traditional tailors' guilds against women clothes makers and sellers.[8] Female enterprises were also called *disorderly* because they were conducted on the edges of the formal economy and combined services and commodities.[9] They offered a variety of products: Mrs. Holt, for whom Hogarth made a trade card, dealt in Italian damasks, velvets, violin strings, capers, anchovies, and sausage. Other enterprises run by women traded in second-hand items, wholesale and retail sales, as well as stolen goods that were taken apart, restyled, and resold. They were businesses functioning outside of regulatory systems.[10]

Like many other women whom scholarship

Patricia Crown

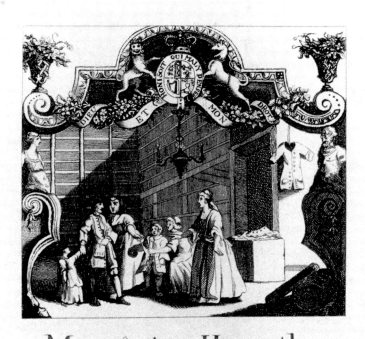

Fig. 89. William Hogarth, *Trade Card for Mary and Ann Hogarth*, 1730. Etching. The Henry E. Huntington Library, San Marino, California

people still ran their business out of their own homes or adjoining building. . . . Women were especially likely so to do. . . . [Evidence refutes] the widely held assumption that middling women could not respectably live on their own and be self-supporting. One sees here evidence of the first substantial body of independent, literate and self-supporting women in English history."[11] Thus Hogarth's mother and sisters were part of the invisible economy of this period.

Married women were unlikely to report themselves as working for pay, especially if they kept boarders or helped their husbands in their shops. Various sources show that most unmarried women, wives, and widows were "wholly or partially maintained by their own paid employment."[12] Indeed, most women worked. Hogarth's wife—the daughter of the most prominent English artist of his day, a gentleman's daughter raised in comfort—had as keen a sense of business as her husband. She managed his estate after his death and was regarded as a capable businesswoman, arranging for the publication and sale of his works and overseeing his artistic reputation and commercial legacy. She secured a special addendum to Hogarth's Engravers' Act, which gave her a further twenty-year copyright on his prints. She also sold Trusler's edition and explanation of her husband's prints from her house in Leicester Square.[13] All these eighteenth-century women were part of what Jan DeVries has called the *industrious* revolution, which preceded the industrial revolution.[14]

Hogarth spent much of his life in neighborhoods where working women were very much in evidence. They worked as apprentices and purveyors in the needle trades: as milliners, seamstresses, mantua makers, dressmakers, petticoat quilters, apron, ribbon, ruffle, hood, and tippet workers. They made and sold jewelry, china, silverwork, perfumes, condoms, confections, maps, prints, and fans. They worked as actresses, dancers, prostitutes, per-

has just started to consider, Hogarth's mother and sisters were contributors to the nascent consumer society in the first half of the eighteenth century. For example, Margaret Hunt's research on middle-class women and trade shows that "many women set up in trade with other women (sometimes their sisters, sometimes not), probably in an effort to compensate for their relatively lesser access to capital in comparison with men and perhaps also to safeguard their title in case of marriage. Most eighteenth-century middling

226

formers, and servants. They were street ven-dors, tallow chandlers, nurses, pawnbrokers, and occasional thieves. Not surprisingly, these industrious women appear in his pictures, often in their very centers.

Women's work and economic activities in Hogarth's period, as well as his depictions of them, have frequently been obscured or over-looked because women's labor was often simi-lar to or overlapped with domestic and sexual work, which has not usually been considered "real" work at all. Even women engaged in clearly commercial enterprises have been erased from sight and history. Ronald Paulson assumed, for instance, that "M. Gamble," a fan maker who published a fan decorated with scenes from *A Harlot's Progress*, was "Mr." Gamble; in fact, she was Martha Gamble.[15] Hugh Phillips's *Mid-Georgian London* illus-trates the interior of Westminster Hall in 1745, showing at least five stalls run by women, but in his description he refers only to male stall-keepers.[16]

Hogarth the shopkeeper, skilled artisan, and entrepreneur was particularly well situated to observe female commercial activity in the developing consumer society of early eighteenth-century England. Because he rarely reduced images of women to trite, reassuring stereo-types, his representations are worthy of our attention. He was an acute observer of both men's and women's experiences. In regard to women, in particular, he always tried to under-stand and convey how power works on women in society—the power of words, money, law, education, gender, and class. I will reexamine some of Hogarth's images of women and com-merce in the light of current research by labor and economic historians and link these insights with what is known of his own relationships with and observations of women.

Hogarth depicted a wide variety of work-ing women. Prostitutes, actresses, domestic ser-vants, street sellers, and a needleworker are most prominent. Female servants appear less fre-quently in significant roles in his works than might be expected, given the number of domes-tics in eighteenth-century London.[17] Court records show them figuring in any number of domestic lawsuits—mainly divorce suits—and in criminal actions such as prosecutions for theft.[18] In plays and novels they interpret or reveal their masters' actions; they are accom-plices or confidantes; they are contrasted with the upper-class characters or become upper-class characters.[19]

A Harlot's Progress shows servants in each scene. The young women in the York Wagon who have traveled with Moll Hackabout are presumably seeking work as servants; there is a laundry maid hanging out clothes. In the sec-ond plate Moll's maid, who is also her accom-plice in deceiving her rich lover, looks much like the women in the York Wagon (admit-tedly, none is individuated). Perhaps Moll hired one of her former companions. In the third scene Moll's servant is older and marked by disease. She is probably meant to represent a superannuated prostitute. She functions in this and subsequent scenes as both exploitative servant and sisterly companion: she takes Moll's fine stockings and shoes; she nurses Moll in her dying moments; she tries to pro-tect, perhaps for her own acquisition, Moll's clothes from being stolen by her landlady; she glares at the malfeasant clergyman who neg-lects his duties at Moll's funeral. In the last scene of *Marriage A-la-Mode* the old nurse displays sorrow at the countess's death and concern for the child. Presumably she stayed in such a job (despite bad food and mean condi-tions) out of feeling for those she nursed. When servants appear in other pictures by Hogarth, it is sometimes difficult to recognize them as such: the woman in the outdoor ver-sion of *Before* and *After* (fig. 26) is identified by Aileen Ribeiro as a lady's maid on the basis of her clothes, but the uninformed viewer

would have difficulty assigning her to a class or occupation.[20]

In the early part of the eighteenth century there were few distinctions of dress, or even sometimes of manners, between ladies' servants and their mistresses. Servants were given their mistresses' discarded clothes; sometimes it was specified by contract that servants receive certain items of their employer's clothing. And many women were in service just long enough to accumulate some savings. D. A. Kent has argued that domestic service allowed women some choice and some economic independence: they were usually hired by contract, and though paid only £4 or £5 a year, they were given food and shelter and had unrestricted use of their own earnings. Furthermore, they might leave their employment at the end of their contract if they chose. They had a certain social mobility and might work in different occupations at different periods in their lives.[21] Male servants were more numerous than female servants in the seventeenth and early eighteenth century, and this is reflected in Hogarth's depictions, but middle-class women were beginning to employ their own servants for personal services. The proliferation of women's servants was seen as an indication of rising standards of comfort, even of luxury.[22]

Two other pictures of women domestics should be noted: Hogarth's group portrait of his servants, including three women, and the portrait of Mary Lewis. Although she is thought to be a relative, Lewis served as a housekeeper and helped to sell prints at the Hogarth house in Leicester Fields. According to John Nichols, Hogarth died in her arms, which suggests that she helped to nurse him in this final illness.[23] There is in these depictions something that suggests sympathy and an attitude of equality, the attitude advised in *The Ladies Dictionary* (1694), which tells its readers not to think servants beneath their attention or to treat them rudely, but to regard them as

"humble friends," some of whom might once have been in a higher station in life.[24]

Female street vendors are another group of workers who appear frequently in Hogarth's pictures. Two of his most striking images are of *The Shrimp Girl* (fig. 97) and the milkmaid in the *Enraged Musician*. Sean Shesgreen's *The Cries and Hawkers of London* (1990) elucidates the history of depictions of street criers and explains the work done by each vendor. Fish and shellfish mongers were low in the hierarchy of vendors, for their wares were perishable. When fish were few or not fresh, street vendors turned to other perishables, such as new asparagus or radishes. The kind and amount of their merchandise depended on the season, the catch, and the harvest.[25] Milkmaids, according to Shesgreen, performed especially arduous work, milking cows twice a day in filthy, dark hovels and carrying the heavy buckets on a yoke through the streets. They often labored for milk wholesalers.[26] Yet Hogarth shows both types of vendors as robust and prospering. *The Shrimp Girl* is vigorous, and the fishwomen in *Beer Street* are neatly dressed and drinking beer (but not drunk); they are even reading. The milkmaid in the *Enraged Musician* is a veritable London Venus, albeit with thickly muscled arms. The milkmaid in *The March to Finchley* also looks healthy and well, if plainly, dressed. In *The Distrest Poet* (fig. 62), the milkmaid—caped, necklaced, her hat ringed with little flowers—is very much in charge of her own business. I cannot account for the discrepancies between written and visual representations; it is unlike Hogarth to sentimentalize these women. He certainly does not soften the images of ballad and broadsheet sellers, who are invariably abject, dirty, tattered, and sometimes maimed. They are always shown holding a baby or pregnant or both. Indeed, the contrast between the milkmaid and the ballad seller in the *Enraged Musician* is arresting: the one superbly erect at the center

of the throng, the other bent and crushed into a corner of the lane.

One of the most interesting and even controversial of Hogarth's female characters is Sarah Young. She is a working woman, a domestic servant or milliner's apprentice who is shown pregnant and betrayed in the first scene of *A Rake's Progress* (fig. 90). She is a counterpoint character to the Harlot and to the Rake. She has usually been slighted by Hogarth scholars as a dim, seduced girl, but her significance as a worker, businesswoman, mother, daughter, and probably a wife is insisted on by Hogarth. It has been assumed that, in the narrative context of the progress, Rakewell betrayed her with a promise of marriage. However, Hogarth may want us to understand that the two were married according to the law and custom that obtained before 1753, a significant point, since it establishes the legitimacy of Sarah's child and her right to protest at the door of the church when Tom bigamously marries another woman. In the picture, Sarah holds a wedding ring and a letter from Tom on which we can read the phrase "marry you." Before the Clandestine Marriage Bill of 1753, which required banns or a license, witnesses, an authorized clergyman, and recording in a marriage register, a binding marriage could take place if a couple promised to live together as man and wife—the marriage coming into existence as soon as consummation occurred. As Eve Bannet argued, "Seductions as well as abductions and clandestine marriages, were, for all intents and purposes, real marriages." The words "marry you" seem to be a promise of marriage in the future, but if those words were followed by sexual consummation, the ambiguity was resolved.[27] In the fifth scene of *A Rake's Progress*, Rakewell is married by a corrupt clergyman in a derelict church. The tablet of commandments six through ten is cracked diagonally, but the only commandment that is actually crossed is the

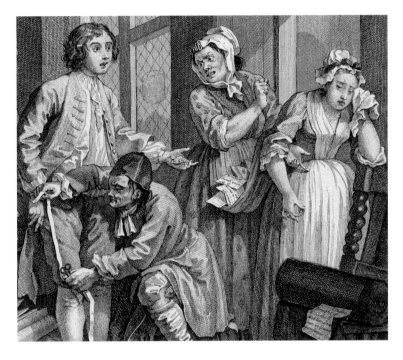

ninth: "Thou shall not bear false witness"—that is, swear falsely before God. Rakewell does this when he denies, as part of the ceremony, his prior marriage.

There were specific reasons for Hogarth to have taken a personal interest in laws about marriage and their effect on women. His own marriage to Jane, the daughter of the painter James Thornhill, was conducted in a church and duly recorded, but it was without the knowledge or consent of the bride's father. Because Jane was underage, the marriage might have been declared invalid. Further, there is no record of his own parents' marriage in the registers of their parish church, perhaps because, as Paulson suggests, they were married in a dissenting church.[28] It may have been, however, because their marriage was performed in the traditional fashion, by mutual promises and consummation, independent of any church ceremony or register. The marriage is recorded in the Gibbons family Bible without any other information, which would have been in accord with

Fig. 90. William Hogarth, *A Rake's Progress*, Plate 1 (detail), 1735. Etching and engraving. University of California, Berkeley Art Museum

custom. Hogarth's patron, Mary Edwards, whose marital vicissitudes have been much described, may not have been married at all, not even clandestinely, as is usually supposed. As Kimberly Chrisman has recently shown, Edwards was rich and independent enough to live with her lover and have a child by him without marriage. She thus retained control of her wealth, a concern shared by rich women and working women alike.[29] Peter Earle observes that many London marriages in the first half of the century "were legally dubious," at least by later standards. That most were private, even covert, and "celebrated with a minimum of publicity" in a tavern or a private house is puzzling in a society where much of "life was a spectator sport."[30] These marriages and others, regular or irregular, with which Hogarth was familiar, were relevant to the lives of working women. It is important to observe that, in *A Rake's Progress* and elsewhere, Hogarth stressed the self-reliance of women, especially where abandoned by reckless men or spouses.

Sarah Young, married or not, does not sink into squalor, prostitution, or despair. She becomes a respectable milliner. (We are free to infer that she establishes herself in business with the money that Rakewell gave her in lieu of public marriage.) She raises her daughter with the help of her mother, who is also represented as a working woman.

When Sarah Young appears in the fourth scene of *A Rake's Progress* (fig. 91) it is as a successful representative of the higher levels of the trade in clothing. She is so well employed that she can pay the Rake's debts and save him from prison. Hogarth suggests that the money Rakewell gave her has been invested by a good businesswoman and returned with interest. Sarah is dressed with the neat elegance characteristic of women in the needle trades. Her clothes are not gaudy or ostentatious. Nevertheless, as signs of her taste and prosperity she is wearing a silk gown, fine linen, a simple necklace, a nicely ribboned cap, and sleeve ruffles. As a milliner, she is in one of the few trades dominated by women. It is the most prestigious of the trades open to women, one to which gentlemen's and clergymen's daughters were sometimes apprenticed. Hogarth makes it clear that her success was achieved through her own talent, resourcefulness, and industry. Her honesty and reliability are in evidence too, since the laces and linens she works with are expensive. This representation of a working woman is unusual; the more common picture, both visual and literary, is of women in commerce selling their bodies. This was the commodity that they purveyed.

James Grantham Turner documents the mean fictions directed at women who resisted coercion and supported themselves and the obscene pamphlets that represented "the economic activity of women as a kind of prostitution."[31] John Brewer writes that "the woman who was a cultural [or commercial] producer, who appealed to or appeared before the public, compromised her virtue because such conduct was construed by many critics as inherently immodest. It laid women open to the charge of being tantamount to the only other independent woman in the cultural public sphere, the punk or prostitute.[32]

Without her mother's help, Sarah Young might have become one of the company of prostitutes in the third scene of *A Rake's Progress*. Yet they, too, are depicted at work—singing, stealing, pouring drink, undressing, displaying themselves in lascivious poses, making seductive conversation, all to sustain themselves financially. Hogarth draws attention to the commercial aspect of prostitution by showing the women engaged in negotiating services and payments. For the unskilled, unemployable Tom and his companion, all this activity is entertainment; for the women, it is labor, requiring training, practice, experience, and discernment.

Fig. 91. William Hogarth, *A Rake's Progress*, Plate 4 (detail), 1735. Etching and engraving. University of California, Berkeley Art Museum

Fig. 92. Richard Houston (Irish, 1721/2–1775), after Philip Mercier (French/German, 1689/91–1760), *Native Meltons*, c. 1756. Mezzotint engraving. Collection of David Alexander

In scene 1 of *A Harlot's Progress* Moll Hackabout, who will become a prostitute, is shown arriving in London to seek work as a seamstress. Hogarth represents her as betrayed by a "false mother," the procuress called Mother Needham. She is either ignored or exploited by social institutions and individuals that should have protected and helped a naive and resource-less young woman: the clergy, the law, doctors, guardians, the educated, the powerful. Had she had better luck or had she been shrewder, she might have worked as a prostitute for a few years, selling sex as "part of an economy of makeshifts—as a normal part of a wide-ranging set of economic and social activities," and gone on to marry and/or enter another trade.[33] Tim Hitchcock notes that "most prostitutes worked for themselves. . . . Prostitutes generally worked the street in pairs, renting a room. . . . Bagnios and bawdy houses were available, but the orga-nization of the trade was almost entirely left in the hands of the women involved."[34] It is inter-esting that public defamation by neighbors as a

whore, a grave insult, was generally provoked by business practices such as cheating, bad debts, flaunting stolen goods, or disgraceful public behavior, rather than by sexual actions as such.[35]

Sexual commerce was one of the disor-derly and unregulated trades, merging with such regular ones as tavern keeping, dealing in secondhand clothes, and other kinds of shop-keeping. The activities of exchanging, stealing, and dealing in second- or third-hand clothing appear in various scenes of *A Harlot's Progress*. In the fourth scene the jailer's wife fingers Moll's lace pinners (part of her headdress) and silk skirt with the obvious intention of acquiring them. In the fifth scene the landlady appropri-ates Moll's shoes and gown from a trunk, while in the last scene Moll's friends try on her caps and gloves; one steals a fatuous suitor's handker-chief (worth one or two shillings) while he helps her pull on a glove. All these items would be recycled in some way and are testimony to the women's resourcefulness.[36]

Female genitals were called "commodities" in the slang of the period.[37] The glossary to Ned Ward's *London Spy* gives the slang defini-tion of *marketplace* as *face*—that is, her market-place sells a woman's commodity.[38] William Wycherly's late seventeenth-century poem, "Juicy, salt commodity," for example, was about an oyster seller. *Native Meltons* (fig. 92), after Philip Mercier's painting, *Oysterinda* (1750), is in the spirit of that poem and also derives from the seventeenth-century Dutch tradition of depicting comely women offering oysters to males who either appear within the painting or are presumed beholders. It was assumed—and there are some factual accounts that support the assumption—that oyster sellers, shrimp girls, milkmaids, strawberry vendors, ballad singers, and female street traders of all kinds were displaying their charms as well as their wares and would sell themselves when their other merchandise was gone or when business was slow.[39] Women shopkeepers too, even

when married, were supposed to be available. Ned Ward writes,

Where women sat in their pinfold, begging of custom with such amorous looks, and in so affable a manner that I could not but fancy they had as much mind to dispose of themselves as the commodities they dealt in. . . . This place is the merchants' seraglio, a nursery of young wagtails for the private consolations of incontinent citizens; for most that you see here come under Chaucer's character of a sempstress, "She keeps a shop for countenance and swyves for mounenance [sustenance]."[40]

Certainly it was difficult to identify sexually available women from the kinds of clothes they wore. Prostitutes, part-time prostitutes, occasional prostitutes, and women who were none of the above all wore more or less the same cut and color of clothing. Even maids wore silk and fine linen, as foreign visitors and native-born observers never tired of remarking. Even though there was a difference between city and country wear in the early part of the century, it became fashionable for city women to wear rustic straw hats and red cloaks.[41] The whores in *The Rake's Orgy* and *The Harlot's Funeral* are arrayed in an assortment of ordinary female clothes. They wear petticoats (skirts), gowns (an open robe worn with a petticoat), stays, caps, handkerchiefs (a square of light fabric covering the neck and breasts), gloves, aprons and short mantles. Ned Ward describes the clothes of prostitutes, stressing that they dress like ordinary women: one in a straw hat and blue apron, like a domestic servant, another in a white sarsenet hood with a posy in her bosom "as if she had just come from the funeral of some good neighbour."[42] It was common for prostitutes to dress with the demure simplicity of Quakers, such as the prostitute heroine of Defoe's novel *Roxana*, for instance. It was the manner in which women wore their clothes—very loose or very tight stays, pinned-up skirts, revealing neckwear, the amount and kind of makeup used—that were

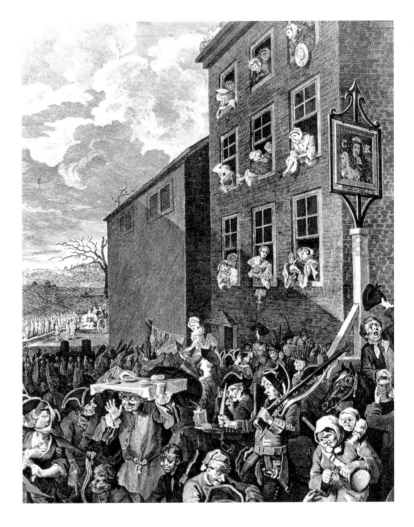

Fig. 93. Luke Sullivan (Irish, 1705–1771), after William Hogarth, *March to Finchley* (detail), 1750. Engraving and etching. The Henry E. Huntington Library, San Marino, California

indicators of profession. Hogarth's representations follow the contemporary verbal descriptions. In *The Rake's Orgy* the extreme disarray of the women's clothes and one woman's literally over-the-top ostrich-feather headdress indicate revelry and lust.[43] The women leaning out the window of the inn in the *March to Finchley* (1750, fig. 93) are whores observing the departure of the army, but none is dressed in a way that would identify her as a prostitute. Their clothes do, however, show something of their status and specialties, according to Rouquet's commentary.[44]

In eighteenth-century fiction, again and

233

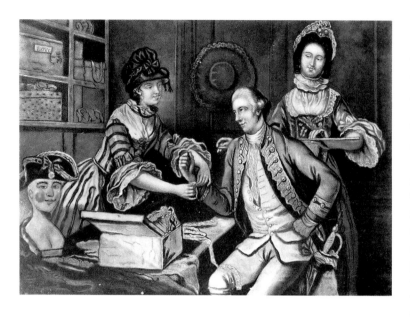

Fig. 94. John Collet (English, c. 1725–1780), *The Rival Milliners*, 1770. Mezzotint engraving. The Henry E. Huntington Library, San Marino, California

again young women begin their careers of prostitution as real or pretended milliners (Fanny Hill, for instance, and the protagonist of *The Life and Intrigues of Mrs. Mary Parrimore* [1729]). John Collet's print of a milliner's shop (1770, fig. 94) reflects the pervasive view of working women, especially those in the needle trades. They were commonly supposed to be at least part-time prostitutes, corrupted by the bodily intimacy of fitting clothes, the semiprivacy of the shop, and the ribaldry and flirting of the vain young men to whom they had to be complaisant. Here two milliner's assistants measure the male customer's length and circumference, and all three smirk with knowing satisfaction.

Hogarth, however, does not allow this reading of Sarah Young, or of most of the female workers he depicts. Women such as they had work to do. They did not labor as hard as they did to excite idle males, although the fantasies of potential male customers would have been part of the allure of consumption, of the power of purchasing—that is, exercising desire and disdain. Many of their customers, after all, were women. Moralists

claimed that women customers were also seduced by working women into desiring luxury, frittering their time away admiring expensive trifles and toys, and displaying themselves in public like the sellers and their wares.

Hogarth's image of *The Savoyard Girl* (fig. 95) is of an itinerant street musician, one of a class of impoverished migratory workers. The Savoyarde is young and fresh-faced but dressed in dark, coarse clothing, performing in a dreary tavern. She is singing for money but not posing enticingly. Artists other than Hogarth, especially those working after 1770, tended to sexualize female laborers, to make them more genteel, as if they were actors in an urban pastoral. Crones, the uncomely, and the haggard were excluded from representations or shown in gross caricature. These later images of pretty women were consonant with the literary representations of the early 1800s, combining picturesque pseudo-poverty with erotic availability.[45] Compare, for instance, *The Shrimp Girl* of circa 1745 and the print made thirty years after it (figs. 97 and 98). In the later image, the girl's hair is smoothed, her neckwear arranged, and an exposed nipple, like a small curled shrimp, is added. Hogarth would have thought such a stale visual pun and provocation unnecessary and, moreover, inaccurate. It is not that he was indifferent to feminine beauty or disapproving of sexual allure. His sensual pleasure in women's looks and attire is recorded in his paintings and in *The Analysis of Beauty*, where he speaks of women, their movements, their faces, hairstyles, and clothing as alluring, bewitching, inviting, and ravishing.[46] (This attitude, incidentally, contrasts with that of many male contemporary writers who condemned and ridiculed female vanity and adornment.) He observed that modern women might be more beautiful than the classical Venus because the living women moved, were expressive and animated.[47] His images of working women show them as comely, plain,

youthful, aged, sexually appealing, physically repulsive—in other words, as individuals, with individual histories and temperaments, with nuances of character added to their different degrees of beauty. What he does not do is promulgate the fantasy that all working women are more or less the same, standardized and purchasable like merchandise.

Hogarth was ever aware of the work required of most women: a variety of household duties and the care of their children, on top of earning money outside the home. This is demonstrated in the seventh scene of *A Rake's Progress* (fig. 96). Sarah Young has been recutting, restyling, and selling Tom's second wife's clothing on the second-hand clothes market—we can see that the gown or skirt she has been working on matches the apron that the older woman wears in great detail, down to pattern, and ruffle. The verses by John Hoadly appended to the print tell that Sarah has been selling small millinery items to help Tom. Sarah's little girl is robust and well cared for. She has been cherished by her mother and grandmother and perhaps by the third woman in the group who looks as if she might be a milliner or milliner's assistant. Peter Earle has written of this period that it "was in fact a very female world in which women worked with women, talked to women and were even for the most part employed by women."[48] Margaret Hunt has also documented the large number of women who set up in trade with other women and shared business and living premises.[49] The third woman in this scene might be part of an informal, cooperative household of female workers like that of Hogarth's mother and sisters or like the one depicted in *Strolling Actresses Dressing in a Barn* (fig. 21). In that print, discussed in this volume by Christina Kiaer, the women rehearse for their performance, or prepare costumes, scenery, footlights, and special effects.[50] Hogarth shows theatrical entertainment turned

inside out. Its seams, patches, stitches, and stains are displayed. He shows the hidden understructure of display, of which women have most intimate knowledge. The women concoct and wear costumes or parts and combinations of costumes appropriate to their roles as inhabitants of the fantasy world of Juno, Syren, Diana, Aurora, Night, and so on. At the same time, they must also function in the actual, non-mythological, human world in a practical way, caring for their children, washing and mending, cooking, and nursing. This work, women's work, domestic labor, is more

Fig. 95. G. Sherlock (Irish, 1738–1806?), after William Hogarth, *The Savoyard Girl*, 1799. Engraving. The Henry E. Huntington Library, San Marino, California

Patricia Crown

Fig. 96. William Hogarth, *A Rake's Progress*, Plate 7 (detail), 1735. Etching and engraving. University of California, Berkeley Art Museum

difficult because it is carried out in a barn, in transit from one performance to another, yet Hogarth shows it accomplished with good humor, cooperation, and kindness. This is a complex image of the pressing, daily labor of creating a pleasing deception on stage, combined with the difficulties of a non-make-believe existence. These women do not live in the abstract, classical space of traditional art and theater but in the disorder necessitated by their occupations. As we know, this print was published just when strolling players had been made illegal, when actresses making a living for themselves and their children were forced into some other occupation or had to return to their original employment as seamstresses and mantua makers.

Hogarth saw women not only as produc-

ers of goods but also as consumers of them. Many of those producers and consumers were women of his own class. Art historians often assume that most of Hogarth's paintings and prints were bought by gentlemen. Certainly, many were commissioned by upper-class men, but we ought to consider an invisible market as well. Lorna Weatherill's studies show that "a far higher proportion of women than men among the tradespeople and large farmers had pictures . . . as well as books," and "women were able to express themselves through the ownership of material goods."[51] Joyce Appleby makes a similar statement about both men and women: "Consumption—the active seeking of personal gratification through material goods—was a force that had to be reckoned with [in early modern Europe]."[52] If we see consumption as a cultural expression of physical needs and changing fashions, as displays of self-expression, particularly by those classes that Hogarth knew best and to which he and his family belonged, it is understandable that luxury products and those who consumed and made them should have had such prominence in his pictures. He said in *The Analysis of Beauty*, "Fancy, the love of change and private and public interests have always given the lead to the fashions of dress and will ever continue to do so. . . . It is fit that they should. Nothing should be restrained."[53]

There have recently been a number of scholarly discussions of attitudes to luxury in Hogarth's period and later, often concentrating on its consumption rather than its production. It has in general been accepted that the disasters that befell the protagonists of *A Rake's Progress*, *A Harlot's Progress*, and *Marriage A-la-Mode* were caused in part by their emulating the rich and desiring similar possessions and styles of self-display. But Hogarth as a dealer in and a creator of luxury products, a writer who had much to say about interior decoration, furniture, and clothing design, certainly

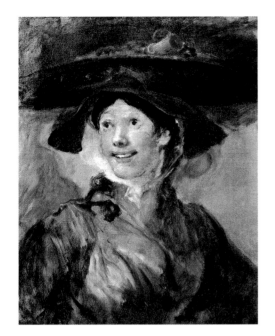

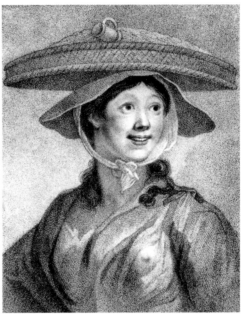

Fig. 97. William Hogarth, *The Shrimp Girl*, c. 1745. Oil on canvas, 25 x 20¾ in. (63.5 x 52.7 cm). The National Gallery, London

Fig. 98. Francesco Bartolozzi (Italian, 1727–1815), after Hogarth, *Shrimps!,* 1782. Stipple engraving. The Henry E. Huntington Library, San Marino, California

thought that life should include "imaginative, ornamental and even aesthetically licentious pleasures."[54] It is not the acquisition of luxurious goods and experience per se that he satirizes in some of his works and associates with their owners' downfalls, but the wrong sort of commodities and pleasures: meritless architecture, dismal paintings, spurious antiquities, silly toys, and silly indulgences. It is the same set of mental and moral qualities that leads the characters to disaster that causes them to desire and buy worthless, yet expensive goods. Richness and variety of goods and pleasure, when their production and use were properly understood, were as much a part of Hogarth's commercial life as of his aesthetic system in *The Analysis of Beauty.*

Discussion of luxury inevitably must deal with Lord Shaftesbury's (and others) identification of a desire for luxury and visual beauty with effeminacy.[55] While Shaftesbury's writings belong to the early part of the century—Hogarth's formative years—it is hard to see any influence on Hogarth's production and

thought. There may have been something antithetical to Hogarth's temperament and ambitions in Shaftesbury's homosocial and authoritarian notions of correct taste. Robert Jones has recently written about women and commerce in Shaftesbury's thinking: "Current taste, in particular, was derided and represented as effeminate consumption, represented throughout *The Characteristics* as the product of women's unwanted intrusion upon men's reasoned and reasonable society. Women presented an especial problem for Shaftesbury, who frequently counseled his readers against association with the 'fair sex' as an activity likely to prove injurious to their civic virtue and to their public reputations."[56] Ronald Paulson has even argued that Hogarth's "Modern Venus" is the embodiment of anti-Shaftesburian aesthetics.[57] And *The Analysis of Beauty* specifically claims women among those who can understand and practice aesthetic principles.[58] It was in the later eighteenth century, after the establishment of the Royal Academy, that Hogarth's work was retrospectively

effeminized, so to speak, because of its association with commerce, the rococo style, and the frequency with which his pictures either foregrounded women or appealed to them.

Hogarth was an observer who apparently was little threatened by female economic, commercial, and cultural agency. It must be acknowledged that he seems to have ignored or deleted the representation of women in occupations or with talents that might have competed with his own; no women artists or writers, women printsellers or engravers, appear either formally or casually in his work. However, neither did he join in the wishful thinking, obsessive complaints, and attacks that were made about and against working women by the majority of contemporary male commentators. He represented, with attention and appropriate complexity, women at work.

Notes

1. Paulson 1991–93a, 1:26.

2. Ibid.

3. Earle 1994, 122.

4. See Ward 1993, 20, 31–34. Ward operated taverns and a coffeehouse between 1715–30.

5. Brown 1927, 97. *Amusements* first appeared in 1700; Brown's *Collected Works* was published in 1707–8.

6. For instance, see Lillywhite 1964, 596.

7. Lemire 1984, 30–39; Ginsburg 1972, 70.

8. Lemire 1994, 61–63.

9. Lemire 1997, 95–120.

10. Ibid., Lemire 1997, 96–97; 121–43.

11. M. Hunt 1996, 134.

12. Ibid., 128–29.

13. Sheila O'Connell's lecture, "Hogarth the Printseller: A Marketing Phenomenon," presented at the Hogarth Tercentenary Conference, Paul Mellon Centre for Studies in British Art, November 1997, included a fully detailed account of Jane Hogarth's marketing of her husband's legacy.

14. Quoted in Lemire 1997, 3.

15. Paulson 1991–93a, 1:312; Clayton 1997, 83, 94, 135, records her activities, as he does those of milliners, silk designers, stationers, and booksellers. For Martha Gamble see also Rosenthal, this volume.

16. Phillips 1964, 20.

17. Kent 1989, 111–12.

18. Stone 1990; Earle 1994, 255–59; Lemire 1984, 121–46.

19. Hill 1996, 208–50.

20. Ribeiro 1983, 43.

21. Kent 1989, 115–18, and Hill 1996, 93–114.

22. Earle 1994, 40–42.

23. Nichols 1781, 57.

24. Anon. 1694, 252; see also Kunzle 1978 for Hogarth's attitude toward women, children, and servants. I am indebted in many ways to Kunzle's works.

25. Shesgreen 1990, 92, 128, 158.

26. Ibid., 120.

27. Bannet 1997, 3, and Outhwaite 1995, 2.

28. Paulson 1991–93a, 1:6.

29. Chrisman forthcoming. See also Tscherny's essay, this volume.

30. Earle 1994, 157–59.

31. Turner 1995, 419–39.

32. J. Brewer 1995, 354.

33. Hitchcock 1997, 174–75.

34. Ibid., 175.

35. Earle 1994, 172–75.

36. Lemire 1991, 67–82.

37. Grose 1786.

38. Ward 1993, 62, 348.

39. Shesgreen 1990, 92, 108, 128; see also Turner 1996, 419–39.

40. Ward quotes Chaucer incorrectly. Chaucer says, "A wyf that heeld for countenance / A shoppe and swyved for hir sustenance."

41. See Buck 1971, 12.

42. Ward 1993, 197.

43. The ostrich feather was a traditional accompaniment in emblem literature for the female personification of lust. See, for instance, de Jongh and Luijten 1997, 284.

44. Rouquet 1746, 185. For the women's overt play with fans as a sign of their profession, see Rosenthal's essay, this volume.

45. Shesgreen 1990, 45, describes this phenomenon in representations from Marcellus Laroon to Francis Wheatley.

46. Hogarth 1997, 34–35, 49, 58, and *passim*.

47. Paulson has most recently summarized Hogarth's thoughts on this subject in Hogarth 1997, xxv–xxvi and xxxi–xxxviii.

48. Earle 1994, 122.

49. M. Hunt 1996, 125–46.

50. See Kiaer's essay, this volume.

51. Weatherill 1986, 150–55.

52. Appleby 1993, 164–65.

53. Hogarth 1997, xxx.

54. Lubbock 1995, 194.

55. See Barrell 1992, 63–87 and Solkin 1993, 13–26, 78–83.

56. R. W. Jones 1998, 21–22.

57. Hogarth 1997, xxiii–xxvi.

58. Ibid., 18.

Embodied Liberty: Why Hogarth's Caricature of John Wilkes Backfired

Amelia Rauser

In the London of the 1760s, there was no more popular figure than John Wilkes. As politician, polemicist, pornographer, and finally, prisoner of the Tower, John Wilkes virtually personified Liberty to thousands of partisans. His triumphs and travails, with opponents as powerful as George III himself, inspired loyal supporters who purchased all manner of trinkets decorated with his visage, from figurines to teapots.[1] But Wilkes's affairs also inspired an unprecedented explosion of political texts and images produced in his support. No single image was more important as a catalyst for this explosion than William Hogarth's caricature of Wilkes, published in 1763 (fig. 99).

Historians of eighteenth-century politics and political imagery have often focused on these Wilkite prints as a sign of the emergence and political mobilization of the new middle classes.[2] Hogarth's print of Wilkes, however, is often excluded from these accounts, not only because it is oppositional to Wilkes but also because, as a sophisticated caricature, it seems unrelated to the bulk of cruder, more emblematic prints.[3]

Hogarth scholars have contributed to this dissociation, since they largely treat his political caricature as part of his own artistic development and oeuvre, rather than focusing on its reception and circulation within the visual culture of political prints.[4] In fact, as the examples in this essay demonstrate, Hogarth's print had a vigorous afterlife in popular prints of which many scholars are unaware.[5] They have instead deduced from an analysis of the print's artistic excellence that it must have been successful as propaganda and that it must have had a devastating effect on its subject. Indeed, Hogarth's best-known interpreter, Ronald Paulson, has described this print as "a masterful and damaging piece of propaganda."[6]

But masterful though it may have been, this print was anything but damaging to Wilkes's political reputation. In this essay, I will argue that Hogarth's caricature of Wilkes, though intended to defame him, in fact backfired, and became instead the template for overwhelmingly positive representations of this icon of radicalism throughout the 1760s and beyond. By assuming that good caricature makes good propaganda and that the connotations and consequences of caricature are consistent across time, scholars have missed a crucial element of this story: that Hogarth's caricature was embraced and celebrated by Wilkes's followers for precisely the elements Hogarth thought would defame him. This fact serves to remind us that caricature and criticism are not always partners in the history of art. This was particularly true in the London of the 1760s, when there was not yet a unified public for political caricature, and when even an artist as socially acute as William Hogarth could misjudge the use of this potent visual language.

In what follows, I will attempt to reintegrate the histories of Hogarth's caricature and contemporary Wilkite political prints, placing his carica-

ture within the visual culture where it actually functioned: the political print trade. Thus, an alternative history of this caricature will emerge that has been largely invisible till now. My claim is that Hogarth made two crucial miscalculations: first in the means of representation, and second in the substance that was represented.

Hogarth's chosen visual language, caricature, no matter how well deployed, was simply inappropriate for political representation in this period. It was not until about 1780 that famous political caricaturists such as James Gillray and Thomas Rowlandson emerged and caricature became the premier visual mode for political representation. Prior to the last two decades of the eighteenth century, caricature had quite different antipolitical, antipublic connotations. Second, Hogarth erred in portraying in derogatory ways traits that Wilkes's followers hailed as exemplary, specifically Wilkes's libertinism and his chauvinistic Englishness. The substance of these miscalculations is made visible in the appropriations made by Wilkes's followers, when they exaggerate certain components of Hogarth's original image. In sum, instead of damaging Wilkes, Hogarth's caricature helped to turn him into one of the most famous radicals of the eighteenth century.

Wilkes and Hogarth: A Rivalry

John Wilkes and William Hogarth started out friendly in the 1750s, when Hogarth was a well-established artist with Whiggish sympa-thies, and Wilkes was a rising politician and man-about-town.[7] Their circles overlapped in places like the Sublime Society of Beefsteaks, which Hogarth helped found in the 1730s and to which Wilkes was elected in January 1754.[8] Wilkes, the son of a prosperous distiller and a nonconforming dissenter, was educated like a gentleman and schooled at the University of Leiden, where he befriended such Enlightenment figures as the Baron d'Holbach. A rake and sensualist who adored the high life of the aristocracy, he also remained politically committed to the emergent capitalist and Enlightenment values of the class from which he came. Until the early 1760s, he viewed William Hogarth as an ally in that cause and as a role model in satire.[9]

But with George III's accession to the throne in 1760, political life was turned upside down and prominent people were forced to choose sides. George III was perceived as an activist monarch, bent on regaining some of the powers and privileges his predecessors had relinquished. The king and his chief advisor, the Scottish Lord Bute, focused on the Seven Years War as the key to the power of the current ministry, led by William Pitt, and they determined to end it. Hogarth was appointed to a sinecure in the government as "Serjeant-Painter" to the king, and he apparently decided that his interests lay with the monarch's. To this end, in 1762 he designed a political print in support of George III's and Lord Bute's peace, called *The Times*.

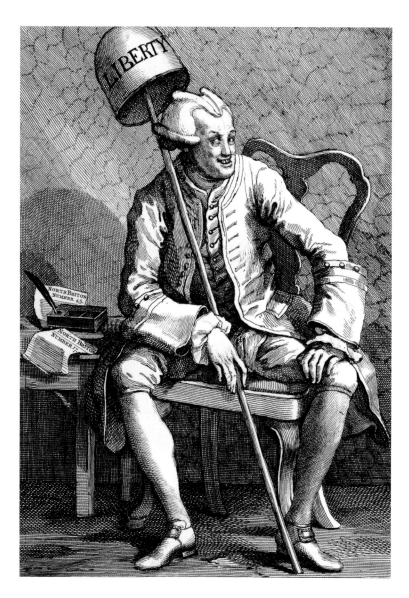

Fig. 99. William Hogarth, *John Wilkes Esqr.*, 1763. Etching. The British Museum, London

Opposite: Fig. 100. William Hogarth, *John Wilkes Esqr.*, 1763. Pen and ink. The British Museum, London

John Wilkes was appalled by this choice. When he heard Hogarth was preparing the print, he warned: "such a proceeding would not only be unfriendly in the highest degree, but extremely injudicious; for such a pencil ought to be universal and moral, to speak to all ages, and to all nations, not to be dipt in the dirt of the faction of a day . . . when it might command the admiration of the whole."[10] This was an appeal to Hogarth's artistic vanity—a plea

to remain "above" party politics, and a warning to stay out of the fray or be prepared for counter-attack. When, however, the print appeared on 7 September, even including small portraits of Wilkes and his compatriot Charles Churchill as figures attempting to hose the king off his throne, the battle was on. Wilkes had been irritating the monarchical faction for some months by publishing the *North Briton*, a journal which criticized Lord Bute and made free-handed use of anti-Scottish jokes and epithets. Number 17 of that paper, published on 25 September, was devoted entirely to an attack on Hogarth in terms that apparently deeply wounded the aging artist. By November, Wilkes regretted the effect of the public fracas on his old mentor: "Mr. Hogarth is said to be dying, and of a broken heart. It grieves me much."[11]

But Wilkes did not withdraw from the fight with the king and his new minister, Lord Bute. When the Peace of Paris was signed in February 1763, Wilkes's invective against Bute increased, and by April Bute's support was so weakened that he was forced to resign. With this, the *North Briton* was expected to cease publication, since its primary target had been brought down. Indeed, publication did cease for two weeks. But on 19 April 1763 the king gave a speech in support of the peace treaty. In response, Wilkes resumed publication with the notorious number 45, published on 23 April 1763, an issue that dared to criticize George III directly, and which resulted in Wilkes's eventual imprisonment and exile. By attacking the monarch himself, Wilkes had stepped over a line beyond which not even his partisans in government would defend him. Wilkes was arrested and his house searched.

Hogarth apparently saw his opportunity for revenge. His caricature was first published on 16 May 1763, two weeks after Wilkes was arrested and held in the Tower of London. Wilkes's comrade Charles Churchill claimed

that Hogarth made the sketch for the caricature (fig. 100) during Wilkes's appearance in court after his arrest: "When Mr. Wilkes was the second time brought from the Tower to Westminster Hall, Hogarth sculked behind a screen in the corner of the gallery of the Court of Common Pleas; and while Lord Chief Justice Pratt was enforcing the great principles of the Constitution [i.e., releasing Wilkes on a technicality], the painter was employed in caricaturing the prisoner."[12] Churchill later wrote a poem on this same portrait event:

> Virtue, with due contempt, saw Hogarth stand,
> The murd'rous pencil in his palsied hand.[13]

The print produced as a result of this drawing is a full-length portrait of Wilkes, and contains much of the symbolism that would remain connected with the Wilkes affair for decades to come. Wilkes is shown hunched over and spread-legged, with crossed eyes that apparently only slightly exaggerated his truly ugly appearance. Wilkes himself called the print "an excellent . . . *caricatura* of what nature had already *caricatured*."[14] Hogarth has given Wilkes a cynical grin and manipulated his wig to suggest two devilish horns atop his head.

Two prominent attributes are included as keys to Wilkes's character. Wilkes's criminal authorship is signalled by a desk containing an inkstand and the two offending issues of the *North Briton*, numbers 17 and 45. The other is the prominently labeled liberty cap and staff, the attribute of the goddess Liberty from classical art and emblem books. By the 1760s "liberty" was such a universally admired quality that political printmakers commonly employed the cap and staff as a marker of the hero of the print.[15] Hogarth's use of it here, then, is ironical—according to M. Dorothy George, the first sardonic use of the liberty cap in a print.[16] It is also a wry comment on Wilkes's status as a self-proclaimed hero of liberty. That irony is made plainer by the odd shape of the liberty

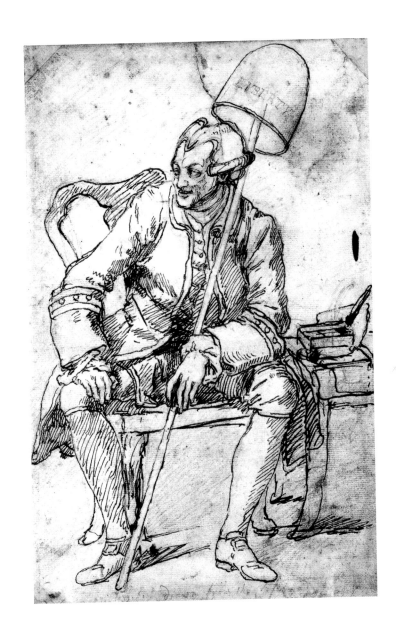

The JACK-BOOT KICK'D DOWN, or ENGLISH WILL Triumphant: A Dream.

FIRST STATE

Fig. 101. Anonymous, *The Jack-Boot Kick'd Down, or English Will Triumphant: A Dream*, 1763. Etching. The British Museum, London

cap, which seems to be a sort of inverted basin—perhaps a chamber pot or a fool's cap—poking fun at the Wilkite embrace of the emblematic symbols of liberty.

As a full-scale treatment by a modern master of the most controversial popular hero of the day, Hogarth's print was an instant sensation. In fact, publishers had a hard time making prints fast enough to sell. One printmaker estimated Hogarth's caricature sold 4,000 copies in a matter of days, and claimed he was kept up all night producing them.[17] Yet Wilkes's cause was wildly popular, while the King and Lord Bute had few partisans in the public discourse. Indeed, it has been estimated that among the political prints that survive from the Peace debate which led to

Wilkes's arrest, only four favor Bute (including Hogarth's *The Times*), while over four hundred are opposed.[18] So who was buying all those copies of Hogarth's caricature, and why?

The Visual Culture of Political Prints

It is important to place the reception of Hogarth's print in the context of other political prints of the period, as a notable example of a commonly available product. Prints such as this one participated in a bustling, ephemeral visual culture.[19] Some were inserted in magazines sent to subscribers all over the country and abroad; others were bought from urban printshops, either in person or through regular subscription. Yet even the lower classes could see political prints in the growing number of

244

Fig. 102. Anonymous, *The Politicians*, 1767. Etching. The British Museum, London

circulating libraries or in many coffeehouses, taverns and barbershops which bought the output of the printers. Cheap, ephemeral prints were also peddled by criers in the streets, and could sometimes be viewed between the mullions of print- and bookshop windows.

During the 1760s and 1770s, political prints generally looked quite different from Hogarth's caricature; instead, they utilized a complex visual language of signs and symbols inherited from the popular emblem books of the seventeenth century, with Cesare Ripa's *Iconologia* the most famous of these. The emblem traditionally had a tripartite structure: the motto, or title of the emblem; the epigram, or the verse illustrating the meaning of the emblem; and the *pictura*, the visual representation of the emblem.[20] All three parts worked together to produce the full interpretation of the emblem.

Wilkite political prints like *The Jack-Boot Kick'd Down, or English Will Triumphant: A Dream*, 1763 (fig. 101), retain this tripartite emblematic structure.[21] Although the *pictura* here is larger than in the emblem books, it is still complemented by a title and by an

245

accompanying verse. Not only is the structure emblematic, but this print also makes use of emblematic symbolism: the boot, which both personifies and imprisons the figure of Lord Bute; and the lion, symbol of Britannia. Furthermore, this print makes use of a completely packed surface, containing different cells of time and space and numerous speech balloons. This is another convention derived from the riddle-like quality of emblems, and one quite different from the naturalistic conventions of post-Renaissance painting, which would have dictated a more unified visual field. This emblematic visual language appears quite obscure today, but in the eighteenth century emblematism was a visual *lingua franca*. Indeed, emblematic prints were closely linked with the visual culture of the city streets.

The Politicians, 1767 (fig. 102) provides clues about both the audience for political prints and the nature of the popular visual language. The print depicts a London street scene with prominent emblematic shop signs. Such signs, ubiquitous at mid-century, were the most visible legacy of the emblem tradition on the streets of London, but handbills, trade tokens and playing cards also shared in this emblematic visual heritage.[22] In moving about the city and conducting their daily business, people of all ranks thus came in contact with emblematic symbology and understood its basic lexicon as well as its idiosyncrasies of visual organization. *The Politicians* also helps illustrate the spaces of consumption and the audience for prints during the Wilkes era. It is difficult to learn much about the producers of political prints, since they were usually anonymous. Like *The Politicians*, most of these prints are unsigned, largely because it was a traditional "rule" of the discourse of the public sphere that speaking anonymously guaranteed the truthfulness of the speaker's words.[23] Anonymity was a sign of honesty and disinterestedness, for it was believed that the anony-

mous speaker had nothing to gain from his opinions; thus, anonymously produced political prints were thought to guarantee the free flow of ideas and opinions in the public sphere.[24]

We do know that these political print designs were generally produced from within the class that consumed them. Until around 1780, there were very few professional political printmakers. Instead, amateurs submitted designs or suggestions to the editors of magazines or to private printsellers or publishers, who would then usually commission a professional engraver to execute the design.[25] This could lead to some interesting differences in the levels of professionalism and finish in the images. Furthermore, the amateur participators in this public discourse were not exclusively aristocratic; rather, merchants, shopkeepers, and guild members were also increasingly concerned with the politics of liberty. Such people were occasionally satirized as "coffeehouse politicians"—people with an intense interest in political affairs, but who were not themselves enfranchised with formal political power. We can see these individuals in *The Politicians* (fig. 102), mingling in the city streets. This printmaker seems to be worried about the new phenomenon of the politicization of the people:

> BRITANIA'S Sons of all Conditions
> Amazing! now are Politicians—
> Bards, Parsons, Lawyers and Physicians
> E'en low Mechanicks too pretend—
> To rail at what they cannot mend.

These citizens are described as intensely interested in political debate, but without hope of any efficacy (they "rail at what they cannot mend"). Not only is this politicking fruitless, but it makes them shirk their work:

> The Taylors from their Stitching cease
> . . . The Cobler too will quit his stall,
> . . . The fellow too that trims your Lamps
> Will freely talk of Fleets and Camps.

The only woman in the political crowd is a ragged political ballad singer; the rest of the figures are professional or mercantile men of various ranks, who crowd the air with speech balloons on the political state of the nation. These figures are depicted as individualists partaking in a public discourse, which centered around values of property rights, free trade, and autonomy from government intervention—or as the politician at the far left puts it: "With all my heart, Liberty and Property and no Excise!"

This group and their networks of extra parliamentary political discussion were the core of support for John Wilkes. Hogarth claimed that his caricature "set everybody else a laughing [but] gauld [galled] him and his adherents to death."[26] Yet it is likely that these Wilkite "politicians" were the chief buyers of Hogarth's caricature in spite of its different goals and appearance, just as they bought the other Wilkite prints of 1763.[27] Were they merely keen to have any representation of their hero, however galling? Or did they see something in Hogarth's image that spoke positively to Wilkes's character?

The Means of Representation: the Problem with Caricature

Certainly, at first many of Wilkes's compatriots considered Hogarth's print offensive. A loyal well-wisher in Wapping, a shipping area in southeast London, wrote Wilkes a letter of support, requesting to know Wilkes's birthday so his club could toast him on it. He quoted a club toast (used to celebrate Wilkes's release from the Tower), which condemned Hogarth's portrait: "Let's drink t'other good Luck, to the brave Squire Wilkes, by J[esu]s he's a Liberty boy like Dean Swift. And the D[evi]l burn my S[ou]l but the thief o' the world Mr. Hog=heart is a very great black-guard for making such a picture as he has done."[28] In addition, several prints attacking Hogarth for his deed appeared immediately.[29]

SAWNEY turn'd BARBER.

My Eye that's the Barber!

I.

WELL, Wonders sure will never cease,
 Thank G—D we've got a glorious Peace;
That Commerce, Arts, and Wealth increase,
 We owe to Scot the Barber.

But this you'll say is all a Hum,
He oft' has whip'd Britannia's Bum,
But see his Finger and his Thumb,
 He now has turn'd her Barber.

II.

In vain may WILKES for Glory strive,
And keep the Patriot alive,
Poor Liberty can never thrive,
 Since Sawney's turn'd the Barber.

The witty World has caught the Whim,
He cuts so close, he shaves so trim,
The Devil cannot cope with him,
 With Sawney Scot the Barber.

III.

His Trade is grown to such a pitch,
No wonder now he's got so rich,
So let th'industrious catch the Itch,
 And that will be the Barber.

He 'as trim'd the Nation, trim'd the K——,
Both France and Spain his Praises ring,
And blythely well all Scotchmen sing
 Since Sawney turn'd the Barber.

IV.

The greatest Lady in the Land,
Can see with Pleasure Sawney stand,
And lather muckly at command,
 And that she thinks the Barber.

So clean he moves his Instrument,
The Nation stares at the Event,
And ev'ry Man wou'd be content,
 Were he like Scot the Barber.

V.

Can Thistles in Old England grow,
I mean the Scotch; once 'twas not so;
Which makes each BRITON cry, Oh! Oh!
 How closely shaves the BARBER.

But tho' he here can trim so well,
The Devil other Tales can tell,
So soon may SAWNEY shave in Hell,
 " My Eye! 'twill be the BARBER.

Wilkes himself was perhaps the least perturbed about Hogarth's print; he praised the caricature's excellence, but derided it as insignificant. Indeed, he wrote that the caricature attacked only his physical self, about which he was unconcerned (he speaks here about himself in the third person): "I never heard that he [Wilkes] once hung over the glassy stream

Fig. 103. Anonymous, *Sawney Turn'd Barber*, 1763. Etching. The British Museum, London

Fig. 104. Anonymous, *Bute and Wilkes*, 1763. Etching. The British Museum, London

like another Narcissus. . . . I fancy he finds himself tolerably happy in the *clay cottage* to which he is *tenant for life* because he has learnt to keep it in good order. While the share of health and animal spirits which heaven has given him shall hold out, I can scarcely imagine he will be one moment peevish about the outside of so precarious, so temporary a habitation."[30] Certainly this is at least part bluster, but it is key that for Wilkes, caricature was an inappropriate means to express truth of character. Hogarth's caricature touched only the "clay cottage" of the body, merely the "temporary habitation" for the soul, which was the true core of a person. This worldview is at odds with the physiognomic school of thought, not yet widely held but intrinsic to the caricatural mode, which argued that the exterior of a person was crucially representative of his or her interior character. But Wilkes's view was shared, I would argue, by the majority of participants in popular political print discourse, who instead

turned to emblems to represent symbolically the truths of the soul, rather than mere blandishments of the surface.[31]

Thus, an inversion and appropriation of Hogarth's image quickly occurred. Soon after it was published, several broadsides appeared which incorporated Hogarth's portrait into scenes that actually praised Wilkes. For example, *Sawney Turn'd Barber* (fig. 103), is an etching accompanied by two columns of verse. In the image, Lord Bute shaves Britannia, while Wilkes, in the Hogarthian pose, watches. Wilkes appears like a collaged element in the *pictura*, eyeing the Prime Minister as he "trims," or contains and diminishes, the nation. Though the ballad below barely mentions Wilkes, he is cast as a clearly heroic and positive figure: the doomed but valiant patriot, who fights even though

> Liberty can never thrive
> Since *Sawney's* turn'd the Barber.

The positive valence attached to Wilkes in this print was reinforced when it was reissued the following year in a collection of anti-Bute satires called *The Scots Scourge*. The commentator in that collection explained, "if WILKES were not by, [Bute would] perhaps cut her throat."[32] The Hogarthian Wilkes, then, is here appropriated to serve not as a figure of ridicule, but as a guardian of liberty, pasted in by the designer—perhaps a coffeehouse politician—to stand watch over the actions of the Prime Minister.

Another instance of the motif, in *Bute and Wilkes* (fig. 104), provides some clues to the specific aspects of Hogarth's image that Wilkites embraced.[33] Here Lord Bute is illustrated feeding a bribe to a replica of the Hogarthian Wilkes.[34] The printmaker seems to have copied the chairs from the previous broadsheet but swapped the characters; instead of Wilkes, here Bute sits on the Chippendale-style chair. The factional loyalties of each char-

acter are marked: in Bute's case, by two little devils wearing argyle socks who clamber up to whisper in his ear; they are labeled "Fingal" and "Timora," referring to the "newly discovered" epic poetry *Ossian*, published earlier that year. Wilkes, meanwhile, is attended by his political patron, Lord Temple, who wails "O! Liberty! O! my Country!" as he peers over Wilkes's chair.

The verse beneath claims that the ministry was attempting to buy Wilkes's silence by making him the administrator of the newly won territory of Canada, a job that he apparently desired but refused. The verse below places Wilkes in noble relation to such venery:

> Asham'd of such meanness, disdaining their gold,
> Wilks answer'd thus, as I'm credibly told,
> 'Avaunt, vile corrupter, I'll take no such thing,
> I'll be true to Old England, the Whigs, and the King.'

Again, Wilkes is the heroic patriot, while Bute is the corrupt fleecer of the nation. But what this print makes quite visible—and the same was true of the *Sawney* broadsheet—is that although this print is pro-Wilkes and anti-ministry, it employs caricature, usually considered a defamatory mode, to depict Wilkes and not for the enemy Bute. Instead, the devilishness of Bute is demonstrated by giving him satanic wings and a forked tail, discreetly concealed from the front, yet floating up behind him as he perches on the delicate chair.

What this paradox suggests, and indeed what the whole misappropriation of Hogarth's caricature reveals, is that caricature was an inappropriate visual mode for political representation in this period. Instead, emblematism and allegory were the visual languages of public address, the proper mode for public and political representation. Political prints were satirical and witty, but generally not ironic; emblematism stressed the objectivity of the message, rather than the subjectivity or idiosyncrasy of the maker of the print.

Caricature, on the other hand, had connotations of elitism, privacy and preciousness that contradicted the disinterested ideals of the public sphere. The "invention" of caricature can be traced to Italian fine artists, from the Carracci to Lorenzo Bernini, who made caricatural portraits of their friends and patrons as a way of displaying their graphic skills.[35] British aristocrats picked up the trend while on their Grand Tours to Italy and brought it back home as an elite parlor game and witty "insider" art form. In the 1740s, Arthur Pond capitalized on the craze for caricature by making prints after caricature drawings by some of these Italian masters and publishing them in series.[36] *The Bearleader*, 1737 (fig. 105), is an example, published by Pond after the artist Pier Leone Ghezzi—notice that even his subject matter is sophisticated, worldly, and elite: a grand tourist and his tutor.[37] It was very rare to see caricatures of political figures before 1780; and this dearth might in part be due to the disastrous history of this very high-profile print by Hogarth.[38] Indeed, Matthew and Mary Darly, avid publishers of elite caricature, solicited designs from their patrons in advertisements that explicitly separated the private from the public and forbade political caricatures: "Ladies and Gentlemen sending their Designs may have them neatly etch'd and printed for their own private amusement . . . or if for publication, shall have ev'ry grateful return and acknowledgment for any Comic Design. Descriptive hints in writing (not political) shall have due honour shewn 'em."[39]

Hogarth took pains to differentiate himself from the caricature craze, especially once Pond's prints of Ghezzi were published in 1736. *Characters and Caricaturas* (fig. 106), the subscription ticket for his *Marriage A-la-Mode* series, was intended to illustrate that Hogarth's depictions expressed superior characterization, which lay at a middle point between vacant idealism and mere grotesque deformity, or

Fig. 105. Pier Leone Ghezzi
(Italian, 1674–1755),
The Bearleader, 1737. Etching.
The British Museum, London

Fig. 106. William Hogarth,
Characters and Caricaturas,
1743. Etching. The British
Museum, London

caricature. The bottom row of heads forms a kind of continuum from ideal to bestial, while the heads above represent Hogarth's expertise as a creator of characters—they are funny and expressive, but not deformed. Hogarth's goal in making this distinction was to raise his work to the standard of fine art. However, in terms of political representation this differentiation is a kind of hairsplitting nicety. The crucial fact remains that whether this portrait of Wilkes is considered "character" or "caricature," it works physiognomically—by expressing personal and political lapses through deformity of the physi-

cal body, rather than through the accretion of emblematic symbols. That kind of representation was beyond the boundaries of political discourse at that moment.[40]

Furthermore, Hogarth's print was, in eighteenth-century terms, "interested"—his print was signed, rather than anonymous and thus disinterested. Hogarth's signature indicated to the Wilkites that this was a self-interested, political ploy for the benefit of the printmaker. Indeed, Hogarth was criticized as a lackey for the king's ministry, a result of his recent appointment as Serjeant Painter to the

King.[41] In sum, Hogarth's caricature represented vilification by the powerful, in the visual language of the powerful—the fashionable and aristocratic mode of caricature—and this made Wilkes even more of a hero to his public.

The Substance of Representation: Embodied Liberty

Not only the means, but also the substance of Hogarth's representation proved a miscalculation. Indeed, the print erred by depicting in derogatory ways aspects of Wilkes's character that were in fact lauded by his middle and lower-class supporters. In the attempt to defame by physiognomy, to make the exterior of the person represent his interior qualities, Hogarth treated as a liability two characteristics which were in fact Wilkes's assets—his libertinism and his English nationalism.

Wilkes had been known publicly as a libertine because of his membership in the Medmenham Monks and other such "Hell-Fire" clubs, long before his arrest for libel.[42] But this aspect of his character came to the foreground in 1763, when, in an attempt at revenge after Wilkes's publication of the *North Briton* number 45, the ministry announced that they had found on Wilkes's own printing press, which was kept in his basement, an erotic poem, the *Essay on Woman*. This led to a new round of charges and resulted in Wilkes being prosecuted simultaneously for publishing an obscene poem and for libeling the king of Great Britain—that is, for both his libertinism and his libertarianism.

Sensing, as the prime minister no doubt did, that these new charges would embarrass and defame Wilkes, Hogarth hinted at Wilkes's libertinism in his physiognomy and pose. This is visible in Wilkes's cross-eyed leer, his spread legs, the way his wig seems to form two horny appendages atop his head (a reference to a satyr), and the shaft of the liberty staff that projects suggestively from between his legs.

Fig. 107. Anonymous, broadsheet, 1763. Woodcut. Library of Congress, Washington, D.C.

But to the surprise of those in power who used it to slander him, Wilkes's libertinism was in fact embraced by his supporters.

A crude woodcut broadside from the late fall, 1763 (fig. 107), testifies to the relationship between Wilkes's libertinism and his underdog libertarianism. The image immediately suggests a contrast between the crude execution of the more "primitive" print medium of woodcut, and the more slick and professional fine etching by Hogarth. It is possible that this is an intentional contrast: not merely a matter of greater or lesser skill on the part of the printmaker, but an aesthetic choice intended to draw attention to the elite and "interested" qualities of Hogarth's print, in contrast to the popular and "plain-spoken" politics of the woodcut. The

Opposite: Fig. 108. Anonymous, *Wilkes and Liberty, a New Song*, 1763. Etching and engraving. The British Museum, London

liberty cap and staff are missing in this version, but the leer and crossed eyes are even more exaggerated. Wilkes's legs are spread impossibly wide and his hand is inserted in his waistcoat, a pose that has great significance. The ballad beneath the image is a folksy narrative of Wilkes's trials and places this story in relation to Hogarth's representation:

> I will not describe or his Make or his Air,
> How his Person is form'd to attract all the Fair;
> I shall not set down how both his Eyes squint,
> You've already seen that in Will Hogarth's Print.
> . . . But I'll tell how he wrote 'gainst great Men in
> Power;
> How he Libell'd the King, and was sent to the Tower;
> How they brought him from thence with on each side
> a Warder,
> And carry'd him back again by the Court's order.

With the phrase, "You've already seen that in Will Hogarth's Print," the writer acknowledges an existing circulation of imagery and text, and the reader's participation in that visual discourse. What the reader has "already seen" is the ugliness and the characteristic leer in Hogarth's representation of Wilkes: "how both his eyes squint." Importantly, the writer does not dispute Hogarth's version of Wilkes, but merely summarizes and re-presents it, as does the printmaker, who largely reproduces it visually with the image above.

But the text also indicates that the central message of Hogarth's print was about the "person" of Wilkes—his physicality and obliquely the signs of his libertinism—and dismisses it, stating that these characteristics don't bear repeating in the ballad. The writer echoes Wilkes's own notion that the body is the mere "clay cottage" in which the true character resides. Instead, the poem proposes to add quite a different narrative to Hogarth's message of Wilkes's embodied libertinism: the story of Wilkes's defiance of the king, how he dared to write against powerful men, and the

price he paid. Thus, the attempt to portray Wilkes as a degraded libertine is instead appropriated to serve as an illustration for the story of Wilkes as a political radical. Hogarth's depiction of a libertine Wilkes ended up emphasizing a defiant individualism that made him an even more powerful icon.

The early prints of Wilkes by his supporters carried another message, just as strong: that Wilkes stood up for old English liberties. This is the second aspect of liberty that is emblematized by Wilkes's body and encoded in the slogan, "Wilkes and Liberty," and it too was implied in Hogarth's caricature. It is visible in the hunched-over posture of Wilkes as he sits in his chair, and in the plain jacket and waistcoat he wears. These small details, again encoded in Wilkes's physicality, were tellingly exaggerated by the copies and appropriations made by followers; this crudity of deportment was remade into a signifier of laudatory, straight-talking Englishness, which his partisans embraced.

The desire for "old English liberty" was based above all on a myth of Anglo-Saxon freedom that supposedly existed before the Norman Conquest.[43] The "Saxon institutions," including representative government and trial by jury, were held to be the basis of modern common law. This was a Whiggish position, because it was above all opposed to absolute authority in either the person of the king or in highly centralized religious institutions. Of course, most Whigs did not go so far as to advocate the abolition of the monarchy altogether, as did the more radical republicans. But while there were large degrees of difference in their commitment to this legacy, all Whigs could rally around a vaguely defined struggle for English liberty, framed as a constant attempt to regain lost ancient rights and liberties.

John Wilkes was particularly associated with this Whiggish English nationalism, especially since his nemesis, Lord Bute, was

conveniently Scottish. A non-Hogarthian representation of Wilkes, in a broadsheet from early 1763, gives a strong indication of the "Englishness" of Wilkes's liberty. In *Wilkes and Liberty, a New Song* (fig. 108), a battle between Bute and Smollett (publisher of the monarchical paper *The Briton*) and Wilkes and Churchill is waged over Britannia, identifiable by her traditional attribute of the shield with the Union Jack.[44] Wilkes is defending Britannia with a shield inscribed "North Briton." In spite of its name, this national symbol, Britannia, does not stand for the unified nation of Great Britain, comprising Scotland, Wales, Ireland and England. Rather, Wilkes's liberty here is a particularly English liberty:

> When *Scottish* Oppression rear'd up its d——n'd
> Head,
> And *Old English* Liberty almost was dead;
> Brave WILKES, like a true *English* Member arose,
> And thunder'd Defiance against *England's* Foes.
> O *sweet* Liberty! WILKES *and* Liberty!
> Old English Liberty, *O*!

Wilkes's arising is likened to that of a "true English Member"; possibly yet another bawdy allusion to his sexual profligacy. But even if this is not a joint allusion to Englishness and libertinism, it is still true that the kind of political liberties for which Wilkes stood could be represented as embodied in him—in his nationality as English.

We have already heard this rhetoric in *Bute and Wilkes* (fig. 104), in the verse invoking "Old England, the Whigs and the King." That print provides other clues to Wilkite chauvinism. The leering, hunched-over Wilkes is opposed to the dandyish Bute, who was known to be proud of his fine legs and wore high heels and stockings with his short breeches to show them off. Wilkes, by contrast, has plain, simple clothing, the jacket and waistcoat of an Alderman or citizen, without the Frenchified or noble appurtenances such as the strip of lace that lines Bute's

WILKES, and LIBERTY. A New Song.

To the Tune of, *Gee ho Dobbin.*

WHEN *Scottish* Oppression rear'd up its d——n'd
 Head,
And *Old English* Liberty almost was dead;
Brave WILKES, like a true *English* Member arose,
And thunder'd Defiance against *England's* Foes.
 O *sweet* Liberty! WILKES *and* Liberty!
 Old English Liberty, O!

With Truth on his Side, the great Friend of his Cause,
He wrote for the Good of his Country and Laws;
No Pension could buy him — no Title or Place,
Could tempt him his Country, or self, to debate.
 O *sweet* Liberty! WILKES *and* Liberty!
 Old English Liberty, O!

To daunt him in vain with Confinement they try'd, 30 *April*
But ah his great Soul e'en the TOWER defy'd;
" *Conduct* me, kind Sir (to the Jailor he said)
" *Where never* Scotch *Rebel, or Traitor, has laid."*
 O *sweet* Liberty! WILKES *and* Liberty!
 Old English Liberty, O!

But the Jailor knew well it was not in his Power,
To find such a Place any-where in the *Tower*;
So begg'd, if he could, he'd the Lodging think well on,
Although it smelt strongly of *Scotch* and *Rebellion.*
 O *brave* Liberty! WILKES *and* Liberty!
 Old English Liberty, O!

The Friend of his Cause, noble TEMPLE appear'd,
(Brave TEMPLE, by each *English* Bosom rever'd) 30 *April*
But such was their Power — or rather their Spite,
That his Lordship of *Wilkes* could not gain the least Sight
 O *poor* Liberty! WILKES *and* Liberty!
 Old English Liberty, O!

One would think then by this, and indeed with some
 Reason,
That poor Colonel *Wilkes* had been guilty of Treason,
For sure such *good* People as now are in Power,
Would ne'er send an innocent Man to the *Tower.*
 O *poor* Liberty! WILKES *and* Liberty!
 Old English Liberty, O!

To *Westminster* then they the Traitor convey'd, May. 3
The Traitor! What Traitor? Why *Wilkes*, as they said,
But when he came there they were all in a Pother,
And they look'd, like a Parcel of Fools, at each other.
 O *poor* Liberty! WILKES *and* Liberty?
 Old English Liberty, O!

Then back to the *Tower* they whirl'd him along, May. 3
Midst the shouts and applause of a well-judging Throng
While the Dupes of Oppression debated, I trow, Sir,
Most wisely in private on what they should do, Sir.
 O *poor* Liberty! WILKES *and* Liberty!
 Old English Liberty, O!

Three Days had elaps'd when to *Westminster-Hall,*
They brought him again, midst the Plaudits of all;
When *Wisdom* and PRATT soon decided the Case, May.
And *Wilkes* was discharg'd without Guilt or Disgrace.
 O *brave* Liberty! WILKES *and* Liberty!
 Old English Liberty, O!

Triumphant they bore him along through the Crowd,
From true *English* Voices Joy eccho'd aloud:
A Fig then for *Sawney*, his Malice is vain,
We have *Wilkes* -- aye and *Wilkes* has his Freedom again
 O *brave* Liberty! WILKES *and* Liberty!
 Old English Liberty, O! May. 1763.

Sold by E. SUMPTER, *Three Doors from* Shoe-Lane, Fleetstreet : *Where may be had,* The British Antidote *to* Caledonian Poison, 2 Vols. Price 6 s.

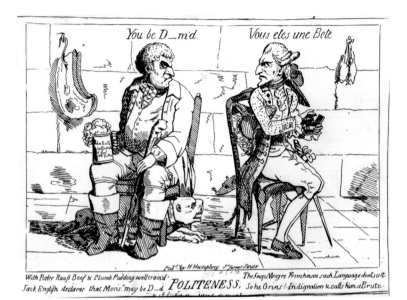

You be D__m'd

Vous etes une Bete

With Porter Rad Beef & Plumb Pudding well cram'd. *POLITENESS.* The Soup Maigre Frenchman such Language dont suit.
Jack English declares that Mons: may be D__d So he Grins Indignation & calls him a Brute.

Fig. 109. James Gillray (British, 1757–1815), *Politeness*, 1779. Etching. The British Museum, London

coat or the neckerchief tied with a pouf at the back. This plainness was already starting to signify a kind of middle-class, mercantile identity that would soon be codified to stand in for England itself in the symbol of John Bull.

In *Politeness*, an etching by James Gillray from 1779 (fig. 109), we can see the fat, plain Englishman with his roast beef and porter being opposed to the foppish, snuff-pinching, dandyish Frenchman who likes to eat garlic and frogs. Their dress and postures have a provocative correspondence with Wilkes and Bute in the earlier print (fig. 104). Like Wilkes, John Bull has the plainer clothes and spread legs; like Bute, the Frenchman wears lace at the front of his neck and a floppy bow at the back. As the ideal Englishman, John Bull was as much identified by his honest middle-class simplicity as anything else, and the attributes of sophistication or aristocracy were all equally unwelcome in the burgeoning iconography of middle-class liberalism. John Bull was not iconographically codified until around 1780, so the depiction of Wilkes in figure 104 might be considered a precursor for

the later abstraction of plain-spoken, xenophobic Englishness.[45]

But the peculiar Englishness of Wilkes's bodily posture is most visible in the woodcut adaptation (fig. 107). Here, the liberty cap is missing, and instead Wilkes places his right hand inside his waistcoat. As Arline Meyer has shown, this was a traditional portrait stance for English gentlemen, having become so standard among the commercial portraitists by the 1740s that the artist Thomas Hudson was accused of not being able to paint hands.[46] According to one early commentator this gesture exemplified the English trait of "boldness tempered with modesty,"[47] because hiding the hand was an antirhetorical gesture. In Wilkes's case, the low position of that hand, hovering near his genitals, might be there to layer a libertine allusion to masturbation on top of the more conventional meaning of straight-talking Englishness.

In Baroque portrait painting, French artists commonly used studied, florid, rhetorical gestures derived from classical prototypes. These portraits—criticized by Hogarth himself in the first plate of *Marriage A-la-Mode*[48]— were offensive to many English commentators. To them, rhetorical gestures implied deceptive speech and dishonest character. Such gestures were distinctly contradicted by the restrained gesture of the hand-in-waistcoat. With one hand in the waistcoat, the portrait's message was that the plain-speaking character of the Englishman would come through on its own— with natural, rather than artificial eloquence— instead of impressing the viewer with frills and surface decoration. Thus, this pose of Wilkes in figure 107 is significantly and distinctly English, a stance that portrays his plain-speaking: not the "Artifice of Words" but the "Bare Knowledge of Things."[49]

In all these appropriations of Hogarth's caricature of John Wilkes, "Wilkes and Liberty" is shown to have two specific meanings: a

personal liberty, emblematized as Wilkes's sexual libertinism and freethinking; and a collective liberty, embodied by Wilkes's Englishness and all the mythical, social, economic, and political freedoms that it entailed. These associations demonstrate why, for at least a brief time, Wilkes was such a powerful symbol of freedom to the burgeoning middle classes.

William Hogarth's print backfired in that it came to function very differently than he intended, by representing as embarrassing personal lapses the prized symbols of bourgeois freedom. He misapprehended the extent to which the lower and middle classes would identify with the extremes of liberty Wilkes represented—extremes that Hogarth and his allies termed unvirtuous and licentious, but that these liberal individualists proclaimed as their ideal. These meanings were unpacked, copied, and adapted from Hogarth's print of John Wilkes by his followers in a way that wasn't anticipated by more elite contemporaries, nor even subsequently much noted by scholars. Retrieving this history helps shed light on the way images, symbols, and visual languages took on very different connotations for different social classes and political factions in the eighteenth century. It might also make us wary of too quickly equating caricature with criticism in the history of art.

Notes

1. The Museum of London has a wonderful collection of these Wilkite memorabilia. Wilkite teapots and the like can also be seen in Drakard 1992.

2. See especially Rudé 1962 and J. Brewer 1976, particularly chapters 8 and 9. Also very helpful are George 1959, 1, ch. 8; and Donald 1996, ch. 2.

3. For example, Diana Donald purposely restricts her account to a discussion of the emblematic nature of Wilkite imagery, an "idiom . . . wholly distinct from Townshend's [and, I would add, Hogarth's] kind of caricature"; Donald 1996, 50. While I agree completely with her account of emblems as the dominant visual

mode of Wilkite prints, in this essay I want to link Hogarth's caricature, which was produced as part of the same discussion and thus must be folded into this history, to this choice of emblematic visual language, and grapple with its impact on the Wilkite prints.

4. Paulson 1971 does make note of (and reproduces) two of the popular retaliations to Hogarth's print, but he is mainly concerned with the trajectory of Hogarth's career rather than the wider exchange of imagery on Wilkes. Antal 1962 discusses the Wilkes print in the context of Hogarth's theories of caricature and expression; 129–30. Uglow 1997 is concerned with the lively tale of interpersonal battle between Wilkes and Hogarth; 675–79. Bindman 1981 uses the print as an example of Hogarth's establishment politics, not new but clarified at the end of his life; 202–3. Bindman 1997a is an exception, reproducing several prints and one porcelain bowl that commented on Hogarth's print; yet because of the catalogue format the analysis of these objects is quite brief; 188–92, 199.

5. An important and welcome exception is the recent article by Shearer West, which acknowledges the impact of Hogarth's caricature on subsequent representations of Wilkes and uses it as a case study for the importance of physiognomy in determining character during the eighteenth century (see West 1999). While West and I agree that Hogarth's version of Wilkes became an iconic representation with largely (and surprisingly) positive connotations for his followers, we disagree about how and why this inversion occurred. West argues that Wilkes's followers appropriated Hogarth's *Wilkes* by inverting the connotations attached to his physiognomy; instead of finding negative, devilish, and lascivious meanings, Wilkites found universal appeal in his physical, human frailties, thus embracing him as one of their own. By contrast, in this essay I will argue that Wilkites rejected physiognomic representation altogether as an elite and "interested" visual mode, and instead favored the abstracted symbolism of emblems. It was Hogarth's misapprehension of the popular distaste for caricature that made his satire of Wilkes backfire.

6. Paulson 1971, 2:384.

7. This account of Wilkes's affairs is substantially indebted to P.D.G. Thomas 1996, Postgate 1930, and Rudé 1962, a superb work of Marxist social history. For the rivalry between Wilkes and Hogarth, see George 1959, 1:128–32; Uglow 1997, 663–83; and Paulson 1971, 354–99.

8. Paulson 1971, 367.

9. Ibid., 368–69.

10. Uglow 1997, 665, quoted from Almon 1805, 3:24–25.

11. Letter from Wilkes to Temple (November 1762), quoted in

Uglow 1997, 671.

12. Quoted by BMC 1870–1954, 4:279, from Churchill's *Epistle to William Hogarth*, published August 1763.

13. Shesgreen 1973, cat. number 98.

14. Uglow 1997, 676; Postgate 1930, 36.

15. My essay, Rauser 1998, contains a discussion of the prominence of this symbolism of liberty in political prints of the era and explains its disuse after the loss of the American war in the 1780s.

16. See George 1959, 1:130.

17. Ibid., 1:131.

18. Ibid., 1:121.

19. See Donald 1996 for an excellent account of the use and circulation of popular and political prints. Clayton 1997 is an extremely thorough account of the buying and selling, use and consumption of all sorts of prints in this period.

20. See Daly 1980 for a discussion of these parts and the roles they play in the decipherment of the emblem.

21. Indeed, Donald 1996, 52, has shown that this emblematic visual language was particularly appropriate for the populist Wilkite cause. However, this visual mode was not limited to the cause of 1763, but remained predominant for all political imagery during this two-decade period.

22. See Donald 1996, 56–57. Note that Donald argues, however, that this language of the streets was a language of the common people, more or less unintelligible to the aristocracy.

23. Habermas 1989, 36. In principle, according to Habermas's analysis, economic, social, and legal dependencies were supposed to be suspended in the public sphere.

24. As a contemporary example of this belief, the editor and founder of the *Freeholder's Magazine* printed in its first issue (September 1769) that he had sworn an oath not to name any submitting author, "consistent with the duty of an honest man, a good member of society, and a loyal subject." The mayor testified this oath was sworn before him at the Mansion House on 9 August 1769.

25. See Press 1977 for statistics on this matter.

26. Hogarth 1955, 221, and quoted in George 1959, 1:131.

27. Many scholars have noted, with some puzzlement, that the print was bought by Wilkite supporters in spite of its supposedly devastating propaganda effects. Frederick Antal speculates that Wilkes's partisans bought it because it was such a good likeness, and they took it as a portrait rather than a cari-cature; Antal 1962, 130. I do not think this is likely; rather, as I will argue below, they saw in the caricature of Wilkes elements that they could appropriate as positive characteristics.

28. Letter from George Springlove, president of the Anti-Calledonian Club, Rose and Crown, Wapping Newstairs, to John Wilkes, 19 May 1763. Add. 30,867, f. 209 (British Museum Manuscripts).

29. George 1959 estimates that at least nine attacks on Hogarth were produced at this time; 1:131.

30. See Postgate 1930, 36; quoted from *English Liberty*, a two-volume collection of miscellaneous materials on the Wilkes affair published in London in 1768 and 1770, including many letters and writings by Wilkes himself.

31. Here is where my account differs most notably from Shearer West's (see West 1999). West argues that Wilkes's followers appropriated Hogarth's *Wilkes* by inverting the connotations attached to his physiognomy, embracing his frailties instead of condemning his devilish lasciviousness. But as presented above, I find more evidence for the rejection of physiognomic modes of representation at this moment. In the prints themselves we see that Wilkite followers turned instead to emblems and abstractions as truth-telling signs and rejected the elite visual mode of caricature as inherently deceptive. It may be that West and I are looking at two different classes of Wilkite followers, and that those who produced the popular prints analyzed here were in deeper opposition to elite visual culture than were the writers who provide most of West's evidence for this point.

32. *The Scots Scourge*, London, printed for J. Pridden, 1765, p. 87.

33. Though undated, this etching is probably from the summer of 1763; I follow Bindman 1997a, 190, in the titling of this print.

34. Bindman 1997a, 190, claims that Bute is made to look like the author of the Wilkes print here, apparently reading the horizontal object in Bute's hand as a pencil or etching needle. But I follow the interpretation of BMC 1870–1954, 4:266, which describes this action as "feeding his companion as a bird is fed, with a short stick, on which is written 'Kaw Jack, have Canada or to the Tower.' " The allusion to birds was explained in a verse that accompanied a reprint of the image in the collection called *The Scots Scourge*: "Here Wilkes like a *Jack daw*, kind *Sawney* wou'd feed" (87). The verse beneath the image itself, in which Bute asks Wilkes to "tell at what price he can make you his friend," also confirms the subject of bribery.

35. This account substantially derives from Gombrich 1941 and Gombrich 1989. It has been challenged by some who point to antecedents in German Reformation prints, for instance, but I agree with Gombrich that these grotesques are different from

the caricatural portraiture of real people, deformed by line and not ridiculed by the accretion of symbols or placement in silly contexts.

36. See Lippincott 1983.

37. "Bearleader" was the slang term for the learned tutor and chaperone who accompanied young men on their Grand Tours.

38. An exception that proves the rule is the political caricature by George Townshend. Donald 1983 and Atherton 1985 have differing accounts of the motives and intentions behind Townshend's printmaking and its problematic reception, but the important point to note is that, as Donald points out, his work was ill received and failed to produce any imitators.

39. Solicitation for volumes of *Caricature, Macaronis, and Characters*, from the early 1770s. See George 1959, 1:147–48.

40. Exactly why this kind of physiognomic depiction was off-limits is still an open question, one that I hope to take up in detail in another forum. Here, I want only to offer the evidence of tradition and explicit prohibition, such as that cited above from the Darlys, that caricature was considered inappropriate for political imagery at this time. I should also add that, according to Ronald Paulson, Hogarth's image of Wilkes is an unusual *caricature* rather than his customary study of *character*. "He never travesties when he portrays a person; which the caricaturist does, saying 'This is all this great man really amounts to.' . . . Hogarth never felt this way about his subjects, except perhaps a little later—as his impatience grew—when he reduced John Wilkes to a squint and a leer." Paulson 1971, 2:290–91.

41. See Paulson's rich account of the invective hurled on both sides in Paulson 1971, 2:354–99.

42. On Wilkes's libertinism, see Sainsbury 1998 and J. Brewer 1976, chapters 8 and 9. Sainsbury's recent account argues convincingly that Wilkes's libertinism was a political asset. Among Wilkes's historians, only Sainsbury and Brewer agree that Wilkes's libertinism was an important part of his public appeal; it is far more common to assert, as Wilkes's most recent biographer, Peter D.G. Thomas, has done, that "the dissolute charac-

ter of Wilkes was always to be a liability to any political cause he championed"; P.D.G. Thomas 1996, 34. However, other scholars have clearly seen libertinism in this period as public and political; for example, see Wagner 1991a and L. Hunt 1993.

43. See Macfarlane 1978 for a detailed account of the myth of the Norman yoke and its long-term effects on English society. The ongoing debate among political scientists, historians, and philosophers about the significance of liberalism versus civic humanism in this period can be instructive for the meaning of liberty to various political factions.

44. The trident was not associated with Britannia until the French Revolutionary war years, when Britons became especially proud of their naval fleet.

45. John Bull was invented as a literary character by John Arbuthnot in the early eighteenth century, but did not take this characteristic form nor be widely used in popular imagery until John Gillray popularized the figure around 1780. For more on the pictorial John Bull, see Mellini and Matthews 1987, Surel 1989, and Taylor 1992.

46. My knowledge of the significance of this posture is due entirely to Meyer 1995. The details I provide to bolster my interpretation of the significance of the Wilkes portrait all come from her excellent essay, without which I would have entirely missed this aspect of meaning. The anecdote about Hudson is on page 49.

47. François Nivelson, *The Book of Genteel Behavior*, 1738, cited by Meyer 1995.

48. The bombastic portrait of the Earl that hangs on the wall, depicting him as Jupiter, was intended as evidence of the Earl's poor taste and general aristocratic foolishness.

49. Meyer 1995, 60, is quoting Thomas Sprat's *History of the Royal Society*. This evidence of visual knowledge of portrait conventions and their specific meanings contradicts Diana Donald's assertion that emblems were "common" and offensive to the elite because they were inartistic, and that caricature was introduced as the result of more sophisticated connoisseurship of art. See Donald 1996, 60.

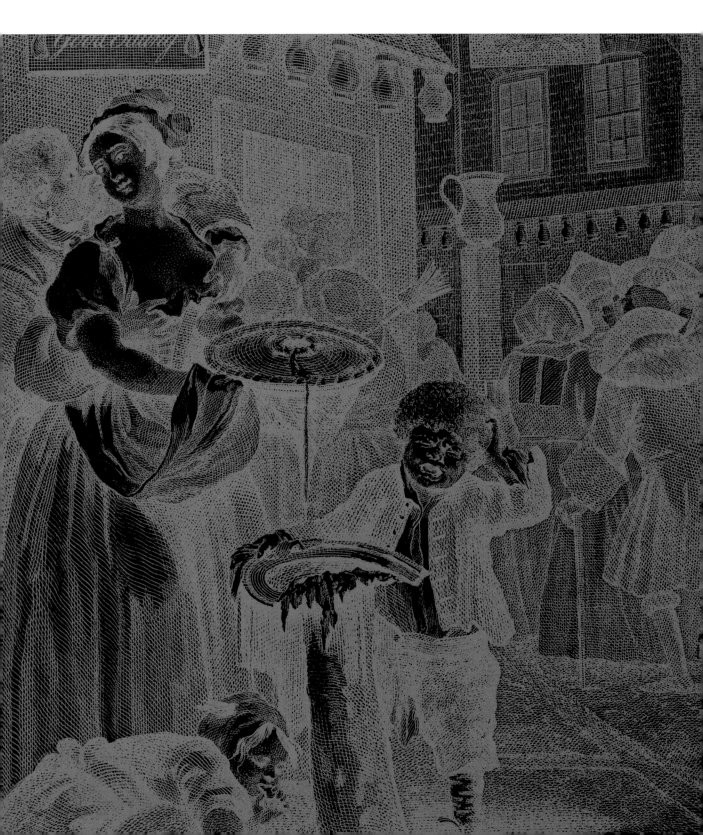

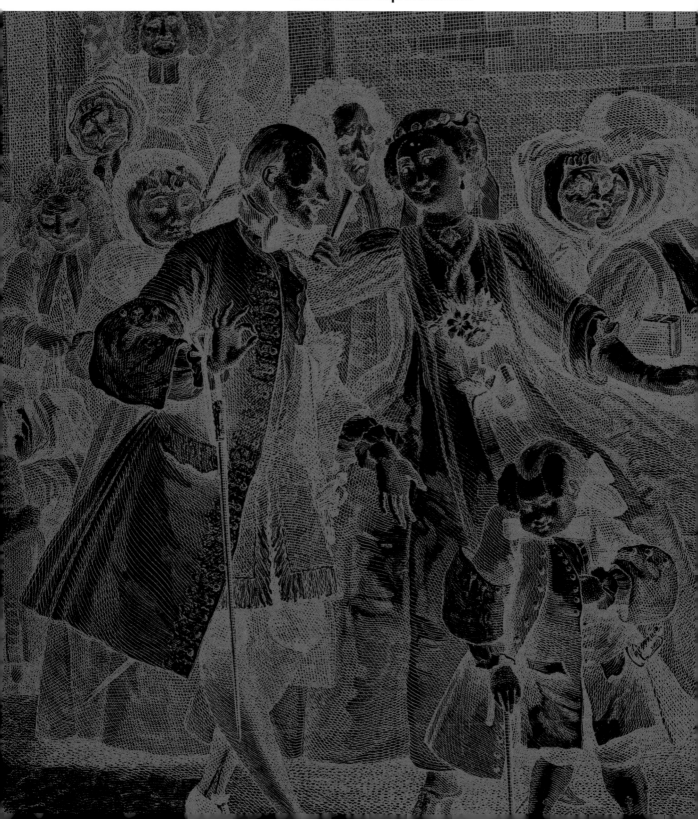

"A Voluptuous Alliance between Africa and Europe": Hogarth's Africans

David Bindman

Since the publication of David Dabydeen's *Hogarth's Blacks: Images of Blacks in Eighteenth-Century Art* in 1985,[1] it has been impossible to ignore the fact that Africans, usually in the role of domestic servants, are a substantial presence in Hogarth's paintings and satirical prints, though, as Dabydeen points out, this was barely remarked upon by earlier commentators. Dabydeen's book attempted to set their representation in the context of eighteenth-century ideas about Africans, making the claim at one point that Hogarth's "sympathy for the 'nobodies'— that is, the lower classes—obviously extends to a sympathy for black people who belong to the same category."[2]

This claim rests on the familiar assumption that Hogarth's own troubled and poverty-stricken youth, as the son of a bankrupt author, would have given him fellow feeling for those unjustly oppressed by the "system." A more cynical view, in the absence of evidence one way or the other, would be that it is just as likely that Hogarth, as he became successful, would have sought to distance himself from those left behind in poverty.

We have virtually no evidence beyond the paintings and prints of Hogarth's attitudes towards Africans, but for him to have had a particular sympathy for Africans, though commendable, would have put him in the minority in his own time, place, and circumstances.[3] He might have shared unease about the motives of slave traders and the common belief that slavery often led to cruelty, but since the morality of the slave trade became a subject for national debate only a few years before Hogarth's death, the onus of proof that he might have had principled objection to the slave trade is on those who believe that he did. In Hogarth's age the rhetoric of British liberty coexisted, if sometimes uneasily, with an implicit acceptance of the appalling cruelty of the slave trade and plantation economy, though they were well distanced from the common experience of most people living in England. None could deny the economic benefits for Britain in her growing mastery of the slave trade. Successive British governments from the mid-seventeenth century onward controlled or supported the trade and employed resources in protecting its routes from foreign intruders. The government was also involved in the Royal African Company,[4] though by 1730, as Hogarth was achieving success as a portrait painter and satirist, it was being overtaken by privately financed expeditions.

Intellectual and theological debates about slavery in the period were less concerned with its morality than with whether those brought up as "savages" were "naturally" slaves and whether they could be educated and therefore converted to Christianity.[5] Plantation slavery was a topic in England more for economic than for moral concern, over the merits or otherwise of producing labor-intensive crops like sugar and tobacco in hot climates far from Europe and the need to defend them from other European powers. Only with the aboli-

tion campaigns that began in the 1760s were these separate discourses brought into conjunction, connecting European patterns of consumption of luxury goods with the slave labor that produced them. The discomfort that this caused to the royal family is wittily satirized by James Gillray in his print *Anti-Saccharrites,—or—John Bull and his Family leaving off the use of Sugar* of 1792; the royal children suffer miserably from the deprivation of sugar, while Queen Charlotte reminds them brightly of the greater sufferings of the slaves on the West Indian plantations: "You can't think how nice it is without sugar;—and then consider how much work you'll save the poor Blackamoors by leaving off the use of it!"[6]

We can get some idea of the underlying meanings for his audience of Hogarth's representations of Africans by using as a starting point a work he must have known: Daniel Defoe's *The Life and Strange Surprising Adventures of Robinson Crusoe*, published in 1719, just as Hogarth was about to begin his own career, also in the City of London.[7] While Defoe is of a slightly earlier generation than Hogarth, it is probable, given their broadly comparable social position in London, that they would have shared certain assumptions, though of course Hogarth's work is not directly comparable in subject matter.

Robinson Crusoe, as is well known, spent twenty-eight years alone on a remote island off the coast of South America before he was rescued. His previous career as a mariner was bound up with trading in slaves from Africa, though it is not explicitly stated. On his first successful adventure, which leads eventually to his own capture and enslavement by pirates, he set up as a "Guiney trader" with an honest sea captain.[8] Guinea, on the west coast of Africa, was a major source of slaves, and later Crusoe notes that a Portuguese ship was "bound to the coast of Guinea for Negroes." In his second phase of prosperity Crusoe settled in Brazil, where he set himself up in the "planting and making of sugar," and after achieving a certain level of prosperity, "I bought me a Negro slave and an European servant also."[9] Becoming restless, he embarked on an expedition to Guinea with the express purpose of acquiring by barter "Negroes for the service of the Brazils, in great numbers." As Crusoe points out, the profit lay in avoiding the *assientos* (permissions) controlled by the Spanish and Portuguese kings; Crusoe's share of the expedition was to manage the trade on the Guinea shore and have "my equal share of the Negroes."[10] Crusoe was, however, shipwrecked on his way to Guinea and ended up on the famous island in the mouth of the Orinooko River.

It has, on occasion, been suggested that Crusoe's shipwreck was divine retribution for his active engagement with the slave trade.[11] Shipwrecks certainly had a role in Crusoe's journey of life, but more as divine punishment for his refusal to accept a life of pious contentment and patient accumulation instead of continuing to seek out riches through speculative

ventures. In other words, he could have acquired slaves not by going on risky expeditions, but by slowly building up his wealth. As Crusoe muses later, "What business had I to leave a settled fortune, a well-stocked plantation, improving and increasing, to turn supercargo to Guinea, to fetch Negroes, when patience and time would have so increased our stock at home that we could have bought them at our door from those whose business it was to fetch them[?]"[12]

Crusoe's creator, Daniel Defoe, was in fact actively involved with the Royal African Company, and he may have been a paid polemicist on its behalf.[13] For Defoe slavery was controversial, but the issue was not its humanity. Defoe's concern was whether the trade in African slaves could best be carried out through the state-controlled Royal African Company or through privately financed expeditions. In that controversy, which attracted a great many pamphlets throughout the early decades of the eighteenth century, Defoe argued for the long-term benefits of state intervention.[14]

There is then in Defoe's fiction and political writings an acceptance of the institution of slavery, not only for its general economic benefits but as a natural part of gentlemanly life in distant lands. But his account of Crusoe's most famous servant, Friday, shows an awareness of the inherent complexities of the relationship between master and slave. In fact Friday only served his master for the last four years of his time on the island, and he was preceded before Crusoe reached the island by Xury, a Moorish youth. Xury serves Crusoe faithfully after Crusoe, escaping from his own enslavement by a pirate, agrees not to drown him.[15] The ever-present fear for the two escapees is landing on the barbarian coast, "where whole nations of Negroes were sure to surround us with their canoes and destroy us; where we could ne'er once go on shore but we

should be devoured by savage beasts, or more merciless savages of human kind."[16] When they do land, Xury is terrified of being eaten by "the wild mans" but nonetheless agrees to offer himself as a sacrifice to allow his master to escape. The area the pair have landed in is the Maghreb, "lying between the Emperor of Morocco's dominions and the Negroes'," and Crusoe's objective was to walk to the Gambia or Senegal, where he might find a passage home with a slave trader. He and Xury meet Africans who were "quite black and stark naked" but not hostile, though this may have been because it was their first experience with the effect of firearms.[17]

Thus Africans—or "savages" or "Negroes"—are seen as either potentially docile or cannibals, a duality of attitude, as Peter Hulme has argued, that can be traced back to Christopher Columbus's first encounter with native Caribbeans.[18] The arrival of Friday twenty-four years after Crusoe has settled on his island is the occasion for an extended meditation on the transformation of a cannibalistic "savage" into a devoted, incorruptible, and Christian servant. The "savages" who bring Friday to Crusoe's island are cannibals who feast on their victims. Friday makes his appearance as their intended victim, and after they have been killed by Crusoe's guns, Friday's own idea is to eat them himself. He "was still a cannibal in his nature," but he is weaned of human flesh by Crusoe, who converts him to Christianity.[19]

Friday, in gratitude for his deliverance from death and from his former benighted state, becomes totally servile, making "all the signs to me of subjection, servitude, and submission imaginable," placing Crusoe's foot upon his neck.[20] In other words, his enslavement is presented as a *voluntary* one, a natural act of gratitude toward one who has spared his life and offered him the inestimable benefits of education. The relationship is obviously paternalistic: "His very affections were tied to me,

like those of a child to a father." Friday is described as being almost European in physiognomy and not as "negroid" in type: "He had all the sweetness and softness of an European in his countenance, especially when he smiled"—and further on—"His face was round and plump; his nose small, not flat like the Negroes; a very good mouth, thin lips, and his fine teeth well set, and white as ivory."[21] In Restoration literature, though ordinary "savages" might be bloodthirsty and cannibalistic, their leaders were often presented as paragons of virtue and classical beauty. In Aphra Behn's novel *Oroonoko* (1688) the eponymous hero is a noble savage, a West Indian black, who is distinguished physically and morally from his tribe; his face is Roman in its nobility, and he lacks the stereotypical flat nose, thick lips, and frizzy hair of the African, though his skin is jet black.[22] If Friday is identifiable at all, he is a Carib, one of the aboriginal inhabitants of the Caribbean before the arrival of African slaves, but he is really a generic "savage" whose color and features are defined not by race or ethnic group but by social position.

One cannot, of course, simply transpose the attitudes embedded in *Robinson Crusoe* to Hogarth, though he did have some acquaintance with slave-trading circles. A number of sitters for Hogarth's early conversation pictures in the late 1720s and early 1730s had connections with the Royal African Company. Furthermore, Hogarth's relationship with his sitters was not just one of servility; he was also part of the world of political affairs through his father-in-law, the painter Sir James Thornhill, who was a Member of Parliament, and this connection helped him get commissions from those in powerful positions.[23]

As it happens, Hogarth painted a portrait group for Captain Woodes Rogers (fig. 110), whose discovery of Alexander Selkirk on the island of Juan Fernandez in 1708, recorded in an account of his travels published in 1712,

was the primary source for *Robinson Crusoe*.[24] Hogarth's painting commemorates Rogers's appointment as Governor of the Bahamas, where his role would have been to protect from the Spaniards and the French a vital link in the passage of goods, including slaves, from the West Indies to America.[25] A number of other patrons of Hogarth's conversation pictures of the 1730s had connections with slave trading, like, according to Webster, the Ashley and Popple families, portrayed together in a conversation group.[26] And there may be others whose connections have yet to be explored. Hogarth then must have mixed in circles in which plantation slavery was discussed as a trade like any other. Indeed, his friend Bishop Hoadly wrote a pamphlet in which Caribbean trade is a prominent topic, though the issue of slavery is never directly raised.[27]

It is probably safe to assume that Hogarth's views on the slave trade would not have been out of line with Defoe's. On the other hand, he would have known families with one or two black servants and been familiar with portraits, either paintings or engravings, in which blacks were represented. Their status in the period would normally have been as chattel slaves, often indicated by a collar they could not remove; and they had varying roles, depending on age and gender, as horse grooms, domestic servants, or fashionable pets. They had often been depicted in full- and three-quarter-length portraits in the seventeenth century in company with the main subject, both female and male, providing an air of courtly display and exoticism, as in, for instance, Van Dyck's *Princess Henrietta of Lorraine*, c. 1634 (fig. 111), and William Dobson's *John, 1st Baron Byron*, c. 1643.[28] By Hogarth's time blacks were beginning to be owned by sea captains, who brought small African children back as trophies, probably from slaving expeditions or by barter, and by upwardly mobile merchant families as well as aristocrats.[29]

Fig. 110. William Hogarth, *Captain Woodes Rogers and his Family*, 1729. Oil on canvas, 16½ x 22 in. (42 x 55.8 cm). The National Maritime Museum, Greenwich

Fig. 111. Anthony Van Dyck (Flemish, 1599–1641), *Princess Henrietta of Lorraine*, c. 1634. Oil on canvas, 84 x 50 in. (213 x 127 cm). The Iveagh Bequest, Kenwood House, London

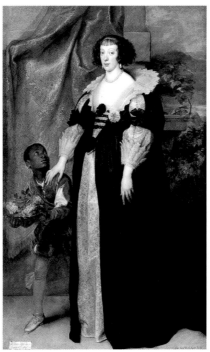

Such apparently docile figures might seem remote from Crusoe's Friday. In grand-manner portraits they are almost always depicted in spectacular finery, often more elaborate than their high-ranking owners, and invariably they look up with deep awe toward their masters and mistresses, acting as a foil to the latter's superiority. In such a context their presence evokes a number of ideas: nature's tribute to nurture, savagery's tribute to gentility, and ceremonial and magnificence on the scale of the great European courts.[30] If, as Defoe suggests, Africans are potentially murderous or even cannibalistic, there is a further implication in such paintings that the master or mistress has tamed their natural savagery by force of personality, or in the case of women, great beauty, into voluntary servitude. The chattel slave in grand portraits is then both a "savage" and ceremonial object, one that might return

to nature if the trappings of civility were removed. Crusoe's relationship to Friday is based on his righteous power to transform the cannibalistic "savage" into a social being, while such paintings show the African, who supposedly knows in his native land only the untamed life of the fetish worshipper and hunter, fashioned into an icon of courtly style.

Hogarth, though he did occasionally include black servants in his serious conversation pieces,[31] as in *The Wollaston Family* (fig. 112) and *Lord George Graham in his Ship's Cabin* (fig. 113), usually comments on this relationship in the context of his satirical work. Black servants are, like Italian paintings or French dancing masters, one of the many signs of the luxury and pretence to courtliness of the dissolute inhabitants of the new residential squares of the

West End of London. In an oil sketch believed to be a first idea for the *Rake's Progress* (fig. 78),[32] the connection is made explicit in the foreground by a small black boy holding up an Italian-type painting of *The Rape of Ganymede*, surrounded by heavily restored Roman busts. In *The Toilette* from *Marriage A-la-Mode* (pl. M4), the parts played by chattel slaves in the public and the more intimate spheres of aristocratic home life are contrasted.[33] The new Countess, though of a merchant family, plays up to her new rank by receiving visitors at a *levée*. (Her social pretensions are also visible in the opera singers and Italian paintings.) The smaller black child on the right (fig. 114), elaborately dressed and very young, is of the kind that was usually treated as a pet and allowed a place in his (or her?) mistress's private rooms and was therefore

Fig. 112. William Hogarth, *The Wollaston Family*, 1730. Oil on canvas, 39 x 49 in. (99 x 124.5 cm). Private collection. On loan to Leicester City Art Gallery

David Bindman

Fig. 113. William Hogarth, *Lord George Graham in his Ship's Cabin*, c. 1742. Oil on canvas, 28 x 35 in. (71 x 88.9 cm). The National Maritime Museum, Greenwich

Fig. 114. Simon François Ravenet (French, 1706/21–1774) after William Hogarth, *Marriage A-la-Mode*, Plate 4, *The Toilette* (detail), 1745. Engraving. Hood Museum of Art, Dartmouth College, Hanover, New Hampshire. Purchased through a gift from the Hermit Hill Charitable Lead Trust

privy to her sex life. This is expressed in the child's gloating knowingness in connecting the horns of the Acteon figure with a cuckold's horns and hence the Countess's impending adultery. This knowingness could be the consequence of either experience of European life or a "natural" predilection to lust or perhaps both.

The older boy, by contrast, is a household servant offering a drink to the lady, who is dressed as a shepherdess (fig. 115). She is rapt in admiration of the great castrato singer Senesino. The boy's expression can be read as one of open-mouthed astonishment at the behavior of the assembled company, observing in them something of the "savagery" of his former life rather than the nobility he might expect from his "civilized" masters and mistresses. He represents the satirical trope of the disillusioned visitor from an exotic land, like Oliver Goldsmith's "Chinaman" in *A Citizen of the World*

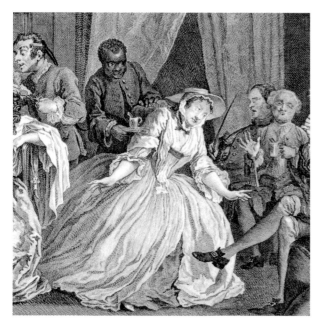

Fig. 115. Simon François Ravenet after William Hogarth, *Marriage A-la-Mode*, Plate 4, *The Toilette* (detail), 1745. Engraving. Hood Museum of Art, Dartmouth College, Hanover, New Hampshire. Purchased through a gift from the Hermit Hill Charitable Lead Trust

Fig. 116. William Hogarth, *The Four Times of the Day*, Plate 2, *Noon* (detail), 1738. Etching and engraving. Hood Museum of Art, Dartmouth College, Hanover, New Hampshire. Purchased through the Guernsey Center Moore 1904 Memorial Fund

(1761) or, as Dabydeen notes, the West Indian slave Julio in James Miller's *Art and Nature* (1738), who remarks with amazement the absurdity of Londoners' pretensions.[34] Julio refers to them as "a parcel of haughty big-looking Savages, that domineer over their Fellow-Creatures, most of whom seem to be better than themselves."

If it is believed that fine clothes and fashionable settings only serve to veil Africans' savage desires, then we might expect them to be represented on occasion as breaking out from the confines of fashionable life. In Hogarth's painting and engraving of "Noon" from *The Four Times of the Day* series (fig. 116), what the German critic Lichtenberg calls "eine etwas üppige Koalition zwischen Afrika und Europa" (a voluptuous alliance between Africa and Europe) takes place as a black youth makes a grab at the breasts of a pretty serving maid, who in her rapture allows the pie she is carrying to spill over.[35] His "savagery" is expressed in unrestrained lust, while she is either unable or unwilling to suppress her own. Dabydeen's suggestion that the motif is based on a Titian

painting of *A Satyr Embracing a Nymph* captures the sense of animal spirits which infects both parties.[36]

Satires like Hogarth's *Rake's Progress* and *Marriage A-la-Mode* and moral tales of self-discovery like *Robinson Crusoe* are part of a broad concern of the period to promote a wider civility based on the subordination of the desire for luxury to public virtue.[37] In the prevailing ideology of "Politeness" the "savage" is not only "other" to the man of civility, but his "savagery" can be correlated with the primitive and selfish desires of Europeans, which are held under restraint by education and sound morals. This "savagery" was also the primal state of humanity in the immemorial past, before the imposition of civil society. Courtly portraiture, Hogarth's satires, and *Robinson Crusoe* all presuppose that the "savage" can be transformed and socialized by the benign pressures of civilization, though not necessarily totally or permanently.

Hogarth's differences from Defoe in profession and perhaps in generation are revealed most clearly in Hogarth's concern with skin

Fig. 117. William Hogarth, *The Analysis of Beauty*, Plate 2 (detail), 1753. Etching and engraving. Lewis Walpole Library, Yale University, Farmington, Connecticut

color, which, in *The Analysis Of Beauty* (1753), he brings within modern discourses of physical science.[38] He argues that human skin derives its visible color from a fluid beneath the outer skin that represents the sole visual difference between the skin color of human beings. The predominant understanding of the physiological cause of "blackness" was that of the seventeenth-century author Marcello Malpighi, who claimed that pigmentation of skin came from the "ethiops" which resided beneath the outer skin[39] and was not unique to those of dark skin but existed in all human beings in varying shades. Hogarth used this theory to argue that human beauty is literally only skin-deep: "the fair young girl, the brown old man, and the negro; nay, all mankind, have the same appearance, and are alike disagreeable to the eye, when the upper skin is taken away."[40] He also claimed that the cutis, which lines the cuticula or outer skin, is "composed of tender threads like network, fill'd with different coloured juices," including "black [for] the negro." This is illustrated by a small vignette in the second of the two full-size engravings Hogarth made for the volume (fig. 117, section 95), where the engraved lines represent the

network of threads as a kind of cross-hatching.[41] The Malpighian theory thus reduces to a minimum the physical differences between whites and blacks and defines those differences in terms of color and not physiognomy.

For a painter, this reduction of difference into a matter of skin color is in contradiction to the well-established stereotype of Africans in literature and art as having, with heroic exceptions like Oroonoko, frizzy hair, thick lips, and a flat nose. It is perhaps significant that Hogarth's most considered representation of an apparently real African, in the painting of the aristocratic sea captain Lord George Graham in his ship's cabin (fig. 113), appears to be completely free of such physiognomic stereotyping. The black boy on the right of the painting is engaged in the difficult task of playing a drum and a flute at the same time. There is nothing obviously servile about his role except that he provides entertainment for Lord George and his chaplain, as do the cook and singer. He is unexotically dressed in a green jacket and vivid cravat, and the vibrant brown color of his face is set against the dead brown of the wood of the ceiling and cabin wall behind him. The face is drawn out of the background by very careful modulation and emphatic highlights on the nose, lower lip, and lower eyelids and with brilliant animating touches of red in the corner of his right eye, giving a slightly bloodshot look. Though a performer and servant, the boy's touching grace suggests the triumph of the painter's observation over the need to give each figure precise social definition or to conform to traditional stereotypes of the African.

The truth effect of the boy musician in the painting can probably be related to Hogarth's concern with observation of the variety of the mundane world expressed a few years later in *The Analysis of Beauty*; but it offers no clue to his attitudes toward slavery, though it says a great deal about his seriousness as a painter. It does,

however, highlight a problem in dealing retrospectively with the issue of European attitudes toward slavery in preabolition eras. Put simply, the issues involving slavery and the nature of non-Europeans in Hogarth's time were not only fluid and unresolved, but they cut across a number of different discourses: the theological, the economic, the social, and increasingly the scientific, and, emerging during the last decade of Hogarth's life, the sentimental.

Notes

1. See Dabydeen 1985.

2. Dabydeen 1987, 131.

3. For a wide-ranging discussion of these issues, see D. Davis 1970, 381f.

4. See Davies 1957.

5. D. Davis 1970, 227f.

6. 27 March 1792; BMC 1870–1954, no. xxx.

7. The edition cited here is the Everyman's Library edition, ed. John Mullan, London, 1992.

8. Defoe 1992, 13.

9. Ibid., 30.

10. Ibid., 32.

11. Rogers 1979, 42.

12. Defoe 1992, 112.

13. Kiern 1988, 242–47.

14. Ibid., 240f.

15. Defoe 1992, 18.

17. Ibid., 24.

18. Hulme 1986, 14–43.

19. Defoe 1992, 175.

20. Ibid., 171.

21. Ibid., 173.

22. "His face was not of that brown rusty black which most of that nation are, but a perfect ebony, or polished jet. . . . His nose was rising and Roman, instead of African and flat; his mouth the finest shaped that could be seen; far from those great turned lips, which are so natural to the rest of the negroes. The whole proportion and air of his face was so nobly and exactly formed, that bating his colour, there could be nothing in nature more beautiful"; Behn 1886, 16–17.

23. Bindman 1997a, 132–35.

24. W. Rogers 1894.

25. Williams 1970, 67.

26. Webster 1979, 27.

27. *An Enquiry into the Reasons of the Conduct of Great Britain, with Relation to the Present State of Affairs in Europe*, 1727.

28. [*Anthony Van Dyck*] 1990, no. 72, and Wilton 1992, no. 9.

29. A fine example of the first is Reynolds's portrait of Captain Ourry (Saltram House, Devon); see Penny 1986, pl. 11. For an example of the latter, see Hogarth's Wollaston family group (Bindman 1981a, pl. 26), where a small black servant can be seen in the background left.

30. See Bindman 1994, 70–71.

31. See note 29 above.

32. Reproduced in Webster 1979, 70.

33. See Bindman 1994, 74.

34. Dabydeen 1987, 57.

35. Lichtenberg 1794, 715.

36. Dabydeen 1987, 52.

37. Lubbock 1995, 184f.

38. Bindman 1997a, 51f.

39. Jordan 1973, 246.

40. Hogarth 1997, 114.

41. Hogarth 1997, 115. For the original drawing and a slightly different text, see Bindman 1997a, 172–73.

A Fashionable Marriage

Lubaina Himid

On Hogarth:

> Garibaldi, "the painter of the people";
> Wordsworth, "this great master";
> Coleridge, "true genius";
> Fielding, "comic history painter";
> George II, "he deserves to be picketed for his
> insolence";
> Vertue, "an ingenious man";
> and Garrick's *The Clandestine Marriage:*

> Poets and painters, who from Nature draw their best
> and richest stories have made this law:
> That each should neighborly assist his brother,
> And steal with decency from one another.
> Tonight your matchless Hogarth gives the thought,
> Which from his canvas to the stage is brought.
> And who so fit to warm the poet's mind
> As he who pictur'd morals and mankind?
> But not the same their characters and scenes;
> Both labour for one end by different means;
> Each as it suits him, takes a separate road,
> Their one great object Marriage-à-la-Mode . . .
> The painter dead, yet still he charms the eye;
> While England lives his fame can never die.

London in the 1980s in the midst of the hedonistic, greedy, self-serving, go-getting opportunistic mayhem was a fabulous location for me as a satirist and wit. Everyone who shook or moved in artistic semicircles or political whirlpools was a deserving dartboard. I took aim and threw.

Hogarth provided the many layers I needed for the perfect plan to reveal the art folk and their intrigues by comparing them to the despicable players on the stage of world politics.

Hogarth, bad-tempered ambitious genius and critic of eighteenth-century manners and morals, painter of theatrical themes, storyteller, history painter, arch xenophobe, proved to be the perfect ally. He painted life as he saw it outside his back door. He had no qualms about heaping ridicule upon aristocratic architects, politicians, moneyed men, stupid women, avaricious families, lazy bureaucrats, and anyone French or Italian. Most important for me, he used black people to highlight the evils and misdeeds of almost everyone he saw; they were signifiers of European hypocrisy and the sordid falseness of white folk. Black people in Hogarth's work nearly always reveal pretentiousness, artificiality, and the dreaded sophistication.

In 1986 I wished to do the same, although I rather liked sophistication. His theatricality and storytelling tableaux fulfilled my desire for spectacle and drama, even though it had been ten years since completing my theater design degree and I had long abandoned any need to work with actors. Hogarth was interested in the time in which he lived—the people who stood in his way as much as those who, like Fielding and Vertue, praised his innovation and risk-taking.

London in the 1980s was a frustrating, infuriating place for me. Experimental work in the laboratory of British art was a full-time struggle: curating small shows, writing reviews and articles, creating new work, strategizing,

sitting on arts board panels, and speaking about the work. All done while writing a thesis on Young Black Artists, written at the Royal College of Art between 1982 and 1984. It was time-consuming and exhausting.

The right wing had won; they were to keep a political stranglehold on the country way into the 1990s. At the time it did not seem possible that the reign of the right could last; now of course they are disguised as the left. Still here: different name, different mask, same hypocrisy, same narrow view, same color. It was important to find a way of revealing this rather obvious political reality while at the same time showing how it was linked to a middle-class, complacent, liberal intellectual art community, which through newspapers like the *Guardian* and institutions such as the Arts Council pretended to be the opposition. Being an advisor on various arts panels gave me a unique insight into the workings of this complicated, many-layered world. Having ineffectual dealers exposed even more, none of it useful or moral or honest. The ever-silent media, however, was the most laughable spanner in the works.

The most important reason for my choosing Hogarth to take a swipe at the seething intrigue of contemporary life was that he used the black person to expose the shady morals of the white main protagonists. Once or twice, in the images *Chairing the Member* and *The Toilette* (fig. 118), there are two black characters, indicating interchange and thriving relationships in the world of slaves and servants,

though the main narrative is of course white and European.

Imagine a large bedroom, hot with the morning scent of the night before. High, dark, curtained walls covered with paintings. On closer inspection the paintings depict rape, rape, and more rape. The violent violation of a woman's body. There is a bed with heavy pink curtains pulled slightly apart, a gilt mirror draped with cloth. There is a screen covered in lewd and "amusing" scenes. The floor is strewn with playing cards and sex toys. There are eleven people in the room, one playing an instrument, one singing, several of them drink hot chocolate, one plays with toys, one serves the drinks, two flirt, one dresses hair, one sleeps, two fawn like idiots. The owner of the house is not there—never mind.

Change the paintings a little. Replace them with late Picassos; plenty of rape scenes to choose from, many women's bodies to penetrate and destroy. Divide the room into two overlapping worlds. Place the black people at the center, politically active, as knowing intelligent catalysts of change and revolution. Here is the scene in London in the middle of the 1980s. It was a crowded, confusing, bitter, and twisted place (fig. 119).

The Critic/Castrato sings, beautifully dressed in an embroidered coat. He is covered in rings, earrings, buckles (gifts from admirers); he dominates the room. His body may be mutilated, but it is enormous. His voice is clear, high, false, and full of artistry; it fills the

Fig. 118. William Hogarth, *Marriage A-la Mode*, Plate 4, *The Toilette*, before 1743. Oil on canvas, 27 x 35 in. (70.5 x 90.8 cm). National Gallery, London

Fig. 119. Lubaina Himid (British, born 1954), *A Fashionable Marriage*, 1986. Multimedia installation, c. 10 x 20 x 8 ft. (300 x 600 x 240 cm). Private collection

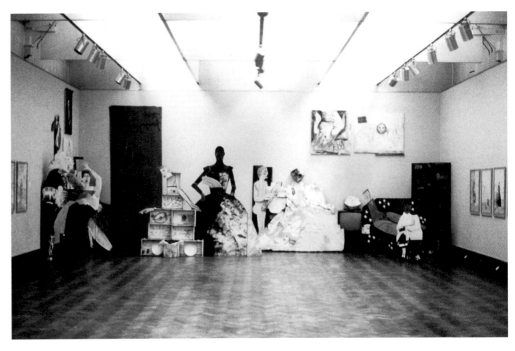

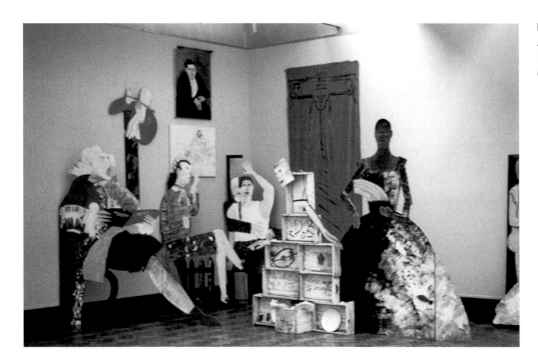

Fig. 120. Lubaina Himid, *A Fashionable Marriage, The Art World*, 1986. Private collection

room. He is seductive, famous—a star. We need him to reassure us of our importance, we need him to bring culture to our lives. The foolish and deluded, breathless and newly arrived find him fascinating. In 1747 he could have been Farinelli, Senesino, Carestini, or all three. His sound covers the snoring and the whispering; the eager listener squeals with delight. In my 1986 version his domain is the half of the room designated as *The Art World* (fig. 120), he appears as the critic. The critic, an empty, self-centered creature who lurks in the twilight between history and the gossip column. The critic loves art but despises artists and tends to see an exhibition as a checkered dance floor upon which he can prance with silken shoes and a smirking mask. The hapless artist takes years to realize that the critic is not an audience or a historian, but akin to a paper advertisement or a radio jingle. The critic's comments may be clear, concise, to the point, current even, but of minute importance over many years of making artwork.

The critic has clothes made from clippings from several revered 1980s publications, *Block*, *Screen*, *Time Out*, and *Creative Camera* (fig. 121). The titles *Block* and *Screen* always remind me of creams used to protect white skin from the heat of the sun. His shirt is a cacophony of rubber gloves, he longs to be fondled or squeezed. He is enormous and heavy, but what he says disappears as quickly as a high note melts in the atmosphere.

The flautist in 1986 became the dealer; he and the critic are in harmony. The dealer, discreet, shadowy, dressed in gray, standing at the back. A silly shopkeeper of no consequence, who must follow the advertisements in order to be at the right place at the right time with artworks pitched at the perfect price. Is he playing our tune? No, he plays to the gallery.

Hogarth links the waiting ambassador with the castrato visually and sexually. The ambassador has his legs tightly crossed, his foot pointing to the inner thighs of the eager listener. His lips are pursed, ready to sip; his

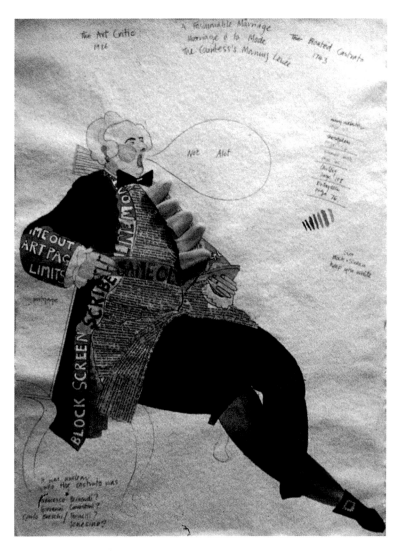

Fig. 121. Lubaina Himid, *A Fashionable Marriage, The Art Critic*, 1986. Acrylic on paper, 72 x 48 in. (183 x 122 cm). Private collection

Opposite: Fig. 122. Lubaina Himid, *A Fashionable Marriage*, (detail), 1986. Private collection

hair is in curlers, ready for pampering. As a cutout, he appears as the dithering art funder, unable to decide between the critic's song and the fad of the day. Should he support the disabled, the black, the women, or wait until someone else gives permission—the countess perhaps? He is made from thin plywood, thinly painted, he sits on a wobbly fence. In the 1980s, funders needed to be seen as acknowledging the "other"; in the 1990s this is seen as ridiculous, far too political, and they swim around in a vacuous deceit.

As the castrato sings, a woman—open-legged, open-armed, open-mouthed, open-fingered, clothes loose, echoing the open bed curtain—delightedly and limply leans toward him, drinking in his song. Her white dress, with its exposed underskirt of pale blue, is set against her pale skin, dainty hat, and red hair. Her tiny foot peeps out like a little tongue beneath her skirt. She is the feminist artist (fig. 122). She is made from empty drawers turned on their sides and casually filled with barely disguised pastiches of the American feminist art movement, which had so dominated the previous ten years—wealthy, white, exclusive, carnivorous, strategic, and knowing. She is sure she is the center of the scene, the prettiest and the most important woman in the room. She hangs on every word the critic says, waiting for something he cannot give. Does she really believe in the funder, the dealer, and the critic? They believe in each other.

Two men are paying attention on and off. In the corner a pudgy fellow sleeps, whip in hand, but next to him, joined at the hip, a tweedy, pale, bewigged companion looks on admiringly, his hand raised in awe, his hot chocolate poised for entry into his plain, bland, pasty face. These two so reminded me of the then very fashionable painters of the time, graduates of the Glasgow School of Art, at once eager and complacent, dozing and strategic (figs. 120 and 128). Mimicking the English world of *Private Eye* and *Gilbert and George*, but out on a provincial limb nevertheless. As contemporary painters, they appear forever entwined, inextricably linked—not waving, not moving from the edge. These men were the saviors of painting, the epitome of a nineteenth-century ideal. The worlds they depicted were peopled by men eccentrically dressed, going forth on Arthurian quests, subsequently meeting themselves coming back. Theirs was not a world of political marginality, but one firmly placed in a private commer-

cial dealer system, which exists to mirror the world of collectors.

Center stage stands a black slave in a sumptuous green uniform (fig. 118). He attempts to give the young woman the attention she so obviously craves; leaning toward her he offers a cup of hot chocolate in which lounges a melting biscuit at a rakish angle. He finds the scene amusing, but it preoccupies him. She ignores him—her loss. This pivotal black figure completely dominated the scenario in the 1986 cutout installation. The transformation of this slave into a black woman artist with articulated arms and an elaborate dress covered in wooden painted fish took the center (fig. 122). She had a larger offering and poured it towards the eager listener: energy. I believed that we as black women artists held the center; in fact, we rented rooms there. The ground shifted and it became clear that little had changed for us in five hundred years. We worked for nothing; we still do. We are signifiers of white corporate wealth, expensive to keep, but oh so decorative and useful for dealing with awkward situations and people. Black women are still useful spice for a bland "postfeminist" dish. In 1986 I was full of hope and looking for a fight as we stormed the citadel.

To help us we needed sharp and committed political minds, black minds convinced that culture could be an effective weapon for change. Hogarth's black slave boy is in charge of the auction lots, is at home in the bedroom, in the world of his mistress and her lover (fig. 114). He is the only character to interact with the audience. Not only is he absolutely in tune with what is happening in the room (world) but his is the role of narrator; he skillfully displays his sex toys gleefully arranged across the floor. There were young women working then in 1986 who could have strengthened the link between politics and culture. However, like the boy/slave sitting at the feet of Silvertongue, the politics of politics got in the way. The links

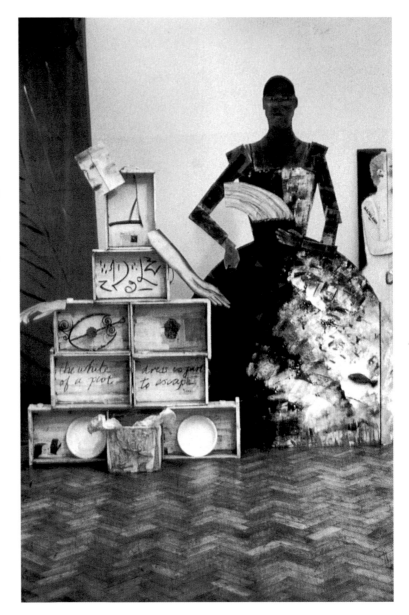

Fig. 123. Lubaina Himid, *A Fashionable Marriage, The Real World*, 1986. Private collection

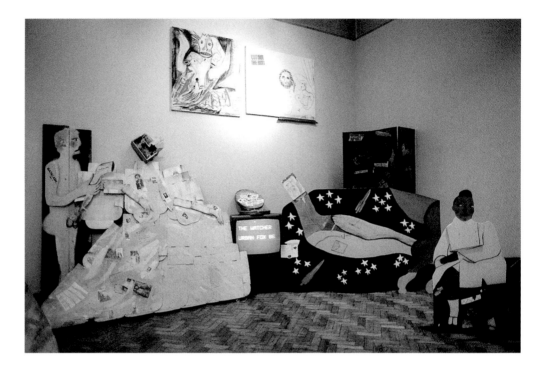

burned out just like the candlewicks, only faster. The boy who became a girl understood the connection between media, representation, and power, understood that the power of global distribution infiltrated the world of the moving image and toyed with revolutionary intervention. While making the piece, all this seemed possible. The slave boy's preoccupation with sex toys became the sober mistressing of modern visual technology. A video screen replaced the gilt mirror, its sound track Handel's *Queen of Sheba*, Ghanaian women singing played over a face masked, veiled, revealed, concealed in turn.

Another servant, hired and white, helped the narrative along in this global and political section of the installation (fig. 123). He is the hairdresser. He fusses, primps, preens, arranges the countess's hair, he listens slightly flushed to Silvertongue; he tries to ignore the castrato. He performs his duty manfully, he is a lackey, a tabloid editor, a cheap trashy novelist, an ambitious young M.P., a short-sleeved shirt in

local government, he does as he is told and gossips accordingly. The 1986 cutout is naked, his penis an electric hairdryer. He is made from bits and pieces of old discarded wood, painted bright ice-cream pink. He is a throwback to some early, infamous, naked, erect cutout men I made in the early 1980s.

The star of the piece for Hogarth is, of course, the countess, who has recently had a baby, so lounges casually at her dressing table, having spent the previous afternoon at the auction rooms, while her husband, the earl, is away (fig. 118). She is having her hair done. She smiles simperingly at her lover, the lawyer Silvertongue. Her dress is flesh or knicker-pink, under heavy yellow. Her toe peeps out; her cheeks are flushed; a pocket watch rests at her vagina. She languorously points an index finger at a note her lover is showing. She is Margaret Thatcher, the first and therefore the last woman prime minister of Britain, leader of the Conservative party, champion of business, destroyer of the unions, the welfare state, and favorite of newspaper proprietors worldwide

(fig. 123). She elegantly wove her way into and out of the latter part of the twentieth century, narrowly escaping assassination. She led her nation to war to save her reputation and courted the United States as if her life depended on it. The left in Britain loathed her. She brought out their most disgusting misogynistic texts and imagery. She went on and on, on and on, until she was defeated by her eunuchs, as usual, in the game of grand intrigue and male frustration. The cutout was made from bits of wood, cardboard, newspaper cuttings, which referred to her policies, her gaffes, and her everyday management. All this and a smattering of plastic trinkets were held together with glue and staples. It wasn't meant to last, nor was she; she does, and so does the cutout.

Her lover, the clever Silvertongue, was played by the most stupid Hollywood actor we could find. His first wife said he was as good in bed as he was on the screen. He could not act. He stayed in the limelight far too long. The makeup ran; he forgot which play he was in, but clever Americans kept prompting from the wings, clapping in all the right places, mopping his brow till the end. We lost. Their policies seeped into the left wing, thought and deed; their legacy limps and crawls on and on.

The time has probably arrived, thirteen years later, for another vicious visualization of art politics and its relationship to global politics. The art of war and the war of art. Hogarth and I may set about it soon.

Lubaina Himid's *A Fashionable Marriage*: A Post-Colonial Hogarthian "Dumb Show"

Bernadette Fort

This volume could not provide a more thought-provoking conclusion on Hogarth's aesthetics of difference than the autobiographical essay by the African-born artist Lubaina Himid on her 1986 work *A Fashionable Marriage* (fig. 119), which takes its inspiration from scene 4 of Hogarth's *Marriage A-la-Mode*.[1] In her *Differencing the Canon: Feminist Desire and the Writing of Art's Histories*, Griselda Pollock discusses the set of strategies available to the artist of African descent aiming to reconfigure the Western canon and make room in it for the long-ignored creative agency of African artists. One of these strategies, which she calls "differencing," is produced, she suggests, "by taking revenge on the cultural canon in which the colonial relations have been inscribed."[2] As Pollock goes on to show, this strategy informed Himid's entire 1992 exhibition at the Rochdale Art Gallery, entitled *Revenge*. "*Revenge*," Pollock writes, "involves a form of quotation and reconfiguration that aims precisely to make possible a historically informed practice of *painting* in the 1990s—a new form of *history* painting necessitated by the urgent need to explode the Western myth of Africa which contributes to the erasure of a creative subjectivity for the artist of African descent."[3]

Four years earlier, taking Hogarth's *Toilette* as a palimpsest for her multimedia installation *A Fashionable Marriage*, Himid had given a different modulation to this artistic mode of "differencing." In a close-up comparative investigation of these two works, this essay proposes to trace not only the surprising aesthetic filiation between Hogarth and a late-twentieth-century black woman artist, but to show how the Hogarthian aesthetics of difference examined in this volume is acknowledged, reappropriated, transformed, and at times turned around by an artist of our times for whom gender and race are fundamental elements of artistic subjectivity.

Born in Zanzibar in 1954, the daughter of a Comoran teacher and a Lancashire textile designer, Himid came to England at a very young age and grew up in an international milieu of artists, musicians, educators, and politicians. While studying for her degrees in theater design at the Wimbledon School of Art and in cultural history at the Royal College of Art, London, Himid wrote a thesis on "Young Black Artists in History Today." In the 1980s she was at the forefront of a group of black women artists who joined forces in the belief that "black women working together are in a unique position to change things."[4] Today she is active on many fronts: as Reader in Contemporary Art at the University of Central Lancashire; as codirector of Maud Sulter's *Rich Women of Zurich*, a gallery devoted to black women artists; as a theorist and interpreter of post-colonial art; and as a feminist activist.

Himid has presented her work in solo and group exhibitions in England, Germany, Austria, Cuba, New Zealand, and the United States. Among the noteworthy events of her

early career are two exhibitions in London in 1983, *Five Black Women at the Africa Center* in Covent Garden and *Black Women Time Now* at the Battersea Arts Center, the only two locations open in England to women artists of African descent in the early 1980s. In 1985 she wrote the manifesto for the exhibition *The Thin Black Line* at the Institute of Contemporary Arts in London, which outlined a politics of black women's art created in defiance of the white and predominantly male art establishment. "All eleven artists in this exhibition," she wrote, "are concerned with the politics and realities of being Black Women. . . . We are claiming what is ours and making ourselves visible. We are eleven of the hundreds of creative Black Women in Britain today. We are here to stay."[5]

Himid's self-affirmation as a black woman artist today is inextricably linked to her attempt to retrieve and memorialize the art and history of long-lost African cultures. Throughout her career she has documented African history and African art from the perspective of the descendants of those who were oppressed, deported, or annihilated in the era of colonialism. Exhibitions such as *Depicting History For Today* (1988), *Columbus Drowning* (1991), *Revenge* (1992), *African Gardens* (1993), *Portraits and Heroes* (1994), and individual works or series such as *No Maps* (1987), *Scenes From the Life of Toussaint l'Ouverture* (1987), and *Hannibal's Sister* (1989) testify to her ongoing artistic engagement with a

historical past marked by African slavery and diaspora, but also by heroic and militant uprisings, from which she draws energy for her art.[6] One of her most recent paintings (*Plan B*), exhibited in 1999 at the Tate Gallery St Ives, shows the dark and deep cargohold of a slave ship, the floor strewn with tiny motionless silhouettes—innumerable, anonymous bodies whose ordeal and death Himid commemorates with single touches of her light, featherlike brush dipped in amber paint.

Differencing and Revenge

What could have attracted Himid to Hogarth's *Marriage A-la Mode*, a work that castigates the rampant disease of British high life in the mid-eighteenth century? Hogarth's "progress," in its subject matter at least, seems far removed from Himid's post-colonial agendas. In this famous series of six paintings, Hogarth weaves the narrative of a dysphoric marriage engineered between their offspring by an impoverished Earl and an avaricious London merchant and displays its dire consequences for the family and society. The progress chronicles the ill-suited couple's growing estrangement, their extramarital love affairs, followed by murder and suicide and finally the extinction of the Earl's lineage.[7] Plate 4 shows a moment of stasis in that narrative. Young Lady Squanderfield, who is now leading the life of a lady of fashion apart from her husband, is shown at her toilette, receiving the attention of her lover, the lawyer Silvertongue, and surrounded by a

host of lackeys and parasites of the beau monde: while a hairdresser styles her hair, a castrato sings a modish aria accompanied by a flautist, and an ambassador and three other guests, two male and one female, listen to the musical entertainment. Two black servants complete the set. Encompassing eleven figures from the London world of fashion in the 1740s, *The Toilette* could be adapted to depict a broad cross-section of the London scene where Himid began her work as an artist in the 1980s. It enabled her to effect by way of transposition a sweeping satire of the key players in the fashionable cultural and political milieu of the British capital.

The major appeal of Hogarth's *Toilette* for Himid was that the scene stands so vividly under the sign of commodification, that of art, class, gender, and race.[8] Hogarth highlights that the arts (music, paintings, and decorative objects) are purchased for show, rather than enjoyed for themselves in a disinterested way. They are signifiers of what Pierre Bourdieu calls "distinction," a means for Viscount and Lady Squanderfield to differentiate themselves socially and move above the fray. The paintings on the walls, expensive Italian mythological scenes, are meant primarily to flaunt their owners' wealth and display their "taste." The bric-a-brac on the floor was acquired at the quintessential commercial event, one where art is most conspicuously reduced to its market value, an auction.

Gender and race are shown to be part and parcel of this pervasive culture of commodification. The very name of "Lady Squander," written on the many invitation cards on the floor, yoking together aristocracy and profligacy, points to a culture of conspicuous waste. The recently acquired title of nobility recalls that the young woman is herself the victim of the institutionalized selling and buying of women that was at the bottom of eighteenth- and nineteenth-century British society (as novels from Samuel

Richardson through Jane Austen and Anthony Trollope persistently show). But the commodification of gender extends also to men: while the merchant's wealthy daughter was bartered for a title in the first scene of *Marriage A-la-Mode*, here she is the one who purchases the service of men. The lawyer sells her his services even as he seeks her sexual favors. The musicians are retainers paid to give cultural cachet to her *toilette*. The castrato was savagely emasculated so as to dispense a rarified pleasure to the fashionable company. As to the male black servants, they are colonial goods that were ferried across the ocean at a very young age and are now displayed as decorative exotic objects to the guests. To make the point crystal-clear, Hogarth yokes the black page at the back to the British colonial economy through a visual metonym, the chocolate he serves. Himid thus found in Hogarth's scene the fundamental concept on which she would build her own indictment of the state of politics and the arts at the end of the twentieth century. Far from being motivated by "revenge," her self-differencing rather sought to elaborate, magnify, and redirect the set of tensions already present in Hogarth's work.

The reworking by the post-colonial artist of a canonic work of art selected for reappropriation can affect either its subject matter or the aesthetic medium used for its representation, or both. On a formal and aesthetic level, Himid's multimedia installation does violence to Hogarth's richly layered painting. The unity of Hogarth's elaborately composed image is ruptured in more ways than one. Each of the original eleven painted figures is yanked out of its secure embedding on the picture's plane and becomes a separate visual entity on its own scale, materialized as a cardboard cutout that stands alone and can be shifted or moved across space. Himid literally *dismantles* Hogarth's aesthetically pleasing rococo composition and reorganizes it in a jarring and

fragmented structure on a large stagelike empty space, which exposes the artificiality and vacuity, as well as the theatricality, of the world in which the figures are positioned.

Himid further ruptures the historical character of the eighteenth-century scene by clothing her figures in heterogeneous costumes. While some characters are dressed in attire strongly reminiscent of Hogarth's figures (the Countess, the castrato), others are featured in comically incongruous twentieth-century hair and dress styles: her "Silvertongue" sports a crew cut and an American cowboy outfit. She undresses Hogarth's hairdresser, leaving him naked, and depersonalizes other characters by fabricating them from a bricolage of everyday objects (for example, Hogarth's "eager listener," the woman who listens transfixed to the castrato, becomes a wobbly mock-sculpture of stacked drawers; his Countess has an eviscerated radio instead of a head).

Himid also intervenes in Hogarth's studied composition by splitting his image into two discrete spatial realms. Her scene becomes a diptych in which the two sides mirror each other: on the right, *The Art World* (fig. 120); on the left, *The Real World* (fig. 123). While Hogarth generally keeps politics (in prints such as *The March to Finley*, *An Election*, *The Times*, etc.) distinct from social satire (*A Harlot's Progress*, *A Rake's Progress*, *Marriage A-la-Mode*), Himid brings the social, the cultural, and the political together on the same stage and makes each interact with and comment on the other. She politicizes Hogarth's image, turning his scene of aristocratic decadence into an allegory of the dysfunction of British cultural politics and world politics in the 1980s.

Keeping the visual Hogarthian prototype fully discernible behind her work and appropriating the gestalt of Hogarth's figures, Himid puts her stamp on the scene by assigning different identities to his characters and casting them in roles that address her own political concerns. Hogarth's main actors, the Countess and Silvertongue, are reincarnated as the rulers of the time: Margaret Thatcher, then Britain's prime minister since 1979, and Ronald Reagan, elected president of the United States in 1980. The caricatural quality of Himid's preparatory drawings for these figures makes clear the subversive gesture of the post-colonial artist debunking imperialist powers and their crass economic and military interests. Her "Thatcher" sports a lavish orange dress ornamented with bananas, the banal symbol of the economic exploitation of the Third World by industrial nations in the twentieth century (fig. 124). Her "Reagan" lounges, in appropriate cowboy outfit, on Silvertongue's sofa, negligently wrapped in a star-spangled throw decorated with shooting rockets (fig. 125). Behind him, a screen displays a panoply of guns, machetes, bazookas, and nuclear warheads, signaling that the imperialism of the West has reached its ultimate star-wars phase.

Himid reconfigures Hogarth's *Marriage A-la-Mode* by transforming the flirtatious banter of the Countess and her lover into the wheeler-dealership underlying late-twentieth-century international politics. Her target in the part of the exhibition called *The Real World* is what she views as Thatcher's political fornication with the smooth-talking leader of the imperialist world. In this latter-day "Fashionable Marriage," each partner, she implies, is equally narcissistic and egoistic, equally obsessed with power, equally oblivious to the poor and to minorities, represented in the foreground by the wistful-looking black adolescent girl. Himid thus imaginatively reworks a satire of the eighteenth-century British marriage of convenience into a satire of the late-twentieth-century coupling of world rulers, and of the unwholesome liaison of capitalism and imperialism, offering her installation as a pointed post-colonial critique of Western politics.

Himid's visual exposure of the alliance

281

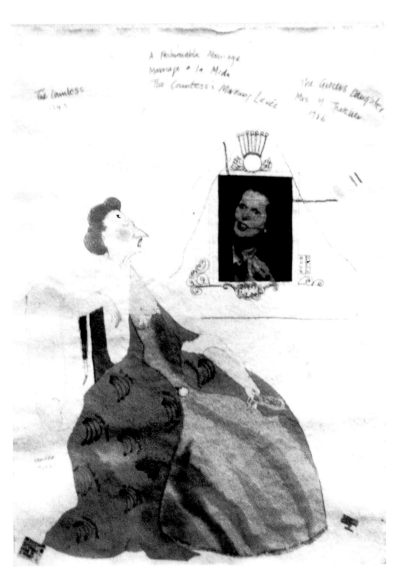

Fig. 124. Lubaina Himid (British, born 1954), *A Fashionable Marriage, Thatcher*, 1986. Acrylic on paper, 72 x 48 in. (183 x 122 cm). The Victoria and Albert Museum, London

between superpowers is intimately linked to her unmasking of contemporary British politics. Her essay proposes an acute analysis of the political and cultural scene in 1980s London from the perspective of an outsider. For her, as for many radical opponents of the regime at the time, the political spectrum in Britain was no longer polarized between left and right. The liberal left colluded with the Thatcher government on political and cultural issues, and it is this degrading collusion, this

"fashionable" marriage of the British left with the right that, according to the artist, was the political leaven for her work: "It was important to find a way of revealing this rather obvious political reality while at the same time showing how it was linked to a middle-class, complacent, liberal intellectual art community, which through newspapers like the *Guardian* and institutions such as the Arts Council pretended to be the opposition." Himid's political awareness was inseparable from by her position as a young black and female artist in need of sponsorship. Her work on various grant-giving arts panels and committees allowed her to experience the workings of cultural politics first-hand: "Being an advisor on various arts panels gave me a unique insight into the workings of this complicated, many-layered world. Having ineffectual dealers exposed even more, none of it useful or moral or honest." As an artist of African descent, she occupied on these panels a hybrid position, that of the outsider-insider, and it is this hybrid perspective that informs her projection of the cultural fauna inhabiting *The Art World* in her installation. There the attendants of the Countess's levee become the menagerie of the art world: the castrato becomes the art critic, the flautist the dealer, the ambassador turns into the art patron, and the two guests at the back into a pair of fashionable British artists.

Thirteen years later, Himid's lapidary literary style still captures the corrosive quality of her 1986 cutouts. The art critic, she writes, both in regard to her artistic representation and to the social/professional type that he incarnates, is "an empty, self-centered creature who lurks in the twilight between history and the gossip column. The critic loves art but despises artists and tends to see an exhibition as a checkered dance floor upon which he can prance with silken shoes and a smirking mask." The art dealer is "a silly shopkeeper of no consequence, who must follow the advertisements

in order to be at the right place at the correct moment with artworks pitched at the perfect price." As to the "dithering art funder," he is marked for her by a constitutional paralysis and is "unable to decide between the critic's song and the fad of the day."

But do the formal fragmentation, the modernization, and the politicization of Hogarth's scene amount to "revenge"? The obvious satiric affinity between the canonic master and the post-colonial artist puts in question the notion of revenge and its applicability to the Hogarth-Himid case. If revenge there is in *A Fashionable Marriage*, it is not against or at the expense of Hogarth, but against the world of crass interests that he attacked, against a culture of commodification, luxury, and exploitation that he showed in eighteenth-century dress and that Himid stages in modern garb. Listening closely to the pithy style and wry humor of her essay, one understands that what drew her to Hogarth in the first place was his fiercely satiric take on life around him. Like Hogarth's, Himid's verbal and visual satire is rooted in an uncanny power for visual observation, trained in Hogarth's own school and on his own paintings. She directs our gaze to details of *The Toilette* (many of which have sexual overtones) that, despite a bustling critical industry, have been overlooked: the eager listener's tiny foot, which peers from under her skirt "like a tongue," or the cup of hot chocolate offered by the black slave, "in which lounges a melting biscuit at a rakish angle." A caustic verbal stylist, Himid, with one lash of her pen, demolishes "the feminist artist" of the American brand with a cascade of devastating epithets and a sure feel for the killer shot: "wealthy, white, exclusive, carnivorous, strategic, and knowing. She is sure she is the center of the scene, the prettiest and the most important woman in the room."

Defying preconceived ideas about the expected "resistance" and "revenge" of the post-colonial woman artist of color against the

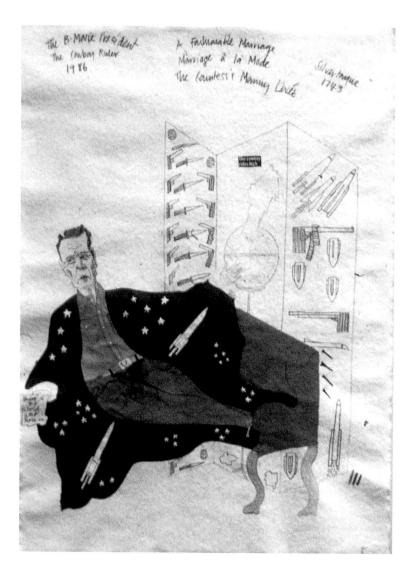

Fig. 125. Lubaina Himid, *A Fashionable Marriage, Reagan*, 1986. Acrylic on paper, 72 x 48 in. (183 x 122 cm). The Victoria and Albert Museum, London

male, notoriously xenophobic, white canonic artist, Himid's written and visual testimony in *A Fashionable Marriage* suggests a consanguinity with Hogarth that merits further consideration. The crux of her "alliance" with him was the adaptation, for her own agendas, of his key instrument, the dumb show.

The Dumb Show

By quoting in her epigraph no fewer than seven admirative "judgments" on Hogarth by writers

and politicians (even George II's testimony is flattering), Himid inscribes herself self-consciously within a tradition of tribute to Hogarth. By quoting at length from Garrick's prologue to *The Clandestine Marriage*, she also signals her implicit adherence to a tenet of eighteenth-century aesthetic theory, the principle of the correspondence or "sisterhood" (regendered by Garrick as *brotherhood*) of the arts: "Poets and Painters . . . have made this law; / That each should neighborly assist his brother / And steal with decency from one another."[9] Just as Garrick the actor and playwright claims inspiration from the painter Hogarth ("Tonight your matchless Hogarth gives the thought, / Which from his canvas to the stage is brought"), so does the twentieth-century painter and multimedia artist marshal her experience in theater and theater design to recast Hogarth's painting in a theatrical mode. In her text, she emphasizes that she felt addressed by Hogarth's "theatricality," which "fulfilled [her] desire for spectacle and drama." Her installation of eleven painted, larger-than-life plywood figures interacting with each other represents a return to, as well as a new embodiment of Hogarth's celebrated concept of the "dumb show," which he himself imported from the theater into the art of painting. As Hogarth wrote in his *Autobiographical Notes*: "Subjects I consider'd as writers do / my Picture was my Stage and men and women my actors who were by certain Means of certain Actions and express[ions] to Exhibit a dumb shew."[10]

Hogarth's much-quoted metaphor is devastatingly literalized in Himid's restaging of his *Marriage A-la-Mode*. She reenergizes his concept of the dumb show by transforming his painted protagonists into caricatural figures that perform a silent (and silly—with a Hogarthian pun on "dumb") pantomime. She uses the medium of plywood cutouts to undercut the mimetic illusion and capitalizes on the fabricated quality of her artifacts to stress the

artificiality of their "real-world" referents. Detached from their secure anchoring on the painted canvas, Himid's freestanding puppets take on a grotesque allure. The artist exploits the planarity of her cardboard figures to the full, getting maximum political purchase out of their lack of depth. Thus she makes her medium carry her message, the props' shallowness signifying the thinness of the world in which their referents move.

In her installation Himid also re-creates Hogarth's virtuoso play with verbal artifacts (pamphlets, broadsides, inscriptions, books, cards, newspapers) satirically inserted within the visual artwork.[11] She draws on Hogarth's Arcimboldesque technique (exemplified in prints such as *Some of the Principal Inhabitants of ye Moon: Royalty, Episcopacy and Law* [fig. 126]), which consists in shaping a face or creating a body out of objects that define or emblematize the character or station of the person. For example, she dresses two of her protagonists in the very newspaper clippings that registered their participation in the ambient culture of artificiality, intellectual dessication, and political reaction of the 1980s. Her vapid art critic is entirely clothed in cuttings from the contemporary art journals to which he supplies copy, journals whose titles, such as *Block, Screen,* and *Time Out,* Himid says, conflating racial and political critique, reminded her of "creams used to protect white skin from the heat of the sun" (fig. 121). Similarly, she dresses her Thatcher figure in newspaper clippings that embody, refer to, or quote "her policies [and] her gaffes," thereby literally imprisoning the prime minister in the discourse that she produced or elicited, turning against her the media empire that she had dominated, reversing the self-aggrandizing and delusionary use that the grande dame of British politics made of print in the public sphere.

Himid's satiric representation of life's dumb show with cut-outs is reinforced by her use of heterogeneous materials and contempo-

rary media. She uses coarse and unrefined materials, such as glue and staples, to put together her figures, both signaling her refusal of complacent mimeticism and stressing her commitment to the unrefined art form against the smooth and sophisticated polish of "successful" art and elite culture. The way in which she paints or clothes them afterward denotes a self-conscious Hogarthian play with metaphor. For example, Hogarth's vapid ambassador, transformed by Himid into the "dithering art funder," is "made from thin plywood, thinly painted; he sits on a wobbly fence." Thus, the art patron's chronic opportunism and his constant anxiety to make the most strategic choice at the right moment ("Should he support the disabled, the black, the women?") are made explicit by the flimsy, precarious quality of the materials used to represent him.

For her white feminist artist, Himid uses "empty drawers turned on their sides and casually filled with barely disguised pastiches of the American feminist art movement, which had so dominated the previous ten years" (fig. 122). Again, the medium of the representation becomes one with its message. Satire inheres here not only in the recycling of prosaic objects (drawers, with an incidental pun on drawers as undergarments) to lampoon the "feminist artist's" self-importance, but in their useless disposition (they are empty and turned on their sides) and in their linkage with other objects, pastiches, which are nothing but imitations of representations. Interestingly, the two bottom drawers on which the stacked "body" of the red-haired white feminist artist rest could be interpreted as send-ups of Judy Chicago's 1970 large installation of thirty-nine place settings, *The Dinner Party*. This ambitious installation, which was first exhibited at the San Francisco Museum of Art and then toured the United States, was conceived by the famous American artist in the first wave of feminism as a collaborative celebration by

Fig. 126. William Hogarth, *Some of the Principal Inhabitants of ye Moon: Royalty, Episcopacy and Law*, 1724. Etching and engraving. Lewis Walpole Library, Yale University, Farmington, Connecticut

women artists in different arts and crafts of female artists elided or marginalized in cultural history. It unleashed heated debates among feminist artists, critics, art historians, museum curators, and politicians for the subsequent two decades.[12] Particularly controversial were the vaginal forms sculpted on the commemorative dinner plates, which were seen as essentializing femininity, as well as the fact that the women artists memorialized in this monumental installation were mostly white, middle-class, and heterosexual. Himid, who does not identify with these exclusionary categories, may

Fig. 127. Lubaina Himid, (British, born 1954), *A Fashionable Marriage*, (detail), 1986. Multimedia installation, c. 10 x 20 x 8 ft. (300 x 600 x 240 cm). Private collection

have expressed her critique of the show by using the two plain white dinner plates as the pedestal on which her American white feminist artist stands.

Himid's free transformative art is manifest also in her use of late-twentieth-century technology, particularly consumer technology geared to women. She adorns Thatcher's naked coiffeur with an electric hair dryer in lieu of a penis, thereby suggesting that the prime minister, always perfectly coiffed, always eager to glamorize her public image, had more use for this implement than for the other (fig. 127). She poses Thatcher in narcissistic self-contemplation, but she puts a television screen in lieu of the Countess's gilt mirror (perhaps to recall the narcissism of soap-opera watchers, but more likely to denounce Thatcher's control of TV and the media). The video screen, furthermore, shows "a

face masked, veiled, revealed, concealed in turn," designed to expose repetitiously, ad nauseam, the prime minister's games of constant simulation and dissimulation.

Autobiographical Notes

There is another strong thread which links Himid's *text* to Hogarth. The retrospective essay that she contributes to this volume resonates with many passages from Hogarth's *Autobiographical Notes*. In particular, her evocation of the struggle to keep herself afloat in the "crowded, confusing, bitter, and twisted place" of the London of the 1980s recalls Hogarth's own jaundiced view of the same scene in the 1730s and 40s. Her confessional text uncannily re-presents the struggle that marked the stages of Hogarth's arduous ascension from lowly silver engraver to painter of the establishment, his need to stake out a space for his artistic practice as a homegrown British artist and to gain both recognition and legal protection for his art (the Hogarth's Act). Hogarth's predicament was to be an engraver of obscure extraction without a friend in high places, then a painter of everyday life in a culture that gave pride of place to grand history painting, foreign masters, and Italianate taste. In a 1737 essay signed "Britophil," he inveighed against the nefarious pact connecting the connoisseurs and art buyers to the London art dealers, who swamped the market with "Ship Loads of dead *Christs*, *Holy Families*, *Madona's*, and other dismal Dark Subjects, neither entertaining nor Ornamental; on which [dealers] scrawl the terrible cramp Names of some *Italian* Masters, and fix on us poor *Englishmen*, the Character of *Universal Dupes*."[13]

Himid's predicament was similar to Hogarth's, but it was complicated by gender and race. She too had to make her way in a fundamentally hostile world dominated by rivals, the fashionable artists of the day, male native British artists trained in the best schools in the

country. She views them, "the graduates from the Glasgow School of Art, at once eager and complacent," as stale epigones of academic painting and the product of savvy entrepreneurship: "Theirs was not a world of political marginality, but one firmly placed in a private commercial dealer system, which exists to mirror the world of collectors." Furthermore, just as Hogarth had his foreign rivals, the French and Italian masters, she had hers. The white feminist artists, who represented the new radical feminist chic in the 1980s, were often foreigners, with the difference that, like so much imported taste in late-twentieth-century Europe, they came not from across the Channel, but from the United States.

In her 1990 essay, "Passion, Discourses on Blackwomen's Creativity: Mapping a Decade of Black Women Artists 1980–98," Himid outlined the precarious position of the black woman artist in this all-white art scene ruled solely by the criteria of prestige and profit: "The black woman artist is not a very safe bet for profit, as she does not have many solo shows. In recent years she has appeared collectively as a footnote in the chronicling of the Feminist Art movement. The black woman, her art and politics was an integral part of this movement but there are not, in Britain at least, the solo shows to prove it."[14] Himid thus denounces the vicious circle in which the increasing commodification of the art world locks the black woman artist out and isolates her: solo shows are what makes the art sell and what drives the prices up. Gallery owners show the works that sell, but to sell, an artist must have already had solo shows.

Himid's installation was prompted by the artist's belief that black women artists could make a difference in this cliquish, fashion-dominated, commodified art world. For a time, cunning impresarios banked on the novelty afforded by artists whose double difference, as black and as women, made them interesting. However, Himid's text, written with hindsight, declares this a short-lived illusion: "I believed that we as black women artists held the center; in fact, we rented rooms there." Just as Hogarth felt "duped," she and her fellow black women artists felt used as fetishistic colonial goods by a ruthless, money-hungry, opportunistic art market. Even today, she writes, black artists are still not considered for themselves, but as a collective commodity whose currency fluctuates according to the winds of fashion: "In the 1980s, funders needed to be seen as acknowledging the 'other'; in the 1990s this is seen as ridiculous, far too political, and they swim around in a vacuous deceit." Whereas Hogarth composed his *Autobiographical Notes* at a time when he could have looked back with satisfaction upon his elevation to the position of Sarjeant Painter to the King and a fairly lucrative business, Himid emphasizes that there is no such hope for black women artists at the end of the twentieth century: "We worked for nothing; we still do. We are signifiers of white corporate wealth. . . . Black women are still useful spice for a bland 'post-feminist' dish."

Revisioning Gender

Like Hogarth in his social and political satire, Himid uses sexuality in her work as a way of exposing social or political dysfunction. In *The Toilette* (fig. 118), Hogarth presents a gallery of figures with warped or "deviant" sexual identities or habits to signify the advanced stage of decadence of this fashionable society. The Countess, a recent mother (a teething ring dangles from her chair) forgets her motherly duties to engage in adultery. Her husband is absent, chasing his own sexual quarry. Except for the lawyer, Hogarth stuffs his painting with a string of effeminate males, starting with the castrato and the flautist (fig. 70; musicians and

Fig. 128. Lubaina Himid, *A Fashionable Marriage, The Boys*, 1986. Acrylic on paper, 72 x 48 in. (183 x 122 cm). Private collection

singers were deemed more susceptible to same-sex attraction); a curious and ludicrous figure with hair in curlers, lips pursed in effeminate affectation, raising his cup to his mouth with a lift of his little finger; and, finally, two grotesque figures, one of whom snores through the concert while the other, sporting a beauty patch on his lip, preciously dangles a fan from his wrist.[15]

Himid picks up these homosexual cues and reworks them for her own satiric ends. For example, exploiting the planary configuration, which makes these last two figures look like Siamese twins in Hogarth's painting (part of a lower body is blocked from view by the projecting arm and skirt of the "eager listener"), she joins them at the hip, sitting these figures ludicrously in one chair, one on the other's lap (fig. 128). Thus, they appear caught in a close, self-reassuring embrace, which parallels Hogarth's infamous reproduction of a Jupiter and Ganymede on the wall (fig. 70). The homosex-

ual innuendos in this male couple serve to lampoon the "British painters of the school of Angst Complacency" (as the caption of the preparatory drawing reads), establishment artists who refuse to take aesthetic risks: "They appear forever entwined, inextricably linked—not waving, not moving from the edge." Himid's self-"differencing" from Hogarth thus operates by means of a complex citational and referential dialectic that, among other strategies, reinflects gender configurations in a satiric way.

Himid emphasizes, expands, or reworks all the instances of unorthodox masculinity with which Hogarth stuffed *The Toilette*. In her dumb show, Hogarth's effeminate hairdresser ("he fusses, preens . . . listens slightly flushed to Silvertongue; he tries to ignore the castrato") becomes a figure emblematic of a brand of spinelessness endemic to many professions: he is, says Himid, "a lackey, a tabloid editor, a cheap trashy novelist, an ambitious young M.P., a short-sleeved shirt in local government; he does as he is told and gossips accordingly." Himid's original drawing for the hairdresser, however, an egregious and blasphematory piece, reverses the signs of effeminacy into their telltale opposite (fig. 129). It shows a huge, bodybuilding, muscle-heavy man with shaved skull—a skinhead—a comb sitting atop the right ear, the mouth uttering "ordinary drivel." On one side of the drawing, her caption reads: "The hairdresser, flattering, tattling, busy wretch, 1743." On the other, Himid lists the various social types that this virility-flaunting male incarnates in the world of the 1980s: "Neo-Nazi Politician/ British Bobby/ CIA Agent/ Sanction Buster/ Greedy Industrialist/ Right-wing Thug." In one hand this nationalist muscle man holds a Union Jack; on his right leg is written "fatherland factor," and on his left, coming out of his penis, "Fuck the future." But his most obscene attribute is the

huge and plump gray rat that strides, tail curled, right across the male organ, exposing this character's insane phantasms of power. In the final installation, this piece of outrageous gendered satire was toned down and incorporated into the narrative and symbolic structure of the image: the muscular thug appears dwarfed, but he is still naked and his buttocks are now delineated provocatively, recalling the tautness that Hogarth gave to the body of the *Farnese Hercules* in the first plate of *The Analysis of Beauty*. His rat-like penis has been transformed into the huge electric dryer with which he styles Thatcher's hair—Himid's satiric metaphor for the servile functions performed by Thatcher's eunuchs.

Himid's art critic is perhaps the most imaginative of her satiric reworkings of Hogarth's gendered stereotypes. Closely modeled on Hogarth's castrato (fig. 70), Himid's critic has the same profile, the same self-satisfied, half-reclining pose, the same huge, fat, bloated body. If the castrato's corpulence in Hogarth was a consequence of his professionally incurred emasculation, the art critic's bloated body in Himid's installation becomes a signifier of his colossal narcissism. In the preparatory drawing, a huge bubble comes out of his wide-open, singing mouth, but the tiny words "Not A lot/ or Not Not" convey the sense that the mountain is here giving birth to a mouse (Himid writes that "what he says disappears as quickly as a high note melts in the atmosphere") (fig. 121). The most outrageous detail in the art critic's rich period costume is the preposterous ruffle of his waistcoat, consisting of five flesh-colored bizarre protuberances. Made of squashable rubber gloves, they signal the art critic's craving for an ego-boosting, delirious reception ("he longs to be fondled or squeezed," Himid writes). These phallic protuberances, both erect and soft, however, evoke the critic's missing virility by overcompensation. At the

Fig. 129. Lubaina Himid, *A Fashionable Marriage, The Lackey*, 1986. Acrylic on paper, 72 x 48 in. (183 x 122 cm). Private collection

same time, they provide a key to what Himid satirizes as the quasi-sexual yearning of feminist artists for the attention of art critics. Her description of Hogarth's "eager listener" applies as well to her satiric representation of the feminist artist: "open-legged, open-armed, open-mouthed, open-fingered, clothes loose . . . delightedly and limply lean[ing] toward him, drinking in his song." Himid thus presents the viewer with a richly textured scene, one in which gender trouble is cannily chanelled into cultural critique and, in particular, into a complex satire of the art world.

Although Himid gets excellent critical mileage from modernizing Hogarth's stereotypes of problematic sexuality (the hypertrophic male, the nymphomaniac, the promiscuous eunuch, the narcissistic gays), she does transcend these stereotypes in a significant way. Where Hogarth had hung Silvertongue's portrait on the wall of the Countess's

bedroom, thereby indicating that the lover had already displaced the husband, Himid hangs, in the half of the installation devoted to the Art World, her own recasting of Picasso's famous portrait of Gertrude Stein (fig. 120). Stein was a pioneering figure of the modernist movement and her salon at 22, rue de Fleurus in Paris was a seminal place of encounter for artists; furthermore, her lifelong relationship with Alice B. Toklas became a famous model for lesbian writers and artists. She reappears often as an inspiration in Himid's work. Her portrait by Picasso in Himid's pictorial reproduction counterbalances the scenes of rape and victimage displayed all over the Countess's bedroom walls in Hogarth's painting. Endowed with the position of the tutelary genius in Himid's installation, she considers the rivalries and sordid politics of the cultural world below with a stern and preoccupied look. American-born, but living in Europe and gathering around her numerous artists from different nations and of different gender and race, Gertrude Stein is not only Himid's counterpoint to the figure of the crazy white feminist artist and the sexless, castrating female politician, she is an image of positive "difference."

Repositioning Race

When a post-colonial artist engages, according to Pollock, in "playing the museum that is canonical art history," it is always with "the explicit revelation that there is, embedded in its significant moments and major monuments, a discourse as much on race as on gender."[16] With its two black protagonists, Hogarth's *Toilette* presented Himid with an embedding of racial otherness that spoke directly to the post-colonial artist's imagination. In the present volume, David Bindman cautions against the sentimentalizing view that Hogarth sympathized with black slaves and reminds us that Hogarth had friends, patrons, and sitters who were fully invested in the colonial enterprise.[17]

While the interpreter must guard against an ahistorical reading of such images, the creative artist, however, need not. Himid's most important "differencing" in her reworking of Hogarth's scene consists in turning around the racial power relations and transforming the white gaze into a black one, in which the black artist recovers subjectivity and agency.

It is important to stress that white viewers, whose "ways of seeing" have been shaped by the subliminal racial ideology naturalized in canonic Western art, have traditionally, as extant criticism shows, registered the two black servants in *The Toilette* as *marginal*, for reasons in which race, class, and aesthetics intermingle: they are black; they belong to the servant class; they have no role in the main action; and they are depicted on the margins of the social circle and of the picture (fourth plate). The youth offering chocolate is at the very back of the room, which he has just entered and will leave as soon as he discharges his mission. He bends forward in a respectful attitude and his body is only half visible. The second, still a child, is in the foreground, but he is playing by himself and is not involved in the socializing that goes on in the room. Futhermore, he is pushed to the right and close to the edge of the painting.

Himid, however, casts on Hogarth's painting a different, post-colonial, gaze that not only valorizes the two black servants, but transforms them into the main protagonists. For her, "Hogarth's black slave boy is *in charge* of the auction lots, is *at home* in the bedroom, in the world of his mistress and her lover. He is *the only character to interact with the audience*. Not only is he absolutely *in tune* with what is happening in the room (world) but his is *the role of narrator*; he displays his sex toys gleefully arranged across the floor" (my italics). Himid thus re-visions the black page boy in affirmative, positive terms. She interprets him as a key figure, both an insider to the world of the Countess and the mediator between the

fictional world of the image and the real world of the beholder. She endows him with knowledge and narrative agency. He can tell what the image does not show, the secrets of the alcove and the ambitions of all the players. He knows the beginning and he knows the ending of the story, and, with his own panoply of toys, like a puppeteer in a show, he can convey this meaning to the viewer (for example, by pointing to the horns of a statue of Actaeon acquired by the Countess at the auction, the page boy proleptically foreshadows the undoing and punishment of Silvertongue for his sexual transgression). Instead of the colonialist figure of the exoticized and objectified black slave, Hogarth's page boy becomes for Himid the only participant in the scene who is endowed with knowledge and foresight. As such, he is a figure of the artist.[18]

But this is not all. The page boy in Himid's installation changes sex, he becomes a female subject (fig. 123). In her essay, Himid implies that she projected in this figure her own efforts to master the new conditions for the making of art in an evolving, technological, mediatic, and global market: "The boy who became a girl understood the connection between media, representation, and power, understood [that] the power of global distribution infiltrated the world of the moving image and toyed with revolutionary intervention. While making the piece all this seemed possible. The slave boy's preoccupation with sex toys became the sober mistressing of modern visual technology. A video screen replaced the gilt mirror, its sound track Handel's *Queen of Sheba*." The choice of Handel and the *Queen of Sheba* as the sound track for her installation could not have been gratuitous. Not only was some of Handel's music performed in his time by castrati, such as Farinelli, whose name is featured in Hogarth's print (fig. 67). But the Queen of Sheba foregrounded the legendary Ethiopian queen of Biblical antiquity. Himid

and Maud Sulter, furthermore, chose a recording of music by Ghanaian women to mix with Handel's *Queen of Sheba*.[19] Whatever words Thatcher may be uttering in her half of the installation, those words are drowned by the voices of black women singing, interwoven with music about a powerful black queen, whose memory has endured across millennia.

The most race-conscious repositioning effected by Himid, and ideologically the most far-ranging one, is the metamorphosis of the black male servant offering hot chocolate at the back of Hogarth's assembly. Reading the composition with a black gaze, Himid, contrary to the white critics' perspective, registers this figure not as marginal, but as occupying a central position on the picture's canvas. Consequently, she transforms it into the key character in her installation. She also radically alters its scale and its gender. Hogarth's stocky black slave now becomes a tall and imposing black woman who, goddess-like, holds center stage in the installation: she is the "blackwoman artist"—the new figure of the double "other" that Himid had promoted in the early 1980s by coining this self-empowering expression (fig. 122). The black woman, moreover, is the only one in the installation to have "articulated arms"—that is, to possess movement, and thus, agency.

Paulson and Dabydeen noted the dichotomy drawn in this and other images by Hogarth between two stereotypes, the presumed savage (black = raw nature) and the presumed civilized person (white = culture). Himid's black woman artist, however, merges nature and culture. The offering of "energy" in place of the hot chocolate from the colonies evokes Himid's belief in the transformative and energizing potential that black women artists can contribute both to contemporary art and to the rewriting of an exclusively white narrative for art history. The ample skirt of her dress is significant in this respect: deployed around her waist, it looks, both in shape and

in color, like a globe on which continents (in dark color) alternate with expansive blue oceans. The wooden painted fish that decorate the dress allude metonymically to the fate of so many African slaves, thousands of artists among them, cast overboard in the ocean, sick or dying, during the ages of slavery.

At the heart of her exhibition "Revenge," Himid had planned a memorial to evoke "the loss of creativity caused [in African art] by the atrocities of the Middle Passage: weavers, potters, sculptors, carvers lost at the bottom of the Atlantic during the centuries of the slave trade."[20] A figure of pride and hope for black art, Himid's hieratic and grave goddess in *A Fashionable Marriage*, frontally positioned at center stage, offers the bountiful creative energy of black women artists.

In Himid's *A Fashionable Marriage*, both the gender and the racial economy obtaining in Hogarth's *Toilette* have been reversed. The "sober mistressing" of the means of modern artistic production by the black woman artist, as evidenced in this installation, has replaced the centuries-old objectification and aestheticization of the African slave in Western art. The myth of an exoticized, eroticized, and objectified Africa that lurks at the back of the Western artistic canon is countered with the image of the knowing and self-possessed African artist, who builds on a rich cultural legacy. Instead of conceiving of cultural and artistic "differencing" in terms of hostility and subversion, however, Himid ends her text with the prospect, in the near future, of a renewed coalition with her old "ally" Hogarth "for another vicious visualization of art politics and its relationship to global politics. The art of war and the war of art. Hogarth and I may set about it soon." This prospect of a new "alliance" between the canonized white Old Master that, as the tercentenary events have shown, Hogarth doubtless has become, and the rebel post-colonial black woman artist,

who seeks to alter and decenter the canon of Western art, is an "*un*fashionable marriage" we can certainly look forward to.

Notes

1. See Lubaina Himid, "*A Fashionable Marriage,*" this volume. All citations from Himid in the text refer to this essay, unless otherwise indicated. I am grateful to the artist for her private comunications on her career and work. About her connection to Hogarth, she wrote: "I read a lot about him in the 1970s when studying Theatre Design. Then in the mid-1980s his themes and fury matched mine. I sought out locations, read more books, and looked at the work all over again."

2. Pollock 1999, 171.

3. Ibid., 172.

4. See the appendix, "Aus Texten Lubaina Himids," in Threuter 1997, 239. My thanks to Angela Rosenthal for directing me to this essay.

5. Cited in Threuter 1997, 231.

6. For a list of Himid's works, see Sulter 1997.

7. For further discussion of *Marriage A-la-Mode* in this volume, see the essays by Maza and Shesgreen and by Solkin, in this volume.

8. For interpretations of *The Toilette*, among others, see Cowley 1983, 101–21; Dabydeen 1985, 74–90; and Paulson 1991–93a, 2:208–29.

9. Lessing 1984.

10. Hogarth 1955, 209.

11. See, for example, Wagner 1995b, ch. 4.

12. See A. Jones 1996.

13. Hogarth 1997, xviii–xix.

14. Himid in Threuter 1997, 240.

15. On Hogarth's portrayal of effeminacy, see essays, this volume, by Hallett, Meyer, and Wagner.

16. Pollock 1999, 172.

17. Bindman, in this volume.

18. Significantly, as a post-colonial artist, Himid is closer to an earlier interpretation, developed by Dabydeen 1985 and Paulson 1991–93a (2:226–29), which holds that Hogarth uses black

servants as outsiders and foils to comment on the vices of the white society that enslaves them: "Most importantly for me, he used black people to highlight the evils and misdeeds of almost everyone he saw; they were signifiers of human hypocrisy and the sordid falseness of white folk; black people in Hogarth's works nearly always reveal pretentiousness, artificiality, and the dreaded sophistication."

19. The *Sheba Feminist Publishers* was a collective feminist press, in which Sulter was active in the early 1980s.

20. Pollock 1999, 190.

Works Cited

Addison 1710
Addison, Joseph. *The Tatler*, no. 260 (7 December 1710).

Addison and Steele 1965
Addison, Joseph, and Richard Steele. *The Spectator (1711–1714)*. Ed. Donald F. Bond, Oxford: The Clarendon Press, 1965.

Adler and Pointon 1993
Adler, Kathleen, and Marcia Pointon, eds. *The Body Imaged: The Human Form and Visual Culture Since the Renaissance*. Cambridge: Cambridge University Press, 1993.

Alexander 1989
Alexander, Helene. *Fans*. London: B. T. Batsford, 1984; Princes Risborough, Buckinghamshire, U.K.: Shire, 1989.

Almon 1805
Almon, John, ed. *The Correspondence of the Late John Wilkes*. 5 vols. [London], 1805.

Anon. in Fracastorius 1686
Anonymous. "To his Friend, The Writer of the Ensuing Translation." In Fracastorius 1686.

Anon. 1693
Anonymous. *The Rake: or, the Libertine's Religion*. London, 1693.

Anon. 1694
Anonymous. *The Ladies Dictionary: Being a General Entertainment for the Fair Sex*. London, 1694.

Anon. 1705
Anonymous. *The Way to be Wiser: Or, a Lecture for a Libertine, with Other Choice Letters, by the Same Hand*. London, 1705.

Anon. 1707
Anonymous. *The Tryal and Conviction of several reputed Sodomites . . . 20th day of October 1707*. British Library 515, 1.2 (205). Greater London R.O.: MJ/SP/September 1707.

Anon. 1718
Anonymous. *The Rake Reform'd: A poem, in a letter to the rakes of the town*. London, 1718.

Anon. 1732
Anonymous. *The Progress of a Rake; or, the Templar's Exit. In Ten Cantos; In Hudibrastick Verse*. London: R. Dickinson, 1732.

Anon. 1732a
Anonymous. *The Rake's Progress: or, the Templar's Exit*. London, 1732.

Anon. 1732b
Anonymous. *The Progress of a Rake*, London, 1732.

Anon. 1732c
Anonymous. *The Progress of a Harlot, As She Is Described in Six Prints, by the Ingenious Mr. Hogarth*. "2nd ed." London, 1732.

Anon. 1733
Anonymous. *The Jew Decoy'd, or The Progress of a Harlot. A New Ballad Opera in Three Acts*. London, 1733.

Anon. ca. 1735
Anonymous. *The Rake of Taste, A Poem, Dedicated to A Pope Esq*. London, ca. 1735.

Anon. 1740
Anonymous. *The Harlot's Progress. Being the Life of the Noted Moll Hackabout, in Six Hudibrastic Canto's*. "6th ed." London, 1740. (Originally published as *A Harlot's Progress, or the Humours of Drury Lane*, 1732.)

Anon. 1746
Anonymous. *Marriage A-la-Mode: An Humorous Tale, in Six Canto's, in Hudibrastick Verse; Being an Explanation of the Six Prints Lately Published by the Ingenious Mr HOGARTH*. London: Weaver Bickerton, 1746.

Anon. 1749
Anonymous. *Satan's Harvest Home: or the Present State of Whorecraft, Adultery, Fornication, Procuring, Pimping, Sodomy and the Game at Flatts*. London: For the Editor, 1749.

Anon. 1885
Anonymous. *The Rake's Progress: or, the Humours of Drury*

Lane, Being the Ramble of a Modern Oxonian; which is a complete key to the eight prints lately published by the celebrated Mr Hogarth. London, 1735; repr. 1885.

Antal 1947
Antal, Frederick. "Hogarth and His Borrowings." *Art Bulletin* 29 (1947): 36–48.

Antal 1952
Antal, Frederick. "The Moral Purpose of Hogarth's Art." *Journal of the Warburg and Courtauld Institutes* 15 (1952): 171ff.

Antal 1962
Antal, Frederick. *Hogarth and His Place in European Art.* New York: Basic Books, 1962.

Appleby 1993
Appleby, Joyce. "Consumption in Early Modern Social Thought." In Brewer and Porter, 1993. 162–73.

Apter 1995
Apter, Emily "*Figura Serpentinata:* Visual Seduction and the Colonial Gaze." In *Spectacles of Realism: Body, Gender, Genre,* eds. Margaret Cohen and Christopher Prendergast, 163–78. Minneapolis: University of Minnesota Press, 1995.

J. Armstrong 1736
Armstrong, John. *The Oeconomy of Love: A Poetical Essay.* London: T. Cooper, 1736.

N. Armstrong 1978
Armstrong, Nancy J. *The Book of Fans.* New York: Mayflower Books, 1978.

N. Armstrong 1984.
Armstrong, Nancy J. *Fans: a Collector's Guide.* London: Souvenir Press, 1984 [1974].

Astell 1986
Astell, Mary. *Notes from The First English Feminist: Reflections Upon Marriage and other writings by Mary Astell.* Ed. Bridget Hill. Aldershot, Hants: Gower, ca. 1986.

Astruc 1737
Astruc, John. *A Treatise of the Venereal Disease, in Six Books.* 2 vols. Trans. William Barrowby. London: W. Innys & R. Manby, 1737.

Atherton 1985
Atherton, Herbert M. "George Townshend Revisited: The Politician as Caricaturist." *Oxford Art Journal* 8, no. 1 (1985): 3–19.

Atterburyana 1727
Atterburyana, being miscellanies by the late Bishop of Rochester etc. London, 1727.

Bal 1991
Bal, Mieke. *Reading "Rembrandt": Beyond the Word-Image Opposition.* Cambridge: Cambridge University Press, 1991.

Bancks 1738
Bancks, John. *Miscellaneous Works in Verse and Prose, of John Bancks.* London, 1738.

Bannet 1997
Bannet, Eve Tavor. "The Marriage Act of 1753: 'A Most Cruel Law for the Fair Sex'." *Eighteenth-Century Studies* 30, no. 3 (Spring 1997): 233–54.

Barbier 1996
Barbier, Patrick. *The World of the Castrati: The History of an Extraordinary Operatic Phenomenon.* Trans. Margaret Crosland. London: Souvenir Press, 1996.

Barnett 1987
Barnett, Dene. *The Art of Gesture: The Practices and Principles of Eighteenth-Century Acting.* Heidelberg: Winter, 1987.

Barrell 1986
Barrell, John. *The Political Theory of Painting from Reynolds to Hazlitt.* New Haven, Conn., and London: Yale University Press, 1986.

Barrell 1992
Barrell, John. *The Birth of Pandora and the Division of Knowledge.* Philadelphia: University of Pennsylvania Press, 1992.

Works Cited

Barthelemy 1987
Barthelemy, Anthony Gerard. *Black Face, Maligned Race: The Representation of Blacks in English Drama from Shakespeare to Southerne*. Baton Rouge: Louisiana State University Press, 1987.

Beckett 1949
Beckett, R. B. *Hogarth*. London: Routledge and Kegan Paul, 1949.

Behn 1886
Behn, Aphra. *Oroonoko; or, the History of the Royal Slave*. London, 1886.

Bender 1987
Bender, John. *Imagining the Penitentiary: Fiction and the Architecture of Mind in Eighteenth-Century England*. Chicago: University of Chicago Press, 1987.

A. Bennett 1980
Bennett, Anna G. *Fans in Fashion: Selections from the Fine Arts Museums of San Francisco*. Exhibition catalogue. San Francisco: Fine Arts Museums of San Francisco, 1980.

A. Bennett 1988
Bennett, Anna G. *Unfolding Beauty: The Art of the Fan: The Collection of Esther Oldham and the Museum of Fine Arts, Boston*. London: Thames and Hudson, 1988.

J. Bennett 1795
Bennett, John. *Letters to a Young Lady* . . . London, 1795.

Berkeley 1722
Berkeley, George, Bishop. *The Ladies Library*. 3 vols. London: Jacob Johnson, 1722.

Bermingham and Brewer 1995
Bermingham, Ann, and John Brewer, eds. *The Consumption of Culture 1600–1800: Image, Object, Text*. London: Routledge, 1995.

Berry 1994
Berry, Christopher J. *The Idea of Luxury: A Conceptual and Historical Investigation*. Cambridge: Cambridge University Press, 1994.

Bertelsen 1983
Bertelsen, Lance. "The Interior Structures of Hogarth's *Marriage A-la-Mode*." *Art History* 6 (1983): 131–42.

Bindman 1981a
Bindman, David. *William Hogarth*. London: Thames and Hudson, 1981.

Bindman 1981b
Bindman, David. "Modern Moral Subjects: A Reading of the Two Progresses." In Bindman 1981a, 55–71.

Bindman 1994
Bindman, David. " 'Am I Not a Man and a Brother?': British Art and Slavery in the Eighteenth Century." *Res: Anthropology and Aesthetics* 26 (1994): 68–82.

Bindman 1997a
Bindman, David, ed. *Hogarth and His Times: Serious Comedy*. Exh. cat. Berkeley and Los Angeles: University of California Press, 1997.

Bindman 1997b
Bindman, David. "The Nature of Satire in the 'Modern Moral Subjects'." In Ogée 1997, 129–40.

Bindman, Ogée, and Wagner forthcoming
Bindman, David, Frédéric Ogée, and Peter Wagner, eds. *Hogarth: Representing Nature's Machines*. Manchester: Manchester University Press, forthcoming.

Blum 1924
Blum, André. *Abraham Bosse et la société française au dix-septième siècle*. Paris: Albert Morancé, 1924.

BMC 1870–1954
Catalogue of Prints and Drawings in the British Museum, Division 1, *Personal and Political Satires*. Vols. 1–4 prepared by F. G. Stephens and Edward Hawkins; vols. 5–11 by M. D. George.

Bohm 1994
Bohm, Arnd. "Gottfried August Bürger: Texts of the Body." *Studies in Eighteenth-Century Culture* 23 (1994): 161–79.

Bond 1965.
Bond, Donald F., ed. *The Spectator*. 5 vols. Oxford: The Clarendon Press, 1965.

Bond 1987
Bond, Donald F., ed. *The Tatler*. 3 vols. Oxford: The Clarendon Press, 1987.

Bourdieu 1992
Bourdieu, Pierre. *Les règles de l'art*. Paris: Seuil, 1992.

Bray 1982
Bray, Alan. *Homosexuality in Renaissance England*. London: Gay Men's Press, 1982.

Bray 1995
Bray, Alan. *Homosexuality in Renaissance England*. New York: Columbia University Press, 1995.

Bremmer and Roodenburg 1991
Bremmer, Jan, and Herman Roodenburg, eds. *A Cultural History of Gestures: From Antiquity to the Present*. Cambridge: Polity, 1991.

Breval 1733
Breval, John Durant ["Joseph Gay"]. *The Lure of Venus, or*

Works Cited

The Harlot's Progress: An Heroic-Comical Poem in Six Cantos. London, 1733.

D. Brewer 1998
Brewer, David. "Readerly Visualization in the Staging of Hogarth." Seminar paper, 19 February 1998, Berkeley Art Museum.

D. Brewer forthcoming
Brewer, David. "Making Hogarth Heritage." *Representations*, forthcoming.

J. Brewer 1976
Brewer, John. *Party Ideology and Popular Politics at the Accession of George III.* Cambridge: Cambridge University Press, 1976.

J. Brewer 1995
Brewer, John. " 'The Most Polite Age and the Most Vicious': Attitudes towards Culture as a Commodity, 1600–1800." In Bermingham and Brewer 1995. 341–61.

J. Brewer 1997
Brewer, John. *The Pleasures of the Imagination: English Culture in the Eighteenth Century.* London: Harper Collins, 1997.

Brewer, McKendrick, and Plumb 1982
Brewer, John, Neil McKendrick, and J. H. Plumb, eds. *The Birth of a Consumer Society*, London: Europa, 1982.

Brewer and Porter 1993
Brewer, John, and Roy Porter, eds. *Consumption and the World of Goods.* London: Routledge, 1993.

Brewer and Staves 1995
Brewer, John, and Susan Staves, eds. *Early Modern Conceptions of Property.* London: Routledge, 1995.

Brown 1730
Brown, Thomas. *The Works of Tom Brown, Serious and Comical.* London, 1730.

Brown 1927
Brown, Thomas. *Amusements Serious and Comic and Other Works.* Ed. Arthur Hayward. London: Routledge, 1927.

Bryson 1983
Bryson, Norman. *Vision and Painting: The Logic of the Gaze.* New Haven, Conn., and London: Yale University Press, 1983.

Buck 1971
Buck, Anne. "Variations in English Women's Dress in the Eighteenth Century." *Folklife* 9 (1971): 5–25.

Burke and Caldwell 1968
Burke, Joseph, and Colin Caldwell, *Hogarth: The Complete Engravings.* New York: H. N. Abrams, 1968.

Burstin 1998
Burstin, Francis. "From the Prodigal Son to the *Rake's Progress*: Hogarth's Forerunners." *Apollo* 148, no. 437 (August 1998): 15–16.

Busch 1977
Busch, Werner. *Nachahmung als bürgerliches Kunstprinzip: Ikonographische Zitate bei Hogarth und in seiner Nachfolge.* Hildesheim and New York: G. Olms, 1977.

Busch 1984
Busch, Werner. "Hogarths und Reynolds Porträts des Schauspielers Garrick." *Zeitschrift für Kunstgeschichte* 47 (1984): 82–99.

Busch 1998
Busch, Werner. "*Marriage A-la-Mode*: Zur Dialektik von Detailgenauigkeit und Vieldeutigkeit bei Hogarth." In *"Marriage A-la-Mode": Hogarth und seine deutschen Bewunderer*, ed. Martina Dillmann and Claude Keisch, 70–84. Berlin: G. und H. Verlag, 1998.

Butler 1967
Butler, Samuel. *Hudibras.* Ed. John Wilders, 1663. Oxford: The Clarendon Press, 1967.

Carretta 1983
Carretta, Vincent. *The Snarling Muse: Verbal and Visual Political Satire from Pope to Churchill.* Philadelphia: University of Pennsylvania, 1983.

Carter 1997
Carter, Philip. "Men about Town: Representations of Foppery and Masculinity in Early Eighteenth-Century Urban Society." In *Gender in Eighteenth-Century England: Roles, Representations and Responsibilities*, eds. Hannah Barker and Elaine Chalus, 31–57. London: Longman Publishing, 1997.

Castle 1982
Castle, Terry. "Matters Not Fit To Be Mentioned: *Fielding's The Female Husband.*" *English Literary History* 49 (1982): 602–22.

Castle 1986
Castle, Terry. *Masquerade and Civilization: The Carnivalesque in Eighteenth-Century English Culture and Fiction.* Stanford, Calif.: Stanford University Press, 1986.

Castle 1987
Castle, Terry. "The Culture of Travesty: Sexuality and Masquerade in Eighteenth-Century England." In *Sexual Underworlds of the Enlightenment*, eds. George S. Rousseau and Roy Porter, 156–80. Manchester: Manchester University Press, 1987.

Castle 1995
Castle, Terry. *The Female Thermometer: Eighteenth-Century Culture and the Invention of the Uncanny.* Oxford: Oxford University Press, 1995.

Works Cited

Charke 1969
Charke, Charlotte. *A Narrative of the Life of Mrs. Charlotte Charke.* [1755] Gainesville, Fla.: Scholars' Facsimiles and Reprints, 1969.

Chrisman forthcoming
Chrisman, Kimberly. "Mary Edwards' Taste in High Life," forthcoming.

Cibber 1733
Cibber, Theophilus. *The Harlot's Progress, or The Ridotto al' Fresco. A Grotesque Pantomime Entertainment.* London, 1733.

Clark 1985
Clark, J.C.D. *English Society, 1688–1832: Ideology, Social Structure, and Political Practice during the Ancien Régime.* New York: Cambridge University Press, 1985.

Clarke and Aycock 1990
Clarke, Bruce, and Wendell Aycock, eds. *The Body and the Text: Comparative Essays in Literature and Medicine.* Lubbock: Texas Technical University Press, 1990.

Classen 1997
Classen, Constance. "Engendering Perception: Gender Ideologies and Sensory Hierarchies in Western History." *Body & Society* 3, no. 2 (June 1997): 1–19.

Clayton 1997
Clayton, Timothy. *The English Print: 1660–1802.* New Haven, Conn., and London: Yale University Press, 1997.

Coffey 1777
Coffey, Charles. *The Devil to Pay; or, the Wives Metamorphos'd. Theatrical Magazine.* London: J. Wenman, 1777.

Cohen 1996
Cohen, Michèle. *Fashioning Masculinity: National Identity and Language in the Eighteenth Century.* London: Routledge, 1996.

Coley and Wensinger 1970
Coley, W. B., and H. Wensinger. *Hogarth on High Life.* Middletown, Conn.: Wesleyan University Press, 1970.

Coryate 1611 (1905)
Coryate, Thomas. *Coryate's crudities; hastily gobled up in five months travels in France, Savoy, Italy, Rhetia commonly called the Grisons country, Helvetia alias Switzerland, some parts of high Germany and the Netherlands* [1611] 2 vols. Glasgow: J. MacLehose; New York: Macmillan, 1611. Repr. 1905.

Cowley 1983
Cowley, Robert S. *"Marriage A-la-Mode": A Review of Hogarth's Narrative Art.* Manchester: Manchester University Press, 1983.

Crown 1999
Crown, Patricia. "The Hogarth Tercentenary: An Overview of Commemorative Events." *Eighteenth-Century Studies* 33, no. 1 (1999): 131–36.

Dabydeen 1985 (1987)
Dabydeen, David. *Hogarth's Blacks: Images of Blacks in Eighteenth-Century Art.* Mundelstrup, Denmark: Dangeroo Press, 1985. Reprint, Manchester: Manchester University Press, 1987.

Daly 1980
Daly, Peter M., ed. *The European Emblem: Toward an Index Emblematicus.* Waterloo, Ontario: Wilfrid Laurier University Press, 1980.

Danet 1700
Danet, Pierre. *A Complete Dictionary of the Greek and Roman Antiquities.* London, 1700.

Davies 1957
Davies, K. G. *The Royal African Company.* London: Longmans Green, 1957.

D. Davis 1970
Davis, David Brion. *The Problem of Slavery in Western Culture.* Harmondsworth: Penguin, 1970.

N. Davis 1975
Davis, Natalie Zemon. "Women on Top." In *Society and Culture in Early Modern France: Eight Essays*, ed. Natalie Zemon Davis, 124–51. Stanford, Calif.: Stanford University Press, 1975.

W. Davis 1996
Davis, Whitney. "Gender." In *Critical Terms for Art History*, eds. Robert S. Nelson and Richard Shiff. Chicago: The University of Chicago Press, 1996.

Defoe 1992
Defoe, Daniel. *The Life and Strange Surprising Adventures of Robinson Crusoe.* Ed. John Mullan. Reprint, London: Everyman's Library, 1992.

de Jongh and Luijten 1997
de Jongh, Eddy, and Ger Luijten. *The Mirror of Everyday Life: Genre Prints in the Netherlands, 1550–1700.* Amsterdam: Rijksmuseum, 1997.

Denizot 1976
Denizot, Paul. "La vieille fille, personnage excentrique du XVIIIe siècle." In *L'excentricité en Grande-Bretagne au 18e siècle*, ed. Michèle Plaisant, 37–58. Lille: Presses Universitaires de Lille, 1976.

DeRitter 1994
DeRitter, Jones. *The Embodment of Characters: The Representation of Physical Experience on Stage and in Print, 1728–1749.* Philadelphia: University of Pennsylvania Press, 1994.

Works Cited

De Vere Green 1979
De Vere Green, Bertha. *A Collector's Guide to Fans over the Ages.* London: F. Muller, 1975; South Brunswick, N.J.: A. S. Barnes, 1979.

Devis 1983
Devis, Arthur. *Polite Society by Arthur Devis, 1712–1787. Portraits of the English Country Gentleman and his Family.* Exh. cat. Preston, Lancashire: The Harris Museum and Art Gallery, 1983.

Doane 1991
Doane, Mary Ann. "Veiling over Desire: Close-ups of the Woman," in Doane, *Femmes Fatales: Feminism, Film Theory, Psychoanalysis.* London: Routledge, 1991, 44–75.

Donald 1983
Donald, Diana. " 'Calumny and Caricatura': Eighteenth-Century Political Prints and the Case of George Townshend." *Art History* 6, no. 1 (March 1983): 44–66.

Donald 1996
Donald, Diana. *The Age of Caricature: Satirical Prints in the Reign of George III.* New Haven, Conn., and London: Yale University Press, 1996.

Drakard 1992
Drakard, David. *Printed English Pottery: History and Humour in the Reign of George III, 1769–1820.* London: J. Horne, 1992.

Dramaticus 1735
"Dramaticus." "On the proposed Regulation of the Theater." *The Gentleman's Magazine* (April 1735).

Du Mortier 1992
Du Mortier, Bianca M. *Waaiers en waaierbladen 1650–1800/Fans and fan leaves 1650–1800.* Trans. Ruth Koenig. Amsterdam: Rijksmuseum; Zwolle: Waanders, 1992.

Duplessis 1859
Duplessis, Georges. *Catalogue de l'oeuvre de Abraham Bosse.* Paris, 1859.

Earle 1994
Earle, Peter. *A City Full of People: Men and Women of London 1650–1750.* London: Methuen, 1994.

Egerton 1997
Egerton, Judy. *Hogarth's Marriage A-la-Mode.* London: National Gallery Publications, 1997.

Egerton 1998
Egerton, Judy. "The Hogarth Tercentenary." *Print Quarterly* 15, no. 3 (Sept. 1998), 322–28.

Einberg 1987
Einberg, Elizabeth, ed. *Manners and Morals: Hogarth and British Painting, 1700–1760.* London: Tate Gallery, 1987.

Einberg 1997
Einberg, Elizabeth. *Hogarth the Painter.* Exh. cat. London: Tate Gallery, 1997.

Einberg and Egerton 1988
Einberg, Elizabeth, and Judy Egerton. *The Age of Hogarth: British Painters Born 1675–1709.* London: Tate Gallery, 1988.

Elshtain 1981
Elshtain, Jean Bethke. *Public Man, Private Woman: Women in Social and Political Thought.* Princeton, N.J.: Princeton University Press, 1981.

A. Erickson 1993
Erickson, Amy Louise. *Women and Property in Early Modern England.* London: Routledge, 1993.

R. Erickson 1986
Erickson, Robert A. *Mother Midnight: Birth, Sex and Fate in Eighteenth-Century Fiction.* New York: AMS Press, 1986.

Fairchilds 1993
Fairchilds, Cissie. "The Production and Marketing of Populuxe Goods in Eighteenth-Century Paris." In Brewer and Porter 1993, 228–48.

Farquhar 1707
Farquhar, George. *The Beaux Stratagem,* 1707.

Ferenczi 1980
Ferenczi, Sandor. "The Fan as a Genital Symbol." In *Theory and Technique of Psycho-Analysis,* ed. John Richman. New York: Brunner and Mazel, (1959) 1980.

Fielding 1742
Fielding, Henry. "Preface." *The History and Adventures of Joseph Andrews and his friend Mr. Abraham Adam.* London, 1742.

Flory 1895
Flory, M. A. *A Book about Fans.* London and New York: Macmillan and Co., 1895.

Foucault 1975
Foucault, Michel. *The Birth of the Clinic: An Archeology of Medical Perception.* Trans. A. M. Sheridan. New York: Vintage Books, 1975.

Foucault 1977
Foucault, Michel. *Discipline and Punish: The Birth of the Prison.* Trans. Alan Sheridan. New York: Pantheon, 1977.

Foucault 1978–86
Foucault, Michel. *The History of Sexuality,* 3 vols. Trans. Robert Hurley. New York: Pantheon, 1978–86.

Works Cited

Foxon 1965
Foxon, David. *Libertine Literature in England, 1660–1745*. New Hyde Park, N.Y.: University Books, 1965.

Fracastorius 1686
Fracastorius, Hieronymus [Girolamo Fracastoro]. *Syphilis: or, A Poetical History of the French Disease*. Trans. Nahum Tate. London: Jacob Tonson, 1686.

Freeman 1980
Freeman, Robert. *The New Grove Dictionary of Music and Musicians*. Stanley Sadie, ed. London: Macmillan, 1980.

Friedrich et al. 1997
Friedrich, Anne, Birgit Haehnel, Viktoria Schmidt-Linsenhoff, and Christina Threuter, *Projektionen: Rassismus und Sexismus in der visuellen Kultur*. Marburg: Jonas Verlag, 1997.

Fuchs 1910
Fuchs, Eduard. *Illustrierte Sittengeschichte: Die galante Zeit*. Berlin, 1910. Repr. Berlin: Guhl, n.d.

Gallagher and Laqueur 1987
Gallagher, Catherine, and Thomas Laqueur, eds. *The Making of the Modern Body*. Berkeley and Los Angeles: University of California Press, 1987.

Gay 1713
Gay, John. *The Fan: A Poem in Three Books*. London: J. Tonson, 1713. Repr. 1714.

Gélis 1984
Gélis, Jacques. *L'Arbre et le fruit: La naissance dans l'Occident moderne*. Paris: Fayard, 1984.

George 1959
George, M. Dorothy. *English Political Caricature*. 2 vols. Oxford: The Clarendon Press, 1959.

Gibson 1989
Gibson, Wendy. *Women in Seventeenth-Century France*. New York: St. Martin's Press, 1989.

Gillis 1985
Gillis, John R. *For Better, For Worse: British Marriages 1600 to the Present*. Oxford: Oxford University Press, 1985.

Gilman 1988
Gilman, Sander. *Disease and Representation: Images of Illness from Madness to AIDS*. Ithaca, N.Y.: Cornell University Press, 1988.

Gilman 1991
Gilman, Sander. *The Jew's Body*. London: Routledge, 1991.

Gilman 1995
Gilman, Sander. *Health and Illness: Images of Difference*. London: Reaktion Books, 1995.

Ginsburg 1972
Ginsburg, Madeleine. "The Tailoring and Dressmaking Trades 1700–1850." *Costume* 6 (1972): 64–71.

Gisborne 1798
Gisborne, Thomas. *Enquiry into the Duties of the Female Sex*. London: A. Strahan, 1798.

Godby 1987
Godby, Michael. "The First Steps of Hogarth's *Harlot's Progress*." *Art History* 10 (1987): 23–37.

Goldsmith 1998
Goldsmith, Netta Murray. *The Worst of Crimes: Homosexuality and the Law in Eighteenth-Century London*. Aldershot: Ashgate, 1998.

Gombrich 1941
Gombrich, Ernst. *Caricature*. Harmondsworth: Penguin, 1941.

Gombrich 1989
Gombrich, Ernst. *Art and Illusion*. Princeton, N.J.: Princeton University Press, 1960. Repr. 1989.

Granville 1862
Granville, Mary. *The Autobiography and Correspondence of Mary Granville, Mrs. Delaney*. London, 1862.

Grice 1977
Grice, Elizabeth. *Rogues and Vagabonds*. Suffolk: Terence Dalton Limited, 1977.

Groddeck and Stadler 1994
Groddeck, Wolfram, and Ulrich Stadler, eds. *Phsysiognomie und Pathogenie: Zur literarischen Darstellung von Individualität*. Berlin: de Gruyter, 1994.

Grose 1786
Grose, Francis. *A Classical Dictionary of the Vulgar Tongue*. London: S. Hooper, 1786.

Gubar 1977
Gubar, Susan. "The Female Monster in Augustan Satire." *Signs* 3, 2 (Winter 1977), 380–94.

Guilhamet 1996
Guilhamet, Leon. "Pox and Satire: Some Representations of Venereal Disease in Restoration and Eighteenth-Century Satire." In Merians 1996. 196–212.

Guratzsch 1987
Guratzsch, Herwig, ed. *William Hogarth. Der Kupferstich als moralische Schaubühne*. Stuttgarth: Hatje, 1987.

Gwilliam 1993
Gwilliam, Tassie. *Samuel Richardson's Fictions of Gender*. Stanford, Calif.: Stanford University Press, 1993.

Works Cited

Habermas 1989
Habermas, Jürgen. *The Structural Transformation of the Public Sphere*. Trans. Thomas Burger. Cambridge, Mass.: MIT Press, 1989.

Haggerty 1999
Haggerty, George E. *Men In Love: Masculinity and Sexuality in the Eighteenth Century*. New York: Columbia University Press, 1999.

Hallett 1999
Hallett, Mark. *The Spectacle of Difference: Graphic Satire in the Age of Hogarth*. New Haven, Conn., and London: Yale University Press, 1999.

Hallett 2000
Hallett, Mark. *Hogarth*. London: Phaidon, 2000.

Halsband 1956
Halsband, R. *The Life of Lady Mary Wortley Montagu*. Oxford: Oxford University Press, 1956.

Hanley 1989
Hanley, Sarah. "Engendering the State: Family Formation and State Building in Early Modern France." *French Historical Studies* 16 (Spring 1989): 4–27.

Hart and Taylor 1998.
Hart, Avril, and Emma Taylor. *Fans*. London: V&A Publications, 1998.

Harth 1992
Harth, Erica. *Cartesian Women: Versions and Subversions of Rational Discourse in the Old Regime*. Ithaca, N.Y.: Cornell University Press, 1992.

Harvey 1685
Harvey, Gideon. *The French Pox*. 5th ed. London, 1685.

Haslam 1996
Haslam, Fiona. *From Hogarth to Rowlandson: Medicine in Art in Eighteenth-Century Britain*. Liverpool: Liverpool University Press, 1996.

Hawkins 1776
Hawkins, Sir John. *A General History of the Science and Practice of Music*, 5 vols. London, 1776.

Hazlitt 1930–34
Hazlitt, William. *The Complete Works of William Hazlitt*, ed. P. P. Howe, after the edition of A. R. Waller and Arnold Glover, 21 vols. London: J. M. Dent & Sons Ltd, 1930–34.

Head 1665
Head, Richard. *The English Rogue*. London, 1665.

Heffernan 1993
Heffernan, James. *Museum of Words: The Poetics of Ekphrasis from Homer to Ashbery*. Chicago: University of Chicago Press, 1993.

Herdan and Herdan 1966
Herdan, Gustav, and Innes Herdan. *Lichtenberg's Commentaries on Hogarth's Engravings*. London: Cresset, 1966.

Hill 1984
Hill, Bridget. *Eighteenth-Century Women: An Anthology*. London: George Allen & Unwin, 1984.

Hill 1989
Hill, Bridget. *Women, Work and Sexual Politics in Eighteenth-Century England*. Oxford: Basil Blackwell, 1989.

Hill 1996
Hill, Bridget. *Servants: English Domestics in the Eighteenth Century*. Oxford: The Clarendon Press, 1996.

Hillman 1994
Hillman, Anne, ed. *The Rake's Diary: The Journal of George Hilton*. Kendal, Curwen Archives Trust, 1994.

Hitchcock 1997
Hitchcock, Tim. *English Sexualities, 1700–1800*. New York: St. Martin's Press, 1997.

Hogarth 1955
Hogarth, William. *The Analysis of Beauty. With the Rejected Passages from the Manuscript Drafts and Autobiographical Notes*, ed. Joseph Burke. Reprint, Oxford: The Clarendon Press, 1955.

Hogarth 1975
Hogarth, William. *The Case of Designers, Engravers, Etchers, &c. Stated, in a Letter to a Member of Parliament*. 1735. Reprint, New York: Columbia University School of Library Science, 1975.

Hogarth 1997
Hogarth, William. *The Analysis of Beauty*. Ed. Ronald Paulson. New Haven, Conn., and London: Yale University Press, 1997.

hooks 1992
hooks, bell. "The Oppositional Gaze: Black Female Spectators." In *Black Looks: Race and Representation*, 115–31. Boston: South End Press, 1992.

Howard 1997
Howard, Jeremy. "Hogarth, Amigoni, and 'The Rake's Levee': New Light on *A Rake's Progress*." *Apollo* (November 1997): 31–37.

Hudson 1979
Thomas Hudson, 1701–1779, Portrait Painter and Collector. Exhibition catalogue. London: Greater London Council, 1979.

Hulme 1986
Hulme, Peter. *Colonial Encounters: Europe and the Native Caribbean*. London: Methuen, 1986.

L. Hunt 1993
Hunt, Lynn, ed. *The Invention of Pornography: Obscenity and the Origins of Modernity, 1500–1800*. New York: Zone Books, 1993.

M. Hunt 1996
Hunt, Margaret. *The Middling Sort: Commerce, Gender, and the Family in England, 1660–1780*. Berkeley and Los Angeles: University of California Press, 1996.

James 1743–45
James, Robert. *A Medicinal Dictionary*. 3 vols. London: T. Osborne, 1743–45.

Jessop 1957
Jessop, T. E., ed. *The Works of George Berkeley Bishop of Cloyne*. Vol. 6, *An Essay Towards Preventing the Ruin of Great Britain* [1721]. Edinburgh and London: Longmans Green, 1957.

D. Johnson 1989
Johnson, Dorothy. "Corporality and Communication: The Gestural Revolution of Diderot, David and the 'Oath of the Horatii'." *Art Bulletin* 71 (1989): 92–113.

S. Johnson 1773
Johnson, Samuel. *A Dictionary of the English Language*. 4th ed. 3 vols. London: W. Strahan, 1773.

A. Jones 1996
Jones, Amelia. "Sexual Politics: Judy Chicago's 'Dinner Party' " in *Feminist Art History*. Berkeley and Los Angeles: University of California Press, 1996.

E. Jones 1998
Jones, Edwin. *The English Nation: The Great Myth*. Thrupp, Gloustershire: Sutton, 1998.

R. W. Jones 1998
Jones, Robert W. *Gender and the Formation of Taste in Eighteenth-Century Britain: The Analysis of Beauty*. Cambridge: Cambridge University Press, 1998.

Jordan 1973
Jordan, Winthrop D. *White over Black: American Attitudes Towards the Negro, 1550–1812*. Baltimore: Penguin, 1973.

Josipovici 1982
Josipovici, Gabriel. *Writing and the Body*. Brighton: Harvester Press, 1982.

Kames 1796
Kames, Lord Henry Home. *Elements of Criticism*. Edinburgh, 1796.

Kelly and von Mücke 1994
Kelly, Veronica, and Dorothea von Mücke, eds. *Body and Text in the Eighteenth Century*. Stanford, Calif.: Stanford University Press, 1994.

Kemp 1997
Kemp, Wolfgang. *Die Räume der Maler. Zur Bilderzählung bei Giotto*. Munich: Beck, 1997.

Kent 1989
Kent, D. A. "Ubiquitous but Invisible: Female Domestic Servants in Mid-Eighteenth-Century London." *History Workshop* 28 (Autumn 1989): 111–28.

Kiaer 1993
Kiaer, Christina. "Professional Femininity in Hogarth's *Strolling Actresses Dressing in a Barn*." *Art History* 16, no. 2 (1993): 239–65. Repr. in this volume.

Kiern 1988
Kiern, T. "Daniel Defoe and the Royal African Company." *Historical Research* 61 (1988): 242–47.

King 1994
King, Thomas. "Performing 'Akimbo': Queer Pride and Epistemological Prejudice." In *The Politics and Poetics of Camp*, ed. Moe Meyer. London: Routledge, 1994.

Klein 1994
Klein, Lawrence. *Shaftesbury and the Culture of Politeness: Moral Discourse and Cultural Politics in Early Eighteenth-Century England*. Cambridge: Cambridge University Press, 1994.

Kleiner 1992
Kleiner, Diana E. E. *Roman Sculpture*. New Haven, Conn., and London: Yale University Press, 1992.

Knab 1996
Knab, Janina. *Ästhetik der Anmut: Studien zur 'Schönheit der Bewegung' im 18. Jahrhundert*. Frankfurt: Lang, 1996.

Knapp 1990
Knapp, Volker, ed. *Die Sprache der Zeichen und Bilder: Rhetorik und nonverbale Kommunikation in der frühen Neuzeit*. Marburg: Hitzeroth, 1990.

Kopplin 1983
Kopplin, Monika. *Kompositionen im Halbrund: Fächerblatter aus vier Jahrhunderten*. Exh. cat. Stuttgart: Staatsgalerie, 1983.

Korte 1993
Korte, Barbara. *Körpersprache in der Literatur*. Tübingen: Francke, 1993.

Krämer 1998
Krämer, Thomas. "Zur Darstellung der Frau(en) in *A Harlot's Progress* von William Hogarth." M.A. thesis. Universität Koblenz-Landau (Abteilung Landau), 1998.

Kramnick 1968
Kramnick, Isaac. *Bolingbroke and His Circle*. Cambridge, Mass.: Harvard University Press, 1968.

Krysmanski 1996
Krysmanski, Bernd. *Hogarth's "Enthusiasm Delineated": Nachahmung als Kritik am Kennertum*, 2 vols. Hildesheim: Olms, 1996.

Krysmanski 1998
Krysmanski, Bernd. "Lust in Hogarth's *Sleeping Congregation*—Or, How to Waste Time in Post-Puritan England." *Art History* 21, no. 3 (September 1998): 393–408.

Krysmanski 1999
Krysmanski, Bernd W. *A Hogarth Bibliography, 1697–1997*. Hildesheim: Olms, 1999.

Kunzle 1966
Kunzle, David. "Plagiaries by Memory of the Rake's Progress." *Journal of the Warburg and Courtauld Institutes* 29 (1966): 311–48.

Kunzle 1973a
Kunzle, David. *History of the Comic Strip*. Berkeley and Los Angeles: University of California Press, 1973.

Kunzle 1973b
Kunzle, David. "The Corset as Erotic Alchemy: From Rococo Galanterie to Montaut's Physiologies." In *Woman as Sex Object: Studies in Erotic Art, 1730–1970*, ed. Thomas B. Hess and Linda Nochlin, 91–165. London: Allen Lane, 1973.

Kunzle 1978
Kunzle, David. "The Ravaged Child in the Corrupt City." In *Changing Images of the Family*, ed. Virginia Tufte and Barbara Meyerhoff, 99–140. New Haven, Conn., and London: Yale University Press, 1978.

Lawson 1998
Lawson, James. "Hogarth's Plotting of 'Marriage A-la-Mode'." *Word and Image* 14 (1998): 267–80.

Learmount 1985
Learmount, Brian. *A History of the Auction*. Frome and London: Butler and Tanner, 1985.

Le Blanc 1747
Le Blanc, Abbé Jean Bernard. *Letters on the English and French Nations*. Dublin, 1747.

Lemire 1984
Lemire, Beverly. "Developing Consumerism and the Ready-Made Clothing Trade in Britain 1750–1800." *Textile History* 15 (1984): 21–44.

Lemire 1991
Lemire, Beverly. "Peddling Fashion: Salesman, Pawnbrokers, Tailors, Thieves and the Second-Hand Clothes Trade in England c.1700–1800." *Textile History* 22, no. 1 (1991): 67–82.

Lemire 1994
Lemire, Beverly. "Redressing the History of the Clothing Trade in England: Ready-Made Clothing, Guilds, and Women Workers, 1650–1800." *Dress* 21 (1994): 61–73.

Lemire 1997
Lemire, Beverly. *Dress, Culture and Commerce: The English Clothing Trade before the Factory, 1660–1800*. New York: St. Martin's Press, 1997.

Lessing 1984
Lessing, Gotthold Ephraim. *Laocoon: An Essay on the Limits of Painting and Poetry*. Trans. Edward Allen McCormick. Baltimore: Johns Hopkins University Press, 1984.

Lexis 1975
Lexis: Dictionnaire de la langue française. Paris: Larousse, 1975.

Lichtenberg 1808
Lichtenberg, Georg Christoph. *Erklärungen der Hogarthischen Kupferstiche*. Göttingen: H. Dietrich, 1808.

Lichtenberg 1794 (1835)
Lichtenberg, Georg Christoph. *Ausfürliche Erklärung der Hogarthischen Kupferstiche; mit verkleinerten aber vollständigen Copien derselben von E. Riepenhausen*. Göttingen: Dieterich'sche Buchhandlung, [1794] 1835.

Lichtenberg 1966
Lichtenberg, Georg Christoph. *The World of Hogarth: Lichtenberg's Commentaries on Hogarth's Engravings*. Trans. Innes and Gustav Herdan. Boston: Houghton Mifflin, 1966.

Lichtenberg 1983
Lichtenberg, Georg Christoph. *Schriften und Briefe*. Ed. Franz H. Mautner. Vol. 3. Frankfurt: Insel Verlag, 1983.

Lichtenberg 1991
Lichtenberg, Georg Christoph. *Ausführliche Erklärung der Hogarthischen Kupferstiche*. Ed. Franz H. Mautner. Frankfurt: Insel Verlag, 1991.

Lillywhite 1964
Lillywhite, Bryant. *London Coffee Houses: A Reference Book of Coffee Houses of the 17th, 18th and 19th Centuries*. London: George Allen, 1964.

Lippincott 1983
Lippincott, Louise. *Selling Art in Georgian London: The Rise of Arthur Pond*. New Haven, Conn., and London: Yale University Press, 1983.

Locke 1698
Locke, John. *Two Treatises of Government*. London, 1698.

Lovell 1995
Lovell, Terry. "Subjective Powers? Consumption, the Reading Public, and Domestic Woman in Early Eighteenth-Century England." In Brewer and Bermingham. 1995.

Lowe 1992
Lowe, Fred N. "Hogarth, Beauty Spots, and Sexually Transmitted Diseases." *British Journal for Eighteenth-Century Studies* 15 (1992): 71–79.

Lowe 1996
Lowe, Fred N. "The Meaning of Venereal Disease in Hogarth's Graphic Art." In Merians 1996, 168–83.

Lubbock 1995
Lubbock, Jules. *The Tyranny of Taste: The Politics of Architecture and Design in Britain, 1550–1960.* New Haven, Conn., and London: Yale University Press, 1995.

Lyttleton 1734
Lyttleton, George. *Letters From a Persian in England to a Friend at Ispahan.* London, 1734.

Macey 1976
Macey, Samuel L. "Hogarth and the Iconography of Time." *Studies in Eighteenth-Century Culture* 5 (1976): 41–53.

Macfarlane 1978
Macfarlane, Alan. *The Origins of English Individualism: The Family, Property, and Social Transition.* New York: Cambridge University Press, 1978.

Mandeville 1724
Mandeville, Bernard. *A Modest Defence of Publick Stews, or, An Essay upon Whoring, as it is Now Practis'd in these Kingdoms.* London: A. Moore near St. Paul's, 1724.

Mandeville 1924
Mandeville, Bernard. *The Fable of the Bees: or, Private Vices, Publick Benefits.* 2 vols. 1723. 1729. Ed. F. B. Kaye. Oxford: The Clarendon Press, 1924.

Marten 1708
Marten, John. *A Treatise of all the Degrees and Symptoms of the Venereal Disease, in both sexes.* 6th ed. London: Crouch, 1708.

Mayor 1980
Mayor, Susan. *Fans.* New York: Mayflower Books, 1980.

Maza 1996
Maza, Sarah. "Stories in History: Cultural Narratives in Recent Works in European History." *American Historical Review* 101 (December 1996): 1493–1515.

Maza 1997
Maza, Sarah. "Luxury, Morality, and Social Change: Why There Was No Middle-Class Consciousness in Prerevolutionary France." *Journal of Modern History* 69 (June 1997): 216–21.

McCormick 1997
McCormick, Ian, ed. *Secret Sexualities: A Sourcebook of 17th and 18th Century Writing.* London: Routledge, 1997.

McFarlane 1997
McFarlane, Cameron. *The Sodomite in Fiction and Satire, 1660–1750.* New York: Columbia University Press, 1997.

McWilliam 1993
McWilliam, Neil. *Hogarth.* London: Studio Editions, 1993.

Mee n.d.
Mee, Arthur, ed. *Leicestershire and Rutland.* London, n.d.

Meehan 1986
Meehan, Michael. *Liberty and Poetics in Eighteenth-Century England.* Wolfeboro, N.H.: Croome Helm, 1986.

Mellini and Matthews 1987
Mellini, Peter, and Roy T. Matthews. "John Bull's Family Arises." *History Today* 37 (1987): 17–23.

Merians 1996
Merians, Linda E., ed. *The Secret Malady: Venereal Disease in Eighteenth-Century Britain and France.* Lexington: University Press of Kentucky, 1996.

Meyer 1995
Meyer, Arline. "Re-dressing Classical Statuary: The Eighteenth-Century 'Hand-in-Waistcoat' Portrait." *Art Bulletin* 77, 1 (March 1995): 45–64.

Miller 1992
Miller, J. Hillis. *Illustration.* London: Reaktion Books, 1992.

Mirzoeff 1992
Mirzoeff, Nicholas. "Body Talk: Deafness, Sign and Visual Language in the Ancien Régime." *Eighteenth-Century Studies* 25, no. 4 (1992): 561–85.

Möller 1996
Möller, Joachim, ed. *Hogarth in Context: Ten Essays with a Bibliography.* Marburg: Jonas Verlag, 1996.

Montagu 1994
Montagu, Jennifer. *The Expression of the Passions: The Origin and Influence of Charles Le Brun's 'Conférence sur l'expression générale et particulière'.* New Haven, Conn., and London: Yale University Press, 1994.

Montfaucon 1722
Montfaucon, Bernard de. *L'Antiquité expliquée et représentée en figures. Tome Premier. Les Dieux des Grecs & des Romains.* Paris, 1722.

New Canting 1725
New Canting Dictionary. London, 1725.

Nichols 1781
Nichols, John, ed. *Biographical Anecdotes of William Hogarth; And a Catalogue of his Works Chronologically Arranged; with*

Occasional Remarks. London: J. B. Nichols, 1781; 2nd ed. 1782; 3rd ed. 1785. Repr. London, 1971.

Nichols 1833
Nichols, John, ed. *Anecdotes of William Hogarth, written by himself, with essays on his life and genius, and criticisms on his works, selected from Walpole, Gilpin, J. Ireland, Lamb, Phillips, and others. To which are added a catalogue of his prints; account of their variations, and principal copies; lists of paintings, drawings, &c.* London: J. B. Nichols, 1833. Repr. London: Cornmarket Press, 1970.

Nichols and Steevens 1808–17
Nichols, John, and George Steevens. *The Genuine Works of William Hogarth: Illustrated with Biographical Anecdotes, a Chronological Catalogue, and Commentary; by John Nichols . . . and the Late George Steevens.* 5 vols. London: Longman, Hurst, Rees, and Orme, 1808–17.

E. F. Noel 1910
Noel, E. F. *Some Letters and Records of the Noel Family.* London, 1910.

W.F.N. Noel 1910
Noel, W.F.N. *Edwards of Welham, Co. Leicester and of Ketton, Co. Rutland.* Oakham, 1910.

Norton 1992
Norton, Rictor. *Mother Clap's Molly House: The Gay Subculture in England, 1700–1830.* London: GMP Publishers, 1992.

Nussbaum 1984
Nussbaum, Felicity A. *The Brink of All We Hate: English Satires on Women, 1660–1750.* Lexington: University Press of Kentucky, 1984.

O'Dench 1990
O'Dench, E. "Prodigal Sons and Fair Penitents: Eighteenth Century Popular Prints." *Art History* 13, no. 3 (1990): 318–43.

Ogée 1996
Ogée, Frédéric. "Sterne and Fragonard: The Escapades of Death." In *Icons-Texts-Iconotexts*, ed. Peter Wagner, 136–48. Berlin and New York: Walter de Gruyter, 1996.

Ogée, 1997
Ogée, Frédéric, ed. *The Dumb Show: Image and Society in the Works of William Hogarth. Studies on Voltaire and the Eighteenth Century*, 357. Oxford: Voltaire Foundation, 1997.

Okin 1983–84
Okin, Susan Moller. "Patriarchy and Married Women's Property in England: Questions on Some Current Views." *Eighteenth-Century Studies* 17, no. 2 (1983–84): 121–38.

Oldham 1978
Oldham, Esther. "The Mystery of a Curious Fan: A Mask Fan." In Armstrong 1978, 119–27.

Oppé 1948
Oppé, A. P. *The Drawings of William Hogarth.* London and New York: Phaidon Press, 1948.

Outhwaite 1995
Outhwaite, R. B. *Clandestine Marriage in England, 1500–1850.* London: Hambledon Press, 1995.

Pardailhé-Galabrun 1988
Pardailhé-Galabrun, Annick. *La Naissance de l'intime: trois mille foyers parisiens, XVIIe–XVIIIe siècle.* Paris: Presses Universitaires de France, 1988.

Parmal 1990
Parmal, Pamela A. *Beauty in Hand: The Art of the Fan.* Exh. cat. Museum of Fine Arts, Rhode Island School of Design, 1990.

Pateman 1989
Pateman, Carole. *The Disorder of Women. Democracy, Feminism and Political Theory.* Oxford: Oxford University Press, 1989.

Patterson 1997
Patterson, Craig. "Eighteenth-Century Molly Houses and the Twentieth-Century Search for Sexual Identity." In *Illicit Sex: Identity Politics in Early Modern Culture*, ed. Thomas DiPiero and Pat Gill, 256–69. Athens: University of Georgia Press, 1997.

Paulson 1965 (1970, 1989a)
Paulson, Ronald. *Hogarth's Graphic Works: First Complete Edition*, 2 vols. New Haven, Conn., and London: Yale University Press, 1965; 2nd ed. 1970; 3rd ed. London: The Print Room, 1989.

Paulson 1970
Paulson, Ronald. *Hogarth's Graphic Works.* 2nd ed. 2 vols. New Haven, Conn., and London: Yale University Press 1970.

Paulson 1971
Paulson, Ronald. *Hogarth: His Life, Art, and Times.* 2 vols. New Haven: Published for the Paul Mellon Centre for Studies in British Art by Yale University Press, 1971.

Paulson 1979
Paulson, Ronald. *Popular and Polite Art in the Age of Hogarth and Fielding.* Notre Dame, Ind.: University of Notre Dame Press, 1979.

Paulson 1989b
Paulson, Ronald. *Breaking and Remaking: Aesthetic Practice in England, 1700–1820.* New Brunswick, N.J.: Rutgers University Press, 1989.

Paulson 1991–93a
Paulson, Ronald. *Hogarth.* 3 vols. New Brunswick, N.J.: Rutgers University Press, 1991–93.

Paulson 1991–93b
Paulson, Ronald. "Patron and Public (II): *A Rake's Progress* and the Engraver's Act." In Paulson 1991–93a, 2:15–47.

Paulson 1992
Paulson, Ronald. *Hogarth: High Art and Low, 1732–1750*. New Brunswick, N.J.: Rutgers University Press, 1992.

Paulson 1995
Paulson, Ronald. "Hogarth and the Distribution of Visual Images." *Studies in British Art* 1 (1995): 27–46.

Paulson 1996a
Paulson, Ronald. *The Beautiful, Novel, and Strange: Aesthetics and Heterodoxy*. Baltimore: Johns Hopkins University Press, 1996.

Paulson 1996b
Paulson, Ronald. "Putting out the Fire in Her Imperial Majesty's Apartment: Opposition Politics, Anticlericalism, and Aesthetics." *English Literary History* 63 (1996): 79–108.

Pears 1988
Pears, Iain. *The Discovery of Painting*. New Haven, Conn., and London: Yale University Press, 1988.

Penny 1986
Penny, N. *Reynolds*. Exh. cat. London: Royal Academy, 1986.

Perry 1990
Perry, Ruth. "Mary Astell and the Feminist Critique of Possessive Individualism." *Eighteenth-Century Studies* 23, 4 (Summer 1990): 444–57.

Phillips 1964
Phillips, Hugh. *Mid-Georgian London: A Topographical and Social Survey of Central and Western London about 1750*. London: Collins, 1964.

Pietz 1985
Pietz, William. "The Problem of the Fetish, I." *Res: Anthropology and Aesthetics* 9 (Spring 1985): 5–16.

Pillorget 1979
Pillorget, René. *La tige et le rameau: familles anglaise et française 16e–18e siècles*. Paris: Calmann-Levy, 1979.

Plumb 1956–60
Plumb, J. H. *Sir Robert Walpole*. 2 vols. London: Cresset Press, 1956–60.

Podro 1998
Podro, Michael. *Depiction*. New Haven, Conn., and London: Yale University Press, 1998.

Pointon 1993
Pointon, Marcia. *Hanging the Head*. New Haven, Conn., and London: Yale University Press, 1993.

Pollak 1978
Pollak, Ellen. "Comment on Susan Gubar's 'The Female Monster in Augustan Satire '." *Signs* 3, 3 (Spring 1978): 728–32.

Pollak 1985
Pollak, Ellen. *The Poetics of Sexual Myth: Gender and Ideology in the Verse of Swift and Pope*. Chicago: University of Chicago Press, 1985.

Pollock 1996
Pollock, Griselda, ed. *Generations and Geographies in the Visual Arts: Feminist Readings*. London: Routledge, 1996.

Pollock 1999
Pollock, Griselda. *Differencing the Canon: Feminist Desire and the Writing of Art's Histories*. London: Routledge, 1999.

Pope 1954
Pope, Alexander. "Moral Essays. Epistle II: To a Lady; Of the Characters of Women." In *The Poetry of Pope*, ed. M. H. Abrams. Arlington Heights, Ill.: Harlan Davidson, Inc., 1954.

Porter 1982
Porter, Roy. "Mixed Feelings: The Enlightenment and Sexuality in Eighteenth-Century Britain." In *Sexuality in Eighteenth-Century Britain*, ed. P. G. Boucé, 1–27. Manchester: Manchester University Press, 1982.

Porter 1985
Porter, Roy. "Making Faces: Physiognomy and Fashion in Eighteenth-Century England," *Études Anglaises* 38, no. 4 (October–December 1985): 385–96.

Porter 1991
Porter, Roy. "History of the Body." In *New Perspectives on Historical Writing*, ed. Peter Burke, 206–33. Cambridge, England: Polity Press, 1991.

Porter 1997a
Porter, Roy. *The Greatest Benefit to Mankind: A Medical History of Humanity from Antiquity to the Present*. London: Harper Collins, 1997.

Porter 1997b
Porter, Roy. "Bethlem/Bedlam: Methods of Madness?" *History Today* 47, no. 10 (October 1997): 41–47.

Postgate 1930
Postgate, Raymond. *That Devil Wilkes*. London: Denis Dobson, 1930. Repr. 1956.

Pound 1998
Pound, Richard. " 'Fury After Licentious Pleasures': *A Rake's Progress* and Concerns About Luxury in Eighteenth-Century England." *Apollo* 148 (August 1998): 17–25.

Works Cited

Press 1977
Press, Charles. "The Georgian Political Print and Democratic Institutions." *Comparative Studies in Society and History* 19 (1977): 216–38.

Raines 1967
Raines, Robert. *Marcellus Laroon*. London: Routledge and Kegan Paul, 1967.

Rauser 1998
Rauser, Amelia. "Death or Liberty: British Political Prints and the Struggle for Symbols in the American Revolution." *Oxford Art Journal* 21, no. 2 (1998): 151–71.

Ribeiro 1983
Ribeiro, Aileen. *A Visual History of Costume: The Eighteenth Century*. London: Batsford, 1983.

J. Richardson 1995
Richardson, John. *London and Its People*. London: Barrie and Jenkins, 1995.

S. Richardson 1972
Richardson, Samuel. *The History of Sir Charles Grandison*. 3 vols. Ed. Jocelyn Harris. London: Oxford University Press, 1972.

Roberts and Porter 1993
Roberts, Marie M., and Roy Porter, eds. *Literature and Medicine During the Eighteenth Century*. London: Routledge, 1993.

Robinson 1736
Robinson, Nicholas. *A New Treatise of the Venereal Disease*. London: J. J. & P. Knapton, 1736.

Robinson [ca. 1755]
Robinson, Nicholas. *An Essay on the Gout, and all Gouty Afflictions Incident to affect Mankind*. London: Edward Robinson, ca. 1755.

Roche 1987
Roche, Daniel. *The People of Paris: An Essay on Popular Culture in the Eighteenth Century*. Trans. Marie Evans and Gwynne Lewis. Berkeley and Los Angeles: University of California Press, 1987.

Rochester 1968
Rochester, John Wilmot, Earl of. *The Complete Poems of John Wilmot, Earl of Rochester*. David M. Vieth, ed. New Haven, Conn., and London: Yale University Press, 1968.

P. Rogers 1979
Rogers, Pat. *Robinson Crusoe*. London and Boston: G. Allen & Unwin, 1979.

P. Rogers 1982
Rogers, Pat. "The Breeches Part." In *Sexuality in the Eighteenth Century*, ed. Paul-Gabriel Boucé. Manchester: Manchester University Press, 1982.

W. Rogers 1894
Rogers, Woodes. *Life Aboard a British Privateer in the Time of Queen Anne*. London, n.d.; [facsimile of 1794 ed.] London: Chapman & Hall, 1894.

Rogoff 1996
Rogoff, Irit. "Gossip as Testimony: A Postmodern Signature." In Pollock 1996, 58–65.

Rosenfeld 1939
Rosenfeld, Sybil. *Strolling Players and Drama in the Provinces, 1660–1765*. Cambridge: Cambridge University Press, 1939.

Rosenfeld 1960
Rosenfeld, Sybil. *The Theater of the London Fairs in the Eighteenth Century*. Cambridge: Cambridge University Press, 1960.

Rosselli 1988
Rosselli, John. "The Castrati as a Professional Group and a Social Phenomenon, 1550–1850." *Acta Musicologica* LX (October 1988): 142–79.

Rouquet 1746
Rouquet, Jean André. *Lettres de Monsieur *** à un de ses amis à Paris, pour lui expliquer les estampes de Monsieur Hogarth*. London, 1746.

Rowland 1998
Rowland, Jon Thomas. *'Swords in Myrtle Dress'd': Toward a Rhetoric of Sodom: Gay Readings in Homosexual Politics and Poetics in the Eighteenth Century*. Madison, N.J.: Fairleigh Dickinson University Press, 1998.

Rudé 1962
Rudé, George. *Wilkes and Liberty: A Social Study of 1763 to 1774*. Oxford: The Clarendon Press, 1962.

Rumbold 1989
Rumbold, Valerie. *Women's Place in Pope's World*. Cambridge: Cambridge University Press, 1989.

Sainsbury 1998
Sainsbury, John. "Wilkes and Libertinism." In *Studies in Eighteenth-Century Culture*, vol. 26. Ed. Syndy M. Conger and Julie C. Hayes. Baltimore: Johns Hopkins University Press, 1998.

Salomon 1996
Salomon, Nanette. "The Venus Pudica: Uncovering Art History's 'Hidden Agendas' and Pernicious Pedigrees." In Pollock 1996. 69–87.

Santesso 1999
Santesso, Aaron. "William Hogarth and the Tradition of Sexual Scissors," *Studies in English Literature 1500–1900* 39, no. 3 (Summer 1999): 499–521.

Works Cited

Saussure 1995
Saussure, César de. *A Foreign View of England in the Reigns of George I and George II*. London: Caliban, 1995.

Sawday 1995
Sawday, Jonathan. *The Body Emblazoned: Dissection and the Human Body in Renaissance Culture*. London: Routledge, 1995.

Scarry 1988
Scarry, Elaine, ed. *Literature and the Body*. Baltimore: Johns Hopkins University Press, 1988.

Scholz 1997
Scholz, Susanne. "Body Narratives: Writing the Nation and Fashioning the Subject in Early Modern England." *Zeitschrift für Anglistik und Amerikanistik* 45 (1997): 97–111.

Schreiber 1893
Schreiber, Lady Charlotte. *Catalogues of the Collection of Fan and Fan-Leaves*. Ed. Lionel Cust. London: Longman's, 1893.

Sekora 1977
Sekora, John. *Luxury: The Concept in Western Thought from Eden to Smollett*. Baltimore: Johns Hopkins University Press, 1977.

Senelick 1990
Senelick, Laurence. "Mollies or Men of Mode? Sodomy and the Eighteenth-Century London Stage." *Journal of the History of Sexuality* 1, 1 (1990): 33–67.

Shee 1805
Shee, M. A. *Rhymes on Art*. London, 1805.

Shesgreen 1973
Shesgreen, Sean. *Engravings by Hogarth*. New York: Dover, 1973.

Shesgreen 1976
Shesgreen, Sean. "Hogarth's *Industry and Idleness*: A Reading." *Eighteenth-Century Studies* 9 (1976): 569–98.

Shesgreen 1983
Shesgreen, Sean. *Hogarth and the Times-of-the-Day Tradition*. Ithaca, N.Y.: Cornell University Press, 1983.

Shesgreen 1990
Shesgreen, Sean. *The Cries and Hawkers of London: Engraving and Drawings by Marcellus Laroon*. Stanford, Calif.: Stanford University Press, 1990.

Sintelaer 1709
Sintelaer, John. *The Scourge of Venus and Mercury, Represented in a Treatise of the Venereal Disease*. London, 1709.

Smith 1982
Smith, Hilda L. *Reason's Disciples: Seventeenth-Century English Feminists*. Urbana: University of Illinois Press, 1982.

Solkin 1986
Solkin, David H. "Great Pictures or Great Men? Reynolds, Male Portraiture, and the Power of Art." *Oxford Art Journal* 2, no. 9 (1986), 42–49.

Solkin 1993
Solkin, David H. *Painting for Money: The Visual Arts and the Public Sphere in Eighteenth-Century England*. New Haven, Conn., and London: Yale University Press, 1993.

Sontag 1983
Sontag, Susan. *Illness as Metaphor*. New York: Farrar, Straus and Giroux, 1978; Harmondsworth: Penguin Books, 1983.

Stafford 1991
Stafford, Barbara M. *Body Criticism: Imaging the Unseen in Enlightenment Art and Medicine*. Cambridge, Mass.: MIT Press, 1991.

Stafford 1994
Stafford, Barbara M. *Artful Science: Enlightenment, Entertainment, and the Eclipse of Visual Education*. Cambridge, Mass.: MIT Press, 1994.

Standen 1965
Standen, Edith. "Instruments for Agitating the Air." *Metropolitan Museum of Art Bulletin* 23, no. 7 (1965): 243–57.

Starobinski 1964
Starobinski, Jean. *L'Invention de la liberté*. Genève: Skira, 1964.

Stone 1977
Stone, Lawrence. *The Family, Sex and Marriage in England, 1500–1800*. New York: Harper and Row, 1977.

Stone 1990
Stone, Lawrence. *The Road to Divorce: England, 1530–1897*. Oxford: Oxford University Press, 1990.

Sulter 1997
Sulter, Maud. *Lubaina Himid: Venetian Maps*. Preston, England: Harris Museum and Gallery, 1997.

Surel 1989
Surel, Jeanine. "John Bull." In *Patriotism: The Making and Unmaking of British National Identity*, ed. Raphael Samuel, trans. Kathy Hodgkin. London: Routledge, 1989.

Swift 1939
Swift, Jonathan. *The Prose Works of Jonathan Swift*. Ed. Herbert Davis. Vol. I, *"A Tale of a Tub" with other early works*. 1703; Oxford: Basil Blackwell, 1939.

Swift 1955
Swift, Jonathan. *The Prose Works of Jonathan Swift*. Ed. Herbert Davis. Vol. 12, *Irish Tracts, 1728–1733, The Intelligencer IX*. 1728; Oxford: Basil Blackwell, 1955.

Swift 1958
Swift, Jonathan. *Collected Poems of Jonathan Swift*, 2 vols. Ed. Joseph Horrell. Cambridge, Mass.: Harvard University Press, 1958.

Works Cited

Swift 1959
Swift, Jonathan. *Gulliver's Travels*. 1726; Oxford: Basil Blackwell, 1959.

Sydenham 1742
Sydenham, Thomas. *The Entire Works of Dr. Thomas Sydenham*. London: Edmund Cave, 1742.

Taylor 1992
Taylor, Miles. "John Bull and the Iconography of Public Opinion in England, c.1712–1929." *Past and Present* 134 (February 1992): 93–128.

B. Thomas 1994
Thomas, Brook. *Cross-Examinations of Law and Literature: Cooper, Hawthorne, Stowe and Melville*. Cambridge: Cambridge University Press, 1994.

P.D.G. Thomas 1996
Thomas, Peter D. G. *John Wilkes: A Friend to Liberty*. Oxford: Oxford University Press, 1996.

Threuter 1997
Threuter, Christina. "Lubaina Himid: Black Woman Artist." In Friedrich et al. 1997, 230–42.

Traer 1982
Traer, James. *Marriage and the Family in Eighteenth-Century France*. Ithaca, N.Y.: Cornell University Press, 1982.

Trumbach 1977
Trumbach, Randolph. "London's Sodomites: Homosexual Behavior and Western Culture in the Eighteenth Century." *Journal of Social History* 11 (1977): 1–33.

Trumbach 1978
Trumbach, Randolph. *The Rise of the Egalitarian Family: Aristocratic Kinship and Domestic Relations in Eighteenth-Century England*. New York: Academic Press, 1978.

Trumbach 1985
Trumbach, Randolph. "Sodomitical Subcultures, Sodomitical Roles, and the Gender Revolution of the Eighteenth Century: The Recent Historiography." *Eighteenth-Century Life* 9 (1985): 109–21.

Trumbach 1988
Trumbach, Randolph. *Sex and the Gender Revolution*. 1. *Heterosexuality and the Third Gender in Enlightenment London*. Chicago: University of Chicago Press, 1988.

Trumbach 1989
Trumbach, Randolph. "Sodomitical Assaults, Gender Role, and Sexual Development in Eighteenth-Century London." In *The Pursuit of Sodomy: Male Homosexuality in Renaissance and Enlightenment Europe*, ed. Kent Gerard and Gert Hekma, 407–29. New York and London: Harrington Park Press, 1989.

Trumbach 1990
Trumbach, Randolph. "The Birth of the Queen: Sodomy and the Emergence of Gender Equality in Modern Culture, 1660–1750." In *Hidden From History: Reclaiming the Gay and Lesbian Past*, ed. Martin Duberman, Martha Vicinus, and George Chauncey, Jr., 129–40. New York: Meridian, 1990.

Trumbach 1993
Trumbach, Randolph. "Erotic Fantasy and Male Libertinism in Enlightenment England." In L. Hunt 1993. 253–82.

Trumbach 1997
Trumbach, Randolph. "London's Sodomites: Homosexual Behavior and Western Culture in the Eighteenth Century," *Journal of Social History* 11, 1 (Fall 1997): 15.

Tscherny 1997
Tscherny, Nadia. "*An Un-Married Woman: Mary Edwards, William Hogarth, and a Case of Eighteenth-Century British Patronage*." In *Women and Art in Early Modern Europe: Patrons, Collectors, Connoisseurs*, ed. Cynthia Lawrence, 236–54. College Park: Pennsylvania State University Press. 1997.

Turner 1995
Turner, James Grantham. "News from the New Exchange: Commodity, Erotic Fantasy and the Female Entrepreneur." In Brewer and Bermingham 1995. 419–39.

Tytler 1995
Tytler, Graeme. "Lavater and Physiognomy in English Fiction 1790–1832." *Eighteenth-Century Fiction* 7 (1995): 294–310.

Uglow 1997
Uglow, Jennifer S. *Hogarth: A Life and a World*. New York: Farrar, Straus, and Giroux, 1997.

[Anthony Van Dyck] 1990
Anthony Van Dyck. Exhibition catalogue. Washington, D.C.: National Gallery of Art, 1990.

Vertue 1934
Vertue, George. *Notebooks*, vol. 3. *The Walpole Society* 22. Oxford: Oxford University Press, 1934.

Vila 1994
Vila, Anne C. "Enlightened Minds and Scholarly Bodies from Tissot to Sade." *Studies in Eighteenth-Century Culture* 23 (1994): 207–21.

von Hagens 1997
von Hagens, Gunther, ed. *Körperwelten: Einblicke in den menschlichen Körper*. Mannheim: Landesmuseum für Technik und Arbeit, 1997.

Wagner 1988
Wagner, Peter. *Eros Revived: Erotica of the Enlightenment in England and America*. London: Secker & Warburg, 1988.

Wagner 1990
Wagner, Peter. *Eros Revived: Erotica of the Enlightenment in England and America*. London: Paladin, 1990.

Wagner 1991a
Wagner, Peter, ed. *Erotica and the Enlightenment*. Frankfurt and New York: Peter Lang, 1991.

Wagner 1991b
Wagner, Peter. "Eroticism in Graphic Art: The Case of William Hogarth." *Studies in Eighteenth-Century Culture* 21 (1991): 53–75.

Wagner 1992
Wagner, Peter. "Eroticism in Graphic Art: Hogarth and Rowlandson." In *L'Érotisme en Angleterre. XVIIè–XVIIIè siècles*, ed. Jean-François Gournay, 87–98. Lille: Presses Universitaires de Lille, 1992.

Wagner 1993a
Wagner, Peter. "The Satire on Doctors in Hogarth's Graphic Works." In *Literature and Medicine During the Eighteenth Century*, ed. Marie M. Roberts and Roy Porter, 200–226. London: Routledge, 1993.

Wagner 1993b
Wagner, Peter. "Hogarth and the English Popular Mentalité." *Mentalities/Mentalités* 8 (1993): 24–43.

Wagner 1995a
Wagner, Peter. "How to (Mis)read Hogarth, or, Ekphrasis Galore." In *1650–1850: Ideas, Aesthetics, and Inquiries in the Early Modern Era*, ed. Kevin L. Cope, 2. New York: AMS Press, 1995.

Wagner 1995b
Wagner, Peter. *Reading Iconotexts: From Swift to the French Revolution*. London: Reaktion Books, 1995.

Wagner 1996a
Wagner, Peter, ed. *Icons-Texts-Iconotexts: Essays on Ekphrasis and Intermediality*. Berlin: de Gruyter, 1996.

Wagner 1996b
Wagner, Peter. "The Continental Foreigner in Hogarth's Graphic Art." In Serge Soupel, ed. *La Grande-Bretagne et l'Europe des lumières*. Paris: Presses de la Sorbonne, 1996: 107–32.

Wagner 1997
Wagner, Peter. "The Artist at Work: A (De)constructive View of Hogarth's 'Beer Street'." In Ogée 1997, 117–27.

Wagner 1998
Wagner, Peter. "Hogarthian Frames: The 'New' Eighteenth-Century Aesthetics." In *Das 18. Jahrhundert*, ed. Monika Fludernik and Ruth Nestvold, 277–303. Trier: Wissenschaftlicher Verlag Trier, 1998.

Wahrman 1995
Wahrman, Dror. *Imagining the Middle Class: The Political Representation of Class in Britain, c. 1780–1840*. Cambridge: Cambridge University Press, 1995.

Walkowitz 1992
Walkowitz, Judith. *City of Dreadful Delight: Narratives of Sexual Danger in Late-Victorian London*. Chicago: University of Chicago Press, 1992.

Walpole 1954
Walpole, Horace. *The Yale Edition of Horace Walpole's Correspondence*. Ed. W. S. Lewis, Warren Hunting Smith, and George L. Lamb. New Haven, Conn., and London: Yale University Press, 1954.

Ward 1993
Ward, Edward. *The London Spy*. Ed. Paul Hyland. Reprint, 4th edition, 1709; East Lansing, Mich.: Colleagues Press, 1993.

Wark 1972
Wark, Robert R. "Hogarth's Narrative Method in Practice and Theory." In *England in the Restoration and Early Eighteenth-Century*, ed. H. T. Swedenberg, 161–72. Berkeley and Los Angeles: University of California Press, 1972.

Weatherill 1986
Weatherill, Lorna. "A Possession of One's Own: Women and Consumer Behavior in England, 1660–1740." *Journal of British Studies* 25 (April 1986): 131–56.

Webster 1979
Webster, Mary. *Hogarth*. London: Studio Vista, 1979.

Weldon 1993
Weldon, Fay. *The Life and Loves of a She Devil*. London: Sceptre, 1993.

West 1999
West, Shearer. "Wilkes's Squint: Synecdochic Physiognomy and Political Identity in Eighteenth-Century Print Culture." *Eighteenth-Century Studies* 32, no. 4 (1999): 65–84.

Wheatley 1989
Wheatley, Ivison. *The Language of the Fan: An Exhibition at Fairfax House, York*. Castlegate and York: York Civic Trust, 1989.

Wilkes 1759
Wilkes, Thomas. *A General View of the Stage*. London: J. Coote, 1759.

Williams 1970
Williams, Eric E. *From Columbus to Castro: The History of the Caribbean, 1492–1969*. London: Deutsch, 1970.

Wilton 1992
Wilton, A. *The Swagger Portrait*. Exh. cat. London: Tate Gallery, 1992.

Woolliscroft 1910
Woolliscroft Rhead, G. *History of the Fan*. London: Keagan, Paul Trubner; Philadelphia: J. B. Lippincott, 1910.

Woolston 1728
Woolston, Thomas. *First Discourse*. London: T. Woolston, 1728.

Contributors

David Bindman, Durning-Lawrence Professor of Art History at University College London, has written books and exhibition catalogues on artists including William Blake, William Hogarth, Henry Fuseli, and John Flaxman. He is general editor of *Blake's Illuminated Books* (William Blake Trust and Princeton University Press). His recent publications include *Roubiliac and the Eighteenth-Century Monument: Sculpture as Theatre* (with Malcolm Baker, 1995) and *Hogarth and His Times: Serious Comedy* (1997), which is also a catalogue of the exhibition he curated, *Hogarth and His Times: Serious Comedy* (British Museum, London, and Berkeley Art Museum, University of California, Berkeley).

Patricia Crown is Professor of Art History and Women's Studies, University of Missouri. She is the author of numerous articles on British visual culture between 1750 and 1850. The original research for "Hogarth's Working Women: Commerce and Consumption" was done while holding a Robert R. Wark Fellowship and curating the exhibition "Images of Women by Hogarth and his Contemporaries" at the Huntington Library, Art Collections and Botanical Gardens, San Marino, California. Crown is currently working on depictions of women in British eighteenth- and nineteenth-century art and on the roles of women in the production and consumption of art, especially book illustration and popular art.

Bernadette Fort is Weinberg College Board of Visitors Research and Teaching Professor of French at Northwestern University. Her research concentrates on eighteenth-century French literature, cultural history, and art criticism. Her publications as author and editor include *Le Langage de l'ambiguïté dans l'oeuvre de Crébillon fils* (1979), *Fictions of the French Revolution* (1991), *The Mémoires secrets and the Culture of Publicity* (with J. Popkin, 1998), and *Les Salons des Mémoires secrets* (1999). In 1997 she organized with Angela Rosenthal a symposium on "Hogarth and His Times Reconsidered" at Northwestern University. Fort is editor-in-chief of the interdisciplinary journal *Eighteenth-Century Studies*.

Mark Hallett teaches in the Department of Art History at the University of York and specializes in the history of British art. His published work includes essays on Canaletto's images of London and on painting in late Georgian England. His chief area of interest over recent years has been the satiric art of the eighteenth century. He is the author of *The Spectacle of Difference: Graphic Satire in the Age of Hogarth* (1999) and *Hogarth* (2000). He is currently working on the exhibition culture of late-eighteenth-century London and the satirical works of James Gillray.

Lubaina Himid is Reader in Contemporary Art at the University of Central Lancashire, U.K. She is a writer, curator, scholar, and visual artist. She has organized several groundbreaking exhibitions, notably "Five Black Women At the African Center" (1983, King Street, Covent Garden, London), "Black Women Time Now" (1983, Battersea Arts Centre, London), and especially "The Thin Black Line" (1985, Institute of Contemporary Art [ICA], London), which established her as a leading figure within the British feminist art movement. Her own works have been exhibited, among other places, at the Tate Gallery St. Ives, the Steinbaum Krauss Gallery, New York, and the 5th Biennale of Havana, Cuba. Her work is in permanent collections at the Tate Gallery, London, and the Arts Council of Great Britain.

Christina Kiaer is Assistant Professor of Art History at Columbia University, where she specializes in modern art. Her main areas of interest are Soviet and feminist art. She is currently preparing a book on the "socialist objects" of Russian Constructivism. She co-organized a conference on Hogarth at Columbia University in 1998.

Frédéric Ogée is Professor in the English Department of the Université Paris VII-Denis Diderot, where he teaches British eighteenth-century literature and art. He has published on writers and artists of the period, and edited two volumes on Hogarth: *The Dumb Show: Image and Society in the Works of William Hogarth* (1997) and *Hogarth: Representing Nature's Machines* (in collaboration with David Bindman and Peter Wagner, forthcoming). In 1997, he co-organized with Peter Wagner an international conference and an exhibition at the William Andrews Clark Library (UCLA) to mark the tercentenary of Hogarth's birth.

Sarah Maza is Jane Long Professor of Arts and Sciences at Northwestern University and a specialist in the social and cul-

Contributors

tural history of eighteenth- and nineteenth-century France. She is the author of *Servants and Masters in Eighteenth-Century France* (1983) and *Private Lives and Public Affairs: The Causes Célèbres of Prerevolutionary France* (1993). She is currently writing a book on the bourgeoisie in the French social imaginary.

Richard Meyer, Assistant Professor of Art History at the University of Southern California, specializes in twentieth-century art and the history of photography. His scholarly work focuses on questions of gender and sexuality within modern art and visual culture. In 1996, Meyer curated the exhibition "Paul Cadmus: The Sailor Trilogy" for the Whitney Museum of American Art, New York. His book, *Outlaw Representation: Censorship and Homosexuality in Twentieth-Century American Art*, will be published by Oxford University Press in 2001.

Amelia Rauser is Assistant Professor of Art History at Skidmore College, New York. A specialist in eighteenth-century British political prints, she is currently working on the emergence of caricature as the dominant visual language of popular political satire at the end of the eighteenth century, studying the links between this new visual mode and emergent Romantic notions of the self and its representations.

Angela Rosenthal is Assistant Professor of Art History at Dartmouth College. She is the author of *Angelika Kauffmann: Bildnismalerei im 18. Jahrhundert* (Reimer, 1996), a book presently being reworked for publication in English. Her articles on contemporary art and on eighteenth- and nineteenth-century visual culture have appeared in *Art History*, *Kritische Berichte*, as well as other journals and anthologies. Rosenthal is coeditor of the German feminist art journal *Frauen Kunst Wissenschaft* and has curated and cocurated a number of exhibitions, including "William Hogarth and Eighteenth-Century Print Culture" (Northwestern University, 1997). She is working on a project addressing race and eighteenth-century European art.

Sean Shesgreen, Professor of English at Northern Illinois University, DeKalb, Illinois, is a specialist on Hogarth and early-modern prints. Among his publications are *Engravings by Hogarth* (1973), *Hogarth and the Times-of-The-Day Tradition* (1983), and *The Criers and Hawkers of London: Engravings and Drawings by Marcellus Laroon* (1990). He is completing a study entitled *Images Of The Outcast: The Urban Poor In The London Cries, 1600–1900*.

David Solkin is Reader in History of Art at the Courtauld Institute of Art, University of London. He is the author of *Painting for Money: The Visual Arts and the Public Sphere in Eighteenth-Century England* (1993) and is currently writing a book on masculinity in eighteenth- and nineteenth-century British narrative art. Dr. Solkin is also editing a volume of essays, *'A Rage for Exhibitions': Displaying Modern Art in Somerset House, 1780–1836*, to be published in conjunction with a major exhibition to be held at the Courtauld Gallery during the autumn and winter of 2001–2.

Nadia Tscherny is an independent scholar and curator who writes primarily on eighteenth- and nineteenth-century British portraiture. She was assistant curator at the Frick Collection in New York and has curated several exhibitions, including "Romney's 'Flaxman Modeling the Bust of Hayley'," (Yale Center for British Art, New Haven, Connecticut). She is the author of *The Frick Collection: A Guide to Works of Art on Exhibition* (1989) and coauthor of *Paintings from the Frick Collection* (1990). Her most recent book is *Romance and Chivalry: History and Literature Reflected in Early Nineteenth-Century French Painting* (1996).

James Grantham Turner is Professor of English at the University of California, Berkeley. In addition to editing Robert Paltock's *Life and Adventures of Peter Wilkins* (1990) and two collections of essays, he has written numerous articles on seventeenth- and eighteenth-century culture (including an essay on Stourhead in *Art Bulletin*) and two books: *The Politics of Landscape: Rural Scenery and Society in English Poetry, 1630–1660* (1979) and *One Flesh: Paradisal Marriage and Sexual Relations in the Age of Milton* (1987; second edition 1994). *Libertines and Radicals in Early Modern London: Sexuality, Politics and Literary Culture, 1630–1685* is forthcoming from Cambridge University Press.

Peter Wagner is Professor of English and American Literature at Universität Koblenz-Landau in Landau, Germany. His publications in English include numerous essays and volumes on seventeenth-century American Puritanism, Enlightenment erotica, text-image relations, and Hogarth. He is the editor of *Erotica and the Enlightenment* (1991) and *Icons-Texts-Iconotexts: Essays on Ekphrasis and Intermediality* (1996) and the author of *Eros Revived: Erotica of the Enlightenment in England and America* (1988) and *Reading Iconotexts: From Swift to the French Revolution* (1995). He is currently working on verbal-visual representations of women in the eighteenth century.

Index

Index

Photography Credits

Albright-Knox Art Gallery, Buffalo, New York (fig. 20)

Photograph © 1998, The Art Institute of Chicago. All Rights Reserved (fig. 50)

Courtesy of the Trustees of the Ashmolean Museum, Oxford (fig. 78)

By permission of The British Library, London (figs. 52, 54, 57, 61, 63)

© Copyright The British Museum, London (figs. 4, 7, 12, 25, 42, 49, 55, 62, 65, 68, 77, 99–106, 108, 109)

Charles Deering McCormick Library of Special Collections, Northwestern University Library, Evanston, Illinois (fig. 16)

Courtesy of Christie's, London (fig. 19)

Cincinnati Art Museum (fig. 23)

English Heritage Photo Library, London (fig. 111)

Courtesy of the Fitzwilliam Museum, Cambridge, England (fig. 26)

Copyright The Frick Collection, New York (fig. 86)

Glasgow Museums, Art Gallery and Museum, Kelvingrove (fig. 5)

Courtesy of Guildhall Library, Corporation of London (fig. 64)

Courtesy of Lubaina Himid (figs. 119–25, 127–29)

Hood Museum of Art, Dartmouth College, Hanover, New Hampshire, photo Jeffrey Nintzel (figs. 18, 36, 38, 43, 46–48, 70, 73, 74, 76, 79, 114–16, pls. M1–M6)

Reproduced by permission of The Henry E. Huntington Library, San Marino, California (figs. 24, 89, 93–95, 98)

Courtesy of the Print Collection, Lewis Walpole Library, Yale University, Farmington, Connecticut (figs. 15, 17, 21, 22, 27, 28, 40, 44, 45, 71, 80–85, 117, 126)

Courtesy of the Library of Congress, Washington, D.C. (fig. 107)

All rights reserved, The Metropolitan Museum of Art, New York (fig. 59)

Courtesy, Museum of Fine Arts, Boston. Reproduced with permission. © 2000 Museum of Fine Arts, Boston. All rights reserved (fig. 41)

© National Gallery, London (figs. 97, 118)

© National Maritime Museum, London (figs. 110, 113)

Courtesy of the Paul Mellon Centre, London (fig. 112)

Rijksprentenkabinet, Rijksmuseum Amsterdam (fig. 53)

Courtesy of the Romanian National Museum of Art, Budapest (fig. 69)

The Royal Collection © 1999 Her Majesty Queen Elizabeth II (fig. 6)

Photograph courtesy of Sotheby's, London (fig. 87)

Tate, London 2000 (figs. 56, 88)

University of California, Berkeley Art Museum, photo Benjamin Blackwell (figs. 1, 3, 8–11, 13, 14, 34, 35, 39, 51, 60, 66, 67, 72, 90, 91, 96, pls. H1–H6, R1–R8)

University of California, The Bancroft Library, Berkeley (fig. 2)

Reproduced by permission of the University of York Library (fig. 58)

Collection of Peter Wagner. Photo by Fotolabor, Universität Koblenz-Landau, Abteilung Landau, Koblenz, Germany (figs. 29–33, 37)

All rights reserved (figs. 75, 92)

WITHDRAWN BRITISH MUSEUM 2001